8E

UNDERSTANDING ART

Lois Fichner-Rathus

The College of New Jersey

THOMSON

WADSWORTH

Australia • Brazil • Canada • Mexico • Singapore • Spain
United Kingdom • United States

THOMSON
WADSWORTH

Understanding Art, Eighth Edition
Lois Fichner-Rathus

Publisher: Clark Baxter
Acquisition Editor: John R. Swanson
Development Editor: Sharon Adams Poore
Assistant Editor: Anne Gittinger
Editorial Assistant: Allison Roper
Technology Project Manager: David Lionetti
Senior Marketing Manager: Mark Orr
Marketing Assistant: Alexandra Tran
Marketing Communications Manager: Stacey Purviance
Senior Project Manager, Editorial Production: Kimberly Adams
Creative Director: Rob Hugel
Executive Art Director: Maria Epes

Print Buyer: Barbara Britton
Permissions Editor: Joohee Lee
Production Service: G & S Book Services
Text Designer: tani hasegawa
Photo Researcher: Linda Sykes
Copy Editor: Cynthia Lindlof
Cover Designer: tani hasegawa
Cover Image: Wolfgang Volz / Redux Pictures
Cover Printer: Phoenix Color Corp
Compositor: G & S Book Services
Printer: Courier Corporation / Kendallville

Printed in the United States of America
1 2 3 4 5 6 7 10 09 08 07 06

Library of Congress Control Number: 2005931874

Student Edition: ISBN 0-495-00692-0

Thomson Higher Education
10 Davis Drive
Belmont, CA 94002-3098
USA

For more information about our products, contact us at:
Thomson Learning Academic Resource Center
1-800-423-0563
For permission to use material from this text or product, submit a request online at **http://www.thomsonrights.com.**
Any additional questions about permissions can be submitted by e-mail to **thomsonrights@thomson.com.**

CONTENTS

YOUR MULTIMEDIA RESOURCES

Chapter 1

ThomsonNOW™

ArtExperience 2.0 CD-ROM

Flashcards

A Closer Look—A Portrait in the Flesh

Compare + Contrast—The *Piano Lesson*(s) by Henri Matisse and Romare Bearden

Field Trips—Leonardo's *Mona Lisa,* Michelangelo's *Moses**

Art Project—The Purposes of Art*

Pretest, Personalized Study Plan, post test, pod casts*

Companion Site
http://art.wadsworth.com/Fichner-Rathus_8e

Chapter 1 Quiz, InfoTrac® College Edition Readings and Exercises, Talking Flashcards, and more

Chapter 2

ThomsonNOW™

ArtExperience 2.0 CD-ROM

Flashcards

A Closer Look—Picasso's *Les Demoiselles d'Avignon* with Colescott's *Les Demoiselles d'Alabama Vestidas*

Foundations—Visual Elements

Field Trip—The Palace of Fine Arts, Botticelli's *The Birth of Venus,* Brandt's *Mondrian Variations, Nationale-Nederlanden Building,* Monet's *Haystack at Sunset Near Giverny**

Art Project—Walking Your Pen*

Companion Site
http://art.wadsworth.com/Fichner-Rathus_8e

Chapter 2 Quiz, InfoTrac® College Edition Readings and Exercises, Talking Flashcards, and more

Chapter 3

ThomsonNOW™

ArtExperience 2.0 CD-ROM

Flashcards

A Closer Look—Claes Oldenburg: On Clothespins, Baseball Bats, and Other Monuments

Foundations—Principles of Design

Field Trips—Niki de Saint-Phalle's *Stravinsky Fountain,* Michelangelo's *The Fall of Man**

Art Project—Balance, Focal Point, and Rhythm*

Pretest, Personalized Study Plan, post test, pod casts*

Companion Site
http://art.wadsworth.com/Fichner-Rathus_8e

** only available on* **ThomsonNOW™**

Chapter 3 Quiz, InfoTrac® College Edition Readings and Exercises, Talking Flashcards, and more

Chapter 4

ThomsonNOW™

ArtExperience 2.0 CD-ROM

Flashcards

Compare + Contrast—Wood's *American Gothic* with Rosenthal's *He Said . . . She Said*

Compare + Contrast—David's *The Oath of the Horatii* with Kruger's *Untitled: We Don't Need Another Hero*

Foundations—Style, Form, and Content

Art Project—Formal Analysis of *The Birth of Venus**

Pretest, Personalized Study Plan, post test, pod casts*

Companion Site
http://art.wadsworth.com/Fichner-Rathus_8e

Chapter 4 Quiz, InfoTrac® College Edition Readings and Exercises, Talking Flashcards, and more

Chapter 5

ThomsonNOW™

ArtExperience 2.0 CD-ROM

Flashcards

A Closer Look—Life, Death, and Dwelling in the Deep South

A Closer Look—Paper Dolls for a Post-Columbian World

In the Studio—Drawing

Art Project—Contour Drawing*

Pretest, Personalized Study Plan, post test, pod casts*

Companion Site
http://art.wadsworth.com/Fichner-Rathus_8e

Chapter 5 Quiz, InfoTrac® College Edition Readings and Exercises, Talking Flashcards, and more

Chapter 6

ThomsonNOW™

ArtExperience 2.0 CD-ROM

Flashcards

A Closer Look—The George Washingtons of Stuart and Lichtenstein

A Closer Look—Super Heros: East Meets West

In the Studio—Painting

Art Project—Different Kinds of Paint*

Pretest, Personalized Study Plan, post test, pod casts*

Companion Site
http://art.wadsworth.com/Fichner-Rathus_8e

Chapter 6 Quiz, InfoTrac® College Edition Readings and Exercises, Talking Flashcards, and more

*only available on **ThomsonNOW™**

Chapter 14

Chapter 15

Chapter 16

Chapter 17

Chapter 18

Chapter 19

Chapter 20

*only available on **ThomsonNOW***

PREFACE

Everyone wants to understand art. Why not try to understand the song of a bird?
Why does one love the night, flowers, everything around one without trying
to understand them? But in the case of a painting, people have to understand.

—Pablo Picasso

There is a note of frustration in Picasso's statement, reflecting perhaps the burden of having to explain his paintings to viewers who were trying desperately to understand them. Perhaps he was concerned that some of the "indescribable" in art, that which mesmerizes, enchants, frightens, and delights, would be, quite literally, lost in translation. Maybe he was guarding against affixing meaning to his work that he as the artist never intended. Picasso seems to suggest, in this quote, that mystery enhances experience and that too much knowledge will compromise the authenticity of the relationship between art and the viewer. Do you think Picasso was right?

Here we are, together, embarking on the study of art and art history between the covers of a book called *Understanding Art*. Maybe we can declare Picasso's view half right, and it can serve as our cue for how to confront what we are about to see. A textbook on art is not like a textbook in other academic disciplines. Yes, there is a special vocabulary of art. Yes, this vocabulary is woven into a language that, once learned, enables us to better verbalize the visual. But the most important aspect of an art book is its images, because a student's journey toward understanding art ought to always begin with looking.

Think of this art appreciation textbook as your "*i*-book"—it begins with looking at *i*mages. Having said that, *learning to look* is equally important for art appreciation, and that's where some other "*i*-words" play an important role: *i*nformation, *i*nsight, and *i*nterpretation. We gather information about how a work of art is

conceived and constructed using visual elements, design principles, composition, content, style, symbolism. We explore the motives of artists and the historical, social, political, even personal contexts in which a work of art came into existence. These investigations will lend insight into the complex factors contributing to the creation of works of art. And as we gather confidence in our knowledge and insights, we will turn more comfortably to the dimension of interpretation, your dimension. It is here where the "I" really counts, for we all bring the weight of our own experience to our interpretations, our unique perceptions to our likes or dislikes of a work of art.

Picasso said, in the same interview, "People who try to explain pictures are usually barking up the wrong tree." The words *explain* and *understand,* though, have very different meanings. One can argue that only artists can *explain* their work, can make intelligible something that is not known or not understood. But *understanding* is defined as full awareness or knowledge that is arrived at through an intellectual or emotional process—including the ability to extract meaning or to interpret. The ability to *appreciate,* or to perceive the value or worth of something from a discriminating perspective, then, is the consummate reward of understanding.

The Approach of *Understanding Art*

The eighth edition of *Understanding Art,* like earlier editions, remains a textbook that is intended to work both for students and professors. *Understanding Art* continues to serve as a tool to help organize and enlighten this demanding, often whirlwindlike course. My goal has been to write a book that would do it all: edify and inform students and, at the same time, keep them engaged, animated, and inspired while meeting the desire of instructors for comprehensive exposition. All in all, *Understanding Art* contains a fully balanced approach to appreciating art. The understanding and appreciation of art are enhanced by familiarity with three areas of art: the language of art (visual elements, principles of design, and style), the nature of the media used in art, and the history of art.

Features

The eighth edition of *Understanding Art* contains unique features that stimulate student interest, emphasize key points in art fundamentals and art history, highlight contemporary events in art, and reflect the ways in which professors teach.

Compare and Contrast™ These features show two or more works of art side by side and phrase questions that help students focus on stylistic and technical similarities and differ-

ences. They parallel the time-honored pedagogical technique of presenting slides in class for comparison and contrast. For example, "Compare and Contrast Wood's *American Gothic* with Rosenthal's *He Said . . . She Said*" in Chapter 4 shows how artists may use different styles to illustrate themes about similar subjects.

Among the additions to the eighth edition, we compare and contrast the *Piano Lesson* by Henri Matisse with that of Romare Bearden (Chapter 1) and the *Susannah and the Elders* of Tintoretto with that of Gentileschi (Chapter 16). The feature on the *Piano Lesson*(s) shows how artists use various methods of composition to impose order on the elements in a work of art. Tintoretto and Gentileschi tell more or less the same biblical story about Susannah, but we see that in Tintoretto's version, Susannah could be viewed as something of a temptress, whereas Artemisia Gentileschi portrays Susannah as a victim of prying eyes and lies.

Exercises on both the CD-ROM and ThomsonNOW include interactive exercises directly linked to all the Compare and Contrast features.

A Closer Look These features offer insights into artists' personalities and delve into various topics in greater depth. In chapter 5, "Life, Death, and Dwelling in the Deep South" highlights an African American artist's portrayal of the organic relationship between a woman and her home in South Carolina. "Paper Dolls for a Post-Columbian World," also in Chapter 5, shows how a Native American artist uses biting humor to display some of the "gifts" of European Americans to Native Americans. In Chapter 18, "Why Did van Gogh Cut Off His Ear?" offers a number of explanations, including psychodynamic hypotheses, for why the Postimpressionist mutilated himself.

Among the new A Closer Look features in the eighth edition we find "Christo and Jeanne-Claude: *The Gates, Central Park, New York City, 1979–2005*" (Chapter 9) and "King Tut: The Face That Launched a Thousand High-Res Images" (Chapter 12). These features, like several others, highlight important events in art. In the case of *The Gates,* we have a monumental installation that transformed the winter heart of the city of New York. With the feature on King Tut, we describe how contemporary scanning techniques have helped us form a picture of the face of a ruler who lived some 3,300 years ago.

A Closer Look is also expanded upon further through the CD-ROM and ThomsonNOW.

ArtTour™ The eighth edition includes eight ArtTours on the cities of New York, Chicago, Washington D.C., Jerusalem, Rome, Dallas/Fort Worth, London, and Paris. Each ArtTour is rich in photographs and works of art. The

ArtTours are no mere lists of works and sites and museums in these cities. Instead, the tours literally walk students through the cities, providing them with routes they can take to benefit from the cultural riches that are available.

The new ArtTours on Chicago and Dallas/Fort Worth, in the north-central and south-central parts of the United States, will help many students appreciate the art and architecture that are situated close to home.

The companion CD-ROM and ThomsonNOW expand on the ArtTours with helpful "travel-guide" information, such as additional photos, maps, restaurant guides, and links to useful web pages. The tours are meant to encourage students to travel as well as to guide them once they have reached their destinations.

Quotations Quotations at the top of pages by artists, critics, and others allow students to "get into the minds" of artists and others in the art world. For example, Chapter 20, "Contemporary Art," includes quotations by Joseph Kosuth, Adolph Gottlieb, Lee Krasner, Willem de Kooning, Agnes Martin, Henry Moore, Jean Tinguely, Daniel Libeskind, http://www.designboom.com/portrait/beecroft.html (on the performance art of Vanessa Beecroft), Ken Feingold, Sarah Lucas, William Pope.L, and Kara Walker.

Glossary Key terms are boldface in the text and defined in a glossary at the end of the textbook. A "Talking Glossary" also appears on the companion website.

The Contents of the Eighth Edition of *Understanding Art*

The eighth edition of *Understanding Art* contains many new images ranging from ancient times to the present day, such as new views of the Egyptian pharaoh Tutankhamen, the grand chambers and halls of the Vatican captured by the news media when Pope Benedict XVI was elected, and new buildings by Santiago Calatrava and David Childs/Daniel Liebeskind under development for "Ground Zero" in Manhattan.

The book is organized into the following parts:

I. Introduction The first chapter of the text, "What Is Art?" helps the student arrive at a definition of art by discussing the things that art does, from enhancing our environment to protesting injustice and raising social consciousness.

II. The Language of Art Chapters 2–4 provide comprehensive discussion of the visual elements of art, principles of design, and style, form, and content. The language of art is then applied throughout the remainder of the text in discussions of media and surveys of art through the ages and throughout the world.

III. Two-Dimensional Media Chapters 5–8—on drawing, painting, printmaking, and imaging—explain how artists combine the visual elements of art to create two-dimensional compositions. The media discussed are as traditional as drawing a pencil across a sheet of paper and as innovative as spray painting color fields and clicking a mouse to access a menu of electronic techniques and design elements.

IV. Three-Dimensional Media Chapters 9–11 discuss the opportunities and issues provided by three-dimensional art forms, including sculpture, architecture, and craft and design.

V. Art through the Ages Chapters 12–17 contain a solid core of art history on the development of art from ancient times to the dawn of the modern era. Chapter 17, "Art beyond the West," introduces students to art forms beyond the Western tradition, for example, the art of Africa, the South Pacific, and the Americas; the Islamic art of the Near, Middle, and Far East; Indian art; and the art of China and Japan. The chapter offers a broadening experience, as students learn that much of this art cannot be appreciated by means of the same concepts and standards that are applied to Western Art.

VI. Art in Modern and Postmodern Times Chapters 18–20 examine the great changes that have occurred in the world of art since the late eighteenth century. These chapters attempt to answer the question, "Just what is modern about modern art?" Whereas some artists have rejected the flatness of the canvas and moved art into innumerable new directions, some have maintained traditional paths. Controversy and conflict are part of the modern history of art. But movements such as Postmodern art and Deconstructivist architecture also make it possible to speak of the "modern world and beyond." Although nobody can say exactly where art is going, these chapters discuss the various movements and works that appear to be most vital at the current moment.

Student Resources

ArtExperience 2.0 **CD-ROM** This book-specific CD-ROM, which may be packaged with every new copy of the book, gives students interactive, hands-on experience and access to a host of technology resources in six modules to help them understand art (see page viii for a chapter-by-chapter list).

Foundations. Divided into three subtopics—Visual Elements, Principles of Design, and Style, Form, and Con-

tent—this section includes interactive exercises using line art and fine art images to demonstrate the points of the text.

In the Studio. This section features video footage of actual studio art classes so that students can get a peek at the art-making process. Each clip includes interviews of both students and instructors. Classes include drawing, painting, lithography, wheelworking, sculpture-plastercasting, architecture, and glassblowing.

Compare and Contrast. This section expands on the text features with quizzes that allow students to check their understanding.

Flashcards. This section allows students to make flashcards to create study sets using the images from within the text. Students can hide or show the caption information for review purposes. Most of the images in the text are available as digital flashcards.

A Closer Look. Expanding on A Closer Look features in the book, this section offers students web links to further resources on the topic discussed.

ArtTours. Additional photos, maps, restaurant guides, and links to helpful web pages are supplied for further touring.

ThomsonNOW for Fichner-Rathus's *Understanding Art,* **Eighth Edition** ThomsonNOW is a web-based study system that saves time for students and instructors by providing a complete package of diagnostic quizzes (pretests and posttests, a personalized study plan, the contents of the CD-ROM, and a grade book for instructors). Thomson-NOW utilizes an intelligent and pedagogically accurate system to help students formulate a personalized study plan based on their current understanding of course material. Professors can track their students' progress via a grade book, which is compatible with WebCT and Blackboard course management systems.

On the ThomsonNOW product, students will also find the following features: ArtTours to supplement the ArtTours from the text; brief "Field Trips," which include photos of Monet's garden at Giverny, the Piazza della Signoria in Florence, and Olmsted's Central Park in New York City; Art Projects; and Study Notes offering brief outlines of the central concepts.

Companion Website Students and professors using *Understanding Art* will also benefit from the book's dynamic interactive website. The website will help students grasp the material of the text and also link them to the world of art. The following features are found on the website: tutorial quizzing; InfoTrac® College Edition exercises; Internet activities; artist flashcards and glossary flashcards with pronunciations; and more (see page viii for a chapter-by-chapter list).

Study Guide The *Study Guide* by Ruth Pettigrew (Colorado State University) helps students learn the terms, works of art, and concepts in each chapter. The assignments and projects foster an understanding of art in different media, time periods, and styles. Sections of the *Study Guide* include "Understanding Concepts," "Making Connections," "Enhancing Your Observational Powers," and "Preparing for Tests."

Thinking and Writing about Art *Thinking and Writing about Art,* written by Lois Fichner-Rathus, enhances students' critical thinking and interpretive skills.

SlideGuide with Student Test Packet The *SlideGuide with Student Test Packet* helps students learn and study more effectively inside and outside the classroom. The *SlideGuide* allows students to take notes alongside representations of the art images shown in class, and the *Student Test Packet* offers a practice test with complete answers for each chapter of the book.

InfoTrac College Edition InfoTrac College Edition may be packaged for free with every new copy of this book. Upon instructors' request, students receive a four-month subscription to this extensive online library, opening the door to the full text (not just abstracts) of countless articles from thousands of publications, going back more than 20 years.

Instructor Resources

Multimedia Manager with Instructor's Resources and JoinIn™ on Turning Point® This CD-ROM set contains everything instructors need to prepare for class, present innovative lectures, and create quizzes and tests. The Multimedia Manager CD-ROM set includes the following resources for instructors:

High-quality digital images show the maps, diagrams, and fine art images presented in the text.

Microsoft® PowerPoint® lecture outlines include maps and images and can be used as they are or adapted by instructors.

The *Instructor's Manual* features summaries and methods for approaching each chapter.

The *Test Bank* includes multiple-choice, matching, short answer, and essay questions formatted for use with ExamView® Computerized Testing. ExamView offers a Quick Test Wizard and an Online Test Wizard—step-by-step guides through the process of creating tests. The software's unique capability shows instructors the test on-screen exactly as it will print or display online. Tests can include up to 250 questions with as many as 12 question types. ExamView's complete word-processing capabilities allow entry

of an unlimited number of new questions and editing of existing questions.

Image-specific questions for use with JoinIn on Turning Point software enable professors to pose questions in their lectures that students can respond to with personal response systems, or "clickers." Questions specifically created for use with this software are provided alongside images from *Understanding Art* on Microsoft PowerPoint slides.

The *Resource Integration Guide* offers instructors a chapter-by-chapter breakdown of all the supplementary resources for *Understanding Art.*

Slide Set A set of slides contains 150 select, high-quality images from the text.

WebTutor™ on Blackboard and WebCT WebTutor on WebCT and Blackboard provides text-specific, preformatted content and total flexibility for easily creating and managing a personal website. WebTutor's course management tool gives instructors the ability to provide virtual office hours, post syllabi, set up threaded discussions, track student progress with the quizzing material, and much more. For students, WebTutor offers real-time access to a full array of study tools also found on the book companion website.

Acknowledgments

I consider myself fortunate to have studied with a fine group of artists, art historians, and art professionals who helped shape my love of art and my thinking about art throughout my career. *Understanding Art* would not have taken its present form and might not have come into being without the broad knowledge, skills, and dedication of James S. Ackerman, Stanford Anderson, Wayne V. Anderson, Whitney Chadwick, Michael Graves, George Heard Hamilton, Ann Sutherland Harris, Julius S. Held, Sam Hunter, Henry A. Millon, Konrad Oberhuber, John C. Overbeck, Michael Rinehart, Andrew C. Ritchie, Mark W. Roskill, Theodore Roszak, Miriam Schapiro, Bernice Steinbaum, and Jack Tworkov.

I'd like to thank the following people for contributing to the ancillary package for the eighth edition, William Allen, Arkansas State University; Cynthia Andreas, Lynn University; Patricia Belleville, Eastern Illinois University; Joy Bertinuson, American River College; Lynn Metcalf, St. Cloud State University; Kate Plowden, Piedmont Technical College; Ruth Pettigrew, Colorado State University; and Gay Sweely, Eastern Kentucky University.

I also wish to thank those reviewers who helped in revising this edition: Patricia Belleville, Eastern Illinois University; Phyllis Evans, South Texas College; Rosemary Goodell, Baton Rouge Community College; Jennifer

Hecker, SUNY College at Brockport; Lee Stanton, Columbia College of Missouri; and Gay Sweely, Eastern Kentucky University.

The eighth edition of *Understanding Art* is also indebted to the support and expertise of a fine group of Thomson Wadsworth publishing professionals. Let me begin by acknowledging the support of Susan Badger, CEO; Sean Wakely, President; Marcus Boggs, Editor-in-Chief, Humanities; Clark Baxter, Publisher; John R. Swanson, Acquisitions Editor; Sharon Adams Poore, Senior Development Editor; Anne Gittinger, Assistant Editor; Allison Roper, Editorial Assistant; Kim Adams, Senior Production Project Manager; Mark Orr, Senior Marketing Manager; and David Lionetti, Technology Project Manager. I must also acknowledge the tireless professionalism of Gretchen Otto of G & S Book Services who, with her colleagues, has provided the resources to make the eighth edition the finest edition.

Lois Fichner-Rathus
UnderstandingArt@aol.com

About the Author

Lois Fichner-Rathus is Professor of Art in the Art Department of The College of New Jersey. She holds a combined undergraduate degree in fine arts and art history, an M.A. from the Williams College Graduate Program in the History of Art, and a Ph.D. in the History, Theory, and Criticism of Art from the Massachusetts Institute of Technology. Her areas of specialization include contemporary art, feminist art history and criticism, and modern art and architecture. She has authored grants, contributed to books, curated exhibitions, published articles in professional journals, and exhibited her large-format photographic prints. She resides in New York.

The eighth edition of Understanding Art *is dedicated to my daughters—seen here with me on a college field trip to Paris. (From left to right: Jordan, Taylor, the author, Allyn)*

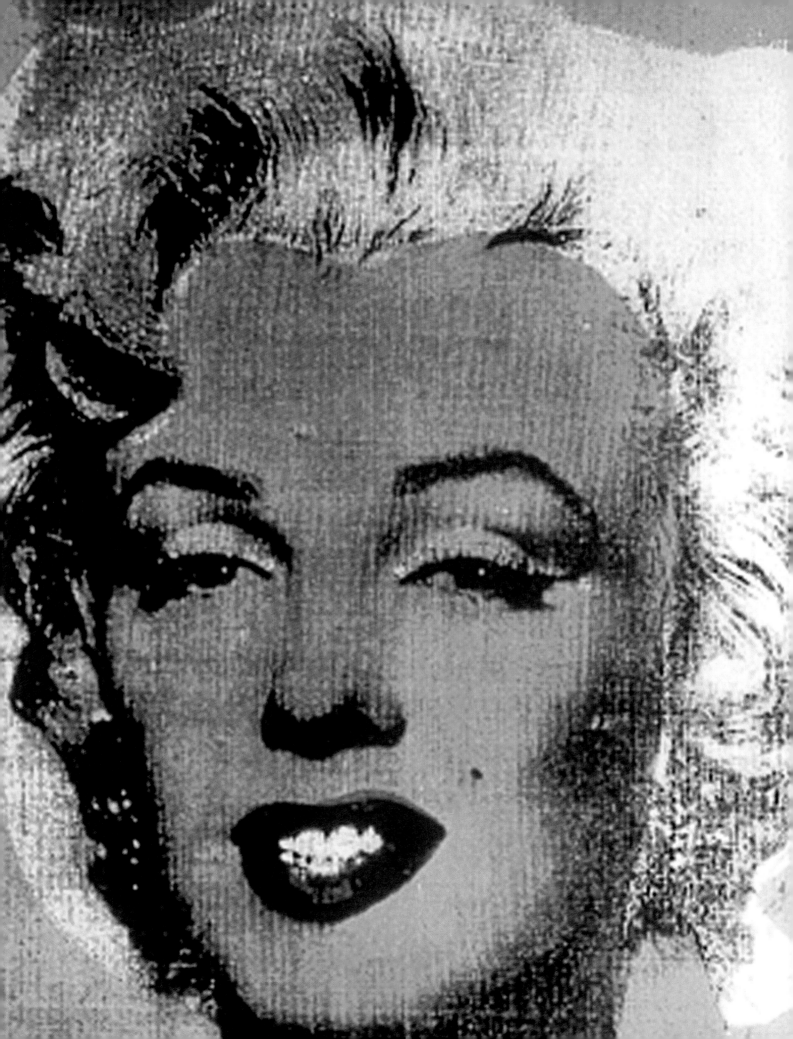

WHAT IS ART?

Everyone wants to understand art. Why not try to understand the song of a bird? Why does one love the night, flowers, everything around one without trying to understand them? But in the case of a painting, people have to understand.

—Pablo Picasso

Beauty, truth, immortality, order, harmony—these concepts and ideals have occupied us since the dawn of history. They enrich our lives and encourage us to extend ourselves beyond the limits of flesh and blood. Without them, life would be but a mean struggle for survival, and the value of survival itself would be unclear.

It is in the sciences and the arts that we strive to weave our experiences into coherent bodies of knowledge and to communicate them. Many of us are more comfortable with the sciences than with the arts. Science teaches us that the universe is not ruled purely by chance. The sciences provide ways of observing the world and experimenting so that we can learn what forces determine the courses of atoms and galaxies. Even those of us who do not consider ourselves "scientific" recognize that the scientific method permits us to predict and control many important events on a grand scale.

The beautiful is in nature, and it is encountered in the most diverse forms of reality.
Once it is found, it belongs to art, or, rather, to the artist who discovers it.

— Gustave Courbet

The arts are more elusive to define, more difficult to gather into a conceptual net. We would probably all agree that the arts enhance daily experience; some of us would contend that they are linked to the very quality of life. Art has touched everyone, and art is all around us. Crayon drawings, paper cutouts, and the like are part of the daily lives of our children—an integral function of both magnet and refrigerator door. We all look for art to brighten our dormitory rooms, enhance our interior decor, beautify our cities, and embellish our places of worship. We are certain that we do not want to be without the arts, yet we are hard pressed to define them and sometimes even to understand them. In fact, the very word *art* encompasses many meanings, including ability, process, and product. As ability, art is the human capacity to make things of beauty and things that stir us; it is creativity. As process, art encompasses acts such as drawing, painting, sculpting, designing buildings, and using the camera to create memorable works. This definition is ever expanding, as materials and methods are employed in innovative ways to bring forth a creative product. As product, art is the completed work—an etching, a sculpture, a structure, a tapestry. If as individuals we do not understand science, we are at least comforted by the thought that others do. With art, however, the experience of a work is unique. Reactions to a work will vary according to the nature of the individual, time period, place, and culture. And although we may find ourselves before a work of art that has us befuddled, saying, "I hate it! I don't understand it!" we suspect that there is something about the very nature of art that transcends understanding.

This book is about the visual arts. Despite their often enigmatic nature, we shall try to share something of what is known about them so that understanding may begin. We do not aim to force our aesthetic preferences on you; if in the end you dislike a work as much as you did to start, that is completely acceptable. But we will aim to heighten awareness of what we respond to in a work of art and try to communicate why what an artist has done is important. In this way, you can counter with, "I hate it, but at least I understand it."

As in many areas of study—languages, computers, the sciences—amassing a basic vocabulary is intrinsic to understanding the material. You will want to be able to describe the attributes of a work of art and be able to express your reactions to it. The language or vocabulary of art includes the visual elements, principles of design, style, form, and content. We shall see how the visual elements of art, such as line, shape, and color, are composed according to principles of design into works of art with certain styles and content. We shall examine many media, including drawing, painting, printmaking, the camera and computer arts, sculpture, architecture, ceramics, and fiber arts.

When asked why we should study history, the historian answers that we must know about the past in order to have a sense of where we are and where we may be going. This argument also holds true for the arts; there is more to art history than memorizing dates! Examining a work in its historical, social, and political context will enable you to have a more meaningful dialogue with that work. You will be amazed and entertained by the ways in which the creative process has been intertwined with world events and individual personalities. We shall follow the journey of art, therefore, from the wall paintings of our Stone Age ancestors through the graffiti art of today's subway station. The media, the forms, the styles, and the subjects may evolve and change from millennium to millennium, from day to day, but uniting threads lie in the persistent quest for beauty or for truth or for self-expression.

Many philosophers have argued that art serves no function, that it exists for its own sake. Some have asserted that there is something about the essence of art that transcends the human occupation with usefulness. Others have held that in trying to analyze art too closely, one loses sight of its beauty and wonderment.

These may be valid points of view. Nevertheless, our understanding and appreciation of art often can be enhanced by asking the questions "Why was this created?" "What is its purpose?" In this section we shall see that works of art come into existence for a host of reasons that are as varied as the human condition. Perhaps we will not arrive at a single definition of art, but we can come to understand art by knowing what art does.

ART CREATES BEAUTY

Art has always added beauty to our lives. At times, the artist has looked to nature as the standard of beauty and has thus imitated it. At other times, the artist has aimed to improve

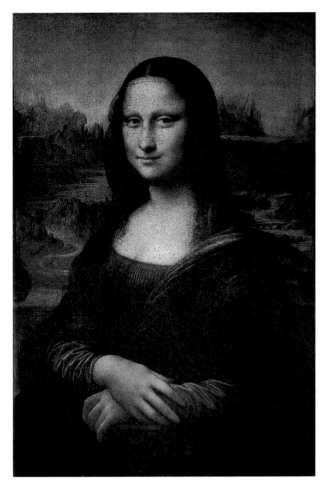

1-1 LEONARDO DA VINCI.
Mona Lisa (c. 1503–1505).
Oil on wood panel. 30¼″ × 21″.
Louvre Museum, Paris/Réunion des Musées Nationaux/Art Resource, New York.

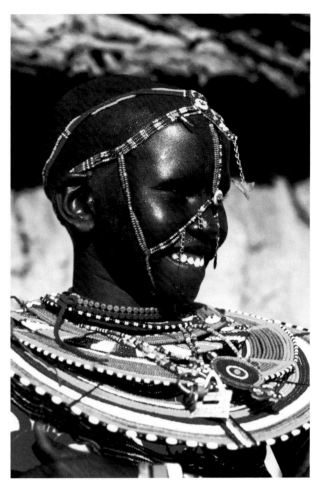

1-2 Kenyan woman, Masai tribe.
Standards for beauty can differ from culture to culture.
Copyright Jim Zuckerman/CORBIS.

upon nature, developing an alternative standard—an idealized form. Standards of beauty in and of themselves are by no means universal. The Classical Greeks were obsessed with their idea of beauty and fashioned mathematical formulas for rendering the human body in sculpture so that it would achieve a majesty and perfection unknown in nature. The sixteenth-century artist Leonardo da Vinci, in what is perhaps the most famous painting in the history of Western art, enchants generations of viewers with the eternal beauty and mysteriousness of the smiling *Mona Lisa* (Fig. 1-1). But appreciation of the stately repose and refined features of this Italian woman is tied to an affinity to a Western standard of beauty. Elsewhere in the world, these very features might seem alien, unattractive, or undesirable. On the other hand, the standard of beauty in some non-Western societies that hold scarification, body painting, tattooing, and adornment (Fig. 1-2) both beautiful and sacred may seem odd and un-

attractive to someone from the Western world. One art form need not be seen as intrinsically superior to the other; in these works, quite simply, beauty is in the eye of the society's beholder.

ART ENHANCES OUR ENVIRONMENT

We have all decided at one time or another to change the color of our bedrooms. We have hung a poster or painting here rather than there, and we have arranged a vase of flowers or placed a potted plant in just the right spot in the room. We may not have created works of art, but we did accomplish one thing: We managed to delight our senses and turn our otherwise ordinary environments into pleasurable havens.

A Portrait in the Flesh

For centuries, artists have devoted their full resources, their lives, to their work. Orlan has also offered her pound of flesh—to the surgeon's scalpel.

Orlan (Fig. 1-3) is a French multimedia performance artist who has been undergoing a series of cosmetic operations to create, in herself, a composite sketch of what Western art has long set forth as the pinnacle of human beauty: the facial features that we find in classic works such as Botticelli's *The Birth of Venus* (Fig. 1-4), Leonardo's *Mona Lisa* (Fig. 1-1), and Boucher's *Europa,* or, more specifically, Venus's chin, the Mona Lisa's forehead, and Europa's mouth.

Most people undergo cosmetic surgery in private, but not Orlan. Several of her operations have been performances or media events. Her first series of operations were carried out in France and Belgium. The operating rooms were filled with symbols of flowering womanhood in a form compatible with medicine: sterilized plastic fruit. There were huge photos of Orlan, and the surgeons and their assistants were decked out not in surgical greens but in costumes created by celebrated couturiers. A recent operation was performed in the New York office of a cosmetic surgeon and transmitted via satellite to the Sandra Gering Gallery in the city's famed SoHo district. Orlan did not lie unconscious in a hospital gown. Rather, she lay awake in a long black dress and read from a work on psychoanalysis while the surgeon implanted silicone in her face to imitate the protruding forehead of *Mona Lisa.*

When will it all end? Orlan says that "I will stop my work when it is as close as possible to the computer composite,"* as the lips of Europa split into a smile. ∎

*Margalit Fox, "A Portrait in Skin and Bone," *New York Times,* November 21, 1993, V8.

1-3 French performance artist Orlan, who has dedicated herself to embodying Western classic beauty as found in the works of Leonardo, Botticelli, and Boucher through multiple plastic surgeries. Here Orlan is being "prepped" for one in a series of operations.
Copyright 2003 Orlan/Artists Rights Society (ARS), New York/ADAGP, Paris.

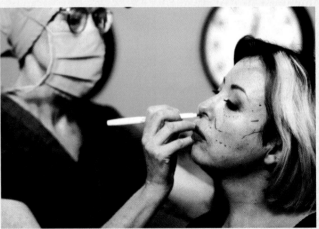

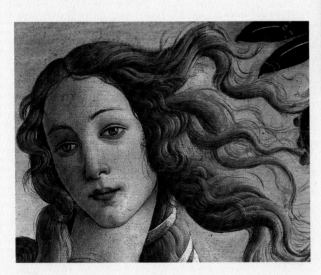

1-4 SANDRO BOTTICELLI.
The Birth of Venus (1486). Detail.
Tempera on canvas. 5'8⅞" × 9'1⅐".
Uffizi Gallery, Florence/Scala/Art Resource, New York.

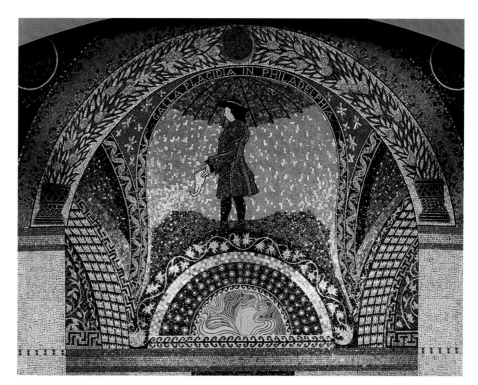

1-5 JOYCE KOZLOFF.
Galla Placidia in Philadelphia
(1985).
Mosaic installation.
13′ × 16′.
Penn Center Suburban Station,
Philadelphia. Courtesy of Henri
Gross, Penn Associates, Philadelphia.

Works of art have been used to create pleasing environments for centuries. Paintings are not merely objects of beauty in themselves; they also hang on walls and can be painted directly on them. Sculptures find their way into rooms, courts, and gardens; photographs are found in books; and fiber arts are seen on walls and floors. Whatever other functions they may serve, many works of art are also decorative. Joyce Kozloff's *Galla Placidia in Philadelphia* (Fig. 1-5), a mosaic for the Penn Center Suburban Station in that city, elevates decorative patterns to the level of fine art and raises the art-historical consciousness of the casual commuter. The original Mausoleum of Galla Placidia is the fifth-century chapel and burial place of a Byzantine empress, a landmark monument known for its complex and colorful mosaics. Kozloff's own intricate and diverse designs dazzle the eye and stimulate the intellect, providing an oasis of color in an otherwise humdrum city scene.

Glass sculptor Dale Chihuly's *Fioridi Como* (Fig. 1-6) is a 70-foot-long ceiling piece that is suspended above the reception area of the Bellagio Hotel in Las Vegas. The visitor must pass under the work—or astutely determine to avoid it—to register at the hotel or stroll into the casino. Chihuly has also "decorated" public spaces with his many chandeliers in places ranging from Venice to the countryside of Washington State. Their common message seems to be "You are now in another place." You can click your heels beneath *Fioridi Como* (the small town of Bellagio, after which the

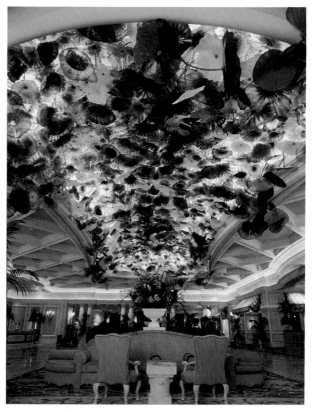

1-6 DALE CHIHULY.
Fioridi Como (1998).
70′ × 30′ × 12′
Bellagio Hotel, Las Vegas, NV. Courtesy of Dale Chihuly, Seattle, WA.

It is the glory and good of Art,
That Art remains the one way possible
Of speaking truths, to mouths like mine at least.

—Robert Browning

hotel is named, lies on the shore of Italy's spectacular Lake Como), but you will find, like Dorothy in *The Wizard of Oz,* that you aren't in Kansas anymore.

ART REVEALS TRUTH

Art is a powerful tool, and the artist knows this well. It can be used to replicate reality in the finest detail, tricking the eye into perceiving truth in imitation. The ancient Greeks, the Renaissance artist, the contemporary Photorealist painter, all, in their way, pursued truth and attempted to reveal it: truth about how the world looks; truth about how the world works. But artists have also reached outward to describe truths about humanity and have reached inward to describe truths about themselves. Sometimes their pursuit has led them to beauty, at other times to shame and outrage. The "ugly truth," just like the beautiful truth, provides a valid commentary on the human condition.

In her self-portraits, the Mexican painter Frida Kahlo used her tragic life as an emblem for human suffering. At the age of 18, she was injured when a streetcar slammed into a bus on which she was a passenger. The accident left her with many serious wounds, including a fractured pelvis and vertebrae, and chronic pain. Kahlo's marriage to the painter Diego Rivera was also painful. She once told a friend, "I have suffered two serious accidents in my life, one in which a streetcar ran over me. . . . The other accident was Diego."[1] As in *Diego in My Thoughts* (Fig. 1-7), her face is always painted with extreme realism and set within a compressed space, requiring the viewer to confront the "true" Frida. When asked why she painted herself so often, she replied, "Porque estoy muy sola" (Because I am all alone). Those who knew Kahlo conjecture that she painted self-portraits in order to "survive, to endure, to conquer death."

Another haunting portrayal of unvarnished truth can be seen in Robert Mapplethorpe's *Self-Portrait* (Fig. 1-8). The veracity of the photographic medium is

[1] Martha Zamora, *Frida Kahlo: The Brush of Anguish* (San Francisco: Chronicle Books, 1990), 37.

1-7 FRIDA KAHLO.
Diego in My Thoughts (Diego y yo) (1949).
Oil on canvas, mounted on Masonite. 24″ × 36″.
Courtesy of Mary-Anne Martin Fine Art, New York.
Copyright 2005 Banco de Mexico Trust.

All passes. Art alone
Enduring stays to us;
The Bust outlasts the throne,
The coin, Tiberius.
—Henry Austin Dobson

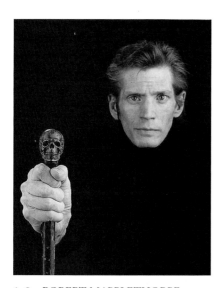

1-8 ROBERT MAPPLETHORPE.
Self-Portrait (1988).
Gelatin silver print.
MAP #1860 copyright 2003 The Robert
Mapplethorpe Foundation. Courtesy of Art &
Commerce Anthology.

In *Four Marilyns* (Fig. 1-9), Pop artist Andy Warhol participated in the cultural immortalization of a film icon of the 1960s by reproducing a well-known photograph of Monroe on canvas. Proclaimed a "sex symbol" of the silver screen, she rapidly rose to fame and shocked her fans by taking her own life at an early age. In the decades since Monroe's death, her image is still found on posters and calendars, books and songs are still written about her, and the public's appetite for information about her early years and romances remains insatiable. In other renderings, Warhol

inescapable; the viewer is forced to confront the artist's troublesome gaze. But the portrait also discloses the truth about Mapplethorpe's battle with AIDS, and perhaps suggests an attempt to reconcile his inevitable death. The artist's skeletal head slips into a background haze while his tightly clenched fist grips a cane with a skull and juts forward into sharp focus. The anger and defiance of Mapplethorpe's whitened knuckles contrast with the soft, almost pained expression of the artist's face.

ART IMMORTALIZES

In the face of certain death, an artist such as Robert Mapplethorpe can defy mortality by creating a work that will keep his talents and his tragedy in the public's consciousness for decades. Human beings are the only species conscious of death, and for millennia, they have used art to overleap the limits of this life.

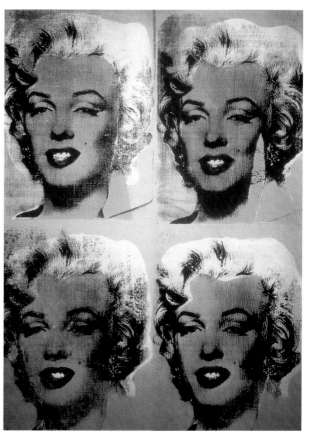

1-9 ANDY WARHOL.
Four Marilyns (1962).
Synthetic polymer paint and silkscreen ink on canvas.
30″ × 23⅞″.
Copyright 2003 Andy Warhol Foundation for the Visual Arts, Inc./
Artists Rights Society (ARS), New York/Art Resource, New York.

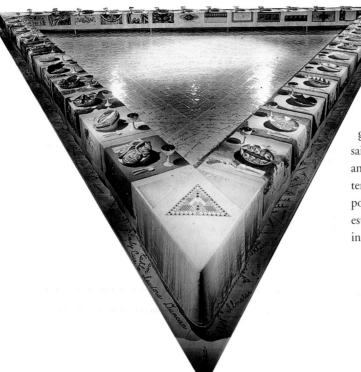

arranged multiple images of the star as if lined up on supermarket shelves, commenting, perhaps, on the ways in which contemporary flesh peddlers have packaged and sold her—in death as well as life.

The lines between life and death, between place and time, are temporarily dissolved in the renowned installation *The Dinner Party* (Fig. 1-10) by feminist artist Judy Chicago. The idea for this multimedia work, which is constructed to honor and immortalize history's notable women, revolves around a fantastic dinner party, where the guests of honor meet before place settings designed to reflect their personalities and accomplishments. Chicago and numerous other women artists have invested much energy in alerting the public to the significant role of women in the arts and society.

ART EXPRESSES RELIGIOUS BELIEFS

The quest for immortality is the bedrock of organized religion. From the cradle of civilization to the contemporary era, from Asia to the Americas, and from the Crimea to the Cameroon, human beings across time and cultures have sought answers to the unanswerable and have salved their souls with belief in life after death. It is not surprising that in the absence of physical embodiments for the deities they fashioned, humans developed art forms to visually render the unseen. Often the physical attributes granted to their gods were a reflection of humans themselves. It has been said, for example, that the Greeks made their men into gods and their gods into men. In other societies, deities were often represented as powerful and mysterious animals, or composite men-beasts. Ritual and ceremony grew alongside the establishment of religions and the representation of deities, in actual or symbolic form. Until modern times, one could

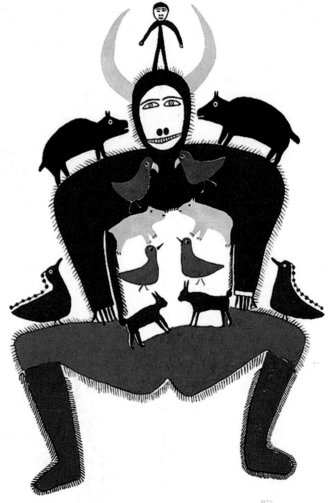

probably study the history of art in terms of works expressing religious values alone.

Art has been used to express hopes for fertility, to propitiate the gods, to symbolize great religious events and values, and to commend heavenward the souls of the departed. Inuit artist Jessie Oonark, who lived in the Canadian Arctic, created the image *A Shaman's Helping Spirits* (Fig. 1-11) as a symbol of the healing rituals associated with the medicine men of her culture. Shamanism is a religion based on a belief in good and evil spirits that can be controlled and influenced only by the power of the shaman, a kind of priest. The strong, flat shapes and bright colors lend a directness and vitality to her expression.

Another artist of color, Aaron Douglas, translated a biblical story into a work that speaks to the African American sensibility. In his *Noah's Ark* (Fig. 1-12), one of seven paintings based on James Weldon Johnson's book *God's Trombones: Seven Negro Sermons in Verse,* Douglas expressed a powerful vision of the great flood. Animals enter the ark in pairs as lightning flashes about them, and the sky turns a hazy gray purple with the impending storm. African men, rendered in rough-hewn profile, ready the ark and direct the action in a dynamically choreographed composition that takes possession of and personalizes the biblical event for Douglas's race and culture.

The spectacular Hagia Sophia (Fig. 1-13) was built as a Christian church in 532–537 CE. After the Ottoman conquest of 1453, it was converted to an Islamic mosque. In contemporary Istanbul, the building serves as a museum. The dome of the ancient church is a wonder. Although it is made of stone, it seems to float on the light that streams through the windows encircling its base like diamonds in a necklace. Light sparkles in the mosaic tiles and is reflected by glistening marble surfaces and ceremonial objects. Intellectually, the visitor may ponder how that monstrous weight is supported and how the dome can have survived century upon century of earthquakes and human assaults. But emotionally, it seems as if paradise is beckoning outside the dome.

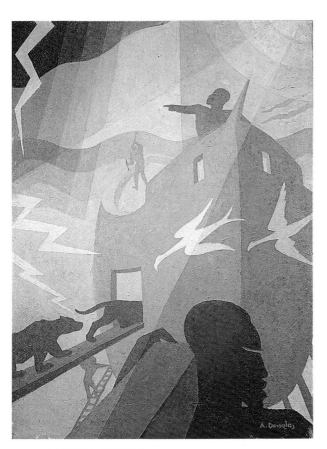

1-12 AARON DOUGLAS.
Noah's Ark (c. 1927).
Oil on masonite. 48″ × 36″.
The Carl Van Vechten Gallery of Fine Arts, Fisk University, Nashville, TN.

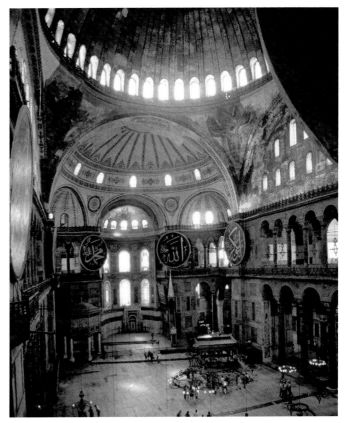

1-13 ANTHEMIUS OF TRALLES AND ISIDORUS OF MILETUS.
Hagia Sophia, Constantinople (modern-day Istanbul), Turkey (532–537 CE).
Interior view.
Copyright Lawrence Manning/CORBIS.

ART EXPRESSES FANTASY

Art also serves as a vehicle by which artists can express their inmost fantasies. Whereas some have labored to reconstruct reality and commemorate actual experiences, others have used art to give vent to their imaginary inner lives. There are many types of fantasies, such as those found in dreams and daydreams or simply the objects and landscapes that are conceived in the imagination. The French painter Odilon Redon once said that there is "a kind of drawing which the imagination has liberated from any concern with the details of reality in order to allow it to serve freely for the representation of things conceived" in the mind. In an attempt to capture the inner self, many twentieth-century artists looked to the psychoanalytic writings of Sigmund Freud and Carl Jung, who suggested that primeval forces are at work in the unconscious reaches of the mind. These artists sought to use their art as an outlet for these unconscious forces, as we shall see in Chapters 19 and 20.

Marc Chagall's self-portrait, *I and the Village* (Fig. 1-14), provides a fragmented image of the artist among fantasized objects that seem to float in and out of one another. Fleeting memories of life in his Russian village are assembled like so many pieces of a dreamlike puzzle, reflecting the very frag-

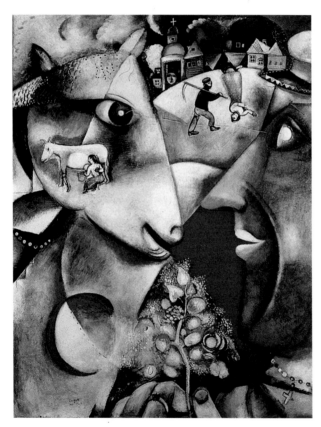

1-14 MARC CHAGALL.
I and the Village (1911).
Oil on canvas. 6′3⅝″ × 4′11⅝″.
The Museum of Modern Art, New York. Mrs. Simon Guggenheim Fund. Copyright The Museum of Modern Art, New York. Licensed by SCALA / Art Resource, New York. Copyright 2003 Artists Rights Society (ARS), New York / ADAGP, Paris.

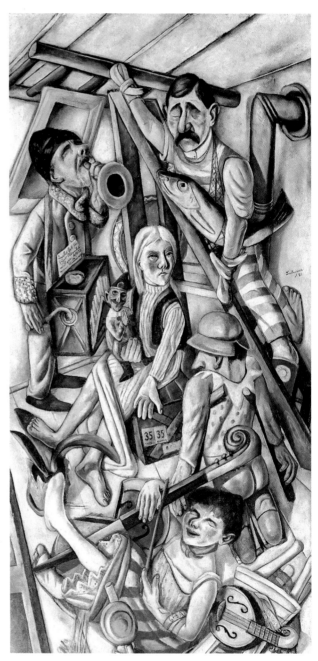

1-15 MAX BECKMANN.
The Dream (1921).
Oil on canvas. 73⅛″ × 35″.
The Saint Louis Art Museum. Bequest of Morton D. May. Copyright 2003 Artists Rights Society (ARS), New York / VG Bild-Kunst, Bonn.

mentary nature of memory itself. Chagall's world is a happy, though private one; the strange juxtaposition of images is reconciled only in the artist's own mind.

A similar process of fragmentation and juxtaposition was employed by German artist Max Beckmann in *The Dream* (Fig. 1-15), but with a very different effect. The suggestion of space and atmosphere in Chagall's painting has given way to a claustrophobic room in which figures are compressed into a zigzag group. The soft, rolling hills and curving lines that gave the village painting its pleasant, dreamy quality have been forfeited for harsh, angular shapes and deformations. Horror hides in every nook and cranny, from the amputated and bandaged hands of the man in red stripes to the blinded street musician and maimed harlequin. Are these marionettes from some dark comedy or human puppets locked in a world of manipulation and hopelessness?

ART STIMULATES THE INTELLECT AND FIRES THE EMOTIONS

Art has the power to make us think profoundly, to make us feel deeply. Beautiful or controversial works of all media can trigger many associations for us. Whether we gaze upon a landscape painting that reminds us of a vacation past, an abstract work that challenges our grasp of geometry, or a quilt that evokes family ties and traditions, it is almost impossible to truly confront a work and remain unaffected. We may think about what the subjects are doing, thinking, and feeling. We may reflect on the purposes of the artist. We may seek to trace the sources of our own emotional response or advance our self-knowledge and our knowledge of the outside world.

Consider Jenny Holzer's installation of **conceptual art** illuminating the interior spiral of New York's Solomon R. Guggenheim Museum (Fig. 1-16). Conceptual art does not necessarily represent only external objects. It also challenges the traditional view of the artist as creative visionary, skilled craftsperson, and master of one's media. The "art" lies in the artist's conception. **Wordworks** such as this seem to comment on the impersonal information systems of modern times, while posing a challenge to the formal premises of art and stirring an intellectual response in the viewer. Holzer's wordworks compel readers to stop and think, sometimes through the presentation of piercing feminist declarations. This particular piece urges readers to reconsider the rules by which they live and warns that sometimes we do not rethink our lives until we are faced with disaster.

At its most extreme, the conceptual art product may exist solely in the mind of the artist, with or without a

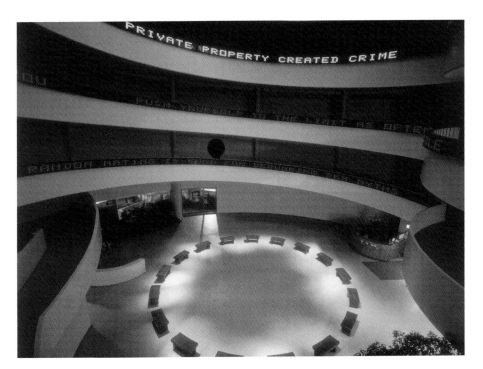

1-16 JENNY HOLZER.
Untitled (1989–1990).
Selection from "Truism: Inflammatory Essays, The Living Series, The Survival Series, Under a Rock, Laments, and Mother and Child Text."
LED electronic display signboard installation. 11″ × 162′ × 44″ (27.9 cm × 49.4 m × 111.8 cm).
Installation at the Solomon R. Guggenheim Museum, New York. Copyright 2003 Jenny Holzer/Artists Rights Society (ARS), New York. Courtesy of the Solomon R. Guggenheim Museum, New York.

Art is harmony.

—Georges Seurat

*I try not to have things look as if chance had brought them together,
but as if they had a necessary bond between them.*

—Jean-François Millet

physical embodiment. Consider these: a wordwork by Robert Barry—

*ALL THE THINGS I KNOW
BUT OF WHICH I AM NOT
AT THE MOMENT THINKING—
1:36 PM; JUNE 15, 1969*

or a concept by artist Lawrence Weiner, sold to a patron, who installed the work himself: "A two-inch wide, one-inch deep trench, cut across a standard one-car driveway."

ART CREATES ORDER AND HARMONY

Artists and scientists have been intrigued by, and have ventured to discover and describe, the underlying order of nature. The Classical Greeks fine-polished the rough edges of nature by applying mathematical formulas to the human figure to perfect it; the nineteenth-century painter Paul Cézanne once remarked that all of nature could be reduced to the cylinder, the sphere, and the cone.

One of the most perfect expressions of order and harmony is found in the fragile Japanese sand garden (Fig. 1-17). These medieval gardens are frequently part of a pavilion complex and are tended by the practitioners of **Zen,** a Buddhist sect that seeks inner harmony through introspection and meditation. The gentle raked pattern of the sand symbolizes water and rocks, mountains reaching heavenward.

Such gardens do not invite the observer to mill about; their perfection precludes walking. They are microcosms, really—universes unto themselves.

When can order pose a threat to harmony and psychological well-being? Perhaps this is the question that Laurie Simmons set out to answer in her color photograph called

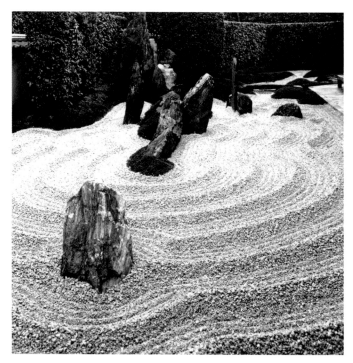

1–17 Ryoanji Zen Temple, Japanese sand garden, Kyoto, Japan.
Copyright 2005 Topfoto/The Image Works.

The *Piano Lesson*(s) by Matisse and Bearden

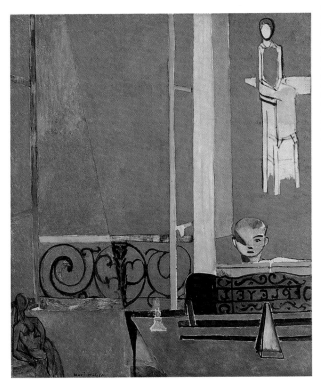

1-18 HENRI MATISSE.
Piano Lesson (1916).
Oil on canvas. 8′½″ × 6′11¾″.

Courtesy of Museum of Modern Art New York. Mrs. Simon Guggenheim Fund. Copyright 2003 Succession H. Matisse, Paris/Artists Rights Society (ARS), New York/Art Resource, New York.

Frequently an artist will use composition, or the arrangement of elements, to impose order. In Henri Matisse's *Piano Lesson* (Fig. 1-18), every object, every color, every line seems to be placed to lead the eye around the canvas. The pea green wedge of drapery at the window is repeated in the shape of the metronome atop the piano, the wrought-iron grillwork at the window is complemented by the curvilinear lines of the music desk, and the enigmatic figure in the upper right background finds her counterpart in a small sculpture placed diagonally across the canvas. Through contrast and repetition, unity within the diversity is achieved. The painting exudes solitude, resulting from the regularity of the compositional elements more than the atmosphere in the room. The boy's face appears quite tense, in fact, under the watchful eye of the seated woman behind him.

With Matisse's painting in mind, does Romare Bearden's *Piano Lesson* (Fig. 1-19) appear then to be an example of disharmony, of disorder? Certainly it is a cacophony of shapes, lines, and unpredictable vantage points. But as in Matisse's painting, color repetition draws the composition's dis-

parate parts together—the red of background is balanced by the touches of red in the costumes of the figures up front; an undulating green strip on the piano is echoed in the billowing green drapes beyond. Ironically, there seems to be a more genuine feeling of serenity, in spite of the jumbled atmosphere. Is it because Matisse's seated woman—not touching? not feeling?—has a more flesh-and-blood counterpart in Bearden's work—a teacher? a mother?—who guides the young girl with the loving placement of a hand on her shoulder? When seen side by side, these paintings convey two different experiences. Matisse's piano student seems a product of his surroundings, a child of privilege partaking in an obligatory cultural ritual. Bearden's student, an African American girl in an apartment decorated catch-as-catch-can, seems to be breaking the bonds of her surroundings through the transcendence of music. ■

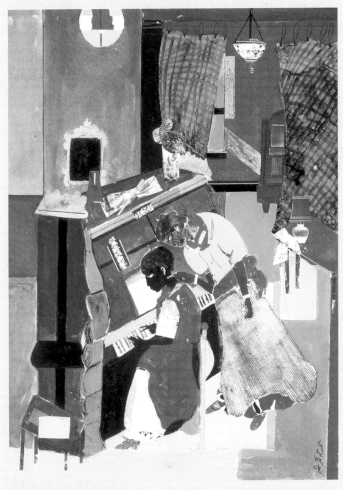

1-19 ROMARE BEARDEN.
Piano Lesson (1983).
Oil with collage.

Collection of Walter O. Evans. Copyright 2005 The Romare Bearden Foundation. Licensed by VAGA, New York.

1-20 LAURIE SIMMONS.
Red Library #2 (1983).
Color photograph. 48½″ × 38¼″.
Collection of the artist. Courtesy of Metro Pictures, New York.

Red Library #2 (Fig. 1-20). Here, in a compulsively organized library, where nothing is a hair out of place, a robot-like woman assesses her job well done. She has become one with her task; even her dress, hair, and skin match the decor.

ART EXPRESSES CHAOS

Just as beauty has its dark side and the intellect is balanced by the emotion, so, too, do order and harmony presume the existence of chaos. Artists have portrayed chaos in many

1-21 JAUNE QUICK-TO-SEE SMITH.
Eclipse (1987).
Oil on canvas. 60″ × 60″.
Collection of the artist.

ways throughout the history of art, seeking analogies in apocalyptic events such as war, famine, or natural catastrophe. But chaos can be suggested even in the absence of specific content. In *Eclipse* (Fig. 1-21), without reference to nature or reality, Native American artist Jaune Quick-to-See Smith creates an agitated, chaotic atmosphere of color, line, shape, and movement. The artist grew up on the Flathead Indian reservation in Montana and uses a full vocabulary of Native American geometric motifs and organic images from the rich pictorial culture of her ancestors.

ART RECORDS AND COMMEMORATES EXPERIENCE

From humanity's earliest days, art has served to record and communicate experiences and events. From prehistoric cave paintings, thought to record significant events in the history of Paleolithic societies, to a work such as the Vietnam Memorial in Washington, D.C., installed in honor of

Art is not a handicraft; it is the transmission of feeling the artist has experienced.

—Leo Tolstoy

1-22 LOUISA CHASE.
Storm (1981).
Oil on canvas. 90″ × 120″.
Denver Art Museum. Purchased with funds from National Endowment for the Arts Matching Fund and Alliance for Contemporary Art.

American service personnel who died during this country's involvement in that war, art has been used to inform future generations of what and who have gone before them. Art also serves to convey the personal experiences of an artist in ways that words cannot.

American painter Louisa Chase was inspired to paint nature's unbridled power as revealed in waves, waterfalls, and thunderstorms, though the intensity of her subjects is often tempered by her own presence in the piece. In *Storm* (Fig. 1-22), a cluster of thick, black clouds lets go a torrent of rain, which, in league with the decorative **palette** of pinks and purples, turns an artificial blue. The highly charged im-

ages on the left side of the canvas are balanced on the right by the most delicate of ferns, spiraling upward, nourished by the downpour. Beneath the sprig, the artist's hand cups the raindrops, becoming part of the painting and part of nature's event as well. Chase said of a similar storm painting, "During the [marking] process I do become the storm—lost—yet not lost. An amazing feeling of losing myself yet remaining totally conscious."[2]

[2] Louisa Chase, journal entry for February 20, 1984, in *Louisa Chase* (New York: Robert Miller Gallery, 1984).

[On The Steerage*] I stood spellbound for a while, looking and looking. Could I photograph what I felt, looking and looking and still looking? I saw shapes related to each other. I saw a picture of shapes and underlying that the feeling I had about life. . . . Rembrandt came into my mind and I wondered would he have felt as I was feeling.*

—Alfred Stieglitz (about *The Steerage*)

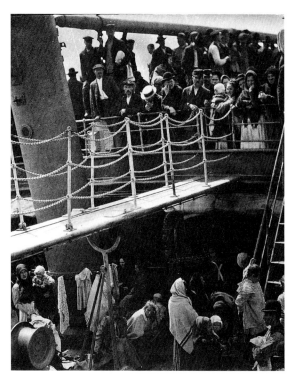

1-23 ALFRED STIEGLITZ.
The Steerage (1907).
Photograph.
Courtesy of The Royal Photographic Society/Heritage
Images Partnership (HIP), heritage-images.com.

The photographer Alfred Stieglitz, who recognized the medium as a fine art as well as a tool for recording events, happened upon the striking composition of *The Steerage* (Fig. 1-23) on an Atlantic crossing aboard the *Kaiser Wilhelm II.* He rushed to his cabin for his camera, hoping that the upper and lower masses of humanity would maintain their balanced relationships to one another, to the drawbridge that divides the scene, to the stairway, the funnel, and the horizontal beam of the mast. The "steerage" of a ship was the least expensive accommodation. Here the "huddled masses" seem suspended in limbo by machinery and by

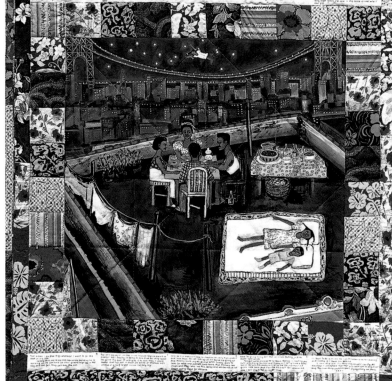

1-24 FAITH RINGGOLD.
Tar Beach (1988).
Acrylic paint on canvas and pieced fabric.
74″ × 68½″.
Collection of the Solomon R. Guggenheim Museum,
New York.

Works of art all through the ages show us in the clearest fashion how mankind has changed,
how a stage that has once appeared never reappears.

—Philipp Otto Runge

symbolic as well as actual bridges. Yet the tenacious human spirit may best be symbolized by the jaunty patch of light that strikes the straw hat of one passenger on the upper deck. Stieglitz was utterly fascinated and moved by what he saw.

More than 80 years after Stieglitz captured the great hope of immigrants entering New York harbor, African American artist Faith Ringgold tells the story of life and dreams on a tar-covered rooftop. *Tar Beach* (Fig. 1-24) is a painted patchwork quilt that stitches together the artist's memories of family, friends, and feelings while growing up in Harlem. Ringgold is noted for her use of materials and techniques associated with women's traditions as well as her use of narrative or storytelling, a strong tradition in African American families. A large, painted square with images of Faith, her brother, her parents, and neighbors dominates the quilt and is framed with brightly patterned pieces of fabric. Along the top and bottom are inserts crowded with Ringgold's written description of her experiences. This wonderfully innocent and joyful monologue begins:

> I will always remember when the stars fell down around me and lifted me up above the George Washington Bridge . . .

ART REFLECTS THE SOCIAL AND CULTURAL CONTEXT

Faith Ringgold's *Tar Beach* tells us the story of a young girl growing up in Harlem. Her experiences take place within a specific social and cultural context. In recording experience, artists frequently record the activities and objects of their times and places, reflecting contemporary fashions and beliefs as well as the states of the crafts and sciences.

The architecture, the hairstyles, hats, and shoulder pads, even the price of cigars (only five cents) all set Edward Hopper's *Nighthawks* (Fig. 1-25) unmistakably in an American city during the late 1930s or 1940s. The subject is commonplace and uneventful, though somewhat eerie. There is a tension between the desolate spaces of the vacant street and the corner diner. Familiar objects become distant. The warm patch of artificial light seems precious, even precarious, as if night and all its troubled symbols are threatening to break in on disordered lives. Hopper uses a specific sociocultural context to communicate an unsettling, introspective mood of aloneness, of being outside the mainstream of experience.

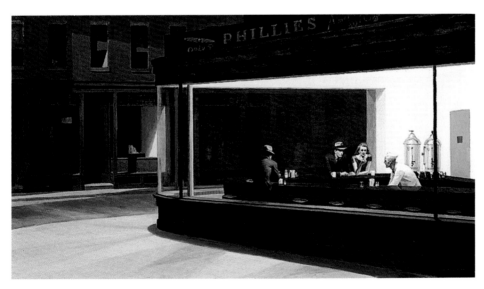

1-25 EDWARD HOPPER.
Nighthawks (1942).
Oil on canvas.
30″ × 60″.
Courtesy of the Art Institute of Chicago, Friends of American Art Collection.

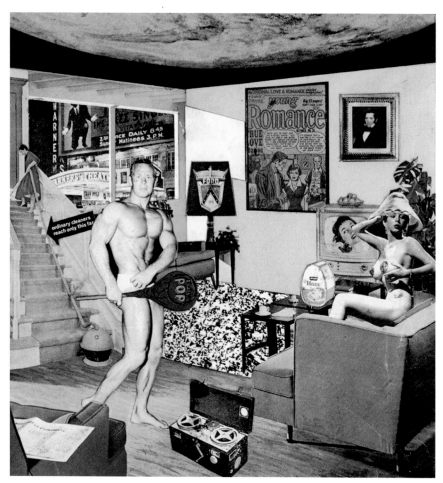

In Richard Hamilton's *Just What Is It That Makes Today's Homes So Different, So Appealing?* (Fig. 1-26), the aims are identical, but the result is self-mocking, upbeat, and altogether fun. This little collage functions as a veritable time capsule for the 1950s, a decade during which the speedy advance of technology finds everyone buying pieces of the American dream. What is that dream? Comic books, TV, movies, and tape recorders; canned hams and TV dinners; enviable physiques, Tootsie Pops, vacuum cleaners that finally let the "lady of the house" clean all the stairs at once. Hamilton's piece serves as a memento of the time and the place and the values of the decade for future generations.

1-26 RICHARD HAMILTON.
Just What Is It That Makes Today's Homes So Different, So Appealing? (1956). Collage. 10¼″ × 9¾″.
Kunsthalle Tübingen, Germany. Collection of G. F. Zundel.

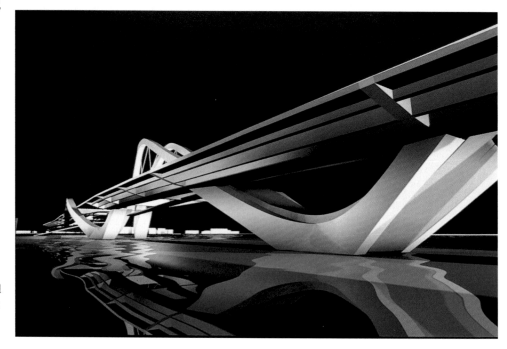

1-27 ZAHA HADID.
Sheikh Zayed Bridge, Abu Dhabi, to be completed in 2006. Designed by Zaha Hadid
Zaha Hadid/ESTO.

We more commonly think of visual art (painting and sculpture, for example) when we consider the connection between art and social or cultural context, but art history is full of examples of architecture that reflect or embody the ideas or beliefs of a people at a point in time. Think of the Parthenon in Classical Athens or Chartres Cathedral in the Middle Ages. Symbolism is often disguised in architecture, but sometimes it is the very essence of its design. Zaha Hadid's Sheik Zayed Bridge (Fig. 1-27), connecting Abu Dhabi island to the mainland, is composed of sweeping, irregular rhythms of arches. Hadid has acknowledged the influence of Arabic calligraphy on the flowing forms of her structures, but in this work, the arches—each different from one another in height and span—reflect the dunes of the nearby topography, thus connecting it (metaphorically and literally) to a specific place and time.

ART PROTESTS INJUSTICE AND RAISES SOCIAL CONSCIOUSNESS

As other people have, artists have taken on bitter struggles against the injustices of their times and have tried to persuade others to join them in their causes, and it has been natural for them to use their creative skills to do so.

The nineteenth-century Spanish painter Francisco Goya used his art to satirize the political foibles of his day and to condemn the horrors of war (see Fig. 18-8). In the twentieth century another Spanish painter, Pablo Picasso, would condemn war in his masterpiece *Guernica* (see Fig. 19-10).

Goya's French contemporary Eugène Delacroix painted the familiar image of *Liberty Leading the People* (Fig. 1-28)

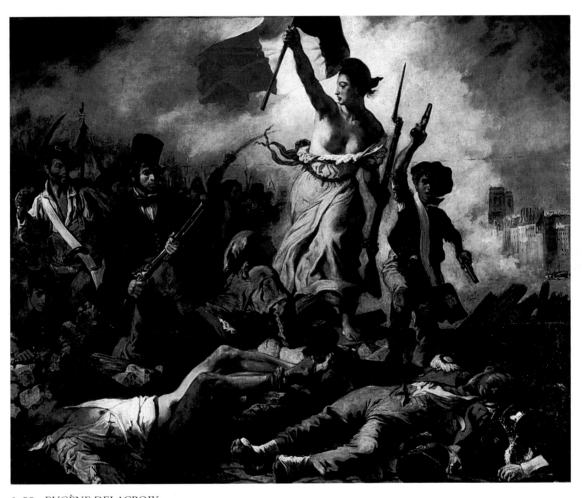

1-28 EUGÈNE DELACROIX.
Liberty Leading the People (1830).
Oil on canvas. 8'6" × 10'10".
Louvre Museum, Paris/Réunion des Musées Nationaux/Art Resource, New York.

Art has always been employed by the different social classes who hold the balance of power as one instrument of domination—hence, a political instrument. One can analyze epoch after epoch—from the Stone Age to our own day—and see that there is no form of art which does not also play an essential political role.

—Diego Rivera

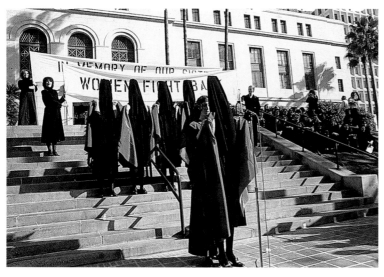

1-29　SUZANNE LACY AND LESLIE LABOWITZ.
In Mourning and in Rage (1977).
Performance at Los Angeles City Hall.
Photograph courtesy of Suzanne Lacy and
Leslie Labowitz.

in order to keep the spirit of the French Revolution alive in 1830. In this painting, people of all classes are united in rising up against injustice, led onward by an allegorical figure of liberty. Rifles, swords, a flag—even pistols—join in an upward rhythm, underscoring the pyramid shape of the composition.

Suzanne Lacy and Leslie Labowitz's performance *In Mourning and in Rage* (Fig. 1-29), was a carefully orchestrated media event reminiscent of ancient public rituals. Members of feminist groups donned black robes to commemorate women who had been victims of rape-murders and to protest the shoddy media coverage usually given such tragedies.

Millions of us have grown up with a benevolent, maternal Aunt Jemima. She has graced packages of pancake mix and bottles of maple syrup for generations. How many of us have really thought about what she symbolizes? Artists such as African American artist Betye Saar have been doubly offended by Aunt Jemima's state of servitude, which harks

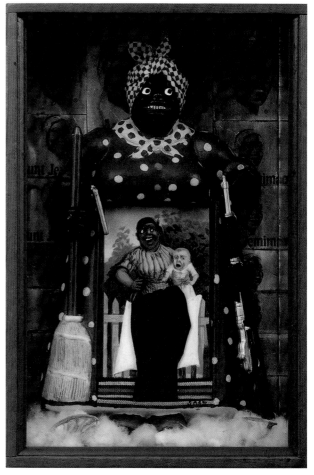

1-30　BETYE SAAR.
The Liberation of Aunt Jemima (1972).
Mixed media. 11¾″ × 8″ × 2¾″.
University of California, Berkeley Art Museum, purchased with the aid of funds from the National Endowment for the Arts (selected by the Committee for the Acquisition of Afro-American Art).

not only to the days of slavery but also to the suffocating traditional domestic role of the female. Sharon F. Patton notes:

> The Liberation of Aunt Jemima subverts the black mammy stereotype of the black American woman: a heavy, dark-skinned maternal figure, of smiling demeanor. This stereotype, started in the nineteenth century, was still popular culture's favorite representation of the African-American woman. She features in Hollywood films and notably as the advertising and packaging image for Pillsbury's "Aunt Jemima's Pancake Mix."[3]

The Aunt Jemima in Betye Saar's *The Liberation of Aunt Jemima* (Fig. 1-30) is revised to reflect the quest for libera-

tion from servitude and the stereotype. She holds a broomstick in one hand but a rifle in the other. Before her stands a portrait with a small white child violated by a clenched black fist representing the symbol of Black Power. The image of the liberated Aunt Jemima confronts viewers and compels them to cast off the stereotypes that lead to intolerance.

ART ELEVATES THE COMMONPLACE

Have you come across embroidered dish towels or aprons with the words *God Bless Our Happy Home* or *I Hate Housework*? Miriam Schapiro's *Wonderland* (Fig. 1-31) is a collage

[3] Sharon F. Patton, *African-American Art* (New York: Oxford University Press, 1998), 201.

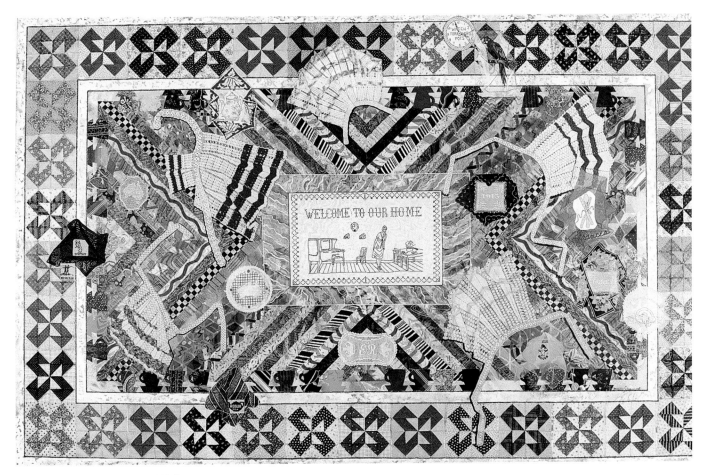

1-31 MIRIAM SCHAPIRO.
Wonderland (1983).
Acrylic and fabric collage on canvas. 90″ × 144″ (framed).
Smithsonian American Art Museum, Washington, D.C./Art Resource, New York.

ART MEETS THE NEEDS OF THE ARTIST

Artists may have special talents and perceptive qualities, but they are also people with needs and the motivation to meet those needs. Psychologists speak of the need for "self-actualization"—that is, the need to fulfill one's unique potential. Self-actualizing people have needs for novelty, exploration, and understanding; and they have aesthetic needs for art, beauty, and order. Under perfect circumstances, art permits the individual to meet needs for achievement or self-actualization and, at the same time, to earn a living.

Murals such as José Clemente Orozco's *Epic of American Civilization: Hispano-America* (Fig. 1-33) were created for a branch of the Works Progress Administration (WPA), a federal work–relief program intended to help people in the United States, including artists, survive the Great Depression. The WPA made it possible for many artists to meet basic survival needs while continuing to work, and be paid, as artists. Scores of public buildings were decorated with murals or canvas paintings by artists in the Fine Arts Program (FAP) of the WPA. Some of them were among the best known of their generation. Orozco's epic also met another, personal need—the need to call attention to and express his outrage at what he believed to be financial and military injustices imposed upon the Mexican peasant.

Creating works of art that are accepted by one's audience can lead to an artist's social acceptance and recognition. But sometimes art really is created only to meet the needs of the artist and nothing beyond—with no thought to a sale, or exhibition, or review, or recognition. Such is the story of *outsider art,* a catch-all category that has been used for works by untrained artists; self-taught artists who have been incarcerated for committing crimes and who use the circumstances of their isolation as a motive for creating; people who are psychologically compromised and sometimes institutionalized for conditions ranging from autism (Fig. 1-34) to schizophrenia. Works of art by these individuals and others like them are almost always *not* intended to be seen. Thus, in the purest sense, they come into existence to meet some essential emotional or psychological need of the artist and the artist alone.

As we noted at the outset, the question "What is art?" has no single answer and raises many other questions. Our discussion of the meanings and purposes of art is meant to facilitate the individual endeavor to understand art but is not intended to be exhaustive. Some people will feel that we have omitted several important meanings and purposes of

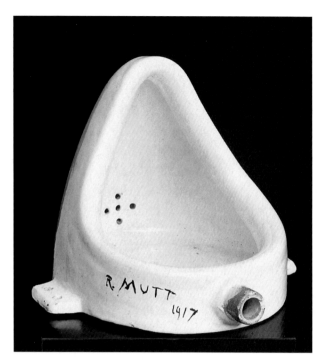

1-32　MARCEL DUCHAMP.
Fountain (1917).
1951 version after lost original. Porcelain urinal. H: 24″.
Courtesy Sidney Janis Gallery, New York. Copyright 2003 Artists Rights Society (ARS), New York/ADAGP, Paris/Succession Marcel Duchamp.

that reflects her "femmage" aesthetic—her interest in depicting women's domestic culture. The work contains ordinary doilies, needlework, crocheted aprons, handkerchiefs, and quilt blocks, all anchored to a geometric patterned background that is augmented with brushstrokes of paint. In the center is the most commonplace of the commonplace: an embroidered image of a housewife who curtsies beneath the legend "Welcome to Our Home."

Some of the more interesting elevations of the commonplace to the realm of art are found in the **readymades** and **assemblages** of twentieth-century artists. Marcel Duchamp's *Fountain* (Fig. 1-32) is a urinal, turned upside down and labeled. Pablo Picasso's *Bull's Head* (see Fig. 9-20) is fashioned from the seat and handlebars of an old bicycle. In **Pop art,** the dependence on commonplace objects and visual clichés reaches a peak. Prepared foods, soup and beer cans, media images of beautiful women and automobile accidents—these became the subject matter of Pop art. As we saw in Figures 1-9 and 1-26, Pop art impels us to cast a more critical eye on the symbols and objects with which we surround ourselves.

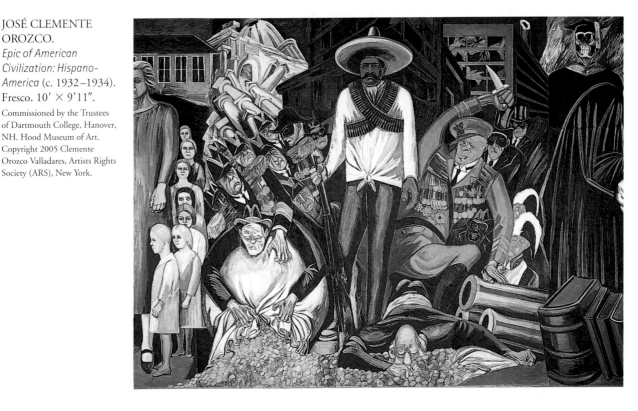

1-33 JOSÉ CLEMENTE
OROZCO.
*Epic of American
Civilization: Hispano-
America* (c. 1932–1934).
Fresco. 10′ × 9′11″.

Commissioned by the Trustees
of Dartmouth College, Hanover,
NH. Hood Museum of Art.
Copyright 2005 Clemente
Orozco Valladares, Artists Rights
Society (ARS), New York.

1-34 MATTHEW I. SMITH.
Untitled (n.d.).
Graphite on paper. 8½″ × 11″.
Courtesy Frank Maresca.

art; others will think we have included too many. But these considerations hint at the richness and elusiveness of the concept of art.

In Chapters 2, 3, and 4 we expand our discussion of the meanings and purposes of art to include the "language" of art. These chapters will not provide us with a precise definition of art either, but they will afford us insight into the ways in which artists use elements of art such as line, shape, and color to create compositions of a certain style and content. Even though art has always been with us, the understanding of art is in its infancy.

2 ————————

VISUAL ELEMENTS OF ART

I found I could say things with color and shapes that I couldn't say in any other way—things I had no words for.

—Georgia O'Keeffe

Color and shape are but two of the visual elements of art. The language of art is the very language of our visual and tactile experiences in the world, and the words or vocabulary of this language consist of the visual elements of *line, shape, light, value, color, texture, space, time,* and *motion.* Line can define shape; light can reveal it. Color can describe the world around us and reveal the worlds within us; we are blue with sorrow, red with rage. Texture is linked with all the emotion of touching, with the cold sharpness of rock or the warm, yielding sensations of flesh. We exist in space; we occupy space and space envelops us. Time allows us to develop into what we are capable of being; time ultimately takes from us what we have been. We are all in motion through space, in a solar system that is traversing the rim of our galaxy at thousands of miles per second, or rotating on the surface of our own globe at a thousand miles per hour. Yet it is the smaller

motion—the motion of lifting an arm or of riding through a field—that we are more likely to sense and hence to represent in art.

This vocabulary—*line, shape, light, value, color, texture, space, time,* and *motion*—makes up what we call the **visual elements** or **plastic elements** of art. Artists select from a variety of media, including, but by no means limited to, drawing, painting, sculpture, architecture, photography, textiles, and ceramics. They then employ the visual elements of art to express themselves in the chosen medium. In their self-expression, they use these elements to design compositions of a certain style, form, and content.

Visual elements, design, style, form, and content—these make up the language of art. A language is a means of communicating thoughts and feelings. In spoken and written languages we communicate by means of sounds and symbols; in the visual arts we communicate through the visual media we find in this book—although by the time this book is in print, there may well be new ones.

Languages such as English and French have symbols—words—that are combined according to rules of grammar to create a message. The visual arts have a "vocabulary" of visual elements that are combined according to the "grammar" of art, or principles of design. These principles include unity, balance, rhythm, scale, and proportion, among others. The composition of the elements creates the style, form, and content of the work—even if this content is an abstract image and not a natural subject such as a human figure or a landscape.

In this chapter we explore the basic vocabulary or visual elements in the language of art. In Chapter 3 we see how artists use principles of design. In Chapter 4 we learn about the style, form, and content of works of art.

LINE

Line is at once the simplest and most complex of the elements of art. It serves as a basic building block around which an art form is constructed and, by itself, has the capacity to evoke forests of thought and emotion. In geometry, we learn that line is made up of an infinite number of points and that the shortest distance between two points is a straight line. In art, a line is more commonly defined as a moving dot.

Characteristics of Line

Measure of Line

The **measure** of a line is its length and its width. If we conceptualize line as a moving dot, the dots that compose it can be of any size, creating a line of lesser or greater width, and of any number, creating a shorter or a longer line.

Some works of art, such as Sol LeWitt's *Lines from Four Corners to Points on a Grid* (Fig. 2-1), have lines whose measures are carefully devised. LeWitt's lines are so precise and mathematical that he was acutely conscious of their measure. The act of measuring to create exact mathematical relationships seems to be intrinsic to the work—or *is* the work. LeWitt's installations are temporary; their "ownership" means possession of a set of instructions for reproducing them. The Whitney Museum of American Art owns the work (the instructions), but once placed it (the instructions) "on loan" to the Museum of Modern Art.

By contrast, the very notion of measuring the lengths of line that are both the subject and the process of Jackson Pollock's *Number 14: Gray* (Fig. 2-2) seems ludicrous and incomprehensible. Pollock's lines weave and overlap and swell and pinch, creating a sense of infinite flow and freedom from constraint (where constraint is defined as logical and mathematical measurement). LeWitt's lines are precise; Pollock's are gestural, fluid, and loose. The effects of the LeWitt and the Pollock are very different. The LeWitt is static; the Pollock grows and recedes. The LeWitt encourages us to think; the Pollock encourages us to dream.

Expressive Qualities of Line

The works by LeWitt and Pollock also reveal the expressive characteristics of line. Lines may be perceived as delicate, tentative, elegant, assertive, forceful, or even brutal. The lines in the LeWitt installation are assertive but cold. The emotional human element is missing. The work seems to express the human capacity to detach the intellect from emotional response, and perhaps to program computers (and other people) to carry out precise instructions. The lines in the Pollock work combine the apparently incongruous expressive qualities of delicacy and force. They are well rounded and human, combining intellect with passion. The LeWitt suggests the presence of a plan. The Pollock suggests the presence of a human being weaving elegantly through the complexities of thought and life.

2-2 JACKSON POLLOCK.
Number 14: Gray (1948).
Enamel and gesso on paper. 22¾″ × 31″.

Types of Line

The variety of line would seem to be as infinite as the number of points that, we are told, determine it. Lines can be straight or curved. They can be vertical, horizontal, or diagonal. A curved line can be circular or oval. It can run full circle to join itself where it began, thereby creating a complete shape. Curved lines can also be segments or arcs—parts of circles or ovals. As a line proceeds, it can change direction abruptly: A straight line that stops and changes course becomes a zigzag. A curved line that forms an arc and then reverses direction becomes wavy. Circular and oval lines that turn ever inward on themselves create vertiginous spirals. Art's most basic element is a tool of infinite variety.

Contour lines are created by the edges of things. They are perceived when three-dimensional shapes curve back into space. Edges are perceived because the objects differ from the backgrounds in value (lighter versus darker), texture, or color. If you hold up your arm so that you perceive it against the wall (or, if you are outside, the sky), you will discriminate its edge—its contour line—because the wall is

2-3　EDWARD WESTON.
Knees (1927).
Gelatin silver print. $6\frac{1}{4}"\times9\frac{3}{16}"$.
San Francisco Museum of Art, San Francisco, CA. Alan M. Bender Collection. Alan M. Bender Fund Purchase.

lighter or darker, because it differs from the wall in color, and because the texture of flesh differs from the wallboard or plaster or wood or brick—whatever—of the wall.

Edward Weston's photograph *Knees* (Fig. 2-3) highlights the aesthetic possibilities in contour lines. Weston was drawn to the sculptural forms of the human figure, plant life, and natural inanimate objects such as rocks. In *Knees,* the contour lines (edges) of the legs are created by the subtle differences in value (light and dark) and texture between the legs and the wall and the floor. The legs take on the abstract quality of an exercise to demonstrate how contour lines define the human form and how shading creates or *models* roundness.

Actual line can be distinguished from *implied line.* The points in **actual line** are connected and continuous. The Le-Witt (Fig. 2-1) and Pollock (Fig. 2-2) are examples of works with actual line. Works with **implied line** are completed by the viewer. An implied line can be a discontinuous line that the viewer reads as continuous because of the overall context of the image. Implied lines can be suggested by series of points or dots, as in Part B of Figure 2-4. They can be suggested by the nearby endpoints of series of parallel or nearly parallel lines of different lengths, as in Part C of Figure 2-4. The movements and glances of the figures in a composition also imply lines.

One of the hallmarks of Renaissance paintings is the use of implied lines to create or echo the structure of the composition. Geometric shapes such as triangles and circles are suggested through the use of linear patterns created by the position and physical gestures of the participants and, often, glances between them. These shapes often serve as the central focus and the main organizational device of the com-

A

B

C

2-4 A, B, and C Actual line (A) versus two kinds of implied
lines, one formed by dots (B) and the other formed by psy-
chologically connecting the edges of a series of straight
lines (C).

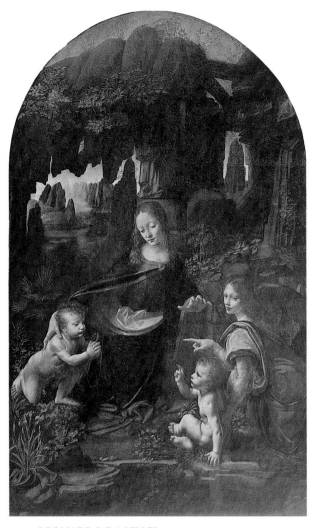

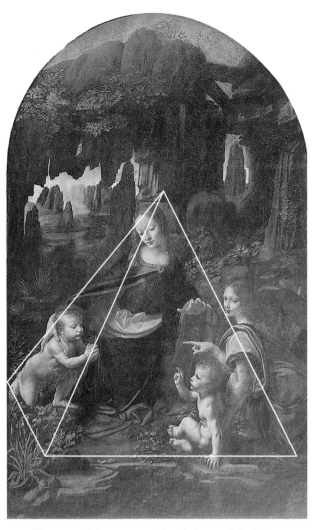

2-5 LEONARDO DA VINCI.
Madonna of the Rocks (c. 1483).
Oil on panel, transferred to canvas. 78½″ × 48″.
Louvre Museum, Paris/Réunion des Musées Nationaux/Art Resource,
New York.

2-6 The pyramidal structure of the *Madonna of the Rocks.*

positions. In the *Madonna of the Rocks* (Fig. 2-5), Leonardo da Vinci places the head of the Virgin Mary in the apex of a rather broad, stable pyramid formed not by actual lines but by the extension of her arms and the direction of her glance. The base of the pyramid is suggested by an implied line that joins the "endpoints" of the baby Jesus and the infant John the Baptist. Figure 2-6 highlights the pyramidal structure of the composition.

Implied line also refers to the gaps that exist in an otherwise continuous outline, as we find in Larry Rivers's *Dutch Masters and Cigars* (Fig. 2-7). As a twentieth-century Pop artist, Rivers reworked many images that had become hackneyed, such as Rembrandt's masterpiece *The Syndics of the Drapers' Guild* (see Fig. 16-19), which was painted in the 1660s and achieved a wider audience—one might say—through its placement on the inside cover of Dutch Masters cigar boxes in the 1900s. Some of Rivers's lines are forceful and complete, but many of them stop short. He leaves it to us, for example, to complete the implied outlines of some of the figures and the cigars. The image is with us, but not entirely. The use of implied line seems to compel us to confront the question as to where the image really "belongs"—

2-7 LARRY RIVERS.
Dutch Masters and Cigars (1963).
Oil on canvas.
96″ × 67¾″.

on the wall of a museum in Amsterdam or on millions of cigar boxes? Perhaps Rivers's answer is that the image rightly resides in our collective cultural consciousness, emerging then receding, emerging then receding.

Functions of Line

The line, as an element of art, is alive with possibilities. Artists use line to outline shapes, to evoke forms and movement, to imply solid mass, or for its own sake. In groupings, lines can create shadows and even visual illusions.

To Outline and Shape

When you make or observe an outline, you are describing or suggesting the edge of a form or a shape. It is line that defines a shape or form as separate from its surrounding space; it is line that gives birth to shape or form. It is line that grants them substance.

Lines made of brass wire separate the figures in Alexander Calder's whimsical *The Brass Family* (Fig. 2-8) from their surrounding space. Yet space also flows through because these are not contour lines; these are outlines. Calder gave birth to many such playful figures and groupings. Given the openness of the figures, it is easy for them to maintain their balancing act. The wire outline of genitals and breasts makes them toylike rather than evocative or erotic. Note the intersection of implied triangles in the overall shape (Fig. 2-9).

In addition to defining shape, line can also function as form itself. *Madonna and Child* (Fig. 2-10) by Rimma Gerlovina and Valeriy Gerlovin is a revision of one of the most popular religious themes of the Renaissance. Taking their cue from works by artists such as Raphael, the Gerlovins use their signature combination of the body and braided hair to embroider a contemporary image of the Virgin Mary and the infant Jesus. The Gerlovins are the principal subjects of their work, and in this piece Gerlovina serves as the model for the Virgin. Braid extensions of her own

2-8 ALEXANDER CALDER.
The Brass Family (1927).
Brass wire and painted wood. 66⅜″ × 40″ × 8″.
Collection of the Whitney Museum of American Art, New York. Gift of the artist. Copyright 2003 Estate of Alexander Calder/Artists Rights Society (ARS), New York.

2-9 The intersecting triangles that define the structure of the overall composition of *The Brass Family.*

sandy brown hair cascade from a sculptural head
whose three-dimensionality stands in marked con-
trast to the flatness of the rippling braids. These
braids flow into the contours of the Christ-child's
body, nested in the palm of a sculpted hand.

To Create Depth and Texture

The face of Elizabeth Catlett's sturdy *Sharecropper*
(Fig. 2-11) is etched by series of short, vigorous
lines that are echoed in the atmosphere that sur-
rounds her. The lines give the woman's features a
gaunt, hollowed-out look and are also used to cre-
ate a harsh texture in a turbulent environment. The
textures of her garment, hair, and hat are also rep-
resented by series of lines.

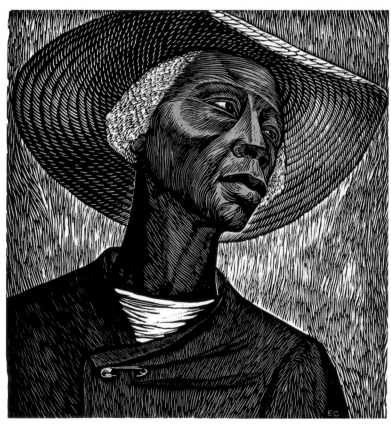

2-11 ELIZABETH CATLETT.
Sharecropper (1968).
Color linocut. 26″ × 22″.

Dots and lines can be used to create the illusion of three-dimensionality through shading. Part A shows the method of stippling, in which shading is represented by a pattern of dots that thickens and thins. Part B represents shading by means of hatching—that is, using a series of closely spaced parallel lines. Part C shows the method of cross-hatching, in which the series of lines intersects another series of lines. Part D shows how directional changes in hatching can define contours.

A. Stippling

B. Hatching

C. Cross-hatching

D. Contour hatching

Modeling on a two-dimensional surface is the creation of the illusion of roundness or three dimensions through the use of light and shadow. As shown in Figure 2-12, shadows can be created by the use of dots and lines. Part A shows the method of **stippling,** of using a pattern of dots that thickens and thins. Areas where the dots are thicker are darker and create the illusion of being more shaded. Part B shows the technique of **hatching,** or using series of closely spaced parallel lines to achieve a similar effect. Areas in which lines are closer together appear to be more shaded. **Cross-hatching,** shown in Part C, is similar to hatching, but as the name implies, series of lines run in different directions and cross one another.

Contours can be created when hatching changes direction, as in Part D. Notice how the sharecropper's face is carved by hatching that alters direction to give shape to the wells of the eyes, the nose, the lips, and the chin. Directional changes in hatching also define the prominent anatomic features of the sharecropper's neck.

To Suggest Direction and Movement

Renaissance artist Sandro Botticelli's *The Birth of Venus* (Fig. 2-13) shows how line can be used to outline forms and evoke movement. In this painting, firm lines carve out the figures from the rigid horizontal of the horizon and the ver-

2-13 SANDRO BOTTICELLI.
The Birth of Venus
(c. 1482).
Oil on canvas.
5′8⅞″ × 9′1⅞″.
Uffizi Gallery, Florence/Scala/
Art Resource, New York.

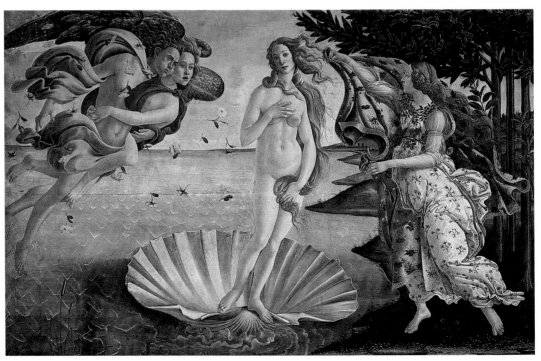

2-14 JACOB LAWRENCE.
Harriet Tubman Series, No. 4 (1939–1940).
Casein tempera on gessoed hardboard. $12'' \times 17\frac{7}{8}''$.
Hampton University Museum, Hampton, VA. Copyright 2005 Artists
Rights Society (ARS), New York.

ticals of the trees. Straight lines carry the breath of the
Zephyr from the left, and the curved lines of the drapery
imply the movement of the Zephyrs and of the nymph to
the right. Implied compositional lines give this work an
overall triangular structure.

Horizontal lines, like horizon lines, suggest stability.
Vertical lines, like the sweeping verticals in skyscrapers, defy
gravity and suggest assertiveness. Diagonal lines are often
used to imply movement and directionality, as in the direc-
tionality and movement of the breath of the Zephyr in *The
Birth of Venus*. African American artist Jacob Lawrence used
assertive sticklike diagonals to give the slave children in his
painting (Fig. 2-14) a powerful sense of movement and di-
rectionality. While the horizon line provides a somewhat
stable world, the brightly clad children perform acrobatic
leaps, their branchlike limbs akin to the wood above. The
enduring world implied by the horizon is shattered by the
agitated back and forth of the brushed lines that define
ground and sky. Such turmoil presumably awaits the chil-
dren once they mature and realize their lot in life.

SHAPE, VOLUME, AND MASS

The word *shape* has many meanings. Parents or teachers may
tell you to "shape up" when they are concerned about your
behavior. When you started arranging things in your dorm
room or apartment, you may have thoughts as things begin
to "take shape." Such expressions suggest "definition"—that
is, pulling things together within defined boundaries to dis-
tinguish them from what surrounds them. We say our bod-
ies are "out of shape" when they violate our preferred physi-
cal contours. In works of art, **shapes** are defined as the areas
within a composition that have boundaries that separate
them from what surrounds them; shapes make these areas
distinct.

Shapes are formed when intersecting or connected lines
enclose space. In Botticelli's *The Birth of Venus* and in the
Lawrence painting, for example, shape is clearly communi-
cated by lines that enclose specific areas of the painting.
Shape can also be communicated through patches of color
or texture. In three-dimensional works, such as sculpture

The more basic the color, the more inward: the more pure.

—Piet Mondrian

2-15 PIET MONDRIAN.
Composition with Red, Blue, and Yellow (1930).
Oil on canvas. 28½″ × 21¼″.

2-16 HELENE BRANDT.
Mondrian Variations, Construction No. 3B with Four Red Squares and Two Planes (1996).
Welded steel, wood, paint. 22″ × 19″ × 17″.

and architecture, shape is discerned when the work is viewed against its environment. The edges, colors, and textures of the work give it shape against the background. Piet Mondrian's *Composition with Red, Blue, and Yellow* (Fig. 2-15) features colorful geometric shapes—rectangles of various dimensions—that are created when vertical and horizontal black lines slice through the canvas space and intersect to define areas distinct from the rest of the surface.

The word **form** is often used to speak about shape in sculpture or architecture—three-dimensional works of art. Helene Brandt's *Mondrian Variations, Construction No. 3B with Four Red Squares and Two Planes* (Fig. 2-16) is a translation of Mondrian's composition into three dimensions. Therefore, some artists and people who write about art

might prefer to speak of the *form* of the Brandt sculpture rather than its *shape*. Others use the word *shape* to apply to both two-dimensional and three-dimensional works of art. We will use the terms interchangeably.

The word **volume** refers to the mass or bulk of a three-dimensional work. The volume of a work is the amount of space it contains. In geometry, the volume of a rectangular solid is computed as its length times its width times its height. But one might use the concept more loosely to say that a structure has a great *volume* as a way of generally describing its enormity. Gerrit Rietveldt's Schroeder House in Utrecht (Fig. 2-17) seems to be a volumetric translation of Mondrian's geometric shapes. Here is an example of the usefulness of the term *volume* as it conveys a sense of containment.

2-17 GERRIT RIETVELDT.
Schroeder House, Utrecht (1924).

Copyright Jannes Linders. Copyright 2003 Artists
Rights Society (ARS), New York/Beeldrect,
Amsterdam.

Mass

Like volume, the term *mass* also has a spe-
cific meaning in science. In physics, the mass
of an object reflects the amount of force it
would require to move it. Objects that have
more mass are harder to budge. In three-
dimensional art, the **mass** of an object refers
to its bulk. A solid work made of steel with
the same dimensions as Helene Brandt's
sculpture would have more mass.

We would be hard pressed to conjure a
better exemplar of mass than Rachel White-
read's Holocaust Memorial in Vienna
(Fig. 2-18). It possesses the gravity of a stone
pyramid (see Fig. 12-14) and evokes the sim-
plicity and serenity of a mausoleum. Built
of concrete and weighing 250 tons, the me-
morial is designed as an inverted library—
the "books" protrude on the outside—in
recognition of the significance of study to the

2-18 RACHEL WHITEREAD.
Holocaust Memorial, Vienna (2000).

Copyright Reuters NewMedia Inc./CORBIS.

2-19 ELIHU VEDDER.
The Questioner of the Sphinx (1863).
Oil on canvas. 36¼″ × 42¼″.
Museum of Fine Arts, Boston. Bequest of Mrs. Martin Brimmer (06.2430).

Jewish people, "the people of the book." But the doors to this "library" are bolted, making the books inaccessible. In the wake of the destruction of the Austrian Jewish community, there is no longer any use for them. The names of the places to which the country's Jews were deported for annihilation are inscribed in alphabetical order around the exterior. There is murder, death, and loss here, and the massiveness of the memorial shapes a sense of gloom that cannot be lifted.

Actual Mass versus Implied Mass

The Whiteread Memorial has **actual mass.** It occupies three-dimensional space and has measurable volume and weight.

Objects that are depicted as three-dimensional on a two-dimensional surface (such as a drawing or a painting) have what we call **implied mass.** That is, they create the illusion of possessing volume, having weight, and occupying three-dimensional space. Consider a two-dimensional work of art that features massive shapes found, along with the Pyramids, in Egypt's Valley of the Kings. In *The Questioner of the Sphinx* (Fig. 2-19), Elihu Vedder meticulously portrays the remnants of a colossal sculpture amidst the

ruins of temples and the unending sands of the desert. His realistic style helps create the illusion of three dimensions on the two-dimensional canvas surface. The extraordinary mass of the oversized stone head is implied, whereas the archeological remains that it intends to invoke have actual mass.

Types of Shape

Shapes that are found in geometric figures such as rectangles and circles are called **geometric shapes.** Geometric shapes are regular and precise. They may be made up of straight (rectilinear) or curved (curvilinear) lines, but they have an unnatural, mathematical appearance. Shapes that resemble organisms found in nature—the forms of animals and plant life—are called **organic shapes** and have a natural appearance. Most of the organic shapes found in art are soft, curvilinear, and irregular, although some natural shapes, such as those found in the structure of crystals, are harsh and angular. Artists also work with *biomorphic* and *amorphous* shapes.

Geometric shapes can be **rectilinear** when straight lines intersect to form them. Geometric shapes can also be **curvilinear** when curving lines intersect to form them or when

they circle back to join themselves and make up closed geometric figures. Geometric shapes frequently look crisp, or hard edged. David Smith explored the relationships among diverse geometric shapes such as cylinders, cubes, and disks in works such as *Cubi XVIII* (Fig. 2-20). His *Cubi* series represent nothing found in nature. Rather, they are abstract geometric concepts rendered in steel.

Frank Gehry, the architect of the Guggenheim Museum in Bilbao, Spain (Fig. 2-21), refers to his work as a "metallic flower." Others have found the billowing, curvilinear shapes to be reminiscent of ships, linking the machine-tooled structure that is perched on the water's edge to the history of Bilbao as an international seaport. It is as if free-floating geometric shapes have collided on this site, and on another day, they might have assumed a different configuration.

2-20 DAVID SMITH. *Cubi XVIII* (1964).
Polished stainless steel. 9'7¾" × 5' × 1'9¾".
Museum of Fine Arts, Boston. Gift of Susan W. and Stephen B. Paine.
Copyright Estate of David Smith. Licensed by VAGA, New York.

2-21 FRANK GEHRY.
Guggenheim Museum, Bilbao, Spain (1997).
Copyright E. Streichan/ZEFA/CORBIS.

Picasso's *Les Demoiselles d'Avignon* with Colescott's *Les Demoiselles d'Alabama: Vestidas*

In the year 1907, a young Pablo Picasso unveiled a painting that he had been secretly working on for a couple of years. A culmination of what was known as his Rose Period, this new work—*Les Demoiselles d'Avignon* (Fig. 2-22)—would turn the tide of modern painting. Picasso had studied the work of African and Iberian artists in Parisian museums and galleries. He was struck by the universality of the masks, believing that their rough-hewn, simplified, and angular features crossed time and culture. This was the painting that launched the movement called Cubism, which geometricizes organic forms. The contours of the body in *Demoiselles* are harsh and rectilinear, forming straighter lines than are found in nature. The women in the painting are expressionless and lack identity; some of them even have rectilinear masks in lieu of faces. The intellectual exercise of transforming the hu-man form into geometric shapes takes precedence over any interest in expressing the plight of these women, who are prostitutes in the French underworld. The "figures" in the work transcend the period and culture in which the women lived and worked.

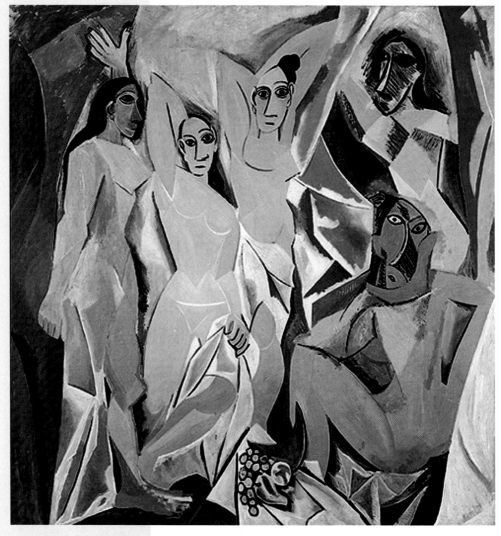

2-22 PABLO PICASSO.
Les Demoiselles d'Avignon (1907).
Oil on canvas. 8′ × 7′8″.

The Museum of Modern Art, New York. Acquired through the Lillie P. Bliss Bequest.
Copyright 2003 Estate of Pablo Picasso/Artists Rights Society (ARS), New York.

You have heard the expression "Clothing makes the man." In Robert Colescott's *Les Demoiselles d'Alabama: Vestidas* (Fig. 2-23), it could be argued that clothing makes the woman. The women in Picasso's painting are dehumanized in part by their nudity. The subjects of Colescott's painting, executed some 80 years later, are given strong individuality by their choice of costume. Colescott's painting is one of the thousands of instances in which one artist transforms the work of another in a certain way to make a certain point. Picasso's nudes have a harsh and jagged quality that gives an overall splintered quality to his work; the movement of the women seems to be abrupt and choppy. By contrast, Colescott's women are well rounded (in the literal sense) and fleshy—they are natural, organic, "real" counterparts to Picasso's geometry. The flowing, curvilinear lines of the women cause them to undulate across the canvas with fluid movement.

Whereas Picasso's rectilinear women are timeless (and "placeless"), the curvilinear, clothed women of Colescott are very much tied to their time and place—an American South full of life and spontaneity and emotional expression. Whereas Picasso seemed to relish the intellectual transformation of the prostitutes into timeless figures, Colescott seems to revel in the tangibility and sensuality of his sexy subjects.

■

2-23 ROBERT COLESCOTT.
Les Demoiselles d'Alabama: Vestidas (1985).
Acrylic on canvas. 96″ × 92″.
Collection of Hanford Yang, New York.

2-24 ELIZABETH MURRAY.
Careless Love (1995–1996).
Oil on shaped canvas with wood.
106½″ × 99½″ × 27″.
Courtesy of PaceWildenstein.

Elizabeth Murray's *Careless Love* (Fig. 2-24) is reminiscent of any number of bodily organs or underwater life—although no medical student or botanist could ever quite place it according to kingdom, phylum, and so on. The shape looks rawly excised from some creature. The interlacing tubes are reminiscent of veins and capillaries carrying who knows what (or who wants to know what). Such imagery is said to have a **biomorphic** shape—that is, it has the form (the Greek *morphē*) of biological entities. Rather than have strictly defined shapes, whose boundaries are unyielding, biomorphic shapes seem to ebb and flow, expand and contract, or metamorphose as directed by some inner life force.

Shapes need not be clearly defined or derived from nature or the laws of geometry. Many artists, such as the contemporary painter Helen Frankenthaler, create **amorphous** shapes. In *Bay Side* (Fig. 2-25), Frankenthaler literally poured paint onto her canvas, creating a nebulous work dense in form and rich in texture. The "contents" of the loosely defined shapes spill beyond their boundaries, filling the canvas with irregularly shaped pools of poured paint.

2-25 HELEN FRANKENTHALER.
Bay Side (1967).
Acrylic on canvas.
Copyright Helen Frankenthaler. Courtesy of the André Emmerich Gallery, New York.

Time is not just a mental concept or a mathematical abstraction in the salt desert of Utah's great basin. It can also take on a physical presence.

—Nancy Holt

Positive and Negative Shapes

Viewers usually focus on the objects or figures represented in works of art. These are referred to as the **positive shapes.** Whatever is left over in the composition, whether empty space or space filled with other imagery, is termed the **negative shape** or shapes of the composition.

Positive and negative shapes in a work of art have a **figure–ground** relationship. The part or parts of the work that are seen as what the artist intended to depict are the

figure, and the other parts are seen as the ground, or background. Barbara Kruger's *What Big Muscles You Have!* (Fig. 2-26) illustrates that the figure and ground can be distinct even when the relationship between the two is not so clear-cut. Against a satirical running text of the mindless mantra of a hero-worshiper, Kruger sums up the litany with the proclamation "What big muscles you have!" The viewer identifies the larger type as figure and the smaller type of the running text as ground. Notice the visual tension between

2-26 BARBARA KRUGER.
What Big Muscles You Have! (1985).
Vinyl lettering on Plexiglas. 60″ × 80″.
Centre Georges Pompidou, Paris. Copyright Art Resource, New York.

2-28 A Rubin vase.

> Gestalt psychologists use this drawing to illustrate the fact that humans tend to perceive objects within their context. When we focus on the vase, it is the figure, and the white shapes to the sides are part of the ground. But when we focus on the "profiles of heads" suggested by the white shapes where they intersect with the sides of the vase, the vase becomes the ground. The drawing is ambiguous; that is, it can be perceived in different ways. As a result, the viewer may experience figure–ground reversals.

2-27 NANCY HOLT.
Sun Tunnels (1973–1976).
Concrete. Great Basin Desert, UT.

the large and small type. As we read the larger type, our eye shifts to the pattern and flow of the words behind, and vice versa. The smaller type serves as a kind of psychological wallpaper, signifying one of the horrors of an age of male supremacy that Kruger hopes we left behind in the last millennium.

For many sculptors, negative shapes, or open spaces, are part and parcel of their compositions. The positive shapes in Nancy Holt's *Sun Tunnels* (Fig. 2-27) consist of the huge concrete pipes she placed in the Utah desert. But the views framed by looking through the interiors of these massive structures—the voids, or negative shapes—have as much or more meaning than the solids. The flow of air and light through the pipes—the "sun tunnels"—lends them a lightness of being that contrasts with their actual mass. The artist has, in effect, enlisted the sun as an element in her composition.

Gestalt psychologists have noted that shapes can be ambiguous, so as to encourage **figure–ground reversals** with

viewers. Figure 2-28 shows a Rubin vase, which is a classic illustration of figure–ground reversals found in psychology textbooks. The central shape is that of a vase, and when the viewer focuses on it, it is the figure. But "carved" into the sides of the vase are the shapes of human profiles; when the viewer focuses on them, they become the figure and the vase becomes the ground. The point of the Gestalt psychologists is that we tend to perceive things *in context.* When we are focusing on the profiles, the vase is relegated to be perceived as ground, not figure.

The visual ambiguity between figure and ground is a key aspect of John Klima's Screenshot from *Earth, Landsat-7 layer* (Fig. 2-29). *Earth* is an electronic work culled from the Internet that consists of multiple layers of data about our planet. All the information is projected onto a spherical map of Earth as shot from weather satellites. The combination of two- and three-dimensional views of the planet and several layers of imagery send the viewer's eye darting back and forth, searching for a resting place. In a sense, the flood of confusing information in the work appears to comment on the perceptual crashes that take place on the information superhighway every day.

Edward Steichen's photograph of the sculptor Auguste Rodin silhouetted against his sculpted portrait of Victor Hugo (Fig. 2-30) creates a visual limbo between figure and ground. The eye readily perceives the contours of the face of Rodin sitting opposite his bronze sculpture of *The Thinker,* also set against the Hugo sculpture. The viewer's sense of what is a positive shape and what is a negative shape undergoes reversals, as the white-clouded image of the background work seems to float toward the viewer. The spectrelike image of Hugo hovers between and above the dark images, filling the space between them and pushing them visually into the background.

2-29 JOHN KLIMA.
Screenshot from *Earth, Landsat-7 layer* (2001).
Courtesy, Postmasters Gallery, New York. Copyright John Klima.

2-30 EDWARD STEICHEN.
Rodin with His Sculptures "Victor Hugo" and "The Thinker" (1902).
Carbon print, toned.
From *Camera Work* 11 (July 1905), 35. Courtesy of The Royal Photographic Society/ Heritage Image Partnership (HIP), heritage-images.com.

LIGHT AND VALUE

Light is fascinating stuff. It radiates. It illuminates. It dazzles. It glows. It beckons like a beacon. We speak of the "light of reason." We speak of genius as "brilliance." **Visible light** is part of the spectrum of electromagnetic energy that also includes radio waves and cosmic rays. It undulates wave-like throughout the universe. It bounces off objects and excites cells in our eyes, enabling us to see. Light is at the very core of the visual arts. Without light there is no art. Without light there is no life.

One of the lobes of the brain contains a theater for light. Somehow it distinguishes light from dark. Somehow it translates wavelengths of energy into colors. We perceive the colors of the visible spectrum, ranging from violet to red. Although red has the longest wavelength of the colors of the visible spectrum, these waves are measured in terms of *bil-lionths* of a meter. And if our eyes were sensitive to light of a slightly longer wavelength, we would perceive infrared light waves. Sources of heat, such as our mates, would then literally glow in the dark. And our perceptions, and our visible arts, would be quite different.

Light makes it possible for us to see points, lines, shapes, and textures. All of these can be perceived as light against dark or in the case of a pencil line on a sheet of paper, as dark against light. Light against dark, dark against light—in the language of art these are said to be differences in *value*.

The **value** of a color of a surface is its lightness or darkness. The value is determined by the amount of light reflected by the surface: the greater the amount of light reflected, the lighter the surface. More light is reflected by a white surface than by a gray surface, and gray reflects more than black. White, therefore, is lighter than gray, and gray is lighter than black.

2–31 A value scale of grays.
Do the circles become darker as they move to the right, or do they only appear to do so? How does this value scale support the view of Gestalt psychologists that people make judgments about the objects they perceive that are based on the context of those objects?

2–32 Value contrast.
Artists and designers know that figures with high value contrast are easier to see. They tend to "pop" out at the viewer. Why is Part A of this figure relatively difficult to read? Why are Parts B and C easier to read?

A

2-33 HENRI ROUSSEAU.
The Sleeping Gypsy (1897).
Oil on canvas. 4′3″ × 6′7″.
The Museum of Modern Art, New York. Gift of
Mrs. Simon Guggenheim/Art Resource, New York.

B

2-34 HENRI ROUSSEAU.
The Sleeping Gypsy, rendered in a palette
of grays.

Infinite shades of gray lie between black and white. Figure 2-31 is a value scale of gray that contains seven shades of gray, varying between a gray that is almost black to the left and one that is slightly off-white to the right. When we describe works of art in terms of value, not only do we distinguish their range of grays but we also characterize their *relative* lightness and darkness, that is, their value contrast. **Value contrast** refers to the degrees of difference between shades of gray. Look again at Figure 2-31. Note that there are circles within the squares. Each of them is exactly of the same value (they are all equally dark). However, their value contrast with the squares that contain them differs. The circle and square in the center are of the same value, and therefore they have no value contrast. The circles at either end of the scale have high value contrast with the squares that contain them.

Drawing objects or figures with high value contrast makes them easy to see, or makes them "pop." Consider Figure 2-32. Part A shows a gray sentence typed on gray paper that is nearly as dark; it is difficult to read. Part B shows nearly black type on off-white paper; it is easy to read. Part C shows light type that is "dropped out" of dark gray—it, too, pops out at the reader because of high value contrast.

We can discuss the relative lightness and darkness in a work regardless of whether it is a black-and-white or full-color composition. Sometimes it is easier to discriminate value contrasts in looking at black-and-white reproductions of color works. Figure 2-33 shows Rousseau's *The Sleeping Gypsy* in its original color. In Figure 2-34 its richly colored palette is transformed into an infinite palette of grays. What is captured in the gray version is the relative lightness or darkness of the hues in the original painting. The nearly

white body of the mandolin echoes the value and shape of the moon, and both pop out at the viewer from the surrounding darker grays. The spectrum of hues that compose the tunic of the gypsy is reduced to harmonious variations in gray.

Although the circles in Figure 2-31 are all of the same value, when they are placed within a lighter square, they appear to be darker. Thus, the circles seem to be getting darker as they move to the right, even though they remain the same. The mandolin in Figure 2-34 looks brighter than it would if it were lying in the gypsy's lap. Why?

Chiaroscuro

Artists use many methods to create the illusion of three dimensions in two-dimensional media such as painting, drawing, or printmaking. They frequently rely on a pattern of values termed **chiaroscuro,** or the gradual shifting from light to dark through a successive gradation of tones across a curved surface. By use of many gradations of value, artists can give objects portrayed on a flat surface a rounded, three-dimensional appearance.

In *La Source* (Fig. 2-35), Pierre-Paul Prud'hon creates the illusion of rounded surfaces on blue gray paper by using black and white chalk to portray light gradually dissolving into shade. His subtle modeling of the nude is facilitated by the middle value of the paper and the gradation of tones from light to dark through a series of changing grays. Prud'hon's light source is not raking and harsh, but diffuse and natural. The forms are not sharply outlined; we must work to find outlining anywhere but in the drapery and in the hair. The softly brushed edges of the figure lead your eye to perceive three-dimensional form (continuing around into space) rather than flat, two-dimensional shape.

Picasso used chiaroscuro in his *Self-Portrait* (Fig. 2-36), sketched at the age of 19. Although he restricted himself to

2-35 PIERRE-PAUL PRUD'HON.
La Source (c. 1801).
Black and white chalk on blue gray paper. 21³⁄₁₆″ × 15⁵⁄₁₆″.
Sterling and Francine Clark Art Institute, Williamstown, MA.

2-36 PABLO PICASSO.
Self-Portrait (1900).
Charcoal on paper. 8⁷⁄₈″ × 6½″.
Museu Picasso, Barcelona. Copyright 2003 Estate of Pablo Picasso/Artists Rights Society (ARS), New York.

the use of charcoal, he managed to effect a more subtle gradation of tone through shading that softly delineates his facial features. Sharp contrasts are eliminated by the choice of a buff-colored paper that provides a uniform flesh tone. In effect, the sides of the nose and cheek are built up through the use of soft shadows. The chin and jaw jut out above the neck through the use of sharper shadowing. The eyes achieve their intensity because they are a dark counterpoint to the evenly modeled flesh. There is a tension between the angularity of the lines in the drawing and the modeling. If you focus on the lines, the drawing may seem to be more angular and geometric than organic. But the use of chiaroscuro creates a more subtle and human rounding of the face.

Descriptive and Expressive Properties of Value

Values—black, grays, white—may be used purely to describe objects, or they can be used to evoke emotional responses in the viewer.

Black and white may have expressive properties or symbolic associations. Consider the photograph of a performance piece by Lorraine O'Grady (Fig. 2-37) staged in protest of the opening of an exhibit entitled "Personae," which featured the work of nine white artists and *no* artists of color. Labeling herself "Mlle Bourgeoisie Noire" (or Miss Middle-Class Black), O'Grady appeared in an evening gown constructed of 180 pairs of white gloves and shouted poems that lashed out against the racial politics of the art establishment. Clearly, the white gloves were both evocative and provocative. They were at once a symbol of high society and servitude, of the elegant attire of the exclusive dinner party and the vaudevillian costume of blackface and white-gloved hands.

Even though Robert Ryman's *Winsor 6* (Fig. 2-38) may seem very far removed from the symbolic references of O'Grady's character, his composition nonetheless suggests a certain purity that is associated with white. Indeed, the theory behind his minimalist work was expressed by the art critic Clement Greenberg, who encouraged artists to emphasize the "objecthood" or actuality of their works. The issue to Greenberg and Ryman was not what the painting represented but rather the existence of the painting as an object in its own right.

2-37 LORRAINE O'GRADY. *Mlle Bourgeoise Noire Goes to the New Museum* (1981). Courtesy of the artist.

2-38 ROBERT RYMAN. *Winsor 6* (1965). Oil on linen. 75¾″ × 75¾″. Private Collection. Courtesy Thomas Amman Fine Art, Zürich.

It is only after years of preparation that the young artist should touch color—
not color used descriptively, that is, but as a means of personal expression.

—Henri Matisse

COLOR

Color is a central element in our spoken language as well as in the language of art. The language connects emotion with color: we speak of being blue with sorrow, red with anger, green with envy.

The color in works of art can also trigger strong emotional responses in the observer, working hand in hand with line and shape to enrich the viewing experience. The Postimpressionist Vincent van Gogh often chose color more for its emotive qualities rather than for its fidelity to nature. Likewise in some amorphous abstract works, such as *Bay Side* (Fig. 2-25), color itself seems to be much of the "message" being communicated by the artist.

What is color? You have no doubt seen a rainbow or observed how light sometimes separates into several colors when it is filtered through a window. Sir Isaac Newton discovered that sunlight, or white light, can be broken down into different colors by a triangular glass solid called a **prism** (Fig. 2-39).

Psychological Dimensions of Color: Hue, Value, and Saturation

The wavelength of light determines its color, or **hue.** The visible spectrum consists of the colors red, orange, yellow, green, blue, indigo, and violet. The wavelength for red is longer than that for orange, and so on through violet.

The value of a color, like the value of any light, is its degree of lightness or darkness. If we wrap the colors of the spectrum around into a circle, we create a color wheel such as that shown in Figure 2-40. (We must add some purples not found in the spectrum to complete the circle.) Yellow is the lightest of the colors on the wheel, and violet is the darkest. As we work our way around from yellow to violet, we encounter progressively darker colors. Blue green is about equal in value to red orange, but green is lighter than red.

The colors on the green–blue side of the color wheel are considered **cool** in "temperature," whereas the colors on the yellow–orange–red side are considered **warm.** Perhaps greens and blues suggest the coolness of the ocean or the sky, and hot things tend to burn red or orange. A room decorated in green or blue may appear more appealing on a hot day in July than a room decorated in red or orange. On a canvas, warm colors seem to advance toward the picture plane. Cool colors, on the other hand, seem to recede.

The **saturation** of a color is its pureness. Pure hues have the greatest intensity, or brightness. The saturation, and hence the intensity, decrease when another hue or black, gray, or white is added. Artists produce **shades** of a given hue by adding black, and **tints** by adding white.

2-39 Prism.
 A prism breaks down white light into the colors of the visible spectrum.
 Courtesy of Bausch & Lomb.

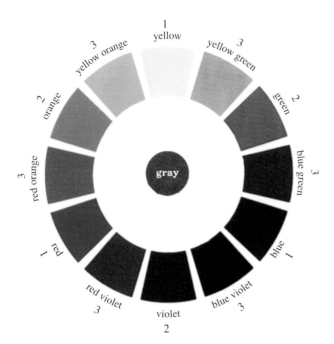

2-40 A color wheel.
The color wheel bends the colors of the visible spectrum into a circle and adds a few missing hues to complete the circle.

Complementary versus Analogous Colors

The colors opposite each other on the color wheel are said to be **complementary.** Red-green and blue-yellow are the major complementary pairs. If we mix complementary colors together, they dissolve into neutral gray.

Wait! You may say that blue and yellow cannot be "complementary" because by mixing **pigments** of blue and yellow, we create green, not gray. That is true, but we are talking about mixing *lights,* not pigments. Light is the source of all color; pigments reflect and absorb different wavelengths of light selectively. The mixture of lights is an *additive* process (Fig. 2-41), whereas the mixture of pigments is *subtractive* (Fig. 2-42).

Pigments attain their colors by absorbing light from certain segments of the spectrum and reflecting the rest. For example, we see most plant life as green because the pigment in chlorophyll absorbs most of the red, blue, and violet wavelengths of light. The remaining green is reflected. A red pigment absorbs most of the spectrum but reflects red. White pigment reflects all colors equally. Black pigment reflects very little light; it absorbs all wavelengths without prejudice. Black and white may be considered colors, but not hues.

Black, white, and their mixture of gray are **achromatic,** or neutral, "colors," also referred to simply as **neutrals.**

The pigments of red, blue, and yellow are the **primary colors,** those that we cannot produce by mixing other hues. Mixing pigments of the primary colors creates **secondary colors.** The three secondary colors are orange (derived from mixing red and yellow), green (blue and yellow), and violet (red and blue), denoted by the number 2 on the color wheel. **Tertiary colors** are created by mixing pigments of primary and adjoining secondary colors and are denoted by a 3 on the color wheel.

Hues that lie next to one another on the color wheel are **analogous.** They form families of color, such as yellow and

2-41 Additive color mixtures.
One adds colors by mixing lights.
Copyright Fritz Goro, Time & Life Pictures/Getty Images.

2-42 Subtractive color mixtures.
One subtracts colors by mixing pigments.
Copyright Fritz Goro, Time & Life Pictures/Getty Images.

orange, orange and red, and green and blue. As we work our way around the wheel, the families intermarry, such as blue with violet and violet with red. Works that use closely related families of color seem harmonious, such as Romare Bearden's *J Mood* (Fig. 2-43). Works that juxtapose colors that lie across from one another on the color wheel will have the opposite effect. They will appear jarring and discordant rather than harmonious.

Victor Vasarely's *Orion* (Fig. 2-44) is an assemblage of paper cutouts that take on different intensities depending on their backgrounds. Vasarely, an Op artist, sought to create optical illusions in many of his works. In *Orion,* the shifts from warm to cool hues cause elements of the arrangement to move toward or away from the viewer. The progressions of circles and ellipses within lighter and darker squares contribute to the pulsating sense of the piece.

Many pictures show a balance of hues, although artists do not necessarily think in terms of complementary and analogous colors. Artists may simply experiment with their compositions until they find them pleasing, but our analyzing their use of color and other elements of art helps us appreciate their work.

2-45 CLAUDE MONET.
Haystack at Sunset near Giverny (1891).
Oil on canvas. $28^{7}/8'' \times 36^{1}/2''$.

Local versus Optical Color

Have you ever driven at night and wondered whether vague, wavy lines in the distance outlined the peaks of hills or the bases of clouds? Objects may take on different hues as a function of distance or lighting conditions. The greenness of the trees on a mountain may make a strong impression from the base of the mountain, but from a distant vantage point the atmospheric scattering of light rays may dissolve the hue into a blue haze. Light-colored objects take on a dark appearance when lit strongly from behind. Hues fade as late afternoon wends its way to dusk and dusk to night. **Local color** is defined as the hue of an object as created by the colors its surface reflects under normal lighting conditions. **Optical color** is defined as our perceptions of color, which can vary markedly with lighting conditions.

Consider the *Haystack at Sunset near Giverny* (Fig. 2-45) by the French Impressionist Claude Monet. Hay is light brown or straw colored, but Monet's haystack takes on fiery hues, reflecting the angle of the light from the departing sun. The upper reach of the stack, especially, is given a forceful silhouette through flowing swaths of dark color. Surely the pigments of the surface of the haystack are no darker than the roofs of the houses that cling tenuously to an implied horizontal line across the center left of the picture. But the sun washes out their pigmentation. Nor can we with certainty interpret the horizontal above the roofs. Is it the top of a distant hill or the base of a cloud? Only in the visual sanctuary to the front of the haystack do a few possibly accurate greens and browns assert themselves. The amorphous shapes and pulsating color fields of *Haystack* lend the painting a powerful emotional impact.

In *The Night Café* (Fig. 2-46), Vincent van Gogh used color expressively rather than realistically. A café is generally

2-46 VINCENT VAN GOGH.
The Night Café (1888).
Oil on canvas. $27^{1}/2'' \times 35''$.

2-47 ERWIN REDL.
Matrix IV 30/5/01
Installation view of at Creative Time's "Massless Medium:
Exploration in Sensory Immersion." The Brooklyn Bridge
Anchorage, Brooklyn, NY.
Collection of the artist.

surround the lamps create lights that never were—
a psychological display of brilliance and agitation.

The familiar expression "sensory overload"
reaches new heights (literally) in Erwin Redl's
Matrix IV 30/5/01 (Fig. 2-47), an installation
that immerses the viewer in a cool and highly
saturated "blueness." The LED display is usually
thought of as a medium for carrying information,
but Redl's wall of light—constructed of LED
points, lines, and grids—is used as a medium
for sensory stimulation. Some of his installations
are programmed to change slowly as the viewer
looks on, in sharp contrast to the rapidly changing
electronic displays that usually confront viewers
today.

Texture is another element of art that can
evoke a strong emotional response.

TEXTURE

The softness of skin and silk, the coarseness of
rawhide and homespun cloth, the coolness of stone
and tile, the warmth of wood—these are but a few
of the **textures** that artists capture in their works.
The word *texture* derives from the Latin for "weav-
ing," and it is used to describe the surface character
of woven fabrics and other materials as experienced
primarily through the sense of touch.

The element of texture adds a significant di-
mension to art beyond representation. An artist
may emphasize or even distort the textures of ob-
jects to evoke a powerful emotional response in the
viewer. Consider the contrasting use of texture—
and the differing emotional impact—of Leon Kossoff's
Portrait of Father, No. 2 (Fig. 2-48) and Marie Laurencin's
Mother and Child (Fig. 2-49). The first contains the harsh,
gouged textures of **impasto**—that is, the thick buildup of
paint on the surface of the canvas. The textures formed by
the technique give rise to an overall aggressive, confronta-
tional feeling. If you try to imagine the image rendered
with smoother, flatter strokes, some of the dysphoria might
well be diminished. As it is, the texture might suggest to
some the type of father/authority figure that the psychoana-
lyst Sigmund Freud believed young boys fear. In Freud's
theory, fathers are dangerous rivals for the affections of their
mothers.

Laurencin's *Mother and Child*, like Kossoff's *Portrait of
Father, No. 2,* is an oil painting. But here the brushstrokes

seen as a place to unwind and relax in the company of
friends, yet the artist chose this harsh palette to tell the
world that this is a place where one "can ruin oneself." The
red of the walls and the green of the ceiling clash, yet the
billiard table and the floor, which both contain reds and
greens, marry the two. The agitated swirls of local color that

2–48 LEON KOSSOFF.
Portrait of Father, No. 2 (1972).
Oil on board. 60″ × 36″.
Courtesy of L. A. Louver, Venice, CA.

2–49 MARIE LAURENCIN.
Mother and Child (1928).
Oil on canvas. 32″ × 25½″ (81.3 cm × 63.8 cm).
Photo copyright The Detroit Institute of Arts. City of Detroit Purchase.
Copyright 2003 Artists Rights Society (ARS), New York/ADAGP, Paris.

are shorter and flatter, and they gradually build up the imagery rather than "carve" it. The overall texture of *Mother and Child* is soft and seems comforting, reinforcing the feeling of tenderness between mother and child.

In these contrasting portraits, the role of texture surpasses the literal content of the works—that is, they are both portraits of people—to add an emotional dimension for the viewer. The father becomes an oppressive figure by virtue of the tension in the texture, and the mother becomes a symbol of nurturance by virtue of the tranquility in the texture. In both portraits, texture augments the meaning of the work.

Types of Texture

In three-dimensional media such as sculpture, crafts, and architecture, the materials themselves have definable textures or *actual texture*. In a two-dimensional medium such as painting, we discuss texture in other terms. For example, the surface of a painting has an *actual* texture—it can be rough, smooth, or something in between. But we typically discuss the surface only when the texture is palpable or unusual, as when thick impasto is used or when an unusual material is added to the surface.

2-50 VINCENT VAN GOGH.
Irises (1889).
Oil on canvas. 28″ × 36¾″.
Collection of the J. Paul Getty Museum, Los Angeles.

2-51 RACHEL RUYSCH.
Flower Still Life (after 1700).
Oil on canvas. 29¾″ × 23⅞″.
The Toledo Museum of Art, OH.
Purchased with funds from the Libbey Endowment,
gift of Edward Drummond Libbey.

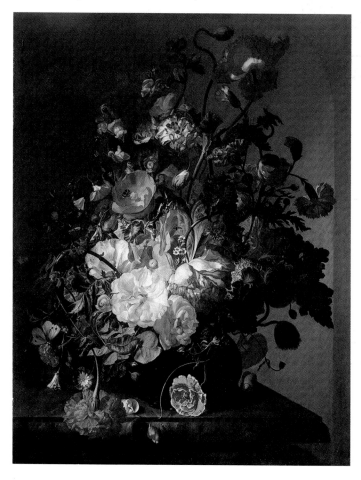

Actual Texture

Actual texture is *tactile.* When you touch an object, your fingertips register sensations of its actual texture—rough, smooth, sharp, hard, soft. Any work of art has actual texture—whether it is the hard, cold texture of marble or the rough texture of pigment on canvas. Vincent van Gogh's *Irises* (Fig. 2-50) is rendered with a great deal of surface texture. Van Gogh used impasto—the most common painting technique that yields actual texture—to define his forms, and he often deviated from realistic colors and textures to heighten the emotional impact of his work. The surface texture of the painting goes beyond the real texture of the blossom to communicate an emotional intensity and passion for painting that is independent of the subject matter and more linked to the artistic process—that is, to the artist's method of using gestural brushstrokes to express his sensibilities.

Visual Texture

Simulated texture in a work of art is referred to as **visual texture.** Artists use line, color, and other elements of art to create the illusion of various textures in flat drawings and paintings. The surface of Rachel Ruysch's *Flower Still Life* (Fig. 2-51) is smooth and glasslike; however, an abundance of textures is *simulated* by the painstaking detail of the flowers and leaves.

2-52 DAVID GILHOOLY.
Bowl of Chocolate Moose (1989).
Ceramic. 10″ × 6″ × 7″ (25.4 cm × 15.2 cm × 17.8 cm).
Courtesy of the artist.

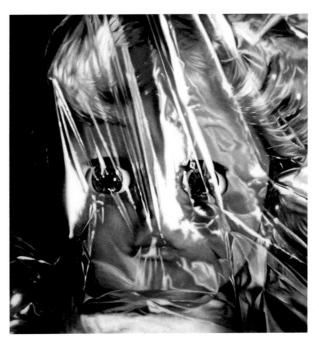

2-53 JAMES ROSENQUIST.
Gift Wrapped Doll #19 (1992).
Oil on canvas. 60″ × 60″ (152 cm × 152 cm).
Copyright 2003 James Rosenquist. Licensed by VAGA, New York.

Artists employ a variety of materials to create visual texture, or the illusion of surfaces or textures far removed from their actual texture. Touch Gilhooly's *Bowl of Chocolate Moose* (Fig. 2-52), and, your eyes will tell you, your hand will come away covered with that sticky confection. The surface may appear to be warm and pliable, as if this chocolate moose were panting and melting away into an edible dessert. In fact, it is hard and cool to the touch. The actual texture of the ceramic from which it is made is completely contrary to the illusion that the artist has achieved. *Chocolate Moose* is an artistic pun of virtuoso technique that demonstrates how the visual texture of a work of art affects our response to it. What memories does it conjure up for you? Eating a chocolate bar on a warm summer day?

The success of the visual pun in Gilhooly's *Chocolate Moose* is wholly dependent on the artist's ability to fool the eye. Artists call this **trompe l'oeil**—the French phrase that literally means "trick the eye." Trompe l'oeil has made its appearance throughout the history of art, from first century BCE Roman wall painting to contemporary Photorealism.

In *Gift-Wrapped Doll #19* (Fig. 2-53), Pop artist James Rosenquist uses a common medium—oil on canvas—to simulate the texture of cellophane wrapped around the head of a wide-eyed porcelain doll. The folds of the transparent wrap reflect light, tearing across the innocent face like white-hot rods. We feel, as observers, that were we to poke at the cellophane, we would hear a crackling sound and the pattern of lightning-like stripes would change direction. The image of a doll is usually that of a cuddly companion, but Rosenquist's specimen is haunting and sinister. Perhaps it is a commentary on the ways in which the Western ideal of beauty—blue eyes, blond hair, and a "Cupid's bow" mouth—can suffocate the little girls who grow into women.

Subversive Texture

Textures are sometimes chosen or created by the artist to subvert or undermine our ideas about the objects that they depict. **Subversive texture** compels the viewer to look again at an object and to think about it more deeply.

2-54 MERET OPPENHEIM.
Object (1936).
Fur-covered cup, saucer, and spoon. Overall height: 2⅞″.

You may take objects such as a cup, saucer, and spoon for granted, but not after viewing Meret Oppenheim's *Object* (Fig. 2-54). Oppenheim uses subversive texture in lining a cup, saucer, and spoon with fur. Teacups are usually connected with civilized and refined settings and occasions. The coarse primal fur completely subverts these associations, rendering the thought of drinking from this particular cup repugnant. *Object* also shows how textures can simultaneously attract and repel us. Does Oppenheim want the viewer to ponder the violence that has enabled civilization to grow and endure?

SPACE

"No man is an island, entire of itself," wrote the poet John Donne. If Donne had been speaking of art, he might have written, "No subject exists in and of itself." A building has a site, a sculpture is surrounded by space, and even artists who work in two-dimensional media such as drawing and painting create figures that bear relationships to one another and to their grounds. Objects exist in three-dimensional space. Artists either carve out or model their works within three-dimensional space, or else somehow come to terms with three-dimensional space through two-dimensional art forms.

In Chapters 9 and 10, which discuss the three-dimensional art forms of sculpture and architecture, we explore ways in which artists situate their objects in space and envelop space. In Chapter 10 we chronicle the age-old attempt to enclose vast reaches of space that began with massive support systems and currently focuses on lightweight steel-cage and shell-like structures. In this section we will examine ways in which artists who work in two dimensions create the illusion of depth—that is, the third dimension.

Overlapping

When nearby objects are placed in front of more distant objects, they obscure part or all of the distant objects. Figure 2-55 shows two circles and two arcs, but our perceptual experiences encourage us to interpret the drawing as showing four circles, two in the foreground and two in back. Likewise, it is this perceptual phenomenon that allows an artist to create the illusion of depth by overlapping objects, or apparently placing one in front of another. There are any number of works in your textbook that illustrate the technique of overlapping and its effect in suggesting space—whether deep, as in Church's *Heart of the Andes* (Fig. 2-65), or shallow, as in Beckmann's *The Dream* (see Fig. 1-15).

We decided to make grand history paintings of a small local history.

—Destroy All Monsters Collective

2-55 Overlapping circles and arcs.

In *The Heart of Detroit by Moonlight* (Fig. 2-56), part of an installation by the Destroy All Monsters Collective that appeared in the 2002 Whitney Biennial Exhibition, the overlapping of images of popular (and not-so-popular) Detroit personages—local TV hosts, rock singers, and musical legends—reads like so much pushing and shoving as the personalities joust for position and the attention and money of the viewer-listener. The backdrop of the city on which the figures are superimposed—a seemingly random collection of skyscrapers—recedes from the picture plane, a safe haven that seems impossible to reach. What we are left with is what is literally "in our faces." One of the messages of the piece, according to a participating artist, is that mass media can obliterate any local scene, yet it can also popularize nearly random local "stars" around the globe—transforming them into cultural phenomena, even in the most unlikely far-off places.

Relative Size and Linear Perspective

The farther objects are from us, the smaller they appear to the eye. To re-create this visual phenomenon and to create the illusion of three-dimensionality on a two-dimensional surface, such as a canvas, artists employ a variety of techniques, among them **relative size** and **linear perspective.** For example, in the Church painting (Fig. 2-65), objects in the foreground are smaller in size and scale relative to the mountains in the distance, making them look even more imperious.

2-56 DESTROY ALL MONSTERS COLLECTIVE. *The Heart of Detroit by Moonlight* (2000). From the installation *Strange Früt: Rock Apocrypha,* 2000–2001. Acrylic on canvas. 120″ × 204″.

Collection of the artists. Courtesy, Patrick Painter, Inc., Santa Monica, CA.

2-57 NI ZAN.
Rongxi Studio (Late Yuan / Early Ming dynasty, 1372 CE).
Hanging scroll; ink on paper. H: 29¼″.
National Palace Museum, Taipei, Taiwan, Republic of China.

In the Chinese ink drawing shown in Figure 2-57, the natural elements at the top and bottom of the scroll are shown at the same size, as if they were seen from the same distance. Yet the viewer—particularly the schooled viewer—tends to perceive the hills at the top as being far-

2-58 A visual illusion.

ther away. Again, objects depicted at the bottom of a work tend to be perceived as closer to the viewer.

Note how the cylinders in Figure 2-58 appear to grow larger toward the top of the composition. Why? For at least two reasons: (1) Objects at the bottom of a composition are usually perceived as being closer to the picture plane, and (2) the converging lines are perceived as being parallel, even when they are not. However, if they were parallel, then space would have to recede toward the center right of the composition, and the cylinder in that region would have to be farthest from the viewer. According to rules of perspective, a distant object that appears to be equal in size to a nearby object would have to be larger, so we perceive the cylinder to the right as the largest, although it is equal in size to the others.

Figures 2-59 through 2-62 show that the illusion of depth can be created in art by making parallel lines come together, or converge, at one or more **vanishing points** on an actual or implied horizon. The height of the **horizon** in the composition corresponds to the apparent location of the viewer's eyes, that is, the **vantage point** of the viewer. As we shall see in later chapters, the Greeks and Romans had some notion of linear perspective, but Renaissance artists such as Leonardo da Vinci refined perspective.

In **one-point perspective** (Fig. 2-59), parallel lines converge at a single vanishing point on the horizon. Photorealist Richard Estes's *Williamsburg Bridge* (Fig. 2-63) offers the consummate exercise in one-point perspective. One can locate the vanishing point by following converging parallel lines (Fig. 2-64) to where they intersect near the center of the composition. By placing the vanishing point at the eye

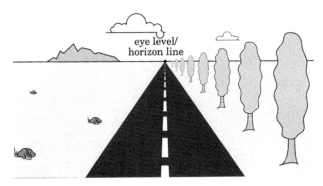

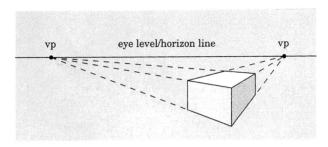

2-59 One-point perspective.

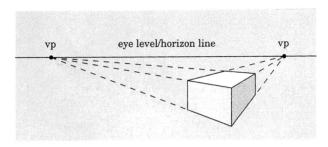

2-60 Two-point perspective.

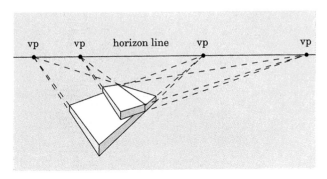

2-61 Perspective drawing of objects set at different angles.

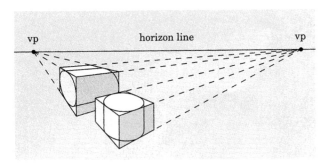

2-62 Curved objects drawn in perspective.

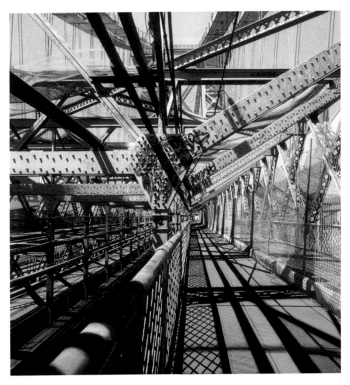

2-63 RICHARD ESTES.
Williamsburg Bridge (1995).
Oil on canvas. 32″ × 32″.
Copyright Richard Estes. Courtesy, Marlborough Gallery, New York.

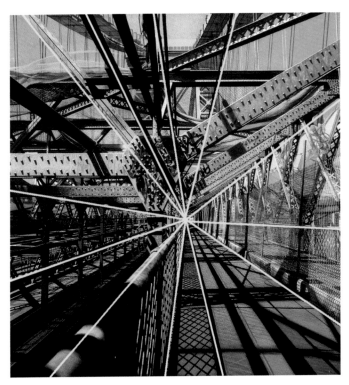

2-64 Converging parallel lines intersect at the vanishing point.

First study science, and then follow with practice based on science. . . . The painter who draws by practice and judgment of the eye without the use of reason is like the mirror that reproduces within itself all the objects which are set opposite to it without knowledge of the same. . . . The youth ought first to learn perspective, then the proportions of everything, then he should learn from the hand of a good master.

—Leonardo da Vinci

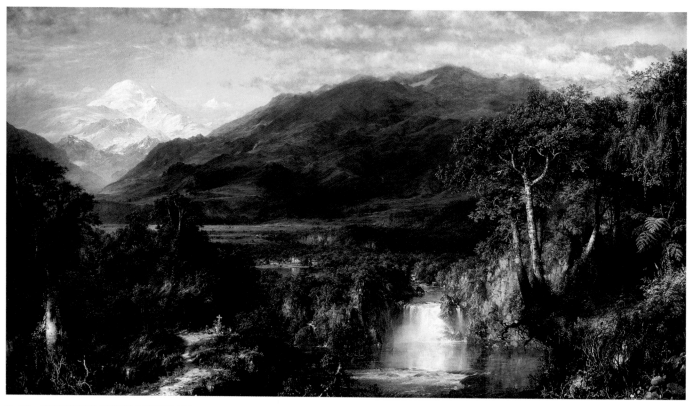

2-65 FREDERIC EDWIN CHURCH.
Heart of the Andes (1859).
Oil on canvas. 66⅛″ × 119¼″ (168 cm × 302.9 cm).
Courtesy of The Metropolitan Museum of Art. Bequest of Margaret E. Dows, 1909 (09.95). Photograph copyright 1979 The Metropolitan Museum of Art, New York.

level of a person walking across the bridge, Estes heightens the impression of "being there."

In **two-point perspective** (Fig. 2-60), two sets of parallel lines converge at separate vanishing points on the horizon. Two-point perspective is appropriate for representing the recession of objects that are seen from an angle, or obliquely.

We can use additional sets of parallel lines to depict objects that are set at different angles, as shown in Figure 2-61. Figure 2-62 shows how curved objects may be "carved out" of rectangular solids.

2-66 SYLVIA PLIMACK MANGOLD.
Schunnemunk Mountain (1979).
Oil on canvas. 60″ × 80⅛″.
Courtesy of Dallas Museum of Art, Dallas, TX.

Atmospheric Perspective

In **atmospheric perspective** (also called *aerial perspective*), the illusion of depth is created by techniques such as texture gradients, brightness gradients, color saturation, and the manipulation of warm and cool colors.

A gradient is a progressive change. The effect of a **texture gradient** relies on the fact that closer objects are perceived as having rougher or more detailed surfaces. In the Estes painting, the metal girders in the foreground are more detailed than those in the distance, facilitating the perception of depth. The effect of a **brightness gradient** is due to the lesser intensity of distant objects.

Frederic Edwin Church's masterpiece, *The Heart of the Andes* (Fig. 2-65), relies in part on atmospheric perspective to create the illusion of deep vistas. The foreground of the picture contains such botanical detail that the painting could serve as a scientific record of the species indigenous to the region. As the vista recedes into the distance, the plants and hills become less textured and the colors become less saturated. Church belonged to the Hudson River School of nineteenth-century American painting. The group's members used landscape as a vehicle for communicating the feeling of awe they experienced when they encountered the romantic, scientific, and religious ideas of the era—a world without limits. Vasarely's *Orion* (Fig. 2-44) uses some principles of atmospheric perspective to help create the illusion of movement through a vibrating effect. The brightest, most intense circles are perceived as being closest to the viewer, although, of course, all the mounted scraps of paper are right on the picture plane.

The haunting painting *Schunnemunk Mountain* (Fig. 2-66) reveals Sylvia Plimack Mangold's fascination with the transitional moments of the day. Here in the evening of the Hudson River Valley, brightness gradients employing purple, navy, and cobalt set the hills beneath the sky. The dark foreground is rendered more vacant by twinkling lights that suggest habitation in the valley beyond.

I paint with shapes.

—Alexander Calder

TIME AND MOTION

Objects and figures exist and move not only through space but also through the dimension of time. In its inexorable forward flow, time provides us with the chance to develop and grasp the visions of our dreams. Time also creates the stark limits beyond which none of us may extend.

Artists through the ages have sought to represent three-dimensional space in two-dimensional art forms as well as to represent, or imply, movement and the passage of time. Only in modern times have art forms such as cinematography and video been developed that involve *actual* movement and *actual* time.

Actual Motion

Artists create or capture **actual motion** in various ways. **Kinetic art** (from the Greek *kinesis,* meaning "movement") and photography are two of them. Most works of art sit quietly on the wall or, perhaps, on a pedestal, but kinetic art is designed to move.

The **mobiles** of Alexander Calder are some of the most popular examples of kinetic art in the twentieth century. The colossal mobile that hangs in the interior of the East Building of the National Gallery of Art (Fig. 2-67) is composed of winglike dashes and disks of different sizes that are cantilevered from metal rods such that they can rotate horizontally—in orbits—as currents of air press against them. However, the center of gravity remains stable, so the entire sculpture is hung from a single point. Unlike a painting, the mobile changes according to the movement of air above and the movement of the observer below, who might shift vantage points to create new compositions, new relationships among the shapes and lines.

Philippe Halsman's photograph *Dali Atomicus* (Fig. 2-68) **stopped time** to capture motion. The man in the photograph is the Surrealist artist Salvador Dalí. To make this photo, the photographer counted to four, at which time Dalí leapt into the air. The photographer's assistants tossed a bucket of water and three cats across the room. The photographer's wife held the chair in the air. The result you see represents the twenty-sixth effort to juggle the elements of the photograph to catch a fascinating image.

2-67 ALEXANDER CALDER.
Untitled (1972).
East Building mobile.

National Gallery of Art, Washington, DC.
Gift of the Collectors Committee. Copyright
2003 Board of Trustees, National Gallery of Art,
Washington, DC, 1976. Copyright 2003
Estate of Alexander Calder/Artists Rights Society
(ARS), New York.

2-68 PHILIPPE HALSMAN.
Dali Atomicus (1948).
Gelatin silver print.
Courtesy of the Halsman Estate.

2-69 GIANLORENZO BERNINI.
Apollo and Daphne (1622–1624).
Marble. 7′6″.
Galleria Borghese, Rome.

Implied Motion and Time

Dali Atomicus captured motion by stopping time. Other works of art *imply* motion; that is, the viewer infers that motion is occurring or has occurred. **Implied motion** and **implied time** are found in Baroque sculptor Gianlorenzo Bernini's *Apollo and Daphne* (Fig. 2-69) through the use of diagonal lines of force that help simulate movement from left to right. In the Greek myth, the wood nymph Daphne beseeches the gods to help her escape the overtures of Apollo. As Apollo gains on her, her prayer is answered in a most ironic manner because the gods choose to facilitate her "escape" by transforming her into a tree. In Bernini's sculpture we see Daphne just at the point when bark begins to enfold her body, her toes begin to take root, and her fingertips are transformed into the branches of a laurel. The passage of time is implied as she is caught in the midst of her transformation.

In *Apollo and Daphne*, motion is implied in the fluid strides and seamless transfiguration of Daphne. Motion can also be implied through repetitive imagery. We are all familiar with the way in which comic strips suggest the motion of the characters by repetition of imagery that changes slightly from frame to frame. This technique spans time and culture.

2-70 IDA APPLEBROOG.
I Can't (1981).
Ink and Rhoplex on vellum. Seven parts: 10½″ × 9½″ (6); 9 × 9½″ (1).
Cincinnati Art Museum, Gift of RSM Co. Courtesy Ronald Feldman Fine Arts, New York.

The multiple panels of Ida Applebroog's *I Can't* (Fig. 2-70) imply the passage of time in the same way that frames are used to advance a narrative in comic books or film storyboards. A barren scene with two women, their relationship unknown, is repeated six times. Only the words *I can't* and *Please,* randomly assigned to some panels, break up the cloying repetitive rhythm of the work. In the end one of the women is taken away at gunpoint. This panel is set apart from the others in size and color, although it still has the same, bland, uneventful quality as the others. When we read the words *Let's all kiss Mommy goodbye,* on the other hand, the last panel acts like a disturbing period at the end of a sentence.

The Illusion of Motion

There is a difference between implied motion and the illusion of motion. Works such as *Apollo and Daphne* imply that motion has occurred or that time has passed. In other works, artists use techniques to suggest that motion is *in the process of occurring* rather than having occurred. We say that these works contain the illusion of motion.

Early experiments with photography provided an illusion of the figure in motion through the method of rapid multiple exposures. In his *Man Pole Vaulting* (Fig. 2-71), Thomas Eakins—better known for his paintings—used photo sequences to study the movement of the human body.

2-71 THOMAS EAKINS.
Man Pole Vaulting
(c. 1884).
Photograph.
Metropolitan Museum of Art, New York. Gift of Charles Bregler, 1941 (41.142.11). All rights reserved by The Metropolitan Museum of Art, New York.

In the wake of these experiments, a number of artists created the illusion of motion by applying the visual results of multiple-exposure photography to their paintings.

Marcel Duchamp's *Nude Descending a Staircase #2* (Fig. 2-72) in effect creates multiple exposures of a machine-tooled figure walking down a flight of stairs. The overlapping of shapes and the repetition of linear patterns blur the contours of the figure. Even though an unkind critic labeled the Duchamp painting "an explosion in a shingle factory," it symbolized the dynamism of the modern machine era.

Umberto Boccioni's *Dynamism of a Soccer Player* (Fig. 2-73) reveals the obsession with the dynamism of the modern machine era of a school of artists called Futurists, who worked in the Italy of 100 years ago. On approaching the painting, one is struck by the sensation of motion long before it becomes possible to decipher the limbs of a running athlete. Spirals, arcs, and what seem to be flame-licked shapes swirl around a core of energy and fan outward, leaving traces of themselves in the surrounding environment. Wedges of sky fall on the figure like so many spotlights, breaking the solids into bits of prismatic color. The soccer player courses, pulsates, and hurtles ahead, cutting through space and time as the viewer is visually drawn into the work by lines and shapes that appear to encircle and ensnare.

2-72 MARCEL DUCHAMP.
Nude Descending a Staircase #2 (1912).
Oil on canvas. 58″ × 35″.

Philadelphia Museum of Art, Louise and Walter Arensberg Collection. Copyright 2005 Artist Rights Society (ARS), New York/ADAGP, Paris/ Succession Marcel Duchamp/Art Resource, New York.

2-73 UMBERTO BOCCIONI.
Dynamism of a Soccer Player (1913).
Oil on canvas. 6′4⅛″ × 6′7⅛″.

Museum of Modern Art, New York. The Sidney and Harriet Janis Collection. Copyright Art Resource, New York.

When objects move rapidly, it can be difficult to perceive their shapes. They can be "lost in a blur." Blurring outlines is therefore another way to create the illusion of motion. In the photo-piece *Kitchen Tantrums* (Figs. 2-74 and 2-75), rather than stop time, the photographers used slow shutter speeds so that the objects would have the time to visibly move during the time that the film was exposed to light. In one photo, the woman throwing the tantrum tosses potatoes into the air. Her agitation as well as movement is suggested by the blurred outlines of her head and arms. The movement of the bowl and potatoes is suggested by the blurring of their outlines. In other photos, the potatoes take on a life of their own, apparently having gone from a random airborne pattern to a self-controlled juggling act of some sort. Increased speed is indicated by greater blurring of their shapes.

The movement of the 1960s and 1970s known as **Op Art** was based on creating optical sensations of movement through the repetition and manipulation of color, shape, and line. In kinetic sculpture, movement is real, whether activated by currents of air or motors. In Op Art, bold and apparently vibrating lines and colors create the illusion of movement. Bridget Riley's *Cataract 3* (Fig. 2-76) is composed of a series of curved lines that change in thickness and proximity to one another. These changes seem to suggest waves, but they also create a powerful illusion of rippling movement. Complementary red and green colors also contribute to the illusion of vibration. When we look at a color for an extended period of time, we tend to perceive its **afterimage.** Red is the afterimage of green, and vice versa. Therefore, there seems to be a pulsating in Riley's selection of

2-74 and 2-75
BERNHARD JOHANNES AND ANNA BLUME.
Kitchen Tantrums (1986–1987).
Photo-piece. 51⅛″ × 35⅞″.
Courtesy of the artist.

2-76 BRIDGET RILEY.
Cataract 3 (1967).
Emulsion on canvas.
5′10½″ × 5′10½″
British Council, London.
Copyright Bridget Riley.

color as well as in the tendency of the eye to perceive the lines as rippling.

There are many other ways of creating the illusion of motion, including contemporary cinematography and video. Motion pictures create an illusion of movement so real that it cannot be distinguished from real movement by the naked eye. Motion pictures do not move in the way that they seem to move.[1] Rather, they create the illusion of movement through **stroboscopic motion.** In this method, the viewer is shown from 16 to 24 still pictures per second. Each picture or frame differs slightly from the one that preceded it. The individual who views the frames in rapid succession has the psychological experience—the *illusion*—of seeing moving objects rather than a series of still pictures. It does not matter whether viewers know that they are watching a progression of still images; the illusion of movement is so powerful that it is experienced as real movement. Motion pictures may *capture* real movement, but the way in which they *depict* movement involves illusion.

If the visual elements are considered the basic vocabulary of art, principles of design might be viewed as the grammar of art. Artists use principles of design to combine the visual elements into compositions. In art, as in life, this "language" is idiosyncratic to the individual.

[1] Certainly the film moves through the projector so that the frames are projected onto the screen in rapid succession. But each frame contains a still (unmoving) image.

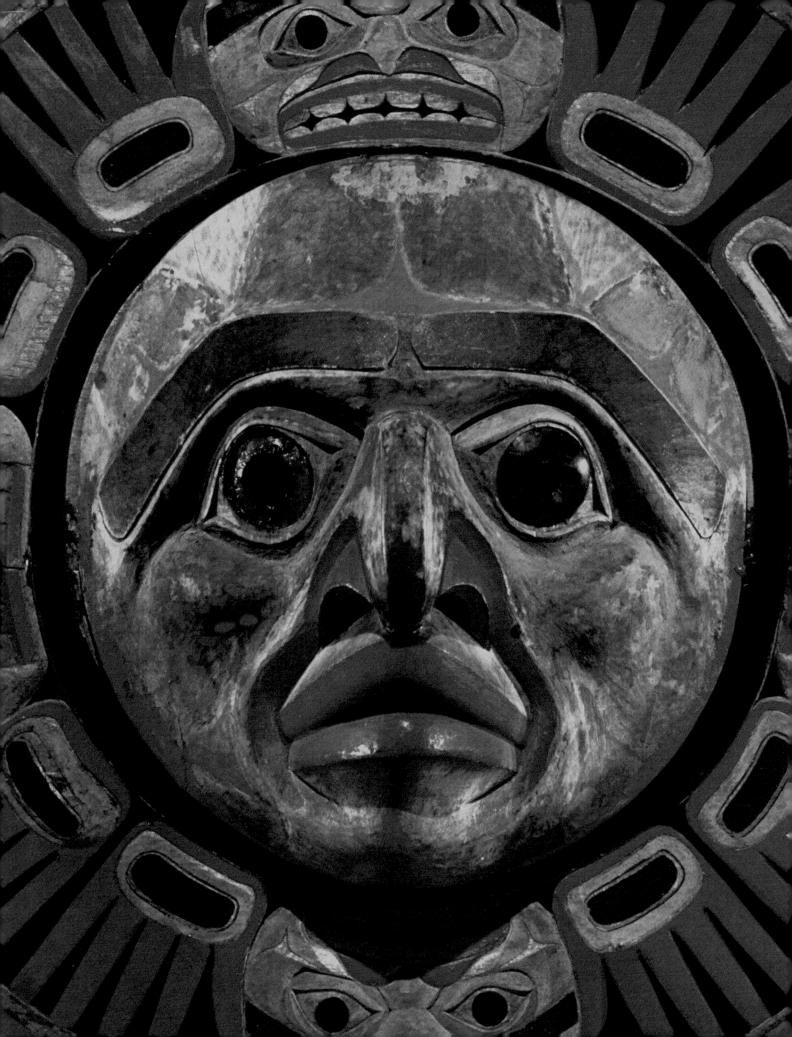

PRINCIPLES OF DESIGN

He searched disorder for its unifying principle.

—Brian O'Doherty on Stuart Davis

Unity is one of the principles of design, and principles of design, like visual elements, are also part of the basic language of art. Just as people use principles of grammar to combine words into sentences, artists use principles of design to combine the visual elements of art into compositions that have a certain style, form, and content.

Design or **composition** is a process—the act of organizing the visual elements to effect a desired aesthetic in a work of art. Designs can occur at random, as exemplified by the old mathematical saw that an infinite number of monkeys pecking away at an infinite number of typewriters would eventually (though mindlessly) produce *Hamlet*. But when artists create compositions, they consciously draw upon design principles such as unity and variety, balance, emphasis and focal point, rhythm, scale, and proportion. This is not to say that all artists necessarily apply these principles, or even always recognize the extent of their presence in their work. Indeed, some artists prefer to purposefully violate them.

Irritation is made possible in the first place by formal clarity and precise scale.

—Katharina Fritsch

UNITY AND VARIETY

Unity is oneness or wholeness. A work of art achieves unity when its parts seem necessary to the composition as a whole. It is the exaggerated unity, the **extreme unity,** of Katharina Fritsch's *Rattenkönig* (Rat-King) (Fig. 3-1) that impacts the

3–1 KATHARINA FRITSCH.
Rattenkönig (Rat-King) (1993).
Polyester resin. H: 2.8 m.
From the installation at Dia Center for the Arts, 548 West 22nd Street, New York, NY, April 1993–June 1994. Photo by Bill Jacobson. Courtesy, Dia Center for the Arts. Copyright 2003 Artists Rights Society (ARS), New York.

viewer—that, and the fact that the rats are nine feet tall and seem to be poised for attack like so many troops from the legendary Roman infantry. Although the composition was inspired by the artist's encounter with a rat hole behind an unnamed New York art institution, the title of the work harks back to the battle between the nutcracker-turned-prince and the evil Rat King in Tchaikovsky's beloved (albeit scary) ballet. The work achieves extreme unity through its repetition of shapes, the exactitude of the "copies," and their placement in a precise circular configuration. Artists generally prefer to place some variety within a unified composition to add visual interest, but the principle of variety is most often subservient to the sense of oneness or overall unity in a work. The more you look at works of art, the better you will become at sensing the unity of compositions and at pinpointing the ways that artists achieve it. Sometimes the techniques will be obvious, and at other times they will be subtler.

Variety seems to rule the day—or night as the case may be—in Archibald Motley Jr.'s *Saturday Night* (Fig. 3-2), with a captivating array of characters—from the dining and drinking patrons and the waiters balancing their orders on tottering trays to one particularly flamboyant woman in a flame red costume who seems lost in the expressive rhythms of her solo dance. Yet this cacophony of sights and sounds and movements achieves a sense of oneness through a unified color field. To be sure, there is also some variety in the color scheme: The eye leaps from patches of black to black and from white to white, mimicking the riot of movement in the nightclub. However, the overall composition is unified by the pulsating reds that seem to emanate from the center of the dance floor and bathe the atmosphere with emotion, energy, and an almost mystical glow.

3–2 ARCHIBALD J. MOTLEY JR.
Saturday Night (1935).
Oil on canvas. 81.3 cm × 101.6 cm.
The Howard University Gallery of Art, Washington, DC.

3-3 THOMAS HART BENTON.
Palisades, from the American Historical Epic series (1919–1924).
Oil on cotton duck on aluminum honeycomb panel. 66⅛″ × 72″.

The Nelson-Atkins Museum of Art, Kansas City, MO. Bequest of the artist (F75-21/2). Copyright 2003 T. H. Benton and Rita P. Benton Testamentary Trusts. Licensed by VAGA, New York.

Although color harmonies also contribute to a sense of oneness in Thomas Hart Benton's *Palisades* (Fig. 3-3), the curvilinear rhythms of shape and line are the strongest purveyors of unity in this work. Here the diversity of the players in this mythologized narrative of American history—the Spanish conquistador, the European colonizer, the Native American—are joined symbolically and pictorially by the echoing shapes and lines and rhythms that define and distinguish the figures and landscape elements. The emergence of a visual pattern of similar elements dominates the individual parts.

When working with the principles of variety and unity, an artist will often keep one or more aspects of the work constant so that in spite of the multiplicity of images or elements, the composition's overall unity will not be compromised. In Renée Green's witty installation (Fig. 3-4), unrelenting patterns of rose-and-white chintz unify the diverse objects of the interior setting—from chairs and hassocks to drapes and wall coverings. In her presentation of a mock showroom in which one might find groupings of furniture collections that mimic a homelike setting, Green educates the "shopper" in the fine art of creating (or at least buying) "ambience"—that intangible certain something, that distinct atmosphere that makes a house a home.

3-4 RENÉE GREEN.
Installation view (1993).

Galerie Metropol, Vienna, Austria. Christian Nagel Photography, Cologne.

3-6 EMMA AMOS.
Measuring Measuring (1995).
Acrylic on linen canvas, African fabric,
laser-transfer photographs. 84″ × 70″.
Courtesy of the artist. Marlborough Gallery, New York.

3-5 BEVERLY PEPPER.
Thel (1976–1977).
Cor-Ten steel and ground covering.
H: 1′3″ × W: 1′6″ × L: 11′3″.
As installed at Dartmouth College, Hanover, NH.
Copyright Beverly Pepper. Courtesy, Marlborough Gallery,
New York.

Beverly Pepper also achieves unity in *Thel*
(Fig. 3-5) by maintaining a constant element. *Thel* is
a sculpture that is at once anomalous and yet com-
pletely integrated with its site. Set before a traditional
"Ivy" building on the Dartmouth College campus,
the ribbonlike configuration of steel is unified with its
surroundings through the inclusion of a triangular
patch of turf that continues from the lawn up the
sloping side of the metal pyramid. *Thel* alters the reg-
ularity of the environment and yet seems a logical
part of the whole.

All of the works we have discussed have **visual
unity;** most embrace the principle of variety within
unity. There is, however, a way to achieve unity in a compo-
sition that does not rely on the consistency or repetition of
the elements of art. Sometimes artists pursue, instead, a
unity of ideas and impose a **conceptual unity** on their
work. They will recognize that the strength of a composition
lies in the diversity of elements and their juxtaposition.
They reject visual harmonies in favor of discordant punctua-
tions and focus on the relationships between the meaning
and functions of the images. Emma Amos's *Measuring Mea-
suring* (Fig. 3-6) offers an example of conceptual unity. The
"ideal" human form is represented by works of art from the
Western canon flanking the seminude figure of an African
woman. "Measuring" has at least a double meaning—the
measure of the African standard of beauty against that of the
Western tradition and the measure of black against white.
The images are physically incongruous, and the elements of
the composition do not encourage visual unity. What unites
this composition is the concept behind the work—the chal-
lenge to address the standard and the canon.

BALANCE

Most people prefer to have some stability in their lives, to
have their lives on a "firm footing." In the same way, most
people respond positively to some degree of balance in the
visual arts. When we walk, run, or perform an athletic feat,
balance refers to the way in which our weight is distributed,
or shifts, so that we remain in control of our movements.
Balance in art also refers to the distribution of the weight—
of the actual or apparent weight of the elements of a compo-
sition. As the athlete uses balance to control movement, so

might the artist choose to use balance to control the distribution or emphasis of elements such as line or shape or color in a composition.

The Classical Greek artist Polykleitos was perhaps the first artist to observe the body's shifting of weight in order to achieve balance and to develop a set of rules to apply this observation to representations of the figure. In his *Doryphoros* (Fig. 3-7), or Spear Bearer, Polykleitos featured his weight-shift principle. He observed that when the body is at rest, one leg bears the weight of the body and the other is relaxed. Further, in order for the body to balance itself, the upper torso shifts, as if corresponding to an S curve, so that the arm opposite the tensed leg is tensed, and the one opposite the relaxed leg is relaxed. Thus, with the weight-shift principle, tension and tension and relaxation and

relaxation are read diagonally across the body. Overall figural balance is achieved.

Actual Balance and Pictorial Balance

Sculptures such as *Doryphoros* have *actual weight* and may thus also have **actual balance.** Even though actual weight and actual balance are not typically at issue in two-dimensional works such as drawings, paintings, and prints, we nonetheless do speak of balance in these compositions. **Pictorial balance** refers to the distribution of the apparent or *visual weight* of the elements in works that are basically two-dimensional, and there are many ways to achieve it. Brazilian artist Lygia Clark's photograph of her performance piece *Cabeça Coletiva* (Collective Head) (Fig. 3-8) possesses

3-7 POLYKLEITOS.
Doryphoros (c. 450–440 BCE).
Roman copy after bronze Greek
original. Marble. 6′6″.
National Museum, Naples.
Copyright Scala/Art Resource, New York.

3-8 LYGIA CLARK.
Cabeça Coletiva (Collective Head) (1975).
Courtesy, Cultural Association, "The World of Lygia Clark" and "Family Clark's Collection." Copyright 2003 Artists Rights Society (ARS), New York/ADAGP, Paris.

both actual and pictorial balance. She and her students filled a large hatlike object with fruit, shoes, love letters—even money—and walked amidst the public, distributing the offerings. The photo reveals that the bearer of gifts is literally engaged in a balancing act while the visual weight of his figure is balanced to the left and right by the companions who guide him.

Symmetrical Balance

You can divide the human body in half vertically, and in the ideal, as in Leonardo da Vinci's most famous drawing, *Proportion of the Human Figure* (Fig. 3-9), there will be an exact correspondence between the left and right sides. **Symmetry** refers to similarity of form or arrangement on either side of a dividing line or plane, or to correspondence of parts in size, shape, and position. When the correspondence is exact, as in Leonardo's drawing, we refer to it as *pure* or *formal symmetry*. In reality, of course, nature is not as perfect as Leonardo would have had it.

Examples of pure or formal symmetry appear no more frequently in art than in nature. More typically, **symmetrical balance** is created through *approximate* symmetry, in which the whole of the work has a symmetrical feeling, but slight variations provide more visual interest than would a mirror image. When the variations to the right and left side of the composition are *more* than slight, yet there remains an overall sense of balance, there is said to be **asymmetrical balance.**

In *pure* or *formal symmetry,* also known as **bilateral symmetry,** everything in a composition to either side of an actual or imaginary line is the same. The regularity and predictability of symmetry cannot help but conjure a sense of peace, calm, comfort, and order. The effect of repetition can be mesmerizing. In architectural works like the United States Capitol Building (Fig. 3-10)—the house in which the laws of the land are created—repetition and symmetry can imply rationality and decorum, tying the structure of the building to a certain symbolic ideal. The design of the Capitol consists of a solid rectangular structure flanked by identical wings that extend from the central part of the building, project forward at right angles, and culminate in "temple fronts" that echo the main entrance beneath a hemispherical dome. An ordinary citizen of the republic takes pride in the architectural grandeur, feels secure in the balance of all of the parts, and—with the obvious references to Greek architecture of the Golden Age—feels a part of the

3-9 LEONARDO DA VINCI.
Proportion of the Human Figure (after Vitruvius)
(c. 1485–1490).
Pen and ink. 13½″ × 9¾″.
Academia, Venice, Italy. Copyright Art Resource, New York.

history of democracy. It is no coincidence that for the nation's Capitol, our founders adapted structures such as the Parthenon of Athens in the hope of associating the new republic with the ancient birthplace of democracy.

In many works of art, the symmetry is *approximate* rather than exact. For example, the overall impression of Korean-born video installation artist Nam June Paik's *Fin de Siècle II* (Fig. 3-11) is one of symmetry, attributable to the repetition of the video monitors on the left and right sides of the composition. However, the actual array of monitors is not precisely repeated, and the images being displayed at any given moment also differ. Paik is fascinated by the intersections of video and music, and the visual images change in sync with or in counterpoint to a pulsating electronic rock score. The approximate symmetry provides variety within

3-10 The United States Capitol Building, Washington, DC.
Copyright Kenneth Garrett / Woodfin Camp Associates.

3-11 NAM JUNE PAIK.
Fin de Siècle II (1989).
201 television sets and four laser discs.
480″ × 168″ × 60″.
(1,219.2 cm × 426.7
cm × 152.5 cm) overall.
Whitney Museum of American Art, New York.
Gift of Lalia and Thurston Twigg-Smith.
Copyright Whitney Museum, New York /
Electronic Arts Intermix (EAI), New York.

the overall unified work. If both sides of the composition were exactly the same, consisting of the same monitors displaying the same images, would the bilateral symmetry strengthen or weaken the composition? Would it add or subtract visual interest?

Asymmetrical Balance

When your eyes are telling you that the elements of a composition are skewed but your brain is registering overall balance, chances are you are witnessing asymmetrical balance.

3-12 VINCENT LAFORET (2004).
A pedestrian on Eighth Avenue across from the Port Authority Bus Terminal braved the conditions on Monday evening, December 6, 2004.
Vincent Laforet/ The New York Times.

3-13 HELEN M. TURNER.
Morning News (1915).
Oil on canvas. 16″ × 14″.
Jersey City Museum, Jersey City, NJ.
Gift of Helen M. Turner.

There is probably a human tendency to effect balance at any cost. Sometimes the right and left sides of a composition bear visibly different shapes, colors, textures, or other elements, yet they are arranged or "weighted" in such a way that the impression, in total, is one of balance. In such cases, the artist has employed the design principle of *asymmetrical* or *informal balance.*

Vincent Laforet's photograph (Fig. 3-12) is both asymmetrical and balanced. Against a blurred backdrop of cars and trucks stopped at a traffic light, a black silhouette sporting a large red umbrella on the left is balanced by glowing spheres of city lights that seem to hover in the fog like UFOs. Once again, the viewer can engage in a compositional exercise to ascertain the value of placement and of color in achieving the sense of overall balance: cover the red umbrella, or change its color to black or white, and the result will be one of imbalance.

A high contrast of values can be used to establish asymmetrical balance, as the potency of black against white provides a certain visual weight. In Helen M. Turner's *Morning News* (Fig. 3-13), well-placed touches of color in an asym-

3-14 DEBORAH BUTTERFIELD.
Verde (1990).
Found steel. 79″ × 108″ × 31″.
Courtesy Edward Thorp Gallery, New York.

metrical composition are responsible for the overall visual balance. The artist has placed the figure well to the right, and the newspaper she holds forms a distinct diagonal that leads our eye in this direction. Along an imaginary opposing diagonal, however, patches and swaths of red paint balance the more prominent shapes of the woman and her gazette. The eye bounces from one bright area of saturated color to another against the field of blacks, whites, and grays, pulling the opposing sides together—bringing them into balance. *Morning News* is also an example of how vibrant color will command the viewer's attention, diminishing the effect of other compositional elements. Cover up the red and your eyes will begin to linger on the painting's shapes, lines, and textures.

In Deborah Butterfield's *Verde* (Fig. 3-14), the mane and head of the horse are defined by greenish strips of steel that enframe void space. (The title *Verde* calls our attention to the finish of the steel, a greenish coating referred to as *verdigris*.) The *actual weight* of this upper part of the horse

is negligible. The body, on the other hand, is composed of heavy molded sheets of steel, approximating the volume of the animal's torso. Overall visual balance is achieved in this work because the outlines of the head and neck, silhouetted against the white wall, pop out at the viewer. They become so prominent that they carry enough *visual weight* to balance the more densely compacted sheet metal of the animal's body.

Horizontal, Vertical, and Radial Balance

In works of art with **horizontal balance,** the elements at the left and right sides of the composition seem to be about equal in number or visual emphasis. The United States Capitol Building (Fig. 3-10) and *Fin de Siècle II* (Fig. 3-11) have horizontal balance. So, too, does Gertrude Käsebier's delicately textured photograph *Blessed Art Thou among*

3-16 Bella Coola mask, British Columbia
(before 1897).
Wood. D: 24¾".
American Museum of Natural History, New York.

3-15 GERTRUDE KÄSEBIER.
Blessed Art Thou among Women (c. 1898).
Photograph.
Courtesy of The Royal Photographic Society/Heritage Image Partnership
(HIP), heritage-images.com.

Women (Fig. 3-15). Notice how the dark value of the girl's dress is balanced both by the dark wall to the left and by the woman's hair. Similarly, the stark light value of the vertical shaft of the doorway to the left and the light values of the right side of the composition are in equilibrium.

In **vertical balance,** the elements at the top and bottom of the composition are in balance. In the case of **radial balance,** the design elements radiate from a center point. Radial balance is familiar to us because nature offers us so many examples. From the petals of a daisy and the filaments of a spider's web to the sun's powerful rays, lines or shapes radiate from a central point and lead the viewer's eye in a circular pattern around the source.

Radial balance is frequently a major principle of design in art forms such as ceramics, jewelry, basketry, stained glass, and other crafts. The Native American Bella Coola mask (Fig. 3-16) consists of a stylized face of a sun god surrounded by an alternating pattern of masks and outstretched hands. The fingertips radiate from the stylized palms toward the circumference of the mask, mimicking the rays of the celestial body that grants warmth and sustenance.

Even if the circular pattern is visually incomplete, it is possible to create centrifugal forces within a composition that accord radial balance. The viewer's eye will take the cue

of the composition, the forces create an overall visual balance as the viewer completes the circular rhythm.

Imbalance

Balance affords a certain level of comfort. The viewer will usually try to impose balance on a work, even when there is asymmetry. But not all art is about comfort; not all art aims to be aesthetically pleasing. Some artists aim to shock the viewer or to play into a viewer's discomfort by creating works with **imbalance.**

Consider Robert Capa's photograph *Death of a Loyalist Soldier* (Fig. 3-18), which was taken during the Spanish Civil War. The photographer has captured the soldier just as an enemy rifleman shot him. By allowing the composition to remain unbalanced, or weighted on the left, the drama of the moment is intensified. The long black shadow behind the soldier seems to pull the figure toward the ground, as he stumbles from the impact of the bullet. The photographer no doubt maintained the visual imbalance in the composition to correspond with the physical imbalance of the victim.

In Capa's photograph, there is a clear sense of movement. The soldier has been running down a grassy hill and suddenly falls backward. Imbalance in a work of art can be used to capture a sense of movement—the fourth dimension—in a two-dimensional or a three-dimensional work.

from what is present and will then "complete" the circular pattern. In Barbara Morgan's photograph of Martha Graham (Fig. 3-17), the folds of the pioneer dancer's costume emanate from the central point of her torso and are set into pinwheel-like motion by the radial extension of her leg. Although the radial pattern is contained within the right side

Niki de Saint-Phalle's *Black Venus* (Fig. 3-19) is a larger-than-life figure of a woman in a psychedelic bathing suit who is catching a beach ball. The placement of the legs and feet at the very least suggests a precariously balanced body. She seems to leap into the air to catch the ball, defying gravity and her own ponderousness. In spite of, or because of, her mountainous appearance, the unbalanced position of her lower body gives the figure a contradictory sense of weightlessness. Niki de Saint-Phalle challenges the ideal of feminine beauty in the Western tradition with figures such as *Black Venus.* How does this spirited form stand apart from traditional Western nudes such as the *Venus of Urbino* (see Fig. 15-28)?

EMPHASIS AND FOCAL POINT

For the most part, we do not view a work of art as we read a page of text. The eye does not start in the upper left corner and then systematically work its way to the right in rows. Rather, some feature of the work usually commands our attention. Artists use the design principle of **emphasis** to focus the viewer's attention on one or more parts of a composition by accentuating certain shapes, intensifying value

3-19 NIKI DE SAINT-PHALLE.
Black Venus (1967).
Painted polyester. 110″ × 35″ × 24″.
Whitney Museum of American Art, New York.
Gift of Howard and Jean Lipman Foundation.
Copyright 2003 Artists Rights Society (ARS),
New York/ADAGP, Paris.

3-20 RICHARD HAMILTON.
My Marilyn (1966).
Silkscreen, printed in color.
20¼″ × 25″.
Copyright The Museum of Modern Art,
New York. Joseph G. Mayer Foundation Fund.
Licensed by Scala/Art Resource, New York.
Copyright Artists Rights Society (ARS),
New York/DACS, London.

3-21 CHUCK CLOSE.
Lucas II (1987).
Oil on canvas. 36″ × 30″.

The Museum of Modern Art, New York. Photo courtesy of
PaceWildenstein. Copyright Chuck Close.

3-22 JASPER JOHNS.
Between the Clock and the Bed (1981).
Encaustic on canvas (three panels). $6'\frac{1}{8}'' \times 10'6\frac{3}{8}''$.

Copyright The Museum of Modern Art, New York. Gift of Agnes Gund.
Licensed by Scala/Art Resource, New York. Copyright Jasper Johns.
Licensed by VAGA, New York.

or color, featuring directional lines, or strategically placing the objects and images. Emphasis can be used to create **focal points** or specific parts of the work that seize and hold the viewer's interest.

Consider Richard Hamilton's screen print *My Marilyn* (Fig. 3-20). The composition has a unifying regularity of color—a limited palette—and a repetition of the shapes and images that lead the viewer's eye to crisscross the surface. At first glance the work seems completely devoid of emphasis and focal point. Only after the eye picks up the large *X*'s that cancel out the figures does one see the degree to which the artist has directed the viewer's gaze: He causes the eye to move around and then land on the image of Marilyn in the lower right corner, which—because there is no *X* through it—becomes the focal point of the composition. In so many works of art, the artist—by using various forms of emphasis—seems to be saying to the viewer, "Look here. Look here!" In Hamilton's *My Marilyn,* the focal point emerges by virtue of the artist saying, "Don't look here."

As if the overwhelming presence of the face—that is, the *content*—in Chuck Close's *Lucas II* (Fig. 3-21) is not enough to focus the viewer's attention on the center of the composition, the artist emphasizes or draws our eye to a single point—the focal point—between the subject's eyes by creating a targetlike pattern of concentric circles around it. The circles are intersected by broken lines of color that radiate from the center, causing a sense of simultaneous movement outward from the center point and back inward.

Color contributes to the focal point of *Lucas II* in a very dramatic way, but more subtle distributions of value and color can direct the viewer's gaze, as in Jasper Johns's *Between the Clock and the Bed* (Fig. 3-22). The rhythmic interplay of line across the entirety of the three-paneled painting has a degree of uniformity that is altered by a concentration of warmer yellowish hues in the center. In a work that would otherwise seem to have no focal point, this patch of color concentrates the viewer's attention. Whereas the work is given unity by the allover pattern of lines, shifts in color create variety throughout the piece.

If today's arts love the machine, technology and organization, if they aspire to precision and reject anything vague and dreamy, this implies an instinctive repudiation of Chaos and a longing to find the form appropriate to our times.

— Oskar Schlemmer

3-23 PABLO PICASSO.
Family of Saltimbanques
(1905).
Oil on canvas.
83¾″ × 90⅜″.

National Gallery of Art, Washington, DC. Chester Dale Collection. Copyright 2003 Estate of Pablo Picasso/Artists Rights Society (ARS), New York.

In Pablo Picasso's *Family of Saltimbanques* (Fig. 3-23), we see that artists sometimes use the method of emphasis by isolation, in which they separate one object or figure from the many. Amidst a rather desolate landscape, figures of circus performers stand silent, seemingly frozen in their sculptural poses. The patterns, colors, and costume variety of the main figural group are, interestingly, less visually significant than the more delicately rendered figure of the woman seated apart from them in the lower right. Picasso has emphasized her aloneness by pulling her from the group. Her solitude draws us into her private musings; her inner world becomes the focus of our attention.

Oskar Schlemmer's *Bauhaus Stairway* (Fig. 3-24) uses directional lines and color to give his composition a focal point. The painting has an overall bluish tonality, against which the bright red orange of a woman's sweater leaps out

toward the viewer. The diagonal thrusts of the staircase converge at her torso and are echoed in repetitive triangles to her right.

Areas of emphasis are created by Varnette Honeywood in *The Caregiver* (Fig. 3-25) in the deep black silhouettes that stand in sharp contrast to a composition that is otherwise a kaleidoscope of color and pattern. The repetition of outstretched hands draws the viewer's attention to a tabletop strewn with first-aid supplies and a Holy Bible, while the strong profile of the African American woman—the caregiver—leads us to a cross-stitched wall hanging bearing the words *Prayer Is the Answer.* The strong black shapes capture our attention and spotlight the images in the composition that convey its meaning. Honeywood leaves us with the message that there are some things that modern medicine cannot heal, that healing sometimes comes from within.

The power of content can sometimes overwhelm the power of shape, texture, and other elements of art to the point that in spite of other devices used to create focal points, the image will have the tendency to negate or override them. In Edgar Degas's *Woman Leaning near a Vase of*

3-24 OSKAR SCHLEMMER.
Bauhaus Stairway (1932).
Oil on canvas. $63^{7}/_{8}'' \times 45''$.

Museum of Modern Art, New York. Gift of Philip Johnson. Copyright Art Resource, New York.

3-25 VARNETTE P. HONEYWOOD.
The Caregiver (1995).
Acrylic on canvas. $37'' \times 52''$.

Copyright Varnette P. Honeywood, 1995.

I like repetition because it includes an endless sequence of substitutes and missed encounters.

—Sherrie Levine

3-26 EDGAR DEGAS.
Woman Leaning near a Vase of Flowers (Mme Paul Valpinçon; erroneously called *Woman with Chrysanthemums*) (1865). Oil on canvas. 29″ × 36½″.

The Metropolitan Museum of Art, New York. H. O. Havemeyer Collection. Bequest of Mrs. H. O. Havemeyer, 1929 (29.100.128). Copyright The Metropolitan Museum of Art, New York.

Flowers (Fig. 3-26), the centerpiece—quite literally—of the composition is an enormous bouquet of chrysanthemums. It has almost everything one could ask of a focal point—central position, brilliant color, dominant texture. And yet our eyes are drawn to the woman who sits off to the side of the vase, daydreaming, gazing beyond the borders of the canvas. A viewer's gaze is seduced by the sight of a human face.

RHYTHM

The world would be a meaningless jumble of sights and sounds were it not for the regular repetition of sensory impressions. Natural **rhythms,** or orderly progressions, regulate events ranging from the orbits of the planets to the unfolding of the genetic code into flesh and blood. Artists can enhance or exaggerate individual elements in their compositions through minor and major variations in rhythm. And rhythm can move a viewer visually as well as emotionally. Repetitive patterns can be used to lead the eye over the landscape of the work and to evoke a psychological response in the viewer.

Regular repetition is the easiest and most precise way to create rhythm. In fact, it is a dominant design principle in Fritsch's *Rattenkönig* (Fig. 3-1), which we have already discussed in the context of unity.

Rhythm can be present in a work of art even if there is a slight variation in repetition. Magdalena Abakanowicz's

Backs (Fig. 3-27), from a series of body works called *Alterations,* consists of 80 fiber sculptures representing human backs. Although the individual forms look like hunched-over figures, they are without heads, legs, or arms. Even the fronts of the torsos have been hollowed out, leaving an actual and symbolic human shell. In this work, the artist, whose mother was mutilated by the Nazis in World War II, seems to bring to her work the memory of the dehumanization she witnessed. The potency of this message is in large part due to the repetition of forms that have lost their individuality.

Rhythms are found also in architecture. The ceiling of the mosque at Córdoba, Spain (Fig. 3-28), is supported by a rhythmic progression of arches that span the distances between the columns. Mosques constructed with this design could be expanded in any direction by adding columns and arches as the congregation grew.

3-27 MAGDALENA ABAKANOWICZ.
Backs (1976–1982).
Burlap and glue. 80 pieces, 3 sizes: 61 cm × 50 cm × 55 cm; 69 cm × 56 cm × 66 cm; 72 cm × 59 cm × 69 cm.

Copyright Magdalena Abakanowicz. Courtesy of the Marlborough Gallery, New York. Licensed by VAGA, New York.

3-28 Sanctuary of the Mosque at Córdoba, Spain (Islamic) (786–987 CE). Interior view.
Adam Woofitt/Corbis.

Making art is about objectifying your experience of the world, transforming the flow of moments into something visual, or textual, or musical. Art creates a kind of commentary.

—Barbara Kruger

SCALE

Scale refers to size—small, big, or in between. **Scale** is the relative size of an object compared with others of its kind, its setting, or human dimensions. The Great Pyramids at Giza (see Fig. 12-14) and the skyscrapers of New York are imposing because of their scale, that is, their size compared with the size of other buildings, their sites, and people. Their overall size is essential to their impact.

Barbara Kruger's multimedia installation *Power Pleasure Desire Disgust* (Fig. 3-29) combines steadily changing video images of talking heads and projections of the artist's signature phrases and text all over the gallery floors and walls. The overwhelming scale of the work envelops us so completely and the slogans bombard us so relentlessly that it may seem as though the thoughts expressed in the environment have somehow originated in our own minds—phrases we may have once used to hurt others or they us, comments that may have cut to the quick. But interspersed with the bitter are flashes of wit, even flirtatiousness, as the work touches on communication across boundaries of gender and social definition. Thoughts are compelling and haunting

things, made all the more inescapable by the sheer size of their verbal and written articulation.

In the Count de Montizon's photograph *The Hippopotamus at the Zoological Gardens, Regent's Park* (Fig. 3-30), we see how artists communicate the scale of objects in their works by comparing them with other objects. In this photograph, a specimen record of the zoo's prized tenant, the photographer used *relative* size to communicate size. We see that it takes nine people standing shoulder to shoulder to match the length of one animal lazing in the sun. The photographer used the relationship between the familiar (the observers) and the unfamiliar (the hippopotamus) to communicate the size of the hippo to those who weren't there to witness it firsthand. At the time the picture was taken, 1852, the hippopotamus was not yet a familiar denizen of zoos in Europe and the United States. A gift from the pasha of Egypt to Queen Victoria, this hippo was the main attraction at the London Zoo.

Nineteenth-century London's hippopotamus was exotic, its size dramatic. In relation to the scale of ordinary human beings, it was extraordinary. In viewing the photograph, a person could pretty much grasp the magnitude of

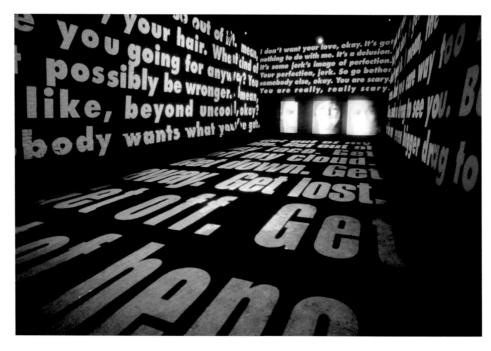

3-29 BARBARA KRUGER. *Power Pleasure Desire Disgust* (1997). Multimedia installation.
Courtesy of Deitch Projects, New York.

My painting is not revolutionary. Why should I delude myself that it is informed by a fighting spirit?

—Frida Kahlo

3-30 COUNT DE MONTIZON.
*The Hippopotamus at the Zoological Gardens,
Regent's Park* (1852).
Salted-paper print.
From the *Photographic Album of the Year*, 1855. The Royal Photographic Society, Bath, England.

the animal. By contrast, in Magritte's *Personal Values* (Fig. 3-31) it is impossible for the viewer to comprehend the dimensions of any of the objects within the work because their familiar size relationships are subverted. We don't know whether the objects—the comb and matchstick and glass—are blown out of proportion or whether the bed has shrunk. We cannot rely on our experience of actual dimension to make sense of the content of the work, so our tendency to understand size in relation to other things fails us.

Hierarchical Scaling

Standing "ten feet tall" is a familiar idiom. We use it to describe heroes or to communicate a certain pride we feel in our own accomplishments. It describes our feelings about a deed that sets others or ourselves above the rest, even if for one fleeting moment. In the visual arts, this metaphor, this idiom, finds its analogy in **hierarchical scaling,** or the use of relative size to indicate the relative importance of the objects or people being depicted. The method has been used for literally thousands of years. In ancient Egyptian art, members of royalty and nobility are sized consistently larger than the underlings surrounding them, making very clear their social positions. In medieval manuscript illumination, artists often had their celes-

3-31 RENÉ MAGRITTE.
Personal Values (1952).
Oil on canvas. $31^5/8'' \times 39^1/2''$
(80 cm \times 100 cm).
Copyright 2003 C. Herscovici, Brussels/Artists Rights Society (ARS), New York/Art Resources, New York.

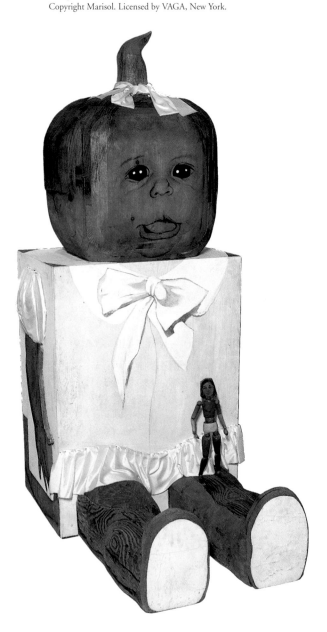

tial figures, such as angels and saints, tower over humans. Closer to home, the Mexican artist Frida Kahlo used hierarchical scaling in a modern work to reveal an old-fashioned relationship between husband and wife (Fig. 3-32). Even though both she and her husband, Diego Rivera, were renowned artists in their own right, he loomed as the dominant personality—domestically and artistically. Even the ambiguous title of the painting, *Frida y Diego Rivera o Frida Kahlo y Diego Rivera* (Frida and Diego Rivera or Frida Kahlo and Diego Rivera), reveals her struggle with identity. Under each moniker and in each role—wife and artist— Kahlo portrays herself as quite literally less of a figure. History, it turns out, was kinder to Frida than she was to herself.

Distortion of Scale

Some artists distort or even subvert the realistic scale of objects to challenge the viewer to look at the familiar in a new way. Sometimes they are interested in providing a new perspective on the forms of things; sometimes on the relationships between things.

It is in part the play on the viewer's sense of scale that creates the visual shock and sheer humor of Marisol's *Baby Girl* (Fig. 3-33). A wooden doll with adjustable limbs and

Claes Oldenburg: On Clothespins, Baseball Bats, and Other Monuments

When one drives around Philadelphia's Center Square, one is impressed by the broadness of the avenues, the classical columns and arches of City Hall, the steel and glass curtain walls of the new office buildings, and . . . by a 45-foot-tall clothespin (Fig. 3-34).

Why a clothespin? "I like everything about clothespins," reported Pop artist Claes Oldenburg, "even the name." The clothespin sculpture, aptly called *Clothespin* by its creator, was erected as a tribute to the 1976 Bicentennial. The line down the center of the pin suggests an updating of the cracked Liberty Bell, and the spring could be viewed as spelling out '76. More-

over, the clothespin consists of two structures clasped together, by a spring, in an embrace—an appropriate symbol for Philadelphia, the City of Brotherly Love. One might think that this symbolism was incidental, but Oldenburg had earlier made a silkscreen comparing his clothespin to Brancusi's *The Kiss* (see Fig. 4-6), which also depicts an embrace.

Clothespin is just one of the ordinary objects to which Oldenburg has lent monumentality by upgrading their scale. His 24-foot-high *Lipstick* rises serenely on a Yale University quadrangle, and the Houston Public Library sports an 18-foot-high mouse. The plaza of the Social Security Administration building in Chicago, a city that supports two major league baseball franchises, is punctuated by a 100-foot-tall baseball bat. Oldenburg has drawings of typewriter erasers and upside-down ice-cream cones whose waffle patterns rival the faces of the Egyptian pyramids.

It could be argued that the subjects of Oldenburg's monuments are trivial, but we must also admit that they have a certain symbolic meaning and depth for Americans. In centuries to come, they may say more about twentieth-century America than would a few more bronze riders on horseback. ■

3-34 CLAES OLDENBURG.
Clothespin (1976).
Cor-Ten steel with stainless steel base. H: 45'.
Courtesy PaceWildenstein.

I find it important to draw attention to thinking and doing as well as to what happens in between, to lightness and heaviness, to the energy that oscillates between.

—Magdalena Jetelová

3-35 MAGDALENA JETELOVÁ.
Domestication of a Pyramid (1992).
Red quartz sand. H: 15 m.
Austrian Museum for Applied Art, Vienna, Austria. Courtesy of the artist.

torso—the sort used for drawing exercises in art classes— sports a portrait of Marisol herself. It is perched on the stocky thigh of the baby, who neither looks at nor touches the "toy." The baby girl, by any other definition a subject that suggests delicacy and softness, is transformed into a cumbersome hunk of a figure. Only the shirring of her puffy sleeves and frilly gathers of her white dress soften the harshness of the overall form. Marisol's manipulation of scale and

our perception of it are confirmed by the fact that in looking at the illustration of this work in your book (without sneaking a peek at the dimensions), you would have no real sense of how large or small the work actually is.

Czech-German artist Magdalena Jetelová's installation *Domestication of a Pyramid* (Fig. 3-35) is all about scale, space, and power. Many of Jetelová's installations transform spaces by invasions that challenge the viewer to rethink their

architecture and history. The colossal Egyptian pyramids are made of blocks of stone and look as though they will occupy their open desert sites until the end of time. Jetelová invaded the Austrian Museum of Applied Art with a "pyramid" of red sand. She brought a much smaller and far more irregular version of the familiar shape indoors, thereby "domesticating" it. But it is far from tame. It is only about one-tenth the height of the pyramids at Giza, and it is made of material that could blow away in the desert wind. Yet its size in relation to the museum interior renders the powder oppressive and the architecture fragile and dollhouselike. The incursion of the timeless shape into the vestibule of the museum compels visitors to view the familiar architectural form of the building, with its colonnades and arcades, from a new perspective. "Look at this space again and consider whether it will endure," declares the installation.

PROPORTION

"Everything is relative." That is, we tend to think of objects or of works of art as large or small according to their relationships to other things—often to ourselves. However, the objects depicted within works of art can also be large or small in relationship to one another and to the work as a whole. **Proportion,** then, is the comparative relationship, or ratio, of things to one another.

Artists through the ages have sought to determine the proper or most appealing ratios of parts of works to one another and the whole. They have used proportion to represent what they believed to be the ideal or the beautiful. They also have disregarded or subverted proportion to achieve special effects—often to compel viewers to take a new look at the familiar.

The Canon of Proportions: "Keeping Things in Proportion"

The ancient Greeks tied their vision of ideal beauty to what they considered the "proper" proportions of the human body. Polykleitos is credited with the derivation of a **canon of proportions**—a set of rules about body parts and their dimensions relative to one another that became the standard for creating the ideal figure. The physical manifestation of his canon was his *Doryphoros* (Fig. 3-7). Every part of the body is either a specific fraction or multiple of every other part. Ideally, for Polykleitos, the head is one-eighth of the

3-36 ALICE NEEL.
The Family (John Gruen, Jane Wilson and Julia) (1970).
Oil on canvas. 4′11⅞″ × 5′.
Copyright Estate of Alice Neel. Courtesy, Robert Miller Gallery, New York.

total height of the body and the width from shoulder to shoulder should not exceed one-fourth of the body's height.

Violating the Canon for Expressive Purposes

If the *Doryphoros* represents ideal form, Alice Neel's *The Family* (Fig. 3-36) leaves the canon behind in what appears to be the pursuit of unidealized form. The enlarged heads, elongated fingers and calves, and outsized feet are glaring obstacles to realistic representation. And yet, somehow, there is an overarching realism in spite of these artistic liberties that emanates from the relationships among the family members.

The Golden Mean

Just as the Greeks developed a canon of proportions for representing the human figure in the ideal, they developed the concept of the **golden mean** or the **golden section** in order to create ideal proportions in architecture. The golden mean requires that a small part of a work should relate to a larger

3-37 The golden mean.

To create the golden mean, a line is divided ("sectioned") so that the ratio of the shorter segment (AB) is to the larger segment (BC) as the larger segment (BC) is to the whole (AC). Line segment BC is 1.618 times the length of segment AB. Segment BC is the "mean" in the sense that its length lies between the smaller segment (AB) and the entire line (AC). The Greeks considered segment BC to be "golden" in that its use created what they considered to be ideal proportions in architecture.

part of the work as the larger part relates to the whole. The line in Figure 3-37 is divided, or *sectioned,* at point B so that the ratio of the shorter segment (AB) is to the larger segment (BC), as the larger segment (BC) is to the whole line (AC). Segment BC is the golden mean.

The rectangle in Figure 3-38 is based on the golden mean and is termed a **golden rectangle.** Its width is 1.618 times its height. The golden rectangle was thought by the Greeks to be the most pleasing rectangle, and it became the basis for many temple designs.

A golden rectangle can be made either by measuring the lengths of the lines or by rotating the diagonal of the half square, as shown in Figure 3-38. We can also rotate the diagonal of the square in both directions, sort of like a windshield wiper. If we add the second smaller rectangle, we obtain a rectangle that is made up of a central square and two smaller rectangles (Fig. 3-39). The entire rectangle is called a **root five rectangle** because its length is 2.236 (the square root of 5) times its width.

The proportions of the root five rectangle have also served as the frame for various works of art and architecture. If you superimpose a diagram of a root five rectangle over a photograph of the east facade of the Parthenon (Fig. 3-40), you can see the almost compulsive adherence to geometric order that the Greeks visited on their places of worship. The facade is constructed of eight columns. The four in the center fit within the central square of the root five rectangle. The portions of the facade occupying the flanking rectangles include the two end columns to either side as well as the outermost points defined by the steps leading to the temple platform.

Most viewers are unaware of the mathematical basis for the Parthenon's design, but they come away with an overall impression of harmony and order. The root five rectangle is

3-38 The golden rectangle.
The width of this rectangle is exactly 1.618 times its height. The triangle can be created by rotating the diagonal of the half square on the left (outlined in red) to the base on the right (point C). This "ideal" rectangle became the basis for the floor plans of Greek temples and represented the artistic embodiment of the Greek maxim "Moderation in all things."

3-39 The root five rectangle.
One obtains a root five rectangle by rotating the diagonal of the square in Fig. 3.38 in both directions. The rectangle obtains its name from the fact that its length is 2.236 (the square root of the number 5) times its width. The root five rectangle has frequently been used to define the frame for works of art, including buildings (see Fig. 3.40) and paintings (see Fig. 3.41).

also the foundation of some paintings that have harmonious compositions. Michelangelo's *The Fall of Man and the Expulsion from the Garden of Eden* (Fig. 3-41), from the Sistine ceiling (see Figs. 15-21 to 15-23), maximizes the components of the root five rectangle. The central square contains

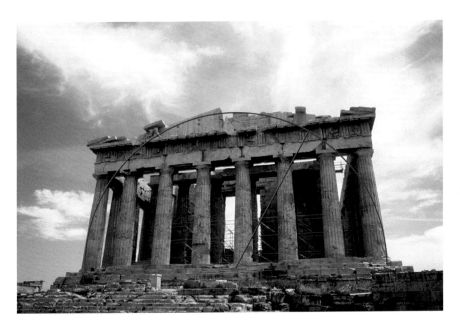

3-40 The east facade of the Parthenon, superimposed with a root five rectangle. When we do not consider the gable (which is absent in this photograph), the facade of the Parthenon is a root five rectangle.

Borromeo/Art Resource, New York.

3-41 MICHELANGELO.
The Fall of Man and the Expulsion from the Garden of Eden
(1508–1512). Portion of the Sistine Chapel ceiling.
Fresco.

The Vatican, Rome/Art Resource, New York.

the Tree of Knowledge from the book of Genesis, that all-important symbol of the temptation and fall of man. The Tree connects the imagery in the outer parts of the root five rectangle—the repetitive figures of Adam and Eve as separated by time and the serpent. The rectangle to the left pulls toward the center, by virtue of the connection between the serpent and Eve, and the rectangle to the right pushes away from center—into the unwritten landscape of humankind's uncertain future—following the sword that is thrust into Adam's neck by the angel who expels them from Paradise.

The Spiral

The Greeks found further meaning in the golden rectangle by relating it to the spiral, which is found in nature on a microscopic scale, a human scale, and even a cosmic scale. As noted in Figure 3-42, a spiral can be created by extending the golden rectangle in an enlarging, circular manner and connecting the corners of the squares with a curve. On the microscopic scale, let us note that DNA, the genetic material that determines the form of the structures of all living things, takes the form of a double spiral, or helix. On the

human scale, we see that the spiral is found in the chambered nautilus and in the pattern of seeds in the head of a sunflower. On the cosmic scale, we find that galaxies such as our own Milky Way spin as vast spirals that light takes millions of years to traverse. No wonder, then, that the spiral has been the source of study and inspiration.

We see the spiral in works as diverse as the Great Mosque at Samarra (see Fig. 17-25) in Iraq to Robert Smithson's *Spiral Jetty* (see Fig. 9-19) in the Great Salt Lake in Utah. Bruce Nauman's neon-lit spiral sculpture *Having Fun / Good Life, Symptoms* (Fig. 3-43) works like a mantra. Two series of words spiral inward through the colors of the spectrum. The spiral on the left contains pairs of antonyms, and the one on the right repeats phrases about having fun. The eye tries to follow the curves to decode the words; however, each spiral requires opposing eye movements, possibly adding to the viewer's visual "symptoms"—and the assorted "fever and chills" of the modern age.

Each age has had its fever and chills, of course, along with its smooth sailing. Artists have strived to capture moments of each of them.

3-42 A spiral.
This spiral is drawn by extending the golden rectangle in a circular manner, increasing its size with each rotation, and then connecting the corners of the squares with a curve. Such spirals found in nature can be small (microscopic) in scale, as is the case with DNA; cosmic in scale, as with spiral-shaped galaxies; and human in scale, as in the cases of the sizes of spiral-shaped snails and flowers.

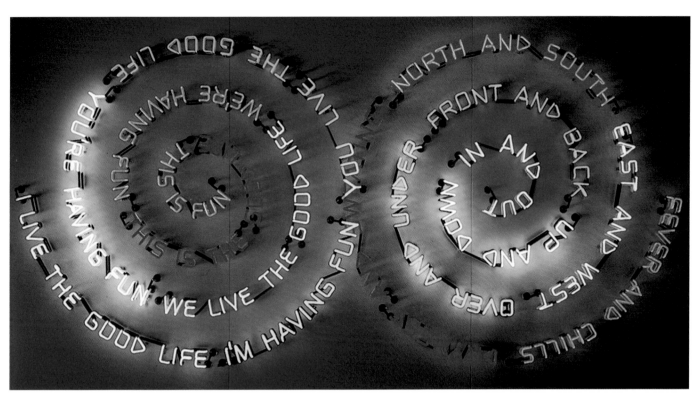

3-43 BRUCE NAUMAN.
Having Fun / Good Life, Symptoms (1985).
Neon and glass tubing. 69″ × 131¼″.

Carnegie Museum of Art. Copyright 2003 Bruce Nauman/Artists Rights
Society (ARS), New York.

STYLE, FORM, AND CONTENT

The duty of an artist is to strain against the bonds of the existing style.

—Philip Johnson

Human languages combine words according to rules of grammar to express and communicate emotions and meanings. Artists use the language of art to combine the visual elements of art according to principles of design. The resultant works of art are said to have style and form and to express and communicate a certain content.

Despite individual differences—and despite wholesale revolutions!—through the ages a number of characteristic methods of expression have developed that we refer to as *style.* Works of art can also be said to have a certain *form,* which is the totality of what we see—the product of the composition of the visual elements according to (or in total violation of) principles of design. The *content* of a work includes not only its form but also its subject matter and its underlying meanings or themes. Some works of art can seem to be devoid of content other than the pencil marks or, perhaps, the swaths of paint we find on a sheet of paper or on a canvas.

But many are filled with levels of content, more of which are perceived by some viewers than by others. The content of a work varies with the amount of information available to the viewer. For example, viewers who are aware of the symbolism of a particular work of art will find more content in it. Awareness of style, form, and content helps viewers understand and appreciate the visual arts more fully.

STYLE

In the visual arts, **style** refers to a distinctive handling of elements and media associated with the work of an individual artist, a school or movement, or specific culture or time period. Familiar subjects may come and go, but it is in the style of the artist—the unique handling—that creativity, originality, and authenticity dwell.

One of the best ways to illustrate stylistic differences is to choose a group of works with a common theme (such as those illustrated in Figures 4-1 through 4-10) and challenge ourselves to articulate the similarities and differences among them. The first and seemingly obvious connection is that all of the works represent couples. Yet immediately we are struck by the differences among them, both in terms of the stories they imply and the style in which they are rendered. To begin with, the images demand that we get beyond the conventional definition of "couple," for not all couples are composed of a male and a female. What is really striking, however, are the variations in *style,* sometimes linked to the use of different media and sometimes connected to diverse cultural contexts, but always indicative of the characteristic approach of the artist to the subject.

Art, Culture, and Context

The Mayan ceramic couple (Fig. 4-1), for example, is an eighth- to tenth-century pre-Columbian sculpture, whose garments, hairstyles, and facial features link it to the life and times of the Yucatecan people before the onslaught of the Europeans. Similar telltale attributes connect Roy Lichtenstein's *Forget It! Forget Me!* (Fig. 4-2) to the United States in the decade of the 1960s. Henri de Toulouse-Lautrec's *The Two Girlfriends* (Fig. 4-3) transports us to the demimonde

4-1 *Amorous Couple* (Mayan, Late Classic, 700–900 CE). Polychromed ceramic. H: 9¾".

Copyright Detroit Institute of the Arts, Detroit, MI. Sounders Society Purchase, Katherine Margaret Kay Bequest Fund and New Endowment Fund.

4-2 ROY LICHTENSTEIN.
Forget It, Forget Me! (1962).
Magna and oil on canvas. 79⅞″ × 68″.

Rose Art Museum, Brandeis University, Waltham, MA. Gevirtz-Minuchin Purchase Fund 1962. Copyright Roy Lichtenstein.

How can you say one style is better than another? You ought to be able to be an Abstract-Expressionist

next week, or a Pop artist, or a realist, without feeling you've given up something.

—Andy Warhol

4-3 HENRI DE TOULOUSE-LAUTREC.
The Two Girlfriends (1894).
Oil on cardboard. 48 cm × 34.5 cm.
Musée Toulouse-Lautrec, Albi. Copyright Corbis.

4-4 ROBERT MAPPLETHORPE.
Ken Moody and Robert Sherman (1984).
Photograph.
Copyright The Estate of Robert Mapplethorpe. Courtesy Art and Commerce Anthology.

of turn-of-the-century Paris where, as we were told in the film *Moulin Rouge,* the greatest thing is to love and be loved in return. The weather-worn faces and postcard-perfect surroundings in Grant Wood's *American Gothic* (Fig. 4-9) suggest the duality of rural life in modern America—hardship and serenity—whereas contemporary photographer Robert Mapplethorpe (Fig. 4-4) drew the world's attention to what it was like to be gay and living in America at the turn of the millennium. The tumult of Germany in the years leading up to World War I can be felt in the dark palette, whirling brushstrokes, and **existentialist** expressions in Oskar

4-6 CONSTANTIN BRANCUSI.
The Kiss (c. 1912).
Limestone. H: 23″; W: 13″; D: 10″.

Kokoschka's *The Tempest* (Fig. 4-5). Donna Rosenthal's *He Said . . . She Said* (Fig. 4-10) seems to tap into some sort of collective unconscious ballroom in its unique yet universal ruminations. Constantin Brancusi's *The Kiss* (Fig. 4-6) could be said to transcend context in the simple accessibility or readability of its subject.

In their abstraction, Jackson Pollock's *Male and Female* (Fig. 4-7) and Barbara Hepworth's *Two Figures* (Fig. 4-8) are more difficult to decipher. Pollock's painting was created while he was undergoing psychoanalytic therapy and ought to be read in that context. It reveals a complex scheme of images that he believed were derived from his collective unconscious mind. Hepworth, by contrast, aims to disconnect her work from context by reducing her figures to their most common denominators—organic vertical shapes punctuated by softly modeled voids. Yet curiously, when we view *Two Figures* in the context of this grouping of "couples," it seems to belong, even if eyes may resist making a connection.

Context has a profound influence on style. We can see this in the similarities among artists of a specific era, regardless of their individual "signature." Claude Monet and Auguste Renoir, for example—both Impressionist artists working in nineteenth-century France—are recognized for their

My aim in painting has always been the most exact transcription possible
of my most intimate impression of nature.

—Edward Hopper

All the really good ideas I ever had came to me while I was milking a cow.

—Grant Wood

4-7 JACKSON POLLOCK.
Male and Female (1942).
Oil on canvas. 73⅓″ × 49″.

4-8 BARBARA HEPWORTH (1903–1975).
Two Figures (Menhirs) (1954–1955).
Teak. H: 54″.

distinct styles, but they have more in common with each other than they do with, say, Rembrandt. And although you probably wouldn't mistake one for the other, the works of both artists are very much a product of their culture at a moment in time.

Styles in art are numerous, ever changing, and ever new. The vocabulary we use to discuss style, on the other hand, has been fairly standard for a long time.

I observe the effects of traditional and societal influences on the lives of women. . . .
I use text, repetition, and the cultural symbolism of clothing to expose the struggles between
the internal and external self. The manner in which I compose my work gives clues to age-old
personal and collective realities, the longings, presumptions, and predicaments of women.

—Donna Rosenthal

Realistic Art

Realism refers to the portrayal of people and things as they are seen by the eye or really thought to be, without idealization, without distortion. Wood's painting (Fig. 4-9) is described as realistic in terms of style. The term, with a capital *R,* also defines a specific school of art that flowered during the mid-nineteenth century in France. Realism featured subjects culled from daily life and experience and developed a new respect for the real substance of the artist's materials.

Grant Wood's renowned *American Gothic* is a painstakingly realistic portrait of the staid virtues of the rural life in America. It is also one of our more commercialized works of art; images derived from it have adorned boxes of breakfast cereal, greeting cards, and numerous other products. Note the repetition of the pitchfork pattern in the man's shirtfront, the upper-story window of the house, and in the plant on the porch. He is very much tied to his environment. Were it not for the incongruously spry curl falling from the mistress's otherwise tucked-tight hairdo, we might view this composition—as well as the sitters therein—as solid, stolid, and monotonous.

We think of most photographs as realistic. The very nature of the technique—shooting, capturing, documenting—suggests candid truth, unadulterated reality. Although photographers in the twentieth-century and beyond have pursued photography as an art form and strained against the bonds of representation, the impact of Mapplethorpe's photographs is largely due to his unflinching realism (Fig. 4-4).

Realistic versus Representational Art

The Lichtenstein couple (Fig. 4-2) is portrayed in a style that departs from strict Realism, yet the observer clearly identifies the caricature-like renderings of the figures as that of a man and woman. This is representational art. It presents natural objects in recognizable, though not realistic, form. *Forget it! Forget me!* is an example of Pop Art, which adopts the visual clichés of the comic strip. Donna Rosenthal's *He Said . . . She Said* (Fig. 4-10) also clearly depicts an interaction between a man and a woman, in this case capturing the verbal clichés of the human comedy. Both works can be described as representational.

The term **representational art,** often used synonymously with **figurative art,** is defined as art that portrays, however altered or distorted, things perceived in the visible world. The people in the Lichtenstein work may not be realistic, but they are clearly recognizable. The Mayan couple (Fig. 4-1) and Toulouse-Lautrec's *The Two Girlfriends* (Fig. 4-3) are similarly representational but not realistic.

Expressionistic Art

In expressionistic art, form and color are freely distorted by the artist in order to achieve a heightened emotional impact. **Expressionism** also refers to a modern art movement, but many earlier works are expressionistic in the broader sense of the term.

In *The Burial of Count Orgaz* (see Fig. 15-30), El Greco's expressionistic elongation of the heavenly figures seems to emphasize their ethereal spirituality. Postimpressionist Vincent van Gogh relied on both an expressionistic palette and brushwork to transfer emotion to his canvases.

Kokoschka's expressionistic painting *The Tempest* (Fig. 4-5) is marked by frenzied brushstrokes that mirror the torment of his inner life as well as the impending darkness of war in Germany. Reclining figures occupy the center of a dark, imaginary landscape. Images of earth, water, and flesh merge in a common palette and bevy of strokes; little distinguishes one from another. All seem caught up in a churning sky, very much in danger of being swept away.

Abstract Art

The term **abstract** applies to art that departs significantly from the actual appearance of things. Such art may be completely **nonobjective,** that is, it may make no reference whatsoever to nature or reality. On the other hand, abstract art may be rooted in nature, even though the finished product bears little resemblance to the source that inspired it. A number of aspects of the Brancusi sculpture (Fig. 4-6) are recognizable. One can discern an upper torso, arms, eyes, and hair. Yet the artist seems to have been more interested in the independent relationships of the shapes than in being true to the human form. For this reason we would more likely characterize *The Kiss* as abstract rather than representational.

Wood's *American Gothic* with Rosenthal's *He Said . . . She Said*

The style of a work of art refers to the characteristic ways in which artists express themselves and the times in which they live. In our consideration of the theme of couples, we were able to assess the way in which a full range of media, methods, and styles contributes to the uniqueness of each work. If we add to these the historical and cultural contexts of the works, we gain insight into the ways in which art reflects its place and time.

Consider Grant Wood's *American Gothic* and Donna Rosenthal's *He Said . . . She Said*. On a trip to Europe in the 1920s, Wood was influenced by the realistic works of fifteenth-century German and Flemish painters. His initial goal in *American Gothic* (Fig. 4-9) was to render realistically the rural Iowan house in the background of the painting. He enlisted a local dentist along with his own sister to pose as models for the farmer and his wife. The realism of their faces is so exacting and their expressions so intent that the viewer cannot but wonder what thoughts lie buried in their minds.

And then there is the expression "to wear one's heart on one's sleeve." In Rosenthal's *He Said . . . She Said* (Fig. 4-10), thoughts and feelings are broadcast plainly, as the (implied) individuals quite literally wear their thoughts on their clothes—a suit and party dress made from the pages of discarded books and newspapers. We know exactly what's on their minds, verbalized through cultural stereotypes of the conflicting wishes of males and females—his reluctance to make a commitment, her hope that he will still remember her in the morning. Other works by Rosenthal express man's desire for sex and woman's desire for security. Stereotypes are, of course, extreme; they represent conventional notions and not individual conceptions. Yet Rosenthal succeeds in her communication with the viewer in large part because we identify with these phrases.

As the physical couple is absent from the work, we are left with the notion that the clothes make the individual. This is conceptual art; that is, the ideas being expressed by the artist have greater meaning than their physical expression. ∎

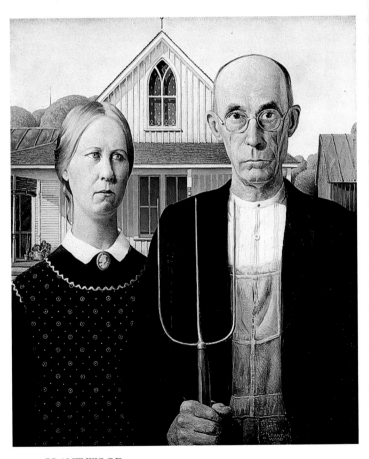

4-9　GRANT WOOD.
American Gothic (1930).
Oil on beaverboard. 29⁷⁄₈″ × 24⁷⁄₈″.

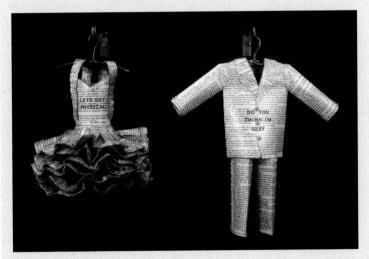

4-10　DONNA ROSENTHAL.
He Said . . . She Said: "Let's get physical"—"Do you think I'm sexy" (1999).
Mixed media. Suit: 12″ × 12″ × 1½″; dress: 10″ × 8″ × 8″.
Courtesy, Bernice Steinbaum Gallery, Miami, FL.

Copy nature and you infringe on the work of our Lord. Interpret nature and you are an artist.

—Jacques Lipchitz

Abstract painting is abstract. It confronts you.

—Jackson Pollock

In *The Kiss,* the human torso is reduced to a simple block form. Twentieth-century proponents of **Cubism,** such as Pablo Picasso and Georges Braque (see Figs. 19-7 and 19-8) also transcribed natural forms into largely angular geometrical equivalents. To some degree, despite their reduction to essential geometrical components and line–shape relationships, the figures of Picasso and Braque remain somewhat decipherable. In any event, both artists—in spite of some brief dabbling in nonobjectivity—abstracted from reality.

Jackson Pollock's *Male and Female* (Fig. 4-7) "figures" are a great deal more difficult to discern than Brancusi's, but the totemic shapes bear some visual cues that suggest gender differences. At the time of the painting, Pollock was undergoing psychoanalysis, and he was quite convinced that the unconscious played a major role in his art. Using a method called **psychic automatism,** Pollock attempted to clear his mind of purpose and concerns so that inner conflicts and ideas could find expression through his work. The result in *Male and Female* is abstraction.

Although much of Barbara Hepworth's sculpture has been inspired by nature, it is not always derived from nature. That is why we characterize work such as *Two Figures* (Fig. 4-8) as nonobjective. That is, it is not intended to make any reference to reality. On the other hand, entitling the piece *Two Figures* places viewers in a quandary. It sends us searching for details that might represent the human form, even gender differences. Is the taller "figure" the male? Could the concave shapes in the shorter figure suggest femininity? Here the connection to reality may be fully in the eye of the beholder. The truth is that nonobjective artists do this type of thing quite a lot. Sometimes they label their paintings and sculptures *Untitled* partially as a way to discourage Rorschach-like readings of their work. At other times, they assign titles to their nonobjective works based on some association that is triggered by the work itself.

A case in point is Judy Pfaff's *Voodoo* (Fig. 4-11), a nonobjective painting in which highly saturated colors and jagged shapes comprise the content and spirit of the work. Though the elements and technique are the "subject" of the work, the title suggests the presence of mysterious figures undulating in a Caribbean jungle undergrowth. One of the issues that many viewers have with nonobjective art is that

4-11 JUDY PFAFF.
Voodoo (1981).
Contact paper collage on Mylar. 98″ × 60″ (framed).
Albright-Knox Art Gallery, Buffalo; Edmund Hayes Fund, 1983.

> *To give a body and a perfect form to your thought, this alone is what it is to be an artist.*
>
> —Jacques-Louis David

they want it to make sense. They want to connect it with something familiar—even if the "familiar" in this case is as abstruse as the title, *Voodoo.* But nonobjective art is just that—nonobjective—and viewers might come closer to the intention of the artist by allowing themselves to focus on what's there rather than to go on scavenger hunts for what probably isn't.

FORM

The form of a work refers to its totality as a work of art Form includes the elements, design principles, and composition of a work of art. A work's *form* might include, for example, the colors that are used, the textures and shapes, the illusion of three dimensions, the balance, rhythm, or unity of design. **Formalist criticism,** by extension, is an approach to art criticism that concentrates primarily on the elements and design of works of art rather than on historical factors or the biography of the artist.

CONTENT

The **content** of a work of art is everything that is contained in it. The content of a work refers not only to its lines or forms but also to its subject matter and its underlying meanings or themes.

The Levels of Content

We may think of works of art as containing three levels of content: (1) subject matter, (2) elements and composition, and (3) underlying or symbolic meanings or themes.

Consider a comparison between the subject matter of two visually similar paintings as a way of exploring these levels. In 1793, just a few years after the taking of the Bastille and the start of the French Revolution, Jacques-Louis David painted *Death of Marat* (Fig. 4-12), a memorial to a political martyr. Almost 200 years later, Sandow Birk appropriated David's image for *Death of Manuel* (Fig. 4-13), his graphic deposition on urban violence.

4-12 JACQUES-LOUIS DAVID.
Death of Marat (1793).
Oil on canvas. 63¾″ × 49⅛″.
Musées Royaux des Beaux-Arts de Belgique, Brussels/Erich Lessing/
Art Resource, New York.

4-13 SANDOW BIRK.
Death of Manuel (1992).
Oil on canvas. 33″ × 25″.
Koplin Gallery, Los Angeles.

David's *The Oath of the Horatii* with Kruger's *Untitled (We Don't Need Another Hero)*

The Oath of the Horatii (Fig. 4-14), by Jacques-Louis David, is one of the most readily recognizable works of the nineteenth century—indeed, the whole of the history of art. It is a landmark composition—symbolically and pictorially. David worked for the king of France in the days before the French Revolution. Ironically, although the *Oath* was painted for Louis XVI, who along with his wife, Marie Antoinette, would lose his head to the guillotine, the painting became an almost instant symbol of the Revolution. The loyalty, courage, and sacrifice it portrayed were an inspiration to the downtrodden masses in their uprising against the French

monarchy. David, because of his position, was imprisoned along with the members of the court and other French aristocracy, only to be—as it were—"bailed out" by another who could use his services as a painter. Thus David, court painter to the French king, would become painter to Napoleon Bonaparte, who would eventually crown himself emperor.

Pictorially, the work is also groundbreaking. It compresses space and forces us to concentrate on the meticulously rendered figures in the foreground. This treatment of space would open the door to the flattening of space in Modernist paintings. The tradition of treating the picture frame as a win-

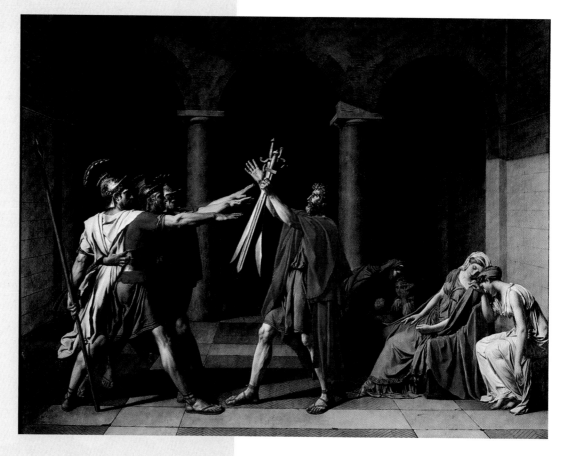

4-14 JACQUES-LOUIS DAVID. *The Oath of the Horatii* (1784). Oil on canvas. 11′ × 14′.
Louvre Museum, Paris/RMN/Art Resource, New York

dow frame through which one peers into the infinite distance would be abandoned by many artists in favor of the two-dimensionality of the canvas.

Knowing something of the historical circumstances under which *The Oath of the Horatii* was created, and understanding what is new about it in terms of style and composition, helps us appreciate its significance. But our full comprehension and appreciation of the work can only occur with our consideration and interpretation of the subject matter. The subject of David's *The Oath of the Horatii* is, on the face of things, fairly easy to read. Three brothers—the Horatii—swear their allegiance to Rome on swords held high by their father. They pledge to come back victorious or not come back at all. Their forward thrusting and stable stance convey strength, commitment, bravery. And there is something else—something that has been referred to by feminist critics and scholars as a *subtext,* or additional level of content in the work. David's *Oath* is also a painting about the ideology of gender differences. The women in the painting collapse in the background, terrified at the prospect of the death of the brothers. To make matters worse, one of the Horatii sisters is engaged to be married to one of the enemy. She might lose her brother to the hands of her fiancé, or vice versa. The women's posture, in opposition to the men's, represents, according to historian Linda Nochlin, "the clear-cut opposition between masculine strength and feminine weakness offered by the ide-

ological discourse of the period." Whatever else the content of this painting is about, it is also about the relationship of the sexes and gender–role stereotypes.

A number of contemporary feminist artists have challenged the traditional discourse of gender ideology as damaging both to men and women. Barbara Kruger's *Untitled (We Don't Need Another Hero)* (Fig. 4-15) can be interpreted as an "answer" to David's *Oath.* In appropriating a Norman Rockwell illustration to depict the "innocence" of gender ideology—in this case, the requisite fawning of a little girl over the budding muscles of her male counterpart—Kruger violates the innocuous vignette with a cautionary band blazing the words *We don't need another hero.* The representation of the opposition between strength and weakness—male and female—is confronted and replaced with the gender discourse of a more socially aware era.

The subject matter of these works is strangely related, oddly linked. Visually, the works could not be more dissimilar. In David's composition, the subtext of gender ideology exits simultaneously with the main narrative—that of the soldiers preparing for battle. In Kruger's work, by contrast, the main narrative *is* gender ideology—and how to counteract it. In both, however, the essential nature of evaluating the content, or subject matter of the works we view, is underscored. They are, after all, really about the same thing, aren't they? ∎

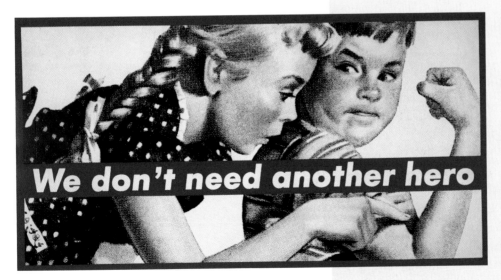

4-15 BARBARA KRUGER. *Untitled (We Don't Need Another Hero)* (1987). Photographic silkscreen, vinyl lettering on Plexiglas. 109″ × 210″.

Collection of Emily Fisher Landau, New York. Courtesy of Mary Boone Gallery, New York.

The artist does not draw what he sees, but what he must make others see.
Only when he no longer knows what he is doing does the painter do good things.

—Edgar Degas

Visual formulation of our reaction to life.

—Josef Albers, on the content of art

There is a macabre similarity between the two paintings in their elements and composition. David's Marat is found dead in his bath—murdered by a counterrevolutionary fanatic named Charlotte Corday. The artist brings the viewer face-to-face with the slaughtered hero, whose arm drops lifeless and whose sympathetic facial expression leans toward us yearningly. Birk's *Manuel* is rendered in the same pose, although Marat's bath has been replaced with a Chevy Impala, riddled with bullets. Marat's left hand holds a false letter requesting a visit from the would-be murderer; Manuel's left hand grasps the steering wheel of his car. Marat's head is wrapped in a turban; Manuel's, in a brightly printed bandana. In both paintings, the figure is set in the extreme foreground and the backgrounds are monochromatic and nondescript. The spatial depth is severely limited. This dramatic silhouette effect, coupled with the strong linear style used to render the figure, creates the feeling of a sculptural frieze.

The underlying themes or symbolism in these works may not bear the same relationship as do the elements and composition. Yet the choice of the David prototype suggests ideas of revolution, heroism as it is defined within a group or culture, and the cold-blooded murder of the unsuspecting victim. The appropriation of the David image by Birk validates the historic significance of the eighteenth-century painting. Understanding the relationship between the two makes each more meaningful to the viewer.

Iconography

I prefer winter and fall, when you feel the bone structure in the landscape—the loneliness of it—the dread feeling of winter. Something waits beneath it—the whole story doesn't show.

—Andrew Wyeth

Winter is a perennial symbol of death and aloneness in the arts, and fall is a common symbol of either harvest or decline. Yet artists who paint the winter or the fall, or who write of them, may not directly speak of death or of the harvest. "The whole story" does not always show but rather may lie beneath a work of art.

Iconography is the study of the themes and symbols in the visual arts—the figures and images that lend works their underlying meanings. Bronzino's sixteenth-century masterpiece *Venus, Cupid, Folly, and Time (The Exposure of Luxury)* (Fig. 4-16) is a classic example of works in which there is much more than meets the eye. The painting weaves an intricate allegory, with many actors, many symbols. Venus, undraped by Time and spread in a languorous diagonal across the front plane, is fondled by her son Cupid. Folly prepares to cast roses on the couple, while Hatred and Inconstancy (with two left hands) lurk in the background. Masks, symbolizing falseness, and other objects, meanings known or unknown, complete the scene.

4-16 BRONZINO.
Venus, Cupid, Folly, and Time (The Exposure of Luxury)
(c. 1546).
Oil on wood. Approx. 61″ × 56¾″.
Courtesy of the Trustees of the National Gallery, London.

I would like to leave a will and testament to declare everything void at my death, and it's not unrealistic. I mean it, because only I know the work as it ought to be. All posthumous interpretations are less.

—Dan Flavin

Works such as these offer an intricate iconographic puzzle. Is Bronzino saying that love in an environment of hatred and that inconstancy is foolish or doomed? Is something being suggested about incest? self-love? Can one fully appreciate Bronzino's painting without being aware of its iconography? Is it sufficient to respond to the elements and composition, to the figure of a woman being openly fondled before an unlikely array of onlookers? No simple answer is possible, and a Mannerist artist such as Bronzino would have intended this ambiguity. Certainly one could appreciate the composition and the subject matter for their own sake, but awareness of the symbolism enriches the viewing experience.

Whereas Bronzino's painting illustrates a complex allegory, the symbolism of which would seem relevant only to the initiated, Willie Bester's *Semekazi (Migrant Miseries)* (Fig. 4-17) uses images and objects to communicate a tragic story to anyone who will listen. Bester is an artist who was classified as "colored" under South African apartheid rule and thus, as with most nonwhite artists, was deprived of opportunities for formal training in art. Collages such as *Semekazi* combine painting with found objects in a densely covered surface that seems, in its lack of space and air, to reflect the squalid living conditions among black Africans. The many images and objects serve as symbols of rampant oppression and deprivation affecting a whole people, while a single portrait of a worker in the center of the composition—peering from under bedsprings—serves as a single case study.

The paintings by Bronzino and Bester, as far apart in time, tenor, and experience as can be imagined, both supply the viewer with clear, familiar images intended to communicate certain underlying themes. But in some cases, the underlying themes may be at least in part the invention of the viewer. In Helen Frankenthaler's *Bay Side* (see Fig. 2-25), for example, we may interpret the juncture of the blue and tan fields as surf meeting sand. Did the artist intend this symbolism, however, or is it our own invention? Many of us love a puzzle and are willing to spend a great deal of time attempting to decipher the possible iconography of a work of art. In other cases, the subject matter of a work may be in the eye of the beholder.

Our exposition of the language of art is now complete. We have seen that artists use the visual elements of art in com-

4-17　WILLIE BESTER.
Semekazi (Migrant Miseries) (1993).
Oil, enamel paint, and mixed media on board.
49¼″ × 49¼″.
By courtesy of Sotheby's Picture Library. Copyright 2005 Willie Bester.

positions that employ various principles of design. Their compositions are usually created within certain traditional and contemporary styles. The totality of the form of their works—everything that we see in them—also has certain subject matter or content, which may exist on several levels. Our understanding of these various levels of content helps us appreciate the works.

Several chapters follow that show how artists apply the language of art to works in two dimensions and three dimensions. Then we survey the history of art, where we see how artists through the ages and around the globe have spoken a similar language. Although it may take us adults years to become fluent in the spoken languages of other peoples in other times and other places, we may find ourselves capable of more readily understanding the language in their visual works.

DRAWING

*Drawing . . . is the necessary beginning of everything in art,
and not having it, one has nothing.*

—Giorgio Vasari

The first sketch was probably an accident. Perhaps some Stone Age human idly ran a twig through soft clay and was astounded to find an impression of this gesture in the ground. Perhaps this individual then made such impressions as signs for family members (as in an arrow pointing "that way") and to record experiences, such as the hunt for a beast or a gathering around a fire. Similarly, a child may learn to trace a shell fragment through damp sand at the shore's edge. Soon the child is drawing sketches of geometric shapes, animals, toys, and people. Michelangelo was engaging in an essentially similar act when he sketched his models from life— albeit with a bit more skill and flair.

In this chapter we discuss drawing, the most basic of the two-dimensional art forms. In the next two chapters we will discuss two other forms of two-dimensional art—painting and printmaking. We shall see how people over the centuries have used a variety of materials, frequently from surprising sources, to express themselves through two-dimensional art forms.

I have always . . . wanted to copy and taken pleasure in copying, either from originals,
but above all from reproductions, every work of art that touched my feelings
or stirred my enthusiasm or just interested me particularly.

—Alberto Giacometti

In its broadest definition, **drawing** is the result of an implement running over a surface and leaving some trace of the gesture. But as we shall discover, the art of drawing goes far beyond this simple description.

The surface, or **support,** onto which an image is sketched is usually, although not always, two dimensional. Most often the support is **monochromatic** paper or parchment, although drawings can be found on a variety of surfaces. The implements can range from charcoal (which is burnt wood) to bristle brushes dipped in ink. Most drawings, by virtue of the implements, consist of black and tones of gray. But many full-color drawings have also been created with colored chalks, pastels, and wax crayons.

Some drawings are predominantly **linear;** others are constructed solely by tonal contrasts. The quality of line and the nature of shading are affected by the texture of the support. We shall see how the artist capitalizes on the idiosyncratic characteristics of the implements and support to capture a desired expression in the drawing.

CATEGORIES OF DRAWING

Drawing is basic to the visual arts. For centuries, painters and sculptors have made countless preparatory sketches for their major projects, working out difficulties on paper before approaching the more permanent medium of paint or bronze. Architects proceed in the same fashion, outlining buildings in detail before breaking ground. Drawing has also served artists as a kind of shorthand method for recording ideas.

Artists carry sketchbooks everywhere, and perhaps there is no one better known for his "little book of leaves" than Leonardo da Vinci, who advised artists to note everything and when the book was "full, [to] keep it to serve [their]

5-1 REMBRANDT VAN RIJN.
Copy of Leonardo da Vinci's
Last Supper.
Red chalk on paper.
14″ × 18¼″.

future plans, and take another and carry on with it." Leonardo's own work also served as inspiration for generations of artists who, like Rembrandt (Fig. 5-1), copied his masterpieces. Imitation has been said to be the sincerest form of flattery, and art-world luminaries and students alike have "gone to school on" the works of the masters. Copying permits the artist to, in a sense, retrace another artist's steps—from conception to completion. Far from being an exercise in mere duplication, the effort can lead to an understanding and feeling of form, of rhythm, of design. Sometimes such copies give us a bit of insight into how an artist might have changed a composition, in the artist's view, for the better. Although Leonardo's setting for the *Last Supper* is quite spare, with a simple rectangular window behind the figure of Jesus, Rembrandt has added an elaborate draped canopy and more architectural detail, no doubt more befitting of the event in his eyes. Rembrandt copied Leonardo's famed fresco from an engraving that another artist made after the original. Many artists in history have traveled well beyond their cities of origin, however, to meet the works of the masters and to unlock their secrets through the scrutiny of copying.

But drawing does not serve only a utilitarian purpose. In most cases, drawing is the most direct way of bringing what is in the artist's mind to the artist's surface. Many artists enjoy the sheer spontaneity of drawing, tracing a pencil or piece of chalk across a sheet of paper to capture directly their thoughts or to record the slightest movement of their hand.

Many drawings, by contrast, stand as complete works of art. Gary Kelley's sensual and rhythmic pastel drawing (Fig. 5-2) possesses all of the detail, all of the "finish" of a work of art in a medium that might be considered more "permanent." Its powerful zigzag composition contributes to the sense of life and movement, as do the contrasts between the harsh angularity of the male singer's zoot suit and the sinuous curves of the woman who writhes in response to his music. Kelley's drawing was commissioned as a promotional piece for the Mississippi Delta Blues Festival and was no doubt purposefully reminiscent of the Harlem jazz age as depicted by 1930s African American artists such as Archibald J. Motley Jr. (see Fig. 3-2).

Drawings may thus be said to fall into at least three categories:

1. Sketches that record an idea or provide information about something the artist has seen.

2. Plans or preparatory studies for other projects, such as buildings, sculptures, crafts, paintings, plays, and films.

3. Fully developed and autonomous works of art.

5-2　GARY KELLEY.
Promotion for the Mississippi Delta Blues Festival (c. 1989). Pastel. 24″ × 14″.
Courtesy of the artist and Richard Solomon.

DRAWING MATERIALS

Over the millennia, methods of drawing have become increasingly sophisticated and materials more varied and standardized. It would seem that we have come a long way from our prehistoric ancestors' use of twigs, hollow reeds, and lumps of clay. Drawing materials can be divided into two major groups: *dry media* and *fluid media.*

Dry Media

The **dry media** used in drawing include silverpoint, pencil, charcoal, chalk, pastel, and wax crayon.

Drawing is the honesty of the art. There is no possibility of cheating. It is either good or bad.

—Salvador Dalí

Silverpoint

Silverpoint is one of the oldest drawing media. It was used widely from the late Middle Ages to the early 1500s. Silverpoint drawings are created by dragging a silver-tipped implement over a surface that has been coated with a **ground** of bone dust or chalk mixed with **gum,** water, and **pigment.** This ground is sufficiently coarse to allow small flecks of silver from the instrument to adhere to the prepared surface as it is drawn across. These bits of metal form the lines of the drawing; they are barely visible at the start but eventually oxidize, becoming tarnished or darkened and making the image visible. Each silverpoint line, a soft gray to begin with, mellows and darkens to a grayish brown hue. If the artist desires to make one area of the drawing appear darker than others, it is necessary to build up a series of close, parallel, or cross-hatched, lines in that area to give the impression of deepened tone. Because they lack sharp tonal contrasts, the resultant drawings are often extremely delicate in appearance.

The technique of working in silverpoint is itself delicate. The medium allows for little or no correction. Thus, the artist is not in a position to experiment while working. There must be a fairly concrete notion of what the final product will look like, and the lines must be accurate and confidently drawn. The nineteenth-century *Head of a Man* (Fig. 5-3) by the French artist Alphonse Legros illustrates the way in which the artist must use techniques of cross-hatching and clusters of small lines to model form with the silverpoint medium. The portrait is a dramatic record of the topography of a man's face, rendered with the utmost clarity and control. Legros concentrates his efforts—and the viewer's attention—on the intent gaze of the face; the hair and collar are only faintly suggested. Working in silverpoint has its rewards. The drawings, painstakingly rendered, are flawless in execution, their finish exquisite and polished. But the technique is not for the fainthearted. Students interested in working in silverpoint are encouraged to create detailed preliminary sketches in hard pencil before launching into the other, more permanent and less forgiving medium.

Pencil

Silverpoint was largely replaced by the lead **pencil,** which came into use during the 1500s. Medieval monks, like the ancient Egyptians, ruled lines with metallic lead. Pencils as

5-3 ALPHONSE LEGROS.
Head of a Man (19th century).
Silverpoint on white ground.

we know them began to be mass-produced in the late eighteenth century.

A pencil is composed of a thin rod of **graphite** encased within wood or paper. The graphite is ground to dust and mixed with clay, and the mixture is baked to harden the clay. The relative hardness or softness of the implement depends on the quantity of clay in the mixture. The more clay, the harder the pencil.

Pencil is capable of producing a wide range of effects. Lines drawn with hard pencil can be thin and light in tone; those rendered in soft lead can be thick and dark. The sharp point of the pencil will create a firm, fine line suitable for meticulous detail. Softer areas of tone can be achieved through a buildup of parallel lines, smudging, or stroking the support with the side of the lead tip.

As seen in the contrasting works of Giorgio de Chirico and Albert Giacometti, pencil can be manipulated to achieve dramatically different effects that complement the subject. Chirico's mannequin (Fig. 5-4) is a controlled construction of wood pieces that have been fitted together to

5-4 GIORGIO DE CHIRICO.
Condottiero (1917).
Pencil. 12³⁄₈″ × 8¹⁄₂″.
Staatliche Graphische Sammlung, Munich. Copyright Foundation Giorgio de Chirico. Copyright 2003 Artists Rights Society (ARS), New York/SIAE, Rome.

5-5 ALBERTO GIACOMETTI.
Head (1946).
Pencil.
5⁷⁄₈″ × 4¹⁄₄″.
Copyright 2003 Artists Rights Society (ARS), New York.

the likenesses of muscles, ligaments, and tendons. The precision of the construction is communicated through the fine lines of a hard pencil point.

Giacometti's drawing (Fig. 5-5), on the other hand, is a free expression of energy or, perhaps, anxiety. The highly abstracted head seems bound up in a frozen psychological state, one of inner turmoil created by the artist's agitated scribbling and reworking of bold pencil strokes. The contrast of thick black lines against the harsh white paper seems to echo the expressive nature of the drawing rather than convey the features of the subject. Giacometti was clearly not interested in creating a portrait likeness. Rather, he used his medium to render the distorted impression of an agitated figure, perhaps projecting his own inner conflict onto his subject. Chirico, by contrast, used pencil in a more static and controlled manner to present us with a factual duplication of his bizarre inanimate object.

Drawing is perhaps the most traditional of media. The exercise of drawing from life has been integral to the art academy experience for hundreds of years, a method by which the human form might be painstakingly analyzed and recorded. Perhaps this is why, in part, Adrian Piper chose the medium of drawing to render her dramatic *Self-Portrait Exaggerating My Negroid Features* (Fig. 5-6). With it, Piper invites the spectator to focus on those aspects of her physical genetic composition that reveal her mixed black and white parentage. The portrait gives us an unflinching record of Piper's countenance, but perhaps more important, the image

5-6 ADRIAN PIPER.
Self-Portrait Exaggerating My Negroid Features (1981).
Pencil on paper. 10″ × 8″.
Collection of the artist.

challenges us to confront our prejudices about the physical differences between the races.

Adrian Piper authored "calling cards" to hand out to people whom she overhears making racist remarks: "I regret any discomfort my presence is causing you, just as I am sure you regret the discomfort your racism is causing me."

Charcoal

Charcoal, like pencil, has a long history as a drawing implement. Used by our primitive ancestors to create images on cave walls, these initially crumbly pieces of burnt wood or bone now take the form of prepared sticks that are formed by the controlled charring of special hardwoods. Charcoal sticks are available in a number of textures that vary from hard to soft. The sticks may be sharpened with sandpaper to form fine and clear lines or may be dragged flat across the surface to form diffuse areas of varied tone. Like pencil, charcoal may also be smudged or rubbed to create a hazy effect.

When charcoal is dragged across a surface, bits of the material adhere to that surface, just as in the case of silverpoint and pencil. But charcoal particles rub off more easily, and thus the completed drawings must be sprayed with a solution of thinned varnish to keep them affixed. Also, because of the way in which the charcoal is dispersed over a surface, the nature of the support is evident in each stroke. Coarsely textured paper will yield a grainy image, whereas smooth paper will provide a clear, almost pencil-like line.

A self-portrait of the German Expressionist Käthe Kollwitz (Fig. 5-7) reveals one aspect of the character of the charcoal medium. Delicate lines of sharpened charcoal drawn over broader areas of subtle shading enunciate the

5-7 KÄTHE KOLLWITZ.
Self-Portrait (1924).
Charcoal. 18¾″ × 25″.
National Gallery of Art, Washington, DC. Rosenwald Collection.
Copyright 2003 Artists Rights Society (ARS), New York/VG Bild-Kunst, Bonn.

5-8 CLAUDIO BRAVO.
Package (1969).
Charcoal, pastel, and sanguine. 30⅞″ × 22½″.
Baltimore Museum of Art, Baltimore, MD.
Copyright Christies Images/Corbis.

two main points of interest: the artist's face and her hand. Between these two points—that of intellect and that of skill—runs a surge of energy described by aggressive, jagged strokes overlaying the lightly sketched contour of her forearm.

Values in the drawing range from hints of white at the artist's knuckles, cheekbone, and hair to the deepest blacks of the palm of her hand, eyes, and mouth. The finer lines override the texture of the paper, whereas the shaded areas, particularly around the neck and chest area, reveal the faint white lines and tiny flecks of pulp that are visual remnants of the papermaking process.

Charcoal can be expressive or descriptive, depending on its method of application. Claudio Bravo's *Package* (Fig. 5-8) is a finely rendered, trompe l'oeil drawing that bears almost no trace of the artist's gesture and almost no indication of the "dusty" quality of the media—primarily charcoal and pastel. The illusion of the smooth sheen and crinkled indentations of the wrapping paper, attributed to painstaking gradations in value, is so convincing that the implied texture of

the package completely overrides the actual texture of the drawing materials. The viewer is enticed to touch the forbidden surfaces, just to test whether they are real.

Chalk and Pastel

The effects of charcoal, **chalk**, and **pastel** as they are drawn against the paper surface are very similar, though the compositions of the media differ. Chalk and pastel consist of pigment and a **binder**, such as **gum arabic**, shaped into workable sticks.

Chalks are available in a number of colors, some of which occur in nature. **Ocher**, for example, derives its dark yellow tint from iron oxide in some clays. **Umber** acquires its characteristic yellowish or reddish brown color from earth containing oxides of manganese and iron. Other popular "organic" or "earth" colors include white, black, and a red called **sanguine.**

Michelangelo used red chalk in a sketch for the Sistine Chapel (see Chapter 15), in which he attempted to work out certain aspects of the figure of the Libyan Sibyl (Fig. 5-9).

Quick, sketchy notations of the model's profile, feet, and toes lead to a detailed torso rendered with confident lines and precisely defined tonal areas built up from hatching. The exactness of muscular detail and emphasis on the edges of the body provide insight into the concerns of an artist whose forte was sculpture.

In contrast to Michelangelo's essentially linear approach to his medium, the *Portrait of a Woman* (Fig. 5-10) by the nineteenth-century French painter Jean-Baptiste Carpeaux appears to materialize from the background through subtle tonal contrasts. Whereas Michelangelo emphasized the edges of his model, Carpeaux was more interested in the subtle roundness of his model's form. Carpeaux capitalized on the effect of soft chalk drawn across a coarsely textured paper to create a hazy atmosphere that envelops the sitter.

Pastels consist of ground chalk mixed with powdered pigments and a binder. Whereas chalk drawings can be traced to prehistoric times, pastels did not come into wide use until the 1400s. They were introduced to France only in the 1700s, but within a century pastels captured the imagination of many important painters. Their wide range of brilliant colors offered a painter's palette for use in the more spontaneous medium of drawing.

One of the masters of pastel drawing was the nineteenth-century French painter and sculptor Edgar Degas. The directness and spontaneity of the medium was well

5-9 MICHELANGELO.
Studies for *The Libyan Sybil* (1510–1511).
Red chalk. 11⅜″ × 8⅜″.
The Metropolitan Museum of Art. Joseph Pulitzer Bequest, 1924 (24.197.2).
Copyright 1995 The Metropolitan Museum of Art, New York.

5-10 JEAN-BAPTISTE CARPEAUX.
Portrait of a Woman (1874).
Black chalk heightened with white, on buff paper.
7⅞″ × 5⅞″.
Sterling and Francine Clark Art Institute, Williamstown, MA.

If I could have had my own way, I would have confined myself entirely to black and white.

—Edgar Degas

5-11 EDGAR DEGAS.
Woman at Her Toilette (1903).
Pastel on paper. 30″ × 30½″.
Mr. and Mrs. Martin Ryerson Collection. Photograph courtesy of The Art Institute of Chicago.

5-12 JAUNE QUICK-TO-SEE SMITH.
The Environment: Be a Shepherd (1989).
Charcoal, colored chalk, and pastel. 47″ × 31¼″.
Collection of Lois Fichner-Rathus.

suited to some of his favorite subjects: ballet dancers in motion, horses racing toward a finish line, and women caught unaware in the midst of commonplace activities. Degas's *Woman at Her Toilette* (Fig. 5-11) is a veritable explosion of glowing color. The pastels are manipulated in countless ways to create a host of different effects. The contours of the figure are boldly sketched, whereas the flesh is composed of more erratic lines that create a sense of roundness through a spectrum of color. Degas scratched the pastels over the surface to form sharp lines or dragged them flatly to create more free-flowing strokes. At times the colors were left pure and intense, and at other times subtle harmonies were rendered through blending or smudging.

Jaune Quick-to-See Smith's *The Environment: Be a Shepherd* (Fig. 5-12) is an effective combination of drawing media: charcoal, colored chalk, and pastel. The earth tones of sepia, brown, greens, and grays evoke the desert Southwest and enhance the imagery of a Native American narrative. The upper right and lower left bear charcoal sketches of a horse and rural church; they are overworked, leaving ghostlike images of themselves reverberating in space. In the center, a shepherd's (priest's?) robe hovers with arms outstretched, like a spectre admonishing the abusers of the environment. Throughout the drawing, contrasting images that refer to intertwined cultural legacies are held together with tenuous, grasslike strokes. The media and the sketchy manner in which they are handled effectively creates the feeling of a "mental sketchbook"—fleeting memories sparked by incongruous objects.

Crayon

Strictly defined, the term **crayon** includes any drawing material in stick form. Thus, charcoal, chalk, and pastels are crayons, as are the wax implements you used on walls, floors, and occasionally coloring books when you were a child. One of the most popular commercially manufactured crayons for artists is the **conté crayon.** Its effects on paper are similar to those of chalk and pastel, although its harder texture makes possible a greater clarity.

Life, Death, and Dwelling in the Deep South

Some years ago, African American sculptor Beverly Buchanan came to know Ms. Mary Lou Furcron. Both artists, one might say. Both the builders of structures. Both nurturing, creative, and colorful. Ever since this meeting, Buchanan's life and art have revolved around the art and life of the Southern shack dweller.

It's an existence unto itself, as the photographs indicate (Fig. 5-13). Ms. Furcron's shack reflects her life, and her life reflects the shack in which she lived. She devoted a part of each day to maintaining the structure, replacing rotted posts with new logs; using bark, lathing, and other odd materials to repair the siding. The shack stood as an organic and ever-evolving structure—an extension of Ms. Furcron herself. As the shack required her constant attention for its survival, her move to a nursing home brought its rapid disrepair. Just one month after Ms. Furcron's departure, the shack was unrecognizable as its former self.

Buchanan's art, in sculpture, and especially in drawing, reflects a structural approach to the creation of the shack image. As Ms. Furcron built with the recycled remnants of nature and human existence, so does Beverly Buchanan. Her mixed-media shacks are created from old pieces of wood, metal, and found objects, such as in *Hometown—Shotgun Shack* (Fig. 5-14). Her oil pastel drawing *Henriette's Yard* (Fig. 5-15) is vigorously and lovingly constructed of a myriad of vibrant strokes. These strokes at once serve as the building blocks of the shack image and the very stuff that reduces the structure to an almost indecipherable explosion of color. The precarious balance of the shacks in relation to one another and the uncertain ground in which they stand, further symbolize the precious and fragile nature of the shack dwelling, and human existence. ∎

5-14 BEVERLY BUCHANAN.
Hometown—Shotgun Shack
(1992).
Wood, mixed media.
12″ × 9¼″ × 15″.
Courtesy of Bernice Steinbaum Gallery, Miami.

5-15 BEVERLY BUCHANAN.
Henriette's Yard (1995).
Oil pastel on paper. 60″ × 60″.
Collection of Lois Fichner-Rathus.
Courtesy of Bernice Steinbaum Gallery, Miami.

A

B

5-13 Photographs of Ms. Mary Lou Furcron's home.
Photo A shows the shack while Ms. Furcron was living in it and tending to it. Photo B shows the shack just one month after her placement in a nursing home.
Photographs courtesy of Bernice Steinbaum Gallery, Miami.

5-16 CHUCK CLOSE.
Self-Portrait / Conté Crayon (1979).
Conté crayon on paper. 29½" × 22".
Private collection. Courtesy of the Pace Gallery.

In his *Self-Portrait / Conté Crayon* (Fig. 5-16), Chuck Close seems less interested in clarity than in creating the illusion of a grainy and blurry photographic likeness. The artist superimposed a grid over his portrait and then transferred the "contents" of each of the squares of this grid to another, enlarged grid on a 29½" × 22" piece of drawing paper using conté crayon. By working square by square, Close could focus on the almost infinite tonal variations inherent in black-and-white photography and attempt to re-create them through scribbled, hatched, blurred, and smudged lines. The contrasts in value differentiate the details of the artist's portrait—from his bald head and eyeglasses to his mustache and beard. Many of the artist's unidealized portraits are based on this grid-transfer method, some featuring the vibrant colors of pastel and oil paint (see Fig. 3-21).

Wax crayons, like pastels, combine ground pigment with a binder—in this case, wax. Wax crayon moves easily over a support to form lines that have a characteristic sheen. These lines are less apt to smudge than charcoal, chalk, and pastels.

Fluid Media

The primary **fluid medium** used in drawing is ink, and the instruments used to carry the medium are pen and brush. Appearing in Egyptian **papyrus** drawings and ancient Chinese scrolls, ink has a history that stretches back thousands of years. Some ancient peoples made ink from the dyes of plants, squid, and octopus. By the second century CE, blue

black inks were being derived from galls found on oak trees. The oldest-known type of ink is India or China ink, which is used in oriental **calligraphy** to this day. It is a solution of carbon black and water, and it is permanent and rich black in color.

As with the dry media, dramatically different effects can be achieved with fluid media through a variety of techniques. For example, the artist may alter the composition of the medium by diluting it with water to achieve lighter tones, or may vary the widths of brushes and pen points to achieve lines of different character.

Pen and Ink

Pens also have been used since ancient times. The earliest ones were hollow reeds that were slit at the ends to allow a controlled flow of ink. **Quills** plucked from live birds became popular writing instruments during the Middle Ages. These were replaced in the nineteenth century by the mass-produced metal **nib,** which is slipped into a wooden **stylus.** Many artists use these pens today.

Pen and ink are used to create drawings that are essentially linear, although the nature of the line can vary considerably according to the type of instrument employed. A fine, rigid nib will provide a clear, precise line that is uniform in thickness. Lines created by a more flexible quill tip, by contrast, will vary in width according to the amount of pressure the artist's hand exerts.

Jean Dubuffet all but fills his *Garden* (Fig. 5-17) with pen-and-ink scribbles of varying thicknesses outlining

5-17 JEAN DUBUFFET.
Garden (1952).
Pen and carbon ink on glazed white wove paper.
18¾" × 23¾".
The Art Institute of Chicago. Copyright 2003 Artists Rights Society (ARS), New York/ADAGP, Paris.

Paper Dolls for a Post-Columbian World

Mark Twain once wrote that the ink with which history has been written is fluid prejudice. Most of us are just beginning to understand that there are two sides to every historical event, and that any accurate examination of history must include the view of the vanquished, the story of the minority group, a look at the peripheral events that are part of the human story.

Native American artist Jaune Quick-to-See Smith has challenged our perception of Columbus's expedition to the New World by sardonically focusing on its destructive aftermath. She offers us her pen-and-pastel version of paper dolls, a familiar childhood pastime, which in her hands assumes all sorts of political connotations. Our Native American couple are called Barbie and Ken Plenty Horses (Fig. 5-18). Their clothing ensembles include some "ethnic wear" (politically correct) amidst a priest's robe, maid's uniform, saloon keeper's costume, and alternate sheaths of skin infested with smallpox. Is this what has become of the Native American population in the name of Western "civilization"? ■

5-18 JAUNE QUICK-TO-SEE SMITH.
Paper Dolls for a Post Columbian World with Ensembles Contributed by the U.S. Government (1991).
Pastel and pen on paper.
40″ × 29″.

Collection of Dr. and Mrs. Harold Steinbaum. Courtesy of Bernice Steinbaum Gallery, Miami.

Drawing is like making an expressive gesture with the advantage of permanence.

—Henri Matisse

mostly organic shapes. Just as a garden's plant life may give the eye a variegated experience of texture as well as color, Dubuffet's lines vary in length and thickness, sometimes culminating in little pools of ink. Here and there more angular, even craggy shapes suggest a path or an outcropping of rock, but the artist's aim is not to realistically depict any garden you might have visited. Rather, the high horizon line and the endless intertwining create an overall sense of being ensnared within a sea of shapes and textures.

Pen and Wash

Fine, clear lines of pure ink are often combined in drawings with **wash**—diluted ink that is applied with a brush. Wash provides a tonal emphasis absent in pen-and-ink drawings.

In Giovanni Battista Tiepolo's eighteenth-century drawing (Fig. 5-19), the contours of the biblical figures are described in pen and ink, but their volume derives from a clever use of wash. An illusion of three-dimensionality is created by pulling the white of the untouched paper forward to function as form and enhancing it with contrasting areas of light and dark wash. The gestural vitality of the pen lines and the generous swaths of watery ink accentuate the composition's dynamic movement.

Brush and Ink

Brushes are extremely versatile drawing implements. They are available in a wide variety of materials, textures, and shapes that afford many different effects. The nature of a line in brush and ink will depend on whether the brush is bristle or nylon, thin or thick, pointed or flat tipped. Likewise, characteristics of the support—texture, absorbency, and the like—will influence the character of the completed drawing. Brush and ink touched to silk leaves an impression quite different from that produced by brush and ink touched to paper.

Japanese artists are masters of the brush-and-ink medium. They have used it for centuries for every type of

5-19 GIOVANNI BATTISTA TIEPOLO.
Hagar and Ishmael in the Wilderness (c. 1725–1735).
Pen, brush and brown ink, and wash, over sketch in black chalk. 16½″ × 11⅛″.
Sterling and Francine Clark Art Institute, Williamstown, MA.

5-20 KATSUSHIKA HOKUSAI (1760–1849).
Boy Playing Flute.
Ink and brush on paper. 4½″ × 6¼″.
Courtesy of Freer Gallery of Art, Smithsonian Institution, Washington, DC.

It is only by much drawing, drawing everything, drawing unceasingly that one fine day one is very surprised to find it possible to express something in its true spirit.

—Camille Pissarro

calligraphy, ranging from works of art to everyday writing. Their facility with the technique is most evident in seemingly casual sketches such as those done in the late eighteenth and early nineteenth centuries by Japanese artist Katsushika Hokusai (Fig. 5-20). Longer, flowing lines range from thick and dark to thin and faint, capturing, respectively, the heavy folds of the boy's clothing and the pale flesh of his youthful limbs. Short, brisk strokes humorously describe the similarity between the hemp of the woven basket and the youngster's disheveled hair. There is an extraordinary simplicity to the drawing attributable to the surety and ease with which Hokusai handles his medium.

Brush and Wash

The medium of brush and wash is even more versatile than that of brush and ink. Although it can duplicate the linearity of brush-and-ink drawings, it can also be used to create images solely through tonal contrasts. The ink can be diluted to varying degrees to provide a wide tonal range. Different effects can be achieved either by adding water directly to the ink or by moistening the support before drawing.

It is again surprising to note how adaptable the drawing media can be to different artistic styles or subjects. Consider the drawings by the Italian Renaissance master Leonardo da Vinci (Fig. 5-21) and the seventeenth-century French

5-21 LEONARDO DA VINCI. *Study of Drapery* (c. 1473). Brush, gray wash, heightened with white, on linen. $7^3/8'' \times 9^1/4''$.
Louvre Museum, Paris. Copyright RMN/Art Resource, New York.

5-22 CLAUDE LORRAIN.
Tiber above Rome (c. 1640).
Brush and wash.

painter Claude Lorrain (Fig. 5-22). Even upon close inspection, one would not guess that both works were created in the same medium, despite their tonal emphasis. Leonardo captured the intricacies of drapery as it falls over the human form, dramatically lit to provide harsh contrasts between surfaces and crevices. The voluminous folds are realized through a meticulous study of tonal contrasts.

The shape of Lorrain's landscape also relies on tonal variations rather than line, but here the similarity ends. Leonardo's drawing is descriptive, and almost photographic in its realism. Lorrain's work is suggestive—a quick rendition of the artist's visual impression of the landscape. Whereas Leonardo worked his wash over linen, Lorrain worked on damp paper. By touching a brush dipped in ink to the wet surface, Lorrain made his forms dissolve into the surrounding field and lose their distinct contours. Broadly brushed liquid formations constructed of varying tones yield the impression of groves of trees on the bank of a body of water that leads to distant mountains. These nondescript areas of diffuse wash were here and there given more definition through bolder lines and brushstrokes applied after the paper was dry. Leonardo used brush and wash to reveal form. Lorrain used it to define space.

CARTOONS

The word **cartoon** derives from the Italian *cartone,* meaning "paper." Originally, cartoons were full-scale preliminary drawings done on paper for projects such as fresco paintings, stained glass, or tapestries. The meaning of cartoon was expanded to include humorous and satirical drawings when a parody of fresco cartoons submitted for decoration of the Houses of Parliament appeared in an English magazine in 1843. Regardless of their targets, all modern cartoons rely on caricature, the gross exaggeration and distortion of natural features to ridicule a social or political target.

Honoré Daumier is perhaps the only famous painter to devote so great a part of his production—some 4,000 works—to cartoons. Known for his riveting images of social and moral injustices in nineteenth-century France, he also created caricatures in which he displayed a sharp, sardonic

wit. Daumier's *Three Lawyers* (Fig. 5-23) is a taunting illustration of what he perceived to be the grossly overstated importance of this professional group. Each lawyer strains to raise his nose and eyebrows higher than those of his comrades, effectively communicating his self-adulation. The absurd superficiality of the trio's conversation is communicated by their attempts to strike a meaningful pose in their clownlike embodiments.

Cartoons have a long history of social commentary, consciousness raising, and political activism. We are all familiar with the children's books of Dr. Seuss, but few of us are aware of Theodor Seuss Geisel's political cartoons (Fig. 5-24). For two years during World War II, Dr. Seuss was the chief editorial cartoonist for the New York tabloid newspaper *PM*. During that time, he drew more than 400 cartoons, many of which pertained to the war effort. It's fascinating to see Dr. Seuss's legendary, signature style (and creatures) called into service for an altogether different purpose.

Drawing is among the most personal things you can do. It doesn't have any rhetoric or anything to tell. It's a dialogue between the art and yourself.

—Santiago Calatrava, architect

NEWTON DISCOVERS SURREALISM

5-25 ROBERT JOLLEY.
New Yorker cartoon. *Newton Discovers Surrealism.*
Cartoon by Richard Jolley.
www.cartoonstock.com Used by permission.

Although cartoon drawing styles vary widely, what they often have in common is the visual pun, or play on words, images, or ideas—such as the *New Yorker* cartoon in Figure 5-25. A bit of a inside joke, so to speak, the artist combines the legend of Newton's apple—which fell out of a tree, popped him on the head, and initiated his reflections on the laws of gravity—with Dalí's infamous piano scene from his Surrealist film *Un Chien Andalou* (see Fig. 8-36). The cartoon artist has, through a play on visual images, managed to defang the more gruesome aspect of the Dalí film still and replace it with something that works as a humorous anachronism.

NEW APPROACHES TO DRAWING

Drawings display endless versatility in terms of their intended purposes, their media, and their techniques. It is not unusual to find drawings that are not "drawn" at all on materials that are far removed from traditional paper. You'd be right to ask, "What *is* a drawing after all?"

Jackson Pollock, an American artist working in the 1940s and 1950s, dripped and whipped enamel paint onto paper surfaces. His spontaneous gestures read like an almost-but-not-quite-recognizable calligraphy (Fig. 5-26). The expansive definition of drawing has led the medium from its traditional roots to one, like painting or printmaking, that is an end in itself. Galleries such as The Drawing Center in New York City feature exhibitions of drawings exclusively, concentrating on both historical and cutting-edge work (Fig. 5-27).

5-26 JACKSON POLLOCK.
Untitled (1950).
Pencil, duco on paper. 22″ × 59⅜″.

Graphische Sammlung, Staatsgalerie, Stuttgart.
Copyright 2005 Pollack-Krasner Foundation/Artists Rights Society (ARS),
New York

5-27 MARGARET HONDA
Exchange (2003–2004).
Vinyl on Mylar, 50 elements. Dimensions variable.

Photo Cathy Carver/The Drawing Center, New York.

PAINTING

Suddenly I realized that each brushstroke is a decision. . . . In the end I realize that whatever meaning that picture has is the accumulated meaning of ten thousand brushstrokes, each one being decided as it was painted.

—Robert Motherwell

The line between drawing and painting is sometimes blurred. The art historian will speak of linear aspects in painting or painterly qualities in drawing. At times the materials used in the two media will overlap. **Painting** is generally defined as the application of pigment to a surface. Yet we have already seen the use of pigment in pastel drawings.

Paint can be applied to a number of surfaces. It has been used throughout history to decorate pottery, enhance sculpture, and embellish architecture. In this section we shall explain the composition of paint and explore painting in works created on two-dimensional supports.

Just dash something down if you see a blank canvas staring at you. . . . You do not know how paralyzing it is, that blank staring of the canvas which says to the painter: You do not know anything.

—Vincent van Gogh

PAINT

To most of us, paint is synonymous with color. The color in a paint derives from its pigment. The pigment in powdered form is mixed with a binding agent, or **vehicle,** and a solvent, or **medium,** to form **paint**—the liquid material that imparts color to a surface.

Pigments are available in a wide chromatic range. Their color is derived from chemicals and minerals found in plant and animal life, clay, soil, and sand.

Different vehicles are employed in different painting media. The main criterion for a successful vehicle is that it hold the pigments together. Lime plaster, wax, egg, oil, acrylic plastic, water, and gum arabic are commonly used vehicles. Unfortunately, most vehicles are subject to long-term problems such as cracking, yellowing, or discoloration.

The task of a medium is to provide fluency to the paint so that the color may be readily dispersed over the surface.

Water or turpentine is frequently used as a thinning agent for this purpose.

TYPES OF PAINTING

A variety of supports and tools have been used throughout the history of art to create paintings. We shall discuss the characteristics of several types of painting.

Fresco

Fresco is the art of painting on plaster. **Buon fresco,** or true fresco, is executed on damp, lime plaster; **fresco secco** is painting on dry plaster. In buon fresco, the pigments are mixed only with water, and the lime of the plaster wall acts as a binder. As the wall dries, the painted image on it becomes permanent. In fresco secco—a less popular and less

6-1 GIOTTO.
Lamentation (c. 1305).
Fresco. 7'7" × 7'9".
Scrovegni Chapel, Padua, Italy/Alinair/
Art Resource, New York.

Remember that a picture—before being a horse, a nude, or some sort of anecdote—
is essentially a flat surface covered with colors assembled in a certain order.

—Maurice Denis

permanent method—pigments are combined with a vehicle of glue that affixes the color to the dry wall.

Fresco painters encounter a number of problems. Because in true fresco the paint must be applied to fresh, damp plaster, the artist cannot bite off more than it is possible to chew—or paint—in one day. For this reason, large fresco paintings are composed of small sections, each of which has been painted in a day. The artist tries to arrange the sections so that the joints will not be obvious, but sometimes it is not possible to do so. In a fourteenth-century fresco painting by the Italian master Giotto (Fig. 6-1), these joints are clearly evident, particularly in the sky, where the artist was not able to complete the vast expanse of blue all at once. It is not surprising that sixteenth-century art historian Giorgio Vasari wrote that of all the methods painters employ, fresco painting "is the most masterly and beautiful, because it consists in doing in a single day that which, in other methods, may be retouched day after day, over the work already done."

Another problem: Although fresco paintings can be brilliant in color, some pigments will not form chemical bonds with lime. Thus, these pigments are not suitable for the medium. Artists in Giotto's era, for example, encountered a great deal of difficulty with the color blue. Such lime resistance limits the artist's palette and can make tonal transitions difficult.

Leonardo da Vinci, in his famous *The Last Supper* (Fig. 15-17), attempted to meet these nuisances head-on, only to suffer disastrous consequences. The experimental materials and methods he employed to achieve superior results were unsuccessful. He lived to see his masterpiece disintegrate beyond repair.

Despite these problems, fresco painting enjoyed immense popularity from prehistoric times until its full flowering in the Renaissance. Although it fell out of favor for several centuries thereafter, Mexican muralists revived the art of fresco after World War I.

Encaustic

One of the earliest methods of applying color to a surface was **encaustic.** It consists of pigment in a wax vehicle that has been heated to a liquid state. The ancient Egyptians and Greeks tinted their sculptures with encaustic to grant them

6-2 *Mummy Portrait of a Man* (Egypto-Roman, Faiyum, c. 160–179 CE).
Encaustic on wood. 14″ × 8″.
Albright-Knox Art Gallery, Buffalo, NY.
Charles Clifton Fund, 1938.

a lifelike appearance. The Romans applied encaustic to walls, using hot irons. Often, as in the Egyptian *Mummy Portrait of a Man* (Fig. 6-2) dating back to the second century CE, the medium was applied to small, portable wooden panels covered with cloth. As evidenced by the startling realism and freshness of the portrait, encaustic is an extremely durable medium whose colors remain vibrant and whose surface maintains a hard luster.

But encaustic is a difficult medium to manipulate: one must keep the molten wax at a constant temperature. For this reason, it has been used only by a handful of contemporary artists.

6-3 KAY WALKINGSTICK.
Solstice (1982).
Acrylic and wax on canvas. 48″ × 48″ × 3½″.
Collection of the artist.

Native American painter Kay Walkingstick derives a certain plasticity from her very different use of acrylic and wax on canvas (Fig. 6-3). In *Solstice,* two flattened arcs of sharply contrasting hues are about to merge in a viscous sea of mauve and purple. The canoelike image, although common to Native American symbolism, can also be viewed as an abstraction signifying the shifting of seasons from autumn to winter—a kind of quiet cosmological passage. Walkingstick builds her textural surface through successive layers of colored wax, gouging the field here and there with lines that reveal the palette of the lower layers. It is at once an image of power and of solitude.

Tempera

Tempera, like encaustic, was popular for centuries, but its traditional composition—ground pigments mixed with a vehicle of egg yolk or whole eggs thinned with water—is rarely used today. Tempera now describes a medium in which pigment can be mixed with an emulsion of milk, different types of glues or gums, and even the juices and saps of plants and trees. The use of tempera dates back to the Greeks and Romans. Tempera was the exclusive painting medium of artists during the Middle Ages. Not until the invention of oil paint in northern Europe in the 1300s did tempera fall out of favor.

Tempera offered many advantages. It was an extremely durable medium if applied to a properly prepared surface. Pure and brilliant colors were attainable. Colors did not become compromised by gradual oxidation. Also, the consistency and fluidity of the mixture allowed for a great deal of precision. Tempera, unlike oil paint, however, dries quickly and is difficult to rework. Also, unlike oils, it cannot provide subtle gradations of tone.

Tempera can be applied to wood or canvas panels, although the latter did not come into wide use until the 1500s. Both types of supports were prepared by covering the surface with a ground. The ground was generally a combination of powdered chalk or plaster and animal glue called **gesso.** The gesso ground provided a smooth, glistening white surface on which to apply color.

All that is desirable in the tempera medium can be found in Figure 6-4, the panel painting by the fifteenth-century Italian artist Gentile da Fabriano. Combined with the technique of **gilding**—the application of thinly hammered sheets of gold to the panel surface—the luminous reds and blues and pearly grays of the tempera paint provide a sumptuous display. The fine details of the ornate costumes testify to the precision made possible by **egg tempera.**

Several contemporary artists, such as the Swiss Photorealist painter Franz Gertsch, have also been enticed by the exactness and intricacies made possible by tempera. Suited to a methodical and painstaking approach to painting, this medium of the old masters yields unparalleled displays of contrasting textures and sharp-focused realism, as shown in Gertsch's large-scale portrait of *Silvia* (Fig. 6-5).

Oil

The transition from egg tempera to **oil paint** was gradual. For many years following the introduction of the oil medium, artists used it only to apply a finishing coat of glazes to an underpainting of tempera. **Glazing,** or the application of multiple layers of transparent films of paint to a surface, afforded subtle tonal variations and imparted a warm atmosphere not possible with tempera alone. Oil paints have been in wide use since the fifteenth century.

Oil paint consists of ground pigments combined with a linseed oil vehicle and turpentine medium or thinner. Oil paint is naturally slow in drying, but drying can be facilitated with various agents added to the basic mixture.

Oil painting's broad range of capabilities makes it a favorite among artists. It can be applied with any number of brushes or painting knives. Colors can be blended easily, offering a palette of almost limitless range. Slow drying facilitates the reworking of problem areas. When it is finely

6-4 GENTILE DA FABRIANO.
Adoration of the Magi (1423).
Tempera on wood panel. 9'10⅛" × 9'3".
Uffizi Gallery, Florence. Copyright Scala/Art Resource, New York.

6-5 FRANZ GERTSCH.
Silvia (1998).
Tempera on unprimed canvas. 9'6¼" × 9'2¼".
Copyright Museum Franzgertsch, Burgdorf, Switzerland.

A good painter is to paint two things, namely, man and the working of man's mind.

—Leonardo da Vinci

applied, oil paint can capture the most intricate detail. When it is broadly brushed, it can render diaphanous fields of pulsating color. Oil paint can be diluted to a barely tinted film to achieve subtle flesh tones, or it can be applied in thick impasto that physically constructs an image, as *Head of St. Matthew* (Fig. 6-6) by a follower of Rembrandt.

The first oil paintings were executed on wood panels, and then a gradual shift was made to canvas supports. Like wood panels, the canvas surface is covered with a gesso ground prior to painting. The pliability of fabric stretched over a wooden framework renders the working surface more receptive to the pressure of the artist's implement. The light

6-6 FOLLOWER OF REMBRANDT VAN RIJN. *Head of St. Matthew* (c. 1661). Oil on wood. 9⅞″ × 7¾″.
National Gallery of Art, Washington, DC. Widener Collection.

The *George Washington*s of Stuart and Lichtenstein

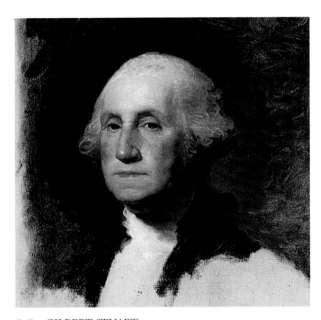

6-7 GILBERT STUART.
George Washington (1796) (detail).
Oil on canvas. 39⅝″ × 34½″ (entire work).

The National Portrait Gallery, Smithsonian Institution, Washington, DC.
Copyright National Portrait Gallery, Smithsonian Institution/Art Resource,
New York.

The versatility of oil paint is seen in portraits of George Washington by two American artists who worked centuries apart. Gilbert Stuart's familiar eighteenth-century portrait (Fig. 6-7) provides us with our stereotypical image of Washington. The work was left unfinished; much of the composition still reveals the reflective gesso ground. How did Stuart create a realistic likeness with his brushwork and modeling? The illusion of three-dimensionality is provided by the graceful play of light across the surfaces of Washington's face. Some features are sharply defined, others cast into shadow. Although this image is second nature to us, we can still notice the sensitivity with which Stuart portrayed his famous sitter. What do the delicate treatment of the pensive eyes and the firm outline of the determined jaw tell us about the personality traits of the wise and aging leader?

Roy Lichtenstein's contemporary portrait (Fig. 6-8), by contrast, is an image of glamour and success. What gives us this impression? A younger, debonair Washington is presented as if on a campaign poster, or as a comic-strip hero

with a chiseled profile akin to that of Dick Tracy. The eyes are alert and enthralling; the chin is jaunty and confident. How does Lichtenstein capitalize on oil paint's clarity and precision? Sharp contrasts, crisp lines, and dot patterning such as that found in comic strips deprive the painting of any subtlety or atmosphere. The rich modeling that imparted a sense of roundness to Stuart's figure is replaced by stylized shadows that sit flatly on the canvas. Lichtenstein forsakes the psychological portrait in favor of billboard advertising. This is a Washington who has suffered visual saturation by the contemporary media; the physical characteristics tell us nothing of the human being to whom they refer. ∎

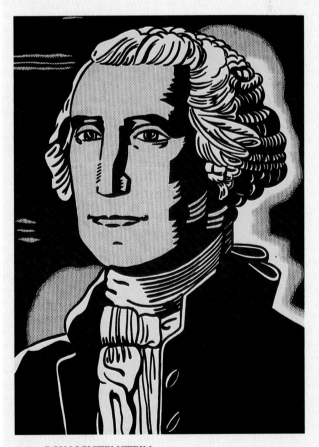

6-8 ROY LICHTENSTEIN.
George Washington (1962).
Oil on canvas. 51″ × 38″.

Copyright Roy Lichtenstein.

6-9 ED PASCHKE.
Anesthesio (1987).
Oil on linen. 68″ × 80″.
Phyllis Kind Gallery, Chicago and New York. Courtesy of the artist.

ing, and, as it is water soluble, it requires no flammable substances for use or cleanup.

One of the few effects of oil paint that cannot be duplicated in acrylic is delicate nuance of colors. Like oil, however, acrylic paint can be used thinly or thickly; it can be applied in transparent films or opaque impastos, as in Helen Oji's *Mount St. Helen's* (Fig. 6-10). The artist fills the shaped canvas with an explosion of color and texture that simulates the unbridled power of one of the world's few active volcanoes. This image, which gave rise to a whole series on these natural wonders, serves, from another perspective, as "textile" ornamentation for a Japanese kimono. Canvases shaped in this garment design first preoccupied Oji in an earlier series, and here the reference to her Japanese heritage (her parents were interned during World War II, while she grew up in California) and the volcano image may symbolize a convergence of cultures from both sides of the Pacific.

weight of canvas also allows for larger compositions than were possible on wooden panels.

Contemporary artist Ed Paschke's oil painting of Abraham Lincoln (Fig. 6-9) resurrects a hackneyed image by traversing it with abstract patches of neonlike color. The effect is not unlike that attained by a teenager who defaces a poster of a presidential candidate with spray paint, or it could almost be a face on a video screen with electronic color bleeding through irrelevantly on the image. In either case, environmental "noise" obscures the target. Ironically, the need to work to see through the obfuscating patches of color renders the image of the president more tantalizing.

Acrylic

Acrylic paint offers many of the advantages of oil paint, but "without the mess." Acrylic paint is a mixture of pigment and a plastic vehicle that can be thinned (and washed off brushes and hands) with water. Unlike linseed oil, the synthetic resin of the binder dries colorless and does not gradually compromise the brilliance of the colors. Also, unlike oil paint, acrylic can be used on a variety of surfaces that need no special preparation. Acrylic paint is flexible and fast dry-

6-10 HELEN OJI.
Mount St. Helen's (1980).
Acrylic, Rhoplex, glitter on paper. 60″ × 72″.
Collection of Home Insurance Company, New York.

A C L O S E R L O O K

Superheroes: East Meets West

The acrylic paintings of Japanese American Roger Shimomura blend Western Pop Art with traditional Japanese imagery as found in *ukiyo-e* prints. As a child during World War II, Shimomura was interned with his parents and grandparents in Idaho. At the same time, ironically, his uncle served with the valiant 442nd division of Japanese Americans. Shimomura remembers statements made by white Americans about Japanese Americans during this deeply disturbing period. For example, Idaho's attorney general remarked, "We want to keep this a white man's country."

Shimomura's *Untitled* (Fig. 6-11) is at first glance an amusing clash of American and Japanese pop cultures. American cartoon characters, Donald Duck, Pinocchio, Dick Tracy, and the combination Batman-Superman, vie for space on the crowded canvas with Japanese Samurai warriors and a contemporary Japanese. The battle of East and West imagery may reflect the tensions within the artist regarding his ancestral roots and his chosen country. This is succinctly symbolized in the inclusion of Shimomura's self-portrait-as-Statue-of-Liberty in the extreme upper left. In this painting, conflicts between people and cultures are safely if not satirically played out among their stereotypes and myths. ∎

6-11 ROGER SHIMOMURA.
Untitled (1984).
Acrylic on canvas.
60″ × 72″.
Courtesy of the artist and Bernice
Steinbaum Gallery, Miami.

Watercolor

The term **watercolor** originally defined any painting medium that employed water as a solvent. Thus, fresco and egg tempera have been called watercolor processes. But today watercolor refers to a specific technique called **aquarelle,** in which transparent films of paint are applied to a white, absorbent surface. Contemporary watercolors are composed of pigments and a gum arabic vehicle, thinned, of course, with a medium of water.

Variations of the watercolor medium have been employed for centuries. Ancient Egyptian artists used a form of watercolor in their paintings. Watercolor was also used extensively for manuscript illumination during the Middle Ages, as we shall see in Chapter 14. **Gouache,** or watercolor mixed with a high concentration of vehicle and an opaque ingredient such as chalk, was the principle painting medium during the Byzantine and Romanesque eras of Christian art. This variation has enjoyed popularity across time and a myriad of styles and is used to great effect by many contemporary artists, such as David Hockney (Fig. 6-12).

Transparent watercolor, however, did not appear until the fifteenth century. It is a difficult medium to manipulate, despite its simple components. Tints are achieved by diluting the colors with various quantities of water. White, then, does not exist; white must be derived by allowing the white of the paper to "shine" through the color of the composition or by leaving areas of the paper exposed. To achieve the latter effect, all areas of whiteness must be mapped out with precision before the first stroke of color is applied.

With oil paint and acrylic, the artist sometimes overpaints areas of the canvas in order to make corrections or to blend colors. With transparent watercolors, overpainting obscures the underlying layers of color. For this reason, corrections are virtually impossible, so the artist must have the ability to plan ahead, as well as a sure hand and a stout heart. When used skillfully, watercolor has an unparalleled freshness and delicacy. The colors are pure and brilliant, and the range of effects surprisingly broad.

Contemporary painter Ralph Goings—one of the driving forces behind and consistent contributors to the school of Photorealism—uses transparent watercolor ingeniously. His virtuoso handling of the medium can be seen in works such as *Rock Ola* (Fig. 6-13), which belie the difficulties of the medium. Confident strokes of color precisely define the gleaming "retro" chrome surfaces of a diner interior—the classic backdrop for the countertop jukebox and standard "still life with ketchup bottle and ashtray." Washes are kept

6-12 DAVID HOCKNEY. *Punchinello with Block,* for Ravel's *L'Enfant et les Sortilèges* (1980). Gouache on paper. 14″ × 17″.
Copyright David Hockney.

6-13 RALPH GOINGS.
Rock Ola (1992).
Watercolor on paper. 14″ × 20¾″.
Courtesy O. K. Harris Works of Art.

6-14 EMIL NOLDE.
Still Life, Tulips (c. 1930).
Watercolor on paper. 18½″ × 13½″.
Collection of the North Carolina Museum of Art, Raleigh.
Bequest of W. R. Valentiner.

to a minimum, as the painting emphasizes form over color, line over tonal patterns.

The broader appeal of watercolor, however, is not to be found in its capability of rendering meticulous detail. When the medium came into wide use during the sixteenth century, it was seen as having other, very different advantages. The fluidity of watercolor was conducive to rapid sketches and preparatory studies. Simple materials allowed for portability. Artists were able to cart their materials to any location, indoors or outdoors, and to register spontaneously their impressions of a host of subjects.

Of course, watercolor is also used for paintings that stand as completed statements. Artists such as the German Expressionist Emil Nolde (Fig. 6-14) were enticed by the transparency of tinted washes. Such washes permitted a delicate fusion of colors. As with the drawing medium of brush and wash, the effect is atmospheric. The edges of the forms are softened; they seem to diffuse into one another or the surrounding field. Unlike Dürer, who used watercolor in a descriptive, linear manner, Nolde creates his explosions of blossoms through delicately balanced patches of bold color and diaphanous washes. The composition is brightened by the white of the paper, which is brought forward to create forms as assertive as those in color.

Spray Paint

One can consider that spray painting has had a rather long history. The subtle coloration marking different species of animals on the walls of Paleolithic caves was probably achieved by blowing pigments onto a surface through hollowed-out reeds. Why are they there: decoration? ritual? history? Oddly enough, these questions can be asked of the contemporary graffiti artist and the thousands upon thousands of writings that range in definition from "tags" to "master" works. Why do they do it? Is it art? urban ritual? Will it speak in history to trials of inner-city living?

Everyone has seen graffiti, but the complexity of the work and the social atmosphere from which it is derived may not be common knowledge. Stylized signatures, or

Painting is self-discovery. Every good artist paints what he is.

—Jackson Pollock

6-15 CRASH (JOHN MATOS).
Arcadia Revisited (1988).
Spray paint on canvas. 96¼″ × 68″.
Courtesy of the artist.

"tags," can be seen everywhere; it seems as though no urban surface—interior or exterior—is immune. Some are more likely to call this defacing public property than creating works of art, but how do we describe the elaborate urban "landscapes" that might cover the outside of an entire subway car, filling the space with a masterful composition of shapes, lines, textures, and colors? On the street, they are called masterworks, and their artists are indeed legendary.

Some graffiti writers have "ascended" to the art **gallery** scene, exchanging their steel "canvases" for some of fabric and their high-speed exhibition spaces for highbrow gallery

walls. One such artist, Crash (or John Matos), created a parody of his own subway style in a complex canvas work called *Arcadia Revisited* (Fig. 6-15). All the tools and techniques of his trade—commercial cans of spray paint, the Benday dots of comic-strip fame, the sharp lines of the tag writer's logos, the diffuse spray technique that adds dimensionality to an array of otherwise flat objects—are used to describe a violent clash of cultural icons that are fragmented, superimposed, and barely contained within the confines of the canvas.

MIXED MEDIA

Contemporary painters have in many cases combined traditional painting techniques with other materials, or they have painted on nontraditional supports, stretching the definition of what has usually been considered painting. For example, in *The Bed* (Fig. 20-14), Pop artist Robert Rauschenberg splashed and brushed paint on a quilt and pillow, which he then hung on a wall like a canvas work and labeled a "combine painting." The Synthetic Cubists of the early twentieth century, Picasso and Braque, were the first to incorporate pieces of newsprint, wallpaper, labels from wine bottles, and oilcloth into their paintings. These works were called *papiers collés* and have come to be called **collages.**

The base media for Howardena Pindell's *Autobiography: Water / Ancestors, Middle Passage / Family Ghosts* (Fig. 6-16) are tempera and acrylic, but the work, on sewn canvas, also incorporates an array of techniques and substances—markers, oil stick, paper, photo-transfer, and vinyl tape. The detail achieved is quite remarkable. The artist seems to float in a shimmering pool of shallow water, while all around her images and objects of memory seem to enter and exit her consciousness. Included among them are the prominent white shape of an African slave ship, a reference to Pindell's African ancestry, and the whitened face of the artist's portrait that may have been influenced by Michael Jackson's "Thriller" makeup. The work resembles as much a weaving as a painting, further reflecting the tapestry-like nature of human recollection.

Miriam Schapiro is best known for her paint and fabric constructions, which she has labeled "femmage," to express what she sees as their unification of feminine imagery and materials with the medium of collage. In *Maid of Honour* (Fig. 6-17), Schapiro combines bits of intricately patterned fabric with acrylic pigments on a traditional canvas support

to construct a highly decorative garment that is presented as a work of art. The painting is a celebration of women's experiences with sewing, quilting, needlework, and decoration.

The two-dimensional media we have discussed in Chapters 5 and 6, drawing and painting, create unique works whose availability to the general public is usually limited to photographic renditions in books such as this. Even the intrepid museum goer usually visits only a small number of collections. So let us now turn our attention to the two-dimensional medium that has allowed millions of people to own original works by masters—printmaking.

6-17 MIRIAM SCHAPIRO.
Maid of Honour (1984).
Acrylic and fabric on canvas. 60″ × 50″.
Collection of Lois Fichner-Rathus.

6-16 HOWARDENA PINDELL.
Autobiography: Water / Ancestors, Middle Passage / Family Ghosts (1988).
Acrylic, tempera, cattle markers, oil stick, paper, polymer photo-transfer, and vinyl tape on sewn canvas. 118″ × 71″.
Collection Wadsworth Atheneum, Hartford, CT. Ella Gallup Sumner and Mary Catlin Sumner Collection.

PRINTMAKING

In comparison with painting and sculpture, engraving is a cosmopolitan art,
the immediate inter-relation of different countries being facilitated
by the portable nature of its creations.

—Arthur M. Hind

The value of drawings and paintings lies, in part, in their uniqueness. Hours, weeks, sometimes years are expended in the creation of these one-of-a-kind works. Printmaking permits the reproduction of these coveted works as well as the production of multiple copies of original prints. Printmaking is an important artistic medium for at least two reasons. First, it allows people to study great works of art from a distance. Second, because prints are less expensive than unique works by the same artist, they make it possible for the general public, not just the wealthy few, to own original works. With prints, art has become accessible. Like some drawings, however, prints not only serve a functional purpose but may be considered works of art in themselves.

METHODS OF PRINTMAKING

The printmaking process begins with a design or image made in or on a surface by hitting or pressing with a tool. The image is then transferred to paper or a similar material. The transferred image is called the **print.** The working surface, or **matrix,** varies according to the printmaking technique. Matrices include wood blocks, metal plates, stone slabs, and silkscreens. There are special tools for working with each kind of matrix, but the images in printmaking are usually rendered in ink.

Printmaking processes are divided into four major categories: relief, intaglio, lithography, and serigraphy (Fig. 7-1). We shall examine a variety of techniques within each of them. Finally, we will consider the monotype and the combining of printmaking media with other media.

RELIEF

In **relief printing,** the matrix is carved with knives or gouges. Areas that are not meant to be printed are cut below the surface of the matrix (Fig. 7-1A), and areas that form the image and are meant to be printed are left raised. Ink is then applied to the raised surfaces, often from a roller. The matrix is pressed against a sheet of paper, and the image is transferred. The transferred image is the print. Relief printing includes woodcut and wood engraving.

Woodcut

Woodcut is the oldest form of printmaking. The ancient Chinese stamped patterns onto textiles and paper using carved wood blocks. The Romans used woodcuts to stamp symbols or letters on surfaces for purposes of identification. During the 1400s in Europe, woodcuts provided multiple copies of religious images for worshipers. After the invention of the printing press, woodcut assumed an important role in book illustration.

Woodcuts are made by cutting along the grain of the flat surface of a wooden board with a knife. Different types of wood and different gouging tools yield various effects.

Wood Engraving

The technique of **wood engraving** and its effects differ significantly from those of woodcuts. Whereas in woodcuts the flat surface of boards is used, in wood engraving many

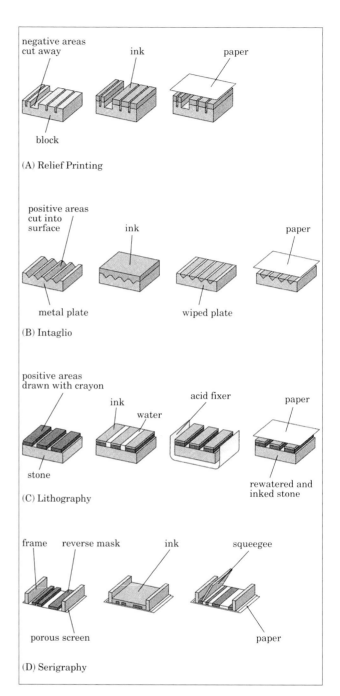

7-1 Printmaking technologies.

thin layers of wood are **laminated.** Then the ends of these sections are planed flat, yielding a hard, nondirectional surface. In contrast to the softer matrix used for the woodcut, the matrix for the wood engraving makes it relatively easy to work lines in varying directions. These lines are **incised** or

Hiroshige's *Rain Shower on Ohashi Bridge* with Xiaomo's *Family by the Lotus Pond*

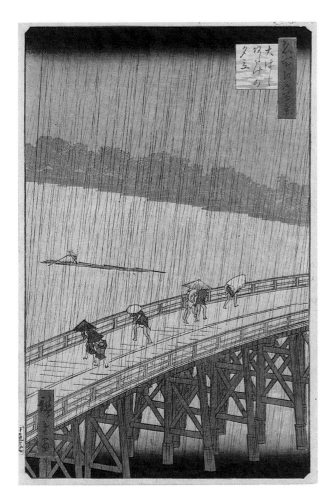

7-2 ANDO HIROSHIGE.
Rain Shower on Ohashi Bridge (1857).
Color woodblock on paper. 13⅞″ × 9⅛″.
The Cleveland Museum of Art. Gift of J. J. Wade.

vide a delicate counterpoint to bold shapes and broad areas of color and create the illusion of a drawing.

The meticulous process by which Hiroshige achieved his sharply defined images is used to a very different effect in Zhao Xiaomo's *Family by the Lotus Pond* (Fig. 7-3). This contemporary Chinese printmaker uses a range of woodblock techniques to create complex, energetic compositions that often simulate oil paintings. Inspired by Chinese peasant paintings, as they are not bound by "academic rules," Xiaomo creates mosaic-like surfaces with bold, two-dimensional patterns.

How does the visual impact of these two works differ? Consider the use of line, shape, and color. ■

7-3 ZHAO XIAOMO.
Family by the Lotus Pond (1998).
Multiblock woodcut printed with water-soluble ink.
42.7 cm × 41.7 cm.
Art Institute of Chicago.

Ando Hiroshige, a nineteenth-century Japanese artist, achieved the finest detail in his works by choosing a close-grained wood and by tightly controlling the movement of his carving tools. Clean-cut, uniform lines define the steady rain and the individuals who tread huddled against the downpour across a wooden footbridge (Fig. 7-2). These fine lines pro-

7–4 Burin.

engraved with tools such as a **burin** or **graver** (Fig. 7-4) instead of being cut with knives and gouges. The lines can be extremely fine and are often used in close alignment to give the illusion of tonal gradations. This process was used to illustrate newspapers, such as *Harper's Weekly,* during the nineteenth century.

The razor-sharp tips of engraving implements and the hardness of the end-grain blocks make possible the exacting precision found in wood engravings such as that by Paul Landacre (Fig. 7-5), a well-known twentieth-century American printmaker. Tight, threadlike, parallel, and cross-hatched lines compose the tonal areas that define the form. The rhythmic, flowing lines of the seedling's unfurling leaves contrast dramatically with the fine, prickly lines that emanate like rays from the young corn plant. The print is a display of technical prowess in a most demanding and painstaking medium.

INTAGLIO

The popularity of relief printing declined with the introduction of the **intaglio** process. Intaglio prints are created by using metal plates into which lines have been incised. The plates are covered with ink, which is forced into the linear depressions, and then the surface is carefully wiped. The cut depressions retain the ink, whereas the flat surfaces are clean. Paper is laid atop the plate, and then paper and plate are passed through a printing press, forcing the paper into the incised lines to pick up the ink, thereby accepting the image. In a reversal of the relief process, then, intaglio prints are derived from designs or images that lie *below* the surface of the matrix (Fig. 7-1B).

7–5 PAUL LANDACRE.
Growing Corn (1940).
Wood engraving. $8\frac{1}{2}'' \times 4\frac{1}{4}''$.
Library of Congress, Washington, DC.

Intaglio printing encompasses many different media, the most common of which are engraving, drypoint, etching, and mezzotint and aquatint. Some artists have used these techniques recently in interesting variations or combinations and have pioneered approaches using modern equipment such as the camera and computer.

Engraving

Although **engraving** has been used to decorate metal surfaces such as bronze mirrors or gold and silver drinking vessels since ancient times, the earliest engravings printed on paper did not appear until the fifteenth century. In engraving, the artist creates clean-cut lines on a plate of copper, zinc, or steel, forcing the sharpened point of a burin across the surface with the heel of the hand. Because the lines are transferred to paper under very high pressure, they not only reveal the ink from the grooves but have a ridgelike texture themselves that can be felt by running a finger across the print.

An early, famous engraving came from the hand of the fifteenth-century Italian painter Antonio Pollaiuolo (Fig. 7-6). Deep lines that hold a greater amount of ink define the contours of the ten fighting figures. As Landacre did, Pollaiuolo used parallel groupings of thinner and thus lighter lines to render the tonal gradations that define the exaggerated musculature. The detail of the print is described with the utmost precision, revealing the artist's painstaking mastery of the burin.

Drypoint

Drypoint is engraving with a simple twist. In drypoint, a needle is dragged across the surface, and a metal burr, or rough edge, is left in its wake to one side of the furrow. The burr retains particles of ink, creating a softened rather than crisp line when printed. The burr sits above the surface of the matrix and therefore is fragile. After many printings, it will break down, resulting in a line that simply looks engraved.

7-6 ANTONIO POLLAIUOLO.
Battle of Ten Naked Men (c. 1465–1470).
Engraving. 15½″ × 23³⁄₁₆″.

The Metropolitan Museum of Art, New York. Purchase, Joseph Pulitzer Bequest, 1917 (17.50.99). Photograph, all rights reserved, The Metropolitan Museum of Art.

7-7 REMBRANDT VAN RIJN.
Christ Crucified between the Two Thieves (1653).
Drypoint, 4th state. 15″ × 17½″.
Courtesy Museum of Fine Arts, Boston. Katherine E. Bullard Fund
in memory of Frances Bullard and bequest of Mrs. Russell W. Baker.

The characteristic velvety appearance of drypoint lines is seen in Rembrandt's *Christ Crucified between the Two Thieves* (Fig. 7-7). The more distinct lines were rendered with a burin, whereas the softer lines were created with a drypoint needle. Rembrandt used the blurriness of the drypoint line to enhance the sense of chaos attending the Crucifixion and the darkness of the encroaching storm. Lines fall like black curtains enshrouding the crowd, and rays of bright light illuminate the figure of Jesus and splash down onto the spectators.

Etching

Although they are both intaglio processes, **etching** differs from engraving in the way the lines are cut into the matrix. With engraving, the depth of the line corresponds to the amount of force used to push or draw an implement over the surface. With etching, minimal pressure is exerted to determine the depth of line. A chemical process does the work.

In etching, the metal plate is covered with a liquid, acid-resistant ground consisting of wax or resin. When the

What I am after, above all, is expression.

—Henri Matisse

ground has hardened, the image is drawn upon it with a fine needle. Little pressure is exerted to expose the ground; the plate itself is not scratched. When the drawing is completed, the matrix is slipped into an acid bath, which immediately begins to eat away, or etch, the exposed areas of the plate. This etching process yields the sunken line that holds the ink. The artist leaves the plate in the acid solution just long enough to achieve the desired depth of line. If a variety of tones is desired, the artist may pull the plate out of the acid solution after a while, cover lines of sufficient depth with the acid-resistant ground, and replace the plate in the bath for further etching of the remaining exposed lines. The longer

7-9 GIOVANNI DOMENICO TIEPOLO.
A Negro (1770).
Etching, 2nd state.
Courtesy Museum of Fine Arts, Boston. George R. Nutter Fund.

the plate remains in the acid solution, the deeper the etching. Deeper crevices hold more ink, and for this reason they print darker lines.

Etching is a versatile medium, capable of many types of lines and effects. The modern French painter Henri Matisse used but a few dozen uniformly etched lines to describe the essential features of a woman, *Loulou Distracted* (Fig. 7-8). The extraordinarily simple yet complete image attests to the delicacy that can be achieved with etching.

Whereas Matisse's figure takes shape through the careful placement of line, the subject of the etching by Giovanni Domenico Tiepolo (who was the son of Giovanni Battista Tiepolo) exists by virtue of textural and tonal contrasts (Fig. 7-9). This eighteenth-century Italian artist used a variety of wavy and curving lines to differentiate skin from cloth, fur from hair, figure from ground. Lines are spaced to provide a range of tones from the sharp white of the paper to the rich black of the man's clothing. The overall texture creates a hazy atmosphere that caresses the pensive figure.

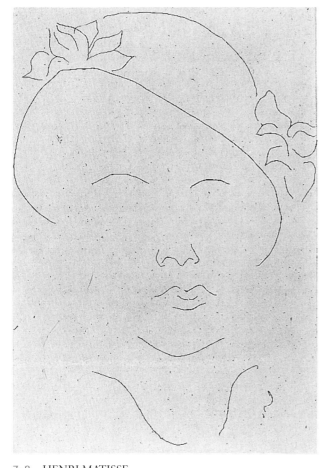

7-8 HENRI MATISSE.
Loulou Distracted (1914).
Etching, printed in black. $7^{1}/_{16}'' \times 5''$.
The Museum of Modern Art, New York. Purchase. Copyright 2003 Succession H. Matisse, Paris/Artists Rights Society (ARS), New York/ Art Resource, New York.

Hung Liu: Chinese Traditions Unbound

In many ways, Hung Liu epitomizes the concerns and preoccupations of the Chinese artist whose life experiences during that country's Cultural Revolution have shaped their art, indeed their very existence. In 1984, Hung Liu arrived in the United States, in her words, with her "Five-thousand-year-old culture on my back. Late-twentieth-century world in my face. . . . My Alien number is 28333359." For four years in her home country, she was forced to work in the fields. In her chosen country, she is now a professor at Mills College and has had one-woman shows in New York, San Francisco, and Texas. Her art is one that focuses on what she has called "the peculiar ironies which result when ancient Chinese images are 'reprocessed' within contemporary Western materials, processes, and modes of display."

Figure 7-10 shows an untitled mixed-media print, whose main image consists of a photo-etching onto which are affixed small rectangular wooden blocks—mahjong pieces—bearing the "high-fashion" portraits of Chinese women. The inspiration for this print, and full oil paintings on the same theme, came from a series of photographs of Chinese prostitutes from the early 1900s that Hung Liu discovered on a recent return trip to China. When the Communist revolution took hold and all able-bodied individuals were forced into labor, these women were forced into prostitution because the traditions of oppression that led to the practice of binding their feet made them unfit for physical toil. They could barely walk.

Hung Liu feels the need to make known the pain, suffering, and degradation of generations of women before her:

> *Although I do not have bound feet, the invisible spiritual burdens fall heavy on me. . . . I communicate with the characters in my paintings, prostitutes—these completely subjugated people—with reverence, sympathy, and awe. They had no real names. Probably no children. I want to make up stories for them. Who were they? Did they leave any trace in history?*

In Hung Liu's work we come to understand a piece of history. We are challenged to reflect, as she does, upon human rights and freedoms, spiritual and physical oppression, political expression, and silenced voices. ∎

7-10 HUNG LIU.
Untitled (1992).
Photo-etching, mixed media.
33″ × 22½″.

Collection of Lois Fichner-Rathus.
Photo courtesy of Bernice Steinbaum Gallery,
Miami, FL.

The artist is a receptacle for the emotions that come from all over the place:
from the sky, from the earth, from a scrap of paper, from a passing shape, from a spider's web.

—Pablo Picasso

Mezzotint and Aquatint

Engraving, drypoint, and etching are essentially linear media. With these techniques, designs or images are created by cutting lines into a plate. The illusion of tonal gradations is achieved by altering the number and concentration of lines. Sometime in the mid-seventeenth century the Dutchman Ludwig von Siegen developed a technique whereby broad tonal areas could be achieved by nonlinear engraving, that is, engraving that does *not* depend on line. The medium was called **mezzotint,** from the Italian word meaning "half tint."

With mezzotint engraving, the entire metal plate is worked over with a curved, multitoothed implement called a **hatcher.** The hatcher is "rocked" back and forth over the surface, producing thousands of tiny pits that will hold ink. If printed at this point, the plate would yield an allover consistent, velvety black print. But the mezzotint engraver uses this evenly pitted surface as a point of departure. The artist creates an image by gradually scraping and burnishing the areas of the plate that are meant to be lighter. These areas will hold less ink and therefore will produce lighter tones.

The more persistent the scraping, the shallower the pits and the lighter the tone. A broad range of tones is achieved as the artist works from the rich black of the rocked surface to the highly polished pitless areas that will yield bright whites. Mezzotint is a rarely used, painstaking, and time-consuming procedure.

The subtle tonal gradations achieved by the mezzotint process can be duplicated with a much easier and quicker etching technique called **aquatint.** In aquatint a metal plate is evenly covered with a fine powder of acid-resistant resin. The plate is then heated, causing the resin to melt and adhere to the surface. As in line etching, the matrix is placed in an acid bath, where its uncovered surfaces are eaten away by the solution. The depth of tone is controlled by removing the plate from the acid and covering the pits that have been sufficiently etched.

Aquatint is often used in conjunction with line etching and is frequently manipulated to resemble tones produced by wash drawings. In *The Painter and His Model* (Fig. 7-11), Pablo Picasso brought the forms out of void space by defining their limits with dynamic patches of aquatint.

7-11 PABLO PICASSO.
The Painter and His Model
(1964).
Etching and aquatint.
12⅝″ × 18½″.

Courtesy Museum of Fine Arts, Boston. Lee M. Friedman Fund. Copyright 2003 Estate of Pablo Picasso/Artists Rights Society (ARS), New York.

These tonal areas resemble swaths of ink typical of wash drawings. Descriptive details of the figures are rendered in fine or ragged lines, etched to varying depths.

Other Etching Techniques

Different effects may also be achieved in etching by using grounds of different substances. **Soft-ground etching,** for example, employs a ground of softened wax and can be used to render the effects of crayon or pencil drawings. In a technique called **lift-ground,** the artist creates the illusion of a brush-and-ink drawing by actually brushing a solution of sugar and water onto a resin-coated plate. When the plate is slipped into the acid bath, the sugar dissolves, lifting the brushed image off the plate to expose the metal beneath. As in all etching media, these exposed areas accept the ink.

Given that the printing process implies the use of ink to produce an image, can we have prints without ink? The answer is yes—with the medium called **gauffrage,** or inkless intaglio. Joseph Albers, a twentieth-century American abstract artist, created *Solo V,* the geometric image shown in Figure 7-12, by etching the lines of his design to two different depths. Furrows in the plate appear as raised surfaces when printed. We seem to feel the image with our eyes, as light plays across the surface of the paper to enhance its legibility. Perceptual shifts occur as the viewer focuses now on the thick, now on the thin lines. In trying to puzzle out the logic of the form, the viewer soon discovers that Albers has offered a frustrating illustration of "impossible perspective."

LITHOGRAPHY

Lithography was invented at the dawn of the nineteenth century by the German playwright Aloys Senefelder. Unlike relief and intaglio printing, which rely on cuts in a matrix surface to produce an image, the lithography matrix is flat. Lithography is a surface or **planographic printing** process (Fig. 7-1C).

7-12　JOSEF ALBERS.
　　　Solo V (1958).
　　　Inkless intaglio. $6\frac{5}{8}'' \times 8\frac{5}{8}''$.
　　　The Brooklyn Museum, Brooklyn, NY. Augustus A. Healy Fund.
　　　Copyright 2003 The Josef and Anni Albers Foundation/Artists
　　　Rights Society (ARS), New York.

7-13　HENRI DE TOULOUSE-LAUTREC.
　　　The Seated Clowness (1896).
　　　Lithograph printed in five colors. $20\frac{1}{2}'' \times 16''$.
　　　The Metropolitan Museum of Art, New York. The Alfred Stieglitz
　　　Collection, 1949 (49.55.50). Photograph copyright 1984 The Metropolitan
　　　Museum of Art, New York.

7-14 KÄTHE KOLLWITZ.
The Mothers (1919).
Lithograph. 17³/₄″ × 23″.

Philadelphia Museum of Art. Given by Dr. and Mrs. William
Wolgin. Copyright 2003 Artists Rights Society (ARS),
New York/BG Bild-Kunst, Bonn.

In lithography, the artist draws an image with a greasy crayon directly on a flat stone slab. Bavarian limestone is considered the best material for the slab. Sometimes a specially sensitized metal plate is used, but a metal surface will not produce the often-desired grainy appearance in the print. Small particles of crayon adhere to the granular texture of the stone matrix. After the design is complete, a solution of nitric acid is applied as a fixative. The entire surface of the matrix is then dampened with water. The untouched areas of the surface accept the water, but the waxy crayon marks repel it.

A roller is then used to cover the stone with an oily ink. This ink adheres to the crayon drawing but repels the water. When paper is pressed to the stone surface, the ink on the crayon is transferred to the paper, revealing the image.

Different lithographic methods yield different results. Black crayon on grainy stone can look quite like the crayon drawing it is. Color lithographs employing brush techniques can be mistaken for paintings. Henri de Toulouse-Lautrec, a nineteenth-century French painter and lithographer, was well versed in the medium's flexibility, as is evident in his portrait of a woman clown (Fig. 7-13). The outlines of the figures were drawn with a crayon, and the broad areas of her tights and ruffled collar were brushed in with liquid crayon. The overall spray effect that dapples the surface of the print was probably achieved by his scraping a fingernail along a stiff brush loaded with the liquid substance.

The impact of Käthe Kollwitz's lithograph *The Mothers* (Fig. 7-14), which highlights the plight of lower-class German mothers left alone to fend for their children after World War I, could not be further removed from that of *The Seated Clowness.* The high contrast of the black and white and the coarse quality of the wax crayon yield a sense of desperation suggestive of a newspaper documentary photograph. All the imagery is thrust toward the picture plane, as in high relief. The harsh contours of protective shoulders, arms, and hands contrast with the more delicately rendered faces and heads of the children—all contributing to the poignancy of the work.

SERIGRAPHY

In **serigraphy**—also known as **silkscreen printing**—stencils are used to create the design or image. Unlike the case with other graphic processes, these images can be rendered in paint as well as ink.

One serigraphic process begins with a screen constructed of a piece of silk, nylon, or fine metal mesh stretched on a frame. A stencil with a cutout design is then affixed to the screen, and paper or canvas is placed beneath (Fig. 7-1D). The artist forces paint or ink through the open areas of the stencil with a flat, rubber-bladed implement called a **squeegee,** similar to those used in washing windows.

I think it was colors and weights and pushes and pulls and how to make a surface.

—Alex Katz, when asked what he learned from Matisse

7-15 ALEX KATZ.
Red Coat (1983).
Silkscreen, printed in color. 58″ × 29″.
The Museum of Modern Art, New York. John B. Turner Fund.
Copyright Alex Katz / Licensed by VAGA, New York.

The image on the support corresponds to the shape cut out of the stencil. Several stencils may be used to apply different colors to the same print.

Images can also be "painted" on a screen with use of a varnishlike substance that prevents paint or ink from passing through the mesh. This technique allows for more gestural images than cutout stencils would provide. Recently a serigraphic process called **photo silkscreen** has been developed; it allows the artist to create photographic images on a screen covered with a light-sensitive gel.

Serigraphy was first developed as a commercial medium and is still used as such to create anything from posters to labels on cans of food. The American Pop artist Andy Warhol raised the commercial aspects of serigraphy to the level of fine art in many of his silkscreen prints of the 1960s, such as *Four Marilyns* (see Fig. 1-9). These faithful renditions of celebrities and everyday items satirize the mass media's bombardment of the consumer with advertising. They also have their amusing side.

Alex Katz defines his forms with razor-sharp edges, fixing his subjects in an exact time and place by the details of their clothing and hairstyles. At the same time he transcends their temporal and spatial limits by simplifying and transforming their figures into something akin to icons. For example, the subject's intense red lips in his silkscreen *Red Coat* (Fig. 7-15) serve as a symbol of contemporary glamour. *Red Coat* looks something like a photograph transported into another medium. The individual shapes seem carved into a single plane like sawed jigsaw puzzle pieces. As in a photo, the edges of the silkscreen crop off parts of the image. The woman looks like a "supermodel," with her features exaggerated as they might be in a "cover girl" image.

MONOTYPE

Monotype is a printmaking process, but it overlaps the other two-dimensional media of drawing and painting. Like drawing and printmaking, monotype yields but a single image, and like them, therefore, it is a unique work of art.

In monotype, drawing or painting is created with oil paint or watercolor on a nonabsorbent surface of any material. Brushes are used, but sometimes fine detail is rendered by scratching paint off the plate with sharp implements. A

piece of paper is then laid on the surface, and the image is transferred by hand rubbing the back of the paper or passing the matrix and paper through a press. The result, as can be seen in a monotype by Edgar Degas (Fig. 7-16), has all the spontaneity of a drawing and the lushness of a painting.

In Chapter 8 we conclude our discussion of two-dimensional media with an examination of imaging—photography, film, video, and digital arts. In Chapters 9 and 10 we turn our attention to sculpture and architecture. In drawing, painting, and printmaking, artists have frequently attempted to create the illusion of three-dimensionality. We shall see some of the opportunities and problems that attend actual artistic expression in three dimensions.

IMAGING: PHOTOGRAPHY, FILM, VIDEO, AND DIGITAL ARTS

Look at the things around you, the immediate world around you. If you are alive,
it will mean something to you, and if you care enough about photography,
and if you know how to use it, you will want to photograph that meaning.

—Edward Weston

Technology has revolutionized the visual arts. For thousands of years one of the central goals of art was to imitate nature as exactly as possible. Today any one of us can point a camera at a person or an object and capture a realistic image. "Point-and-shoot" cameras no longer even require that we place the subject in proper focus or that we regulate the amount of light so as not to overexpose or underexpose the subject. Technology can do all these things for us.

Similarly, the art of the stage was once available only to those who lived in the great urban centers. Now and then a traveling troupe of actors might come by or local groups might put on a show of sorts, but most people had little or no idea of the ways in which drama, opera, dance, and other performing arts could affect their lives. The advent of motion pictures, or cinematography, suddenly brought a flood of new imagery into new local theaters, and a new form of communal activity was born. People from every station of life could flock to the movie theater on the week-

end. Over time, cinematography evolved into an art form independent of its beginnings as a mirror of the stage.

More recently, television has brought this imagery into the home, where people can watch everything from the performing arts to sporting events in privacy and from the multiple vantage points that several cameras, rather than a single set of eyes, can provide. Fine artists have also appropriated television—or, more precisely, the technology that makes television possible—to produce **video art.** Technology has also given rise to the computer as a creative video-mediated tool. With the aid of artificial intelligence, we can instantly view models of objects from all sides. We can be led to feel as though we are sweeping in on our solar system from the black reaches of space, then flying down to the surface of our planet and landing where the programmer would set us down. Millions of children spend hours playing video games, such as *Tetris,* which challenges them to rotate plummeting polygons to construct a solid wall, or *Tomb Raider,* which requires them to evade or blast a host of enemies before their computer-drawn heroes and heroines plunge into an abyss. Computer technology and computer-generated images have likewise been appropriated by fine artists in the creation of **digital art.** From illustrations of blue jeans that rocket through space, to snappy graphics that headline sporting events, to the web design that greets us every time we go online, computer-generated images punctuate our daily lives. DVDs, multimedia computers, and software that can blend or distort one shape or face into another are bringing a "virtual reality" into our lives that is in some ways more alluring than, well, "real reality."

In this chapter we discuss photography, film (cinematography), video, and digital arts. These media have given rise to unique possibilities for artistic expression.

PHOTOGRAPHY

Photography is a science and an art. The word *photography* is derived from Greek roots meaning "to write with light." The scientific aspects of photography concern the ways in which images of objects are made on a **photosensitive** surface, such as film, by light that passes through a **lens.** Chemical changes occur in the film so that the images are recorded. This much of the process—the creation of an objective image of the light that has passed through the lens—is mechanical.

8-1 ANSEL ADAMS.
Moon and Half Dome, Yosemite National Park, California (1960).
Copyright The Ansel Adams Publishing Rights Trust.

8-2 SHIRO SHIRAHATA.
Moon over Fuji (1972).
Universal Mountains Pictorial Museum, Echigo-Yuzawa, Japan

Photography records the gamut of feelings written on the human face, the beauty of the earth and skies that man has inherited and the wealth and confusion man has created.

—Edward Steichen

8-3 NASA.
Earthrise (1969).
Photo courtesy of NASA.

It would be grossly inaccurate, however, to think of the *art* of photography as mechanical. Photographers make artistic choices, from the most mundane to the most sophisticated. They decide which films and lenses to use, and which photographs they will retain or discard. They manipulate lighting conditions or printing processes to achieve dazzling or dreamy effects. Always, but always, they are in search of subjects—ordinary, extraordinary, universal, personal.

Photography is truly an art of the hand, head, and heart. The photographer must understand films and grasp skills related to using the camera and, in most cases, to developing **prints.** The photographer must also have the intellect and the passion to search for and to see what is important in things—what is beautiful, harmonious, universal, and worth recording.

Photography is a matter of selection and interpretation. Similar subjects seen through the eyes of different photographers will yield wildly different results. In Ansel Adams's *Moon and Half Dome, Yosemite National Park, California* (Fig. 8-1), majestic cliffs leap into a deep, cold sky. From our earthbound vantage point, the perfect order of the desolate, spherical moon contrasts with the coarseness of the living rock. Yet we know that its geometric polish is an illusion wrought by distance—the moon's surface is just as rough

and chaotic. Adams's composition is as much about shape and texture as it is a photograph of a feature of the California landscape. Distance and scale come sharply into focus: This is a story of humans dwarfed by nature and nature dwarfed by the stars.

In *Moon over Fuji* (Fig. 8-2), photographer Shiro Shirahata renders Japan's extinct volcano with the etherealness and serenity of a Japanese scroll painting. The blackened peak recedes, deathlike, into the slate blue surroundings while the most piercing of moons hovers above, seemingly full of life. The vast space that separates the upper and lower portions of the narrow photograph is pregnant with suggestions of the relationships between the heavens and the earth.

In the early nineteenth century, when photography was invented, the stuff of which *Earthrise* (Fig. 8-3) is made

would have been only fantasy. In this NASA photograph, taken during the first landing on the moon, the sharp lights and darks of the lunar landing module are silhouetted against the grays of the softly textured moon and balanced by the high-contrast values of black space and the arc of Earth above. The distance of the home planet lends it an abstract, geometric appearance. Out here, in space, the heavy landing module is very much closer and, despite its mechanical grotesqueness, it looks, frankly, much more like home.

Thus, the mood, stylistic inclinations, cultural biases, and technical preferences of the artist-photographer influence the nature of the creative product. As observers, we are as enriched by the diversity of this medium as by any other of the visual arts media.

Let us now consider two of the technical aspects of photography: cameras and films. Then we chronicle the history of photography.

Cameras

Cameras may look very different from one another and boast a variety of equipment, but they all possess certain basic features. As you can see in Figure 8-4, the camera is similar to the human eye. In both cases, light enters a narrow opening and is projected onto a photosensitive surface.

The amount of light that enters the eye is determined by the size of the *pupil,* which is an opening in the muscle called the *iris;* the size of the pupil responds automatically to the amount of light that strikes the eye. The amount of light that enters a camera is determined by the size of the open-

ing, or **aperture,** in the **shutter.** The aperture opening can be adjusted manually or, in advanced cameras, automatically. The size of the aperture, or opening, is the so-called **stop.** The smaller the f-stop, the larger the opening. The shutter can also be made to remain open to light for various amounts of time, ranging from a few thousandths of a second—in which case **candid** shots of fast action may be taken—to a second or more.

When the light enters the eye, the *lens* keeps it in focus by responding automatically to its distance from the object. The light is then projected onto the retina, which consists of cells that are sensitive to light and dark and to color. Nerves transmit visual sensations of objects from the retina to the brain.

In the same way, the camera lens focuses light onto a photosensitive surface such as **film.** A camera lens can be focused manually or automatically. Many photographers purposely take pictures that are out of focus, for their soft, blurred effects. **Telephoto lenses** magnify faraway objects and tend to collapse the spaces between distant objects that recede from us. **Wide-angle lenses** allow a broad view of objects within a confined area.

In their early days, cameras tended to be large and were placed on mounts. Today's cameras are usually small and held by hand. *The Steerage* (see Fig. 1-23) was shot with an early handheld camera. Many contemporary cameras contain angled mirrors that allow the photographer to see directly through the lens and thereby to be precisely aware of the image that is being projected onto the film.

Film

When an image is "shot," it is recorded on a device such as film or an electronic memory device such as a disk or "memory stick." Contemporary black-and-white films are very thin, yet they contain several layers, most of which form a protective coat and backing for the photosensitive layer. The "active" layer contains an **emulsion** of small particles of a photosensitive silver salt (usually silver halide) suspended in gelatin.

After the film is exposed to light and treated chemically, it becomes a **negative,** in which metallic silver is formed from the crystals of silver halide. In this negative, areas of dark and light are reversed. Because the negatives are transparent, light passes through them to a print surface, which becomes the final photograph, or print. Here the areas of light and dark are reversed again, now matching the shading of the original subject. Prints are also usually made significantly larger than the negative.

retina (photosensitive surface)

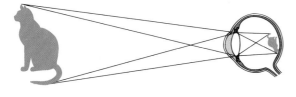

film (photosensitive surface)

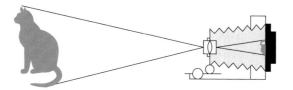

8-4 The camera and the human eye compared.

Black-and-white films differ in color sensitivity (the ability to show colors like red and green as different shades), in contrast (the tendency to show gradations of gray as well as black and white), in graininess (the textural quality, as reflective of the size of the silver halide crystals), and in speed (the amount of exposure time necessary to record an image). Photographers select films that will heighten the effects they seek to portray.

Color film is more complex than black-and-white film, but similar in principle. Color film also contains several layers, some of which are protective and provide backing. There are two basic kinds of color film: **color reversal film** and **color negative film.** Both types of color film contain three light-sensitive layers.

Prints are made directly from *color reversal film.* Therefore, each of the photosensitive layers corresponds to one of the primary colors in additive color mixtures: blue, green, or red. When color reversal film is exposed to light and treated chemically, mixtures of the primary colors emerge, yielding a full-color image of the photographic subject.

Negatives are made from *color negative film.* Therefore, each photosensitive layer corresponds to the complement of the primary color it represents. (Additive color mixtures and primary and complementary colors are explained in Chapter 2.)

Color films, like black-and-white films, differ in color sensitivity, contrast, graininess, and speed. But color films also differ in their appropriateness for natural (daylight) or artificial (indoor) lighting conditions.

Digital Photography

Today **digital photography** abounds. Digital cameras translate the visual images that pass through the lens into bits of digital information, which are recorded on an electronic storage device such as a disk, not on film. High-quality (translation: extremely expensive) digital cameras take photos whose **resolution**—that is, sharpness—rivals that of images recorded on film. The stored information can then be displayed on a computer monitor. Rather than have several prints made, the photographer can "back up" the information repeatedly. It can also be sent over the Internet in digital form. Printed images can also be scanned, of course, which coverts them into digital formats, and then stored on computer hard drives or sent over the Internet.

Digital photography has some advantages. One is that the photographer need not deal with film—loading and unloading it and having it developed. The images can be displayed immediately on a computer monitor or a screen built into the camera. Software then permits you to manipulate the images as desired. You can also print them out as you print out any other image or text.

The disadvantages are that (most) digital images do not have the sharpness of film images. They take a tremendous amount of storage space (several megabytes each!) on your hard drive. Also, your printer may not print images that approach the quality of film images, even if you have stored enough information to do so. To get "professional-quality" prints, you may have to invest in professional equipment or take your disk elsewhere, just as you have to take film to a lab or processor to be developed. But the price of this equipment is falling steadily, and it may soon be that nearly anyone will be able to afford digital equipment that rivals the resolution of more traditional photography.

History of Photography

The cameras and films described previously are rather recent inventions. Photography has a long and fascinating history. Although true photography does not appear much before the mid-nineteenth century, some of its principles can be traced back another 300 years, to the *camera obscura.*

The Camera Obscura

The **camera obscura**—literally, the covered-over or darkened room—was used by Renaissance artists to help them accurately portray depth, or perspective, on two-dimensional surfaces. The camera obscura could be a box, as shown in Figure 8-5, or an actual room with a small hole that admits light through one wall. The beam of light projects the outside scene upside down on a surface within the box. The

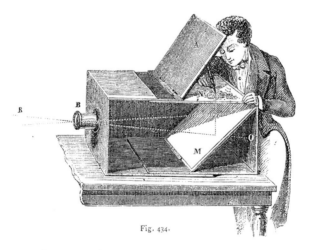

8–5 The camera obscura.
Illustration copyright Ann Ronan Picture Library, Oxfordshire, UK.

artist then simply traces the scene, as shown, to achieve a proper perspective—to truly imitate nature.

Development of Photosensitive Surfaces

The camera obscura could only temporarily focus an image on a surface while a person labored to copy it by tracing. The next developments in photography concerned the search for photosensitive surfaces that could permanently affix images. These developments came by bits and pieces.

In 1727 the German physicist Heinrich Schulze discovered that silver salts had light-sensitive qualities, but he never tried to record natural images. In 1802 Thomas Wedgwood, son of the well-known English potter, reported his discovery that paper soaked in silver nitrate did take on projected images as a chemical reaction to light. Unfortunately, the images were not permanent.

Heliography

In 1826 the Frenchman Joseph-Nicéphore Niepce invented **heliography. Bitumen,** or asphalt residue, was placed on a pewter plate to create a photosensitive surface. The bitumen was soluble in **lavender oil** if kept in the dark, but insoluble if struck by light. Niepce used a kind of camera obscura to expose the plate for several hours, and then he washed the plate in lavender oil. The pewter showed through where there had been little or no light, creating the image of the darker areas of the scene. The bitumen remained where the light had struck, however, leaving lighter values.

The Daguerreotype

The **daguerreotype** resulted from a partnership formed in 1829 between Niepce and another Frenchman, Louis-Jacques-Mandé Daguerre. The daguerreotype used a thin sheet of silver-plated copper. The plate was chemically treated, placed in a camera obscura, and exposed to a narrow beam of light. After exposure, the plate was treated chemically again.

Figure 8-6 shows the first successful daguerreotype, taken in 1837. Remarkably clear images could be recorded by this process. In this work, called *The Artist's Studio*, Daguerre, a landscape painter, sensitively assembled deeply textured objects and sculptures. The contrasting light and dark values help create an illusion of depth.

There were drawbacks to the daguerreotype. It had to be exposed from 5 to 40 minutes, requiring long sittings. The recorded image was reversed, left to right, and was so delicate that it had to be sealed behind glass to remain fixed. Also, the plate that was exposed to light became the actual

8-6　LOUIS-JACQUES-MANDÉ DAGUERRE.
The Artist's Studio (1837).
Société Française de Photographie, Paris.

daguerreotype. There was no negative, and consequently, copies could not be made. However, some refinements of the process did come rapidly. Within 10 years the exposure time had been reduced to about 30 to 60 seconds, and the process had become so inexpensive that families could purchase two portraits for a quarter. Daguerreotype studios opened all across Europe and the United States, and families began to collect the rigid, stylized pictures that now seem to reflect days gone by.

The Negative

The negative was invented in 1839 by British scientist William Henry Fox Talbot. Talbot found that sensitized paper, coated with emulsions, could be substituted for the copper plate of the daguerreotype. He would place an object, such as a sprig of a plant, on the paper and expose the arrangement to light. The paper was darkened by the exposure in all areas except those covered by the object. Translucent areas, allowing some passage of light, resulted in a range of grays. Talbot's first so-called photogenic drawings (Fig. 8-7), created by this process, seem eerie, though lyrically beautiful. The delicacy of the image underscores the impracticality of the process: How on earth would you "photograph" an elephant?

As with the daguerreotype, this process produced completed photographs in which the left and right of the image were reversed. In Talbot's photogenic drawings, the light and dark values of the image were also inverted. Talbot improved

on his early experiments with his development of the **contact print.** He placed the negative in contact with a second sheet of sensitized paper and exposed them both to light. The resultant print was a "positive," with left and right, and light and dark, again as in the original subject. Many prints could be made from the negative. Unfortunately, the prints were not as sharp as daguerreotypes, because they incorporated the texture of the paper on which they were captured. Subsequent advances led to methods in which pictures with the clarity of daguerreotypes could be printed from black-and-white as well as color negatives.

Photography improved rapidly for the next 50 or 60 years—faster emulsions, glass-plate negatives, better camera lenses—and photographs became more and more available to the general public. The next major step in the history of photography came with the introduction by Louis Lumière of the "autochrome" color process in 1907. Autochromes were glass plates coated with three layers of dyed potato starch that served as color filters. A layer of silver bro-

8-8 LOUIS LUMIÈRE.
Young Lady with an Umbrella (1906–1910).
Autochrome.
Société Lumière, Paris.

8-7 WILLIAM HENRY FOX TALBOT.
Botanical Specimen (1839).
Photogenic drawing.
Royal Photographic Society, Bath, England. Heritage Image Partnership (HIP), heritage-images.com.

mide emulsion covered the starch. When the autochrome was developed, it yielded a positive color transparency. Lumière's autochrome photographs, such as *Young Lady with an Umbrella* (Fig. 8-8), are akin to paintings by Postimpressionist artist Georges Seurat (see Fig. 18-25), an avid student of color theory, as well as to works by other photographers in the pictorial style. Autochrome technology was not replaced until 1932, when Kodak began to produce color film that applied the same principles to more advanced materials.

Portraits

By the 1850s, photographic technology and the demands of a growing middle class in the wake of the American and French revolutions came together to create a burgeoning business in portrait photography. Having a likeness of one-self was formerly reserved for the wealthy, who could afford to commission painters. Photography became the democratic equalizer. The rich, the famous, and average bourgeois citizens could now become memorable, could now make their presence known long after their flesh had rejoined the elements from which it was composed.

Photographic studios spread like wildfire, and many photographers, such as Julia Margaret Cameron and Gaspard Felix Tournachon—called "Nadar"—vied for famous clientele. Cameron's impressive portfolio included portraits

8-9 NADAR.
Sarah Bernhardt (1859).
Bibliothèque Nationale, Paris. Copyright Photos 12, Paris.

of Charles Dickens; Alfred, Lord Tennyson; and Henry Wadsworth Longfellow. Figure 8-9 is Nadar's 1859 portrait of the actress Sarah Bernhardt. It was printed from a glass plate, which could be used several times to create sharp copies. Early portrait photographers such as Nadar imitated both nature and the arts, using costumes and props that recall Romantic paintings or sculpted busts caressed by flowing drapery. The photograph is soft and smoothly textured, with middle-range values predominating; Bernhardt is sensitively portrayed—pensive and brooding, but not downcast.

Photojournalism

Prior to the nineteenth century there were few illustrations in newspapers and magazines. Those that did appear were usually in the form of engravings or drawings. Photography revolutionized the capacity of the news media to bring realistic representations of important events before the eyes of the public. Pioneers such as Mathew Brady and Alexander Gardner first used the camera to record major historical events such as the U.S. Civil War. The photographers and their crews trudged down the roads alongside the soldiers, horses drawing their equipment behind them in wagons referred to by the soldiers as "Whatsits."

Equipment available to Brady and Gardner did not allow them to capture candid scenes, so there is no direct record of the bloody to and fro of the battle lines, no photographic record of each lunge and parry. Instead, they brought home photographs of officers and of life in the camps along the lines. Although battle scenes themselves would not hold still for Gardner's cameras, the litter of death and devastation caused by the war and pictured in Gardner's *Home of a Rebel Sharpshooter, Gettysburg* (Fig. 8-10) most certainly did. Despite their novelty and their accuracy, not many works of such graphic nature were sold. There are at least three reasons for this tempered success. First, the state of the art of photography made the photographs high priced. Second, methods for reproducing photographs on newsprint were not invented until about 1900; therefore, the works of the photojournalists were usually rendered as drawings, and the drawings translated into woodcuts before they appeared in the papers. Third, the American public might not have been ready to face the brutal realities they portrayed. In a similar vein, social commentators have suggested that the will of many Americans to persist in the Vietnam War was sapped by the incessant barrage of televised war imagery.

During the Great Depression of the 1930s, the conscience of the nation was stirred by the work of many photographers hired by the Farm Security Administration. Dorothea Lange and Walker Evans, among others, portrayed the lifestyles of migrant farmworkers and sharecroppers. Lange's *Migrant Mother* (Fig. 8-11) is a heartrending record of a 32-year-old woman who is out of work but cannot move on because the tires have been sold from the family car to purchase food for her seven children. The etching in the forehead is an eloquent expression of the mother's thoughts; the lines at the outer edges of her eyes tell the story of a woman who has aged beyond her years. Lange crops her photograph close to her subjects; they fill the print from edge to edge, forcing us to confront them rather than allowing us to seek comfort in a corner of the print not consigned to such an overt display of human misery. The migrant mother and her children, who turn away from the camera and heighten the futility of their plight, are as much constrained by the camera's viewfinder as they are by their circumstances.

Documentary photography records the social scene of our time. It mirrors the present and documents [it] for the future. Its focus is man in his relation to mankind. It records his customs at work, at war, at play. . . . It portrays his institutions. . . . It shows not merely their facades, but seeks to reveal the manner in which they function, absorb the life, hold the loyalty, and influence the behavior of human beings.

—Dorothea Lange

In the very year that Lange photographed the migrant mother, Robert Capa's fearless coverage of the Spanish Civil War resulted in such incredible photographs as *Death of a Loyalist Soldier* (see Fig. 3-18). During the early 1940s, photographers such as Margaret Bourke-White carried their handheld cameras into combat and captured tragic images of the butchery in Europe and in the Pacific. In 1929 Bourke-White became a staff photographer for *Fortune,* a new magazine published by Henry Luce. When Luce founded *Life* in 1936, Bourke-White became one of its original staff photographers. Like Dorothea Lange, she recorded the poverty of the Great Depression, but in the 1940s she traveled abroad to become one of the first female war photojournalists. As World War II was drawing to an end in Europe, Bourke-White arrived at the Nazi concentration camp

8-11 DOROTHEA LANGE.
Migrant Mother, Nipomo, California (1936).
Gelatin silver print. $12\frac{1}{2}$″ × $9\frac{7}{8}$″.
Copyright The Dorothea Lange Collection. The Oakland Museum of Art. Gift of Paul S. Taylor.

8-10 ALEXANDER GARDNER.
Home of a Rebel Sharpshooter, Gettysburg (July 1863).
Wet-plate photograph.
Courtesy of the Chicago Historical Society.

8-12 MARGARET BOURKE-WHITE.
The Living Dead of Buchenwald, April 1945 (1945).
Time & Life Pictures/Getty Images.

8-13 RON BERARD.
Untitled (2001).
Copyright Ron J. Berard.

of Buchenwald in time for its liberation by Gen. George S. Patton. Her photograph *The Living Dead of Buchenwald* (Fig. 8-12), published in *Life* in 1945, has become a classic image of the Holocaust, the Nazi effort to annihilate the Jewish people. The indifferent countenance of each survivor expresses, paradoxically, all that he has witnessed and endured. In her book *Dear Fatherland, Rest Quietly,* Bourke-White put into words her own reactions to Buchenwald. In doing so, she showed how artistic creation, an intensely emotional experience, can also have the effect of objectifying the subject of creation:

> I kept telling myself that I would believe the indescribably horrible sight in the courtyard before me only when I had a chance to look at my own photographs. Using the camera was almost a relief; it interposed a slight barrier between myself and the white horror in front of me . . . it made me ashamed to be a member of the human race.[1]

Dorothea Lange traveled rural America to photograph the effects of the Depression, and Margaret Bourke-White followed the U.S. troops abroad during World War II. As Bourke-White discovered, one of the keys to photojournalism is being in the right place at the right time—or in the wrong place at the wrong time. Photographer Ron Berard was also in the right—or wrong—place. He was living on an upper floor of an apartment building in Battery Park City, across a highway from the World Trade Center, on September 11, 2001, when Arab terrorists hijacked commercial aircraft and flew them into the twin towers, causing

their collapse and the loss of nearly 3,000 lives. His photograph (Fig. 8-13) captures the hellish quality of the destruction—the shard of the curtain wall that remained, the pile of rubble, the charred facade of a still-standing neighbor. The eerie smoke that rose from the pit would continue to rise for two months.

Another of Berard's photographs—an American flag flying, flapping, snapping against the grim background of the devastation of the World Trade Center site—was picked up by *Time* magazine. Yet perhaps the best-known photo from the tragedy of September 11 is the one taken a day later by Thomas E. Franklin, a staff photographer for *The Record,* a local New Jersey newspaper. That image (Fig. 8-15) of firefighters raising the flag amidst the rubble—a symbol of survival, heroism, and pride—was made into a U.S. postage stamp. Its content, design, and

[1] Margaret Bourke-White, *Dear Fatherland, Rest Quietly* (New York: Simon and Schuster, 1946), 73.

The Raising of the Flag at Iwo Jima with the Raising of the Flag at the World Trade Center

They were both photographs taken by people who just happened to be there. They were both photographs that captured heroes of the moment, ordinary fighters from ordinary ranks giving loft to hope amidst death and destruction. And they were both photographs destined to become American icons—symbols of strength and liberty woven of the threads of their time into the fabric of history.

Joe Rosenthal's photograph (Fig. 8-14) of marines raising an American flag on the Japanese island of Iwo Jima gained such celebrity that it was used as the basis for a memorial in Washington, D.C. Thomas E. Franklin's record of firefighters raising the American flag (Fig. 8-15) up a felled pole became such a visual symbol for Ground Zero that the scene is commemorated on a U.S. postage stamp. The relationship between the two images was coincidental but immediately recognized by news commentators along with the rest of us who were familiar with the indelible images of World War II. Beyond the visual similarities, which were clear enough, lay the desire to mark the war against terror as equivalent to the war against Fascism and Nazism. The connection between the two photographs also enabled Americans to assign victory—the circumstances of the Iwo Jima image—to what appeared to be the depths of defeat—the utter destruction of the World Trade Center towers and the loss of thousands of innocent lives. ■

8-15 THOMAS E. FRANKLIN.
The Flag Raising at Ground Zero (2001).
Copyright 2001 The Record (Bergen County, NJ),
Thomas E. Franklin/Corbis SABA.

8-14 JOE ROSENTHAL.
Old Glory Goes Up on Mt. Suribachi, Iwo Jima (1945).
Gelatin silver print. 34.5 cm × 26.7 cm.
Joe Rosenthal/AP Photo.

It gradually began to dawn on me that something must be wrong with the art of painting as practiced at that time. With my camera I could procure the same results as those attained by painters. . . . I could express the same moods. Artists who saw my earlier photographs began to tell me that they envied me; that they felt my photographs were superior to their paintings, but that, unfortunately, photography was not an art. . . . There and then I started my fight— or rather my conscious struggle for the recognition of photography as a new medium of expression, to be respected in its own right, on the same basis as any other art form.

—Alfred Stieglitz

emotional impact have been compared with the equally famous photograph of U.S. Marines raising the flag on the Pacific island of Iwo Jima during World War II.

Photography as an Art Form

Photographers became aware of the potential of their medium as an art form more than 100 years ago. Edward Weston, Paul Strand, Edward Steichen, and others argued that photographers must not attempt to imitate painting but must find modes of expression that are truer to their medium. Synergistically, painters were free to move toward abstraction because the "obligation" to faithfully record nature was now assumed by the photographer. Why, after all, do what a camera can do better? In 1902 Alfred Stieglitz founded the Photo-Secession, a group dedicated to advancing photography as a separate art form. Stieglitz himself enjoyed taking pictures under adverse weather conditions and at odd times of day to show the versatility of his medium and the diversity of his expression.

Edward Steichen's *The Flatiron Building—Evening* (Fig. 8-16), photographed a century ago, is among the foremost early examples of the photograph as a work of art. It is an exquisitely sensitive nocturne of haunting shapes looming in a rain-soaked atmosphere. The branch in the foreground provides the viewer with a psychological vantage point as it cuts across the composition like a bolt of lightning or an artery pulsing with life. The values are predominantly middle grays, although here and there, beaconlike, street lamps sparkle in the distance. The infinite gradations of gray in the cast-iron skyscraper after which the picture is named, and in the surrounding structures, yield an immeasurable softness. Although much is present that we cannot readily see, there is nothing gloomy or frightening about the scene. Rather, it

seems pregnant with wonderful things that will happen as the rain stops and the twentieth century progresses.

It was not long before artists began to manipulate their medium so that they, too, could venture beyond mere imitation. The first steps were tentative, building on the familiar and the readily acceptable. Photographer James VanDerZee, known for his visual narrative of life in New York's Harlem, experimented with painted backgrounds and double-exposed images in otherwise traditional portraits. *Future Expectations* (Fig. 8-17) is both a visual record of a young

8-16 EDWARD STEICHEN.
The Flatiron Building—Evening (1906).
Courtesy of the Library of Congress.

couple on their wedding day and a symbol of their hopes and anticipations—a comfortable home with a blazing hearth, and beautiful children, secure in their love.

In the realm of photography and fantasy, we may take a quantum leap to the present day, when technology is such that the only impediment to the most innovative results is the artist's ability to fathom the unfathomable. In what sharp contrast to VanDerZee's interior stands Sandy Skoglund's *Radioactive Cats* (Fig. 8-18)! Hopes and expectations for the "good life" fade into the dullness of gray, as a phlegmatic elderly couple live out their colorless lives. Yet sparks of life and humor permeate the deadly pallor of their environment—in the form of neon green cats. Skoglund sculpted the plaster cats herself and painted the room gray, controlling every aspect of the set before she shot the scene. Yet it is the photograph itself that stands as the completed work of art.

From cats to dogs . . . artist-photographer William Wegman happened upon his most famous subject when his Weimeraner puppy virtually insisted on performing before his lights. Man Ray, named by Wegman after the Surrealist photographer, posed willingly in hundreds of staged sets that range from the credible to the farcical. *Blue Period*

8-17 JAMES VANDERZEE.
Future Expectations (c. 1915).
Gelatin silver print.

8-18 SANDY SKOGLUND.
Radioactive Cats (1980).
Cibachrome. 30″ × 40″.

Collection of the artist.

8-19 WILLIAM WEGMAN.
Blue Period (1981).
Color Polaroid photograph. 24″ × 20″.
Copyright William Wegman. Courtesy PaceWildenstein MacGill.

8-20 CINDY SHERMAN.
Untitled (1984).
Color photograph. 71″ × 48½″.
Metro Pictures, New York.

(Fig. 8-19) is a spoof on Pablo Picasso's painting *The Old Guitarist* (see Fig. 19-6), enframed in a souvenir version in the left lower foreground. In both works a guitar cuts diagonally across the composition, adding the only contrasting color to the otherwise monochromatic blue background. The heads of the old man and of Man Ray hang, melancholy, over the soulful instrument. As Picasso gave the old man's flesh a bluish cast, so did Wegman tint the Weimaraner's muzzle. In Wegman's photograph, however, we find the pièce de résistance—an object laden with profound meaning for the guitarist's stand-in: a blue rubber bone.

In contemporary photography, artists often use themselves as subjects. Cindy Sherman adopts diverse personae for her photographs. She recalls a mundane, early inspiration for her approach:

> I had all this makeup. I just wanted to see how transformed I could look. It was like painting in a way.[2]

[2] Cindy Sherman, in Gerald Marzorati, "Imitation of Life," *Artnews 82* (September 1983): 84–85.

Soon she set herself before elaborate backdrops, costumed in a limitless wardrobe. Dress designers began to ask her to use their haute couture in her photographs, and works such as *Untitled* (Fig. 8-20) were actually shot as part of an advertising assignment for French *Vogue.* The result is less a sales device than a harsh view of the fashion industry. Sherman appears as a disheveled model with a troubling expression. Something here is very wrong. Regimented stripes go awry as the fabric of her dress is stretched taut across her thighs and knees. Her hands rest oddly in her lap, fingertips red with what seems to be blood. And then there is the smile—an unsettling leer implying madness.

Skoglund, Wegman, and Sherman are photographers who work, by their own admission, as painters. Painter David Hockney has used photography to construct unified compositions whose sum total of parts has a far greater impact than the whole. In the process of photographing a subject like *Pearblossom Highway 11–18th April 1986 #2* (Fig. 8-21), Hockney fragments the panorama, only to rebuild it in his studio. It is almost as if he were reconstruct-

*I see my work as a pictorial excursus on the topic of feminism and contemporary Islam—
a discussion that puts certain myths and realities under the microscope and comes to the conclusion
that these are much more complex than many of us had thought.*

—Shirin Neshat

8-21 DAVID HOCKNEY.
*Pearblossom Highway
11–18th April 1986 #2* (1986).
Photographic collage.
78″ × 111″.
Copyright 1986 David Hockney.

ing the scene as most of us do from fragmented memories. The result is a shimmering mosaic that elevates the commonplace to the level of fine art.

Iranian-American photographer and video artist Shirin Neshat came to the United States as a teenager, before the shah was removed from power, and returned in 1990 to witness a nation transformed by the rule of Islamic clergy. She was particularly concerned about how life had changed for Iranian women, who now had limited opportunities outside the home and were veiled behind black chadors. Figure 8-22 is one of a series called *Women of Allah,* in which guns or flowers are frequently juxtaposed with vulnerable though rebellious faces and hands that emerge from beneath the veil. The exposed flesh is overwritten with sensual or political texts by Iranian women in the native tongue of Farsi. To a non-Arabic-speaking Westerner, the calligraphic writing may first appear to be little more than a mélange of elegant and mysterious patterns and designs. Yet there is no mistak-

8-22 SHIRIN NESHAT.
Untitled (Women of Allah) (1994).
Gelatin silver print, ink. 36 cm × 28 cm.
Courtesy of Thomas Rehbein Gallery, Köln, Germany.

ing its purpose as one of resistance. The photos are unlikely to be seen and "decoded" by the eyes of Iranians living in Iran, but the message of the artist to the world outside is clear.

Evolving technology has made it possible for photographers to achieve dazzling images such as the one in Harold Edgerton's *Fan and Flame Vortices* (Fig. 8-23). Edgerton is an electrical engineer who invented the strobe light, a device that emits brief and brilliant flashes of light that seem to slow or stop the action of people or objects in motion. *Fan and Flame Vortices* is a high-speed photograph of a metal fan blade rotating at 3,600 revolutions per minute through the flame emitted by an alcohol burner. Changes in the density of the air and other gases are responsible for the fluctuating colors. Edgerton, like many other contemporary photographers, has used technological innovations to transform some of the mundane objects of the real world into vibrant abstract images.

8-23 HAROLD EDGERTON.
Fan and Flame Vortices (1973).
Dye transfer print. 13″ × 20″.
Copyright Kim Vandiver & Harold Edgerton. Courtesy of Palm Press, Inc.

Photographs have the capacity to stir us; because of their size, our relationship to them is intimate. At times they speak frankly to us; sometimes they leave much to the imagination. Because they are frozen moments in time, we can only wonder about what had gone before and what came after. This capacity to stir us is intensified, expanded, and altered in the art of cinematography. A large screen, movement, and—since the 1930s—sound capture the visual and auditory senses of the audience like no other medium.

CINEMATOGRAPHY

The magic of **cinematography**—the art of making motion pictures—envelops our senses. Some members of the audience demand to be so encompassed that they sit in the front row, with the screen looming above them like a tidal wave. What associations does cinematography evoke for you? The big screen? The silver screen? The drive-in, with long lines for hot dogs and french fries? Speakers blasting from the walls? Popcorn? Ushers complaining about bringing drinks to the seats? Gum sticking to your shoe? Teenagers laughing, shouting, and necking? All these are part of Americana. Couples not only have their "song"; they often have their "movie"—what they saw on one of their first dates, what spoke to them deeply in their emotional vulnerability.

Varieties of Cinematographic Techniques

Despite their power to move us, motion pictures, or "movies," do not really move themselves. The illusion of movement is created by stroboscopic motion, which is the presentation of a rapid progression of images of stationary objects. The audience is shown 16 to 24 pictures or frames per second, like those shown in the series of Muybridge photographs (Fig. 8-24). Each picture or frame differs slightly from that preceding it. Showing them in rapid succession creates the illusion of movement. (Children similarly draw series of shapes or figures along the outer margins of books, then flip the pages to create the illusion of movement.)

At a rate of 22 or 24 frames per second, the "motion" in a film seems smooth and natural. At fewer than 16 or so frames per second, it is choppy. For that reason, **slow motion** is achieved by filming 100 or more frames per second. When they are played back at 22 or 24 frames per second, movement appears to be very slow yet smooth and natural.

A film is—or should be—more like music than like fiction. It should be a progression of moods and feelings. The theme, what's behind the emotion, the meaning, all that comes later.

—Stanley Kubrick

8-24 EADWEARD MUYBRIDGE.
Galloping Horse (1878).
International Museum of Photography at George Eastman House, Rochester, NY.

Eadweard Muybridge's *Galloping Horse* sequence was shot in 1878 by 24 cameras placed along a racetrack and was made possible by new fast-acting photosensitive plates. (If these plates had been developed 15 years earlier, Brady could have bequeathed us a photographic record of Civil War battle scenes.) Muybridge had been commissioned to settle a bet as to whether racehorses ever had all hooves off the ground at once. He found that they did, but also that they never assumed the "rocking-horse" position in which the front and back legs are simultaneously extended.

Muybridge is generally credited with performing the first successful experiments in cinematography. He fashioned a device that could photograph a rapid sequence of images, and he invented the **zoogyroscope,** which projected these images onto a screen.

The motion-picture camera and projector were perfected by the inventor of the light bulb, Thomas Edison, toward the end of the nineteenth century. In 1893 the

photographer Alexander Black made a motion picture of the president of the United States. In 1894 Thomas Edison's assistant Fred Ott was immortalized on film in the act of sneezing. Out of these inauspicious beginnings, a new medium for the visual arts was suddenly born.

Within a few short years, commercial movie houses sprang up across the nation and motion-picture productions were distributed for public consumption. Sound was added to visual sensations by means of a **sound track,** and a number of silent film stars with noncompelling voices fell by the wayside.

Additional innovations have had a checkered history. There have been expansions to wider and wider screens, including Cinemascope, Cinerama, Panavision, and films that are projected completely around the audience on a 360-degree strip wall or on the inner surface of a hemispherical dome. Stereophonic sound has been introduced. Three-dimensional (3-D) movies requiring special eyeglasses

have been made. Today stereophonic sound, color, and reasonably wide screens remain in common use. But what photographers have noted about the role of photographic equipment seems also to apply to cinematography: the vision or creativity of the cinematographer is more important than technical advances.

Let us now consider a number of cinematographic techniques more closely: use of the fixed camera, the moving camera, editing, color, animation, and special effects.

Fixed Cameras and Staged Productions

With a stage play, the audience is fixed and must observe from a single vantage point. Similarly, many early motion pictures used a single camera that was more or less fixed in place. Actors came onstage and exited before them.

For the most part, the Busby Berkeley musicals of the 1930s (Fig. 8-25) were shot on indoor stages that pretended to be nothing but stages. The motion picture had not yet broken free from the stage that had preceded it. Many directors used cinematography to bring the stages of the great urban centers to small cities and rural towns. We can note that the musicals of the 1930s were everything that the photographs of Dorothea Lange and the other Depression photographers were not: they were bubbly, frivolous, light, even saucy. Perhaps they helped Americans make it through. Some musicals of the 1930s showed apple-cheeked "kids" getting their break on the Great White Way. Others portrayed the imaginary shenanigans of the wealthy few in an innocent era when Hollywood believed that they would offer amusement and inspiration to destitute audiences rather than stir feelings of social conflict through depiction of conspicuous consumption and frivolity.

The Mobile Camera

Film critics usually argue that motion pictures should tell their stories in ways that are inimitable through any other medium. One way is through the mobile camera. Film pioneer D. W. Griffith is credited with making the camera mobile. He attached motion-picture cameras to rapidly moving vehicles and used them to **pan** across expanses of scenery and action, as in the battle scenes in his *Birth of a Nation* (Fig. 8-26). Today it is not unusual for cameras to be placed aboard rapidly moving vehicles and also to **zoom** in on and away from their targets.

Editing

Griffith is also credited with making many advances in film editing. **Editing** is the separating and assembling, sometimes called "patching and pasting," of sequences of film. Editing helps make stories coherent and heightens dramatic impact.

In **narrative editing,** multiple cameras are used during the progress of the same scene or story location. Then shots are selected from various vantage points and projected in sequence. Close-ups may be interspersed with **longshots,** providing the audience with abundant perspectives on the action while advancing the story. Close-ups usually better communicate the emotional responses of the actors, whereas longshots describe the setting, as in Alfred Hitchcock's thriller, *North by Northwest* (Fig. 8-27).

In **parallel editing,** the story shifts back and forth from one event or scene to another. Scenes of one segment of a battlefield may be interspersed with events taking place on another or back home, collapsing space. Time may also be collapsed through parallel editing, with the cinematographer shifting back and forth between past, present, and future.

In the **flashback,** one form of parallel editing, the story line is interrupted by the portrayal or narration of an earlier episode, often through the implied fantasies of a principal character. Orson Welles's *Citizen Kane* (Fig. 8-28) innovated the use of the flashback. The flashback usually gives current action more meaning. In the **flash-forward,** editing permits the audience glimpses of the future. The flash-forward is frequently used at the beginning of dramatic television shows to capture the interest of the viewer who may be switching channels.

Motion pictures may proceed from one scene to another by means of **fading.** The current scene becomes gradually dimmer, or *fades out.* The subsequent scene then grows progressively brighter, or *fades in.* In the more rapid, current technique of the **dissolve,** the subsequent scene becomes brighter and the current scene fades out so that the first scene seems to dissolve into the second.

8-27 ALFRED HITCHCOCK.
Film still from *North by Northwest.*
Copyright 1959 Metro-Goldwyn-Mayer. Copyright Ann Ronan Picture Library, Oxfordshire, UK.

8-28 ORSON WELLES.
Film still from *Citizen Kane.*
Copyright 1941 RKO Radio Pictures. Copyright Ann Ronan Picture Library, Oxfordshire, UK.

I love Mickey Mouse more than any woman I have ever known.

—Walt Disney

In **montage,** a sequence of abruptly alternating images or scenes conveys associated ideas or the passage of time. Images can suddenly flash into focus or whirl about for impact, as in a series of newspaper headlines meant to show the progress of the actors over time.

Color

Color came into use in the 1930s. One early color film, *The Wizard of Oz,* depicted the farm world of Kansas in black and white and the imaginary Oz in glorious, often expressionistic color. Madonna sort of reverses the pattern in *Truth or Dare,* where her stage performances (fantasy?) are in color and her (real?) backstage life is in black and white. Yet interestingly, this pattern is now frequently reversed in music videos, where fantasy is often portrayed in black and white and reality in (everyday, natural?) color.

The screen version of Margaret Mitchell's *Gone with the Wind* (Fig. 8-29) was one of the first color epics, or "spectaculars." It remains one of the highest-grossing works of all film eras. In addition to the sweeping **panoramas** of the Civil War battlefield wounded and the burning of Atlanta, *Gone with the Wind* included close-ups of the passion and fire communicated by Clark Gable as Rhett Butler and Vivien Leigh as Scarlett O'Hara.

8-30 BRAD BIRD.
Film still from *The Incredibles* (2004),
a Walt Disney Production.
Topfoto/The Image Works.

Animation

Animation is the creation of a motion picture by photographing a series of drawings, each of which shows a stage of movement that differs slightly from the one preceding it. As a result, projecting the frames in rapid sequence creates the illusion of movement. The first cartoons were in black and white and employed a great deal of repetition.

During the 1930s, Walt Disney's studios began to produce full-color stories and images that have become part of our collective unconscious mind. Disney characters such as Mickey Mouse, Donald Duck, Bambi, Snow White, and Pinocchio are national treasures. In recent years, Disney has collaborated with Pixar Animation Studios to create a new generation of animated films, including *Toy Story; Finding Nemo; Monsters, Inc.;* and *The Incredibles* (Fig. 8-30).

Special Effects

Over the years, filmmakers have raised the technical bar for special effects in their action movies. The industry has come a long way from tiny exploding capsules planted in the ground to simulate gunfire to the extravaganzas of effects in films such as *The Lord of the Rings, Star Wars,* or *Batman Begins* (Fig. 8-31). Complex motorized, remote-controlled models (the great white shark in *Jaws,* dinosaurs in *Jurassic*

8-29 VICTOR FLEMING.
"The Burning of Atlanta," a film still from
Gone with the Wind.
Selznick/MGM/The Kobal Collection.

8-31 CHRISTOPHER NOLAN.
Christian Bale as Batman in *Batman Begins*
(2005), a Warner Brothers film.
The Everett Collection.

Park, starships and out-of-this-world inhabitants in *Star Wars,* prototype vehicles like the batmobile in *Batman Begins*) and extensive computer graphics combine to create an extreme illusion of the director's reality.

Varieties of Cinematographic Experience

No discussion of cinematography can hope to recount adequately the richness of the motion-picture experience. Broadly speaking, motion pictures are visual experiences that entertain or move us. For example, as in novels, we identify with characters and become wrapped up in plots.

Like other artists, cinematographers make us laugh (consider the great films of the Marx Brothers and Laurel and Hardy); create propaganda, satire, social commentary, fantasy, and symbolism; express artistic theories; and reflect artistic styles. Let us consider some of these more closely.

Propaganda

Although there are some early (and choppy) film records of World War I, cinematography was ready for World War II. In fact, while many American actors were embattled in Europe and the Pacific, former president Ronald Reagan was making films for the United States that depicted the valor of the Allied soldiers and the malevolence of the enemy.

ups, and aerial and ground-level views. Her montage of people, monuments, and flag-bedecked buildings unified flesh and stone into a hymn to Nazism. The United States, England, Canada, and some other nations paid a backhanded compliment to the power of *Triumph of the Will* by banning it.

Satire

Satire is the flip side of propaganda. Although Riefenstahl glorified national socialism in Germany, American filmmakers derided it. In one cartoon, for example, Daffy Duck clubs a realistic-looking, speechifying Adolf Hitler over the head with a mallet. Hitler dissolves into tears and calls for his mommy. British-American filmmaker Charlie Chaplin added to the derision of the führer in *The Great Dictator* (Fig. 8-33). The film and television series *M*A*S*H* was set during the Korean War, but it satirized authoritarianism through the ages.

Social Commentary

Filmmakers, like documentary photographers, have made their social comments. *The Grapes of Wrath* (Fig. 8-34), based on the John Steinbeck novel, depicts one family's struggle for survival during the Great Depression, when the banks failed and the Midwest farm basket of the United States turned into the Dust Bowl. Like a Dorothea Lange photograph, the camera comes in to record hopelessness and despair. Cinematographers have commented on everything from *Divorce, American Style* to *The Killing Fields* of Southeast Asia to the excesses of *Wall Street*.

Our adversaries were active as well. Prior to the war, in fact, German director Leni Riefenstahl made what is considered one of the greatest (though also most pernicious) propaganda films of all time, *Triumph of the Will* (Fig. 8-32). Riefenstahl transformed the people and events of a historic event, the 1935 Nürnberg Congress, into abstract, symbolic patterns through the juxtaposition of longshots and close-

I can make an audience laugh, scream with terror, smile, believe in legends, become indignant, take offense, become enthusiastic, lower itself or yawn with boredom. I am, then, either a deceiver or—when the audience is aware of the fraud—an illusionist. I am able to mystify, and I have at my disposal the most precious and the most astounding device [the motion-picture camera] that has ever, since history began, been put into the hands of the juggler.

—Ingmar Bergman

8-35 ROBERT WIENE.
Film still from *The Cabinet of Dr. Caligari* (1919).
Copyright Ann Ronan Picture Library, Oxfordshire, UK.

8-36 SALVADOR DALÍ AND LUIS BUÑUEL.
Film still from *Un Chien Andalou* (1928).
Copyright 2003 Artists Rights Society (ARS)/New York.

Fantasy

Fantasy and flights of fancy are not limited to paintings, drawings, and the written word. In the experimental films of Robert Wiene and Salvador Dalí and Luis Buñuel, events are not confined to the material world as it is; they occupy and express the inmost images of the cinematographer. The sets for Wiene's *The Cabinet of Doctor Caligari* (Fig. 8-35) were created by three painters who employed Expressionist devices such as angular, distorted planes and sheer perspectives. The hallucinatory backdrop removes the protagonist, a carnival hypnotist who causes a sleepwalker to murder people who displease him, from the realm of reality. The muddy line between the authentic and the fantastic is further obscured by the film's ending, in which the hypnotist becomes a mental patient telling an imaginary tale. (It is akin to the ravings of the mad Salieri, who, through flashbacks, recounts his actual and fantasized interactions with Mozart in the film *Amadeus*.)

Caligari has a story, albeit an unusual one, but Dalí and Buñuel's surrealistic *Un Chien Andalou* (Fig. 8-36)

has a script (if you can call it a script) without order or meaning in the traditional sense. In the shocking opening scene, normal vision is annulled by the slicing of an eyeball. The audience is then propelled through a series of disconnected, dreamlike scenes.

Symbolism

In writing about *Un Chien Andalou*, Buñuel claimed that his aims were to evoke instinctive reactions of attraction and repulsion in the audience, but that nothing in the film *symbolized* anything.[3] Fantastic cinematographers often portray their depths of mind literally. They create on the screen the images that dwell deep within. Other cinematographers, such as Ingmar Bergman, do frequently express aspects of the inner world through symbols.

[3] Luis Buñuel, "Notes on the Making of *Un Chien Andalou*," in *Art in Cinema*, a symposium held at the San Francisco Museum of Art (repr., New York: Arno Press, 1968).

8-37 INGMAR BERGMAN. Film still from *The Seventh Seal* (1956).

Copyright Ann Ronan Picture Library, Oxfordshire, UK.

Since the 1950s, filmgoers have been struck by Bergman's mostly black-and-white films (Fig. 8-37). As in so much other art, nature serves as counterpoint to the vicissitudes of the human spirit in Bergman's films. The Swedish summers are short and precious. The bleak winters seem, to Bergman, to be the enduring fact of life. Against their backdrop, he portrays modern alienation from comforting religion and tradition. Bergman's films have ranged from jocular comedies to unrelieved dark dramas, and his bewitching screen images have brought together Nordic mythology and themes of love, death, and ultimate aloneness.

VIDEO

Video is used in television and in experimental video and mixed-media works that incorporate video monitors. The techniques of cinematography—methods of editing and so on—also apply to video.

Over a period of about 60 years, television has radically altered American life and placed the American lifestyle before the world. Commercial television broadcasts many of the images that reflect and create our common contemporary culture—from the pop world of Britney to the underworld of *The Sopranos*. Children spend as many hours in front of a TV set as they do in school. Congressional committees debate the impact of televised violence. For many people, television is an indispensable companion.

"Live" coverage enabled hundreds of millions of TV viewers to witness Neil Armstrong's first steps on the Moon. Many millions watched in horror the "live" assassination of John F. Kennedy and the explosion of the *Challenger* space shuttle. Viewers who came to be called "gulf potatoes" seemed to be addicted to the televising of the Gulf War, the nation's first real video war—which began with CNN's "live" description of fighter-bombers over Baghdad in 1991. In 2001 viewers watched the destruction of the World Trade Center "live"—whether from the suburbs of New York or from Chicago or Los Angeles. We were a single community connected by wireless broadcasting and by cable.

The sights and sounds that are recorded by the television camera are transformed into electronic messages in the form of lengthy digital codes (a pattern of ones and zeroes). The digital information is transmitted wirelessly or by cable.

8-38　NAM JUNE PAIK.
Global Groove (1973).
Videotape still.
Courtesy Electronic Arts Intermix (EAI), New York.

The television set then reconstructs the digital information into visual images and sounds.

Commercial television is most often used to transmit news, sporting events, staged events, and films to viewers. Korean-born Nam June Paik and other fine artists, however, have appropriated video as their medium in the creation of works of art—video art. Video art is to be distinguished from the commercial efforts of the television establishment.

Paik's *Global Groove* (Fig. 8-38) flashes fragmented segments of Japanese Pepsi commercials, Korean drummers, a videotaped theater group, poet Allen Ginsberg reading from his work, women tap dancers, and a musical piece in which a cellist draws her bow across a man's back. The stream of consciousness is somewhat surrealistic, but the imagery provides a reasonably recognizable pastiche of television worldwide.

In *Three Mountains* (Fig. 8-39), Japanese artist Shigeko Kubota incorporates video into a pyramidal sculptural piece, a combination intended to re-create the experience of the open western landscape. Video monitors are installed in a plywood base—the cutouts lined with mirrors. The mixed-media work confronts the viewer with multiple images of the Grand Canyon, as seen from a helicopter; a drive along Echo Cliff, Arizona; a Taos, New Mexico, sunset; and a Teton sunset. Kubota commented:

> My mountains exist in fractured and extended time and space. My vanishing point is reversed, located behind your brain. Then, distorted by mirrors and angles, it vanishes in many points at once. Lines of perspective stretch on and on, crossing at steep angles, sharp, like cold thin mountain air.[4]

[4] Shigeko Kubota, *Video Sculptures* (Berlin: Daadgalerie; Essen: Museum Folkwang; Zurich: Kunsthaus, 1982), 37.

8-39　SHIGEKO KUBOTA.
Three Mountains (1976–1979).
Four-channel video installation with 3 mountains, constructed of plywood and plastic mirrors, containing 7 monitors; Mountain I: 38″ × 17″ at top and 59″ × 59″ at base;
Mountains II and III: 67″ × 21″ at top and 100″ × 60″ at base; 4 color videotapes, each 30 minutes.
Collection of the artist. Courtesy Electronic Arts Intermix, New York.

8-40 DARA BIRNBAUM.
PM Magazine (1982).
Installation at San Francisco Museum of Modern Art,
May 9 – September 16, 1997; five-channel color video
and sound installation. Installation panel 6′ × 8′.

San Francisco Museum of Modern Art. Purchased through a gift of Rena
Bransten and the Accessions Committee Fund. Gift of Collectors Forum,
Doris and Donald G. Fisher, Evelyn and Walter Haas Jr., Byron R. Meyer,
and Norah and Norman Stone.

8-41 BILL VIOLA.
The Crossing (1996).
Two-channel color video and stereo-sound installation,
continuous loop. 192″ × 330″ × 684″ (487.7 cm ×
838.2 cm × 1,737.4 cm).

Solomon R. Guggenheim Museum, New York. Gift, The Bohen Founda-
tion (2000.2000.61). Photograph by Sally Ritts. © The Solomon R.
Guggenheim Foundation, New York.

Dara Birnbaum's provocative videotapes and multi-
media installations contribute to the contemporary dis-
course on art, television, and feminism. Her works appro-
priate and subvert the power of mass-media images to
comment on the myths and stereotypes of our culture. Her
installation *PM Magazine* (Fig. 8-40) appropriated and
modified footage from the former network magazine–
format show to reveal how news and entertainment formats
can exploit women. (How many older, unglamorous female
TV news anchors and reporters do we see? How many "im-
portant" stories involve bizarre incidents of sex and violence?)

Bill Viola's *The Crossing* (Fig. 8-41) is a video/sound
installation that engulfs the senses and attempts to transport
the viewer into a spiritual realm. In this piece the artist
simultaneously projects two video channels on separate
16-foot-high screens or on the back and front of the same
screen. In each video a man enveloped in darkness appears
and approaches until he fills the screen. On one channel, a
fire breaks out at his feet and grows until the man is appar-
ently consumed in flames (the content is not what we would
call graphic or disturbing, however). On the other channel,
the one shown here, drops of water fall onto the man's head,
develop into rivulets, and then inundate him. The sound
tracks accompany the screenings with audio images of tor-
rential rain and of a raging inferno. The dual videos wash
over the viewer with their contrasts of cool and hot colors
and their encompassing sound. Critics speak about the
spiritual nature of Viola's work, but it is also about the here-
and-now reality of the sensory experiences created by his
art form.

In *Getaway #2* (Fig. 8-42), Tony Oursler projects a
videotape with a sound track onto the cloth face of a life-
size doll "hiding" adolescent-like beneath a mattress. A
critic described his experiences as he and a companion ob-
served another couple viewing the work in Williamstown,
Massachusetts:

Tony Oursler is super-clever. He knows that we unreflectively absorb television images and voices, making their public content part of our private lives, so he literally makes television part of us— our heads—and uses it to project our inner lives back into the outer world.

—Donald Kuspit

8-42 TONY OURSLER.
Getaway #2 (1994).
Mattress, cloth, LCD projector, VCR, videotape.
16″ × 117½″ × 86″ overall.
Whitney Museum of American Art, New York.
Purchased with funds from the Contemporary Painting
and Sculpture Committee.

We followed a couple into the gallery, and I saw one of them later taking great pains to get down on the ground to better see a piece consisting of a life-size doll whose head is underneath a mattress. The doll's projected face is yelling, "Hey, you! Get outta here!," plus various obscenities and epithets; and the aforementioned viewer, upon a heroic struggle to get up again after that better look, exclaimed, "Whew! I almost became part of that piece!"[5]

[5] Devon Damonte, "Vital Video in Williamstown: Personal Reflections on Some New Museum Exhibits in Western Mass," September 1999. http://www.newenglandfilm.com/news/archives/99september/museum.htm.

I can empathize. I usually have to drag my youngest child through exhibitions, but when *Getaway #2* was "doing its thing" (that is, arguing with her and insulting her) at the Whitney a couple of years back, she was spellbound and would not leave the gallery in which the piece was installed and uttering its R-rated phrases. It took weeks before we stopped hearing her parrotlike renditions of the doll's naughty verbal bits. The message of many of Oursler's video works seems to be that people are unusually receptive to video images. They absorb them and then spout them. Television creates some of the most salient of the images we share in our culture—both video and audio—and as with

The role of the artist has to be different from what it was fifty or even twenty years ago. I am continually amazed at the number of artists who continue to work as if the camera were never invented, as if Andy Warhol never existed, as if airplanes, and computers, and videotape were never heard of.

—Keith Haring

any effort to define or describe the individual, we must wonder where the person's "individuality" leaves off and cultural influences begin. Perhaps they become so enmeshed that it is impossible to define the borders. Oursler seems to be saying that the border is porous.

DIGITAL ART

As we enter the new millennium in the arts, most readers undoubtedly have toyed with computer programs like Microsoft's *Paint* or *Paintbrush.* Software such as this, typically part of the computer manufacturer's standard package, enables the user—artistic or otherwise—to create illustrations by manipulating stock shapes, drawing "freehand," "spray painting" color fields, or enhancing the images with a variety of textural patterns—all of which are selected by directing the mouse to a menu of techniques and design elements. The resultant shapes or drawings can be flipped and rotated or stretched in any direction. Even word-processing programs such as Word and WordPerfect can be used to distort and otherwise play with images. The user-artist needn't have the talent to draw a straight line, simply the ability to point and click. For most of us, the results are literally "child's play," but career artists who have sealed their reputations in other media have also been tempted by the computer as an artistic tool. Keith Haring, the infamous subway graffittist-turned-mainstream-artist, created *Untitled* (Fig. 8-43) on the Images paint system of the New York Institute of Technology. Haring's paintings are characterized by animated, mostly featureless figures bounded by thick, signature outlines, and his computer-generated image bears a close resemblance to his other work. Drawing on a computer screen must have seemed a natural segue for Haring. Haring is an experimenter by nature, an artist who challenged and pushed the limits, so his exploration of the possibilities of the computer as tool is not surprising. Yet when Haring created *Untitled* in 1983, he probably could only have

imagined the directions that computer art would take in the coming decades.

Only within the last century have the horizons of artists been expanded by technological advances encompassing anything and everything from the development of quick-drying acrylic paints to the advent of film and video. The computer has greatly expanded what can be achieved in these media and others. Today computer graphics software programs offer palettes of more than 16 million colors, which can be selected and produced on the monitor almost instantaneously. Compositions can be recolored in seconds. Effects of light and shade and simulated textured surfaces

8-43　KEITH HARING.
Untitled (1983).
35 mm slide of work created on the New York Institute of Technology's Images paint system.
Courtesy of the New York Institute of Technology.

8-44 ROBERT LAZZARINI.
Study for *Payphone* (2001).
Mixed media. 108″ × 84″ × 48″.
Collection of the artist. Courtesy Pierogi, Brooklyn, NY.

8-45 YAEL KARANEK.
Digital landscape in the sunset/sunrise desert terrain of
World of Awe (2000).
Courtesy of the artist.

can be produced with the point and click of a mouse. Software programs enable artists to create three-dimensional representations with such astounding realism that they cannot be distinguished from photos or films of real objects in space. They can be viewed from any vantage point and in any perspective. Images can be saved or stored in any stage of their development, be brought back into the computer's memory at will, and modified as desired, without touching the original image. It is difficult to believe that these images are stored in computers as series of zeroes and ones, and not as pictures, but they are.

The herd of galloping dinosaurs in *Jurassic Park* was made possible by computer animation. Computer graphics is used to create environments as in video games (for example, the "tombs" raided by Lara Croft) or the virtual-reality world of the 1999 film *Matrix.*

Figure 8-43 is an example of *digital art.* Broadly speaking, digital art is the production of images by artists with the assistance of the computer. Just as artists have adapted the technical possibilities of photography, film, and video, so too have they appropriated the computer.

Digital artists can distort the commonplace according to meticulous mathematical formulas. Robert Lazzarini uses the computer to alter everyday objects, like the pay phones we find along the streets of cities (Fig. 8-44), and then he builds sculptures based on the modified images. The sculptures are fabricated from the materials used in the actual objects. The viewer might try to get a visual handle on such works by viewing them from the "proper" angle, but no vantage point will "straighten out" these objects. The viewer is compelled to take a new look at the familiar, a goal of art for millennia.

Yael Karanek's digital landscape in *World of Awe* (Fig. 8-45) is a screenshot of an interactive digital "journal" that was purportedly found on a laptop computer in Silicon Canyon. The "traveler" who enters this virtual world will find love letters, travel logs, and a variety of navigation tools that can be used to find a "treasure." The work builds on the notion of "interfaces" (to use a nice digital term) between travel, storytelling, creation, and technology.

Visual artists as well as commercial filmmakers use digital techniques to modify and embellish ordinary imagery. In

Video and interactive systems became a means of following the trail of personal history. That gave me the clue to my real place in the cultural context.

—Lynn Hershman

the storyboard from *Winchester* (Fig. 8-46), Jeremy Blake combines film, drawings, and computer-generated imagery to narrate what he imagines to be the psychological state of Sarah Winchester, the widow of the founder of the Winchester rifle company, who believed that she was being pursued by the ghosts of people who had been killed with her husband's rifles. Over a span of 38 years, she added numerous rooms to her San Jose home, shown here in a spongy space–time continuum, to house friendly apparitions and ward off hostile spirits with noisy construction. The unreality of the resultant DVD reflects the unreality of this peculiar home environment.

Artists not only appropriate the technology of the day but they also appropriate images that have special meaning within a culture. Lynn Hershman's *Digital Venus* (Fig. 8-47) starts with Titian's well-known Renaissance painting *Venus of Urbino* (see Fig. 15-28) and substitutes digital imagery for the sumptuous glazes that defined the body. Many of Hershman's works comment on the voyeurism we find in the video medium, and *Digital Venus* is a way of showing how frequently the images that affect us are composed of pixels—microscopically small bits of digital information that fool our senses into believing we are somehow connecting with a corporeal reality. And like the work of Dara Birnbaum, it addresses feminist issues pertaining to the male gaze and the exploitation of women.

Artists are now only scratching the surface of digital art as a medium. Art courses in digital arts and interactive multimedia have never been more in demand. Just as photography was once termed a "democratizer" in the visual arts—enabling anyone with a camera to capture anything—so has the ubiquitousness of the digital camera and computer opened the door to limitless experimentation among artists and "outsiders" alike (Fig. 8-48).

8-46 JEREMY BLAKE.
Winchester (2002).
Sequence from DVD with sound for plasma or projection, 18-minute continuous loop.
Courtesy Feigen Contemporary, New York.

8-47 LYNN HERSHMAN.
Digital Venus (1996).
Iris print. 102 cm × 152 cm.
Courtesy of the artist. Hotwire Productions.

8-48 LOIS FICHNER-RATHUS.
Hudson River Landscape (2004).
Digital print.
Courtesy of the author.

SCULPTURE

A sculptor is a person obsessed with the form and shape of things, and it's not just the shape of one thing, but the shape of anything and everything: the hard, tense strength, although delicate form of a bone; the strong, solid fleshiness of a beech tree trunk.

—Henry Moore

What is a stone? To a farmer it is an obstacle to be dug and carted from the field. To a Roman warrior it was a powerful missile. To an architect it is a block, among many, to be assembled into a home or a bridge. But to a sculptor it is the repository of inner forms yearning for release. What is a steel girder? To an architect it is part of the skeleton of a skyscraper. To a sculptor it is the backbone of a fantastic animal or machine that never was, except in the imagination.

Stone, metal, wood, clay, plastics, light, and earth—these are some of the materials and elements that we have carved, modeled, assembled, and toyed with to create images of ourselves and to express our inmost fears and fantasies. Each of them affords the artist certain opportunities and limitations for self-expression. In this chapter we will see how they have been used in sculpture to grant three-dimensional reality to ideas. In the next chapter we will see how architects have used them to create aesthetic structures that protect us from the elements and provide settings for communal and intimate activities.

According to Greek myth, Pygmalion, the king of Cyprus, fell in love with the idealized statue of a woman. Aphrodite, goddess of love, heard his prayers and brought the statue to life. In one version of the myth, the statue becomes the goddess herself. In still another, Pygmalion was the sculptor who created the statue. In this myth we find the elements of the human longing for perfection. We glimpse the emotionality that sculptors can pour into their works.

SCULPTURE

Sculpture is the art of carving, casting, modeling, or assembling materials into three-dimensional figures or forms. Within this broad definition, architecture could be seen as a type of sculpture. But architecture serves the utilitarian purpose of providing housing and other structures for work and play, whereas sculptures need serve no practical purpose at all.

It could be argued that sculpture is more capable of grasping the senses than are the two-dimensional art forms of drawing, painting, and printmaking. We view two-dimensional works from vantage points to the front of the support. We might move closer or farther away, or squat or stand on tiptoe to gain new perspective, but the work itself, even if thickly laden with impasto, is essentially flat. **Relief sculptures** are similar to two-dimensional works in that their three-dimensional forms are raised from a flat background. In low relief, or **bas-relief,** especially, the forms project only slightly from the background; in **high relief,** figures project by at least half their natural depth.

But **freestanding sculptures** have fronts, sides, backs, and tops. They invite the viewer to walk around them. Sometimes viewers may climb on them, walk through them, or, as in the case of a Calder mobile, look up at them from beneath. As we move about a sculpture, we are impressed by new revelations. The spaces or voids in and around the work may take on as much meaning as the sculpted forms themselves.

Two-dimensional art forms are not meant to be touched, but much of the pleasure of appreciating a sculpture derives from imagining what it would be like to run one's hands over sensuous curving surfaces of cool marble or hand-rubbed walnut. In many cases we may be prevented by ropes and guards—or by self-control—from touching sculptures, but many are made purposefully to be caressed. Some fool the eye, such as the "leather" jacket modeled from clay (see Fig. 11-2).

Recently developed forms of sculpture may interact with the viewer in other ways. The viewer may become involved in watching a kinetic sculpture run full cycle, or in trying to decipher just what the cycle is. Some kinetic sculptures and light sculptures may also literally be turned on and off, sometimes by the viewer.

Sculpture is a highly familiar medium. For thousands of years we have used sculpture to portray our visions of the gods, saints, and devils. Religious people in earlier times and some even now believe that their gods actually dwell within the stone they chisel or the wood they carve. We have carved and modeled the animals and plants of field and forest. We have exalted our heroes and leaders and commemorated our achievements and catastrophes in stone and other materials. The size of a sculpture has often been commensurate with the power ascribed to the hero or with the magnitude of the event. In addition to serving community and religious functions, sculptures are decorative. They adorn public buildings and parks. They sit on pedestals in walkways and stand in fountains, impervious to the spray, or perhaps contributing to the pool from the mouth or nether parts. Sculptures, of course, also serve as vehicles to express an artist's ideas and feelings.

In our discussion of sculpture, we will first distinguish between subtractive and additive sculpture and describe the techniques of each. Then we will examine the characteristics of a number of works that have been rendered in the traditional materials such as stone, wood, clay, and metal. Finally, we will explore several modern materials and methods, ranging from new metals and found objects to kinetic sculpture, light sculpture, and earthworks.

SUBTRACTIVE AND ADDITIVE TYPES OF SCULPTURE

Sculptural processes are either subtractive or additive. In a **subtractive process,** such as carving, unwanted material is removed. In the **additive processes** of modeling, casting, and constructing, material is added, assembled, or built up to reach its final form.

Carving

In **carving,** the sculptor begins with a block of material and cuts portions of it away until the desired form is created. Carving could be considered the most demanding type of sculpture because the sculptor, like the fresco painter, must have a clear conception of the final product at the outset. The material chosen—stone, wood, ivory—strongly influences the mechanics of the carving process and determines the type of creation that will emerge.

No painter ought to think less of sculpture than of painting
and no sculptor less of painting than of sculpture.

—Michelangelo

9-1 MICHELANGELO.
The Cross-Legged Captive
(c. 1530–1534).
Marble. H: 7'6½".
Galleria dell'Accademia, Florence. Copyright Scala/Art Resource, New York.

Modeling

In **modeling,** a pliable material such as clay or wax is shaped into a three-dimensional form. The artist may manipulate the material by hand and use a variety of tools. Unlike carving, in which the artist must begin with a clear concept of the result, in modeling the artist may work and rework the material until pleasing forms begin to emerge.

Casting

The transition from modeling to casting can be easily seen in Louise Bourgeois's *Portrait of Robert* (Fig. 9-2). Here the artist has expressionistically modeled a pliable material and

9-2 LOUISE BOURGEOIS.
Portrait of Robert (1969).
Cast bronze with white patina. 13″ × 12½″ × 10″.
Courtesy Cheim & Read, New York. Copyright Louise Bourgeois. Licensed by VAGA, New York.

Michelangelo believed that the sculptor liberated forms that already existed within blocks of stone. *The Cross-Legged Captive* (Fig. 9-1) is one of a series of unfinished Michelangelo statues in which the figures remain partly embedded in marble. In its unfinished state, the tension and twisting in the torso almost cause us to experience the struggle of the slave to free himself fully from the marble and, symbolically, from his masters. Despite the massiveness of the musculature, the roughness of the finish imparts a curious softness and humanity to the figure, which further increase our empathy. When we view this sculpture, it's as if we await the emergence of perfection from the imperfect—from the coarse and irregular block of stone. It is Michelangelo's genius that allows the figure to transcend its humble origins.

converted the work to the more permanent bronze medium through a casting process. The white patina she has applied to finish the sculpture curiously subverts the material's typical sheen and grants the work a claylike appearance—the very material with which the artist started.

In the **casting** process, a liquid material is poured into a **mold.** The liquid hardens into the shape of the mold and is then removed. In casting, an original model, made of a material such as wax, clay, or even Styrofoam, can be translated into a more durable material such as bronze. The mold is like a photographic negative, but one of form and not of color; the interior surfaces of the mold carry the reversed impressions of the model's exterior.

Any material that hardens can be used for casting. Bronze has been used most frequently because of its appealing surface and color characteristics, but concrete, plaster, liquid plastics, clay diluted with water, and other materials are also appropriate. Once the mold has been made, the casting may be duplicated a number of times.

The Lost-Wax Technique

Bronze casting is usually accomplished by means of the **lost-wax technique** (Fig. 9-3), which has changed little over the centuries. In this technique, an original model is usually sculpted from clay, and a mold of it is made, usually from sectioned plaster or flexible gelatin. Molten wax is then brushed or poured into the mold to make a hollow wax model. If the wax has been brushed onto the inner surface of the mold, it will form a hollow shell. If the wax is to be poured, a solid core can first be placed into the mold and the liquid wax poured around the core. After the wax hardens, the mold is removed, and the wax model stands as a

hollow replica of the clay. The hollow wax model is placed upside down in a container, and wax rods called **gates** are connected to it. Then a sandy mixture of silica, clay, and plaster is poured into and around the wax model, filling the shell and the container. The mixture hardens into a fire-resistant mold, or **investiture.** Thus, the process uses two models and two molds: models of clay and wax, and molds of plaster or gelatin and of the silica mixture.

The silica mold, or investiture, is turned over and placed in a **kiln.** As the investiture becomes heated, the wax turns molten once more and runs out. Hence the term *lost-wax technique.* The investiture is turned over again while it is still hot, and molten bronze is poured in. As the metal flows into the mold, air escapes through the gates so that no air pockets are left within. The bronze is given time to harden. Then the investiture and core are removed, leaving the bronze sculpture with strange projections where the molten metal had flowed up through the gates as it filled the mold. The projections are removed, and the surface of the bronze is **burnished** or treated chemically to take on the texture and color desired by the sculptor, as we shall see in the following bronze sculptures.

A statue by the French Impressionist Edgar Degas has an interesting history and metamorphosis from wax to bronze. As Degas grew blind, he turned to sculpture so that he could work out anatomical problems through the sense of touch. With one exception, his wax or clay experiments were left crumbling in his studio or discarded, although the intact figures were cast as a limited edition of bronze sculptures after his death. The exception was *The Little Dancer* (Fig. 9-4), which he showed as a wax model at the 1881 Impressionist exhibition and later cast in bronze. This diminutive painted wax figure startled the public and critics alike with its innovative sculptural realism: It sported real hair,

9-3 The lost-wax technique.

9-4 EDGAR DEGAS.
The Little Dancer, 14 Years Old
(1880–1881).
Bronze. H: 39″.
Copyright Sterling and Francine Clark
Art Institute, Williamstown, MA.

Plaster is an incredible recorder of what is there, more effective to me than the movie camera.

— George Segal

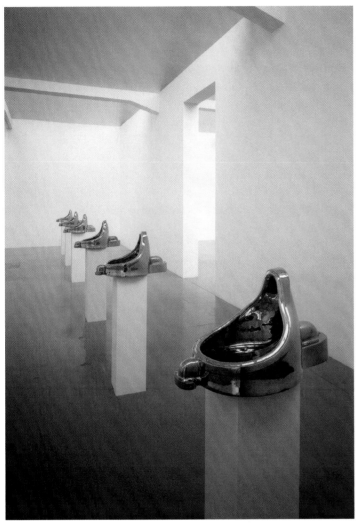

9-5 SHERRIE LEVINE.
Fountains after Duchamp (1991).
Bronze. Installation view at Sherrie Levine Exhibition
in the Zürich Kunsthalle (2.11.1991–3.1.1992),
Zürich, Switzerland.
Courtesy of the Jablonka Gallery, Köln, Germany.

a satin hair ribbon, a canvas bodice, and a tulle skirt. The styles of hair and clothing make the 14-year-old ballerina very much a product of her time and place.

Sherrie Levine's *Fountains after Duchamp* (Fig. 9-5) consists of a series of bronze urinals, turned on their backs and displayed on pedestals as if to invite serious study and contemplation. The urinals pay homage to Marcel

Duchamp's Dada masterpiece, *Fountain* (see Fig. 1-32), and in so doing, they represent what lies at the heart of Levine's artistic concept and strategy: the critical appropriation of objects and images that already exist in the visual lexicon of high art and mass culture. If Duchamp invested his ready-mades with a new *idea*—the reconsideration of ordinary objects in the artist's self-defined and self-imposed context of fine art—Levine's objects and reproductions are invested with a reconsideration of issues such as authorship and originality in relation to art making. Many contemporary artists come upon the art scene at a time when it seems that perhaps everything that can be done has been done. Some push to develop new styles, new subjects, new ways of conceptualizing and defining art. Sherrie Levine, the foremost representative of "appropriation art," embraces what she believes to be the reality of working during a time when the major accomplishments in modernism have already been recorded as history. Her point of departure seems to be "There is nothing new under the sun. Now where does that take me?"

Casting of Human Models

Three Figures and Four Benches (Fig. 9-6) by George Segal features intriguing variation on the casting process. Segal produced ghostlike replicas of human beings by means of

9-6 GEORGE SEGAL.
Three Figures and Four Benches (1979).
Painted bronze. 52″ × 144″ × 58″.
Theo Anderson, Allentown, PA.

plaster casts. Live models were covered in plaster-soaked cloth, which was molded and kneaded by the artist's hands. When the plaster was dry, the cast was removed in sections and then reassembled into whole figures. *Three Figures and Four Benches* was then cast in bronze, but the white surface of the original plaster cast was retained. Segal's figures are literally and figuratively shells. In unimaginable aloneness, his apparitions occupy an urban landscape of buses, gas stations, diners, and other settings. The amorphousness of the surface textures is not unlike that of the Nakian sculpture, placing the figures further into what seems a kind of limbo of contemporary life. Although the figures are connected by virtue of their common medium, they do not seem to speak to one another or interact in any way. They are at once connected and disconnected, sharing a place and time and yet lost in their inner worlds.

Construction

In construction, or **constructed sculpture,** forms are built from materials such as wood, paper and string, sheet metal, and wire. As we shall see in works by Picasso, Louise Nevelson, and other artists, traditional carving, modeling, and casting are abandoned in favor of techniques such as pasting and welding.

TYPES OF MATERIALS

Sculptors have probably employed every known material in their works. Different materials tend to be worked in different ways, and they can also create very different effects. In this section we will explore the varieties of ways in which sculptors have worked with the traditional materials of stone, wood, clay, and metal. In the section on modern and contemporary materials and methods, we shall see how sculptors have worked with nontraditional materials, such as plastic and light.

Stone

Stone is an extremely hard, durable material that may be carved, scraped, drilled, and polished. The durability that makes stone so appropriate for monuments and statues that are meant to communicate with future generations also makes working with stone a tedious process. The granite used by ancient Egyptians was extremely resistant to detailed carving, which is one reason that Egyptian stone figures were simplified and resemble the shape of the quarried blocks. The Greeks used their abundant white marble to embody the idealized human form in action and in repose. However, they painted their marble statues, suggesting that they valued the material more for its durability than for its color or texture.

The hand tools used with stone—such as the chisel, mallet, and **rasp**—have not changed much over the centuries. But contemporary sculptors do not find working with stone to be quite so laborious because they can use power tools for chipping away large areas of unwanted material and for polishing the finished piece.

The Stone Age *Venus of Willendorf* (see Fig. 12-2) has endured for perhaps 25,000 years. The same stone that lent such durability to this rotund fertility figure apparently pressed the technological limits of the sculptor. There are clues that the artist found the stone medium arduous. As with ancient Egyptian sculpture, the shape of the figurine probably adheres closely to that of the block or large pebble from which it was carved. The rough finish further suggests the primitive nature of the artist's flint tools.

It is a leap from the stone art of the Stone Age to the sculpture of, say, Michelangelo in *The Cross-Legged Captive* (Fig. 9-1) or the *David* (see Fig. 15-26). The *Captive,* like the *Venus,* does not stray far from the shape of the block or precariously extend its limbs. But except for the eternal nature of the *David,* the statue belies the nature of the material. The furrowed brow, the taut muscles, the veins in the hand all breathe life into the work.

The *Apollo and Daphne* (see Fig. 2-69) of the Italian Baroque sculptor and architect Gianlorenzo Bernini shows us yet more of the potential of marble. Marble can also capture the softness and sensuousness of flesh and the textures of hair, leaves, and bark. Observe the hundreds of slender projections, and imagine the intricacy of cutting away the obstinate stone to reveal them. In his *David* (see Fig. 15-27), Bernini portrays the moment in which the youth is twisting in preparation to fire the sling. David bites his marble lips; the muscles and veins of the left arm reflect the tightening of the hand; even his marble toes grip the rock beneath. When we view this sculpture, perhaps our own muscles tighten in empathy.

In *Eyes* (Fig. 9-7), by Louise Bourgeois, two precisely tooled spheres are perched atop a marble cube, some of which has been chiseled to create hollows and other irregularities. The carved circular openings in the spheres suggest

the penetrating pupils of eyes, a commonly used symbol among Surrealist artists (see Chapter 19). For Bourgeois, who often incorporated gender allusions in her work, the eyes may represent the female anatomy and the marble block, a house. The two strong shapes in contrast to each other may suggest a woman's relationship to her domestic role, a theme that Bourgeois revisited numerous times in her long career. Although Bourgeois's technique results in a finished work that remains close to the quarried marble block, the perfectly round "eyes," the polish of the surfaces, and the carved "interruptions" create a striking contrast between a deliberate absence and an assertive presence of the artist's hand.

Wood

Wood, like stone, may be carved, scraped, drilled, and polished. But unlike stone, wood may also be permanently molded and bent. Under heat, in fact, plywood can be bent to take on any shape. Wood, like stone, varies in hardness and grain, but it is more readily carved than stone.

Although wooden objects may last for many hundreds of years, wood does not possess the durability of stone and tends to warp and crack. But wood appeals to sculptors because of its grain, color, and workability. Wood is warm to the touch, whereas stone is cold. When polished, wood is sensuous. Wood's **tensile strength** exceeds that of stone, so

9-7 LOUISE BOURGEOIS.
Eyes (1982).
Marble. 74¾″ × 54″ × 45¾″.

The Metropolitan Museum of Art, New York. Anonymous gift (1986.397). Licensed by VAGA, New York. Photograph copyright 1987 The Metropolitan Museum of Art. Copyright Louise Bourgeois.

The Vietnam Veterans Memorial— A Woman's Perspective

It terrified me to have an idea that was solely mine to be no longer a part of my mind, but totally public.

—Maya Ying Lin, on her design for the Vietnam Veterans Memorial in Washington, D.C.

When we view the expanses of the Washington Mall, we are awed by the grand obelisk that is the Washington Monument. We are comforted by the stately columns and familiar shapes of the Lincoln and Jefferson memorials. But many of us do not know how to respond to the two 200-foot-long black granite walls that form a V as they recede into the ground. There is no label—only the names of 58,000 victims chiseled into the silent walls:

> *As we descend along the path that hugs the harsh black granite, we enter the very earth that, in another place, has accepted the bodies of our sons and daughters. Each name is carved not only in the stone, but by virtue of its highly polished surface, in our own reflection, in our physical substance. We are not observers, we are participants. We touch, we write [letters to our loved ones], we leave parts of ourselves behind. This is a woman's vision—to commune, to interact, to collaborate with the piece to fulfill its expressive potential. . . .*
>
> *Maya Ying Lin has foregone the [format of the triumphal monument]. She has given us [the earth mother] Gaea, who, pierced by the ebony scar of suffering death, takes back her children, as she has done since the dawn of humanity.** *

This is Maya Ying Lin's Vietnam Veterans Memorial (Fig. 9-8), completed in 1982 on a two-acre site on the Mall. In order to read the names, we must descend gradually into the earth, and then just as gradually work our way back up. This progress is perhaps symbolic of the nation's involvement in Vietnam. As did the war it commemorates, the eloquently simple design of the memorial also stirs controversy.

This dignified understatement in stone has offended many who would have preferred a more traditional memorial. One conservative magazine branded the design a conspiracy to dishonor the dead. Architecture critic Paul Gapp of *The Chicago Tribune* argued, "The so-called memorial is bizarre . . . neither a building nor sculpture." One Vietnam veteran had called for a statue of an officer offering a fallen soldier to heaven. The public expects a certain heroic quality in its monuments to commemorate those fallen in battle. Lin's work is antiheroic and antitriumphal. Whereas most war monuments speak of giving up our loved ones to a cause, her monument speaks only of giving up our loved ones.

9-8 MAYA YING LIN.
Vietnam Veterans Memorial, Washington, DC (1982).
Polished black granite.
L: 492′.
Copyright Maya Ying Lin and Bluffton Educational College.

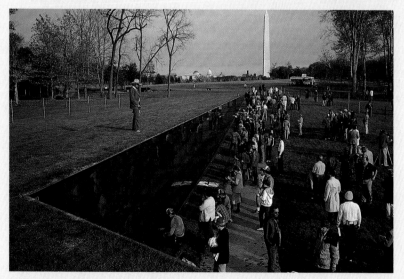

How did the Vietnam Memorial come to be so uniquely designed? It was chosen from 1,421 entries in a national competition. The designer, Maya Ying Lin, is a Chinese American woman who was all of 22 years old at the time she submitted her entry. A native of Ohio, Lin had just graduated from Yale University, where she majored in architecture. Lin recognized that a monumental sculpture or another grand building would have been intrusive in the heart of Washington. Her design meets the competition criteria of being "neither too commanding nor too deferential" and is yet another expression of the versatility of stone. ■

*Lois Fichner-Rathus, "A Woman's Vision of the War," *The New York Times,* August 18, 1991, H6.

projecting wooden parts are less likely than their stone counterparts to break off. In recent years, wood has also become commonly used in assemblages.

The capacity of wood to yield beautiful, rough-hewn beauty is shown in the mask called *Kagle* (Fig. 9-9), by a sculptor of the African Dan people. The Dan of Sierra Leone, the Ivory Coast, and Liberia have carved masks for use in rituals and celebrations. Some Dan masks are polished and refined; others are intentionally crude. *Kagle* is a powerful work of thrusting and receding planes. The abstracted, geometric voids are as commanding as the wooden form itself. Such a mask is believed to endow its wearer with the powers of the bush spirits and is an essential element in the garb of tribal law-enforcement officers.

British sculptor Barbara Hepworth's abstraction *Two Figures* (see Fig. 4-8) is carved from elm wood. Hepworth pierces solid masses to give contour to negative shapes. The concavities, which are painted white, and the voids in her carved figures have as much "shape-meaning"—to use Henry Moore's term—as the solids. The viewer feels the urge to identify each form as male or female, but the sculp-

9-10 PO SHUN LEONG. *Figure* (1993). Mahogany with hidden drawers. H: 50″.
Courtesy of the artist.

9-9 Poro Secret Society mask (*Kagle*). Liberian, Dan people. Wood. H: 9″.
Yale University Art Gallery. Gift of Mr. and Mrs. James Osborn.

tural "evidence" is too scant to allow such classification. At first glance it might seem that a similar artistic effect could have been achieved by carving these figures from marble, but the wood grain imparts a warmth to the surface that would not have been attained in marble. Also, the painting of the concavities lends them a "durability" and hardness not found in the outer surface. Ironically, the voids attain more visual solidity than the outer surfaces.

There is an implied massiveness to both the *Kagle* mask and Hepworth's *Two Figures*. But wood can also be used to create figures and forms of great complexity, delicacy, and intricacy. The rich mahogany surfaces of Po Shun Leong's *Figure* (Fig. 9-10) have been polished, carved, striated, and gouged. There is a restlessness to the patterns, which, coupled with a host of hidden drawers punctuating the form—some open, some closed—creates a sense of constant motion.

One starts to get young at the age of sixty and then it is too late.

—Pablo Picasso

Clay

Clay is more pliable than stone or wood. The modeling of clay is personal and direct; the fingerprints of the sculptor may be found in the material. Children, like sculptors, enjoy the feel and smell of clay.

Unfortunately, clay has little strength, and it is not usually considered a permanent material, even though an **armature** may be used to prevent clay figures from sagging. Because of its weakness, clay is frequently used to make three-dimensional sketches, or models, for sculptures that are to be executed in more durable materials. As was noted earlier, clay models may be translated into bronze figures. In ceramics, clay is fired in a kiln at high temperatures so that it becomes hardened and nonporous. Before firing, clay can also be coated, or glazed, with substances that provide the ceramic object with a glassy monochromatic or polychromatic surface.

Metal

Metal has been used by sculptors for thousands of years. Metals have been cast, **extruded, forged, stamped,** drilled, filed, and burnished. The process of producing cast bronze sculptures has changed little over the centuries. But in recent years artists have also assembled **direct-metal sculptures** by welding, riveting, and soldering. Modern adhesives have also made it possible to glue sections of metal together into three-dimensional constructions.

Different metals have different properties. Bronze has been the most popular casting material because of its pleasing surface and color characteristics. Bronze surfaces can be made dull or glossy. Chemical treatments can produce colors ranging from greenish blacks to golden or deep browns. Because of oxidation, bronze and copper surfaces age to form rich green or greenish blue **patinas.**

The French artist Auguste Rodin is considered by many to be the greatest sculptor of the nineteenth century. Nevertheless, Rodin's *The Walking Man* and similar sculptural fragments were not well received in his day because they have an unfinished look. They were not incomplete, of course. Instead, they reflected Rodin's obsession with the correct rendition of anatomical parts.

MODERN AND CONTEMPORARY MATERIALS AND METHODS

Throughout history sculptors have searched for new forms of expression. They have been quick to experiment with the new materials and approaches that have been made possible by advancing technology. During the past century, technological changes have overleaped themselves, giving rise to new materials, such as plastics and fluorescent lights, and to new ways of working traditional materials.

In this section we will explore a number of new materials and approaches, including constructed sculpture, assemblage, readymades, mixed media, light sculpture, kinetic sculpture, and earthworks. Although the search for novelty has been exhausting, this list is by no means exhaustive.

Constructed Sculpture

In constructed sculpture the artist builds or constructs the sculpture from materials such as cardboard, celluloid, translucent plastic, sheet metal, or wire, frequently creating forms that are lighter than those made from carving stone, modeling clay, or casting metal. Picasso inspired a movement in this direction with works such as *Mandolin and Clarinet* (Fig. 9-11). As critic Robert Hughes remarked, such works were "everything that statues had not been: not monolithic, but open, not cast or carved, but assembled from flat planes."[1] In spirit and style, reliefs from this era were very close to Picasso's paintings. But the unorthodox materials—wood, sheet metal, wire, found objects—challenged all traditions in art making. Sculpture would never be the same.

A Russian visitor to Picasso's Paris studio, Vladimir Tatlin, is credited with having realized the three-dimensional potential of constructed sculpture, which was then further developed in Russia by the brothers Antoine Pevsner and

[1] Robert Hughes, "The Liberty of Thought Itself," *Time,* September 1, 1986, 87.

I began using found objects. I had all this wood lying around
and I began to move it around, I began to compose.

—Louise Nevelson

Naum Gabo. Naum Gabo's *Column* (see Fig. 19-17) epitomizes the ascendance of form and space over mass that is characteristic of many constructed sculptures. Gabo's translucent elements transform masses into planes that frame geometric voids. "Mass" is created in the mind of the viewer by the empty volumes.

Pop artist Claes Oldenburg's *Soft Toilet* (Fig. 9-12) is constructed of vinyl, kapok, cloth, and Plexiglas. Our sensibilities are challenged in a lighthearted work: A familiar object that we know to be hard, cold, and unmovable is rendered soft, supple, and pliable—and certainly unusable.

Assemblage

Assemblage is a form of constructed sculpture in which preexisting, or found, objects, recognizable in form, are integrated by the sculptor into novel combinations that take on

9-11 PABLO PICASSO.
Mandolin and Clarinet (1913).
Wood construction and paint.

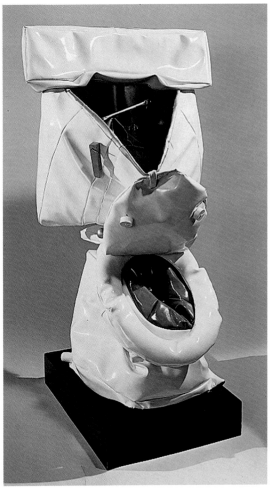

9-12 CLAES OLDENBURG.
Soft Toilet (1966).
Vinyl filled with kapok painted with Liquitex, and wood.
$57\frac{1}{16}'' \times 27\frac{5}{8}'' \times 28\frac{1}{16}''$.

9-13 LOUISE NEVELSON.
Red Tide IV (1960).
Wood, with gold-spray technique.
323 cm × 446 cm × 55 cm.
Rheinisches Bildarchiv, Köln, Germany.
Copyright 2003 Estate of Louise Nevelson/
Artists Rights Society (ARS), New York.

a life and meaning of their own. American artist Louise Nevelson's *Red Tide IV* (Fig. 9-13), like many of her wooden sculptures, is a compartmentalized assemblage of rough-cut geometric shapes and lathed wooden objects with previous lives, such as finials. Similar assemblages include banal objects such as bowling pins, chair slats, and barrel staves and may be painted white or black, as well as gold.

Why walls? Nevelson explains:

I attribute the walls to this: I had loads . . . and loads of creative energy. . . . So I began to stack my sculptures into an environment. . . . I think there is something in the consciousness of the creative person that adds up, and the multiple image that I give, say, in an enormous wall gives me so much satisfaction.[2]

The overall effect of Nevelson's collections is one of nostalgia and mystery. They suggest the pieces of the personal and collective past, of lonely introspective journeys among the cobwebs of Victorian attics—of childhoods that never were. Perhaps they are the very symbol of consciousness, for what is the function of intellect if not to impose order on the bits and pieces of experience?

Nature is the point of departure for Betye Saar's *Ancestral Spirit Chair* (Fig. 9-14). In a work that was influenced by Saar's African ancestry and tribal beliefs concerning ancestor worship, the artist combines remnants of nature and common objects of human existence. The chair is constructed of tree branches that have been sawed, shaped, or left in their natural state, reaching skyward like fingers on a hand. These "fingertips" are capped by a collection of glass saltshakers, and other found objects make their appearance here and there. The chair's surface is adorned with rhythmic white markings suggesting the body painting common to some African peoples. It is a curious piece, inviting, yet seeming to welcome only those who belong.

Perhaps the best-known assemblage is Picasso's *Bull's Head* (Fig. 9-15). Consisting of the seat and handlebars of an old bicycle, the work possesses a rakish vitality. It is immediately and whimsically recognizable as animal—so much so that on first impression, its mundane origins are obscured.

Readymades

The assemblages of Nevelson and Picasso are constructed from found objects. Early in the twentieth century Marcel Duchamp declared that found objects, or readymades, such as bottle racks and urinals, could be literally elevated as works of art by being placed on pedestals—literally or figuratively. No assembly required. The urinal in Figure 1-32— appropriated some 80-plus years later by Sherrie Levine for

[2] Louise Nevelson, *Louise Nevelson: Atmospheres and Environments* (New York: C. N. Potter in association with the Whitney Museum of American Art, 1980), 77.

Mixed Media

In **mixed-media** constructions and assemblages, sculptors use materials and ready-made or found objects that are not normally the elements of a work of art. Contemporary painters also sometimes "mix" their media by attaching objects to their canvases. Robert Rauschenberg, discussed in Chapter 19, has attached ladders, chairs, and electric fans to his paintings and run paint over them as if they were continuations of the canvas. What do we call the result—painting or sculpture?

9-14　BETYE SAAR.
Ancestral Spirit Chair (1992).
Painted wood, bone, glass, plastic, metal, and vine.
60″ × 46″ × 32″.
Smith College Museum of Art, Northampton, MA. Purchased 1992.

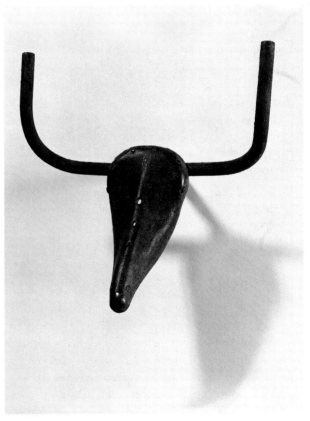

9-15　PABLO PICASSO.
Bull's Head (1943).
Bronze cast of parts of a bicycle. H: 16⅛″.
Réunion des Musées Nationaux, France. Copyright Réunion des Musées Nationaux/Art Resource, New York. Copyright 2003 Estate of Pablo Picasso/Artists Rights Society (ARS), New York.

her *Fountains after Duchamp* (Fig. 9-5)—was turned on its back, put into a new context, and given the title *Fountain*. These adjustments were said by the artist to invest the object with a new *idea*. Duchamp argued that the dimension of taste, good or bad, was irrelevant. The function of the readymade—not that it needed one—was to prompt the spectator to think, and to think again.

Duchamp recognized that artists could take advantage of the concept of the ready-made object and substitute cleverness for solid work should the "making" of readymades become a habit. For this reason Duchamp advised that artists elevate common objects to the realm of art only a few times each year.

9-17 GEORGE RICKEY.
Cluster of Four Cubes (1992).
Stainless steel.

National Gallery of Art Sculpture Garden, Washington, DC. Gift of George Rickey and Patrons' Permanent Fund 1992. Copyright Estate of George Rickey. Licensed by VAGA, New York.

9-16 SIMON RODIA.
Simon Rodia Towers in Watts (1921–1954).
Cement with various objects. H: 98′.

Cultural Affairs Department, Los Angeles.
Copyright Nik Wheeler/CORBIS/RM.

patterns of contrasting and harmonious colors. The towers took 33 years to erect and were built by Rodia's own hands. Rodia, by the way, knew nearly nothing of the world of art.

The sculptural environment known as the *Simon Rodia Towers in Watts* (Fig. 9-16) was constructed by an Italian-born tile setter who immigrated to Watts, a poor neighborhood in Los Angeles. Rodia's whimsical towers are built sturdily enough—of cement on steel frames, the tallest one rising nearly 100 feet. As a mixed-media assemblage, the towers are coated with debris, such as mirror fragments, broken dishes, shards of glass and ceramic tile, and shells. The result is a lacy forest of spires that glisten with magical

Kinetic Sculpture

Sculptors have always been concerned with the portrayal of movement, but **kinetic sculptures** actually do move. Movement may be caused by the wind, magnetic fields, jets of water, electric motors, variations in the intensity of light, or the active manipulation of the observer. During the 1930s, the American sculptor Alexander Calder was one of the early pioneers of the first form of art that made motion as basic an element as shape or color—the mobile. As in his monumental mobile in the East Wing of the National Gallery of

I just enjoy making people have to rethink what painting and sculpture are.

—Michael Hayden

We all have a need to decorate Mother Nature because it all belongs to us.

—Marco Evaristti

Art (see Fig. 2-67), carefully balanced weights are suspended on wires such that the gentlest current of air sets them moving in prescribed orbits.

George Rickey's welded, stainless steel cubes bear the mark of Calder's mobile constructions. Much of the work of both artists responds to the flow of currents of air. In

Rickey's *Cluster of Four Cubes* (Fig. 9-17), burnished steel "boxes" are attached by ball bearings to arms that branch from a trunklike post. The cubes are weighted and balanced to turn effortlessly in light breezes.

Light Sculpture

Natural light has always been an important element in defining sculpture, but only in the past century did sculptors begin to experiment with the use of artificial light in their compositions. Their concern has been with the physical and psychological effects of color and, at times, with the creation of visual illusions.

For more than three decades Michael Hayden has used light in his "Lumetric" sculptures, some of which have been hundreds of feet long and weighed many tons. *Arpeggio* (Fig. 9-18) was commissioned by the Nashville Airport Authority to illuminate the pathway that leads to the terminal. The work consists of two pairs of tapered helixes (spirals) that are illuminated with LED (light-emitting diode) sections of blue, red, green, and amber. The artist has written about his fascination with iridescence in nature—from the skin of the mahi-mahi to butterfly wings and the fine-feathered throats of hummingbirds—and his attempt to emulate or at least suggest this phenomenon in his works.

Land Art

Land art is site-specific work that is created or marked by an artist within natural surroundings. Sometimes large amounts of earth or land are shaped into sculptural forms, as in the **earthworks** of the 1960s and 1970s. These works could be temporary or permanent and included great trenches and drawings in the desert, collections of rocks, shoveled rings in ice and snow, and even installations of mounds of dirt on floors of the urban galleries. Robert

9-18 MICHAEL HAYDEN.
Arpeggio (2000).
Work (light sculpture) installed at the Metro Nashville Airport.
Copyright Michael Hayden. New York.

9-19 ROBERT SMITHSON.
Spiral Jetty, Great Salt
Lake, Utah (1970).
Black rocks, salt, earth,
water, and algae.
L: 1500′; W: 15′.

Copyright Estate of Robert
Smithson. Licensed by VAGA,
New York.

9-20 MARCO EVARISTTI.
The Ice Cube Project (2004).
Red dye and seawater,
Greenland coast.

EPA/HO/Landov.

*The body is our common denominator for our pleasures and our sorrows.
I want to express through it who we are, how we live and die.*

—Kiki Smith

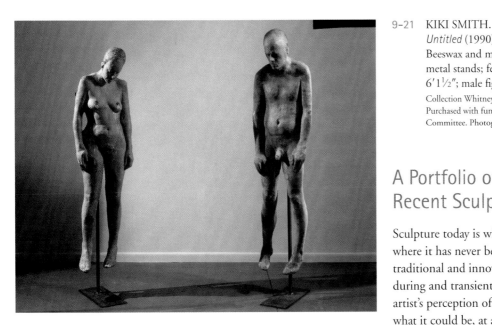

9-21 KIKI SMITH.
Untitled (1990).
Beeswax and microcrystalline wax figures on metal stands; female figure installed height 6′1½″; male figure installed height 6′4¹⁵⁄₁₆″.
Collection Whitney Museum of American Art, New York. Purchased with funds from the Painting and Sculpture Committee. Photograph by Jerry L. Thompson.

A Portfolio of More Recent Sculpture

Sculpture today is where it has always been and where it has never been before. It has always been traditional and innovative; it has always been enduring and transient. It has always represented the artist's perception of what art is, or conception of what it could be, at any given time in history.

Figurative sculpture, for example, is alive and well as we cross into the third millennium. The figures in Kiki Smith's *Untitled* (Fig. 9-21) are hung up, hanging down, hanging around—perhaps being hung out to dry. There is something about them—the hang-dog faces, even the body shapes that makes them sort of "now," but they are not all there, or anywhere.

The artist's realism is, in a sense, more realistic than realism has ever been—even when compared to the "Photorealism" of artists such as Duane Hanson (see Fig. 20-29). The realism in Kiki Smith's couple is almost too painful to observe, too close to the realities of our own physical selves. Smith notes, "Most of the functions of the body are hidden . . . from society," and she thus has aimed to bring them out into the open. Smith has focused her artistic eye on body parts and body by-products; one of her installations consisted of jars filled with bodily fluids from saliva to blood, reflecting her experience as an emergency medical service technician in New York City. In their superrealistic state of age and deterioration, the individuals in Smith's untitled work have lost control over emission of bodily fluids. The woman's figure is stained with, or drained of, milk that drips from her nipples. Semen drips down the man's leg. They are suspended in space, isolated in their loss of control, sharing the frailties of the human condition.

Smithson's *Spiral Jetty* (Fig. 9-19) is composed of rocks and earth bulldozed into a spiral formation in Utah's Great Salt Lake. Over time, salt deposits and algae have accumulated on the jetty, which lay underwater for many years. With a prolonged drought, the jetty began to reemerge in 1999.

Art that "makes marks" in nature is often temporary, however. In March 2004, Danish artist Marco Evaristti set sail in two icebreakers to find the perfect "frozen canvas" among the icebergs off the coast of Greenland. For two hours, a crew of 20 sprayed 780 gallons of red dye onto an almost 10,000-square-foot iceberg (Fig. 9-20). The dye, diluted with seawater, was the same that is used for tinting meat. Evaristti's work can be found—for the time being, at least—near Ilullissat (which means "icebergs" in the Greenlandic language), a town of 4,000 that is popular among tourists for its spectacular and *artistic* scenery.

Christo and Jeanne-Claude: *The Gates, Central Park, New York City, 1979–2005*

As if intentionally timed to shake New York City out of its winter doldrums, 7,503 sensuous saffron panels were gradually released from the tops of 16-foot-tall gates along 23 miles of footpaths throughout Central Park. It was the morning of February 12, 2005—a date that marked the end of artists Christo and Jeanne-Claude's 26-year-long odyssey to bring a major project to their adopted city. For a brief 16 days, the billowy nylon fabric fluttered and snapped and obscured and enframed our favorite park perspectives (Fig. 9-22). Olmsted's and Vaux's majestic plan of ups and downs, of lazy loops and serpentine curves, was being seen or reseen for the first time as we—the participants—wove our walks according to the patterns of the gates. The artists have said that "the temporary quality of their projects is an aesthetic decision," that it "endows the works of art with a feeling of urgency to be seen." For a brief 16 days, it was clear from the crowds in a winter park, from the constant cluster of buses at the 72nd Street entrance, and from the rubbernecking traffic on the streets and avenues bordering the park that the urgency of which Christo and Jeanne-Claude speak was very real.

As with all of artists Christo and Jeanne-Claude's works of environmental art, every aspect of *The Gates* project was financed and fought for by the artists themselves. They developed the concept for *The Gates* back in 1979, but their first proposal to the city in 1981 was rejected. Mayor Michael R. Bloomberg granted permission for the 2005 version of the project on January 22, 2003. The "vital statistics" of *The Gates, Central Park, New York City, 1979–2005,* are staggering. Placed at 12- to 15-foot intervals, 7,503 vinyl gates, 16 feet high, varying in width from 5 feet 6 inches to 18 feet, covered 23 miles of footpaths (Fig. 9-23). The free-hanging, saffron-colored fabric panels dropped from the top of each rectangular vinyl gate to 7 feet

9-22 CHRISTO AND JEANNE-CLAUDE.
The Gates, Central Park, New York City (1979–2005).
Andrew Gombert/EPA/Landov.

9-23　Aerial view of *The Gates* in Central Park with Manhattan skyline.
Photograph by Andrea Mohin / The New York Times.

above the ground—just low enough for small children on their father's shoulders to sneak a touch. The project required more than 1 million square feet of vinyl and 5,300 tons of steel. Hundreds of paid volunteers assembled, installed, maintained, and removed the work, and most of the materials were to be recycled. The estimated cost of the project—borne by the artists alone—was $20 million.

The artists finance their environmental sculptures, which have included *Wrapped Reichstag, Berlin, 1971–95; Surrounded Islands, Biscayne Bay, Greater Miami, Florida, 1980–83; Running Fence, Sonoma and Marin Counties, California, 1972–76;* and others, by selling preparatory drawings and early works by Christo. Much of the funds thus accumulated have been used to cover the cost of the materials used in the project, to pay workers, and, when necessary, for legal fees to combat suits brought by concerned environmentalists (as was the case with the *Running Fence* project).

The environmental art projects of artists Christo and Jeanne-Claude have been seen by millions, who have been enticed to experience their familiar surroundings with a heightened sensibility. Like the artists, I, too, live in New York City. I walked *The Gates* many times over 16 days, with each group of family members and friends who made the pilgrimage. As I read the artists' response to the question, Why was it so important to realize this work in Central Park? ("When our son was a little boy, we used to take him to Central Park every day—he loved to climb the beautiful rocks. Central Park was a part of our life."), I thought of my own daughter, whose school holds gym class on the park's Great Lawn. The Central Park that she will remember as a part of her life growing up in New York will forever include the 16 days when, in clear and in cold and a glorious snowfall, a "golden river" snaked through a barren winter scene, lighting the landscape with flashes of color. ■

I decided to open up the continuum of space. I wanted to remove the work from the limitations of the object, or the definition of the specific object.

—Richard Serra

9-24 JANINE ANTONI.
Chocolate Gnaw (1992).
Chocolate (600 lb before biting), gnawed by the artist.
24″ × 24″ × 24″ (61 cm × 61 cm × 61 cm).
Collection of the Museum of Modern Art, New York. Photo by Brian Forest. Courtesy of the artist and Luhring Augustine, New York.

9-25 SYLVIE FLEURY.
Dog Toy 3 (Crazy Bird) (2000).
Styrofoam, paint. 260 cm × 210 cm × 180 cm.
Courtesy of Mehdi Chouaki.

Janine Antoni's *Chocolate Gnaw* (Fig. 9-24) may be overall reminiscent of a minimalist cube by an artist such as Donald Judd or Tony Smith, but it holds some sensory surprises: Antoni's medium is chocolate, and her sculptural tools consist of what nature has endowed her with—a good set of teeth. The artist's gesture, signature, the art-making process itself, even the "gnawing" question "Is it art?"—so long a part of the critical evaluation of works of art—take on new meaning. Add to that the issue of whether the work is in good taste.

Sylvie Fleury's *Dog Toy 3 (Crazy Bird)* (Fig. 9-25), like Antoni's *Chocolate Gnaw,* seems part and parcel of the "why not" school of contemporary art media. Permanence is clearly not a goal. Chocolate will melt in your mouth or, with a bit of heat, into a nondescript and gooey pool. Neither does Styrofoam endure like the marble of "eternal" works; it can be dented with the point of a pencil, violated with the pressure of a thumb, bitten into to form a perfect impression. Fleury takes a familiar, nonthreatening, squeaky toy animal and raises it to the same nightmarish proportions

that turned the smiling marshmallow man in the film *Ghostbusters* into a menacing monster crushing everything in his wake. Fleury invaded the art world in the 1990s with her series of *Shopping Bags*—installations of designer-labeled bags that appeared to have been left by visitors on the floors of galleries after a day of binge buying in upscale clothing stores. In the tradition of the "bad boy–bad girl" artist, Fleury elevated consumer readymades to art objects as Andy Warhol had done some 30 years earlier.

Nothing could be further removed from Sylvie Fleury's whimsical but clearly identifiable *Dog Toy 3 (Crazy Bird)* than Richard Serra's extraordinary permanent installation of

eight bent-steel sculptures (Fig. 9-26) at the Guggenheim Museum in Bilbao, Spain (see Fig. 2-21). Like Christo and Jeanne-Claude's environmental art, Serra's work is intended to be walked into, around, and through—intended to be experienced rather than viewed. The sheets of steel might enclose the visitor in a protected, almost private space or lead that same visitor, by way of an undulating path, to a more public, socially interactive space. Serra seems to have met his professed goal of "opening up the continuum of space." The mass is solid and the texture is tough, but the concept seems to reflect a nonmaterial realm—a gateway to something other within the real worlds we traverse every day. Unlike the transient "stuff" of Styrofoam—good for packing objects in cartons, useful for holding a cup of coffee—Serra's massive steel pieces convey an instant sense of eternity.

For decades, Richard Serra has been listening to the nature of one of his favorite materials—steel—and using it to create minimalist (in form, certainly not in scale) sculptural objects that express its powerful physical qualities. Like most of the Bilbao installation, many of his works have been monumental in size and site specific. But unlike infamous early pieces such as his *Tilted Art,* which was designed specifically for Foley Square in New York City and was removed shortly after installation because it hampered the progress of pedestrians, the Bilbao works represent an aesthetic whose time has come. Serra's steel surfaces grow more richly textured as time and oxidation work their effects upon them, serving as an apt metaphor for the effect on the visitor's memory that the experience of the installation might have.

In the next chapter we will turn our attention to the shaping of materials into structures that house our work, our play, our family life, our worship, and our sleep—architecture.

9-26　RICHARD SERRA.
Installation view, Guggenheim Museum, Bilbao, Spain.
Photograph by Vincent West/Reuters/Landov.

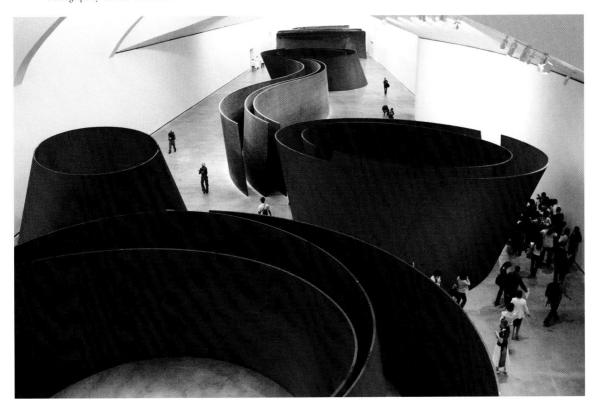

ART TOUR

New York

FRANK LLOYD WRIGHT, Guggenheim Museum.
Rafael Macia/PR.

When we look at New York and the arts, the Big Apple is the big show. For the performing arts—theater and music and dance—there's nothing like Broadway and Lincoln Center.

In terms of the visual arts, New York is renowned, and rightly so, for its museums and architecture, and for its public art, including Central Park and statues popping up everywhere. The Metropolitan Museum of Art houses one of the greatest and broadest collections in the world, including Egyptian, Greek and Roman, Asian, Islamic, Pacific Island, European, American, and contemporary art (which, of course, comes from anywhere and everywhere).

Even the most reluctant museumgoer will be charmed by the nineteenth-century European collection, which includes great paintings by the likes of Cézanne, Monet, Manet, Renoir, Degas, and van Gogh, and sculpture by Rodin. In the contemporary wing, you'll find paintings by Jackson Pollock, Georgia O'Keeffe, and Andy Warhol, for example. During the summer months, the roof of the Met is an outdoor sculpture garden. Take the elevator up for the art and for grand views of Central Park and the city. The main museum sits on Fifth Avenue, within Central Park, in the lower 80s. The Cloisters, which is part of the Met, is devoted to European medieval art and architecture and is located in northern Manhattan's Fort Tryon Park, which seems like a Manhattan island untouched by civilization.

Frank Lloyd Wright's Solomon R. Guggenheim Museum sits across Fifth Avenue from Central Park, about 10 blocks up from the Met, in New York's "Museum Mile." The main exhibition hall houses transient exhibitions. Marcel Breuer's Whitney Museum of American Art is found on Madison Avenue, which parallels Fifth Avenue, one block east, at 75th Street. The Whitney is devoted to American art, and its exhibitions include some of the edgiest and most controversial art in New York. My youngest daughter was captivated by Tony Oursler's *Getaway #2,* which was lying on the floor, repeatedly asking "Are you lookin' at me?" and cursing museumgoers. You can catch lunch in any of these museums.

The Museum of Modern Art (MOMA) has recently undergone a major renovation. The collection of the MOMA contains many familiar and beloved works, works not to be missed: van Gogh's *Starry Night* (Fig. 18-27), Rousseau's *The Sleeping Gypsy* (Fig. 2-33), Picasso's *Les Demoiselles d'Avignon* (Fig. 2-22), Chagall's *I and the Village* (Fig. 1-14), Boccioni's *Dynamism of a Soccer Player* (Fig. 2-73), Dalí's *The Persistence of Memory* (Fig. 19-28), Pollocks, Monets, and . . . the list is, for all practical purposes, endless.

There are almost too many other museums and art galleries to mention. The Morgan Library on Madison Avenue in midtown contains one of the few remaining copies of the Gutenberg Bible (dated 1455). When visiting Harlem, check out the exhibitions at the Studio Museum on 125th Street. The Museo del Barrio is on Fifth Avenue in the 100s (don't forget the charming garden within Central Park across from the Museo). As you're heading back down Fifth Avenue toward the 90s and the Museum Mile, you will find it worthwhile to visit the Jewish Museum and the Cooper-Hewitt National Design Museum. Down in the 70s, past the Met, you'll find the Frick Collection.

New York is also an architecture buff's dream. The Guggenheim and Whitney Museums are to be appreciated as works of art themselves, not just as houses for art. Some of the churches of the city are, well, divine, including the Cathedral of St. John the Divine, on Amsterdam Avenue and

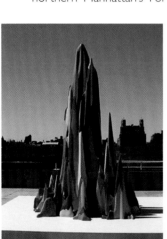

SOL LEWITT, *Splotch #15,* on the roof at the Met.
© 2005 Sol LeWitt/Artists Rights Society (ARS), New York.

THE WHITNEY MUSEUM OF AMERICAN ART.
Jeff Goldbert/Esto.

112th Street. This is the largest cathedral in the world (really), and St. Patrick's Cathedral, on Fifth Avenue at 50th Street, is the largest Catholic cathedral in the United States. The Cathedral of St. John the Divine was begun in 1892 and is about two-thirds finished.

When (and if) sufficient funds are raised, completion will require only about another half century. It is a very people- and environment-oriented cathedral, with chapels containing children's art and fish tanks that illustrate the ecology of the Hudson River.

New York is looking up. That is, visitors to New York are always looking up. Look for the Art Deco stainless steel spire of the Chrysler Building (Lexington Avenue at 42nd Street), which resembles the grille of a car of the 1920s (its gargoyles resemble hood ornaments). It's worth a visit to check out the Art Deco doors of the elevators. The Empire State Building, at Fifth Avenue and 34th Street, provides wonderful views of the city. (King Kong enjoyed a visit to the top in 1933.) If you walk up Park Avenue from midtown, you'll come across the famed Waldorf Astoria Hotel; the Byzantine St. Bartholomew's Church (St. Bart's), with its wonderful ornate detail and gold dome; and prime examples of the steel-cage architecture of the 1950s, Lever House (Fig. 10-15) and the Seagram Building.

Do not forget to spend time in Central Park, one of the city's greatest works of art, regardless of the time of year. It's never too hot to sunbathe or too cold to enjoy the Wolman Skating Rink or a horse-drawn carriage ride (there are blankets in the carriages). Designed by Frederick Law Olmsted, the park is a rectangular strip of grass, trees, hills, and lakes some 21.2 miles long (running from 59th Street to 110th Street) and almost a mile wide (running from Fifth Avenue to Central Park West, which is the equivalent of Eighth Avenue). It forms the geographical and spiritual heart of Manhattan. Museums and other landmarks line its edges. Joggers circle the reservoir, young (and old) children guide miniature yachts in the sailboat pond, animals stretch and growl in the zoo, and lovers meander along its paths. New Yorkers pay a premium for apartments with a view of the park. Multiple roadways pass above and below one another so that through traffic, pedestrian walkways, and bridle paths all function simultaneously. Forty-six bridges and arches—all different—contribute to the harmonious functioning of the transportation system or simply provide decoration. Next to the lake (many blocks below the reservoir), you'll find Bethesda Fountain, where dozens of movies have been shot. A path around the lake will take you into wooded areas that might be 100 miles upstate.

It's worth the extra dollars to eat at the Boathouse (on the lake near Bethesda Fountain) or at Tavern on the Green ("the Green" is Central Park). In the summer, enjoy the amateur acrobats and break-dancers at the fountain, the beat of African drums, and the Rollerblade dancers nearby.

Then there is the unexpected. One summer, for example, New York was invaded by cows. We know that Rockefeller Center has a grand Christmas tree during the holiday season, but unusual pieces of art also show up, like big yellow elephants.

CHINATSU BAN, *VWX Yellow Elephant / HIJ Kiddy Elephant.*
Chiantsu Ban, VWX Yellow Elephant Underwear/HIJ Kiddy Elephant Underwear, 2005. Sculpture at Doris C. Freedman Plaza, 60th Street and Fifth Avenue. A Project of Public Art Fund and the Japan Society. Courtesy Marianne Boesky Gallery, New York. Photo by Tom Powel Imaging. © 2005 Chinatsu Ban/Kaikai Kiki Co., Ltd. All rights reserved.

 To continue your tour and learn more about New York City, go to our website.

ARCHITECTURE

The mother art is architecture. Without an architecture of our own
we have no soul of our own civilization.

—Frank Lloyd Wright

Early humans found their shelters—the mouth of a yawning cave, the underside of a ledge, the boughs of an overspreading tree. But for thousands of years we having been building shelters and fashioning them to our needs. Before we became capable of transporting bulky materials over vast distances, we had to rely on local possibilities. Native Americans constructed huts from sticks and bark and conical teepees from animal skins and wooden poles. They carved their way into the sides of cliffs. African villagers wove sticks and grass into walls and plastered them with mud; their geometrically pure cone roofs sit atop cylindrical bases. Desert peoples learned to dry clay in the sun in the form of bricks. From ice, the Inuit fashioned the dome-shaped igloo.

Architecture is the art and science of designing buildings, bridges, and other structures to help us meet our personal and communal needs. Of all the arts, architecture probably has the greatest impact on our daily lives. For most of us, architecture determines the quality of the environments in which we work, play, meditate, and rest.

Architecture is also a vehicle for artistic expression in three dimensions. More than any other art form, architecture is experienced from within as well as without, and at great length. If sculptures have fronts, backs, sides, tops, and bottoms, buildings have **facades,** foundations, roofs, and a variety of interior spaces that must be planned. If some sculptures are kinetic and some are composed of light sources, buildings may contain complex systems for heating, cooling, lighting, and inner transportation.

Architects, like sculptors, must work within the limits of their materials and the technology of the day. In addition to understanding enough of engineering to determine how materials may be used efficiently to span and enclose sometimes vast spaces, architects must work with other professionals and with contractors who design and install elements of the **service systems** of their buildings.

In a sense the architect is not only an artist but a mediator—a compromiser. The architect mediates between the needs of the client and the properties and aesthetic possibilities of the site. (Today's technology permits the erection of 20-story-high, 20-foot-wide "sliver skyscrapers" on expensive, narrow urban sites, but at what aesthetic cost to a neighborhood of row houses?) The architect balances aesthetics and the building codes of the community. (Since the

1930s, architects in New York City have had to comply with the so-called setback law and step back or contour their high-rises from the street in order to let the sun shine in on an environment that seemed in danger of devolving into a maze of blackened canyons.) Climate, site, materials, building codes, clients, contractors, service systems, and the amount of money available—these are just some of the variables that the architect must employ or contend with to create an aesthetically pleasing, functional structure.

In this section we will explore traditional and modern ways in which architects have come to terms with these variables. We will survey the traditional materials and methods associated with building in stone and wood. Then we will examine a number of modern and contemporary architectural materials and methods, including those associated with cast-iron and steel-cage construction, use of reinforced concrete, and steel cable.

STONE ARCHITECTURE

As a building material, stone is massive and virtually indestructible. Contemporary wood-frame homes frequently sport stone fireplaces, perhaps as a symbol of permanence

10-1 Cliff Dwellings, Mesa Verde, Colorado (Native American, Pre-Columbian).
Topfoto/The Image Works.

Architecture completes nature.

—Giorgio De Chirico

and strength as well as of warmth. The Native American cliff dwellings at Mesa Verde, Colorado (Fig. 10-1), could be considered something of an "earthwork high relief." The cliff itself becomes the back wall or "support" of more than 100 rectangular apartments. Circular, underground **kivas** served as community centers. Construction with stone, **adobe,** and timber creates a mixed-media functional fantasy. Early humans also assembled stone temples and memorials.

Post-and-Lintel Construction

The prehistoric Stonehenge (see Fig. 12-5) probably served religious or astronomical purposes. Its orientation toward the sun and its layout in concentric circles are suggestive of the amphitheaters and temples to follow. Stonehenge is an early example of **post-and-lintel** construction (Fig. 10-2A). Two stones were set upright as supports, and a third was

10-2A Post-and-lintel construction.

10-2B Rounded arches enclosing square bay.

10-2C Pointed arches enclosing rectangular bay.

10-2D Tunnel or barrel vault.

10-2E Groin vault.

10-2F Groin vault showing ribs that carry greatest loads.

10-2G Flying buttress.

10-2H Dome.

10-2I Pendentives.

10-2J Geodesic dome.

10-3 Walls of Fortress of Machu Picchu, Urubamba Valley, Peru (Incan, 1490–1530).
Topfoto/The Image Works.

placed across them, creating an opening beneath. How the massive blocks of Stonehenge were transported and erected remains a mystery.

Early stone structures were erected without benefit of mortar. Their **dry masonry** relied on masterly carving of blocks, strategic placement, and sheer weight for durability. Consider the imposing ruin of the fortress of Machu Picchu, perched high above the Urubamba River in the Peruvian Andes. Its beautiful granite walls (Fig. 10-3), constructed by the Incas, are pieced together so perfectly that not even a knife blade can pass between the blocks. The faces of the Great Pyramids of Egypt (see Fig. 12-14) are assembled as miraculously, perhaps even more so considering the greater mass of the blocks.

10-4 Temple of Amen-Re, Karnak (Egyptian, XVIII dynasty, 1570–1342 BCE).
Copyright George Holton/Photo Researchers, Inc., New York.

An arch is two curves trying to fall.

—Andy Rooney

Stone became the favored material for the public buildings of the Egyptians and the Greeks. The Egyptian Temple of Amen-Re at Karnak (Fig. 10-4) and the Parthenon (see Fig. 13-9) of the Classical period of Greece begin to speak of the elegance as well as the massiveness that can be fashioned from stone. The Temple of Amen-Re is of post-and-lintel construction, but the paintings, relief sculptures, and overall smoothness of the columns belie their function as bearers of stress (see Fig. 12-17). The virtual forest of columns was a structural necessity because of the weight of the massive stone lintels. The Parthenon is also of post-and-lintel construction. Consistent with the Greeks' emphasis on the functional purpose of columns, the surfaces of the marble shafts are free from ornamentation. The Parthenon, which may be the most studied and surveyed building in the world, is discussed at length in Chapter 13.

Arches

Architects of stone also use **arches** to span distances (Figs. 10-2B and 10-2C). Arches have many functions, including supporting other structures, such as roofs, and serving as ac-

tual and symbolic gateways. An Arch of Triumph, as in the city of Paris, provides a visual focus for the return of the conquering hero. Eero Saarinen's Gateway Arch (Fig. 10-5), completed in St. Louis in 1965, stands 630 feet tall at the center and commemorates the westward push of the United States after the Louisiana Purchase of 1803. The Pont du Gard (see Fig. 13-21) near Nîmes, France, employs the arch in a bridge that is part of an aqueduct system. It is a marvel of Roman engineering. Early masonry arches were fashioned from **bricks;** each limestone block of the Pont du Gard weighs up to two tons, and they were assembled without benefit of mortar. The bridge stands and functions today, two millennia after its creation.

In most arches, wedge-shaped blocks of stone, called **voussoirs,** are gradually placed in position ascending a wooden scaffold called a **centering.** When the center, or **keystone,** is set in place, the weight of the blocks is all at once transmitted in an arc laterally and downward, and the centering can be removed. The pull of gravity on each block serves as "cement"; that is, the blocks fall into one another so that the very weight that had made their erection a marvel now prevents them from budging. The **compressive**

10-5 EERO SAARINEN. Jefferson National Expansion Memorial, Gateway Arch, St. Louis, MO (1966). Topfoto/The Image Works.

strength of stone allows the builder to place additional weight above the arch. The Pont du Gard consists of three **tiers** of arches, 161 feet high.

Vaults

An extended arch is called a **vault.** A tunnel or **barrel vault** (Fig. 10-2D) simply places arches behind one another until a desired depth is reached. In this way impressive spaces may be roofed and tunnels may be constructed. Unfortunately, the spaces enclosed by barrel vaults are dark, because piercing them to let in natural light would compromise their strength. The communication of stresses from one arch to another also requires that the centering for each arch be kept in place until the entire vault is completed.

Roman engineers are credited with the creation of the **groin vault,** which overcame limitations of the barrel vault, as early as the third century CE. Groin vaults are constructed by placing barrel vaults at right angles to cover a square space (Fig. 10-2E). In this way the load of the intersecting vaults is transmitted to the corners, necessitating **buttressing** at these points but allowing the sides of the square to be open. The square space enclosed by the groin vault is called a **bay.** Architects could now construct huge buildings by assembling any number of bays. Because the stresses from one groin vault are not transmitted to a large degree to its neighbors, the centering used for one vault can be removed and reused while the building is under construction.

The greatest loads in the groin vault are thrust onto the four arches that compose the sides and the two arches that run diagonally across them. If the capacity of these diagonals is increased to carry a load, by means of **ribs** added to the vault (Fig. 10-2F), the remainder of the roof can be fashioned from stone **webbing** or other materials much lighter in weight. A true stone skeleton is created.

Note in Figure 10-2B that rounded arches can enclose only square bays. One could not use rounded arches in rectangular bays because the longer walls would have higher arches. Architects over the centuries solved the rectangular bay problem in a number of ingenious ways. The most important of these is found in **Gothic** architecture, discussed in Chapter 14, which uses ribbed vaults and **pointed arches.** Pointed arches can be constructed to uniform heights even when the sides of the enclosed space are unequal (Fig. 10-2C). Gothic architecture also employed the so-called **flying buttress** (Fig. 10-2G), a masonry strut that transmits part of the load of a vault to a buttress positioned outside a building.

Most of the great cathedrals of Europe achieve their vast, open interiors through the use of vaults. Massive stone rests benignly above the heads of worshipers and tourists alike, transmitting its brute load laterally and downward. The **Ottonian** St. Michael's (see Fig. 14-11), built in Germany between 1001 and 1031 CE, uses barrel vaulting. Its bays are square, and its walls are blank and massive. The **Romanesque** St. Sernin (see Fig. 14-13), built in France between about 1080 and 1120, uses round arches and square bays. The walls are heavy and blunt, with the main masses subdivided by buttresses. St. Étienne (see Fig. 14-15), completed between 1115 and 1120, has high, rising vaults—some of the earliest to show true ribs—that permit light to enter through a **clerestory.** Stone became a fully elegant structural skeleton in the great Gothic cathedrals such as those at Laon (see Figs. 14-20 and 14-21) and Chartres (see Fig. 14-23) and in the Notre-Dame of Paris (see Fig. 14-22). Lacy buttressing and ample **fenestration** lend these massive buildings an airy lightness that seems consonant with their mission of directing upward the focus of human awareness.

Domes

Domes are hemispherical forms that are rounded when viewed from beneath (see Figs. 10-2H and 10-2J). Like vaults, domes are extensions of the principle of the arch and are capable of enclosing vast reaches of space. (Buckminster Fuller, who designed the American Pavilion [Fig. 10-25] for the 1967 World's Fair in Montreal, proposed that the center of Manhattan should be enclosed in a weather-controlled transparent dome two miles in diameter.) Stresses from the top of the dome are transmitted in all directions to the points at which the circular base meets the foundation, walls, or other structures beneath.

The dome of the Buddhist temple or Stupa of Sanchi, India, completed in the first century CE, rises 50 feet above the ground and causes the worshiper to contemplate the dwelling place of the gods (see Fig. 17-28). It was constructed from stones placed in gradually diminishing concentric circles. Visitors find the domed interior of the Pantheon of Rome (see Fig. 13-28), completed during the second century CE, breathtaking. Like the dome of the Stupa, the rounded inner surface of the Pantheon, 144 feet in diameter, symbolizes the heavens.

The dome of the vast Hagia Sophia (see Fig. 1-13) in Constantinople is 108 feet in diameter. Its architects, building during the sixth century CE, used four triangular surfaces called **pendentives** (Fig. 10-2I) to support the dome on a square base. Pendentives transfer the load from the base of the dome to the **piers** at the corners of the square beneath.

Stone today is rarely used as a structural material. It is expensive to quarry and transport, and it is too massive to handle readily at the site. Metals are lighter and have greater tensile strength, so they are suitable as the skeletons or reinforcers for most of today's larger structures. Still, buildings with steel skeletons are frequently dressed with thin facades, or **veneers,** of costly marble, limestone, and other types of stone. Many tract homes are granted decorative patches of stone across the front facade, and slabs of slate are frequently used to provide minimum-care surfaces for entry halls or patios in private homes.

WOOD ARCHITECTURE

Wood is as beautiful and versatile a material for building as it is for sculpture. It is an abundant and, as many advertisements have proclaimed, renewable resource. It is relatively light in weight and is capable of being worked on the site with readily portable hand tools. Its variety of colors and grains as well as its capacity to accept paint or to weather charmingly when left in its natural state make wood a ubiquitous material. Wood, like stone, can be used as a structural element or as a facade. In many structures it is used as both.

Wood also has its drawbacks. It warps and cracks. It rots. It is also highly flammable and stirs the appetite of termites and other devouring insects. However, modern technology has enhanced the stability and strength of wood as a building material. Chemical treatments decrease wood's vulnerability to rotting from moisture. **Plywood,** which is built up from sheets of wood glued together, is unlikely to warp and is frequently used as an under layer in the exterior walls of small buildings and homes. Laminated wood beams possess great strength and are also unlikely to become distorted in shape from exposure to changing temperatures and levels of humidity.

Architect Paul Schweikher's contemporary northern Arizona home (Fig. 10-6) is a Japanese-inspired clean design of glass and wood in which sturdy but graceful fir timbers provide both a structural system and a primary source of decoration. The cedar **siding** exudes both warmth and crisp elegance. Timbers and siding are integrated into the surrounding red rock country by means of a crushed red sandstone driveway, a rock path bordered in red gravel, and a floor throughout of 4-inch by 8-inch **quarry tile.** There are times during the day when the light is such that the huge panels of glass seem to melt away, and the house is very much one with the Sedona butte on which it sits.

10-6　PAUL SCHWEIKHER.
Schweikher House, Sedona, AZ
(1972).
Courtesy of Fine Home Building Magazine, Taunton Press.

Post-and-Beam Construction

Schweikher's house is of **post-and-beam** construction (Fig. 10-7A), which is similar to post-and-lintel construction; vertical and horizontal timbers are cut and pieced together with wooden pegs. The beams span openings for windows, doors, and interior spaces, and they can also support posts for another story or roof trusses.

Trusses

Trusses are lengths of wood, iron, or steel pieced together in triangular shapes of the sort shown in Figure 10-7B in order to expand the abilities of these materials to span distances. Trusses acquire their strength from the fact that the sides of a triangle, once joined, cannot be forced out of shape. In many buildings, roof trusses are exposed and become elements of the design.

Balloon Framing

Balloon framing (Fig. 10-7C), a product of the industrial revolution, dates back to the beginning of the twentieth century. In balloon framing, factory-cut studs, including the fa-

miliar two-by-four, are mass-produced and assembled at the site using thousands of factory-produced metal nails. Several light, easily handled pieces of wood replace the heavy timber of post-and-beam construction. Entire walls are framed in place or on their sides and then raised into place by a crew of carpenters. The multiple pieces and geometric patterns of balloon framing give it a sturdiness that rivals that of the post and beam, permitting the support of slate or tile roofs. However, the term *balloon* was originally a derisive term: inveterate users of post and beam were skeptical that the frail-looking wooden pieces could provide a rugged building.

Balloon framing, of course, has now been used on millions of smaller buildings, not only homes. Sidings for balloon-framed homes have ranged from **clapboard** to asbestos shingle, brick and stone veneer, and aluminum. Roofs have ranged from asphalt or cedar shingle to tile and slate. These materials vary in cost, and each has certain aesthetic possibilities and practical advantages. Aluminum, for example, is lightweight, durable, and maintenance-free. However, when aluminum siding is shaped like clapboard and given a bogus grain, the intended trompe l'oeil effect usually fails and can create something of an aesthetic embarrassment.

Two other faces of wood are observable in American architect Richard Morris Hunt's Griswold House (Fig. 10-8),

10-7B Trusses.

10-7C Balloon framing.

10-7A Post-and-beam construction.

10-8 RICHARD M. HUNT.
J. N. A. Griswold House, Newport, RI
(1862–1863).
Courtesy of the Newport Art Museum.

built at Newport, Rhode Island, in 1862–1863 in the *Stick style,* and in the Cape Cod–style home in Levittown, Long Island, a suburb of New York City (Fig. 10-9). The Griswold House shows the fanciful possibilities in wood. The Stick style sported a skeletal treatment of exteriors that remind one of an assemblage of matchsticks, open interiors, and a curious interplay of voids and solids and horizontal and vertical lines. Shapes proliferate in this short-lived movement. Turrets and gables and dormers poke the roof in every direction. Trellised porches reinforce a certain wooden laciness. One cannot imagine the Griswold House constructed in any material but wood.

The house at Levittown is more than a home; it is a socio-aesthetic comment on the need for mass suburban housing that impacted so many metropolitan regions during the marriage and baby boom that followed World War II. This house and 17,000 others almost exactly like it were built, with few exceptions, on 60-foot by 100-foot lots that had been carved out from potato fields. In what was to become neighborhood after neighborhood, bulldozers smoothed already flat terrain and concrete slabs were poured. Balloon frames were erected, sided, and roofed. Trees were planted; grass was sown. The houses had an eat-in kitchen, living room, two tiny bedrooms, one bath on the first floor, and an expansion attic. Despite the tedium of the repetition, the original Levittown house achieved a sort of architectural integrity, providing

10-9 Cape Cod–style houses built by Levitt & Sons, Levittown, NY (c. 1947–1951).
Hulton Archive/Getty Images.

living space, the pride of ownership, and an inoffensive facade for a modest price. Driving through Levittown today, it seems that every occupant thrust random additions in random directions as the family grew, despite the limitations of the lots. The trees only partly obscure the results.

No person who is not a great sculptor or painter can be an architect. . . . He can only be a builder.

—John Ruskin

CAST-IRON ARCHITECTURE

Nineteenth-century industrialization also introduced **cast iron** as a building material. It was one of a number of structural materials that would change the face of architecture. Cast iron was a welcome alternative to stone and wood. Like stone, iron has great strength, is heavy, and has a certain brittleness, yet it was the first material to allow the erection of tall buildings with relatively slender walls. Slender iron beams and bolted trusses are also capable of spanning vast interior spaces, freeing them from the forests of columns that are required in stone.

At the mid-nineteenth-century Great Exhibition held in Hyde Park, London, Sir Joseph Paxton's Crystal Palace (Fig. 10-10) covered 17 acres. Like subsequent iron buildings, the Crystal Palace was **prefabricated.** Iron parts were cast at the factory, not the site. The new railroads facilitated their transportation, and it was a simple matter to bolt them together at the exhibition. It was also a relatively simple matter to dismantle the structure and reconstruct it at another site. The iron skeleton, with its myriad arches and trusses, was an integral part of the design. The huge plate-glass paneled walls bore no weight. Paxton asserted that "nature" had been his "engineer," explaining that he merely copied the system of longitudinal and transverse supports that one finds in a leaf. Earlier architects were also familiar with the structure of the leaf, but they did not have the structural materials at hand that would permit them to build, much less conceptualize, such an expression of natural design.

The Crystal Palace was moved after the exhibition, and until heavily damaged by fire, it served as a museum and concert hall. It was demolished in 1941 during World War II, after it was discovered that it was being used as a landmark by German pilots on bombing runs.

The Eiffel Tower (Fig. 10-11) was built in Paris in 1889 for another industrial exhibition. At the time, Gustave Eiffel was castigated by critics for building an open structure lacking the standard masonry facade. Today the Parisian symbol is so familiar that one cannot visualize Paris without the tower's magnificent exposed iron trusses. The pieces of the 1,000-foot-tall tower were prefabricated, and the tower was assembled at the site in 17 months by only 150 workers.

Structures such as these encouraged **steel-cage construction** and the development of the skyscraper.

10-10 Engraving of Sir Joseph Paxton's Crystal Palace, London (1851).

Copyright Ann Ronan Picture Library, Oxfordshire, UK.

10-11 GUSTAVE EIFFEL.
Eiffel Tower, Paris (1889).

Topfoto / The Image Works.

STEEL-CAGE ARCHITECTURE

Steel is a strong metal of iron alloyed with small amounts of carbon and a variety of other metals. Steel is harder than iron, and more rust and fire resistant. It is more expensive than other structural materials, but its great strength permits it to be used in relatively small quantities. Light, narrow, prefabricated I-beams have great tensile strength. They resist bending in any direction and are riveted or welded together into skeletal forms called **steel cages** at the site (Fig. 10-12). Facades and inner walls are hung from the skeleton and frequently contribute more mass to the building than does the skeleton itself.

The Wainwright Building (Fig. 10-13), erected in 1890, is an early example of steel-cage construction. Architect Louis Sullivan, one of the fathers of modern American

10–12 Steel-cage construction.

10–13 Louis Sullivan.
Wainwright Building, St. Louis, MO (1890).

Courtesy Bill Hedrich, Hedrich-Blessing/ Chicago Historical Society.

Less is more.

—Miës van der Rohe

architecture, emphasized the verticality of the structure by running **pilasters** between the windows through the upper stories. Many skyscrapers run pilasters up their entire facades. Sullivan also emphasized the horizontal features of the Wainwright Building. Ornamented horizontal bands separate most of the windows, and a severe decorated **cor-** **nice** crowns the structure. Sullivan's motto was "form follows function," and the rigid horizontal and vertical processions of the elements of the facade suggest the regularity of the rectangular spaces within. Sullivan's early "skyscraper"—in function, in structure, and in simplified form—was a precursor of the twentieth-century behemoths to follow.

10–14 GORDON BUNSHAFT. Lever House, New York (1951–1952). Copyright Angelo Homak/CORBIS.

Architecture is the first manifestation of man creating his own universe.

—Le Corbusier

Well, now that he's finished one building, he'll go write four books about it.

—Frank Lloyd Wright on Le Corbusier

10-15 BURGEE ARCHITECTS WITH PHILIP JOHNSON.
Sony Plaza (formerly AT&T Building), New York (1984).
Photo courtesy of Norman McGrath.

One of these behemoths is New York City's Modernist Lever House (Fig. 10-14). Lever House was designed by Gordon Bunshaft of Skidmore, Owings, and Merrill, a firm that quickly became known for its "minimalist" rectangular solids with their "curtain walls" of glass. The nation was excited about the clean, austere look of Lever House and about its donation of open plaza space to the city. The plaza prevents the shaft from overwhelming its site. The evening light angles down across the plaza and illuminates the avenue beneath.

By the mid-1970s, the clean Modernist look of buildings such as Lever House was overwhelming the urban cityscape. A few buildings of the kind—even a few dozen buildings of the kind—would have been most welcome, but now architectural critics were arguing that a national proliferation of steel-cage rectangular solids was threatening to bury the nation's cities in boredom. Said John Perrault in 1979, "We are sick to death of cold plazas and 'curtain wall' skyscrapers."

By the end of the 1970s, a new steel-cage monster was being bred throughout the land—one that utilized contemporary technology but drew freely from past styles of ornamentation. These **Postmodernist** structures reject the formal simplicity and immaculate finish of **Modernist** architecture in favor of whimsical shapes, colors, and patterns. Postmodern architects revived the concept of the decorative in architecture, an absolute "no-no" for decades in the twentieth century.

One of most interesting aspects of Postmodern architecture is its appropriation of historical motifs; Philip Johnson and John Burgee's AT&T Building in New York City (subsequently sold to Sony) (Fig. 10-15) is one of the earliest examples. The massive tower sits on a forest of columns, reminiscent—to Johnson—of an Egyptian hypostyle hall (Figure 10-4). Its pale pink facade is punctuated with fenestration, although the prominent stone grid lines regulate the pace of the upward sweep. The building is crowned with a broken roof pediment referencing the Chippendale style, which originated with the eighteenth-century

10-16 LUDWIG MIËS VAN DER ROHE.
Farnsworth House, Fox River, Plano, IL (1950).
Courtesy Hedrich-Blessing. Copyright 2000 Artists Rights Society (ARS),
New York/VG Bild-Kunst, Bonn.

British cabinetmaker Thomas Chippendale. Beneath the ornamentation lies a steel-cage structure, now visually all but disguised.

A more surprising, and unusual, example of steel-cage architecture is found in Miës van der Rohe's Farnsworth House (Fig. 10-16). The rhythmic procession of white steel columns suspends it above the Illinois countryside. In its perfect technological elegance, it is in many ways visually remote from its site. Why steel? Less expensive wood could have supported this house of one story and short spans, and wood might have appeared more natural on this sylvan site. The architect's choices, of course, may be read as a symbol of our contemporary remoteness from our feral past. If so, the architect seems to believe that the powerful technology that has freed us is to the good, for the house is as beautiful as it is austere in ornamentation. The Farnsworth House has platforms, steps, and a glass curtain wall that allows the environment to flow through. The steps and platforms provide access to a less well-ordered world below.

REINFORCED CONCRETE ARCHITECTURE

Although cement was first produced in the early 1800s, the use of **reinforced concrete** is said to have begun with a French gardener, Jacques Monier, who proposed strengthening concrete flower pots with a wire mesh in the 1860s. In reinforced concrete, or **ferroconcrete,** steel rods and/or steel mesh are inserted at the points of greatest stress into concrete slabs before they harden. In the resultant slab, stresses are shared by the materials.

Ferroconcrete has many of the advantages of stone and steel, without some of the disadvantages. The steel rods increase the tensile strength of concrete, making it less susceptible to tearing or pulling apart at stress points. The concrete, in turn, prevents the steel from rusting. Reinforced concrete can span greater distances than stone, and it supports more weight than steel. Perhaps the most dramatic ad-

10-17 LE CORBUSIER.
Chapel of Notre-Dame-du-Haut,
Ronchamp, France (1950–1954).
Copyright 2003 Artists Rights Society (ARS), New York/ADAGP, Paris/FLC.

10-18 LE CORBUSIER.
Interior, south wall, Chapel of Notre-Dame-du-Haut.
Copyright 2003 Artists Rights Society (ARS), New York/ADAGP, Paris/FLC.

vantage of reinforced concrete is its capacity to take on natural curved shapes that would be unthinkable in steel or concrete alone. Curved slabs take on the forms of eggshells, bubbles, seashells, and other organic shapes that are naturally engineered for the even spreading of stress throughout their surfaces and are, hence, enduring.

Reinforced concrete, more than other materials, has freed the architect to think freely and sculpturally. There are limits to what ferroconcrete can do, however; initial spatial concepts are frequently somewhat refined by computer-aided calculations of marginally more efficient shapes for distributing stress. Still, it would not be far from the mark to say that buildings of almost any shape and reasonable size are possible today, if one is willing to pay for them. The architects of ferroconcrete have achieved a number of buildings that would have astounded the ancient stone builders— and perhaps Joseph Paxton.

Le Corbusier's chapel of Notre-Dame-du-Haut (Figs. 10-17 and 10-18) is an example of what has been referred to as the "new brutalism," deriving from the French *brut,* meaning "rough, uncut, or raw." The steel web is spun, and the concrete is cast in place, leaving the marks of the wooden forms on its surface. The white walls, dark roof, and white towers are "decorated" only by the texture of the curving reinforced concrete slabs. In places the walls are incredibly thick. Windows of various shapes and sizes expand from small slits and rectangles to form mysterious light tunnels; they not so much light the interior as draw the observer outward. The massive voids of the window apertures recall the huge stone blocks of prehistoric religious structures.

Frank Lloyd Wright's Kaufmann House (Fig. 10-19), which has also become known as "Fallingwater," shows a

10-19 FRANK LLOYD WRIGHT.
Kaufmann House ("Fallingwater"), Bear Run, PA (1936).
Scott Frances/ESTO.

very different application of reinforced concrete. Here cantilevered decks of reinforced concrete rush outward into the surrounding landscape from the building's central core, intersecting in strata that lie parallel to the natural rock formations. Wright's **naturalistic style** integrates his building with its site. In the Kaufmann House, reinforced concrete and stone walls complement the sturdy rock of the Pennsylvania countryside.

For Wright, modern materials did not warrant austerity; geometry did not preclude organic integration with the site. A small waterfall seems mysteriously to originate beneath the broad white planes of a deck. The irregularity of the struc-

tural components—concrete, cut stone, natural stone, and machine-planed surfaces—complements the irregularity of the wooded site. The Kaufmann House, naturalistic, might have always been there. It is right. The Farnsworth House, although not "wrong," is a technological surprise on its landscape.

Israeli architect Moshe Safdie's Habitat (Fig. 10-20) is another expression of the versatility of concrete. Habitat was erected for Expo 67 in Montreal as one solution to the housing problems of the future. Rugged, prefabricated units were stacked like blocks about a common utility core at the site, so that the roof of one unit would provide a private deck for another. Only a couple of Safdie-style "apartment houses" have been erected since, one in Israel and one in Puerto Rico, so today Safdie's beautiful sculptural assemblage evokes more nostalgia than hope for the future. Its unique brand of rugged, blocky excitement is rarely found in mass housing, and this is our loss.

10-20 MOSHE SAFDIE.
Habitat, Expo 67, Montreal (1967).
Copyright Magma Photo, Quebec.

STEEL-CABLE ARCHITECTURE

The notion of suspending bridges from cables is not new. Wood-and-rope suspension bridges have been built in Asia for thousands of years. Iron suspension bridges, such as the Menai Strait Bridge in Wales and the Clifton Bridge near Bristol, England, were erected during the early part of the nineteenth century. But in the Brooklyn Bridge (Fig. 10-21), completed in 1883, John Roebling exploited

10-21 JOHN A. ROEBLING.
Brooklyn Bridge, New York (1869–1883).
Copyright Superstock Photography, Jacksonville, FL.

A doctor can bury his mistakes, but an architect can only advise his clients to plant vines.

—Frank Lloyd Wright

We may live without architecture, and worship without her,
but we cannot remember without her.

—John Ruskin

the great tensile strength of steel to span New York's East River with **steel cable.** In such a cable, many parallel wires share the stress. Steel cable is also flexible, allowing the roadway beneath to sway, within limits, in response to changing weather and traffic conditions.

Roebling used massive vaulted piers of stone masonry to support parabolic webs of steel, which are rendered lacy by the juxtaposition. In many more recent suspension bridges, steel cable spans more than a mile, and in bridges such as the Golden Gate, the George Washington, and the Verrazzano Narrows, the effect is aesthetically stirring.

There is another stirring aspect to the photograph of the Brooklyn Bridge. In the background you see the twin towers of the World Trade Center, which collapsed in the terrorist attack of September 11, 2001. Within months following September 11, dozens of architects and planners were submitting concepts to New York City for "Ground Zero," which included a memorial to those who had been killed in the attack and new buildings that might recapture the upward spirit of the city. At one point in the decision-making process, the commission was awarded to Studio Daniel Libeskind, whose original design for the World Trade Center site appears in Figure 10-22. The twisting structures, about the same height of the original towers, were designed to reduce the dynamic effects of wind, much as the aerodynamic contours of an automobile do. They were to be significantly stronger; a combination of steel on the outside and concrete within would better resist the natural forces of wind and gravity, and the unnatural forces of a terrorist assault. Accompanying the lower buildings was a broadcast tower that would have been the tallest structure in the world. The elements of the plan would have seemed a perfect compromise, taking into account the sobering realities of doing business in a super high-rise skyscraper in a post-9/11 world and the desire of most Americans to build high and build proud. And although these tall structures would reassert the lower Manhattan skyline, which now dips mournfully into the harbor, the twisted planes of the building facades seem to bear some acknowledgment of vulnerability in the wake of the attack by foreign enemies on U.S. soil.

10-22 STUDIO DANIEL LIBESKIND.
Computer-generated drawings of the design selected to rebuild the World Trade Center site, New York City.
Copyright archimation. Courtesy, Studio Daniel Libeskind.

In Lights at Ground Zero, Steps toward Illumination*

For a month in the spring of 2002, twin towers of light at "Ground Zero" served as an architectural memorial to the twin towers of glass and steel that had been felled by terrorists, even if the medium could not be clutched by the hands. It was called *Tribute in Light* (Fig. 10-23), and architectural critic Herbert Muschamp wrote about it in *The New York Times*:

> *"Tribute in Light" was a moving piece of urban spectacle. The project's impact surpassed even the dramatic digital renderings. In the renderings, the twin light towers appeared to be saying something. As realized, they seemed to be looking for something. More a question than a statement, the project set a rhetorical tone worthy of emulation by those who will be shaping the future of Lower Manhattan in days to come.*
>
> *The project was conceived independently by two architects, John Bennett and Gustavo Bonevardi, and two artists, Paul Myoda and Julian LaVerdiere. On learning of each other's work, the two teams joined. Another architect, Richard Nash Gould, was later added. The lighting genius Paul Marantz executed the concept.*
>
> *As realized, the concept gave the impression of an image revealed, rather than designed, as if two lustrous columns have been excavated by an archaeological team from the darkness of time. Like classical columns, the towers were fluted, an effect of the 44 individual high-power lamps used to create each one. Extra lamps at the corners reinforced the architectonic illusion.*
>
> *The effect was similar to that made by missiles thrusting off into space. Though stationary, the light towers appeared aimed for the arrival of signs from above. The eye wanted to follow, not just behold them.*
>
> *Light, Marshall McLuhan reminded us, is a medium. Indeed, in his influential book* Understanding Media, *the Canadian thinker devoted his chapter on architecture to developing that idea. Light is a "pure" communication medium whose power to shape environments is independent of content. In artificial form, light reshaped the boundaries of buildings and entire cities. We encounter that form in its purest state at night, when gazing up at a skyline, or gazing down from an airplane window at suburban sprawl.*
>
> *Ancient builders designed monuments to align sacred sites with the positions of sun and moon. The lightness of Gothic construction was inseparable from the biblical narratives inscribed in stained glass for the benefit of those who couldn't read.*
>
> *But where have our two towers gone? "For the moment I can only cry out that I have lost my splendid mirage," F. Scott Fitzgerald wrote in 1945. "Come back, come back, O glittering and white!"* ∎

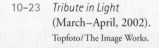

10-23 *Tribute in Light*
(March–April, 2002).
Topfoto/The Image Works.

*Adapted from Herbert Muschamp, March 12, 2002. Copyright © 2002 by The New York Times Company. Reprinted by permission.

10-24 DAVID CHILDS IN COLLABORATION
WITH DANIEL LIBESKIND.
Freedom Tower.
Skidmore, Owings and Merrill / Landov.

But Libeskind's integrated design would not survive the tangle of bureaucratic red tape that gripped (some say crippled) the process. What emerged was a compromise solution between two main architects—Libeskind and David Childs. The so-called Freedom Tower, which Libeskind designed to rise 1,776 feet, was an important symbolic aspect of the plan. According to the architect, that number reflects "a date [America's year of independence from Britain] that speaks to the whole world." Although the tower will still top out at 1,776 feet, its original slender and graceful lines have been replaced by Childs with a much more obviously fortified design (Fig. 10-24) that speaks "safety first." Only the first 70 floors will be occupied by office space, and these sit on a base of concrete and steel about 200 feet high. A lattice

structure filled with windmills at the top of the building will generate 20 percent of the building's energy. This part of the building is designed as cable-suspension structure.

Daniel Libeskind's design was originally chosen from a distinguished group of finalists, including the firm of David Childs. It was the individual who owns the lease on the ill-fated twin towers who appointed Childs the lead architect, putting Childs and Libeskind into what the latter has called "a forced marriage." One critic described the result of the compromise a "Freedom Bunker" in place of Freedom Tower. As this book goes to press, city planners, businesspeople, politicians, architects, families of the victims, and other citizens continue to debate the proper uses of lower Manhattan—of Ground Zero and its adjoining areas and neighborhoods. Even though Child's design appears to be the final vision for the moment, some believe that the process is not yet over. One can only hope for a solution that fits the spirit of the nation and also remains sensitive to the needs of the families of those who lost their lives.

SHELL ARCHITECTURE

Modern materials and methods of engineering have made it possible to enclose spaces with relatively inexpensive shell structures. Masonry domes have been replaced by lightweight shells, which are frequently flatter and certainly capable of spanning greater spaces. Shells have been constructed from reinforced concrete, wood, steel, aluminum, and even plastics and paper. The concept of shell architecture is as old as the canvas tent and as new as the geodesic dome (Fig. 10-25) designed by Buckminster Fuller for the

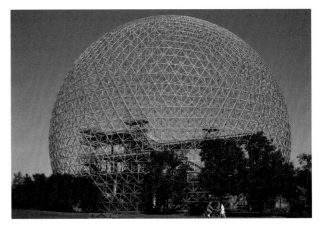

10-25 BUCKMINSTER FULLER.
United States Pavilion, Expo 67, Montreal (1967).
Topfoto / The Image Works.

American Pavilion at Expo 67 in Montreal. In a number of sports arenas, fabric roofs are held up by keeping the air pressure inside the building slightly greater than that outside. Like balloons, these roof structures are literally inflated.

Fuller's shell is an assemblage of lightweight metal trusses into a three-quarter sphere that is 250 feet in diameter. Looking more closely, one sees that the trusses compose six-sided units that give the organic impression of a honeycomb. Light floods the climate-controlled enclosure, creating an environment for any variety of human activity—and any form of additional construction—within. Such domes can be covered with many sorts of weatherproofing, from lightweight metals and fabric to translucent and transparent plastics and glass. Here the engineering requirements clearly create the architectural design.

NEW MATERIALS, NEW VISIONS

In architecture studios and schools, the saying goes, "Convention gets built; innovation gets published." But this adage is systematically being proven wrong as scientists and engineers have combined forces to turn architects' dreams into reality: "If you can think it, we can build it."

In 1997 Frank Gehry transformed architectural design with the use of titanium in the same way that reinforced concrete altered the look of the exterior "skin" of buildings in the 1950s and 1960s. His Guggenheim Museum in Bilbao, Spain (see Fig. 2-21), set a new artistic course for Gehry in terms of his own style and nurtured the adaptation of high-tech metals by architects worldwide. Gehry's Ray and Maria Stata Center (Fig. 10-26), which opened in 2005 on the MIT campus, stands as a visual summation of his most recent designs, materials, and theories of spatial relationships. The 730,000-square-foot complex will be a hub for research in the fields of computer science, linguistics, and philosophy. The assertive clashing of shapes signifies the disparate disciplines that will be housed in the structure, while communal lounges and shared interior spaces encourage interaction, collaboration, and the cross-fertilization of ideas. Gehry said of the Stata center, "It reflects the different groups, the collision of ideas, the energy of people and ideas. . . . That's what will lead to the breakthroughs and the positive results."

Architect Peter Testa's view is that there is a "need to rethink how we assemble buildings" and that it is time to design in collaboration with materials manufacturers and to explore the potential of nascent technologies. Testa and his partner, Devyn Weiser, have designed a high-rise tower out of composite materials (Fig. 10-27). Their skyscraper would be held erect by a cross-hatched lattice made of carbon fiber—a material several times stronger than the traditional steel. The "woven building" would have an interior that is completely open (except for elevator shafts) and void of structural support.

The use and reuse of unorthodox materials by some contemporary architects is also worth noting. Shigeru Ban, a Tokyo architect who has designed public buildings on the principle that art should not be only for the privileged, uses paper tubes and plastic sheets among other materials typically associated with other circumstances. Some of his works include the Paper Refugee Shelter for the United Nations, the Paper Museum and Paper Church in Japan, and a paper-tube arch in the Museum of Modern Art, New York, sculpture garden. He also designed the 45,000-square-foot No-

10-26 FRANK GEHRY.
Ray and Maria Stata Center for Computer, Information, and Intelligence Sciences at MIT, Cambridge, MA (2005).
Gehry Partners, LLC.

10-27 PETER TESTA AND DEVYN WEISNER, TESTA ARCHITECTURE AND DESIGN.
Carbon Tower.
© 2005 Testa Architecture / Design, Los Angeles.

10-28 SHIGERU BAN.
Nomadic Museum (2005).
Tyler Hicks, *The New York Times.*

10-29 SHIGERU BAN.
Model of Nomadic Museum showing shipping containers, paper-tube columns, and roof trusses.
Shigeru Ban Architects.

madic Museum (Figs. 10-28 and 10-29)—a mobile structure whose walls are composed of 148 steel cargo containers; a roof and columns made of paper tubes; and a ceiling made of 1 million used, pressed, paper teabags (tea leaves removed). The museum was constructed to display the work of Gregory Colbert, a Canadian-born artist whose photographs of elephants, whales, and human–animal relationships seem to have a visual and environmental affinity with the structure surrounding them. Sited at one point on Manhattan's historic Pier 54, the Nomadic Museum has an itinerary that includes Santa Monica Pier in California, as well as the Vatican in Rome. According to architect Ban, "It can be seen by more people all over the world if it moves. Maybe it remains in your memory if it's gone."

ART TOUR

Chicago

Go for the lake and the miles of beaches. Go for the deep-pan pizza and hotdogs with the works. Go to cheer for the Chicago Cubs or the Bulls. Go to see Oprah! But while you're in Chicago—for goodness' sake—make time in your day for the most magnificent art and architecture you can imagine.

Situated at the literal crossroads between the East and Midwest, Chicago grew rich on trade opportunities and began to take shape as a major commercial and cultural center in the nineteenth century. The Great Chicago Fire of 1871, however, destroyed most of the downtown buildings in a conflagration that lasted 36 hours. Out of this devastation, after which one-third of the city population was homeless, came one of the greatest building campaigns in U.S. history.

Experiencing Chicago starts with getting to know its neighborhoods—77 in all—and its unique topographic features—such as the Chicago River, which wends its way amidst skyscrapers, or Lake Michigan, which provides 15 miles of recreational beaches. At its heart is the Loop, but the long list contains neighborhoods such as the Magnificent Mile, River North, River West, the Gold Coast, Old Town, Lincoln Park, Wrigleyville, Lakeview, South Loop, and Chinatown.

We all know how good it feels to "be in the loop." But that expression couldn't have more meaning than when it's used to describe the city of Chicago. The Loop in this town refers to the very center of the downtown core and takes its name from the elevated train tracks that encircle the area.

The city of Chicago has always been synonymous with architectural innovation and world-class buildings. Balloon-frame construction (still one of the most common residential building types in the United States today, and so called because it was said to be as simple and easy as blowing up a balloon) originated in 1833 with a Chicago developer. Although most structures of this kind went up in flames in the 1871 fire, you can still see a few of them in the North Side area of the city. After the fire, wood was banned as a building material and cast iron and terra-cotta took its place. Those materials—along with steel—made their most significant impact on the city's commercial architecture. It was here that the first skyscraper was built and the Chicago School of architecture—an internationally celebrated style—was born.

One of the weirder structures in the downtown core is the Monadnock Building, the two halves of which represent old-style and new-style architectural design and materials. One half—the northern half—was designed in 1891 by the firm of Burnham and Root. At 16 stories, it was the tallest masonry building ever to have been constructed. Two years later, the other, southern half was constructed, this time of a steel skeleton covered with a sheath of terra-cotta. This design, by the firm of Holabird and Roche, was pivotal for the future of the skyscraper. Many followed—the Rookery, the Reliance Building, the Marquette Building, to name a few. All of these can be seen within

THE MONADNOCK BUILDING.
Robert Frerck/Odyssey.

the downtown core. Keep your eye out for the signature "Chicago windows" on some of these buildings. They were a stylistic by-product of the Chicago School's structural innovations and consist of a wide central glass pane that doesn't open flanked by two thinner windows that do.

Among the sentimental favorites of Chicago architecture are the Marshall Field and Company and the Carson Pirie Scott department stores. Marshall Field's began as a Renaissance-revival building that ultimately grew to accommodate 124,400 square miles of retail space; its southern atrium features a spectacular glass mosaic dome whose installation was supervised by Louis Comfort Tiffany himself. Louis Sullivan, one of the city's most prolific and beloved architects of the Chicago School, finished the exterior of his steel-frame Carson Pirie Scott building with white terra-cotta and graced the first two stories of the entrance with ornamental cast-iron motifs consisting of organic and geometric forms. You can still pick out the initials *L.H.S.* above the entrance.

Surveying the architectural wonders of Chicago can keep a tourist busy. These historic examples are but the tip of the iceberg. Within the downtown core you'll find Beaux Arts—style gems such as the Chicago Theatre, Neoclassical monuments such as the Chicago Cultural Center and the Art Institute of Chicago (more later on this phenomenal collection), and on the opposite end of the style spectrum, the Sears Tower. Opened in 1974 after three years under construction, the building had, then lost, and then regained the title as the world's tallest building (thanks to the addition of one very tall antenna). Not surprisingly, its sky deck offers unparalleled views of the city, Lake Michigan, and beyond.

THE TRIBUNE TOWER.
Copyright John Zich/zrImages/Corbis.

Extending your tour a bit north, you'll come to the Miracle Mile. There you'll get a glimpse of the Wrigley Building (seat of the chewing gum empire), Marina City's corncob towers, Miës van der Rohe's exposed steel-frame IBM Building, and the Tribune Tower (home to one of the country's most influential newspapers). The Tribune Tower that you see was the winning design in a 1922 international competition calling upon architects to design the most beautiful office building in the world. The entrance features sculptures of figures from Aesop's fables, and gargoyles abound in the upper reaches of the facade. Most peculiar, perhaps, is the collection of stone fragments from the world's great architectural sites embedded in the outer walls of the building. You'll find pieces from London's Westminster Abbey, the Colosseum in Rome, and the Great Wall of China; a rock from Antarctica and one from the moon. Believe it or not, most of these stones were pilfered by *Tribune* foreign correspondents at the behest (command?) of one of the paper's early publishers.

Among Chicago's newest additions to its architecture hall of fame is Frank Gehry's music pavilion for Millennium Park, an extension of Grant Park. Gehry's band shell, home to the Grant Park Symphony, is renowned for a sound system that reaches all of its 14,000 audience members.

Although architecture in Chicago has a way of monopolizing the spotlight, its art collections merit a significant piece of the action. For one thing, the Art Institute of Chicago, a venerable museum of art that was founded in 1879, has what some of us like to call "The Room." This term of endearment refers to a cluster of spaces featuring some of the best-known examples of Impressionist, Post-impressionist, and early twentieth-century art— Monet haystacks, Degas dancers, a van Gogh self-portrait; Cezanne's *Still Life with Basket of Apples* (Fig. 18-26), Picasso's *Old Guitarist* (Fig. 19-6), Hopper's

FRANK GEHRY, Pritzker Pavilion for Millennium Park.
Copyright John Zich/Corbis.

Nighthawks (Fig. 1-25), Wood's *American Gothic* (Fig. 4-9), Toulouse-Lautrec's *At the Moulin Rouge* (Fig. 18-30), and one of Chicago's most prized possessions, Seurat's *A Sunday Afternoon on the Island of La Grand Jatte* (Fig. 18-25)—and more. Students remark that their textbooks unfold before their eyes as they wander these galleries.

Chicago's museums go far beyond the Institute. The Museum of Contemporary Art has an impressive permanent collection (Alexander Calder, Andy Warhol, Cindy Sherman—to mention but a few artists featured in your textbook) mixed with cutting-edge rotating exhibitions by new and established contemporary artists. The Terra Museum of American Art, founded and funded by a man who invented fast-drying ink, is one of the only U.S. collections designed to feature exclusively works by American artists. It includes paintings of the Hudson River School, George Caleb Bingham, and Edward Hopper. The University of Chicago is also the site of both the Oriental Institute (specializing in Middle Eastern antiquities) and the Smart Museum (known for its old master prints, Asian paintings, and postwar Chicago artwork and craft). These museums, and the university, are in Chicago's South Side area, the location also of the famed Frank Lloyd Wright Robie

FRANK LLOYD WRIGHT, Robie House.
Art Resource, NY.

House, designed for the bicycle manufacturer-magnate Frederick Robie. Wright's signature unity among all of the parts—exterior design, interior function, interior decoration—makes this one of the quintessential examples of Wright's Prairie style of architecture.

So grab a hotdog (which, in Chicago, has its own sort of architecture) with ketchup, mustard, relish, onions, and hot peppers and get yourself moving. You still have to meet Sue (the most complete *Tyrannosaurus rex* anywhere, on display at the Field Museum) before you catch the best jazz and blues in the world.

 To continue your tour and learn more about Chicago, go to our website.

CRAFT AND DESIGN

*I think art can exist within any craft tradition. Craft is just another way
of saying means. I think it's a question of conscious intention, finally, and personal
gifts, or giftedness. It seems that in art there is a primacy of idea over both means
or craft, and function. Idea has to transcend both. I think this is probably why
it's so difficult to make art out of something functional, or in a realm
where craft has been nurtured for its own sake.*

—Martin Puryear

An Attic vase, a Navajo rug, Tiffany glass, a Chippendale desk—which is art? Which is craft? Art critics and historians once had certain answers to these questions. Now, however, the perception of the relationship among functional objects, craft materials and techniques, and works of fine art has changed. Consider this story concerning one of the Metropolitan Museum of Art's most precious acquisitions, as retold by art critic Arthur C. Danto.[1] According to Thomas Hoving, the director of the museum at the time of the purchase, the vase in Figure 11-1 is "the single most perfect work of art I ever encountered . . . an object of total adoration." In his memoirs, Hoving further described his feelings upon his first encounter with the piece: "The first thought that came to mind was that I was gazing not at a vase, but at a painting." The director was obviously swept off his feet by

[1] Arthur C. Danto, "Fine Art and the Functional Object," *Glass,* no. 51 (Spring 1993): 24–29.

11-1 EUPHRONIOS AND EUXITHEOS.
Calyx Krater (1st quarter of 5th century BCE).
Ceramic. H: 18″; D: 21¹¹/₁₆″.

The Metropolitan Museum of Art. Bequest of Joseph H. Durkee.
Gift of Darious Ogden Mills, and gift of C. Buxton Love. By exchange
(1972.11.10). Copyright 1999 The Metropolitan Museum of Art,
New York.

this masterpiece of Greek art—a terra-cotta vessel painted with the scene of the *Dead Sarpedon Carried by Thanatos and Hypnos* and signed by both the potter and the painter. But why did Hoving diminish the significance of the potter's craft by essentially dismissing the pot as a mere support for an extraordinary painting? Danto suggests that Hoving's reaction is indicative of an art-world prejudice of sorts—one that attaches less importance to functional objects and decoration of any kind. He warns that "the painting [on the vase] is there to decorate an object of conspicuous utility" and cannot be considered without reference to the vase itself. In fact, doing so precludes any real understanding of the work in the historical and artistic context in which it was created.

What purpose does this esoteric argument have for us who, as students, are trying to understand art? Simply this: The distinction between fine art and functional object is linked to the historical and cultural context in which a work was created. As Danto pointed out, the Greek philosophers praised craftspeople as somewhere between artists and philosophers, but held the view that no one was lower than the artist. Danto paraphrases Plato in *The Republic:* "The carpenter knows how to fashion in real life what the painter can merely imitate; therefore . . . artists have no real knowledge at all, trafficking only in the outward appearance of

things." [2] More than 2,000 years later, a French philosopher would declare, "Only what serves no purpose is truly beautiful." [3] Today, many painters are turning their talent to utilitarian objects or creating paintings with techniques traditional to craft. Ceramic artists are creating works of sculpture, and sculptors are finding innovative ways to manipulate clay, wood, and metal. The glassmaker's art has reached new heights of experimentation while employing centuries-old techniques. For many artists, the distinction between art and craft is an artificial and limiting one. Any and all options should be exercised in pursuit of artistic expression. And the aesthetic and artistic merit of any creative work ought to be recognized.

In this chapter we discuss a variety of media and categories of artistic expression. We consider the materials traditional to craft—clay, glass, fiber, metal, and wood—using historical and contemporary works as evidence of the broad technical and stylistic ranges of the media. We also examine graphic design, industrial design, web design, and urban design. In the realm of design, as with crafts, the distinction between art for art's sake and art for utility's sake is also sometimes blurred.

CERAMICS

Ceramics refers to the art or process of making objects of baked clay. Ceramics includes many objects that range from the familiar pots and bowls of **pottery,** to clay sculptures, to building bricks and the extremely hard tiles that protect the surface of the space shuttles from the intense heat of atmospheric reentry.

Methods of Working with Clay

Ceramics is a venerable craft that was highly refined in the ancient lands of the Middle East and in China. For thousands of years people have modeled, pinched, and patted various types of wet clay into useful vessels and allowed them to dry or bake in the sun, creating hard, durable containers. They have rolled clay into rope shapes, which they coiled around an open space. They have rolled out slabs of clay like dough, cut them into pieces, fastened them together, and smoothed them with simple tools, as Native Americans still do today.

[2] Ibid.
[3] Théophile Gautier, Preface to his novel *Mademoiselle de Maupin,* 1835.

Levine's jacket is, in reality, composed of rolled-out slabs of clay that have the look of leather, and the work also contains stitching and real metal snaps and a zipper. The shifting back and forth between illusion and reality functions as a metaphor for what arts and crafts are all about: in so many instances they transform the world that they represent.

The Potter's Wheel

The potter's wheel (Fig. 11-3) was first used in the Middle East in about 4000 BCE and seems to have come into common use a thousand years later. A pot can be **thrown** quite rapidly and effortlessly on a wheel once the techniques have been mastered, in contrast to the more laborious and time-consuming process of building a pot by coiling. In **coiling,** ropes of clay are fashioned, then stacked upon one another. The walls of the pot are then scraped to a smooth finish and molded to the desired vessel shape. The walls of a wheel-thrown pot tend to be thinner and more uniform in thickness than coiled pots, and the outer and inner surfaces are smoother. This does not suggest, however, that coiled pots in the hands of some craftspeople do not approach wheel-thrown pots in their accomplishment. For example, Native Americans of the southwestern United States have never

11-2 MARILYN LEVINE.
John's Jacket (1981).
Ceramic, zipper, and metal fasteners. 36″ × 23½″ × 7″.
Courtesy of the artist.

They discovered that if they allowed clay vessels to dry, then fired them in a type of oven called a kiln, or over coals, they became waterproof and more durable.

Marilyn Levine's mostly clay *John's Jacket* (Fig. 11-2) shows the whimsical use of materials that sometimes defines the aesthetic of the craftsperson. In galleries we circle suspiciously around works such as these. We are drawn to test out our visual sensations by touching them, and perhaps we are simultaneously amused by and annoyed at the craftsperson who would push our senses to the limit. Perhaps we are also on the lookout for gallery employees who might frown on our using our hands to test what we sense with our eyes, and for fellow patrons who might doubt our intelligence or criticize our quest for tactile sensation. Ultimately, the combination of the phony and the real shock the sense of touch.

11-3 *The Hands of the Potter.*
Conrad Knowles forming a tray and a bowl
for his collection of artful pottery.
Copyright 2005 Fritz Henle Estate.

11-4 MARIA MARTINEZ.
Long-neck Avanyu Vase, black on black (c. 1925–1930).
H: 13″; D: 8½″.
Courtesy Adobe Gallery, Albuquerque.

11-5 JAMES MAKINS.
Junihitoe (1992).
Porcelain. 14½″ × 20″ × 20″.
Courtesy of Barry Rosen & Jaap van Liere Modern and Contemporary Art, collection of the Everson Museum, Syracuse, NY.

used the potter's wheel, yet their hand-built pots can be as thin walled and symmetrical as their wheel-thrown counterparts. A wonderful example of coiling can be found in works by the famous Native American potter Maria Martinez. Her black-on-black vessels (Fig. 11-4), adorned with stylized natural forms, flowers, and animals, are among the finest works of the Pueblo people.

Anyone who has been a student in a ceramics class appreciates the difficulty experienced in mastering the potter's wheel. The body movement, rhythm of the wheel, placement, and force of the fingers must come together like a smoothly choreographed dance. The goal, generally, is to achieve perfect symmetry and a smooth contour. How ironic, then, are the works of James Makins (Fig. 11-5), which, when seen alone, may look like the failed efforts of "frustrated student, Ceramics 101." These objects—vases? vessels? bottles?—are, in effect, records of variations in men-

tal concentration, hand pressure, wheel speed, and glaze experimentation. Set on trays as they are, they suggest ritual or domestic objects or, to some, figures on a stage. The entire composition—incidentally an exceptional example of variety within unity—appears foremost as a sculpture, probably because these bottles seem far from utilitarian.

Glazing

Variation in color and texture is secured by the choice of clay and by glazing. The earliest-known glaze dates from about 3000 BCE and is found on tile from the tomb of the Egyptian king Menes.

Glazes, which contain finely ground minerals, are used in liquid form. They are brushed, sprayed, or poured on ceramics after a preliminary **bisque firing** removes all water. During the second firing, the glaze becomes glasslike, or **vitrifies,** fusing with the clay. It gives the clay a glassy, **nonporous** surface coating that can be shiny or dull, depending on its composition. Glazing can create intricate, glossy patterns across otherwise uniform and dull surfaces.

Contrast the simple, pure form of the vase by Chester Nealie (Fig. 11-6) with the unrefined forms of James Makins. The deep but mellow glaze of the Nealie "bottle" is modulated by light to impart a glowing intensity, in contrast to the opaque and uniform glazes of Makins. In both

Every tool or finger mark, every emotion of making is left in the pot's form and surface to be read as a pathway to creation.

—Guy Petherbridge, about Chester Neale's ceramics

groups, the glazes complement the potters' techniques. The graceful contours of the Nealie vase would lose their sensuality and delicacy with the bold colors and matte finish of the Makins piece. Similarly, the spontaneity, brusqueness, and uniqueness of those lilting bottles would be lost if they were to be enshrouded in a uniform, pearlescent glaze.

Robert Arneson's *Jackson Pollock* (Fig. 11-7) provides a very different example of a glazed ceramic work and illustrates how blurred the line between craft and fine art can be.

11-7 ROBERT ARNESON.
Jackson Pollock (1983).
Glazed ceramic. 23″ × 13″ × 7″.

Collection of Dr. Paul and Stacy Polydoran. Courtesy of George Adams Gallery, New York. Copyright Estate of Robert Arneson. Licensed by VAGA, New York.

11-6 CHESTER NEALIE.
Bottle (2000).
Celadon glaze. H: 30 cm.

Courtesy of the artist, Chester Nealie, woodfire potter.

Arneson's figures are purposefully unrefined, intentionally flawed, mirroring the ceramic artist's view of human nature as imperfect. The subject of the work, Jackson Pollock, was an Abstract Expressionist who became renowned for his drip paintings (see Chapter 19). Arneson's clay portrait unifies the artist and his works by providing the illusion of overall dripping and splattering on the bust.

Types of Ceramics

Ceramic objects and **wares** are classified according to the type of clay and the temperature at which they are fired.

11–8 Mangbetu Portrait Bottle, Zaire
(19th–20th centuries).
Terra-cotta. H: 11⅜″.

The Metropolitan Museum of Art, New York.
The Michael C. Rockefeller Collection.
Bequest of Nelson Rockefeller, 1979. (1979. 206. 246).
Photograph © 1991 The Metropolitan Museum of Art.

Earthenware derives its name from the fact that it is usually red or tan in color. It is made from coarse clay or shale clay and is usually fired at 1,000 to 2,000 degrees Fahrenheit. It is somewhat porous and is used for common bricks and coarse pottery. The Mangbetu bottle from Zaire (Fig. 11-8) is made from **terra-cotta,** a heavy clay earthenware product fired at a higher temperature of about 2,070 to 2,320 degrees Fahrenheit. The head is an effigy or portrait of a Mangbetu citizen. Note that the textural decoration is reminiscent of a basket weave. It was probably fired in the open, on a bed of straw and twigs.

Stoneware is usually gray but may be tan or reddish. It is fired at about 2,300 to 2,700 degrees Fahrenheit. It is slightly porous or fully nonporous and is used for most dinnerware and much ceramic sculpture.

Claudi Casanovas's *Block #43* (Fig. 11-9) is a cubic form ceramic sculpture built around a hollow inner space. The work emphasizes the massive, angular forms inherent in hardened clay; the colors complement the natural earthen materials of the sculpture—black, brown, and beige, even a hint of gold—that we might find in the strata of the planet. The texture and fissures would have it seem that the work has been exposed to harsh elements from without and within. Yet it will endure. Casanovas, a visual artist and poet, wrote about his "blocks":

> *Each piece is a silence*
> *If I were a poet, I would inscribe words there*
> *To bring us closer to the truth*
> *Which urges us on from within*
> *If I were a philosopher, or writer, I would*
> *inscribe words so*
> *That the heart would overflow with knowledge*
> *And the meaning of clarity*
> *If I were a monk I would inscribe prayers in which*
> *all spirit might find repose*
> *And glory in the same Being*
> *Only I am a simple mortal*
> *Surrounded by simple obscurity*
> *And unfailing silences*
> *Each piece is a silence*
> *That is filled with the sounds of your gaze.*[4]

[4]Translated from the Catalan by Marilyn McCull, in Miguel Jimenez, "Claudi Casanovas' Blocks," *Ceramics: Art and Perception*, no. 49 (2002): 45. Reprinted with permission.

Ceramic sculptural works are more specific than traditional sculpture with its expressive force coming from the surface of the body. The surface of the sculpture can be bare clay or clay with oxides and glazes; however, this surface tells us as much about the purpose of the sculpture as does the form itself.

—Tania De Brukyner

11-9 CLAUDI CASANOVAS.
Block #43 (2001).
30 cm × 30 cm × 26 cm.
Copyright Claudi Casanovas.
Photo courtesy of Lois Fichner-Rathus.
Photo reproduced by kind permission of Galerie Besson.

Porcelain is hard, nonporous, and usually white or gray in color. It is made from fine, white kaolin clay and contains other minerals such as feldspar, quartz, and flint in various proportions. It is usually fired at 2,400 to 2,500 degrees Fahrenheit, and it is used for fine dinnerware. Chinese porcelain, or **china,** is white and fired at low temperatures. It is glasslike or vitreous and nonporous, and it may be translucent. It makes a characteristic ringing sound when struck with a fingernail. Porcelain has been used by various cultures for vases and dinnerware for thousands of years. Like other kinds of wares, it has also provided a vehicle for artistic expression.

Harumi Nakashima's *Porcelain Form* (Fig. 11-10) illustrates how the smooth, sophisticated surfaces of fine porcelain stand in contrast

11-10 HARUMI NAKASHIMA.
Porcelain Form (2001).
Porcelain. Inlaid decoration.
50 cm × 45 cm × 40 cm.
European Ceramic Work Centre, The Netherlands.
Photograph by Corné Bastiaansen.

to the rough-hewn, rocklike textures often given center stage in earthenware. Here, the rounded surfaces have a biomorphic or organic quality. The repetition in the polka-dotted glaze complements the rhythms found in the budding protuberances. Whereas the colors of the Casanovas piece connect it with earth and reality, the unnatural blue of Nakashima's dots against the purity of the white surfaces disconnect the work from anything in our tangible experience.

One of the fascinating features of clay is its versatility. Clay can be used to form the refined vessels of Chester Nealie and the crude, slablike structures of both primitive and contemporary workers. It is said that one test of the integrity of a work is its trueness to its material. In the case of ceramics, however, one would be hard pressed to point to any one of the products of clay as representative of its "true" face.

GLASS

Glass, like ceramics, has had a long history and has been used to create fine art and functional objects. The Roman historian Pliny the Elder traced the beginnings of glassmaking (albeit accidental) to an account of Phoenician sailors preparing a meal on a beach. They set their pots on lumps of *natron*—an alkali they had on deck to embalm the dead—lit a fire, and when the hot natron mixed with the sand of the beach, molten glass flowed. In fact, glass predates the Phoenicians and the Romans, and the tale as recounted by Pliny probably has some gaps. But the truth is that the recipe for glass is quite simple; as researchers have found in trying to replay the sailor's experience, it could happen![5] The result may not have been that wondrous substance—transparent or translucent—that has the power to transform light into an ephemeral, jewel-like palette. But it was surely glass.

Techniques of Working Glass

Glass is generally made from molten sand, or **silica,** mixed with minerals such as lead, copper, cobalt, cadmium, lime, soda, or potash. Certain combinations of minerals afford the

[5] William S. Ellis, "Glass: Capturing the Dance of Light," *National Geographic* 184, no. 6 (December 1993): 37–69.

glass a rich quality as found in the stained-glass windows of the great cathedrals and in the more recent stained-glass works of Henri Matisse and Marc Chagall.

As Beethoven created his magnificent final symphony after he became deaf, Henri Matisse achieved something similar in scope in the visual works he created once he became bedridden with a serious illness. Rather than surrender to despair, Matisse found opportunity in disability and experimented with media that permitted him to express himself despite his physical limitations. Whereas he had been primarily known as a painter and sculptor, he turned to pasted paper cutouts, which he had previously used to plan large decorative compositions. Perhaps the incentive for these new works was found after Matisse moved to the Riviera town of Vence, where he was cared for by Dominican nuns while he was ill. To show his appreciation, Matisse designed for them a chapel complete with stained-glass windows, murals, and all the liturgical accoutrements—priests' vestments, an altar, candlesticks, and a crucifix. His stained-glass window, *The Tree of Life* (Fig. 11-11), consists of twin elongated arches—shapes that are familiar in the tradition of stained glass in religious architecture—alive with what appear to be overlays of falling leaves. The luminosity of the color is such that the viewer is dazzled by the sense of growth and movement. Blues and greens "cool down" the light streaming through the window, whereas the brilliant yellow of the shapely oak leaves reinforces the feeling of warmth, of life.

Like ceramics, glass is versatile. Molten glass can be modeled, pressed, rolled, blown, and even spun into threads. **Fiberglass** is glass that has been spun into fine filaments. It can be woven into yarn for textiles, used in woolly masses for insulation, and pressed and molded into a plastic material that is tough enough to be used for the body of an automobile. About 4,000 years ago the Egyptians modeled small bottles and jars from molten glass. Contemporary machine-made glassware is usually pressed. Molten glass is poured into molds and then forced into shape by a plunger. The plate glass used for windows and mirrors is made by passing rollers over molten glass as it cools.

Just as the potter's wheel transformed the making of clay vessels both in terms of quality and quantity, so did the technique of **glassblowing** change the nature of glass production. This technique was developed by the Romans, who created pieces of all shapes, sizes, colors, and functions, making glass containers commonplace. In this method, a hollow tube or blowpipe is dipped into molten glass and then removed. Air is blown through the tube,

11–11 HENRI MATISSE.
Interior of the Chapel of the Rosary, Vence.
At left: *The Tree of Life*, stained glass.

Copyright Succession H. Matisse/Artists Rights Society (ARS), New York.
Photo: H. Del Olmo/Réunion des Musées Nationaux/Art Resource,
New York.

causing the hot glass to form a spherical bubble whose contours are shaped through rolling and pulling with various tools. The process is usually quite rapid, but the glass can be reheated if it must be worked extensively.

Once the desired shape has been achieved, the surface of the glass can be decorated by cutting or **engraving** planes that reflect light in certain patterns, by etching, or by printing.

11-12 Portland Vase (Roman, 3rd century). Cameo-cut glass.

British Museum, London. Heritage Image Partnership (HIP), heritage-images.com.

One of the earliest and best-known pieces of glass-ware is the Roman Portland Vase (Fig. 11-12), which survives from the third century CE. The refinement of the piece testifies to the long tradition of glassmaking in Rome even before that time. The Portland Vase was created in three steps. The underlying form was blown from dark blue glass. Next, a coating of semi-opaque white glass was added to the surface of the basic blue form. Finally, the white glass was carved away to provide the bas-relief of figures and vegetation that circumscribe the vase. The relief consists of many subtle gradations. Where it is thinnest, the blue from beneath shows through to provide a shaded quality. Imagine the patience of the cameo cutter who meticulously chipped glass away from glass, leaving unscratched the brittle blue surface that serves as background for the figures.

In various eras, different world centers became renowned for glassmaking. For example, during the Middle Ages, Venetian glass became known for its lightness and delicacy.

Eighteenth-century Stiegel glass, made in Pennsylvania, became known for its use of flint (lead oxide) to achieve hardness and brightness. So-called **flint glass** is used for lenses of optical instruments and for crystal. Nineteenth-century Sandwich glass—from the town of Sandwich, Massachusetts—was pressed into molds to take on the appearance of a cut pattern. Ornamental Sandwich glass pieces in the shapes of cats, dogs, hens, and ducks became common home decorations.

During the second half of the nineteenth century, Louis Comfort Tiffany designed some of the most handsome **Art Nouveau** interiors. His glassware (Fig. 11-13) attains a similar marriage of simplicity and exotic refinement. Graceful botanical forms swell and become attenuated. The translucent or iridescent glass is decorated by spiral shapes,

11-13 LOUIS COMFORT TIFFANY.
Six pieces of glassware in Art Nouveau
style made by the Tiffany Studio.
Glass, favrile. Height, left to right:
$8^{9}/_{16}"$; $5^{7}/_{8}"$, $18^{11}/_{16}"$; $7^{5}/_{8}"$; $16^{1}/_{4}"$; $4^{1}/_{2}"$.
The Metropolitan Museum of Art, New York
(96.17.42; 41.121.9; 51.121.17–.18; 55.213.22;
55.213.28). Photograph copyright 1987
The Metropolitan Museum of Art, New York.

swirling lines, and floating forms that seem to grow naturally out of the glassblowing process. They keep faith with the Art Nouveau creed that decoration should be a natural expression of the manufacturing process. Tiffany also fashioned many fine candlesticks, lamps, and lighting fixtures from bronze that show the same botanical whimsy he expressed in his glassware.

FIBER ARTS

Fibers are slender, threadlike structures that are derived from animals (for example, wool or silk), vegetable (cotton or linen), or synthetic (rayon, nylon, or fiberglass) sources.

The fiber arts refer to a number of disciplines in which fibers are combined to make functional or decorative objects or works of art. They include, but are not limited to, weaving, embroidery, crochet, and macramé.

Weaving

Weaving was known to the Egyptians, who placed patterned fabrics before the thrones of the pharaohs 5,000 years ago. Only royalty could tread on certain fabrics. According to ancient Greek legend, King Agamemnon showed excessive pride by walking upon purple fabrics that were intended for the gods.

The Chandeliers of Dale Chihuly

*They're going to think we're nuts over there, and of course
we are a little nuts, but we'll get this thing built.*

—Dale Chihuly (about the Icicle Creek chandelier)

11-14 DALE CHIHULY.
Rio delle Torreselle Chandelier (1996), Venice, Italy.
A chandelier installation in the Rio Delle Torre Stelle,
part of the Chihuly over Venice project, Venezia Aperto Vetro.
Photo: Russell Johnson, courtesy Chihuly Studio.

"A little bit nuts." Artists, and even the rest of us, may have felt this way or been characterized this way at some point or another—especially when we were seeing things in an unconventional way. Glass artist Dale Chihuly has redefined the conventional definition and function of "chandelier" by designing works he describes by this name for public spaces from Venice to Jerusalem, from the world's great museums to the wilderness of the great outdoors. Although many chandeliers, in the traditional sense, are ornamental, they are also functional objects used, with candles or electricity, to illuminate an environment. But Chihuly's chandeliers are a different species. They do not emit light of their own. Rather, they reflect and transform ambient light—batteries not included.

Chihuly's extraordinary glassworks capture, amplify, and channel light. In their unusual stylistic juxtaposition with their surroundings, his chandeliers compel passersby to take another look at the context in which they are set—whether the Byzantine architecture and canals we find in Venice (Fig. 11-14), the ancient ruins in Jerusalem, or in the wilderness, the literal natural state of affairs.

Chihuly designed the chandelier shown in Figure 11-15 for the Sleeping Lady mountain retreat at Icicle Creek in the state of Washington. He erected it on an ancient granite boulder among the grand pines of a primeval setting, surrounded by a river and a profusion of wildlife. The chandelier reflects and amplifies the frosted serenity of the site in winter. It enriches visitors' relationship with the area surrounding the retreat and with nature as a whole. The chandelier also adds Chihuly's—and humankind's—personal stamp to a pristine wooded site. It also says something about the vision and the passion of the artist—unique in this case to Dale Chihuly, though made visual by a team of glassblowers and technicians. Does the work have deeper symbolic meanings, meanings that connect it with the history of

Chihuly is a luminist. He uses glass as a literal and metaphorical prism through which he projects both ambient and intense theatrical light to produce sublime, luminous effects. This connects him to the long history of art in which light is cherished, "otherworldly," and implies divine presence.

—Jack Cowart

art and civilization, meanings that connect it with contemporary technology and modes of expression? Much of the answer to that question lies in you. Perhaps you would like to consider these lines from Wallace Stevens's poem "Anecdote of the Jar":

> *I placed a jar in Tennessee,*
> *And round it was, upon a hill.*
> *It made the slovenly wilderness*
> *Surround that hill.*
> *The wilderness rose up to it,*
> *And sprawled around, no longer wild.** ▪

* From *The Collected Poems of Wallace Stevens* by Wallace Stevens, © 1945 by Wallace Stevens and renewed 1982 by Holly Stevens. Used by permission of Alfred A. Knopf, a division of Random House, Inc.

11-15 DALE CHIHULY.
Icicle Creek
Chandelier (1996).
Photo courtesy
of the artist.

11-16 Arbadil carpet, probably Tabriz (1539–1540).
Woolen pile. 34″ × 17½″.

Victoria and Albert Museum, London/Art Resource, New York.

The **weaving** of fabric or cloth is accomplished by interfacing horizontal and vertical threads. The length-wise fibers are called the **warp,** and the crosswise threads are called the **weft** or **woof.** The material and type of weave determine the weight and quality of the cloth. Wool, for example, makes soft, resilient cloth that is easy to dye. Nylon is strong, more durable than wool, mothproof, resistant to mildew and mold, nonallergenic, and easy to dye.

There are a number of types of weaves. The **plain weave** found in burlap, muslin, and cotton broadcloth is the strongest and simplest: the woof thread passes above one warp fiber and beneath the next. In the **satin weave,** woof threads pass above and beneath several warp threads. Warp and woof form broken diagonal patterns in the **twill weave.** In **pile weaving,** which is found in carpeting and in velvet, loops or knots are tied; when the knotting is done, the ends are cut or sheared to create an even surface. In sixteenth-century Persia, where carpet weaving reached an artistic peak, pile patterns often had as many as 1,000 knots to the square inch.

The Persian rug shown in Figure 11-16 was woven in the seventeenth century. Like others of its kind, it portrays the old Islamic concept of Paradise as a garden. Here, a light-colored tree and an assortment of other plants grow on a claret red background. The date palm, the iris, a symbolic tree of life, hyacinths, and tulips were frequently depicted on such rugs.

Weaving is typically carried out by the hand **loom** or a power loom. The Alaskan Chilkat robe (Fig. 11-17), however, was woven by Native American women without benefit of a loom. Chilkat women achieved a very fine texture with a thread made from a core of a strand of cedar bark covered with the wool from a mountain goat. Clan members used robes such as these on important occasions to show off the family crest. Here a strikingly stylized, winged animal occupies the center of a field of eyes, heads, and mysterious symbols.

Traditional weaving techniques may surface in innovative ways in the hands of contemporary artists. Ed Rossbach's wall hanging (Fig. 11-18), which, in overall shape, is not unlike the Chilkat robe, is worlds apart in its choice of materials and strong political message. Rossbach plaits construction paper in such a manner that his image emerges subtly from an overall mottled background.

The surfaces of fabrics can be enhanced by printing, embroidery, tie-dyeing, or batik. Hand printing has been known since ancient times, and Oriental traders brought the practice to Europe. A design was stamped on a fabric with a carved wooden block that had been inked. Contemporary

11-17 DORICA JACKSON.
Chilkat robe (1976).
Cedar bark warp; sheep's wool wefts. W: 60″.
Courtesy of the U.S. Department of the Interior. National Park Service.
Sitka National Historical Park, Sitka, AK.

11-19 Ceremonial feathered basket with bead and shell
pendants. Pomo, CA (American Indian, Pomo, 1900).
H: 3½″.
Phoebe A. Hearst Museum of Anthropology, University of California,
Berkeley.

11-18 ED ROSSBACH.
Handgun (1975).
Plaited construction paper. 40″ × 54″.
The Collection of Craft Alliance. Courtesy of the artist.

machine printing uses inked rollers in the place of blocks, and fabrics can be printed at astonishingly rapid rates. In **embroidery,** the design is made by needlework.

Tie-dyeing and batik both involve dyeing fabrics. In **tie-dyeing,** designs are created by sewing or tying folds in the cloth to prevent the dye from coloring certain sections of fabric (Figs. 11-21 and 11-22). In **batik,** applications of wax prevent the dye from coloring sections of fabric that are to be kept light or white. A series of dye baths and waxings can be used to create subtly deeper colors.

Basketry

In **basketry,** or basket weaving, fibers are also woven together in various patterns. The delightful Pomo gift basket (Fig. 11-19) was woven from grass and glass beads. Triangles of warm primary red leap out from a backdrop of cool primary blue and pale straw. Native Americans from California made extremely fine basketry, with as many as 60 stitches to the inch. Barks, roots, and other fibers supplemented grass, and precious feathers and shells were sometimes used.

METALWORK AND JEWELRY

The refining and working of metals has been known for thousands of years. Iron and its alloys have been used to fashion horseshoes and arrowheads and, more recently, the skeletons of skyscrapers. **Stainless steel** is used in kitchen utensils and furniture. Lightweight aluminum is used in cookware and in aircraft. Bronze is the favorite metal of sculptors. **Brass** is seen everywhere from andirons to candlesticks to beds.

Silver and gold have been prized for millennia for their rarity and their appealing colors and textures. They are used in jewelry, fine tableware, ritual vessels, and sacred objects. In jewelry these precious metals often serve as settings for equally precious gems or polished stones, or their surfaces can be **enameled** by melting powdered glass on them. These metals even find use as currency; in times of political chaos,

The Fiber Arts of Faith Ringgold

Faith Ringgold was born in Harlem in 1930 and educated in the public schools of New York City. Raised with a social conscience, she painted murals and other works inspired by the civil rights movement in the 1960s and, a decade later, took to feminist themes after her exclusion from an all-male exhibition at New York's School of Visual Arts. Ringgold's mother, a fashion designer, was always sewing, the artist recalls, and at this time the artist herself turned to sewing and related techniques—needlepoint, beading, braided ribbon, and sewn fabric—to produce soft sculptures such as those in *Mama Jones, Andrew, Barbara, and Faith* (Fig. 11-20), from her series *The Family of Women.* African garments inspired the clothing of these family members, and the faces are reminiscent of African masks.

More recently, Ringgold is most well known for her narrative quilts, such as the highly acclaimed *Tar Beach* (see Fig. 1-24), which combine traditions common to African Americans and women—storytelling and quilting. *Matisse's Chapel* (Fig. 11-21) is from Ringgold's *French Collection,* which inserts contemporary American artists, other colleagues, and family members into French settings. In one quilt, *Dancing at the Louvre,* friends, including the children of one, are shown in high spirits before the Mona Lisa. In *Picasso's Studio,* the famed Spanish artist (literally) draws inspiration for *Les Demoiselles d'Avignon* from a black model. In an ironic twist on Manet's *Luncheon on the Grass* (see Figure 18-12), a nude Picasso sits on the grass in the company of clothed women. *Matisse's Chapel* places a wedding party composed of the artist's family in the chapel made famous by dint of Matisse's contributions, including *The Tree of Life* (Fig. 11-11).

Crown Heights Children's Story Quilt (Fig. 11-22) is on permanent display at a Brooklyn public school. The quilt pictures 12 folktales of peoples who have contributed to the life of New York, including Jamaicans and West Africans (the top three on the left), the Dutch (upper right), two Native American peoples, Asians, Puerto Ricans, Italian Americans, and Jewish Americans. True to the genre of quilting, the artist uses her skills to patch together the myths and stories of different peoples in a nation composed of diverse ethnic groups. ■

11–20 FAITH RINGGOLD.
Mama Jones, Andrew, Barbara, and Faith (1973).
Embroidery and sewn fabric. 74″ × 69″.
From *The Family of Women* series. Copyright Faith Ringgold.
Artist's collection.

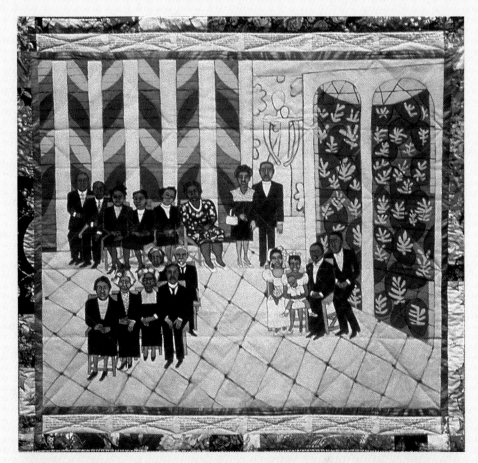

11-21 FAITH RINGGOLD.
Matisse's Chapel (1991).
Acrylic on canvas; tie-dyed,
pieced fabric border.
74″ × 79½″.

From *The French Collection* series,
Part I, #6. Private collection.
Copyright 1994 Faith Ringgold.
Photo courtesy of the New Museum
of Contemporary Art.

11-22 FAITH RINGGOLD.
*Crown Heights Children's Story
Quilt* (1994).
Painted and pieced fabric.
108″ × 144″.

Collection of NYC Board of Education,
New York. Copyright 1994 Faith
Ringgold / The New York City Board
of Education.

11-23 Pectoral piece from Ordzhonikidze,
Russia (4th century BCE).
Gold. D: 12″.
Historical Museum, Kiev.

gold and silver are sought even as the value of paper money drops off to nothing. Threads of gold and silver find their way onto precious china and into the garments and vestments of clergy and kings. Gold leaf adorns books, paintings, and picture frames.

Metals can be hammered into shape, **embossed** with raised designs, and cast according to procedures described for bronze in Chapter 9. Each form of working metal has its own tradition and its advantages and disadvantages.

Ancient Greek goldsmiths wrought some of the finest gold jewelry. The pectoral piece shown in Figure 11-23 was meant to be worn across the breast of some nomadic chieftain from southern Russia and probably buried with him. Fortunately, it was not. People and animals are depicted

with a realism that renders the fanciful **griffins** in the lower register as believable as the horses, dogs, and grasshoppers found elsewhere in the piece. The figures are balanced by the refined scrollwork in the central register, and all are contained by the magnificent coils.

The Renaissance sculptor and goldsmith Benvenuto Cellini created a gold and enamel saltcellar (Fig. 11-24) for the French king Francis I that shows the refinement of his art. Its allegorical significance is merely an excuse for displaying the skill of Cellini's craft. Salt, drawn from the sea, is housed in a boat-shaped salt container and watched over by a figure of Neptune. The pepper, drawn from the earth, is contained in a miniature triumphal arch and guarded by a female personification of Earth. Figures on the base repre-

11-24 BENVENUTO CELLINI.
Saltcellar of Francis I (1539–1543).
Gold and enamel. H: 10⅛″; L: 13¹⁄₁₆″.
Kunsthistorisches Museum, Vienna. Copyright Art Resource,
New York.

11-25 Nose ornament, crayfish, Peru (Loma Negra, 3rd century CE).
Gold, silver, turquoise inlay. H: 4¾″.

The Metropolitan Museum of Art, New York. The Michael C. Rockefeller Memorial Collection. Bequest of Nelson A. Rockefeller, 1979 (1979.206.1236) Photograph copyright 1998 The Metropolitan Museum of Art, New York.

11-26 KIFF SLEMMONS.
Transport (1990).
Sterling silver, aluminum, gauze, mesh, tape, tubing, pearls. 5″ × 14″ × 4½″.

Courtesy of the artist. Photo by Rod Slemmons.

sent the seasons and the segments of the day—all on a piece 13 inches long. Unfortunately, the saltcellar is Cellini's sole major work in gold that survives.

Body ornament, ever growing in popularity to this day, spans history and geography. Consider the nose ornament from Peru in Figure 11-25. The piece is fashioned of gold, silver, and turquoise inlay and is a characteristic example of the ancient Peruvian facility in handling complex metal techniques. Much of the jewelry available for us to see today has been unearthed from tombs of the very wealthy among

Peruvian society. The images and their symbolism remain mostly undeciphered, but archeologists have nonetheless constructed a view of these people from such artifacts.

Kiff Slemmons's *Transport* (Fig. 11-26) is a miniature sculpture that again bridges the supposed gulf between fine art and the functional object. It was constructed for the *Artworks for AIDS* exhibition that was held in Seattle in 1990. It is a miniature two-wheeled cart that refers to the history of mass deaths. Throughout the ages, such carts have been used in cities to truck away the victims of epidemics. The wheels of the cart are clocks with human hands, seeming to tick away as the number of deaths due to AIDS mounts. Hospital waste and a stylized "progress" chart with an alarming indicator of the rising toll of the epidemic complete the political message.

WOOD

Some relatively sophisticated technology is require to convert glass, metal, and clay into something of use. Wood, however, has only to be cut and carved to form a functional object.

Three wood vases hint at the versatility of the medium. The soft, flowing contours of Melvyn Firmager's vase (Fig. 11-27) highlight the swirling grain patterns of the wood, which almost take on the character of glazing on a

11-27 MELVYN FIRMAGER.
Untitled (1993).
Destroyed in 1994
Los Angeles earthquake.
Eucalyptus gunnii.
H: 13½″; D: 8″.

Photo courtesy of Del Mano Gallery, Los Angeles.

Successful designs . . . stand out because . . . they raise the human spirit and make life a little easier.

—Wolf Von Eckardt

An artist is someone who produces things that people don't need to have but that he—for some reason—thinks it would be a good idea to give them.

—Andy Warhol

11-28 DAVID ELLSWORTH.
Vessel (1992).
Norway maple burl. H: 4″; D: 7″.
Courtesy of the artist.

ceramic vase. The simple roundness, highly polished surface, and inherent grain patterns in David Ellsworth's vase (Fig. 11-28) create the illusion of stone.

DESIGN

An array of design disciplines touches us in our daily lives—from every advertisement we see to every product we use. Good design raises our quality of life, even if we are not consciously aware of it. Let us consider the disciplines of graphic design, industrial design, web design, and urban design.

Graphic Design

Graphic design refers to visual arts in which designs or patterns are made for commercial purposes. Examples of graphic design include the postage stamp, greeting cards, book design, advertising brochures, newspaper and maga-

zine ads, billboards, product packages, posters, signs, trademarks, and logos. Frequently, graphic design includes written copy that is set in type. **Typography** refers to the related art or process of setting and arranging type for printing. Once projects, including type, have been designed, they are usually mass-produced by one of the types of printing discussed in Chapter 7, through use of blocks, plates, or screens.

Package Design

The packaging of products is a complicated process. Packaging must catch the eye as a consumer wanders down the aisles of a supermarket or surfs the Internet. It must quickly and effectively communicate something about the nature and quality of the product and, at the same time, reflect the aesthetic preferences of the targeted group of consumers.

The familiarity of many product packages provided fertile inspiration for Pop Art. Andy Warhol was perhaps best known for his series of silkscreens of Campbell's soup cans, but he also produced multiple images of Coca-Cola bottles and oversized assemblages of Brillo boxes made from acrylic silkscreen on wood (Fig. 11-29). Manufacturers use the same silkscreen process for printing many of their packages.

Posters

Posters are mass-produced, often illustrated paperworks that are designed to widely publicize or advertise products or events. Posters are affordable choices for wall art, to which students in residence halls attest, yet vintage signed posters in limited editions can fetch thousands of dollars.

Henri de Toulouse-Lautrec, a late nineteenth-century French artist, is seen by some as the father of the color lithograph poster. Toulouse-Lautrec dwelled in nighttime Paris—its cafés, music halls, nightclubs, and brothels. The posters that he designed for concerts and other performances are among the most well known in the history of art. His designs (Fig. 11-30) are successful because they capture, in a single image, the spirit and personality of the establishment and the performer. Areas of unmodulated color and high-contrast values in the poster design evoke theater lighting

11-29 ANDY WARHOL.
Brillo (1964).
Acrylic silkscreen on wood. 17″ × 17″ × 13″.
Leo Castelli Gallery, New York. Copyright 2003 Andy Warhol
Foundation for the Visual Arts/Artists Rights Society (ARS), New York.

11-30 HENRI DE TOULOUSE-LAUTREC. (1864–1901).
Le Divan Japonais (1892).
Color lithograph. 31⅝″ × 23⅞″.
Musée Toulouse-Lautrec, Albi, France/Erich Lessing/Art Resource, New York.

11-31 MTV logo.
© Jane Butchofsky-Houser/Corbis.

and costuming. The lyrical shapes and undulating lines, coupled with an oblique perspective and bold patterns influenced by Japanese prints, combine to catch the eye and draw the patron to the party. Can you think of some of your favorite posters for rock concerts? Why were the images memorable?

Logos

A **logo** is an emblematic design used to identify and advertise a company or an organization. The most successful corporate identity designs are ones that will spring to mind immediately when you think of the entities that they represent. The next time you are watching MTV (Fig. 11-31), note the persistent

11-32 Cingular Wireless logo.
Courtesy Cingular Wireless.

Industrial Design

Industrial design refers to the planning and artistic enhancement of industrial products ranging from space shuttles and automobiles to microcomputers and MP3 players. To a large degree, the functional and mechanical aspects of these products are the work of engineers. Designers wrap the inner workings in attractive skins or housings.

Form and Function

Consider the forms of the lunar landing module shown in the photograph *Earthrise* (see Fig. 8-3) and of the space shuttle. The forms of each were determined largely by their functions. The lunar landing module needed only to travel from outer space down to the lunar surface and then back from the Moon to an orbiting spacecraft. It never navigated through an atmosphere, so it did not need to be aerodynamic; it could afford its odd shape and many protrusions. The space shuttle, on the other hand, must glide from outer space down to the surface of Earth. To a large degree, its shape is designed mathematically so that the atmosphere will provide a maximum of lift to the underside of its bulky body. The instrument panels in both spacecraft were designed by experts in human psychology and engineering. They had to be placed in strategic locations and differenti-

logo in the corner of your screen. It is instantly recognizable. Whether or not your wireless service is provided by Cingular (Fig. 11-32), you are no doubt familiar with the androgynous orange character that represents the company. Both of these logos appear in print ads but also have their animated counterparts in video versions you see on TV. MTV's "M" pulsates and changes contours and colors; the Cingular "man" leaps and hops and somersaults.

One of today's most visually exciting and successful design campaigns—from product to marketing—is the one for the Apple iPod (Fig. 11-33). From packaging and posters, to its distinctive logo and industrial design, all of the elements interface with and enhance one another. In choosing an iPod MP3 player, the consumer is not only buying a product but buying into a lifestyle.

11-33 Apple iPod logo.
Jackson Tack/Alamy.

11-34 NATHAN GEORGE HORWITT.
Watch Face (1947).
D: 1⅜″.
Specially designed face without numerals; with
silver hands and simple silver dot indicating position
of number 12.
Collection of the Museum of Modern Art, New York.
Gift of the designer. Copyright Art Resource, New York.

ated from one another. In order not to hamper the work
of pilots and navigators, their forms had to suggest their
functions.

In most cases, designers have a larger influence on the
final appearance of a product than they did with the lunar
landing module and the space shuttle. The factors that usu-
ally enter into an industrial design include utility (that is, in
what form is the equipment easiest to use?), cost, and aes-
thetic considerations. The aesthetic appeal of an industrial
product not only provides a sense of satisfaction for the de-
signer and the manufacturer but also affects sales.

New York's Museum of Modern Art has an extensive
collection of superior industrial designs. It includes an end-
lessly broad range of products—chairs, teapots, wrist-
watches, lighting fixtures—assembled with one criterion in
mind: excellence in design. The minimalist appearance of
the Movado watch (Fig. 11-34) is pure and elegant and
signifies efficiency. Rody Graumans's *85 Lamps Lighting Fix-
ture* (Fig. 11-35) brings out the whimsical in the industrial in
its unadulterated clustering of naked light bulbs and wiring.

Web Design

Websites are an inextricable part of the information super-
highway. Any of us cyberspace surfers can go online, access
the website of a popular consumer magazine, and get the lat-

11-35 RODY GRAUMANS.
85 Lamps Lighting Fixture (1992).
Light bulbs, cords, and sockets. H: 39⅜″ (100 cm);
D: 39⅜″ (100 cm).
Droog Design, The Netherlands, MOMA/Art Resource, New York.

est reviews on the new car we're drooling over. We can re-
search without books, order books, book reservations, bid
on a special reserve wine. And a big part of what keeps us at-
tached to our PC's mouse at the end of an electronic umbili-
cal cord is the visual feedback we get when we click. The
better the design of the website, the more tantalizing the
product or service—a clear fact not lost on the thousands
upon thousands of businesses, organizations, agencies, and
individuals for whom the website is the new face and first
face to the consumer in the age of electronics.

11–36 Website: Home page
of the Louvre.
Copyright Louvre Museum, Paris.

We can think of web design as having two key tasks. One is technical and involves programming—how users click their way around a web page, how hot links to other pages and sites are established, and how to insert still images or animated clips and sound. The other task is an aesthetic one, encompassing art and design.

Art museums are among the untold numbers of organizations that can be accessed through websites. The home page of the website of the Louvre (Fig. 11-36) (http://www .louvre.fr) includes a photograph of the exterior of the building, featuring its now famous glass pyramid entrance. Once "inside," users can click their way to some of the more popular works of art in the collection. The Louvre invites you to take a *visite virtuelle en ligne* (a virtual visit online), with text in a number of languages, including English, Spanish, and Japanese. The more mundane but essential information about museum hours and current exhibits is reliably posted, but the functionality of the web design almost pales in comparison to its ability to transport virtual visitors to one of the world's great cultural centers from the comfort of their ergonomically designed computer chairs.

You can visit ArtMuseum.net (http://www.artmuseum .net) to view art "exhibitions" from various participating museums online. When you take your virtual tour of one of these sites, clicking on a "thumbnail" illustration of a work in the collection might enlarge it or display descriptive text. Some websites let you walk through a building or another environment and look in various directions as you do— something like "Super Mario Brothers Visit the Art Institute of Chicago," without the punching, flying, or shooting.

As you surf the web, you have no doubt been struck by the endless variety, quality, and quantity of web design— from sophisticated to tacky, from "high art" to "low art." I, like you, come across interesting websites almost every day, so it was hard to settle for just one or two to highlight in this chapter among the wealth of riches and rags. Some current "faves": websites for the Alvin Ailey American Dance Theater in New York City (known for its brilliant, mind- and body-stretching choreography) (Fig. 11-37) and BBDO (one of the world's premier advertising agencies) (Fig. 11- 38). These and other websites feature hot spots that the user can click on to navigate the site for related web pages and information.

Web design is a big business, and many graphic designers set up shop in this realm. Students can now take web design in their college courses, whereas the rest of us can learn

11-37 Website: Alvin Ailey
American Dance Theater.

Photo copyright Andrew Eccles.
Courtesy of Alvin Ailey
American Dance Theater.

11-38 A web page within
the website of the
advertising agency
BBDO Worldwide.

Courtesy BBDO
Worldwide.

about it in how-to books such as *Web Design for Dummies.* Many individuals, like organizations, have websites on which they include text and uploaded photos and video clips. They serve as anything from electronic business cards to ways for families to keep in touch. Cyberspace collapses the distance that separates us from the important people in our lives.

Urban Design

Perhaps it is in urban design that our desire for order and harmony achieves its most majestic expression. Throughout history most towns and cities have more or less sprung up. They have pushed back the countryside in all directions, as necessary, with little evidence of an overall guiding concept. As a result, the masses of great buildings sometimes press against other masses of great buildings, and transportation becomes a worrisome afterthought. The Rome of the early Republic, for example, was an impoverished seat of empire, little more than a disordered assemblage of seven villages on seven hills. Later, the downtown area was a jumble of narrow streets winding through mud–brick buildings. Not un-

til the first century BCE were the major building programs undertaken by Sulla and then the Caesars.

The new towns of the Roman Empire were laid out largely on a rectangular grid. This pattern was common among centrist states, where bits of land were parceled out to the subjects of mighty rulers. The gridiron was also found to be a useful basis for design throughout history—from the ancient Greeks to the colonial Americans. Many cities of the Near and Middle East, such as Baghdad, have a circular tradition in urban design, which may reflect the belief that they were the hubs of the universe. The throne room of the palace in eighth-century Baghdad was at the center of the circle. The palace—including attendant buildings, a game preserve, and pavilions set in perfumed gardens—was more than a mile in diameter, and the remainder of the population occupied a relatively narrow ring around the palace.

Washington, D.C.

Few urban designs are as simple and rich as Pierre-Charles L'Enfant's plan for Washington, D.C. (Fig. 11-39). The city is cradled between two branches of the Potomac River, yielding an uneven, overall diamond shape. Within the dia-

11-39 PIERRE-CHARLES L'ENFANT.
Plan for Washington, D.C. (1792).
Courtesy of the National Archives.

11-40 REM KOOLHAAS.
Design for Les Halles, Paris.
Rem Koolhaas/OMA/photograph by Hans Werlemann.

mond, a rectangular grid of streets that run east-west and north-south was laid down. Near the center of the diamond, with its west edge at the river, an enormous Mall or green space was set aside. At the east end of the Mall is the Capitol Building. To the north, at its west end, is the president's house (which is now the White House). Broad boulevards radiate from the Capitol and from the White House, cutting across the gridiron. One radiating boulevard runs directly between the Capitol and the White House, and other boulevards parallel it.

The design is a composition in which the masses of the Capitol Building and White House balance one another, and the rhythms of the gridiron pattern and intersecting diagonal boulevards create contrast and unity. The Mall provides an open central gathering place that is as much a part of American culture as it is respite from the congestion of the city.

L'Enfant's plan for Washington, D.C., was inspired by the art and architecture of Neoclassical France. Today, a visitor to both cities will note that avenues and grand boulevards culminate in monuments that punctuate the end of a long vista. Paris is often called the most beautiful city in the world, a title achieved after massive renovations to the city plan by Raoul Haussmann in the nineteenth century. Then, as now, Paris was not without its pockets of urban problems requiring creative and politically sensitive solutions. The Parisian area of Les Halles has long been home to park and commercial spaces as well as a major transit hub. Architect Rem Koolhaas and his firm, OMA, bring together the disparate parts in a transparent design that makes all of the amenities visible to the surrounding neighborhood (Fig. 11-40). Shape and color dominate the plan, with circular gardens and luminous towers rising above the city's infrastructure. The dark, discontinuous, and chaotic environs of the old Les Halles will be transformed, through an innovative and practical urban design, into a signature city monument.

ART TOUR

Washington, D.C.

On July 14, 1789, in what became the defining symbolic moment of the French Revolution, the Bastille prison was stormed by revolutionaries who freed a grand total of seven prisoners. Four years later, with the founding of a new Republic, the doors of the Louvre Museum (containing about 200 works that had belonged to the king) opened to the public.

The point to this story lies in its contrast with the next: In 1936, Andrew Mellon (an American statesman and financier) gave his art collection to the United States of America and built the National Gallery of Art in Washington, D.C., to house it. In subsequent years, other collectors followed suit until the "nation's collection" outgrew its space. Unlike many of the world's great art museums, such as the Louvre, the museums you will see in Washington, D.C., did not begin as private royal collections made accessible to the public only after revolution and democratization. The core of Washington's holdings came from entrepreneurs who willingly, even affectionately, gave their art to their fellow citizens. Much of what you will see in Washington, D.C., is yours by virtue of your citizenship in the United States of America. And seeing just about all of it costs you nothing.

If you're coming to Washington by train, come hungry. You will arrive, most likely, at Union Station—itself a fine example of the Beaux Arts architectural style. From the three main archways that define the entry (based on the Arch of Constantine in Rome!) to the magnificent gilded barrel-vaulted ceiling, Union Station is not simply a transit center to move through—linger and look. It opened in 1907, and for more than 50 years this station was the largest in the world. After careful and costly restoration in 1988, this is now the second most visited site in Washington, D.C. Union Station is home to one of the most fantastic food courts you will ever come upon, with selections to entice every palate. Take a spin around the stalls before you commit to that Maryland crab-cake sandwich.

Union Station is a well-situated starting point for your art tour of the capital. From there, a short stroll along Delaware or Louisiana Avenue will bring you to the U.S. Capitol and the Mall, the site of many museums and memorials. It is here that you will experience the *feeling* of the nation's capital—its Classical architecture (inspired, as was the new democratic government, by Greek and Roman ideals), expanses of tree-lined grassy lawn, reflecting pools, marble and granite monuments. The Capitol Building (Fig. 3-10) is at the "top"—or eastern end—of the Mall and has much to offer to the art seeker. The dome, designed by Thomas U. Walter, is one of the largest in the world. The rotunda (the large, circular space in the interior beneath the dome) contains many paintings and sculptures and is capped by Constantino Brumidi's mural depicting the *Apotheosis of Washington* (bring your binoculars and your sense of humor).

Outside the Capitol, the Mall is arrayed before the visitor, offering a perspective toward the Washington Monument on the west end and all that lies between. The Mall was designed by the French architect Pierre L'Enfant, who imported many of his elements of city planning (grand boulevards, elegant residences, well-situated monuments) from Paris. The first museum on your tour is the National Gallery of Art. The collection is divided between two buildings—East and West. The West (Neoclassical) Building is the earlier museum—the one financed by Andrew Mellon and designed by John Russell Pope. Here the visitor will find Western art spanning the thirteenth through the nineteenth centuries, featuring stellar examples of works by such artists as Giotto, Botticelli, Leonardo da Vinci, Raphael (*The Alba Madonna*), Rembrandt, Rubens (*Daniel in the Lion's Den*), El Greco, Monet (*Woman with a Parasol—Mme Monet and Her Son*), Cassatt, Cézanne, Toulouse-Lautrec (*Quadrille at the Moulin Rouge*), Homer (*Breezing Up*), and Whistler (*Symphony in White, No. 1: The White Girl*), among many, many others of fame and note. And that's just the west wing. The entire East Building, designed by I. M. Pei and one of the few Modernist works of architecture in the city, houses the country's collection of twentieth-century art. A dramatic, soaring

UNION STATION.
Corbis.

Entrance lobby of the National Gallery of Art, Washington, D.C., with sculpture of children holding hands.
© Bernard Annebicque/Corbis Sygma.

SMITHSONIAN CASTLE.

atrium, featuring an enormous mobile by Alexander Calder (Fig. 2-67) and works by Henry Moore, Joan Miró, and Andrew Goldsworthy, is flanked by balconies and galleries in which one will find works from the permanent collection as well as traveling exhibitions. Both museums (connected underground) have wonderful restaurants and bookshops.

One of the highlights of the Mall is the Sculpture Garden of the National Gallery of Art, poised between the West Building and the National Museum of Natural History. Works of modern sculpture pepper the sections of lawn surrounding a refreshing fountain in summer and delightful skating rink in winter. Viewers can walk among and around pieces by Claes Oldenberg, Roy Lichtenstein, Louise Bourgeois, Joan Miró, and others. And from these fun-filled, art-filled surroundings, one can cross over a broad expanse of lawn to another collection of outdoor sculpture belonging to the Hirshhorn Museum, a private-turned-public collection displayed in a cylindrical building affectionately referred to as "the doughnut." Rodin's *The Burghers of Calais* (Fig. 18-40) finds itself in equally prestigious company in this collection.

The Mall contains a staggering number of museums, galleries, and monuments. The old Smithsonian Castle, the building that once housed works that are now found in other sites along the Mall (don't miss wandering through its splendid gardens); the spectacular National Air and Space Museum; such small jewels as the Arthur M. Sackler Gallery of Asian Art, the National Museum of African Art, and the United States Holocaust Memorial Museum just beyond the Washington Monument merely scratch the surface of what one might discover on an art tour of the capital. And to these we must add artistic memorials such as the Vietnam Veterans Memorial, the Korean War Veterans Memorial, and the Franklin D. Roosevelt Memorial, all of which have altered the very concept of meaningful memorials for Washington, D.C., and the country.

For many students in the United States, "the family trip to Washington" was viewed as essential to child rearing. For others, "the school trip to Washington" was the first "independent" trip away from home—traveling on a rowdy bus with one's peers to take in the sights and watch history come alive. Memories of these experiences traverse generations.

We have always understood the importance of symbols to American history. Our own art tours of the nation's capital enable us to understand the importance of art to American people.

MAYA YING LIN, Vietnam Veterans Memorial. Names and Reflections on the Wall.

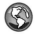 ***To continue your tour and learn more about Washington, D.C., go to our website.***

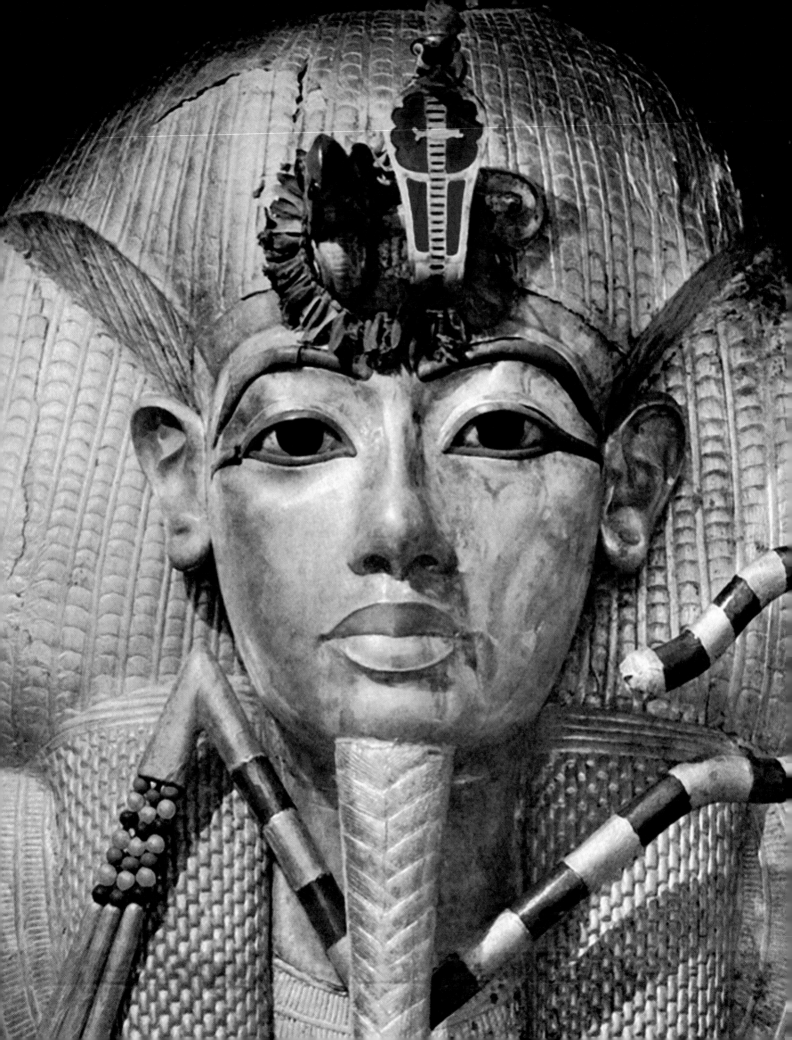

THE ART OF THE ANCIENTS

Art is exalted above religion and race. Not a single solitary soul these days believes in the religion of the Assyrians, the Egyptians, or the Greeks. . . . Only their art, whenever it was beautiful, stands proud and exalted, rising above all time.

—Emil Nolde

The phrase "Stone Age" often conjures up an image of men and women dressed in skins, huddling before a fire in a cave, while the world around them—the elements and the animals—threatens their survival. We do not generally envision prehistoric humankind as intelligent and reflective, as having needs beyond food, shelter, and reproduction. Somehow we never imagine these people as performing religious rituals or as creating works of art. Yet these aspects of life were perhaps as essential to their survival as warmth, nourishment, and offspring.

As the Stone Age progressed from the Paleolithic to the Neolithic periods, people began to lead more stable lives. They settled in villages and shifted from hunting wild animals to herding domesticated animals and farming. They also fashioned tools of stone and bone and created pottery and woven textiles. Most important for our purposes, they became image makers, capturing forms and figures on cave walls with the use of primitive artistic implements.

Stone Age people were preoccupied with protecting themselves from intimidating or unknown forces. To this purpose they created shelters and tools and even images. It is possible, for example, that Stone Age artists tried to ensure the successful capture of prey by first "capturing" it in wall painting. They also tried to ensure their own continuation by carving small fertility goddesses.

Images, symbols, supernatural forces—these were but a few of the concerns of prehistoric and ancient artists. Stone Age people were the first to forge links between religion and life, life and art, and art and religion.

PREHISTORIC ART

Prehistoric art is divided into three phases that correspond to the cultural periods of the Stone Age: **Upper Paleolithic** (the late years of the Old Stone Age), **Mesolithic** (Middle Stone Age), and **Neolithic** (New Stone Age). These periods span roughly the years 14,000 to 2000 BCE.

Works of art from the Stone Age include cave paintings, reliefs, and sculpture of stone, ivory, and bone. The subjects consist mainly of animals, although some highly abstracted human figures have been found. There is no surviving architecture as such. Many Stone Age dwellings consisted of caves and rock shelters. Some impressive "architectural" monuments such as Stonehenge exist, but their functions remain a mystery.

Map 12-1 Prehistoric Europe.

Upper Paleolithic Art

Upper Paleolithic art is the art of the last Ice Age, during which time glaciers covered large areas of northern Europe and North America. As the climate got colder, people retreated into the protective warmth of caves, and it is here that we find their first attempts at artistic creation.

The great cave paintings of the Stone Age were discovered by accident in northern Spain and southwestern France. At Lascaux, France (Map 12-1), two boys whose dog chased a ball into a hole followed the animal and discovered beautiful paintings of bison, horses, and cattle that are estimated to be more than 15,000 years old. At first, because of the crispness and realistic detail of the paintings, they were thought to be forgeries. But in time, geological methods proved their authenticity.

One of the most splendid examples of Stone Age painting, the so-called Hall of Bulls (Fig. 12-1), is found in a cave at Lascaux. Here, superimposed upon one another, are realistic images of horses, bulls, and reindeer that appear to be stampeding in all directions. With one glance, we can understand the early skepticism concerning their authenticity. So fresh, lively, and purely sketched are the forms that they seem to have been rendered yesterday!

In their attempt at **naturalism,** the artists captured the images of the beasts by first confidently outlining the contours of their bodies. They then filled in these dark outlines with details and colored them with shades of ocher and red. The artists seem to have used a variety of techniques ranging from drawing with chunks of raw pigment to applying pigment with fingers and sticks. They also seem to have used an early "spray painting" technique in which dried, ground pigments were blown through a hollowed-out bone or reed. Although the tools were primitive, the techniques and results were not. They used **foreshortening** and contrasts of light and shadow to create the illusion of three-dimensional forms. They strove to achieve a most convincing likeness of the animal.

Why did prehistoric people sketch these forms? Did they create these murals out of a desire to delight the eye, or did they have other reasons? We cannot know for certain. However, it is unlikely that the paintings were merely ornamental, because they were confined to the deepest recesses of the cave, far from the areas that were inhabited, and were not easily reached. Also, the figures were painted atop one another with no apparent regard for composition. It is believed that successive artists added to the drawings, respecting the sacredness of the figures that already existed. It is further believed that the paintings covered the walls and

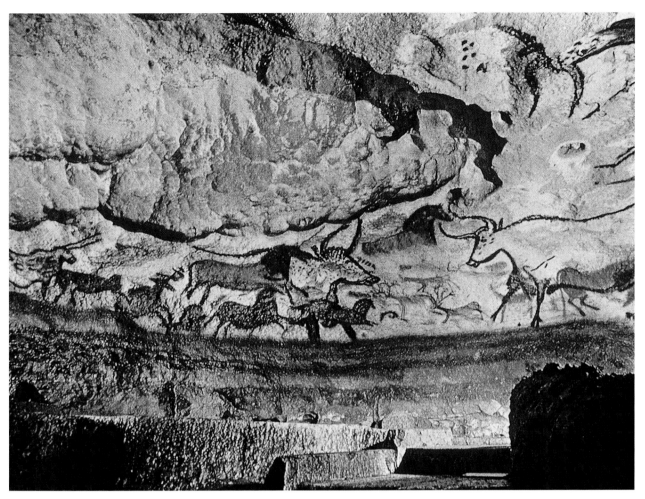

12-1 Hall of Bulls, Lascaux (Dordogne), France
(Upper Paleolithic, c. 15,000–10,000 BCE).
Photo by P. Buckley.

ceilings of a kind of inner sanctuary where religious rituals concerning the capture of prey were performed. Some have suggested that by "capturing" these animals in art, Stone Age hunters believed that they would be guaranteed success in capturing them in life.

The prehistoric artist also attempted to "capture" fertility by creating small sculptures called **Venuses.** The most famous of these is the Venus of Willendorf (Fig.12-2). The tiny figurine is carved of stone and is just over four inches high. As with all sculptures of this type, the female form is highly abstracted, and the emphasis is placed on the anatomical parts associated with fertility: the breasts, swollen abdomen, and enlarged hips. Other parts of the body are subordinated to those related to reproduction. Does this suggest a concern for survival of the species through prog-

eny? Or was this figure of a fertile woman created and carried around as a talisman for fertility of the earth itself—abundance in the food supply? In either, or any other case, people created their images, and perhaps their religion, as a way of coping with these concerns.

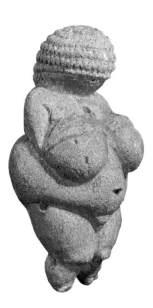

12-2 Venus of Willendorf (Upper Paleolithic) (c. 25,000 BCE). Stone. H: 4³⁄₈″.
Naturhistorisches Museum, Vienna/ Erich Lessing/Art Resource, New York.

12-3　Cormorant or Duck
　　　(c. 33,000–30,000 BCE).
　　　Ivory. L: approx. 1″.

Hilde Jensen, University of Tubingen/
Nature Magazine/AP Wide World Photos.

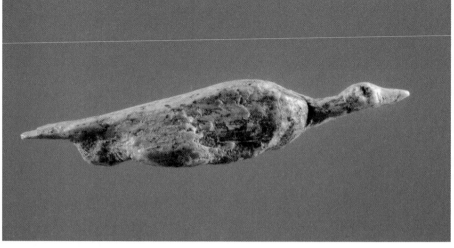

12-4　Ritual Dance (c. 10,000 BCE).
　　　Rock engraving. Cave of Addaura,
　　　Monte Pellegrino (Palermo), Italy.

Soprintendenza Beni Culturali Ambientali,
Palermo. Copyright Canali Photobank,
Milan.

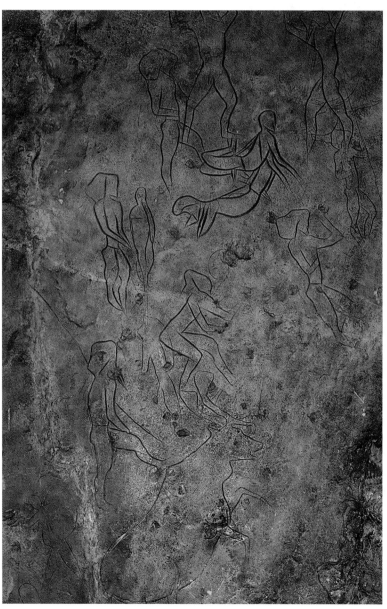

Discoveries of small figurines continue to build our impressions of the nature of artistic skills and expression among the earliest humans. The ivory piece illustrated in Fig. 12-3, resembling a cormorant or a duck, is the oldest-known representation of a bird. Under one inch in length, it has a highly polished surface—as if it had been constantly handled. Archeologists have conjectured that figurines of this size, and in the shapes of animals or half-human–half-animals, were likely personal possessions that expressed common aspects of humans and animals. What is perhaps most surprising about such pieces is their artistic quality, despite the probability that art—as we know it—was never the goal.

Mesolithic Art

The Middle Stone Age began with the final retreat of the glaciers. The climate became milder, and people began to adjust to the new ecological conditions by experimenting with different food-gathering techniques. They established fishing settlements along riverbanks and lived in rock shelters. In the realm of art, a dramatic change took place. Whereas Paleolithic artists emphasized animal forms, Mesolithic artists concentrated on the human figure.

The human figure was abstracted, and the subjects ranged from warriors to ceremonial dancers. Of the many wall paintings and stone carvings that survive, perhaps none is more appealing to the modern eye than the Ritual Dance (Fig. 12-4). Fluid yet concise outlines describe the frenzied

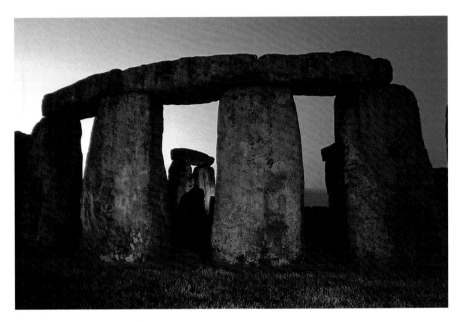

12-5 Stonehenge, Salisbury Plain, Wiltshire, England (Neolithic, c. 1800–1400 BCE). Diameter of circle: 97′. Height of stones aboveground: approx. 24′.
NGS Image Collection, Richard T. Nowitz.

movement of human figures dancing and diving in the presence of animals. These simple and expressive contours call to mind the languid nudes of twentieth-century artists such as Henri Matisse. Whatever the function of a Mesolithic work such as this might have been, it is clear that human beings were beginning to assert their identities as a more self-sufficient species.

Neolithic Art

During the New Stone Age, life became more stable and predictable. People domesticated plants and animals, relinquishing hunting weapons for plows. Toward the end of the Neolithic period in some areas, crops such as maize, squash, and beans were cultivated, metal implements were fashioned, and writing appeared. About 4000 BCE, huge architectural monuments were erected.

The most famous of these monuments is Stonehenge (Fig. 12-5) in southern England. It consists of two concentric rings of stones surrounding others placed in a horseshoe shape. Some of these stones are quite large and weigh several tons. They are called **megaliths,** from Greek, meaning "large stones." The purpose of Stonehenge remains a mystery, although over the years many theories have been advanced to explain it. At one time it was widely believed to have been a druid temple. Lately, some astronomers have suggested that the monument served as a complex calendar that charted the movements of the sun and moon, as well as eclipses. This theory, too, has been contested, but archeologists seem to agree that the structure had some type of religious function.

The Neolithic period probably began about 8000 BCE and spread throughout the world's major river valleys between 6000 and 2000 BCE—the Nile in Egypt, the Tigris and Euphrates in Mesopotamia, the Indus in India, and the

Yellow in China. In the next section we examine the birth of the great Mesopotamian civilizations.

ART OF THE ANCIENT NEAR EAST

Historic (as opposed to prehistoric) societies are marked by a written language, advanced social organization, and developments in the areas of government, science, and art. They are also often linked with the development of agriculture. Historic civilizations began toward the end of the Neolithic period. In this section we will discuss the art of the Mesopotamian civilizations of Sumer, Akkad, Babylonia, Assyria, and Persia. We will begin with Sumer, which flourished in the river valley of the Tigris and Euphrates about 3000 BCE.

Sumer

The Tigris and Euphrates rivers flow through what is now Syria and Iraq, join in their southernmost section, and empty into the Persian Gulf (Map 12-2). The major civilizations of ancient Mesopotamia lay along one or the other of these rivers, and the first to rise to prominence was Sumer.

Sumer was located in the Euphrates River valley in southern Mesopotamia. The origin of its people is unknown, although they may have come from Iran or India. The earliest Sumerian villages date back to prehistoric times. By about 3000 BCE, however, there was a thriving agricultural civilization in Sumer. The Sumerians constructed sophisticated irrigation systems, controlled river flooding, and

worked with metals such as copper, silver, and gold. They had a government based on independently ruled city-states, and they developed a system of writing called **cuneiform,** from the Latin *cuneus,* meaning "wedge"; the characters in cuneiform writing are wedge shaped.

Excavations at major Sumerian cities have revealed sculpture, craft art, and monumental architecture that seems to have been created for worship. Thus, the Sumerian people may have been among the first to establish a formal religion.

One of the most impressive testimonies to the Sumerians' religion-oriented society is the **ziggurat,** a form of temple also found in the Babylonian and Assyrian civilizations of later years. The ziggurat was the focal point of the Sumerian city, towering high above the fields and dwellings. It was a multilevel structure consisting of a core of sun-baked brick faced with fired brick, sometimes of bright colors. Access to the **shrine,** which sat atop the ziggurat, was gained by a series of ramps leading from one level to the next, or in some instances, by a spiral ramp that rose continuously from ground to summit.

The Ziggurat at Ur (Fig. 12-6) is a splendid example of this type of architecture. The base alone is some 50 feet high. Some ziggurats, such as the one erected in Babylon, reached a height of almost 300 feet. The ziggurat at Babylon was dubbed the "Tower of Babel" by the Hebrews, who scorned its construction on the basis that people should never be so proud as to try to reach their God.

The Sumerian gods were primarily deifications of nature. Anu was the god of the sky; Abu, the god of vegetation. Votive sculptures found in the sanctuary of Abu also indicate the Sumerians' preoccupation with religion. A group of these sculptures from Tel Asmar (Fig. 12-7) show

Map 12-2 The Ancient Near East.

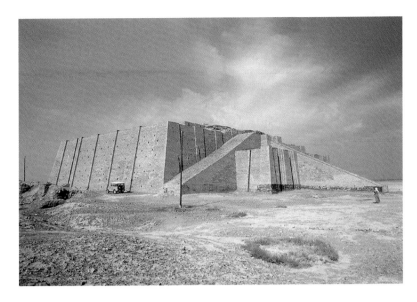

12-6 Ziggurat at Ur (Sumerian, Third dynasty, c. 2100 BCE).
Sun-dried brick.
The Granger Collection.

interesting characteristics. The cylindrical figures wear skirt-like garments, some of whose hems were adorned with feathers. They all stand erect with hands folded over their chests, as if in prayer. The men are distinguished by stylized beards and long, patterned hair. All the figures stare forward with wide eyes that have been inlaid with shell and black limestone, rendering the figures hauntingly realistic despite their strong stylization. The largest figure may represent a king, because it is common to find kings and queens of ancient Near Eastern civilizations towering over their accompanying figures.

These Sumerian statuettes are sculpted from marble, but clay was the most readily available material. It is believed that the Sumerians traded crops for metal, wood, and stone so that they could create works of art from these materials as well. Because of the abundance of clay, however, the Sumerians were expert ceramicists, and their buildings were constructed of mud brick.

The Sumerian repertory of subjects included fantastic creatures such as music-making animals, bearded bulls, and composite man-beasts with bull heads or scorpion bodies. These were rendered in lavishly decorated objects of hammered gold inlaid with **lapis lazuli.** These artworks were found in the Sumerian royal courts. Their function, too, is believed to have been religious. Perhaps they represented struggles between known and unknown forces.

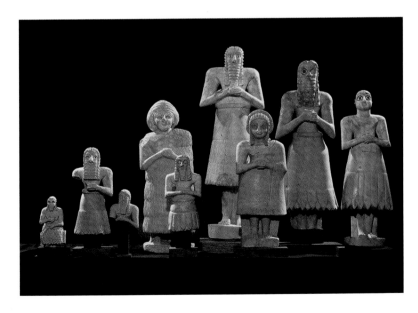

12-7 Statues from Abu Temple, Tel Asmar (Sumerian, Early Dynasty period, c. 2900–2600 BCE).
Marble with shell and black limestone inlay. Height of tallest figures: 30″.
The Oriental Institute Museum, University of Chicago.

For a long time the Sumerians were the principal force in Mesopotamia, but they were not alone. Semitic peoples to the north became increasingly strong, and eventually they established an empire that ruled all of Mesopotamia and assimilated the Sumerian culture.

Akkad

Akkad, located north of Sumer, centered around the valley of the Tigris River. Its government, too, was based on independent city-states, which, along with those of Sumer, eventually came under the influence of the Akkadian ruler Sargon. It was under Sargon and his successors that the civilization of Akkad flourished.

Akkadian art exhibits distinct differences from that of Sumer. It commemorates rulers and warriors instead of offering homage to the gods. It is an art of violence instead of prayer. Also, although artistic conventions are present, they are coupled with a naturalism that was absent from Sumerian art.

Of the little extant Akkadian art, the Stele of Naram Sin (Fig. 12-8) shines as one of the most significant works. This relief sculpture commemorates the military exploits of Sargon's grandson and successor, Naram Sin. The king, represented somewhat larger in scale than the other figures, ascends a mountain, trampling his enemies underfoot. He is accompanied by a group of marching soldiers, spears erect, whose positions contrast strongly with those of the fallen enemy. One wrestles to pull a spear out of his neck, another pleads for mercy, and another falls headfirst off the mountain. The chaos on the right side of the composition is opposed by the rigid advancement on the left. All takes place under the watchful celestial bodies of Ishtar and Shamash, the gods of fertility and justice.

The king and his men are represented in a conceptual manner. That is, the artist rendered the human body in all of its parts as they are known to be, not as they appear at any given moment to the human eye. This method resulted in figures that are a combination of frontal and profile views. Naturalism was reserved for the enemy, whose figures fall in a variety of contorted positions. It may be that the convention of conceptual representation was maintained as a sign of respect. On the other hand, the conceptual manner complements the upright positions of the victorious, whereas the naturalism echoes the disintegration of the enemy camp.

The Akkadian Empire eventually declined, for reasons that are not clear. Historians have traditionally attributed its collapse to the invasion of tribes of barbarians. However, recent archeological research has led to the theory that it was not human violence that put an end to Akkadian supremacy but rather a severe and unrelenting drought that gripped the region for 300 years. With the end of the drought it seems that the Sumerians regained power for a while, but they, too, were eventually overtaken by fierce warring tribes. Mesopotamia remained in a state of chaos

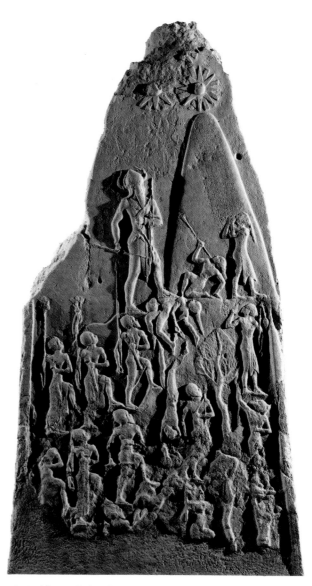

12-8 Victory Stele of Naram Sin
(Akkadian, c. 2300–2200 BCE).
Stone. H: 6′6″.
Louvre Museum, Paris. Copyright Bridgeman Art Library.

When Anu the Sublime, King of the Anunaki, and Bel, the lord of Heaven and earth, who decreed the fate of the land, assigned to Marduk, the over-ruling son of Ea, God of righteousness, dominion over earthly man, and made him great among the Igigi, they called Babylon by his illustrious name, made it great on earth, and founded an everlasting kingdom in it, whose foundations are laid so solidly as those of heaven and earth; then Anu and Bel called by name me, Hammurabi, the exalted prince, who feared God, to bring about the rule of righteousness in the land, to destroy the wicked and the evil-doers; so that the strong should not harm the weak; so that I should rule . . . and enlighten the land, to further the well-being of mankind.

—Preamble to Hammurabi's Code of Laws, translated by L. W. King

until the rise of Babylon under the great lawmaker and ruler, Hammurabi.

Babylonia

During the eighteenth century BCE the Babylonian Empire, under Hammurabi, rose to power and dominated Mesopotamia. Hammurabi's major contribution to civilization was the codification of Mesopotamian laws. Laws had become cloudy and conflicting after the division of Mesopotamia into independent cities.

This law code was inscribed on the Stele of Hammurabi (Fig. 12-9), a relief sculpture of **basalt** that also contains the figures of Hammurabi and Shamash, the god who was believed to have inspired him to the task. The representation of the figures is similar to that reserved for important personages—a combination of frontal and profile views. Shamash is seated on a stylized mountain. His legs and face are shown in profile, and his torso faces front. He gestures toward Hammurabi with a staff that symbolizes his divine power. Hammurabi is also depicted in combined profile and frontal views, although the artist has turned his figure toward us in an attempt at a more naturalistic stance. Draped from shoulder to feet, Hammurabi's figure is columnar, bearing similarity to the cylindrical votive figures of Sumeria's Tel Asmar. Note that at this time the artist conceptualizes the god in human form, not as the composite beast of Sumerian art or the abstracted celestial sphere of the Akkadian period.

After the death of Hammurabi, Mesopotamia was torn apart by invasions. It eventually came under the influence of the Assyrians, a warring people to the north who had had their eyes on the region for hundreds of years.

12-9 Stele (upper portion) inscribed with the *Law Code of Hammurabi*, at Susa (Babylonian, c. 1760 BCE). Diorite. H: 7′4″ (225 cm).
Louvre Museum, Paris. Copyright Art Resource, New York.

Assyria

The ancient empire of Assyria developed along the upper Tigris River. For centuries the Assyrians fought with their neighbors, earning a deserved reputation as a fierce, blood-thirsty people. They eventually prevailed, and from about 900 to 600 BCE they controlled all of Mesopotamia.

The Assyrians owed much to the Babylonians, having been influenced by their art, culture, and religion. Unlike Babylonia, Assyria was an empire built wholly on military endeavors. Because the Assyrians were obsessed with war and conquering, they began to be undermined by economic problems. They spent too much money on military campaigns and eventually depleted their resources. They ignored agriculture and wound up having to import most of their food. Their preoccupation with violence instead of production eventually led to their demise.

Assyrian art became distinct from Babylonian art in about 1500 BCE. The most common art form in Assyria

was carved stone relief depicting scenes of war and hunting. The figures were carved in great detail, and many representations of animals such as horses and lions are to be found. The Assyrians commemorated the activities of their kings, such as royal hunting expeditions, in relief sculptures. One of the most touching and sensitive works of ancient art records such an event. It is ironic that it should come from a culture considered to be insensitive and merciless. The Dying Lioness (Fig. 12-10) is a limestone relief that depicts the carnage resulting from a king's sport. A naturalistically portrayed lioness, bleeding profusely from arrow wounds, emits a pathetic, helpless roar as she drags her hindquarters, paralyzed in the assault. The musculature is clearly defined, and the details are extremely realistic. This is quite different from the way in which kings and other human figures were depicted. In these there is an adherence to convention; the forms are rigid and highly stylized.

Persia

At about the time that the Assyrians were beginning to develop a unique artistic style, another culture was gaining strength just east of Mesopotamia in what is now Iran. It consisted of nomadic warring tribes. By the ninth century BCE the mighty Assyrians had become embroiled in battle with them. By the sixth century BCE the Persian Empire, under King Cyrus, had grown very strong. It eventually conquered great nations such as Egypt and succumbed to defeat only at the hands of the Greeks at the moment when victory seemed to be within its grasp.

The art of Persia consists of sprawling palaces of grand dimensions and sculpture that is almost totally abstract in its simplicity of design. Favorite subjects included animal forms, such as birds and **ibexes,** translated into decorative column capitals or elegant vessels of precious metals. A capital from the Royal Audience Hall of the palace of King Artaxerxes II (Fig. 12-11) illustrates the Persian combination of decorative motifs and stylization. The upper part of the capital consists of beautifully carved back-to-back bulls sharing hindquarters. They rest on intricately carved **volutes** that resemble fronds of vegetation. This stylization leads to the perception of the animals as abstract patterns rather than naturalistic forms and is characteristic of Persian art in general.

In 525 BCE Persia conquered the kingdom of Egypt. But as in Mesopotamia, civilization in Egypt had begun

12-10 The Dying Lioness, from Nineveh
(Assyrian, 660 BCE).
Limestone. H: 13¾″.

British Museum, London. Copyright Heritage Image Partnership (HIP), heritage-images.com.

12-11 Capital from Royal Audience Hall, Palace of King Artaxerxes II, Persepolis (Persian, c. 360 BCE).

Louvre Museum, Paris RMN/Art Resource, New York.

some 3,000 years earlier. In the next section we will trace its art from the early post-Neolithic period to the reign of the boy-king Tut in the fourteenth century BCE.

EGYPTIAN ART

The lush land that lay between the Tigris and Euphrates rivers, providing sustenance for the Mesopotamian civilizations, is called the **Fertile Crescent.** Its counterpart in Egypt, called the **Fertile Ribbon,** hugs the banks of the great Nile River, which flows north from Africa and empties into the Mediterranean Sea (Map 12-2). Like the rivers of the Fertile Crescent, the Nile was an indispensable part of Egyptian life. Without it, Egyptian life would not have existed. For this reason, it also had spiritual significance; the Nile was perceived as a god.

Like Sumerian art, Egyptian art was religious. There are three aspects of Egyptian art and life that stand as unique: their link to *religion,* their link to *death,* and their ongoing use of strict *conventionalism* in the arts that affords a sense of permanence.

The art and culture of Egypt are divided into three periods. The Old Kingdom dates from 2680 to 2258 BCE, the Middle Kingdom from 2000 to 1786 BCE, and the New Kingdom from 1570 to 1342 BCE. Art styles proceed from the Old to the New Kingdom with very few variations. The exception to this trend took place between 1372 and 1350 BCE, during the Amarna Revolution under the leadership of the pharaoh Akhenaton. We will begin our exploration of Egyptian art with the Old Kingdom.

Old Kingdom

Egyptian religion was bound closely to the afterlife. Happiness in the afterlife was believed to be ensured through the continuation of certain aspects of earthly life. Thus, tombs were decorated with everyday objects and scenes depicting common earthly activities. Sculptures of the deceased were placed in the tombs, along with likenesses of the people who surrounded them in life.

In the years prior to the dawn of the Old Kingdom, art consisted of funerary offerings of one type or another, including small, sculpted figures; carvings of ivory; pottery; and slate palettes used for cosmetics. Toward the end of this period, called the Predynastic period, large limestone sculptures for which Egypt became famous began to be created.

Sculpture

Old Kingdom art brought forth a manner of representation that would last thousands of years. It is characterized by a conceptual approach to the rendering of the human figure that we encountered in Mesopotamian relief sculpture. In Egyptian art, the head, pelvis, and legs are presented in profile, whereas the upper torso and eye are shown in a frontal view. The figures tend to be flat, with no sense of three-dimensionality, and they are placed in space with no use of perspective. Thus, no attempt was made to give the illusion of forms moving within three-dimensional space. Relief sculpture was carved very low with a great deal of **incised** detail. Sculpture in the round closely adhered to the block form. Color was applied at times but was not used

12-12 Narmer Palette (Egyptian, Old Kingdom, c. 3200 BCE).
Front (left) and back (right) views.
Slate. H: 25″.

widely because of the relative impermanence of the material. These characteristics were duplicated, with few exceptions, by artists during all periods of Egyptian art. There are instances in which a certain naturalism was sought, but the artist rarely strayed from the inherited stylistic conventions. Art historian Erwin Panofsky has stated that this Egyptian method of working clearly reflects their artistic intention, "directed not toward the variable, but toward the constant, not toward the symbolization of the vital present, but toward the realization of a timeless eternity."

One of the most important sculptures from the Old Kingdom period, the Narmer Palette (Fig. 12-12), illustrates these conventions. The Narmer Palette is an example of a type of **cosmetic palette** found in the Predynastic

period, but it symbolizes much more. It commemorates the unification of Upper Egypt and Lower Egypt, an event that Egyptians saw as marking the beginning of their civilization.

The back of the palette depicts King Narmer in the crown of Upper Egypt (a bowling pin shape) clubbing the head of his enemy. He stands on a horizontal band representing the ground. Beneath his feet, on the lowest part of the palette, lie two dead enemy warriors. To the king's right is a hawk perched on stylized papyrus plants that seem to grow out of the "back" of a strange object with a man's head. The hawk, a symbol for the Egyptian sky god, stands on this symbol of Lower Egypt. Thus, the gods appear to be sanctioning Narmer's takeover of Lower Egypt. The topmost

part of the palette is sculpted with two bull-shaped heads with human features, representing the goddess Hathor, who traditionally symbolized love and joy.

The king is depicted in the typical conventional manner. His head, hips, and legs are sculpted in low relief and rendered in profile. The musculature is defined in incised lines that appear as stylized patterns. His eye and upper torso are shown in full frontal view. He is shown as larger than the people surrounding him, a symbol of his elevated position. The artist has disregarded naturalism and has instead created a kind of timeless rendition of his subject.

The front of the palette is divided into horizontal segments, or **registers,** into which have been placed many figures. The depressed section of the palette held eye paint, and it is emphasized by the entwined necks of lionlike figures being tamed by two men carved in low relief. The top register depicts King Narmer once again, in the process of reviewing the captured and deceased enemy. He is now shown wearing the crown of Lower Egypt and holding the instruments that symbolize his power. To his right are stacks of decapitated bodies. This is not the first time that we have seen a sculpted monument to a royal conquest, complete with gory details. We witnessed it in the Akkadian victory Stele of Naram Sin (Fig. 12-8). In both works the kings are shown in commanding positions, larger than the surrounding figures, but in the Narmer Palette the king is also depicted as a god. This concept of the ruler of Egypt, along with the strict conventions of his representation, would last some 3,000 years.

Tomb sculpture included large-scale figures in the round carved in very hard materials to ensure permanence. These figures consisted of conventionally represented stylized bodies with portrait heads rendered in an idealistic manner. The touch of realism in the faces reflects the function of the sculptures. They were created as images in which the spirit of the deceased could reside if **mummification** failed to provide a sanctuary. The figures are called **Ka figures;** the Ka was the soul thought to inhabit the body after death.

The statue of Khafre (Fig. 12-13), an Old Kingdom pharaoh, is typical of Ka figures. Carved in diorite, a gray green rock, it shows the pharaoh seated on a throne ornamented with lotus blossoms and papyrus. He sits rigidly, and his frontal gaze is reminiscent of the staring eyes of the Mesopotamian votive figures. He is shown with the conventional attributes of the pharaoh: a finely pleated kilt, a linen headdress gracing the shoulders, and a long, thin beard, a part of which has broken off. The sun god **Horus,** represented again as a hawk, sits behind his head. The artist confined his figure to the block of stone from which it was carved instead of allowing it to stand freely in space. The legs and torso are molded to the throne, and the arms and

12-13 Statue of Khafre, from Giza (Egyptian, Old Kingdom, c. 2500 BCE).
Dorite. H: 66″.

Egyptian Museum, Cairo. Copyright Hirmer Archives/Art Resource, New York.

12-14　Great Pyramids at Giza (Egyptian, Old Kingdom,
c. 2570–2500 BCE).

fists remain close to the body. There is a solidity to the figure that echoes its conception as the permanent and enduring resting place for the Ka.

The representation of the body is stylized according to a specific **canon of proportions** relating different anatomical parts to one another. The forms rely on predetermined rules and not on optical fact. Yet a touch of naturalism is present in the facial features, which are rendered with some degree of truth to reality. This naturalism is intermittent in Egyptian art, but more prevalent in the art of the Middle Kingdom and the Amarna period.

Architecture

The most spectacular remains of Old Kingdom Egypt, and the most famous, are the Great Pyramids at Giza (Fig. 12-14). Constructed as tombs, they provided a resting place for the pharaoh, underscored his status as a deity, and lived after him as a monument to his accomplishments. They stand today as haunting images of a civilization long gone, isolated as coarse jewels in an arid wasteland.

The pyramids are massive. The largest has a base that is about 775 feet on a side and is 450 feet high. It is constructed of limestone blocks that weigh about $2\frac{1}{2}$ tons each—2,300,000 of them! Slaves dragged the massive stones up ramps. Thousands of slaves from captive civilizations engaged in this great labor for many generations. Among them, according to the Hebrew Bible, were the Hebrews, who were eventually led out of bondage by Moses. After the stones were placed in position, the exterior slopes of the pyramids were surfaced with white limestone.

The interiors of the pyramids consist of a network of chambers, galleries, and air shafts. One of the problems with the pyramids was that grave robbers found them as impressive as did the pharaohs and wasted no time in plundering the tombs. During the Middle Kingdom, the Egyptians designed more inconspicuous and less easily penetrated dwelling places for their spirits.

Middle Kingdom

The Middle Kingdom witnessed a change in the political hierarchy of Egypt, as the pharaohs began to be threatened by powerful landowners. During the early years of the Middle Kingdom, the development of art was stunted by internal strife. Egypt was finally brought back on track, reorganized, and reunited under King Mentuhotep, and art began to flourish once again.

Middle Kingdom art carried the Old Kingdom style forward, although there was some experimentation outside the mainstream of strict conventionalism. We find this experimentation in extremely sensitive portrait sculptures and freely drawn fresco paintings.

A striking aspect of Middle Kingdom architecture was the rock-cut tombs, which may have been built in an attempt to prevent robberies. They were carved out of the **living rock,** and their entranceways were marked by columned **porticoes** of post-and-lintel construction. These porticoes led to a columned entrance hall, followed by a chamber along the same axis. The walls of the hall and tomb chamber were richly decorated with relief sculpture and painting, much of which had a sense of liveliness not found in Old Kingdom art.

New Kingdom

The Middle Kingdom also collapsed, and Egypt fell under the rule of an Asiatic tribe called the Hyskos. They introduced Bronze Age weapons to Egypt, as well as the horse. Eventually the Egyptians overthrew the Hyskos, and the New Kingdom was launched. It proved to be one of the most vital periods in Egyptian history, marked by expansionism, increased wealth, and economic and political stability.

The art of the New Kingdom combined characteristics of the Old and Middle Kingdom periods. The monumental forms of the earliest centuries were coupled with the freedom of expression of the Middle Kingdom years. As was the case throughout Egyptian art, a certain vitality appeared in the two-dimensional works. Sculpture in the round retained its concentration on solidity and permanence with few stylistic changes.

Egyptian society embraced a death cult, and some of its most significant monuments continued to be linked with death or worship of the dead. During the New Kingdom period, a new architectural form was created—the **mortuary temple.** Mortuary temples were carved out of the living rock, as were the rock-cut tombs of the Middle Kingdom, but their function was quite different. They did not house the mummified remains of the pharaohs but rather served as their place for worship during life, and a place at which they could be worshiped after death.

12-15 Mortuary Temple of Queen Hatshepsut, Thebes (Egyptian,
 New Kingdom, c. 1480 BCE).
 Copyright Edimedia/Corbis.

One of the most impressive mortuary temples of the New Kingdom is that of a female pharaoh, Queen Hatshepsut (Fig. 12-15). The temple backs into imposing cliffs and is divided into three terraces, which are approached by long ramps that rise from the floor of the valley to the top of pillared **colonnades.** Although the terraces are now as barren as the surrounding country, during Hatshepsut's time they were covered with exotic vegetation. The interior of the temple was just as lavishly decorated, with some 200 large sculptures as well as painted relief carvings.

As the civilization of Egypt became more advanced and powerful, there was a tendency to build and sculpt on a monumental scale. Statues and temples reached gigantic proportions. The delicacy and refinement of earlier Egyptian art fell by the wayside in favor of works that reflected the inflated Egyptian ego. Throughout the New Kingdom period, conventionalism was, for the most part, maintained. During the reign of Akhenaton, however, Egypt was offered a brief respite from stylistic rigidity.

The Amarna Revolution: The Reign of Akhenaton and Nefertiti

During the fourteenth century BCE a king by the name of Amenhotep IV rose to power. His reign marked a revolution in both religion and the arts. Amenhotep IV, named for the god Amen, changed his name to Akhenaton in honor of the

King Tut: The Face That Launched a Thousand High-Res Images

The Valley of the Kings, Luxor, Egypt; the fifth of January, 2005. Nearly 3,300 years after his death, the leathery mummy of the legendary boy-king was ever-so-delicately removed from its tomb and guided into a portable CT—what we call "cat"—scanner. It was not the first time that modern technology was employed to feed the curiosity of scientists, archeologists, and museum officials over the mysteries surrounding the reign and death of Tut. More than three decades earlier the mummy was X-rayed twice, in part to try to solve the mystery of the young pharaoh's death; Tutankhamen was crowned at the age of eight and died only 10 years later. These early X-rays revealed a hole at the base of Tut's cranium, leading to the suspicion that he was murdered. This time around, the focus—and the conclusions—changed. Dr. Zahi Hawass, secretary general of the Supreme Council of Antiquities in Cairo, said, "No one hit Tut on the back of the head." Scientists instead concluded that the damage noted in earlier X-rays was probably due to the rough removal of the golden burial mask by the tomb's discoverers. But they found something else: a puncture in Tut's skin over a severe break in the youth's left thigh. As it is known that this accident took place just days before his death, some experts on the scanning team conjectured that this break, and the puncture caused by it, may have led to a serious infection and Tut's consequent death. Otherwise, the young pharaoh was the picture of health—no signs of malnutrition or disease, with strong bones and teeth, and probably five and a half feet tall.

In all, scientists (including experts in anatomy, pathology, and radiology) spent two months analyzing more than 1,700 three-dimensional, high-resolution images taken with computed tomography (CT) scans. Then artists and scholars took a turn. Three independent teams, one each from Egypt, France, and the United States, came up with their own versions of what Tut might very well have looked like in life: a bit of an elongated skull (normal, they say), large lips, a receding chin, and a pronounced overbite that seems to have run in the family (Fig. 12-16). It was the first time—but certainly not the last—that CT scans would be used to reconstruct the faces of the Egyptian celebrity dead.

Although the price tag on this endeavor was most certainly steep, the Egyptian government stood to gain financially from the images. Their release was timed to coincide with the launch of the world-traveling exhibition *Tutankhamen and the Golden Age of the Pharaohs.* Along with the scans and reconstruction images, the exhibit would feature King Tut's diamond crown and gold coffin, along with a total of almost 200 objects from his and various other noteworthy tombs. If history were any predictor of the insatiable thirst for things Egyptian, this, like the original exhibition of treasures from Tut's tomb, would attract millions of visitors. This time, however, it was hoped that the $10 million rental fee for each museum venue would bring in desperately needed funding for a museum being planned beside the pyramids in Giza. As in many parts of the world, antiquities are crumbling. "There are no free meals anymore," Hawass said. "We have a task. These monuments will be gone in 100 years if we don't raise the money to restore them." ∎

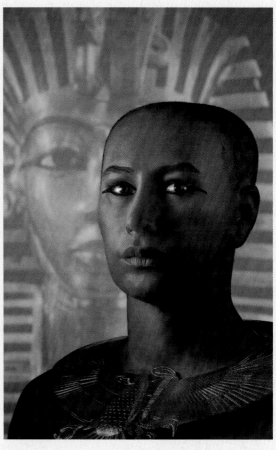

12–16 Reconstruction of face of King Tut.

Kenneth Garrett, Supreme Council of Antiquities and The National Geographic Society.

sun god, Aton, and he declared that Aton was the only god. In his monotheistic fury, Akhenaton spent his life tearing down monuments to the old gods and erecting new ones to Aton.

The art of Akhenaton's reign, or that of the *Amarna period* (so named because the pharaoh moved the capital of Egypt to Tel el-Amarna), was as revolutionary as his approach to religion. The wedge-shaped stylizations that stood as a rigid canon for the representations of the human body were replaced by curving lines and full-bodied forms. The statue of Akhenaton (Fig. 12-17) could not differ more from its precedents in the Old and Middle Kingdoms. The fluid contours of the body contrast strongly with those in earlier sculptures of pharaohs, as do the elongated jaw, thick lips, and thick-lidded eyes. These characteristics suggest that the artist was attempting to create a naturalistic likeness of the pharaoh, "warts and all," as the saying goes.

Aside from its being at odds stylistically with other Egyptian sculptures, the very concept of the work is different. Throughout the previous centuries, adherence to a stylistic formality had been maintained, especially in the sculptures of revered pharaohs. If naturalism was present at all, it was reserved for lesser works depicting lesser figures. During the Amarna period it was used in monumental statues depicting members of the royal family as well.

One of the most beautiful and famous works of art from this period is the bust of Akhenaton's wife, Queen Nefertiti (Fig. 12-18). The classic profile reiterates the linear patterns found in the pharaoh's sculpture. An almost top-heavy crowned head extends gracefully on a long and sensuous neck. The naturalism of the work is enhanced by the paint that is applied to the limestone.

The naturalism of the works of the Amarna period was short-lived, because subsequent pharaohs returned to the more rigid styles of the earlier dynasties. Just as Akhenaton destroyed the images and shrines of gods favored by earlier pharaohs, so did his successors destroy his temples to Aton. With Akhenaton's death came the death of monotheism— for the time being. Some have suggested that Akhenaton's loyalty to a single god may have set a monotheistic example for other religions.

Akhenaton's immediate successor was Tutankhamen— the famed King Tut. Called the boy-king, Tut died at about the age of 18. His tomb was not discovered until 1922, when British archeologists led by Howard Carter unearthed a treasure trove of gold artworks, many inlaid with semi-precious stones. By far, the most spectacular find was the young pharaoh's coffin (Fig. 12-19), made of solid gold and weighing almost 250 pounds. Within this, the last of three

12-17 Pillar statue of Akhenaton from Temple of Amen-Re, Karnak (Egyptian, New Kingdom, c. 1356 BCE). Sandstone, painted.

Egyptian Museum, Cairo. Copyright Art Resource, New York.

A eulogy of Queen Nefertiti:

And the Heiress, Great in the Palace, Fair of Face, Adorned with the Double Plumes,
Mistress of Happiness, Endowed with Favours, at hearing whose voice the King rejoices,
the Chief Wife of the King, his beloved, the Lady of the Two Lands,
Neferneferuaten-Nefertiti, May she live for Ever and Always.

—Cyril Aldred, in *Akhenaten, King of Egypt*

The-beautiful-one-is-come.

—Translation of *Nefertiti*

12-18 Bust of Queen Nefertiti (Egyptian, New Kingdom,
c. 1344 BCE).
Limestone. H: approx. 20″.
Agyptisches Museum State Museums, Berlin/Edimedia/Corbis.

12-19 Coffin of Tutankhamen (c. 1323 BCE).
Gold.
Time & Life Pictures/Getty Images.

nesting coffins, lay the body of the king, wrapped in linen, his face covered with an astounding gold mask. The lid of the coffin was fashioned out of sheet gold, with eyes of aragonite (a semihard mineral) and obsidian (black volcanic glass) and eyebrows inlaid with lapis lazuli. The hands of Tut's effigy cross over the chest and clutch the royal symbols of the crook and the flail, encrusted in deep blue faience—a signature Egyptian opaque glazed earthenware. Carter, upon viewing the revelation of the coffin, described the sense of marvel at the sight: "And as the last was removed a gasp of wonderment escaped our lips, so gorgeous was the sight that met our eye: a golden effigy of the young boy king, of most magnificent workmanship, filled the whole of the interior of the sarcophagus."

Although Tut's coffin and mask are characteristically stylized, Carter observed an element of realism in the fashioning of the face. In fact, some residual stylistic effects of the Amarna period are evident in several works from Tut's reign—curvilinear forms not unlike those seen in the statue of Akhenaton, an emotional naturalism and tenderness in representations of the boy and his queen.

After Akhenaton's death, Egypt returned to normal. That is, the worship of Amen was resumed and art reverted to the rigid stylization of the earlier stages. The divergence that had taken place with Akhenaton and been carried forward briefly by his successor soon disappeared. Instead, the permanence that was so valued by this people endured for another 1,000 years virtually unchanged despite the kingdom's gradual decline.

AEGEAN ART

The Tigris and Euphrates valleys and the Nile River banks provided the climate and conditions for the survival of Mesopotamia and Egypt. Other ancient civilizations also flourished because of their geography. Those of the Aegean—Crete in particular—developed and thrived because of their island location. As maritime powers, they maintained contact with distant cultures with whom they traded—including those of Egypt and Asia Minor.

Up until about 1870 CE, some Aegean civilizations were thought not to have existed. Although they had been sung by the Greek master of the epic, Homer, their strange names were attributed to an overactive imagination. But during the last decades of the nineteenth century, a German archeologist, Heinrich Schliemann, followed the very words of Homer and unearthed some of the ancient sites, including Mycenae, on the mainland of Greece (Map 12-3). Following in Schliemann's footsteps, Sir Arthur Evans excavated on the island of Crete and uncovered remains of the Minoan civilization cited by Homer. The Bronze Age civilizations of **pre-Hellenic** Greece comprised these cultures and that of the Cyclades Islands.

The Cyclades

The Cyclades Islands are part of an archipelago in the Aegean Sea off the southeastern coast of mainland Greece. They are six in number and include Melos, the site where

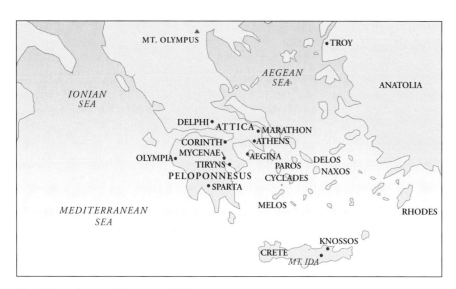

Map 12-3 Greece (5th century BCE).

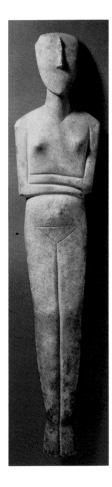

12-20 Cycladic idol, from Amorgos (c. 2500–1100 BCE). Marble. H: 30″.

Ashmolean Museum, Oxford, England.

the famed Venus de Milo (see Fig. 13-16) was found; and Paros, one of the chief quarry locations for marble used in ancient Greece. The Cycladic culture flourished on these six islands during the Early Bronze Age, from roughly 2500 to 2000 BCE.

The art that survives has been culled mostly from tombs and includes pottery and small marble figurines. Most of these figures represent fertility goddesses and appear as pared-down geometric versions of the Venus of Willendorf (Fig. 12-2). The fertility figure in Figure 12-20 is typical of these little sculptures. Note the flattened oval head, the square torso with the bare suggestion of breasts, the arms folded rigidly across the abdomen, and the incised outlines suggesting the pubic region. Some male figures have also been found, most represented as musicians playing highly abstracted instruments. All of these figures are believed to have had a religious function, or at least to have been linked with certain rituals surrounding death.

The Cycladic culture seems to have ended at the same time that the great civilization of Crete was developing. The latter was one of the most remarkable cultures to thrive in the ancient world.

Crete

The civilization that developed on the island of Crete is called the Minoan civilization, named after the legendary king of Crete, Minos. The myths surrounding Minoan life are many, but the most famous is that of the Minotaur of King Minos, a cruel beast that was half man and half bull and that often devoured Greek boys and girls. The youths were supposedly placed within a complex **labyrinth** that the Minotaur roamed and were forced to try to escape a certain death.

Although Homeric reports such as these were deemed to be myth, the actuality of the Minoan civilization was not. Sir Arthur Evans's excavations revealed Crete to be a bustling culture with exciting artistic and architectural remains. Evans divided the history of Minoan civilization into three parts: the Early Minoan period, known as the pre-Palace period, from which survive some small sculptures and pottery; the Middle Minoan period, or the period of the Old Palaces, which began around 2000 BCE and ended three centuries later with what was probably a devastating earthquake; and the Late Minoan period, during which these palaces were reconstructed, which began during the sixteenth century BCE and ended probably in about 1400 BCE. It was at that time that the stronghold of Western civilization shifted from the Aegean to the Greek mainland.

During the Middle Minoan period, the great palaces, including the most famous one at Knossos, were constructed. A form of writing based on **pictographs,** called Linear A, was developed. Refined articles of ivory, metal, and pottery were also produced.

Unlike those of Mesopotamia and Egypt, Minoan architectural projects did not consist of tombs, mortuary temples, or shrines. Instead, the Minoans constructed lavish palaces for their kings and the royal entourage. Not much is known of the old palaces, except for those that were subsequently built on their ruins. Toward the end of the Middle Minoan period, the palace at Knossos was reduced to rubble either by an earthquake or by invaders. About a century after its destruction, however, it was rebuilt on a grander scale. Also during the Late Minoan period, a type of writing called Linear B was developed. This system, finally deciphered in 1953, turned out to be an early form of Greek. The script, found on clay tablets, perhaps indicates the presence of a Greek-speaking people—the Mycenaeans—on Crete during this period.

The most spectacular of the restored palaces on Crete is that at Knossos. It was so sprawling that one can easily understand how the myth of the Minotaur arose. The adjective *labyrinthine* certainly describes it. A variety of rooms were set off major corridors and arranged about a spacious central court. The rooms included the king's and queen's bedrooms, a throne room, reception rooms, servants' quarters, and many other spaces, including rows of **magazines,** or storage areas, where large vessels of grain and wine were embedded

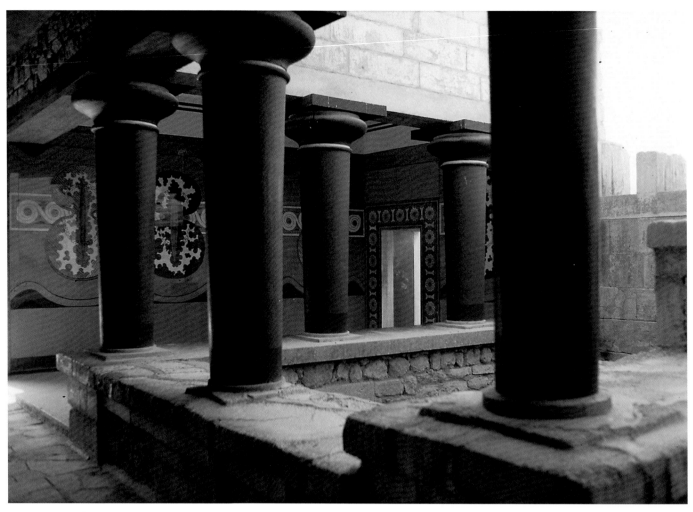

12-21　Queen's bedroom in Palace at Knossos (Late Minoan, c. 1500 BCE).
Copyright Art Resource, New York.

in the earth for safekeeping. The palace was three stories high, and the upper floors were reached by well-lit stairways. Beneath the palace were the makings of an impressive water-supply system of terra-cotta pipes that would have provided running water for bathrooms.

Some of the most interesting decorative aspects of the palace at Knossos—seen in the queen's bedroom (Fig. 12-21)—are its unique columns and its vibrant fresco paintings. The columns, carved of stone, are narrower at the base than at the top. This proportion is the reverse of that of the standard columns found in Mesopotamia, Egypt, and later, in Greece. The columns are crowned by cushion-shaped capitals that loom large over the curious stem of the column shaft, often painted bright red or blue.

The rooms were also adorned with painted panels of plant and animal life. Stylized **rosettes** accent doorways, and delicately painted dolphins swim across the surface of the wall, giving one the impression of looking into a vast aquarium. This fascination with marine life that we also see in pottery of the Late Minoan period is no doubt due to the fact that, as an island, Crete was surrounded by water and was an impressive maritime power.

The palace at Knossos and all the other palaces on Crete were again destroyed sometime in the fifteenth cen-

tury. At this point the Mycenaeans of the Greek mainland may have moved in and occupied the island. However, their stay was short-lived. Knossos, and the Minoan civilization, had been finally destroyed by the year 1200 BCE.

Mycenae

Although the origins of the Mycenaean people are in doubt, we know that they came to the Greek mainland as early as 2000 BCE. They were a Greek-speaking people who were sophisticated in the forging of weapons. They were also versatile potters and architects. The Minoans clearly influenced their art and culture, even though by about 1600 BCE Mycenae was by far the more powerful of the two civilizations. Mycenaeans occupied Crete after the palaces were destroyed. The peak of Mycenaean supremacy lasted about two centuries, from 1400 to 1200 BCE. At the end of that period, invaders from the north—the fierce and undaunted Dorians—gained control of mainland Greece. They inter-

mingled with the Mycenaeans to form the beginnings of the peoples of ancient Greece.

Lacking the natural defense of a surrounding sea that was to Crete's advantage, the Mycenaeans were constantly facing threats from land invaders. They met these threats with strong fortifications, such as the citadels in the major cities of Mycenae and Tiryns. Much of the architecture and art of the Mycenaean civilization reflects the preoccupation with arms.

Architecture

As concerned as the Mycenaeans were with matters of protection, they had not lost their aesthetic sense. Citadels were ornamented with frescoes and sculpture, some of which served as architectural decoration. One of the most famous carved pieces from this civilization is the Lion Gate at Mycenae (Fig. 12-22). This gate served as one of the entranceways to the citadel. The actual gateway consists of a heavy

12-22 Lion Gate at Mycenae (c. 1300 BCE).
Height of sculpture above lintel: 9′6½″.
Copyright Art Resource, New York.

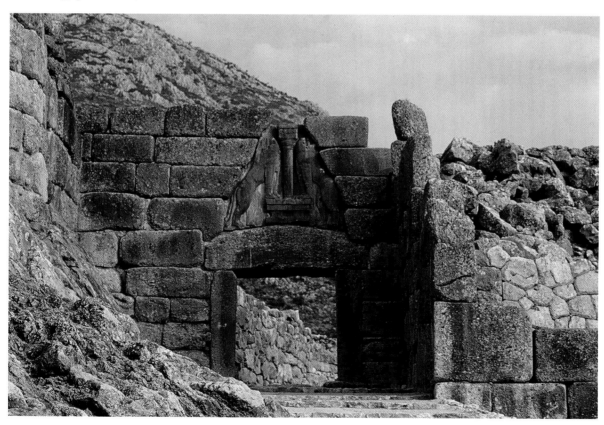

lintel that rests on two massive vertical pillars—another example of post-and-lintel construction. Additional large stones were piled horizontally above the lintel and **beveled** to form an open triangular area; they thus decreased the load to be borne by the lintel. Within this triangular space was placed a thick slab sculpted with lions flanking a column that can be recognized as Minoan in style. The heads of the beasts, now gone, were carved of separate pieces of stone and fitted into place. Although the animal figures are not intact, their prominent and realistic musculature, carved in high relief, is an awesome sight, one that was sure to give an intruder pause.

Another contribution of the Mycenaean architect was the **tholos,** or beehive tomb. During the early phases of the Mycenaean civilization, members of the royal family were buried in so-called **shaft graves.** These were no more than pits in the ground, lined with stones. The only evidence of their existence was a **stele,** a type of headstone, set above the entrance to the grave. As time went on, however, the tombs became more ambitious.

The Treasury of Atreus (Fig. 12-23), a tholos tomb so named by Schliemann because he believed it to have been the tomb of the mythological ancient Greek king Atreus, is typical of such constructions. The Treasury consists of two parts: the dromos, or narrow passageway leading to the tomb proper; and the tholos, or beehive-shaped tomb chamber. The latter's circular walls consist of hundreds of stones laid atop one another in concentric rings of diminishing size. The Treasury rose to a height of some 40 feet and enclosed a vast amount of space, an architectural feat not to be duplicated until the domed ceilings of ancient Rome were constructed.

Gold Work

Homer's favorite epithet for Mycenae was "rich in gold." To be sure, the Mycenaeans apparently had an insatiable desire to have gold and to work with it. This was verified by the shaft grave excavations that were carried out by Schliemann. The tholos tombs were quickly plundered after their construction, suffering the hazards of being ostentatious, much

12-23 The Treasury of Atreus (Mycenaean, c. 1300–1250 BCE).
Copyright Art Resource, New York.

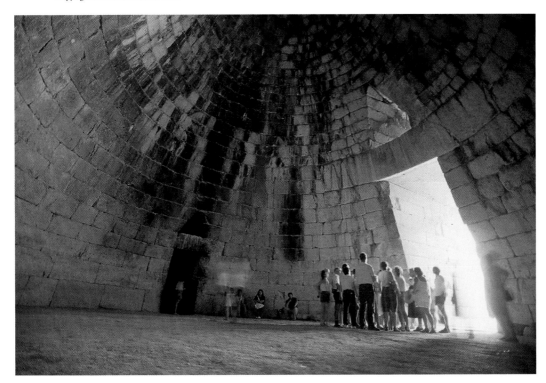

as was the case with the pyramids. But a wealth of treasures was still found by Schliemann in the shaft graves. One such find is a gold death mask (Fig. 12-24). Masks such as these were created from thin, hammered sheets of gold laid over the faces of the deceased. Some elements of the face were stylized, such as the ears, eyebrows, and coffee-bean-like eyes, whereas other features were more naturalistically rendered. Much other craft art was found, including weapons such as inlaid daggers and spectacular gold vessels.

But even the cyclopean walls of the Mycenaean citadels could not ward off enemies for long. After roughly 1200 BCE, the Mycenaean civilization collapsed at the hands of better-equipped warriors—the Dorians. The period following the Dorian invasions of the Greek mainland witnessed no significant developments in art and architecture. But the peoples of this area formed the seeds of one of the world's most influential and magnificent civilizations—that of ancient Greece.

12-24 Funerary mask, from Grave Circle A, Mycenae, Greece (c. 1600–1500 BCE).
Beaten gold. H: 12″.
National Archaeological Museum, Athens. Copyright Art Resource, New York.

ART TOUR

Jerusalem

Jerusalem—a city set in history, a city beset by current events. Jerusalem—a city at once pluralistic and, more than once, intolerant. Jerusalem—spiritually, the home of three of the world's great religions and, emotionally, a house too often divided.

Over its 3,000-year history, Jerusalem and the Holy Land have been coveted territory. The ancient Egyptians battled the Canaanites in the coastal plains around the Dead Sea, bringing them under the rule of the pharaoh. And although the Hebrew tribes that coalesced into the entity known as Israel around 1200 to 1000 BCE came to dominate the region, they met continual violent struggles with such peoples as the Philistines, Assyrians, and Babylonians (who captured Jerusalem in 586 BCE, destroyed Solomon's Temple, and drove the Jews into exile). When the Jews returned to Jerusalem from Babylonian captivity, they built a new temple on the site of the old, ushering in the period of the "Second Temple." Yet even during this era, they were not self-governed; the Persians remained dominant over the region until they themselves were conquered by Alexander the Great.

From that point forward, the Jewish nation met a series of enemies. None were more formidable than ancient Rome, whose legions first took the city of Jerusalem in 63 BCE. For almost 100 years, clashes between the Jews and the Romans were constant, and this, according to the Christian Bible, was the state of affairs into which Jesus was born. Bloody skirmishes led to full-scale war in 66 CE. After four years, the Romans were finally victorious, capturing Jerusalem and destroying the city and the Second Temple. But the subjugation of the Jewish people did not occur until three years later, after a test of wills and military might at the fortress of Masada. It was a subjugation that would not last. A second war was fought from 132 to 135 CE, with Rome victorious once again. This time the Jews were driven from the city of Jerusalem, scattering in what is known as the Diaspora.

Other religions entered the region as watershed historical events took place. When the Roman emperor Constantine converted to Christianity and granted freedom of worship to early Christians in the year 313 CE, the doors to the Holy Land were opened to pilgrims of the new faith, who built churches on sites connected to events in the life of Christ. By the late fourth century, Christianity became the official religion of the Holy Land. A little more than three centuries later, Muslims—followers of Islam and its prophet,

Muhammad—became the new rulers of the Holy Land. Muslims maintain, as do Jews and Christians, that Jerusalem is holy to their religion; they believe that Muhammad ascended into heaven from the same rock in Jerusalem on which, according to the Hebrew Bible, Abraham was about to sacrifice his son Isaac. The Dome of the Rock stands over this site, on which the Jews had originally built their temples. The coming and going of pilgrims to the Holy Land continued for some time, until Jerusalem fell to the Turks in 1071 and Christians were forbidden access to their religious sites. This event led to the Crusades, the military effort to take back the Holy City of Jerusalem and biblical sites.

THE DOME OF THE ROCK.
Copyright Royalty-Free/Corbis.

It is against this historical backdrop that we can make sense of the present-day composition of the Old City of Jerusalem and the nature of its historic sites. Within the walls are four delineated sections: the Christian quarter, the Jewish quarter, the Muslim quarter, and the Armenian quarter. Just outside the fortress walls are the Mount of Olives (on which can be found the Garden of Gethsemane, where the apostle Judas was said to have betrayed Jesus to the Roman authorities) and Mount Zion (the place where it was believed the Last Supper took place.)

The Muslim quarter is the largest and most densely populated of the sections of the Old City and is physically dominated by one of the most extraordinary works of Islamic architecture in the world— the Dome of the Rock. Built in 688–691 CE, the mosque-shrine represents the epitome of Islamic architectural design, from the mathematical relationships of the

THE GARDEN OF GETHSEMANE.
Copyright Richard T. Nowitz/ Corbis.

individual parts to the building as a whole to the supremely ornamented tiles and mosaics of its interior.

Because the Islamic faith traditionally proscribed the rendering of the human figure, the walls and dome contain complex, decorative organic and abstract patterns, sometimes interlaced with Koranic verses and other inscriptions rendered in Arabic calligraphy. The Muslim quarter also in-

cludes the El-Aqsa Mosque, several well-known gates to the Old City (such as the Damascus Gate and Herod's Gate), a museum of Islamic art, and the Central Souk, a covered marketplace selling spices, clothes, and souvenirs. The Muslim quarter is also the site of the Via Dolorosa, venerated as the route taken by Jesus on the way to his Crucifixion.

The spiritual heart of the Jewish quarter of the Old City is the Western Wall—a section of the retaining wall of the Temple Mount that is the only part of the Second Temple complex that survives to this day. Since the sixteenth century it has been Judaism's holiest site, having been reconstructed after Israeli troops gained control of the Jewish quarter during the 1967 war. Jewish pilgrims from all over the world (non-Jews are also allowed to approach the wall) come to what is also known as the Wailing Wall to lament the destruction of the temple and to pray. Many leave prayers inscribed on the smallest bits of paper, tucked into the cracks between the huge stone blocks that make up the wall.

INTERIOR OF THE CHURCH OF THE HOLY SEPULCHRE, SHOWING CALVARY.

Copyright Carmen Redondo/Corbis.

Golgotha, or Calvary (the rock venerated as the site of Christ's Crucifixion), and Christ's tomb (a marble slab that covers the rock on which Jesus' body is believed to have been laid). Flanking the main entrance are a bell tower and many chapels that, together with many small churches, hospices, and souvenir shops, obscure the overall exterior plan of the church. Over centuries, bitter disputes over who "owns" the church would arise until an Ottoman decree in 1852, known as the Status Quo, divided custody of the structure and its holy sites among the Roman Catholics, Copts, Armenians, Greeks, Ethiopians, and Syrians. Every day, a Muslim "key holder," a neutral intermediary, unlocks the doors of the church.

Just within the walls of the Christian quarter, the Citadel of the Old City (most likely the place of Christ's trial and condemnation) now houses the Tower of David Museum of the History of Jerusalem. The museum contains specific routes that offer panoramic views of the city, a close look at archeological remains, and displays and dioramas focused on the three cultural-religious traditions of Jerusalem.

The story of the Armenians in Jerusalem begins in the time of Constantine (the kingdom of Armenia was the first to declare Christianity as its state religion after the emperor's edict of 313) and continues through the early twentieth century, when a large number of Armenian citizens fled to Jerusalem to escape the genocide by the Turks. Although their numbers have dwindled significantly over the decades, the Armenian Church still maintains jurisdiction over such sites as the Church of the Holy Sepulchre, the Mosque of the Ascension, and the Tomb of the Virgin on the Temple Mount. Armenian works of ceramic, mosaic, and manuscript illumination can be seen in the library of St. James Cathedral and in the Mardigian Museum in the Armenian quarter.

THE WESTERN WALL WITH THE DOME OF THE ROCK ABOVE.

Copyright Richard T. Nowitz/Corbis.

Today the Jewish quarter is a mixture of historic sites and contemporary places of business serving the local community as well as tourists. Here, as in the other quarters, souvenir shops abound. Several fascinating excavations have been undertaken in the Jewish quarter, including the Cardo—one of Jerusalem's oldest main thoroughfares. During the era of the Crusades, the Cardo became a covered marketplace; today it remains an exclusive shopping arcade, full of galleries and boutiques. The quarter has several synagogues and archeological museums, of which the Wohl Museum is perhaps best known. It is alive with bustling streets, such as Tiferet Yisrael Street, and squares that are the social centers of the contemporary Jewish quarter. Lovely homes built around courtyards are constructed—by decree of the British military governor in 1917—only of Jerusalem stone, a local material ranging from soft beige to pale rose in color. Many of the common architectural elements and motifs of the three religious traditions are present even in these residential buildings, particularly the arch and the dome.

The Christian quarter of Jerusalem took shape in the shadows of the domes of its most sacred site, the Church of the Holy Sepulchre. Within the walls of this vast structure are two of Christendom's most important monuments:

Modern Jerusalem is as bustling and magnificent a city as one will ever lay eyes on—fashionable hotels, ornate synagogues and mosques, gardens, fountains, upscale shopping districts, colorful markets, important museums. One of the most poignant aspects of this art tour is the recognition that for many, because of the continuing unrest, instability, and violence that grip the city, it is only what lies on these pages that will bring them to Jerusalem.

To continue your tour and learn more about Jerusalem, go to our website.

CLASSICAL ART: GREECE AND ROME

. . . the glory that was Greece
And the grandeur that was Rome.

—Edgar Allan Poe

No other culture has had as far-reaching or lasting an influence on art and civilization as that of ancient Greece. It has been said that "nothing moves in the world which is not Greek in origin." To this day, the Greek influence can be felt in science, mathematics, law, politics, and art. Unlike some other cultures that flourished, died, and left barely an imprint on the pages of history, that of Greece has asserted itself time and again over the 3,000 years since its birth. During the fifteenth century, there was a revival of Greek art and culture called the Renaissance, and on the eve of the French Revolution of 1789, artists of the Neoclassical period again turned to the style and subjects of ancient Greece. Our founders looked to Greek architectural styles for the buildings of our nation's capital, and nearly every small town in America has a bank, post office, or library constructed in the Greek Revival style.

*To claim that we can get along without study of the antique and the classics
is either madness or laziness.*

—Jean-Auguste-Dominique Ingres

Despite its cultural and artistic achievements, ancient Greece was conquered and absorbed by Rome—one of history's strongest and largest empires. Although Greece's political power waned, its influence as a culture did not. It was assimilated by the admiring Romans. The spirit of **Hellenism** lived on in the glorious days of the Roman Empire.

In contrast to the Greeks' intellectual and creative achievements, Rome's cultural contributions lay in the areas of building, city planning, government, and law. Although sometimes thought of as uncultured and crude, the Romans civilized much of the ancient world following military campaigns that are still studied in military academies.

Despite its awesome might, the Roman Empire also fell. It was replaced by a force whose ideals differed greatly and whose kingdom was not of this world—Christianity. In this chapter we shall examine the artistic legacy of Greece and Rome. This legacy—called **Classical art**—has influenced almost all of Western art, from Early Christian mosaics to contemporary Manhattan skyscrapers.

GREECE

The most important concerns of the ancient Greeks were man, reason, and nature, and these concerns formulated their attitude toward life. The Greeks considered themselves (that is, men but not women or slaves) to be the center of the universe—the "measure of all things." This concept is called **humanism.** The value put on the individual led to the development of democracy as a system of government among independent city-states throughout Greece. It was also the responsibility of the individual to reach his or her full potential. Much emphasis was placed on the notion of a "sound body"; physical fitness was of utmost importance. The Greeks also recognized the power of the intellect. Their love of reason and admiration for intellectual pursuits led to the development of **rationalism,** a philosophy in which knowledge is assumed to come from reason alone, without input from the senses. Perfection for the Greeks was the achievement of a sound mind in a sound body (*mens sana in corpore sano*). This is not to say that the Greeks were wholly

without emotion—on the contrary, they were vital and passionate—but the Greeks sought a balance between elements: mind and body, emotion and intellect.

The Greeks had a profound love and respect for nature and viewed human beings as a reflection of its perfect order. In art, this concern manifested itself in a naturalism, or truth to reality, based on a keen observation of nature. But the Greeks were also lovers of beauty. Thus, although they based their representation of the human body on observation, they could not resist perfecting it. The representation of forms according to an accepted notion of beauty or perfection is called **idealism,** and in the realm of art, idealism ruled the Greek mind.

Ancient Greece has given us such names as Aeschylus, Aristophanes, and Sophocles in the world of drama; Homer and Hesiod in the art of poetry; Aristotle, Socrates, and Plato in the field of philosophy; and Archimedes and Euclid in the realms of science and mathematics. It has also given us gods such as Zeus and Apollo and heroes such as Achilles and Odysseus. Even more astonishing is the fact that Greece gave us these figures and achieved its accomplishments during a very short period of its history. Although Greek culture spans almost 1,000 years, its "Golden Age," or period of greatest achievement, lasted no more than 80 years.

As with many civilizations, the development of Greece occurred over a cycle of birth, maturation, perfection, and decline. These points in the cycle correspond to the four periods of Greek art that we will examine in this chapter: Geometric, Archaic, Classical, and Hellenistic.

Geometric Period

The **Geometric period** spanned approximately two centuries, from about 900 to 700 BCE. During this time, a series of invasions took place, resulting in a decline of the arts. Art will flourish during times of peace, but during a period of war there is little time and money available for it. This period is called Geometric because geometric patterns predominated in art during this time. As in Egyptian art, the representation of the human figure was conceptual rather than optical. When the human figure was present, it was

usually reduced to a combination of geometric forms such as circles and triangles. This style changed in later years as Greek artists began to rely more heavily on the observation of nature.

The Dipylon Vase (Fig. 13-1) is a fine example of the Geometric style. The vase takes its name from the site at which it was found—the Dipylon Cemetery in Athens. Except for two distinct bands, the entire body of the Dipylon Vase is decorated with geometric motifs, some of which may have been inspired by the patterns of woven baskets. The painting is meticulous, and the forms are rigidly rendered. The subject of the vase is a funeral procession, which is depicted in the wider bands of the broadest part of the vessel. Highly abstracted female figures with wedge-shaped torsos and profile legs march along with the rigidity of the geometric patterns. In the center there is a bier on which rests the horizontal figure of the deceased. The band below features figures of warriors with apple-core shields and teams of chariots. The deceased was likely a Greek soldier.

These geometric elements can also be seen in small bronze sculptures of the period, but the stylistic development is most evident in the art of vase painting.

Archaic Period

The **Archaic period** spanned roughly the years from 660 to 480 BCE, but the change from the Geometric style to the Archaic style in art was gradual. As Greece expanded its trade with Eastern countries, it was influenced by their art. Flowing forms and fantastic animals inspired by Mesopotamia appeared on Greek pottery. There was a growing emphasis on the human figure, which supplanted geometric motifs.

Vase Painting

During the Archaic period, Eastern patterns and forms gradually disappeared. During the Geometric period the human figure was subordinated to decorative motifs, but in the

13-1 Dipylon Vase with funerary scene (Greek, 8th century BCE). Terra-cotta. H: 42⅝″.

The Metropolitan Museum of Art, New York. Rogers Fund, 1914 (14.130.14). Copyright 1995 The Metropolitan Museum of Art, New York.

The Women Weavers of Ancient Greece

There are no names of important women artists recorded in ancient Greece. Yet there is plenty of evidence that women did have outlets for creative expression in the media of pottery, basketry, and particularly, weaving. It was typical for wealthy women as well as for common women and slaves to weave either as a pastime or to earn a living. Athena, the most important female god in the Greek pantheon, was the patron goddess of weavers and potters, although Athena is better known as the goddess of war and of wisdom.

Stories of women weaving come down to us from Homer in *The Iliad* and *The Odyssey.* Helen of Troy weaves in *The Iliad.* In *The Odyssey,* the saga of the wanderings of Odysseus throughout the Mediterranean following the sacking of Troy, Penelope, Odysseus's wife, ruled Ithaca in her husband's absence and was beset by many suitors who wished her to accept her husband's absence as evidence of his death and to marry one of them. Penelope evaded the suitors through a deception that involved weaving. She promised her suitors that she would marry one of them when she had finished a shroud for Odysseus's father, Laertes. Penelope spent her days weaving the shroud and her nights unraveling it.

The importance of the craft is suggested in a black-figure vase attributed to the Amasis Painter (Fig. 13-2). A large central panel on the body of the vessel contains the images of women working on looms and attending to other tasks in the production of cloth. Some art historians have suggested an even more widespread influence of women's weaving by connecting the patterns of geometric vase painting (Fig. 13-1) with those of Dorian wool fabrics.

The tradition of weaving is thus an early one, but it is one that continues throughout the centuries. In the Middle Ages, for example, noblewomen, nuns, and commoners alike were taught the skills of weaving and embroidery. The most remarkable tapestries of this era were certainly created by women. In our time, artists such as Faith Ringgold (see Figs. 11-20 to 11-22) and Miriam Schapiro (see Fig. 6-17) have explored the expressive possibilities of traditional needlework in their work. ∎

13-2 ATTRIBUTED TO THE AMASIS PAINTER, ATTIC LEKYTHOS.
Women Working Wool on a Loom (Greek, c. 540 BCE).
Terra-cotta. H: 6¾". Said to have been found in Attica.
The Metropolitan Museum of Art, New York. Fletcher Fund, 1931
(31.11.10). Copyright 1999 The Metropolitan Museum of Art, New York.

Archaic period it became the preferred subject. In the François Vase (Fig. 13-3), for example, geometric patterns are restricted to a few areas. The entire body of the vessel, a **volute krater,** is divided into six wide bands featuring the exploits of Greek heroes such as Achilles. Even though the drawing is meticulous and somewhat stilted, the figures of men and animals have been given substance and an attempt at naturalistic gestures has been made. Unlike the figures of the Dipylon Vase, those of the François Vase are not static. In fact, the movement of the battling humans and the prancing horses is quite lively. This energetic mood is enhanced by the spring forms of the volute handles.

The François Vase is one of the finest examples we have of Archaic vase painting. No doubt, those who made it were also proud of their work, because the vessel is signed by both the potter and the painter. The vase is an example of the **black-figure painting technique.** Vases of this kind consist of black figures on a reddish background. This color combination was achieved through a three-stage firing process in the kiln. The decoration was applied to the clay pot using a brush and a **slip,** a liquid of sifted clay. The first stage of the firing process was called the **oxidizing phase** because oxygen was allowed into the kiln. Firing under these conditions turned both the pot and the slip decoration red. In the second phase of firing, called the **reducing phase,** oxygen was eliminated from the kiln, and the vase and the slip both turned black. In the third and final phase, called the **reoxidizing phase,** oxygen was again introduced into the kiln. The coarser material of the pot turned red, whereas the fine clay of the slip remained black. The result was a vase with black figures silhouetted against a red ground. The finer details of the figures were incised with sharp instruments that scraped away portions of the black to expose the red clay underneath. In addition, the vases were painted with touches of red and purple pigment to highlight the forms. Although this technique was fairly versatile, Greek artists did not care for the heavy quality of the black forms. Around 530 BCE, a reversal of the black-figure process was developed, enabling painters to create lighter, more realistic red forms on a black ground.

Architecture

Some of the greatest accomplishments of the Greeks can be witnessed in their architecture. Although their personal dwellings were simple, the dwellings for their gods were fan-

13-3 KLEITIAS.
François Vase. Attic volute krater (Greek, c. 570 BCE).
Ceramic. H: 26″.
Archaeological Museum, Florence. Copyright Art Resource, New York.

tastic monuments. During the Archaic period, an architectural format was developed that provided the basis for temple architecture throughout the history of ancient Greece. It consisted essentially of a central room (derived in shape from the Mycenaean **megaron**) surrounded by a single or double row of columns. This central room, called the **cella,** usually housed the cult statue of the god or goddess to whom the temple was dedicated. The overall shape of the temple was rectangular, and it had a pitched roof.

There were three styles, or orders, in Greek architecture: the **Doric, Ionic,** and **Corinthian.** The Doric order, which originated on the Greek mainland, was the earliest, simplest, and most commonly used. The more ornate Ionic order was introduced by architects from Asia Minor and was generally reserved for smaller temples. The Corinthian order was by far the most intricate of the three and was used later in less significant buildings, but it was the favorite order of Roman architects, who adopted it in the second

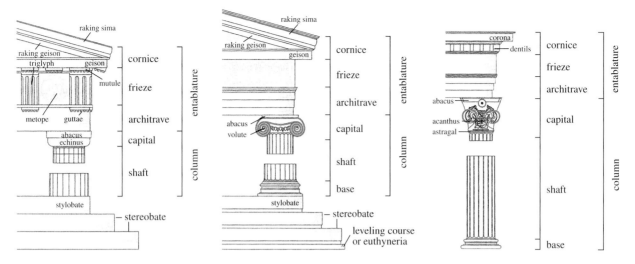

13-4 Left to right: Doric, Ionic, and Corinthian orders.

century BCE. Figure 13-4 compares the Doric, Ionic, and Corinthian orders and illustrates the basic parts of the temple facade. The major weight-bearing elements of the temple are the columns. These cylindrical vertical forms are composed of drums stacked on top of one another and fitted with dowels. They help support the roof structure from either a platform (the **stylobate**) or a base. The main body, or shaft, of the column is crowned by a **capital** that marks a transition from the shaft to a horizontal member (the **entablature**) that directly bears the weight of the roof. In the Doric order, the capital is simple and cushionlike. In the Ionic order it consists of a scroll or volute similar to those seen on the François Vase (Fig. 13-3). The Corinthian capital is by far the most elaborate, consisting of an all-around carving of overlapping acanthus leaves. The columns directly support the entablature, which is divided into three parts: the **architrave, frieze,** and **cornice.** The architrave of the Doric order is a solid, undecorated horizontal band, whereas those of the Ionic and Corinthian orders are subdivided into three narrower horizontal bands. The frieze, which sits directly above the architrave, contains some sculptural decoration. The Doric frieze is divided vertically into compartments called **triglyphs** and **metopes.** The triglyphs were sculpted panels consisting of clusters of three vertical elements. These alternate with panels that were filled with sculpted figures. The Ionic and Corinthian friezes, by contrast, were sculpted with a continuous band of figures or—particularly in the Corinthian order—repetitive patterns. The absence of compartments freed sculptors from having

to work within a square format. Consequently, the decoration flows more freely. The topmost element of the entablature is called a cornice. In all three orders, it consists of a projecting horizontal band. The entablature is crowned by a **pediment,** a triangular member formed by the slope of the roof lines at the short ends of the temple. This space was also ornamented with figures sculpted to fit within the triangular shape.

The Doric order originated in the Archaic period, but it attained perfection in the buildings of the Classical period. The Corinthian order, although developed by the Greeks, was used more universally by the Romans who came after them.

Sculpture

In the Archaic period, sculpture emerged as a principal art form. In addition to sculptural decoration for buildings, freestanding, life-size, and larger-than-life-size statues were executed. Such monumental sculpture was probably inspired by Egyptian figures that Greek travelers would have seen during the early Archaic period.

In Greek temples, the nonstructural members of the building were often ornamented with sculpture. These included the frieze and pediment. Because early Archaic sculptors were forced to work within relatively tight spaces, the figures from this period are often cramped and cumbersome. However, toward the end of the Archaic period, artists compensated for the irregularity of the spaces by arranging figures in poses that corresponded to the peculiarities of the

architectural element. For example, the *Fallen Warrior* (Fig. 13-5) from the Temple of Aphaia at Aegina, was sculpted for one of the sharp angles of its triangular pediment. The warrior's feet would have been wedged into the left corner of the pediment, and his body would have fanned out toward the shield, corresponding to the dimensions of the angle. As in vase painting of the period, the figure is based somewhat on the observation of nature. However, at this early date, stylizations remain as artists were following certain conventions for the representation of the human body. These conventions are most obvious in the sculpting of the warrior's head. He has thick-lidded eyes, overdefined lips that purse in an artificial "smile," and an unnaturally pointed beard. Some of the lines of musculature are also stylized, indicating an obsession with anatomical patterns instead of adherence to optical fact. Yet for its conventional representation, the work reveals a marvelous attention to de-

tail. It is, after all, a pitiful sight. The warrior, wounded in battle, crashes down upon the field with his shield in hand. He struggles to lift himself with his right arm, but to no avail. The hopelessness of the situation is echoed in the helplessness of the left arm, which remains trapped in the grasp of the cumbersome shield. It hangs there useless, the band of the shield restricting its flow of blood. It is an emotionally wrenching scene, and yet the emotion comes from the viewer and not from the warrior. The expression on his face is not consonant with his plight. It remains masklike, bound to the restraining conventions of the Archaic style.

The *Fallen Warrior* from Aegina was created during the last years of the Archaic period, but the history of Archaic Greek sculpture began more than a century earlier. About 600 BCE large, freestanding sculpture began to appear. Some of the earliest of these are the so-called **kouros figures,** which are statues of young men, thought to have

13-5 *Fallen Warrior,* from Temple of Aphaia at Aegina, Greece (490–480 BCE).
Marble. L: 6′.
Staatliche Antikensammlungen und Glypothek, Munich.
Copyright C. M. Dixon. Copyright Heritage Image Partnership (HIP),
heritage-images.com.

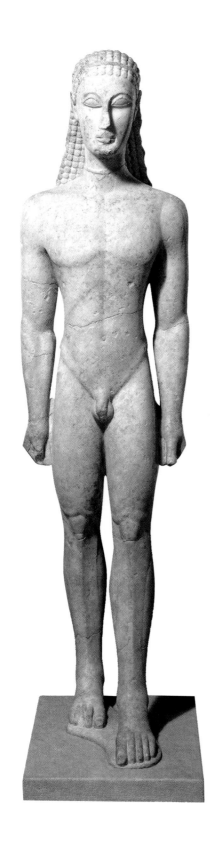

13-6 Kouros figure (Greek, Archaic, c. 600 BCE). Marble. H: 6'4".

The Metropolitan Museum of Art, New York. Fletcher Fund, 1932 (32.11.10). Copyright 1997 The Metropolitan Museum of Art, New York.

been dedicated to a god. Figure 13-6 is typical of these figures. The shape of the body adheres essentially to the block of marble from which it was carved. The arms lie close to the body, the fists are clenched tightly, and one leg advances only slightly. The musculature is full and thick, and parts of the anatomy are emphasized by harsh, patterned lines. The kneecaps, groin muscles, rib cage, and pectoral muscles are all flexed unrealistically. The head has also been treated according to the artistic conventions of the day. The hair is stylized and intricate in pattern. The eyes are thick lidded and stare directly forward. The youth has very high cheekbones and clearly defined lips that appear to curl upward in a smile. This facial expression is seen in most sculpture of the Archaic period. It is believed to have been a convention rather than an actual smile that the sculptor was trying to render. Thus, it is called the "archaic smile."

The function of these figures is unclear, although they may have been executed to commemorate the subject's accomplishments. In its stately repose and grand presence, the figure might impress us as a god rather than a mortal. In looking at this kouros figure, one is reminded of the oft-repeated statement, "The Greeks made their gods into men and their men into gods."

The female counterpart to the kouros is the **kore figure.** Unlike the kouros, the kore is clothed and often embellished with intricate carved detail. The *Peplos Kore* (Fig. 13-7)—so named because the garment the model wears is a **peplos,** or heavy woolen wrap—is one of the most enchanting images in Greek art, partly because touches of paint remain on the sculpture, giving it a lifelike gaze and sensitive expression. We tend to think of Greek architecture and sculpture as pristine and glistening in their pure white surfaces. Yet most sculpture was painted, some in gaudy colors. Architectural sculpture combined red, blue, yellow, green, black, and sometimes gold pigments. None of this painted decoration remains on temple sculpture. However, statues and wooden panels were painted with encaustic, a more durable and permanent medium.

13-7 *Peplos Kore* (Greek, Archaic, c. 530 BCE).
Marble. H: 48″.

Acropolis Museum, Athens. Copyright Art Resource, New York.

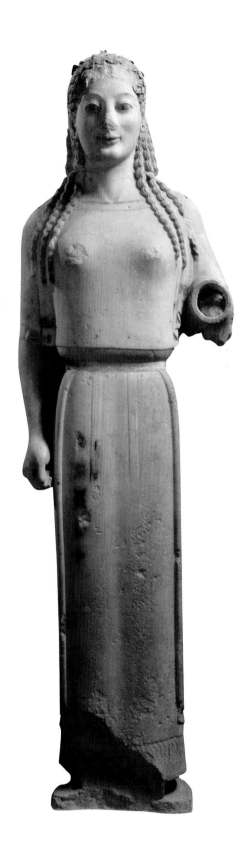

Much of the beauty of the *Peplos Kore* lies in its simplicity. The woman's body is composed of graceful columnar lines echoed in the delicate play of the long braids that grace her shoulders. As is the case in the kouros figures, she remains close to the shape of the marble block. Her right arm, in fact, is attached to her side at the fist. The left arm, now missing, extended outward and probably held a symbolic offering. Although the function of the kore figures is also unknown, some have interpreted them as votive sculptures because many have been found among the ruins of temples.

These architectural and freestanding sculptures were all made of marble. Although expensive, marble was readily available. Some of the finest in the world came from areas immediately around Athens.

The Archaic period was an era of great productivity for the Greeks, but it ended with the invasion of the Persians. After a series of battles, the Persians went for the heart of the Athenian people. In 480 BCE they sacked the **Acropolis,** the sacred hill above the city that was the site of the Athenians' temples. It was a devastating blow, but one from which the proud and enduring Greeks would recover.

Early Classical Art

The change from Archaic to Classical art coincided with the Greek victory over the Persians in a naval battle at Salamis in 480 BCE. The Greek mood was elevated after this feat, and a new sense of unity among the city-states prevailed, propelling the country into what would be called its "Golden Age." Athens, the site of the Acropolis, became the center for all important postwar activity and was especially significant for the development of the arts. The art of the early phase of the Classical period, which lasted some 30 years, is marked by a power and austerity that reflected the Greek character responsible for the defeat of the Persians. Although it indicates great strides from the Archaic style, some of the rigidity of the earlier period remains. The Early Classical style is therefore sometimes referred to as the Severe style.

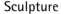

Discobolus (Discus Thrower) (c. 450 BCE).
Roman marble copy after bronze original.
Life-size.

Palazzo Vecchio, Florence. Copyright Edimedia/Corbis.

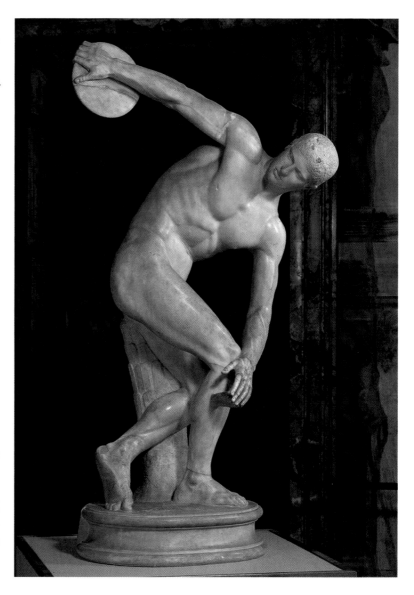

Sculpture

The most significant development in Early
Classical art was the introduction of implied
movement in figure sculpture. This went
hand in hand with the artist's keener obser-
vation of nature. One of the most widely
copied works of this period, which encom-
passes these new elements, is the *Discobolos*
(Fig. 13-8), or Discus Thrower, by Myron.
Like most Greek monumental sculpture, it
survives only in a Roman copy. The life-size
statue depicts an event from the Olympic
Games—the discus throw. The figure, shown
as a young man in his prime, is caught by the
artist at the moment when the arm stops its
swing backward and prepares to sling forward
to release the discus. The athlete's muscles are
tensed as he reaches for the strength to release
the object. His torso intersects the arc shape
of his extended arms, resembling an arrow
pulled taut on a bow. It is an image of pent-
up energy that the artist will not allow to escape. As in most
of Greek Classical art, there is a balance between motion
and stability, between emotion and restraint.

Classical Art

Greek sculpture and architecture reached a height of perfec-
tion during the Classical period. Greece embarked upon a
period of peace—albeit short-lived—and turned its atten-
tion to rebuilding its monuments and advancing art, drama,
and music. The dominating force behind these accomplish-
ments in Athens was the dynamic statesman Pericles. His
reputation was recounted centuries after his death by the
Greek historian Plutarch:

The works of Pericles are . . . admired—though built in a
short time they have lasted for a long time. For, in its beauty,
each work was, even at that time, ancient, and yet, in its per-
fection, each looks even at the present time as if it were fresh
and newly built. Thus there is a certain bloom of newness in
each work and an appearance of being untouched by the wear
of time. It is as if some ever-flowering life and unaging spirit
had been infused into the creation of these works.

Architecture

After the Persians destroyed the Acropolis, the Athenians re-
fused to rebuild their shrines with the fallen stones that the
enemy had touched. What followed, then, was a massive
building campaign under the direction of Pericles. Work
began first on the temple that was sacred to the goddess

Raphael is a great master. Velázquez is a great master. El Greco is a great master,

but the secret of plastic beauty is located at a greater distance:

in the Greeks at the time of Pericles.

—Pablo Picasso

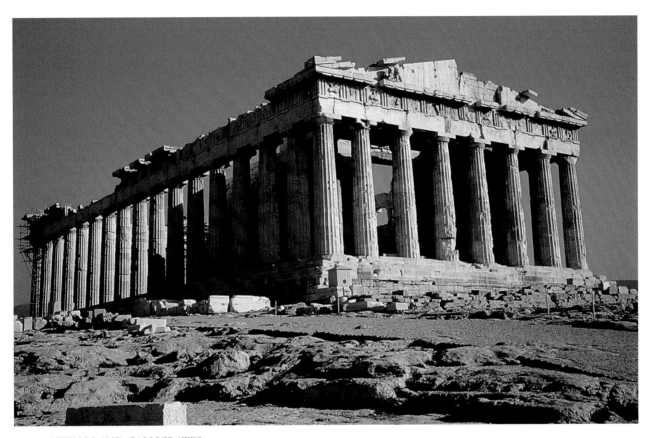

13-9 ICTINOS AND CALLICRATES.
The Parthenon on the Acropolis, Athens (448–432 BCE).
Copyright Getty/Image Bank.

Athena, protector of Athens and its people. This temple, the Parthenon (Fig. 13-9), became one of the most influential buildings in the history of architecture.

Constructed by the architects Ictinos and Callicrates, the Parthenon stands as the most accomplished representative of the Doric order. A single row of Doric columns, now gracefully proportioned, surrounds a two-roomed cella that housed a treasury and a 40-foot-high statue of Athena made of ivory and gold. At first glance, the architecture appears austere, with its rigid progression of vertical elements crowned by the strong horizontal of its entablature. Yet few of the building's lines are strictly vertical or horizontal. For example, the stylobate, or top step of the platform from

which the columns rise, is not straight, but curves downward toward the ends. This convex shape is echoed in the entablature. The columns are not exactly vertical, but rather tilt inward. They are not evenly spaced; the intervals between the corner columns are narrower. The shafts of the columns themselves also differ from one another. The corner columns have a wider diameter, for example. In addition, the shaft of each column swells in diameter as it rises from the base, narrowing once again before reaching the capital. This swelling is called **entasis.**

The reasons for these variations are unknown, although there have been several hypotheses. Errors in construction can be discounted because these variations can be found in

other temples. Some art historians have suggested that the change from straight to curved lines is functional. A convex stylobate, for example, might make drainage easier. Others have suggested that the variations are meant to compensate for perceptual distortions on the part of the viewer that would make straight lines look curved from a distance. Regardless of the actual motive, we can assume that the designers of the Parthenon were after an integrated and organic look to their building. The wide base and relatively narrower roof give the appearance of a structure that is anchored firmly to the ground yet growing dramatically from it. Although it has a grandeur based on a kind of austerity, it also has a lively plasticity. It appears as if the Greeks conceived their architecture as large, freestanding sculpture.

The subsequent history of the Parthenon is both interesting and alarming. In the sixth century CE it was converted into a Christian church, and afterward it was used as an Islamic mosque. The Parthenon survived more or less intact until the seventeenth century, when the Turks used it as an ammunition dump in their war against the Venetians. Venetian rockets hit the bull's eye, and the center portion of the temple was blown out in the explosion. The cella still lies in ruins, although fortunately the exterior columns and entablatures were not beyond repair.

Sculpture

The sculptor Phidias was commissioned by Pericles to oversee the entire sculptural program of the Parthenon. Although he was involved in creating the ivory and gold statue of Athena and thus had no time to carve the architectural sculpture, his assistants followed his style closely. The Phidian style is characterized by a lightness of touch, attention to realistic detail, contrast of textures, and fluidity and spontaneity of movement.

As was the case with other Doric temples, the sculpted surfaces of the Parthenon were confined to the friezes and the pediments. The subjects of the frieze panels consisted of battles between the Lapiths and the Centaurs, the Greeks and the Amazons, and the gods and the giants. In addition, the Parthenon had a continuous Ionic frieze atop the cella wall. This was carved with scenes from the Panathenaic procession, an event that took place every four years when the peplos of the statue of Athena was changed. The pediments depicted the birth of Athena and the contest between Athena and Poseidon for the city of Athens.

The *Three Goddesses* (Fig. 13-10), a figural group from the corner of the east pediment, is typical of the Phidian style. The bodies of the goddesses are weighty and substantial. Their positions are naturalistic and their gestures fluid,

13-10 *The Three Goddesses,* from east pediment of the Parthenon (c. 438–431 BCE).
Marble. Height of center figure: 4′7″.
British Museum, London. Copyright Heritage Image Partnership (HIP), heritage-images.com.

despite the fact that limbs and heads are broken off. The draperies hang over the bodies in a realistic fashion, and there is a marvelous contrast of textures between the heavier garments that wrap around the legs and the more diaphanous fabric covering the upper torsos. The thinner drapery clings to the body as if it were wet, revealing the shapely figures of the goddesses. The intricate play of the linear folds renders a tactile quality not seen in art before this time. The lines both gently envelop the individual figures and integrate them in a dynamically flowing composition. Phidias has indeed come a long way from the Archaic artist for whom the contours of the pediment were all but an insurmountable problem.

Some of the Parthenon sculptures were taken down by Lord Elgin (Thomas Bruce) between 1801 and 1803 while he was British ambassador to Constantinople. He sold them to his government, and they are now on view in the British Museum.

Some of the greatest freestanding sculpture of the Classical period was created by a rival of Phidias named Polykleitos. His favorite medium was bronze and his preferred subject athletes. As with most Greek sculpture, we know his work only from marble Roman copies of the bronze originals.

Polykleitos's work differed markedly from that of Phidias. Whereas the Parthenon sculptor emphasized the reality of appearances and aimed to delight the senses through textural contrasts, Polykleitos's statues were based upon reason and intellect. Rather than mimic nature, he tried to perfect nature by developing a canon of proportions from which he would derive his "ideal" figures.

Polykleitos's most famous sculpture is the *Doryphoros* (Fig. 13-11), or Spear Bearer. The artist has "idealized" the athletic figure—that is, made it more perfect and beautiful—by imposing on it a set of laws relating part to part (for example, the entire body is equal in height to eight heads). Although some of Phidias's spontaneity is lost, the result is an almost godlike image of grandeur and strength. One of the most significant elements of Polykleitos's style is the **weight-shift principle.** The athlete rests his weight on the right leg, which is planted firmly on the ground. It forms a strong vertical that is accented by the vertical of the relaxed arm. These are counterbalanced by a relaxed left leg bent at the knee and a tensed left arm bent at the elbow. Tension and relaxation of limbs are balanced across the body *diagonally.* The relaxed arm opposes the relaxed leg, and the tensed arm is opposite the tensed, weight-bearing leg. The weight-shift principle lends naturalism to the figure. Rather than face forward in a rigid pose, such as that of the kouros figures, the *Doryphoros* stands comfortably at rest. Yet typical

13-11 POLYKLEITOS.
Doryphoros (Spear Bearer) (c. 450–440 BCE). Marble. Roman copy after Greek original. H: 6′6″.
National Museum, Naples. Copyright Art Resource, New York.

of the Polykleitan working method, this appearance of naturalism was derived from a careful balancing of opposing anatomical parts.

Vase Painting

The principle of weight shift and the naturalistic use of implied movement can be seen in Classical vase painting as well. The Argonaut Krater (Fig. 13-12), a red-figure vase decorated by the Niobid Painter, incorporates these elements while devoting significantly more space on the body of the vessel to the human figure. In the Dipylon Vase, the human figure was confined to a single band, whereas the François Vase devoted all of its horizontal bands to the figure (see Figs. 13-1 and 13-3). On later vases, the bands are eliminated and the broad field of the vessel is given over to the human figure in a variety of positions. Until the Classical period, all heads on such vases were arranged on one level. The Niobid Painter, by contrast, attempted to create a three-dimensional space by crudely outlining a foreground, middle ground, and background. This was a noble attempt at naturalism, based on optical perception; but it failed because the artist neglected to reduce the size of the figures he placed in the background. The ability to arrange figures in space convincingly came later with the development of perspective.

Vase painting was not the only two-dimensional art form in ancient Greece. There was also **mural painting,** none of which has survived. It is believed, however, that the Romans copied Greek mural painting, as they did sculpture, and it is thus possible to learn what Greek painting looked like by examining surviving Roman wall painting (Fig. 13-20).

Late Classical Art

Sculpture

The Late Classical period brought a more humanistic and naturalistic style, with emphasis on the expression of emotion. In addition, the stocky muscularity of the Polykleitan ideal was replaced by a more languid sensuality and gracefulness. One of the major proponents of this new style was Praxiteles. His works show a lively spirit that was lacking in some of the more austere sculptures of the Classical period.

The *Hermes and Dionysos* of Praxiteles (Fig. 13-13), interestingly, is the only undisputed original work we have of the Greek masters of the Classical era. Unlike most of the other sculptors, who seem to have favored bronze, Praxiteles excelled in carving. His ability to translate harsh marble surfaces into subtly modeled flesh was unsurpassed. We need only compare his figural group with the *Doryphoros* to witness the changes that had taken place since the Classical period. The *Hermes* is delicately carved and realistic in its muscular emphasis, suggesting a keen observation of nature rather than sculpting according to a rigid canon. The messenger-god holds the infant Dionysos, the god of wine, in his left arm, which is propped up by a tree trunk covered with a drape. His right arm is broken above the elbow but reaches out in front of him. It has been suggested that Hermes once held a bunch of grapes toward which the infant was reaching.

Praxiteles' ability to depict variations in texture is fascinating. Note, for example, the difference between the solid muscularity of Hermes and the soft, chubby body of the infant Dionysos, the rough treatment of Hermes' hair contrasted with the ivory smoothness of his skin, and the deeply carved and billowing drapery against the solidity of the body. This realism is enhanced by the use of a double weight-shift principle. Hermes shifts his weight from the right leg to the left arm, resting it on the tree. The resultant stance is known as an **S curve,** because the contours of the body form an S shape around an imaginary vertical axis.

Perhaps most remarkable is the emotional content of the sculpture. The aloof quality of Classical statuary is re-

13-12 NIOBID PAINTER.
Argonaut Krater, Attic red-figure krater
(Greek, c. 460 BCE).
Ceramic. H: 24¼".
Louvre Museum, Paris. Copyright Art Resource, New York.

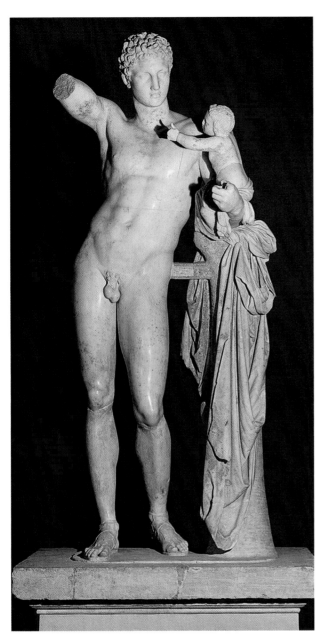

13-13 PRAXITELES.
Hermes and Dionysos (c. 330–320 BCE).
Marble. H: 7′1″.
Museum, Olympia. Copyright Art Resource, New York.

13-14 LYSIPPOS.
Apoxyomenos (c. 330 BCE).
Roman marble copy after a bronze original. H: 6′6¾″.
Vatican Museums, Rome. Copyright Art Resource, New York.

placed with a touching scene between the two gods. Hermes' facial expression as he teases the child is one of pride and amusement. Dionysos, on the other hand, exhibits typical infant behavior—he is all hands and reaching impatiently for something to eat. There still remains a certain balance to the movement and to the emotion, but it is definitely on the wane. In the Hellenistic period, that time-honored balance will no longer be sought, and the emotionalism present in Praxiteles' sculpture will reach new peaks.

The most important and innovative sculptor to follow Praxiteles was Lysippos. He introduced a new canon of proportions that resulted in more slender and graceful figures,

departing from the stockiness of Polykleitos and assuming the fluidity of Praxiteles. Most important, however, was his new concept of the motion of figure in space. All of the sculptures that we have seen so far have had a two-dimensional perspective. That is, the whole of the work can be viewed from a single point before the sculpture. This is not the case in works such as the *Apoxyomenos* (Fig. 13-14) by

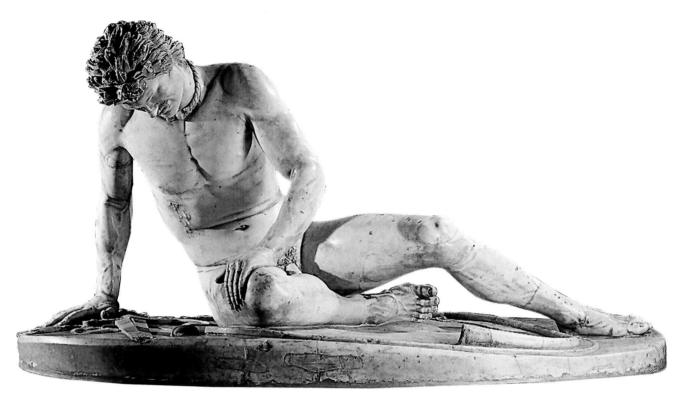

13-15 *The Dying Gaul* (Hellenistic, c. 240–200 BCE).
Roman marble copy after a bronze original. Life-size.
Capitoline Museum, Rome. Copyright Art Resource, New York.

Lysippos. The figure's arms envelop the surrounding space. The athlete is scraping oil from his body, after which he will bathe. This stance forces the viewer to walk around the sculpture to appreciate its details. Rather than adhere to a single plane, as even the S-curve figure of *Hermes* does, the *Apoxyomenos* seems to spiral around a vertical axis.

Lysippos's reputation was almost unsurpassed. In fact, so highly thought of was his work that Alexander the Great, the Macedonian king who spread Greek culture throughout the Near East, chose him as his court sculptor. It is said that Lysippos was the only sculptor permitted to execute portraits of Alexander. Years after the *Apoxyomenos* was created, it was still seen as a magnificent work of art. Pliny, a Roman writer on the arts, recounted an amusing story about the sculpture:

> Lysippos made more statues than any other artist, being, as we said, very prolific in the art; among them was a youth scraping himself with a strigil, which Marcus Agrippa dedi-
> cated in front of his baths and which the Emperor Tiberius was astonishingly fond of. [Tiberius] was, in fact, unable to restrain himself in this case . . . and had it moved to his own bedroom, substituting another statue in its place. When, however, the indignation of the Roman people was so great that it demanded, by an uproar . . . that the Apoxyomenos be replaced, the Emperor, although he had fallen in love with it, put it back.[1]

Hellenistic Art

Greece entered the Hellenistic period under the reign of Alexander the Great. His father had conquered the democratic city-states, and Alexander had been raised amid the art and culture of Greece. When he ascended the throne, he

[1] J. J. Pollitt, *The Art of Greece 1400–31 BCE: Sources and Documents* (Englewood Cliffs, NJ: Prentice-Hall, 1965), 144.

conquered Persia, Egypt, and the entire Near East, bringing with him his beloved Greek culture, or Hellenism. With the vastness of Alexander's empire, the significance of Athens as an artistic and cultural center waned.

Hellenistic art is characterized by excessive, almost theatrical emotion and the use of illusionistic effects to heighten realism. In three-dimensional art, the space surrounding the figures is treated as an extension of the viewer's space, at times narrowing the fine line between art and reality.

Sculpture

The Dying Gaul (Fig. 13-15) illustrates the Hellenistic artist's preoccupation with high drama and unleashed passion. Unlike the *Fallen Warrior* (Fig. 13-5), in which the viewer has to extract the emotion by piecing together scattered realistic details, *The Dying Gaul* presents all of the elements that communicate the pathos of the work. Bleeding from a large wound in his side, the fallen barbarian attempts to sustain his weight on a weakened right arm. His head, with expressionistically rendered disheveled hair, hangs down, appearing to lean on his shoulder. He has lost his battle and is now about to lose his life. Strength seems to drain out of his body and into the ground, even as we watch. Our perspective is that of a theatergoer; the Gaul seems to be sitting on a stage. Although the artist intended to evoke pity and emotion from the viewer, the melodramatic pose of the figure and his position on a stagelike platform detach the viewer from the event. We tend to see the scene as well-acted drama rather than cruel reality.

Hellenistic artists were often drawn to subjects with inherent drama. They did not focus on a balance between emotion and restraint but portrayed human excess. In the midst of this theatricality, however, there was another trend in Hellenistic art that reflected the simplicity and idealism of the Classical period. The harsh realism and passionate emotion of the Hellenistic artist could not be further in spirit from the serene and idealized form of the *Aphrodite of Melos* (Fig. 13-16), often called the *Venus de Milo*. This contradictory style owes more to the artistic legacy of Praxiteles than to the contemporary illusionism of the sculptor of the *Dying Gaul.*

In 146 BCE, the Romans sacked Corinth, a Greek city on the Peloponnesus, after which Greek power waned. Both the territory and the culture of Greece were assimilated by the powerful and growing Roman state. It has been said that "all roads lead to Rome," and so will this chapter. First, however, let us examine the art of the Etruscans, a civilization on the Italian peninsula that predated that of the Romans.

13-16 *Aphrodite of Melos (Venus de Milo)* (Hellenistic, 2nd century BCE).
Marble. Larger than life-size.
Louvre Museum, Paris. Copyright Edimedia/Corbis.

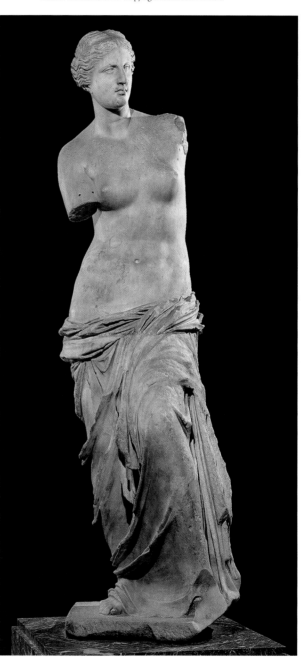

THE ETRUSCANS

The center of power of the Roman state was the peninsula of Italy, but the Romans did not gain supremacy over this area until the fourth century BCE, when they began to conquer the **Etruscans.** The Italian peninsula was inhabited by many peoples, but the Etruscan civilization was the most significant one before that of ancient Rome. The Etruscans had a long and interesting history, dating back to around 700 BCE, the period of transition from the Geometric to the Archaic period in Greece. They were not an indigenous peoples but are believed to have come from Asia Minor. This link may explain some similarities between Etruscan art and culture and that of Eastern countries.

Etruria and Greece had some things in common. Both were great sea powers. Both were divided into independent city-states. The Etruscans even borrowed motifs and styles from the art of Greece. There is one more similarity between the two civilizations: Etruria also fell prey to the Romans. They were no match for Roman organization, especially because neighboring city-states never came to one another's aid in a time of crisis. By 88 BCE, the Romans had vanquished the last of the Etruscans.

Architecture

The only "architecture" that survives from the Etruscan civilization is tombs, the interiors of which were constructed to resemble those of domestic dwellings. The walls were covered with hundreds of everyday items carved in low relief, including such things as kitchen utensils and weapons. The Etruscans apparently wanted to duplicate their earthly environments for "use" in the afterlife.

Sculpture

Much sculpture of bronze and clay has survived from these Etruscan tombs, and we have learned a great deal about the Etruscan people from these finds. For example, even though no architecture survives, we know what the exterior of domestic dwellings looked like from the clay models of homes that served as **cinerary urns.** We have also been able to gain insight into the personalities of the Etruscan people through their figural sculpture, particularly that which topped the lids of their **sarcophagi.**

The Sarcophagus from Cerveteri (Fig. 13-17) is a translation into terra-cotta of the banquet scenes of which the Etruscans were so fond. A man and wife are represented reclining on a lounge and appear to be enjoying some banquet entertainment. Their gestures are sprightly and naturalistic, even though their facial features and hair are rigidly stylized. These stylizations, especially the thick-lidded eyes, resemble Greek sculpture of the Archaic period and were most likely influenced by it. However, the serenity and severity of Archaic Greek art are absent. The Etruscans appear to be as relaxed, happy, and fun loving in death as they were in life.

13-17 Sarcophagus, from Cerveteri (Etruscan, c. 520 BCE). Terra-cotta. L: 6'7".
Museo Nazionale di Villa Giulia, Rome / Erich Lessing/Art Resource, New York.

Ancient art was the tyrant of Egypt, the mistress of Greece, and the servant of Rome.

—Henry Fuseli

ROME

In about 500 BCE the Roman Republic was established, and it would last some four centuries. The Roman arm of strength reached into northern Italy, conquering the Etruscans, who were probably responsible for having civilized Rome in the first place. Eventually it stretched in all directions, gaining supremacy over Greece, western Europe, northern Africa, and parts of the Near East (Map 13-1). No longer was this the republican city of Rome flexing its muscles—this was the Roman Empire.

Roman art combined native talent, needs, and styles with other artistic sources, particularly those of Greece. The art that followed the absorption of Greece into the Roman Empire is thus often called Greco-Roman. It was fashionable for Romans to own—or at the very least, have copies of—Greek works of art. This tendency gave the Romans a reputation as mere imitators of Greek art, and inferior imitators at that. However, Roman art has been reexamined recently for its own merits, and they are many. A marvelous, unabashed eclecticism pervaded much of Roman art, resulting in vigorous and sometimes unpredictable combinations of motifs. The Romans were also fond of a harsh, almost

trompe l'oeil, realism in their portrait sculpture, which had not been seen prior to their time. They were master builders who created some of the grandest monuments in the history of architecture.

The Republican Period

The ancient city of Rome was built on seven hills to the east of the Tiber River and served as the central Italian base from which the Romans would come to control most of the known world in the West. Their illustrious beginnings are traced to the **Republican period,** which followed upon the heels of their final victories over the Etruscans and lasted until the death of Julius Caesar in 44 BCE. The Roman system of government during this time was based on two parties, although the distribution of power was not equitable. The **patricians** ruled the country and could be likened to an aristocratic class. They came from important Roman families and later were characterized as nobility. The majority of the Roman population, however, belonged to the **plebeian class.** Members of this class were common folk and had less say in running the government. They were, however, permitted to elect their patrician representatives. It was during the Republican period that the famed Roman senate became the governing body of Rome. The rulings of the senate were responsible for the numerous Roman conquests that would expand its borders into a seemingly boundless empire.

By virtue of its construction, however, the republic was doomed to crumble. It was never a true democracy. The patricians became richer and more powerful as a result of the plundering of vanquished nations. The lower classes, on the other hand, demanded more and more privileges and resented the wealth and influence of the aristocracy.

After a series of successful military campaigns and the quelling of internal strife in the republic, Julius Caesar emerged as dictator of the Roman Empire. Under Caesar important territories were accumulated, and Roman culture reached a peak of refinement. The language of Greece, its literature, and religion were adopted along with its artistic styles.

Map 13-1 The Roman Empire (2nd century CE).

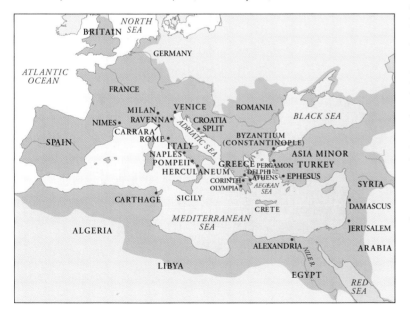

*With the Greeks there's always an aesthetic element. I prefer the virile realism of Rome,
which doesn't embellish. The truthfulness of Roman art—it's like their buildings,
but all the more beautiful in their genuine simplicity.*

—Pablo Picasso

13-18 *Head of a Roman* (Republican period, 1st century BCE). Marble. H: 14⅜″.

The Metropolitan Museum of Art, New York. Rogers Fund, 1912 (12.233). Photograph, all rights reserved, copyright The Metropolitan Museum of Art, New York.

It was customary for Romans to make wax death masks of their loved ones and to keep them around the house, as we do photographs. At times, the wax masks were translated into a more permanent medium, such as bronze or terracotta. The process of making a death mask produced intricately detailed images that recorded every ripple and crevice of the face. Because these sculptures were made from the actual faces and heads of the subjects, their realism is unsurpassed. The *Head of a Roman* (Fig. 13-18) records the facial features of an old man, from his bald head and protruding ears to his furrowed brow and almost cavernous cheeks. No attempt has been made by the artist to idealize the figure. Nor does one get the sense, on the other hand, that the artist emphasized the hideousness of the character. Rather, it serves more as an unimpassioned and uninvolved record of the existence of one man.

Architecture

Rome's greatest contribution lay in architecture, although the most significant buildings, monuments, and civic structures were constructed during the Empire period. Architecture of the Republican period can be stylistically linked to both Greek and Etruscan precedents, as can be seen in the Temple of Fortuna Virilis (Fig. 13-19). From the Greeks, the Romans adopted the Ionic order and post-and-lintel construction. From the Etruscans, they adopted the podium on which the temple stands, as well as the general plan of a wide cella extending to the side columns and a free portico in front. But there are Roman innovations as well. The column shafts, for example, are **monolithic** instead of being composed of drums stacked one atop the other. The columns along the sides of the temple are not freestanding but are engaged. Also, the Ionic frieze has no relief sculpture. The most marked difference between the temples of Greece and of Rome is the feeling that the Romans did not treat their buildings as sculpture. Instead, they designed them straightforwardly, with an eye toward function rather than aesthetics.

On March 15 (the ides of March) in 44 BCE, Julius Caesar was assassinated by members of the senate. With his death came the absolute end of the Roman Republic and the beginnings of the Roman Empire under his successor, Augustus.

Sculpture

Although much Roman art is derived in style from that of Greece, its portrait sculpture originated in a tradition that was wholly Italian. It is in this sculpture that we witness Rome's unique contribution to the arts—that of realism.

13-19 Temple of Fortuna Virilis, Rome (Republican period, late 2nd century BCE).
Copyright Canali Photobank, Milan.

Painting

The walls of Roman domestic dwellings were profusely decorated with frescoes and mosaics, some of which have survived the ravages of time. These murals are significant in themselves, but they also provide a missing stylistic link in the artistic remains of Greece. That country, you will recall, was prolific in mural painting, but none of it has survived.

Roman wall painting passed through several phases, beginning in about 200 BCE and ending with the destruction of Pompeii by the eruption of Mount Vesuvius in 79 CE. The phases have been divided into four overlapping styles.

Ulysses in the Land of the Lestrygonians (Fig. 13-20) is an example of the **Architectural**

13-20 *Ulysses in the Land of the Lestrygonians,* from a Roman patrician house (50–40 BCE).
Fresco. H: 60".
Vatican Library, Rome. Copyright Edimedia/Corbis.

style. Works in this style give the illusion of an opening of space away from the plane of the wall, as if the viewer were looking through a window. In a loosely sketched and liberally painted landscape, the artist recounts a scene from *The Odyssey,* in which Ulysses' men were devoured by a race of giant cannibals. The figures rush through the landscape in a variety of poses and gestures, their forms defined by contrasts of light and shade. They are portrayed convincingly in three-dimensional space through the use of **herringbone perspective,** a system whereby **orthogonals** vanish to a specific point along a vertical line that divides the canvas. It is believed that Greek wall painting was similar to the Roman Architectural style.

With the death of Julius Caesar, a dictator, Rome entered its **Empire period** under the rule of Octavian Caesar—later called Augustus. This period marks the beginning of the Roman Empire, Roman rule by emperor, and the Pax Romana, a 200-year period of peace.

The Early Empire

With the birth of the empire there emerged a desire to glorify the power of Rome by erecting splendid buildings and civic monuments. It was believed that art should be created in the service of the state. Although Roman expansionism left a wake of death and destruction, it was responsible for the construction of cities and the provision of basic human services in the conquered areas.

To their subject peoples, the Roman conquerors gave the benefits of urban planning, including apartment buildings, roads, and bridges. They also provided police and fire protection, water systems, sanitation, and food. They even built recreation facilities for the inhabitants, including gymnasiums, public baths, and theaters. Thus, even in defeat, many peoples reaped benefits because of the Roman desire to glorify the empire through visible contributions.

Architecture

Although the Romans adopted structural systems and certain motifs from Greek architecture, they introduced several innovations in building design. The most significant of these was the arch, and after the second century, the use of concrete to replace cut stone. The combination of these two elements resulted in domed and vaulted structures that were not part of the Greek repertory.

One of the most outstanding Roman civic projects is the **aqueduct,** which carried water over long distances. The Pont du Gard (Fig. 13-21) in southern France carried water more than 30 miles and furnished each recipient with some 100 gallons of water per day. Constructed of three levels of arches, the largest of which spans about 82 feet, the aqueduct is some 900 feet long and 160 feet high. It had to slope down gradually over the long distance in order for gravity to carry the flow of water from the source.

Although the aqueduct's reason for existence is purely functional, the Roman architect did not neglect design. The

13-21 Pont du Gard, Nîmes, France (Early Empire, c. 14 CE). L: 900′; H: 160′.

The series of triumphal arches in Rome is a prototype of the billboard. . . . The triumphal arches in the Roman Forum were spatial markers channeling processional paths within a complex urban landscape. On Route 66 . . . the billboards perform a similar formal-spatial function.

—Robert Venturi

Pont du Gard has long been admired for both its simplicity and its grandeur. The two lower tiers of wide arches, for example, anchor the weighty structure to the earth, whereas the quickened pace of the smaller arches complements the rush of water along the top level. Not only does such a civil project show a concern for function and form, but in works such as the Pont du Gard, the form *follows* the function.

One of the most impressive and famous remains of ancient Rome is the Colosseum (see Fig. 13-23 in the "Compare and Contrast" feature). Dedicated in 80 CE, the structure consists of two back-to-back **amphitheaters** forming an oval arena, around which are tiers of marble seats.

Even in its present condition, having suffered years of pillaging and several earthquakes, the Colosseum is a spectacular sight. The structure is composed of three tiers of arches separated by engaged columns. (This combination of arch and column can also be seen in another type of Roman architectural monument—the triumphal arch [Fig. 13-22]). The Colosseum's lowest level, whose arches provided easy access and exit for the spectators, is punctuated by Doric columns. This order is the weightiest in appearance of the three and thus visually anchors the structure to the ground. The second level utilizes the Ionic order, and the third level the Corinthian. This combination produces a sense of lightness as one proceeds from the bottom to the top tier. Thick entablatures rest atop the rings of columns, firmly delineating the stories. The topmost level is almost all solid masonry, except for a few regularly spaced rectangular openings. It is ornamented with Corinthian pilasters and crowned by a heavy cornice.

The exterior was composed of masonry blocks held in place by metal dowels. These dowels were removed over the years when metal became scarce, and thus gravity is all that remains to keep the structure intact.

13-22 Arch of Constantine, Rome (312–315 CE).
Copyright Canali Photobank, Milan.

COMPARE + CONTRAST

Stadium Designs: Thumbs-Up or Thumbs-Down?

The sports stadium has become an inextricable part of our global landscape and our global culture. Just as diehard U.S. fans root for their football teams in the Louisiana Superdome, Olympic spectators half a world away cheer their country's athletes on to victory under a *super* dome likely erected just for the occasion. A city's bid for host of the Olympic Games can hinge entirely on the stadium it has to offer. These megastructures are not only functional—housing anticipated thousands—but they tend to become symbols of the cities, the teams, or now, the corporations who fund them. There's something about a space like this. The passion of friends and strangers and "fors and againsts" alike creates an odd sense of uniformity regardless of diversity. And it is this very observation that has led some of history's political leaders to use—and abuse—the phenomenon of the stadium for their own propagandistic purposes.

The Colosseum (Fig. 13-23) represented Rome at its best, but it also stood for Rome at its worst. A major feat of architectural engineering coupled with practical design, this vast stadium accommodated as many as 55,000 spectators who—thanks to 80 numbered entrances and stairways—could get from the street to their desig-

13-23 Colosseum, Rome (Early Empire, 80 CE).
Concrete (originally faced with marble).
H: 160′; D: 620′ and 513′.

Copyright Topfoto/The Image Works.

13-24 WERNER MARCH.
Olympic Stadium, Berlin (1936).

Harf Zimmermann/Contact Press Images.

nated seats within 10 minutes. In rain or under blazing sun conditions, a gargantuan canvas could be hoisted from the arena up over the top of the stadium. Although the Colosseum was built for entertainment and festivals, its most notorious events ranged from sadistic contests between animals and men and grueling battles to the death between pairs of gladiators. If one combatant emerged alive but badly wounded, survival might depend on whether the emperor (or the crowd) gave the "thumbs-up" or the "thumbs-down."

As in much architecture, form can follow function and reflect and create meaning. In 1936, Adolph Hitler commissioned Germany's Olympic Stadium in Berlin (Fig. 13-24). Intended to showcase Aryan superiority (even though Jesse Owens, an African American, took four gold medals in track and field as Hitler watched), designer Werner March's stadium is the physical embodiment of Nazi ideals: order, authority, and the no-nonsense power of the state.

How different the message, noted critic Nicolai Ouroussoff, when an architect uses design to cast off the shackles of "nationalist pretensions" and "notions of social conformity" in an effort to imbue the structure—and the country—with a sense of the future. Created in 1960 by Pier Luigi Nervi, the Palazzo dello Sport (Fig. 13-25) in Rome symbolized an emerging internationalism in the wake of World War II. The unadorned and unforgiving pillars of March's Berlin stadium seem of a distant and rejected past. Nervi's innovative, interlacing concrete roof beams define delicacy and seem to defy gravity.

In 2008, China will host the Olympic Games in the city of Beijing. A doughnut-shaped shell crisscrossed with lines of steel as if it were a precious package wrapped in string, the stadium (Fig. 13-26) will house 100,000 spectators and is projected to cost $500 million. But beyond these staggering numbers, and like the Colosseum and the Berlin Stadium, it stands to symbolize the transformation of its city—and its country—into a major political and cultural force of its time. ■

13-25 PIER LUIGI NERVI.
Palazzo dello Sport, Rome (1960).
David Lees/CORBIS.

13-26 HERZOG & DE MEURON.
Beijing Stadium for the 2008 Olympic Games (2005).
Rendering by Herzog & de Meuron Company/China Architecture Design Institute.

13-27 The Pantheon, Rome
(Early Empire, 117–125 CE). Exterior view.
allOver Photography/Alamy.

The Roman engineering genius can be seen most clearly in the Pantheon (Figs. 13-27 and 13-28), a brick and concrete structure originally erected to house sculptures of the Roman gods. Although the building no longer contains these statues, its function remains religious. Since the year 609 CE, it has been a Christian church.

The Pantheon's design combines the simple geometric elements of a circle and a rectangle. The entrance consists of a rectangular portico, complete with Corinthian columns and pediment. The main body of the building, to which the portico is attached, is circular. It is 144 feet in diameter and crowned by a dome equal in height to the diameter. Supporting the massive dome are 20-foot-thick walls pierced with deep niches, which in turn are vaulted in order to accept the downward thrust of the dome and distribute its weight to the solid wall. These deep niches alternate with shallow niches, in which sculptures were placed.

The dome itself consists of a rather thin concrete shell that thickens toward the base. The interior of the dome is **coffered,** or carved with recessed squares that physically and visually lighten the structure. The ceiling was once painted blue, with a bronze rosette in the center of each square. The sole source of light in the Pantheon is the **oculus,** a circular opening in the top of the dome, 30 feet in diameter and open to the sky.

The interior was lavishly decorated with marble slabs and granite columns that glistened in the spotlight of the sun as it filtered through the opening, moving its focus at different times of the day.

It has been said that Roman architecture differs from other ancient architecture in that it emphasizes space rather than solids. Instead of constructing buildings from a variety of forms, the Romans conceptualized a certain space and then proceeded to enframe it. Their methods of harnessing this space were unique in the ancient world and served as a vital precedent for future architecture.

Sculpture

During the Empire period, Roman sculpture took on a different flavor. The pure realism of the Republican period portrait busts was joined to Greek idealism. The result, evident in *Augustus of Primaporta* (Fig. 13-29), was often a cu-

13-28 The Pantheon, Rome (Early Empire, 117–125 CE). Interior view.
Copyright Getty Images/STONE/Paul Chesley.

masses. His officer's cloak is draped about his hips, and his ceremonial armor is embellished with reliefs that portray both historic events and allegorical figures.

As the first emperor, Augustus was determined to construct monuments reflecting the glory, power, and influence of Rome on the Western world. One of the most famous of these monuments is the *Ara Pacis,* or Altar of Peace, created to celebrate the empirewide peace that Augustus was able to achieve. The *Ara Pacis* is composed of four walls surrounding a sacrificial altar. These walls are adorned with relief sculptures of figures and delicately carved floral decoration. Panels such as *The Imperial Procession* (Fig. 13-30) exhibit, once again, a blend of Greek and Roman devices. The right-to-left procession of individuals, unified by the flowing lines of their drapery, clearly refers to the frieze sculptures of the Parthenon. Yet the sculpture differs from its Greek prototype in several respects: The individuals are rendered in portrait likenesses, the relief commemorates a specific event with specific persons present, and these figures are set within a shallow, though very convincing, three-dimensional space. By working in high and low relief, the artist creates the sense of a crowd; fully three rows of people are compressed into this space. They actively turn, gesture, and seem to converse. Despite a noble grandness that gives the panel an idealistic cast, the participants in the procession look and act like real people.

As time went on, the Roman desire to accurately record a person's features gave way to a more introspective portrayal of the personality of the sitter. Although portrait busts remained a favorite format for Roman sculptors, their repertory also included relief sculpture, full-length statuary, and a new design—the **equestrian portrait.**

13-29 *Augustus of Primaporta* (Roman, c. 20 BCE). Marble. H: 6'8".

Vatican Museums, Rome/Scala/Art Resource, New York.

rious juxtaposition of individualized heads with idealized, anatomically perfect bodies in Classical poses. The head of Augustus is somewhat idealized and serene, but his unique facial features are recognizable as those that appeared on empire coins. Augustus adopts an authoritative pose not unlike that of Polykleitos's *Doryphoros* (Fig. 13-11). Attired in military parade armor, he proclaims a diplomatic victory to the

13-30 *Imperial Procession*, from the *Ara Pacis Augustae*, Rome. Marble relief.

Copyright Canali Photobank, Milan.

13-31　*Marcus Aurelius on Horseback,* Capitoline Hill, Rome
(Early Empire, c. 165 CE).
Bronze. Larger than life-size.
Copyright Canali Photobank, Milan.

The bronze sculpture of Marcus Aurelius (Fig. 13-31) depicts the emperor on a sprightly horse, as if caught in the action of gesturing to his troops or recognizing the applause of his people. The sculpture combines the Roman love of realism with the later concern for psychologically penetrating portraits. The commanding presence of the horse is rendered through pronounced musculature, a confident and lively stride, and a vivacious head with snarling mouth, flared nostrils, and protruding veins. In contrast to this image of brute strength is a rather serene image of imperial authority. Marcus Aurelius, clothed in flowing robes, sits erectly on his horse and gestures rather passively. His facial expression is calm and reserved, reflecting his adherence to Stoic philosophy. **Stoicism** advocated an indifference to emotion and things of this world, maintaining that virtue was the most important goal in life.

The equestrian portrait of Marcus Aurelius survives because of a case of mistaken identity. During the Middle Ages, objects of all kinds were melted down because of a severe shortage of metals, and ancient sculptures that portrayed pagan idols were not spared. This statue of Marcus Aurelius was saved because it was mistakenly believed to be a portrait of Constantine, the first Roman emperor to recognize Christianity. The death of Marcus Aurelius brings us to the last years of the Empire period, which were riddled with internal strife. The days of the great Roman Empire were numbered.

The Late Empire

During its late years, the Roman Empire was torn from within. A series of emperors seized the reigns of power only to meet violent deaths, some at the hands of their own soldiers. By the end of the third century, the situation was so unwieldy that the empire was divided into eastern and western sections, with separate rulers for each. When Constantine ascended the throne, he returned to the one-ruler system, but the damage had already been done—the empire had become divided against itself. Constantine then dealt the empire its final blow by dividing its territory among his sons and moving the capital to Constantinople (present-day Istanbul). Thus, imperial power was shifted to the eastern empire, leaving Rome and the western empire vulnerable. These were decisions from which the empire would never recover.

Architecture

Although the empire was crumbling around him, Constantine continued to erect monuments to glorify it. Before moving to the East, he completed a basilica begun by his predecessor Maxentius (Fig. 13-32) that bespoke the

13-32　Basilica of Maxentius and Constantine, Rome
(Late Empire, c. 310–320 CE).
300′ × 215′.
Copyright Canali Photobank, Milan.

grandeur that had been Rome. In ancient Rome, basilicas were large public meeting halls that were usually built around or near the **forums.** The basilica of Maxentius and Constantine was a huge structure, measuring some 300 by 215 feet. It was divided into three rectangular sections, or aisles, the center one reaching a height of 114 feet (Fig. 13-33). The central aisle, called a nave, was covered by a groin vault, a ceiling structure very popular in buildings of such a vast scale. Little remains of the basilica today, but it survived long enough to set a precedent for Christian church architecture. It would serve as the basic plan for basilicas and cathedrals for centuries to come.

Sculpture

Some 300 years before Constantine's reign, a new force began to gnaw at the frayed edges of the Roman Empire—Christianity. A man called Jesus was put to death for his beliefs, it is said, as well as his disregard for Roman authority, and after him, his followers were persecuted by the Romans for the same reasons. The slaying stopped when Constantine proclaimed tolerance of Christianity. This series of events influenced artistic styles, as can be seen in the Head of Constantine the Great (Fig. 13-34). The literalness and materialism of Roman art and life gave way to a new spirituality and otherworldliness in art. The Head of Constantine the Great was part of a mammoth sculpture of the emperor, consisting of a wooden torso covered with bronze and a head and limbs sculpted from marble. The head is 8½ feet high and weighs more than eight tons. The realism and idealism that we have witnessed in Roman sculpture are replaced by an almost archaic rendition of the emperor, complete with an austere expression and thick-lidded, wide-staring eyes. The artist now elaborates the pensive, passive rigidity of form that we sensed in the portrait of Marcus Aurelius. Constantine's face seems both resigned to the fall of his empire and reflective of the Christian emphasis on a kingdom that is not of this world.

13-34 Head of Constantine the Great (Roman, Late Empire, early 4th century CE).

ART TOUR
Rome

Everything about Rome is colossal—from the Colosseum itself (Rome's greatest amphitheater) (Fig. 13-23) to the colossal head of Constantine (Fig. 13-34), which is more than eight feet high. As the center of two of the great powers of the Western world—the Roman Empire and the Catholic Church—the city is rife with symbols that trumpeted their status in the times of their glory. A week of travel to Rome would barely do justice to this treasure trove of art and architecture.

It was said that "all roads lead to Rome," and, in truth, any road the visitor might take would lead to something wonderful. Starting with the Capitol, or the southern summit of Capitoline Hill, you will be in what has been called the symbolic center of the Roman world—its citadel as well as the location of three of its most important temples, including the Temple of Jupiter, where triumphal processions giving thanks for victory reached their climax. In the sixteenth century, Michelangelo, the Florentine artist otherwise famous for his sculpture of *David* (Fig. 15-26) and murals for the ceiling of the Sistine Chapel (Figs. 15-21–15-23), designed the geometric patterns of the elliptical plaza as well as the facades of the buildings that flank it on three sides. In the center stands a replica of the equestrian portrait of Emperor Marcus Aurelius (Fig. 13-31); the real thing can be found just steps away in one of the Capitoline museums, along with an extensive collection of painting and sculpture, including Caravaggio's unusual Baroque portrayal of St. John the Baptist, the *Dying Gaul,* and the excessively large head and assorted limbs from the statue of Constantine.

If you duck around the back of the museums, you'll come to a wonderful view of the Roman forum below. It's good to linger here awhile to get the "lay of the land" before descending to wander among the ruins (miraculously "restored" by way of computer-generated imagery for the film *Gladiator*). The forum was the religious, political, and commercial center of the ancient city—the site of temples, courts of law, and the Senate house, along with food stores and brothels teeming with customers. For the contemporary visitor, even the summer tourist crowds might pale in comparison to the hubbub of the forum at the height of the empire. Of particular interest are the central courtyard of the House of the Vestal Virgins (girls from noble families that served as priestesses tending an eternal flame in the Temple of Vesta), the triumphal arches of the emperors Septimius Severus and Titus, and the monumental barrel vaults that remain from the Basilica of Constantine and Maxentius. One of the most curious, composite structures along the Via Sacra (or sacred way) is the ancient Temple of Antoninus and Faustina, now incorporated into a Catholic church, San Lorenzo in Miranda.

Down in the area of the forum, where cats creep and sleep among the ruins, the visitor will also come upon the Arch of Constantine (a popular backdrop for wedding photos) as well as the spectacular and notorious Colosseum. Built during the reign of Emperor Vespasian in 72 CE, the amphitheater was the site of deadly clashes between gladiators and wild beasts staged as sport and theater for the Roman citizenry by the emperors and upper classes. Stadium seating accommodated up to 55,000 spectators, who, on opening day, witnessed the slaughter of more than 9,000

THE TEMPLE OF ANTONINUS AND
FAUSTINA IN THE FORUM.

TOURISTS BUYING SOUVENIRS
IN FRONT OF THE
COLOSSEUM.

HUNDREDS OF CATS LIVE IN THE FORUM, THE COLOSSEUM, AND OTHER ANCIENT SITES. WOMEN VOLUNTEERS CALLED *LE GATTARE* FEED AND CARE FOR THEM.

wild animals in addition to a mock naval battle. The tiers of the Colosseum, bearing columns in all three orders, or styles—Doric, Ionic, and Corinthian—served as inspiration for architects during the Renaissance. The artistic and architectural sources for the rebirth of Classicism in Italy were not, as it happened, so far from home.

You can ride the 81 bus from the Colosseum to witness the influence of Roman architecture on the grandest cathedral in Christendom, the Basilica of St. Peter's. Its rhythmic colonnades, imposing temple-front facade, and expansive hemispherical dome epitomize the Renaissance relationship to antiquity. St. Peter's (Fig. 16-3) is the emblem of Roman Catholicism and the centerpiece of the Vatican, the world's smallest sovereign state, nestled within the city of Rome and ruled by the pope. The current, commanding building

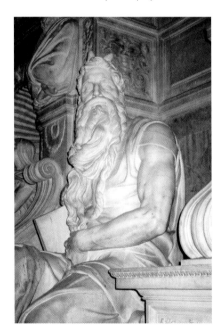

MICHELANGELO, *Moses.*

is constructed on the ruins of an earlier basilica erected by Constantine, who believed the site to be that in which the apostle Peter was buried. In another part of town, Michelangelo's *Moses*—part of the tomb of Pope Julius II—overlooks the shackles believed to have been used to imprison Peter before his execution.

Today St. Peter's itself is also the backdrop for magnificent works by Michelangelo (the *Pietà*—protected by glass since an attack on the sculpture in 1972—and the glorious dome over the main altar, the largest in the world) and by Gianlorenzo Bernini (the Baldacchino, or bronze canopy over the main altar, and several tombs and sculptures throughout the basilica, in addition to the design for the piazza and colonnades that grace the ex-

CASTLE SANT'ANGELO.

terior). Visitors to St. Peter's should be aware that proper attire is required for entry to the cathedral; even in the oppressive heat of a Roman summer day, shorts and sleeveless shirts are forbidden.

The wealth of the popes is even more evident in the sublime collections and treasures of the Vatican Museums (the Hellenistic *Belvedere Torso* and *Laocoön* reside here) and the rooms of the Vatican Palace—including Michelangelo's paintings of the Sistine Chapel ceiling and Raphael's fresco for the Stanze della Segnatura (Fig. 15-20) in the papal apartments.

A grand boulevard—the Via della Conciliazone—leads the traveler from the steps of St. Peter's along the Tevere River toward the Castel Sant'Angelo. Constructed in 139 CE as a mausoleum for Emperor Hadrian, it went on to serve as a medieval citadel and prison, as well as a safe haven for popes (it was connected to the Vatican by an escape corridor). If you continue on foot along this broad avenue, you will eventually wind up in the area of the Roman Pantheon (Figs. 13-27 and 13-28), the great domed temple-turned-Christian-church, initially devoted to the gods and emperors of Rome. Raphael is buried here.

From its romantic fountains and lush gardens to its endless trattorias and pizzerias, museums and monuments, Rome is and has always been a cosmopolitan city on the go. It is a cacophonous mix of old and new (every youthful Roman seems to have a motor scooter and a cell phone), a vast city whose center is so small that a good map—and, even better, pair of running shoes—will take you everywhere.

 To continue your tour and learn more about Rome, go to our website.

CHRISTIAN ART: FROM CATACOMBS TO CATHEDRALS

*Cathedrals are an unassailable witness to human passion. Using what demented
calculation could an animal build such places? I think we know.
An animal with a gorgeous genius for hope.*

—Lionel Tiger

It has been said that the glorious Roman Empire fell to its knees before one mortal man. Of this man we have little factual information, although his life is said to be documented by his followers in the New Testament of the Bible. The month and date of his birth are unknown, although they are observed on December 25. Although originally 1 CE was considered the year of his birth, errors in calculating the calendar mean it may have been as early as 6 BCE. He was a Jew named Jesus, whose followers considered him to be the fulfillment of the biblical messianic prophecy. To the Roman authorities, this was blasphemy, and for this and other crimes, they put Jesus to death when he was in his thirties. After his death, he became known as *Jesus Christ* (*Christ* is synonymous with Messiah).

We cannot attribute the fall of the Roman Empire solely to Jesus or to his followers, the Christians. The empire had been having its own problems, both internal and external. It would also be hard to believe that the organizational abilities and influence of the mighty Roman Empire could have succumbed to a handful of

religious believers. Still the power of spirituality over materialism—and, in this case, of Christianity over worship of the oppressive Caesars—should not be underestimated.

This chapter examines the way in which Christians attempted—through the arts—to glorify Jesus in a period that spans 10 centuries or more.

EARLY CHRISTIAN ART

Christianity flowered among the ruins of the Roman Empire, even if it did not cause the empire to collapse. Over many centuries Christianity, too, had its internal and external problems, but unlike the Roman Empire, it has survived. In fact, the concept of survival is central to the understanding of Christianity and its art during the first centuries after the death of Jesus.

To be a Christian before Emperor Constantine's proclamation of religious tolerance, one had to endure persecution. Under the emperors Nero, Trajan, and Domitian, Christians were slain for their beliefs. The Romans saw the Christians as mad cult members and barbaric subversives who refused to acknowledge the emperor as a god.

In the third century CE, two things happened: First, Emperor Constantine declared in the Edict of Milan that Christianity would be tolerated. Later, he proclaimed Christianity to be the religion of the Roman Empire. Early Christian art, then, can be divided into two phases: the Period of Persecution, before Constantine's proclamation, and then the Period of Recognition.

The Period of Persecution

During the Period of Persecution, Christians worshiped in secret, using private homes as well as chapels in catacombs. The **catacombs** were secret burial places for Christians beneath city streets. A huge network of galleries and burial chambers that accommodated almost 6 million bodies existed beneath the city of Rome (Fig. 14-1). The galleries were carved out of porous stone, and the walls housed niches into which the bodies were placed. Sometimes small chapels were carved out of the gallery walls, and here early Christians worshiped and prayed for the dead. These chapels were very simple, although sometimes they were decorated with frescoes, as in the painted ceiling of the catacomb of Saints Pietro and Marcellino (Fig. 14-2).

The semicircular vault of the chapel was decorated with a cross inscribed in a circle, the symbols for the Christian faith and eternity. The arms of the cross radiate from a central circle in which Jesus is shown as the Good Shepherd and terminate in **lunettes** depicting scenes from the story of Jonah. Between the lunettes stand figures with arms outstretched in an attitude of prayer. These figures are called **orans,** from the Latin *orare,* meaning "to pray." The style of this fresco is reminiscent of the Classical vase and wall painting of Greece and Rome. The poses are realistic, the proportions are Classical, and the drapery falls over the body naturally. The early Christians shared the art and culture of Rome, if not its religion. Therefore, there were bound to be similarities in style.

Not all catacomb frescoes were as finished as the one of Saints Pietro and Marcellino. The lighting was poor in the

14-1 Catacomb di Priscilla, Rome.
Copyright Art Resource, New York.

14-2 *The Good Shepherd* in the Catacomb of Saints Pietro and Marcellino, Rome (Early Christian, early 4th century CE).
Fresco Pontifica Commissione di Architettura Sacra, Vatican City.
Copyright Art Resource, New York.

catacombs, and the artists probably wanted to get the work done quickly to avoid having to breathe in the stench of decaying flesh any longer than necessary. It was also unusual to populate such "illicit" frescoes with human figures. Not only was the Christians' place of worship secret but the representation of their Savior, Jesus, was often just as mysterious. Perhaps for safety's sake, they adopted symbols that were already present in Roman art for their own purposes. For example, the fish was used to symbolize Jesus, and grapes to represent the promise of salvation through the blood Jesus had shed. This use of symbols, perhaps at first a survival tactic (Romans might not suspect their meaning), would be of central importance to Christian art over the centuries. The study and interpretation of symbols is called **iconology,** and a work of art's symbolic meaning is called its iconography. Both words derive from the Greek *eikōn,* meaning "image."

The Period of Recognition

After Constantine adopted Christianity as the faith of the Roman Empire, life for the Christians improved considerably. No longer were they forced to keep their worship secret. Consequently, they poured their energies into constructing houses of worship. It is not surprising that the Christians turned to what they already knew for building models—the basilicas of Rome.

One of the first and most important buildings to be erected during the Early Christian period was the first St. Peter's Cathedral in Rome. The architects of the church, called Old St. Peter's, drew on basilican plans and derived a plan for a Christian cathedral that functioned for centuries to come. The plan of Old St. Peter's (Fig. 14-3) consisted of seven parts. Unlike the Roman basilica, it was entered from one of the short sides, through a kind of gateway called the **propylaeum.** Passing through this gateway, the worshiper entered a large courtyard, or **atrium,** which was open to the sky. Although these two elements were present in the plan of Old St. Peter's and appeared occasionally in subsequent churches, they were not carried forward into later buildings with any regularity. Such was not the case with the remainder of the plan. The worshiper gained access to the heart of the basilica through the **narthex,** a portal or series of portals leading to the interior. The long central aisle of the church was called the **nave,** and it was usually flanked by side aisles. As a worshiper walked away from the narthex and up the nave, he or she encountered the **altar** sitting in the **apse.** The apse was generally found at the easternmost end of the structure and was preceded by the **transept,** a kind of crossing arm that intersected the nave and side aisles and was parallel to the narthex. The transept often extended its "arms" beyond the

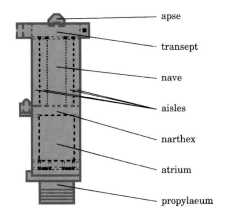

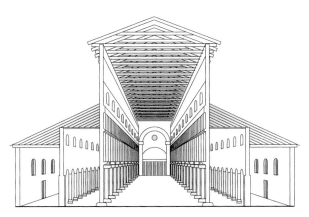

14-3 Plan and section of Old St. Peter's in Rome (Early Christian, first half of the 4th century CE).

boundaries of the side aisles, resembling a cross in structure. Because of its heritage, this plan is often called a **Latin cross plan;** it is also referred to as a **longitudinal plan.**

The longitudinal plan was most prominent in western Europe. Small circular buildings with **central plans** were popular in the East but were used only in ancillary buildings in the West.

Old St. Peter's was decorated lavishly with inlaid marble and **mosaics,** none of which survive. The art of mosaic was adopted from the Romans and composed most of the ornamentation of Early Christian churches. Many of the mosaics were Classical in style. Artists of the Period of Recognition also illuminated manuscripts and created some sculpture and small carvings. Their style, like that of the mosaics, can best be described as Late Roman.

BYZANTINE ART

The term **Byzantine** comes from the town of ancient Byzantium, the site of Constantine's capital, Constantinople. The art called "Byzantine" was produced after the Early Christian

era in Byzantium, but also in Ravenna, Venice, Sicily, Greece, Russia, and other Eastern countries. We may describe the difference between Early Christian and Byzantine art as a transfer from an earthbound realism to a more spiritual, otherworldly style. Byzantine figures appear to be weightless; they hover in an indeterminate space. Byzantine art also uses more symbolism and is far more decorative in detail.

San Vitale, Ravenna

The city of Ravenna, on the Adriatic coast of Italy, was initially settled by the ruler of the western Roman Empire who was trying to escape barbarians by moving his capital from Rome. As it turned out, the move was timely; eight years later, Rome was sacked. The early history of Ravenna was riddled with strife; its leadership changed hands often. It was not until the age of Emperor Justinian that Ravenna attained some stability and that the arts began to flourish.

During Justinian's reign, the church of San Vitale (Fig. 14-4), one of the most elaborately decorated buildings in the Byzantine style, was erected. The church has a central plan. Its perimeter is an octagon. Although the narthex is placed slightly askew, the rest of the plan is highly symmetrical. A dome, also octagonal, rises above the church and is supported by eight massive piers. Between the piers are semicircular niches that extend into a surrounding aisle, or **ambulatory,** like petals of a flower. The "stem" of this flower is a sanctuary that intersects the ambulatory. At the end of this sanctuary is the apse, which in the Byzantine church is often multisided, or polygonal. Unlike the rigid axial alignment of the Latin Cross structures that follow the basilican plan, San Vitale has an organic quality. Soft, curving forms press into the spaces of the church and are countered by geometric shapes that seem to complement their

decorativeness rather than restrain it. The space flows freely, yet the disparate forms are unified.

This vital, organic quality can also be seen in the interior decoration of the church. Columns are crowned by highly decorative capitals carved with complex, interlacing designs. Decorative mosaic borders, organic in inspiration, form repetitive abstract patterns.

This abstracted, patternlike treatment of forms can also be seen in the representation of human figures in San Vitale's mosaics. *Justinian and Attendants* (Fig. 14-5), an apse mosaic, represents the Byzantine style at its peak of perfection in this medium. The mosaic commemorates Justinian's victory over the Goths and proclaims him as ruler of Ravenna and the western half of the empire. His title is symbolically sanctioned by the presence of military and religious figures in his entourage. The figures form a strong horizontal band that marches friezelike across the viewer's space. Although they are placed in groups, some slightly in front of others, the heads form a single line. The heavily draped bodies seem to have no substance. The costumes seem to hang on invisible frames. Thickly lidded eyes stare outward, and gestures are unnatural. Space is suggested by a goldish background and a green, grassy band below the figures' feet, but the placement of the images within this space is uncertain. Notice how the feet hover above the earth. They have nothing to do with the support of these weightless bodies. These characteristics contrast strongly with the Classicism of Early Christian art and with mosaics such as *The Good Shepherd* (Fig. 14-2).

Hagia Sophia, Constantinople

Even though Ravenna was the capital of the western empire, its emperor's most important public building was erected in Constantinople. Constantine moved the capital of the Ro-

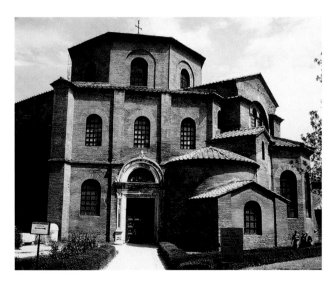

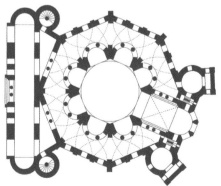

14-4 Church of San Vitale, Ravenna
(Byzantine, 526–547 CE). Exterior and plan.
Copyright Art Resource, New York.

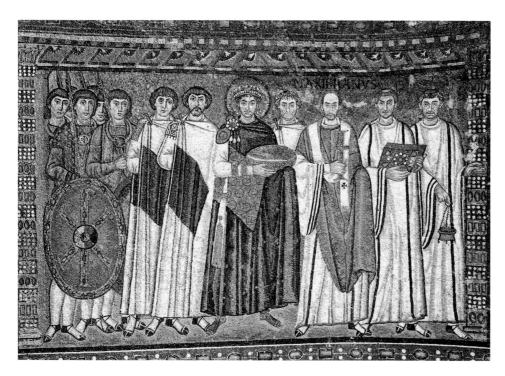

14-5 *Justinian and Attendants*
(Byzantine, c. 547 CE).
Mosaic.
Church of San Vitale, Ravenna.
Copyright Art Resource, New York.

man Empire to the ancient city of Byzantium and renamed it after himself. After his death, the empire was divided into eastern and western halves, and the eastern faction remained in Constantinople. It is in this Turkish city—present-day Istanbul—that Justinian built his Church of the Holy Wisdom, or Hagia Sophia (Fig. 14-6). It is a fantastic structure that has served at one time or other in its history as an **Eastern Orthodox** church, an Islamic mosque, and a museum. The most striking aspects of Hagia Sophia are its overall dimensions and the size of its dome. Its floor plan is approximately 240 by 270 feet (Constantine's basilica in Rome was 300 by 215 feet). The dome is about 108 feet across and rises almost 180 feet above the church floor (the dome of the Pantheon, by contrast, rose to a mere 144 feet). Thus, its grandiose proportions put Hagia Sophia in the same league with the great architectural monuments of Roman times. To create their dome, the architects Anthemius of Tralles and Isidorus of Miletus used pendentive construction (see Chapter 10). Although massive, the dome appears to be light and graceful due to the placement of a ring of

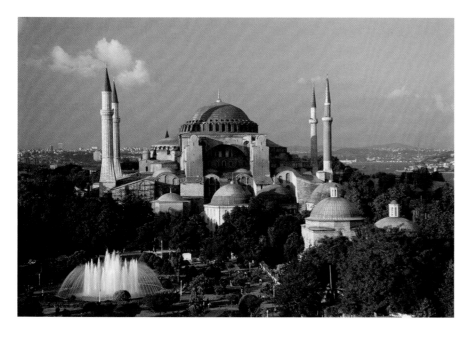

14-6 ANTHEMIUS OF TRALLES AND ISIDORUS OF MILETUS.
Hagia Sophia, Constantinople (modern-day Istanbul), Turkey (532–537 CE).
Exterior view. The four minarets were added following the Ottoman conquest of 1453 when the church was converted to an Islamic mosque.
Richard T. Nowitz/CORBIS.

14-7 St. Mark's, Venice (begun 1063 CE).
Plan and interior view looking toward the apse.
Copyright Topfoto/The Image Works.

arched windows at its base. The light filtering through these windows sometimes gives the impression that the dome is hovering above a ring of light, further emphasizing the building's spaciousness (see Fig. 1-13).

Like most Byzantine churches, the exterior of Hagia Sophia is very plain. The towering **minarets** that grace the corners of the structure are later additions. This plainness contrasts strongly with the interior wall surfaces, which are decorated lavishly with marble inlays and mosaics.

Later Byzantine Art

Byzantine architecture continued to flourish until about the twelfth century, varying between the central and longitudinal plans described earlier. One interesting variation was the **Greek cross plan** used in such buildings as St. Mark's

Cathedral in Venice (Fig. 14-7). In this plan, the "arms" of the cross are equal in length, and the focus of the interior is usually a dome that rises above the intersection of these elements. The long nave of the Latin cross plan is eliminated.

EARLY MEDIEVAL ART

The 1,000 years that span 400 CE and 1400 CE have been called the **Middle Ages** or the "Dark Ages." Some historians consider this millennium a holding pattern between the era of Classical Rome and the rebirth of its art and culture in the Renaissance of the fifteenth century. Some viewed these 1,000 years as a time when the light of Classicism was temporarily extinguished. The negative attitude toward the

Fine craftsmanship is all about you, but you might not notice it. Look more keenly at it and you . . . will make out intricacies, so delicate and subtle, so exact and compact, so full of knots and links, with colors so fresh and vivid, that you might say that all this was the work of an angel, and not of a man.

—Giraldus Cambrensis, c. 1185

people and art of the Middle Ages shifted as awareness of their contributions to economics, religion, scholarship, architecture, and the fine arts has increased. Many works of art from the Early Middle Ages exhibit characteristics similar to those that appear in the small carvings and metalwork of the barbarian tribes who migrated across Eurasia for centuries. An illuminated page from the *Lindisfarne Gospels* (Fig. 14-8) depicts a cross inscribed with incessantly meandering scrolls of many colors. Surrounding the cross are repetitive linear patterns that can be decoded as fantastic snakes consuming themselves. This patterning represents the barbarian obsession with fantastic human–animal forms.

During the barbarian period of migrations, these forms graced many objects—from ship prows to body ornamentation. The same types of forms and patterns that describe the cross page can be seen in a gold plaque from Siberia (Fig. 14-9). It is a highly compact scene of violence and destruction in which an eagle, wolf, tiger, and colt tear at one another to the death. Yet the violent content reads second to a swirl of pleasing lines and patterns. As is often the case in barbarian art, the overall richness and complexity of the design override the content of the work. Such motifs became central to western European decoration during the Early Middle Ages.

14-8 Page from the *Lindisfarne Gospels* (Early Medieval, c. 700 CE).
Illuminated manuscript. 13½″ × 9¾″.
British Library, London. Copyright Heritage Image Partnership (HIP), heritage-images.com.

14-9 Scythian plaque with animal interlace, Altai Mountains, Siberia.
Gold. 5⅛″ × 7¾″.
The State Hermitage Museum, St. Petersburg.

Early Medieval Art **335**

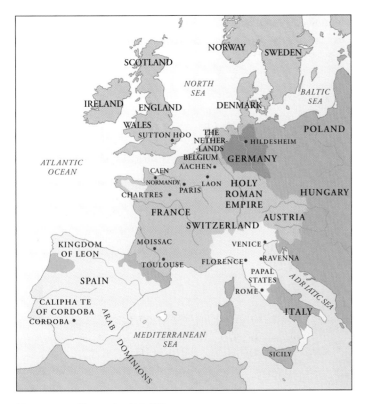

Map 14-1. Europe (c. 800 CE).

14-10 Palatine Chapel of Charlemagne at Aachen
(Carolingian, 792–805 CE). Interior and plan.
Copyright Art Resource, New York.

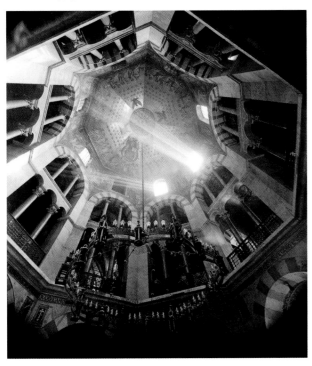

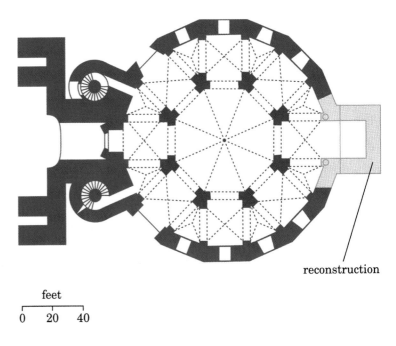

reconstruction

feet
0 20 40

Carolingian Art

The most important name linked to medieval art during the period immediately following the migrations is that of Charlemagne (Charles the Great). This powerful ruler tried to unify the warring factions of Europe under the aegis of Christianity, and modeling his campaign on those of Roman emperors, he succeeded in doing so. In the year 800, Charlemagne was crowned Holy Roman Emperor by the pope, thus establishing a bond among the countries of western Europe that lasted more than a millennium (see Map 14-1).

The period of Charlemagne's supremacy is called the **Carolingian** period. He established his court at Aachen, a western German city on the border of present-day Belgium, and imported the most significant intellectuals and artists of Europe and the Eastern countries.

The Palatine Chapel of Charlemagne

Charlemagne constructed his **Palatine Chapel** (palace chapel) with two architectural styles in mind (Fig. 14-10). He sought to emulate Roman architecture but was probably also influenced by the central plan church of San Vitale, erected under Emperor Justinian. Like San Vitale, the Palatine Chapel is a central plan with an ambulatory and an octagonal dome. However, this is where the similarity ends. The perimeter of Charlemagne's chapel is polygonal, with almost 16 facets instead of San Vitale's 8. There is also greater axial symmetry in the Palatine Chapel due to the logical placement of the narthex.

The interior displays differences from that of San Vitale as well. The semicircular niches that alternated with columns

and pressed into the space of the Ravenna ambulatory have been eliminated at Aachen. There is more definition between the central domed area and the surrounding ambulatory. This clear articulation of parts is a hallmark of Roman design and stands in contrast to the fluid, organic character of some Byzantine architecture. The walls of the Palatine Chapel are divided into three distinct levels, and each level is divided by Roman-inspired archways or series of arches. Classicizing structural elements, decorative motifs, and a general blockiness of form point to the development of Romanesque architecture during the eleventh century. However, even though Charlemagne chose a Classical central plan, the longitudinal plan would be preferred by the later Christian architects.

Manuscript Illumination

Charlemagne's pet project was the decipherment of the true biblical text. Over the years, illiterate scribes with illegible handwriting had gotten the text of the Bible to the point where it was barely decipherable. It was Charlemagne's love of knowledge and pursuit of truth—despite his own illiteracy—that helped keep the flame of scholarship flickering during the Early Middle Ages.

Ottonian Art

Following Charlemagne's death, internal and external strife threatened the existence of the Holy Roman Empire. It was torn apart on several occasions, only to be consolidated time and again under various rulers. The most significant of these were three German emperors, each named Otto, who succeeded one another in what is now called the Ottonian period. In many respects their reigns symbolized an extension of Carolingian ideals, as is evident in the architecture and sculpture of the period.

Architecture

The most important architectural achievement of the Ottonian period was the construction of the abbey church of St. Michael in Hildesheim, Germany (Fig. 14-11).

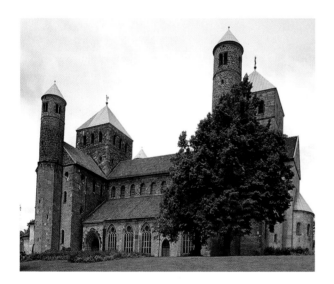

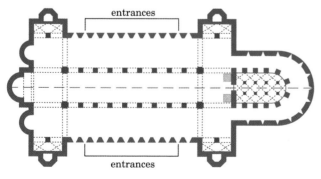

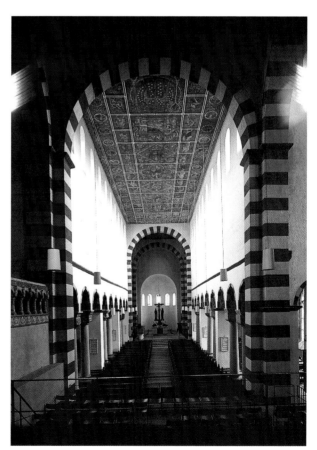

14-11 Abbey Church of St. Michael at Hildesheim, Germany (Ottonian, c. 1001–1031 CE). Restored. Exterior (above); interior (right); and plan (bottom).
Dom-Museum, Hildesheim (Frank Tomio).

14-12 *Adam and Eve Reproached by the Lord*
(Ottonian, 1015 CE).
Panel of bronze doors. 23″ × 43″.
St. Mary's Cathedral, Hildesheim, Germany/
Erich Lessing/Art Resource, New York.

St. Michael's offers us our first glimpse of the modified Roman basilica plan that will serve as a basis for Romanesque architecture.

The abbey church does not retain the propylaeum or atrium of Old St. Peter's, and it uses the lateral entrances of Roman basilicas. But all the other elements of a typical Christian cathedral are present: the narthex, nave, two side aisles, a transept, and a much enlarged apse with an ambulatory. Most significant for the future of Romanesque and Gothic architecture, however, is the use of the **crossing square** to define the spaces within the rest of the church. The crossing square is formed by the intersection of the nave and the transept. In the plan of St. Michael's, for example, the nave consists of three modules that are equal in dimensions to the crossing square and marked off by square pillars. This design is an early example of what is called **square schematism,** in which the crossing square determines the dimensions of the entire structure.

St. Michael's also uses an **alternate support system** in the walls of its nave. In such a system, alternating structural elements (in this case, pillars and columns) bear the weight of the walls and ultimately the load of the ceiling. The alternating elements in St. Michael's read as pillar-column-column-pillar; its alternate support system is then classified as a-b-b-a in terms of repetition of the supporting elements. An alternate support system of one kind or another will be a constant in Romanesque architecture.

As with Old St. Peter's, the exterior of St. Michael's reflects the character of its interior. Nave, side aisles, and other elements of the plan are clearly articulated in the blocky forms of the exterior. The exterior wall surfaces remain unadorned, as were those of the Early Christian and Byzantine churches. However, St. Michael's was the site of the recovery of the art of sculpture, which had not thrived since the fall of Rome.

Sculpture

Adam and Eve Reproached by the Lord (Fig. 14-12), a panel from the bronze doors of St. Mary's Cathedral in Hildesheim (originally commissioned for the Monastery of St. Michael by Bishop Bernward in the eleventh century), represents the first sculpture cast in one piece during the Middle Ages. It closely resembles the manuscript illumination of the period and in mood and style is similar to the Matthew page of the Archbishop Ebbo gospels. It, too, is an emotionally charged work, in which God points his finger accusingly at the pathetic figures of Adam and Eve. They, in turn, try to deflect the blame; Adam points to Eve and Eve gestures toward Satan, who is in the guise of a fantastic dragonlike animal crouched on the ground. These are not Classical figures who bear themselves proudly under stress. Rather, they are pitiful, wasted images that cower and frantically try to escape punishment. In this work, as well as in that of the Romanesque period, God is shown as a merciless judge, and human beings as quivering creatures who must beware of God's wrath.

ROMANESQUE ART

The Romanesque style appeared in the closing decades of the eleventh century among rampant changes in all aspects of European life. Dynasties, such as those of the Carolingian and Ottonian periods, no longer existed. Individual monar-

[After the] year of the millennium, which is now about three years past, there occurred throughout the world, especially in Italy and Gaul, a rebuilding of church basilicas. . . . [Each] Christian people strove against the others to erect nobler ones. It was as if the whole earth, having cast off the old by shaking itself, were clothing itself everywhere in the white robe of the church.

—Raoul Glaber, c. 1003

chies ruled areas of Europe, rivaling one another for land and power. After the barbarians stopped invading and started settling, feudalism began to structure Europe, with monarchies at the head.

Feudalism was not the only force in medieval life of the Romanesque period. Monasticism also gained in importance. The monasteries were still the only places for decent education and had the added attraction of providing guarantees for eternal salvation. Salvation from the fires of hell in the afterlife was a great preoccupation of the Middle Ages and served as the common denominator among classes. Nobility, clergy, and peasantry all directed their spiritual efforts toward this goal.

Two phenomena reflect the medieval obsession with salvation in the afterlife: the Crusades and the great pilgrimages. The Crusades were holy wars waged in an effort to recover the Holy Land from the Muslims, who had taken it over in the seventh century. The pilgrimages were lengthy journeys to visit and worship at sacred shrines or the tombs of saints. Participating in the Crusades and making pilgrimages were seen as weights that would help tip the scale in one's favor on Judgment Day.

The pilgrims' need of a grand place to worship at journey's end gave impetus to church construction during the Romanesque period.

Architecture

In the Romanesque cathedral, there is a clear articulation of parts, with the exterior forms reflecting the interior spaces. The interiors consist of five major areas, with variations on this basic plan evident in different regions of Europe. We can add two Romanesque criteria to this basic format: spaciousness and fireproofing. The large crowds drawn by the pilgrimage fever required larger structures with interior spaces that would not restrict the flow of movement. After barbarian attacks left churches in flames, it was also deemed necessary to fireproof the buildings by eliminating wooden roofs and covering the structures with cut stone.

St. Sernin

The church of St. Sernin (Fig. 14-13) in Toulouse, France, fitted all the requirements of a Romanesque cathedral. An aerial view of the exterior shows the blocky forms that out-

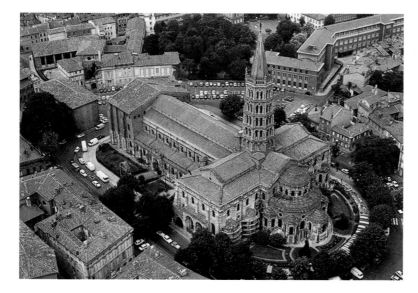

14-13 Church of St. Sernin, Toulouse, France (Romanesque, c. 1080–1120 CE).
Copyright Jean Dieuzaide.

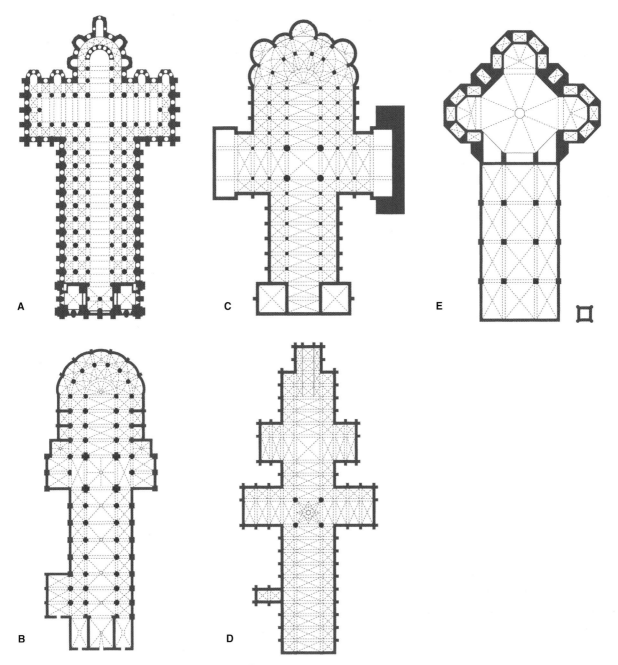

14-14 Basic differences among cathedral plans of the Romanesque and Gothic periods.

Copyright Lois Fichner-Rathus.

line a nave, side aisles, narthex to the west, a prominent transept crowned by a multilevel spire above the crossing square, and an apse at the eastern end from whose ambulatory extend five **radiating chapels.** If you follow the outer aisle up from the narthex in the plan of St. Sernin (Fig. 14-14A), you notice that it continues around the outer borders of the transept arm and runs into the ambulatory around the apse. Along the eastern face of the transept, and around the ambulatory, there is a series of chapels that radiate, or extend, from the aisle. These spaces provided extra room for the crowds of pilgrims and offered free movement around the church, preventing interference with worship in the nave or the celebration of Mass in the apse. Square schematism has been employed in this plan; each rectangular bay mea-

sures one-half of the crossing square, and the dimensions of each square in the side aisles measures one-fourth of the main module.

In St. Sernin, the shift was made from a flat wood ceiling characteristic of the Roman basilica to a stone vault that met the requirement for fireproofing. The ceiling structure, called a barrel vault, resembles a semicircular barrel punctuated by arches that spring from engaged columns in the nave to define each bay. The massive weight of the vault is partially supported by the nave walls and partially by the side aisles that accept a share of the downward thrust. This is somewhat alleviated by the **tribune gallery,** which, in effect, reduces the drop-off from the barrel vault to the lower side aisles. The tribune gallery also provided extra space for the masses of worshipers.

Because the barrel vault rests directly atop the tribune gallery, and because fenestration would weaken the structure of the vault, there is little light in the interior of the cathedral. Lack of light was considered a major problem, and solving it would be the primary concern of future Romanesque architects. The history of Romanesque architecture can be written as the history of vaulting techniques, and the need for light provided the incentive for their development.

St. Étienne

The builders of the cathedral of St. Étienne in Normandy contributed significantly to the future of Romanesque and Gothic architecture in their design of its ceiling vault (Fig. 14-14B). Instead of using a barrel vault that tunnels its way from narthex to apse, they divided the nave of St. Étienne into four distinct modules that reflect the shape of the crossing square. Each of these modules in turn is divided into six parts by ribs that spring from engaged columns and **compound piers** in the nave walls. Some of these ribs connect the midpoints of opposing sides of the squares; they are called **transverse ribs.** Other ribs intersect the space of the module diagonally, as seen in the plan; these are called **diagonal ribs.** An **alternate a-b-a-b support system** is used, with every other engaged column sending up a supporting rib that crosses the vault as a transverse arch. These engaged columns are distinguished from other nonsupporting members by their attachment to pilasters. The vault of St. Étienne is one of the first true rib vaults in that the combination of diagonal and transverse ribs functions as a skeleton that bears some of the weight of the ceiling. In later buildings the role of ribs as support elements will be increased, and reliance on the massiveness of nave walls will be somewhat decreased.

Even though the nave walls of St. Étienne are still quite thick when compared with those of later Romanesque churches, the interior has a sense of lightness that does not exist in St. Sernin. The development of the rib vault made it possible to pierce the walls directly above the tribune gallery with windows. This series of windows that appears cut into the slightly domed modules of the ceiling is called a **clerestory.** The clerestory became a standard element of the Gothic cathedral plan.

The facade of St. Étienne (Fig. 14-15) also served as a model for Gothic architecture. It is divided vertically into

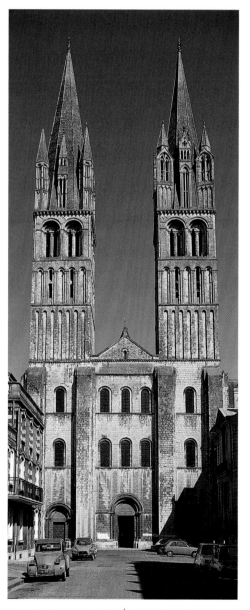

14-15 Cathedral of St. Étienne, Caen, France (Romanesque, 1067–1087 CE).
Copyright John Elk III.

three sections by thick buttresses, reflecting the nave and side aisles of the interior, and horizontally into three bands, pierced by portals on the entrance floor and arched windows on the upper levels. Two bell towers complete the facade, each of which is also divided into three parts (the spires were later additions). This two-tower, tripartite facade appeared again and again in Gothic structures, although the walls were pierced by more carving and fenestration, lending a lighter look. Yet the symmetry and predictability of the St. Étienne design was maintained.

Sculpture

Although we occasionally find freestanding sculpture from the Romanesque and Gothic periods, it was far more common for sculpture to be restricted to architectural decoration around the portals. Some of the most important and elaborate sculptural decoration is found in the cathedral **tympanum**—a semicircular space above the doors to a cathedral—such as that of the cathedral at Autun in Burgundy (Fig. 14-16). The tympanum was an important site for relief carvings because people who entered the church could not help seeing them. When the tympanum of the cathedral at Autun was sculpted, the opportunity was seized to warn the people that their earthly behavior would be judged harshly. The scene depicted is that of the Last Judgment. The tympanum rests on a lintel carved with small figures representing the dead. The archangel Michael stands in the center, dividing the horizontal band of figures into two groups. The naked dead on the left gaze upward, hopeful of achieving eternal reward in heaven, whereas those to the right look downward in despair. Above the lintel, Jesus is depicted as an evenhanded judge, overseeing the process of selection. To his left, tall, thin figures representing the apostles observe the scene while some angels lift bodies into heaven. To Jesus' right, by contrast, is a gruesome event. The dead are snatched up from their graves, and their souls are being weighed on a scale by an angel on the left and a devil-serpent on the right. The devil cheats by adding a little weight, and some of his companions stand ready to grab the souls and fling them into hell.

As in the bronze doors of St. Michael's, humankind is shown as a pitiful, defenseless race, no match for the wiles of Satan. The figures crouch in terror of their surroundings, in strong contrast to the serenity of their impartial judge.

The Romanesque sculptor sought stylistic inspiration in Roman works, the small carvings of the pre-Romanesque era, and especially manuscript illumination. In the early phase of Romanesque art, naturalism was of no concern. The artist turned to art rather than to nature for models, and thus his forms are at least twice, and perhaps 100 times, removed from the original source. It is no wonder, then, that they appear as dolls or marionettes. The figure of Jesus is squashed within a large oval, and his limbs bend in sharp angles in order to fit. Although his drapery seems to correspond to the body beneath, the folds are reduced to stylized patterns of concentric arcs that play across a relatively flat surface. Realism is not the goal. The sculptor is merely trying to convey his frightful message with the details and emotionalism that will have the most dramatic impact on the observing worshiper or penitent sinner.

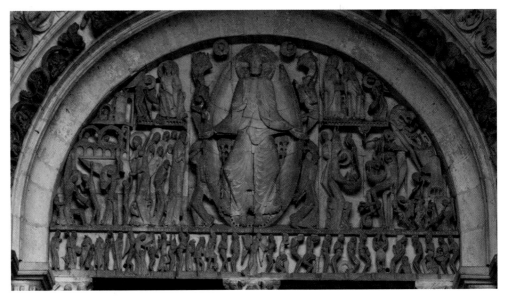

14–16 Cathedral of Saint-Lazare, Autun. West portal. Detail of Last Judgment tympanum, *Weighing of Souls.*
Copyright Archivio Iconografico, S.A./CORBIS.

14-17 *The Annunciation to the Shepherds,* from the *Lectionary of Henry II* (1002–1014 CE). Approx. 17″ × 13″.
Bayerische Staatsbibliothek, Munich.

turn, are portrayed as unnaturally large in relation to the animals. The animals along the bottom edge of the picture stand little more than ankle high. The use of hierarchical scaling implies that humans are less significant than celestial beings and that animals are lower than humans. The symbols in the scene take precedence over truth; reality fades in their wake.

Toward the end of the Romanesque period, artists paid more attention to their surroundings, and there was a significant increase in naturalism. The drapery falls softly rather than in sharp angles, and the body begins to acquire more substance. The gestures are less frantic, and a balance between emotion and restraint begins to reappear. These elements reached their peak of perfection during the Gothic period and pointed to a full-scale revival of Classicism during the Renaissance of the fifteenth century.

Manuscript Illumination

The relationship between Romanesque sculpture and manuscript **illumination** can be seen in *The Annunciation to the Shepherds* (Fig. 14-17), a page from *The Lectionary of Henry II.* As with the figure of Jesus in the Autun tympanum, the long and gangling limbs of the figures join their torsos at odd angles. Drapery falls at harsh, unnatural angles. Sent by God, the angel Gabriel alights on a hilltop to announce the birth of the Christ-child to shepherds tending their flocks. The angel towers over the rocky mound and appears to be almost twice the size of the shepherds. The shepherds, in

Tapestry

Although the tasks of copying sacred texts and illuminating their margins with decorative patterns, symbols, and thumbnail sketches were sometimes given to women, the art form remained primarily a male preserve. Not so with the medium of tapestry. In the Middle Ages, weaving and embroidery were taught to women of all social classes and walks of life. Noblewomen and nuns would find themselves weaving and decorating elaborate tapestries, clothing, and liturgical vestments, using the finest linens, wools, gold and silver thread, pearls, and other gems.

Perhaps the most famous surviving tapestry, the *Bayeux Tapestry* (Fig. 14-18), was almost certainly created by a team of women at the commission of Odo, the bishop of Bayeux. The tapestry describes the invasion of England by William

14-18 *Bayeux Tapestry* (Romanesque, c. 1073–1083 CE). Detail. Wool embroidery on linen. H: 20″; L: 230′.
Musée de la Tapisserie, Bayeux, France. Copyright Edimedia/Corbis.

Hildegard of Bingen

During the Middle Ages, the production and illustration of sacred books took place, for the most part, in the monastery and the abbey, with the greatest percentage of scribes and painters being men. Yet some upper-class women looking for an alternative to marriage and eager to follow these and other intellectual and aesthetic pursuits entered the contemplative life of the nunnery.

One such woman was the German abbess Hildegard of Bingen (1098–1179). Hildegard was a mystic whose visions of otherworldly phenomena began during childhood and led to a life of scholarship elucidating her extraordinary experiences. She wrote books on medicine and history, composed music, debated political and religious issues, and designed illustrations to accompany written records of her visions. Hildegard also devised a secret language. Her most valuable work is the *Liber Scivias,* a text built around images of light and darkness. Sun, stars, moon, and flaming orbs struggle against dragons, demons, and other denizens of darkness.

Figure 14-19 is a twelfth-century copy of Hildegard's *Vision of the Ball of Fire,* an illustration no doubt designed by the abbess and most likely executed by her nuns. An elaborately patterned orb floats in the center of a simpler rectangular frame. Its central symbols are surrounded by a field of star-flowers spreading outward toward a wreath of flames. Here and there one can spot demons spewing forth fire. The neatness of the execution bears similarity to the fine needlepoint and embroidery techniques characteristic of medieval tapestries. Here follows Hildegard's vision on which the painting was based:

> Then I saw a huge image, round and shadowy. It was pointed at the top, like an egg. . . . Its outermost layer was of bright fire. Within lay a dark membrane. Suspended in the bright flames was a burning ball of fire, so large that the entire image received its light. Three more lights burned in a row above it. They gave it support through their glow, so that the light would never be extinguished. ■

14-19 HILDEGARD OF BINGEN.
Vision of the Ball of Fire.
Illumination from the *Liber Scivias*
(12th century CE).
Rupertberg, Germany (original destroyed).

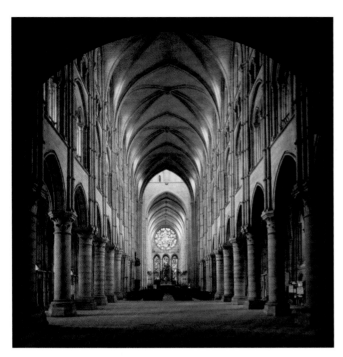

14-20 Interior of Laon Cathedral, view facing east (begun c. 1190 CE).

Copyright Ruggero Vanni/Corbis.

14-21 Exterior of Laon Cathedral, west facade (begun c. 1190 CE).

Copyright Angelo Hornak/Corbis.

the Conqueror in a continuous narrative. Although the tapestry is less than 2 feet in height, it originally measured in excess of 230 running feet and was meant to run clockwise around the entire nave of the Cathedral of Bayeux. In this way, the narrative functioned much in the same way as the continuous narrative of the Ionic frieze of the Parthenon.

GOTHIC ART

Art and architecture of the twelfth and thirteenth centuries is called Gothic. The term *Gothic* originated among historians who believed that the Goths were responsible for the style of this period. Because critics believed that the Gothic style only further buried the light of Classicism, and because the Goths were "barbarians," "Gothic" was used in a disparaging sense. For many years, the most positive criticism of Gothic art was that it was a step forward from the Romanesque. Today such views have been abandoned. "Gothic" is no longer a term of derision, and the Romanesque and Gothic styles are seen as distinct and as responsive to the unique tempers of their times.

Architecture

In the history of art it is rare indeed to be able to trace the development of a particular style to a single work, or the beginning of a movement to a specific date. However, it is generally agreed that the Gothic style of architecture began in 1140 with the construction of the choir of the church of St. Denis near Paris. The vaults of the choir consisted of weight-bearing ribs that formed the skeleton of the ceiling structure. The spaces between the ribs were then filled in with cut stone. At St. Denis the pointed arch is used in the structural skeleton rather than the rounded arches of the Romanesque style. This vault construction also permitted the use of larger areas of stained glass, dissolving the massiveness of the Romanesque wall.

Laon Cathedral

Although Laon Cathedral is considered an Early Gothic building, its plan resembles those of Romanesque churches. For example, the ceiling is a sexpartite rib vault supported by groups of columns in an alternate a-b-a-b rhythm (Fig. 14-20). Yet there were important innovations at Laon. The interior displays a change in wall elevation from three to four levels. A series of arches, or **triforium,** was added above the tribune gallery to pierce further the solid surfaces of the nave walls. The obsession with reducing the appearance of heaviness in the walls can also be seen on the exterior (Fig. 14-21). If we compare the facade of St. Étienne

with that of Laon, we see a change from a massive, fortress-like appearance to one that seems plastic and organic. The facade of Laon Cathedral is divided into three levels, although there is less distinction between them. The portals seem to jut forward from the plane of the facade, providing a tunnel-like entrance. The stone is pierced by arched windows, arcades, and a large **rose window** in the center, and the twin bell towers seem to be constructed of voids rather than solids.

As the Gothic period progressed, all efforts were directed toward the dissolution of stone surfaces. The walls were pierced by greater expanses of glass, nave elevations became higher, and carved details became lacier. There was a mystical quality to these buildings in their seeming exemption from the laws of gravity.

Notre-Dame

One of the most famous buildings in the history of architecture is the Cathedral of Notre-Dame de Paris (Fig. 14-22). Perched on the banks of the Seine, it has enchanted visitors ever since its construction. Notre-Dame is a curious mixture of old and new elements. It retains a sexpartite rib vault and was originally planned to have an Early Gothic four-level wall elevation. It was begun in 1163 and was not completed until almost a century later, undergoing extensive modifications between 1225 and 1250. Some of these changes reflected the development of the High Gothic style, including the elimination of the triforium and the use of flying buttresses to support the nave walls. The exterior of the building also communicates this combination of early and late styles. Although the facade is far more massive than that of Laon Cathedral, the north and south elevations look light and airy due to their fenestration and the lacy buttressing.

14-22 Cathedral of Notre-Dame de Paris (Gothic, begun 1163 CE, completed 1250 CE).
Copyright Topfoto/The Image Works.

Chartres Cathedral

Chartres Cathedral is generally considered to be the first High Gothic church. Unlike Notre-Dame, Chartres was planned to have a three-level wall elevation and flying buttresses. The three-part wall structure allowed for larger windows in the clerestory, admitting more light into the interior (Fig. 14-23). The use of large windows in the clerestory was in turn made possible by the development of the flying buttress.

14-23 Aerial view from the northwest of Chartres Cathedral, Chartres, France (begun 1134 CE, rebuilt after 1194 CE).
Copyright Marc Garanger/Corbis.

In the High Gothic period there is a change from square schematism to a **rectangular bay system** (Fig. 14-14C). In the latter, each rectangular bay has its own cross rib vault, and only one side aisle square flanks each rectangular bay. Thus, the need for an alternate support system is also eliminated. The interior of a High Gothic cathedral presents several dramatic vistas. There is a continuous sweep of space from the narthex to the apse along a nave that is uninterrupted by alternating supports. There is also a strong vertical thrust from floor to vaults that is enhanced by the elimination of the triforium and the increased heights of the arches in the nave arcade and clerestory windows. The solid wall surfaces are further dissolved by quantities of stained glass that flood the interior with a mysterious, soft light. The architects directed all of their efforts to creating a spiritual escape to another world. They did so by defying the properties of matter, by creating the illusion of weightlessness in stone, and by capitalizing on the mesmerizing aspects of colored streams of light.

Gothic Architecture outside France

The cathedral architecture that we have examined thus far was constructed in France, where the Gothic style flourished. Variations on the French Gothic style can also be perceived elsewhere in northern Europe, although in some English and German structures the general "blockiness" of Romanesque architecture was maintained. The plan of Salisbury Cathedral (Fig. 14-14D) in England illustrates some differences between English and French architecture of the Gothic period, as seen in the double transept and the unique square apse. The profile of Salisbury Cathedral also differs from that of a French church in that the bell towers on the western end are level with the rest of the facade, and a tall tower rises above the crossing square. Still, the remaining characteristics of the cathedral, including the rectangular bay system, bear close relationship to the French Gothic style.

In Italy, on the other hand, there was no strict adherence to the French style, as is seen in the Florence Cathedral (Fig. 14-24). The most striking features of its exterior are

14-24 Florence Cathedral (Gothic, begun 1368 CE).
Copyright Art Resource, New York.

the sharp, geometric patterns of green and white marble incrustation and the horizontality, or earthbound quality. These contrast with the vertical lines of the French Gothic cathedral that seem to reach for heaven. The French were obsessed with the visual disintegration of massive stone walls. The Italians, on the other hand, preserved the **mural quality** of the structure. In the cathedral of Florence, there are no flying buttresses. The wall elevation has been reduced to two levels, with a minimum of fenestration.

The Florence Cathedral is also different in plan (Fig. 14-14E) from French cathedrals. A huge octagonal dome overrides the structure. The nave, which seems like an afterthought, consists of four large and clearly defined modules, flanked by rectangular bays in the side aisles. Finally, there is only one bell tower in the Italian cathedral, and it is detached from the facade.

Why would this Italian Gothic cathedral differ so markedly from those of the French? Given its strong roots in Classical Rome, it may be that Italy never succumbed wholeheartedly to Gothicism. It is perhaps for this reason that Italy will be the birthplace of the revival of Classicism during the Renaissance. We shall discuss the Florence Cathedral further in Chapter 15, because the designer of its dome was one of the principal architects of the Renaissance.

Sculpture

Sculpture during the Gothic period exhibits a great change in mood from that of the Romanesque. The iconography is one of redemption rather than damnation. The horrible scenes of Judgment Day that threatened the worshiper upon entering the cathedral were replaced by scenes from the life of Jesus or visions of the **apocalypse.** The Virgin Mary also assumed a primary role. Carved tympanums, whole sculptural programs, even cathedrals themselves (for example, Notre-Dame, which means "Our Lady") were dedicated to her.

Gothic sculpture is still pretty much confined to decoration of cathedral portals. Every square inch of the tympanums, lintels, and **archivolts** of most Gothic cathedrals is carved with a dazzling array of figures and ornamental motifs. However, some of the most advanced full-scale sculpture is to be found adorning the **jambs.** Early Gothic jamb figures, such as those found around the portals of Chartres

14-25 Jamb figures, west portals, Chartres Cathedral (Gothic, c. 1140–1150 CE).

Copyright Scala/Art Resource, New York.

Cathedral (Fig. 14-25; Chartres was rebuilt in the High Gothic style after a fire, but the portal sculpture remained intact), are rigid in their poses, confined by the columns to which they are attached. The drapery falls in predictable folds, at times stylized into patterns reminiscent of manuscript illumination. Yet there is a certain weightiness to the bodies and the elimination of the "hinged" treatment of the limbs that heralds changes from the sculpture of the Romanesque period. During the High Gothic period, these simple elements led to a naturalism that we have not witnessed since Classical times.

The jamb figures of Reims Cathedral (Fig. 14-26) exhibit an interesting combination of styles. No doubt the individual figures were carved by different artists. The detail of the central portal of the facade illustrates two groups of figures. To the left is an **Annunciation** scene with the angel Gabriel and the Virgin Mary, and to the right is a **Visitation**

14-26　Jamb figures, west portals, Reims Cathedral (Gothic, begun 1210 CE).
Copyright Art Resource, New York.

scene depicting the Virgin Mary and Saint Elizabeth. All the figures are detached from columns and instead occupy the spaces between them. Although they have been carved for these specific niches and are perched on small pedestals, they have a freedom of movement not found in the figures of the Chartres jambs.

The Virgin Mary of the Annunciation group is the least advanced in technique of the four figures. Her stance is the most rigid, and her gestures and facial expression are the most stylized. Yet her body has substance, and anatomical details are revealed beneath a drapery that responds realistically to the movement of the limbs.

The figure of Gabriel contrasts strongly in style with that of the Virgin Mary. He seems relatively tall and lanky. His head is small and delicate, and his facial features are refined. His body has a subtle sway that is accented by the flowing lines of his drapery. Stateliness and sweetness characterize this courtly style; it will be carried forward into the Early Renaissance period in the **International Gothic style.**

Yet Classicism will be the major style of the Renaissance, and in the Visitation group of the Reims portals we have a fascinating introduction to it. The weighty figures of Mary and Elizabeth are placed in a **contrapposto** stance. The folds of drapery articulate the movement of the bodies beneath with a realism that we have not seen since Classical times. Even the facial features and hairstyles are reminiscent of Greek and Roman sculpture. Although we have linked the reappearance of naturalism to the Gothic artist's increased awareness of nature, we must speculate that the sculptor of the Visitation group was looking directly to Classical statues for inspiration. The similarities are too strong to be coincidental. With his small and isolated attempt to revive Classicism, this unknown artist stands as a transitional figure between the spiritualism of the medieval world and the rationalism of the Renaissance.

THE RENAISSANCE

*The fundamental principle will be that all steps of learning should be sought
from Nature; the means of perfecting our art will be found
in diligence, study, and application.*

—Leone Battista Alberti

While Columbus was coasting along the shores of the New World in 1492, a 17-year-old Michelangelo Buonarroti was perfecting his craft of chiseling human features from blocks of marble. In 1564, the year that Shakespeare was born, Michelangelo died.

These are but two of the marker dates of the **Renaissance.** *Renaissance* is a French word meaning "rebirth," and the Renaissance in Europe was a period of significant historical, social, and economic events. The old feudal system that had organized Europe during the Middle Ages fell to a system of government based on independent city-states with powerful kings and princes at their helms. The economic face of Europe changed, aided by an expansion of trade and commerce with Eastern countries. The cultural base of Europe shifted from Gothic France to Italy. A plague wiped out the populations of entire cities in Europe and Asia. Speculation on the world beyond, which had so preoccupied the medieval mind, was abandoned in favor of scientific observation of the world at hand. Although Copernicus

proclaimed that the sun and not Earth was at the center of the solar system, humanity, and not heaven, became the center of all things.

THE RENAISSANCE

The Renaissance spans roughly the fourteenth through the sixteenth centuries and is seen by some as the beginning of modern history. During this period we witness a revival of Classical themes in art and literature, a return to the realistic depiction of nature through keen observation, and the revitalization of the Greek philosophy of humanism, in which human dignity, ideas, and capabilities are of central importance.

Although we can speak of a Renaissance period in England, France, and Spain, the two most significant areas of Europe for the arts were Italy in the south, and Flanders (present-day Belgium and the Netherlands) in the north (see Map 15-1). Given its Classical roots, Italy never quite succumbed to Gothicism and readily introduced elements of Greek and Roman art into its works. But Flanders was steeped in the medieval tradition of northern Europe and continued to concern itself with the spiritualism of the Gothic era, enriching it with a supreme realism. The difference in attitudes was summed up during the later Renaissance years by one of Italy's great artists, Michelangelo Buonarroti, not entirely without prejudice:

> Flemish painting will, generally speaking, please the devout better than any painting in Italy, which will never cause him to shed a tear, whereas that of Flanders will cause him to shed many. . . . In Flanders they paint with a view to external exactness or such things as may cheer you and of which you cannot speak ill, as for example saints and prophets. They paint stuffs and masonry, the green grass of the fields, the shadows of trees, and rivers and bridges.[1]

Thus, the subject matter of northern artists remained more consistently religious, although their manner of representation was that of an exact, trompe l'oeil rendition of things of this world. They used the "trick-the-eye" technique to portray mystical religious phenomena in a realistic manner. The exactness of representation of which Michelangelo spoke originated in **manuscript illumination,** where complicated imagery was reduced to a minute scale. Because this imagery illustrated the writings, it was often laden with symbolic meaning. Symbolism was carried forth into **panel paintings,** where iconography was fused with a keen observation of nature.

FIFTEENTH-CENTURY NORTHERN PAINTING

Flemish Painting: From Page to Panel

A certain degree of naturalism appeared in the work of the northern book illustrator during the Gothic period. The manuscript illuminator *illuminated* literary passages with visual imagery. As the art of manuscript illumination progressed, these thumbnail sketches were enlarged to fill

[1] Robert Goldwater and Marco Treves, eds., *Artists on Art* (New York: Pantheon Books, 1972), 68.

Map 15-1 Renaissance Europe (c. 16th century).

greater portions of the manuscript page, eventually covering it entirely. As the text pages became less able to contain this imagery, the northern Renaissance artist shifted to painting in tempera on wood panels.

The Limbourg Brothers

One of the most dazzling texts available to illustrate this transfer from minute to more substantial imagery is *Les Très Riches Heures du Duc de Berry,* a Book of Hours illustrated by the Limbourg brothers (born after 1385, died by 1416) during the opening decades of the fifteenth century. Books of Hours were used by nobility as prayer books and included psalms and litanies to a variety of saints. As did most Books of Hours, *Les Très Riches Heures* contained calendar pages that illustrated domestic tasks and social events of the 12 months of the year. In "May" (Fig. 15-1), one of the calendar pages, we witness a parade of aristocratic gentlemen and ladies who have come in their bejeweled costumes of pastel hues to celebrate the first day of May. Complete with glittering regalia and festive song, the entourage romps through a woodland clearing on carousel-like horses. In the background looms a spectacular castle complex, the chateau of Riom. The calendar pages of *Les Très Riches Heures* are rendered in the **International style,** a manner of painting common throughout Europe during the late fourteenth and early fifteenth centuries. This style is characterized by ornate costumes embellished with gold leaf and by subject matter literally fit for a king, including courtly scenes and splendid processions. The refinement of technique and attention to detail in these calendar pages recall earlier manuscript illumination. These qualities, and a keen observation of the human response to the environment—or in this case the merrymaking—bring to mind Michelangelo's assessment of northern painting as obsessed with representation of the real world through the painstaking rendition of its everyday objects and occurrences.

Although these calendar pages illustrated a holy book, the themes were secular. Renaissance artists tried to reconcile religious subjects with scenes and objects from everyday life, and northern artists accomplished this by using symbolism. Artists would populate ordinary interiors with objects that might bear some spiritual significance. Many, if not most, of the commonplace items might be invested with a special religious meaning. You might ask how you, the ca-

15-1 LIMBOURG BROTHERS.
"May" from *Les Très Riches Heures du Duc de Berry* (1416).
Illumination. $8\frac{7}{8}'' \times 5\frac{3}{8}''$.
Musée Conde, Chantilly, France. Copyright Art Resource, New York.

sual observer, are supposed to decipher the cryptic meaning lurking behind an ordinary kettle. Chances are that you would be unable to do so without a specialized background. Yet you can enjoy the warm feeling of being invited into someone's home when you look at a northern Renaissance interior and be all the more enriched by the knowledge that there really is something more there than meets the eye.

All [Flemish] life was saturated with religion to such an extent that the people were in constant danger of losing sight of the distinction between things spiritual and things temporal.

—Johan Huizinga

Robert Campin, the Master of Flémalle

Attention to detail and the use of commonplace settings were carried forward in the soberly realistic religious figures painted by Robert Campin, the Master of Flémalle (c. 1378–1444). His *Merode Altarpiece* (Fig. 15-2) is a triptych whose three panels, from left to right, contain the kneeling donors of the altarpiece; an Annunciation scene with the Virgin Mary and the angel Gabriel; and Joseph, the foster father of Jesus, at work in his carpentry shop. The architectural setting is a typical contemporary Flemish dwelling. The donors kneel by the doorstep in a garden thick with grass and wildflowers, each of which has special symbolic significance regarding the Virgin Mary. Although the door is ajar, it is not clear whether they are witnessing the event inside or whether Campin has used the open door as a compositional device to lead the spectator's eye into the central panel of the triptych.

In any event, we are visually and psychologically coaxed into viewing this most atypical Annunciation. Mary is depicted as a prim and proper middle-class Flemish woman surrounded by the trappings of a typical Flemish household, all rendered in exacting detail. Just as the closed outdoor garden symbolizes the holiness and purity of the Virgin Mary, the items within also possess symbolic meaning. For example, the bronze kettle hanging in the Gothic niche on the back wall symbolizes the Virgin's body—it will be the immaculate container of the redeemer of the Christian world. More obvious symbols of her purity include the spotless room and the vase of lilies on the table. In the upper left corner of the central panel a small child can be seen, bearing

15-2 ROBERT CAMPIN.
Merode Altarpiece: The Annunciation with Donors and St. Joseph (c. 1425–1428).
Oil on wood. Center: 24¼″ × 24⅞″; Wings: each 25⅜″ × 10⅞″.
The Metropolitan Museum of Art, The Cloisters, New York. Purchase, 1956 (56.70). Copyright 1996 The Metropolitan Museum of Art, New York.

a cross and riding streams of "divine light." The wooden table situated between Mary and Gabriel and the room divider between Mary and Joseph guarantee that the light accomplished the deed. Typically, Joseph is shown as a man too old to have been the biological father of Jesus, although Campin's depiction does not quite follow this tradition. He is gray, but by no means ancient. Jesus' earthly father is busy preparing mousetraps—one on the table and one on the windowsill—commonplace objects that symbolize the belief that Christ was the bait with which Satan would be trapped.

The symbolism in the altarpiece presents a fascinating web for the observer to untangle and interpret. Yet it does not overpower the hard-core realism of the ordinary people and objects. With the exceptions of the slight inconsistency of size and the tilting of planes toward the viewer, Campin offers us a continuous realism that sweeps the three panels. There is no distinction between saintly and common folk; the facial types of the heavenly beings are as individual as the portraits of the donors. Although fifteenth-century viewers would have been aware of the symbolism and the sacredness of the event, they would have also been permitted to become "a part" of the scene, so to speak, and to react to it as if the people in the painting were their peers and just happened to find themselves in extraordinary circumstances.

Jan van Eyck

We might say that Campin "humanized" his Mary and Joseph in the *Merode Altarpiece.* As religious subjects became more secular in nature and the figures themselves became rendered as "human," an interest in ordinary, secular subject matter sprang up. During the fifteenth century in northern Europe we have the development of what is known as **genre painting,** painting that depicts ordinary people engaged in run-of-the-mill activities. These paintings make little or no reference to religion; they exist almost as art for art's sake. Yet they are no less devoid of symbolism.

Giovanni Arnolfini and His Bride (Fig. 15-3) was executed by one of the most prominent and significant Flemish painters of the fifteenth century, Jan van Eyck (c. 1395–1441). This unique double portrait was commissioned by an Italian businessman working in Bruges to serve as a kind of marriage contract, or record of the couple's taking of marriage vows in the presence of two witnesses. The significance of such a document—in this case a visual one—is emphasized by the art historian Erwin Panofsky: According to Catholic dogma, the sacrament of matrimony is "immediately accomplished by the mutual consent of the persons to be married when this consent is expressed by words and actions" in the presence of two or three witnesses. Records

15-3 JAN VAN EYCK.
Giovanni Arnolfini and His Bride (1434).
Oil on wood. 33″ × 22½″.
Reproduced by Courtesy of the Trustees, The National Gallery, London. Copyright Edimedia/Corbis.

of the marriage were necessary to avoid lawsuits in which "the validity of the marriage could be neither proved nor disproved for want of reliable witnesses."[2]

Once again we see the northern artist's striking realism and fidelity to detail offering us exact records of the facial features of the wedding couple. The figures of the two witnesses are reflected in the convex mirror behind the Arnolfinis. Believe it or not, they are Jan van Eyck and his wife, a fact corroborated by the inscription above the mirror: "Jan van Eyck was here." As in most Flemish paintings, the items scattered about are invested with symbolism relevant to the occasion. The furry dog in the foreground symbolizes fidelity, and the oranges on the windowsill may symbolize victory over death. Giovanni himself has kicked off his shoes out of respect for the holiness of the ground on which this sacrament takes place. Finally, the finial on the bedpost is an

[2] Erwin Panofsky, "Jan van Eyck's 'Arnolfini' Portrait," *Burlington Magazine* 64 (1934): 117–27.

image of St. Margaret, the patroness of childbirth, and around her wooden waist is slung a small whisk broom, a symbol of domesticity. It would seem that Giovanni had his bride's career all mapped out. With Jan van Eyck, Flemish painting reached the height of symbolic realism in both religious and secular subject matter. No one ever quite followed in his footsteps.

German Art

Northern Renaissance painting is not confined to the region of Flanders, and indeed, some of the most emotionally striking work of this period was created by German artists. Their work contains less symbolism and less detail than that of Flemish artists, but their message is often more powerful.

Matthias Grünewald

These characteristics of German Renaissance art can clearly be seen in the *Isenheim Altarpiece* (Fig. 15-4) by Matthias Grünewald (c. 1480–1528), painted more than three-quar-

15-4 MATTHIAS GRÜNEWALD.
The Crucifixion, center panel of *The Isenheim Altarpiece* (exterior) (completed 1515).
Oil on panel. 8'10" × 10'1".
Musée d'Unterlinden, Colmar, France. Copyright Edimedia/Corbis.

ters of a century after Jan van Eyck's Arnolfini portrait. The central panel of the German altarpiece is occupied by a tormented representation of the Crucifixion, one of the most dramatic in the history of art. The dead Christ is flanked by his mother, Mary, the apostle John, and Mary Magdalene to the left, and John the Baptist and a sacrificial lamb to the right. These figures exhibit a bodily tension in their arched backs, clenched hands, and rigidly pointing fingers, creating a melodramatic, anxious tone. The crucified Christ is shown with a deadly pallor. His skin appears cancerous, and his chest is sunken with his last breath. His gnarled hands reach painfully upward, stretching for salvation from the blackened sky. We do not find such impassioned portrayals outside Germany during the Renaissance.

Albrecht Dürer

We appropriately close our discussion of northern Renaissance art with the Italianate master Albrecht Dürer (1471–1528). His passion for the Classical in art stimulated extensive travel in Italy, where he copied the works of the Italian masters, who were also enthralled with the Classical style. The development of the printing press made it possible for him to disseminate the works of the Italian masters throughout northern Europe.

Dürer's *Adam and Eve* (Fig. 15-5) conveys his admiration for the Classical style. In contrast to other German and Flemish artists who rendered figures, Dürer emphasized the idealized beauty of the human body. His Adam and Eve are not everyday figures of the sort Campin depicted in his Virgin Mary. Instead, the images arise from Greek and Roman prototypes. Adam's young muscular body could have been drawn from a live model or from Classical statuary. Eve represents a standard of beauty different from that of other northern artists. The familiar slight build and refined facial features have given way to a more substantial and well-rounded woman. She is reminiscent of a fifth-century BCE Venus in her features and her pose. The symbols associated with the event— the Tree of Knowledge and the Serpent (Satan)— play a secondary role. In *Adam and Eve,* Dürer has chosen to emphasize the profound beauty of the human body. Instead of focusing on the consequences of the event preceding the taking of the fruit as an admonition against sin, we delight in the couple's beauty for its own sake. Indeed, this notion is central to the art of Renaissance Italy.

I hold that the more nearly and accurately a figure is made to resemble man,
so much better the work will be. If the best parts, chosen from many well-formed men,
are fitly united in one figure, it will be worthy of praise.

—Albrecht Dürer

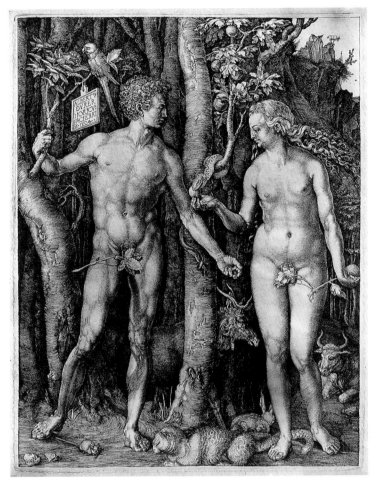

15-5 ALBRECHT DÜRER.
Adam and Eve (1504).
Engraving, 4th state. 9⅞″ × 7⅝″.
The Metropolitan Museum of Art, New York. Fletcher Fund, 1919
(19.73.1). All rights reserved, The Metropolitan Museum of Art, New York.

THE RENAISSANCE IN ITALY

The Early Renaissance

Not only was there a marked difference between northern and Italian Renaissance art but there were notable differences in the art of various sections of Italy itself. Florence

and Rome witnessed a resurgence of Classicism as Roman ruins were excavated in ancient sites, hillsides, and people's backyards. In Siena, on the other hand, the International style lingered, and in Venice a Byzantine influence remained strong. There may be several reasons for this diversity, but the most obvious is that of geography. For example, whereas the Roman artist's stylistic roads led to that ancient city, the trade routes in the northeast brought an Eastern influence to works of art and architecture.

The Italian Renaissance took root and flourished most successfully in Florence. The development of this city's painting, sculpture, and architecture parallels that of the Renaissance in all of Italy. Throughout the Renaissance, as Florence went, so went the country.

Cimabue and Giotto

Some of the earliest changes from a medieval to a Classical style can be perceived in the painting of Florence during the late thirteenth and early fourteenth centuries, the prime exponents being Cimabue and Giotto. So significant were these artists that Dante Alighieri, the fourteenth-century poet, mentioned both of them in his *Purgatory* of *The Divine Comedy:*

> *O gifted men, vainglorious for first place,*
> *how short a time the laurel crown stays green*
> *unless the age that follows lacks all grace!*
> *Once Cimabue thought to hold the field*
> *in painting, and now Giotto has the cry*
> *so that the other's fame, grown dim, must yield.*[3]

Who were these artists? Apparently they were rivals, although Cimabue (c. 1240 – c. 1302) was older than Giotto

[3] From *The Divine Comedy* by Dante Alighieri, trans. John Ciardi. Copyright 1954, 1957, 1959, 1960, 1961, 1965, 1967, 1970 by the Ciardi Family Publishing Trust. Used by permission of W. W. Norton & Company, Inc.

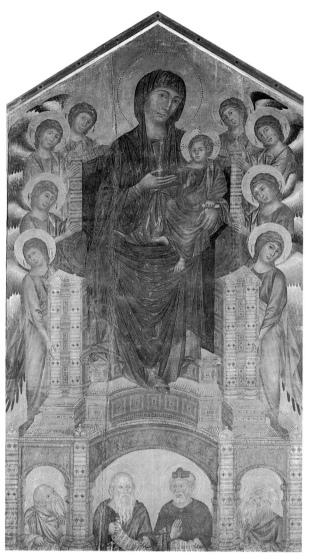

15-6 CIMABUE.
Madonna Enthroned (c. 1280–1290).
Tempera on wood panel. 12'7" × 7'4".
Uffizi Gallery, Florence/Alinari/Art Resource, New York.

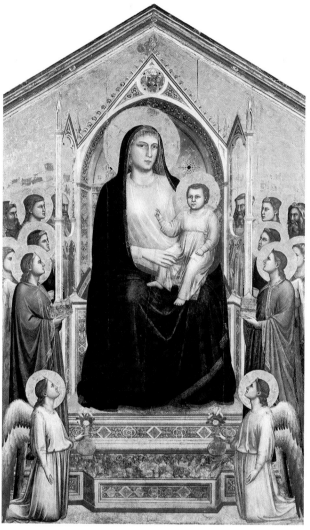

15-7 GIOTTO.
Madonna Enthroned (c. 1310).
Tempera on wood panel. 10'8" × 6'8".
Uffizi Gallery, Florence/Scala/Art Resource, New York.

(c. 1276 – c. 1337) and probably had a formative influence on the latter, who would ultimately steal the limelight.

The similarities and differences between the works of Cimabue and Giotto can be seen in two tempera paintings on wood panels depicting the Madonna and Child enthroned. A curious combination of Late Gothic and Early Renaissance styles betrays Cimabue's composition as a transitional work (Fig. 15-6). The massive throne of the Madonna is Roman in inspiration, with column and arch forms embellished with **intarsia.** The Madonna has a corpo-

real presence that sets her apart from "floating" medieval figures, but the effect is compromised by the unsureness with which she is placed on the throne. She does not sit solidly; her limbs are not firmly "planted." Rather, the legs resemble the "hinged" appendages of Romanesque figures. This characteristic placement of the knees causes the drapery to fall in predictable folds—concentric arcs reminiscent of a more stylized technique. The angels supporting the throne rise parallel to it, their glances forming an abstract zigzag pattern. The resultant lyrical arabesque, the flickering color

patterns of the wings, and the lineup of unobstructed heads recall the Byzantine tradition, particularly the Ravenna mosaics (see Fig. 14-5).

Giotto's rendition of the same theme offers some dramatic differences (Fig. 15-7). The overall impression of the *Madonna Enthroned* is one of stability and corporeality instead of instability and weightlessness. Giotto's Madonna sits firmly on her throne, the outlines of her body and drapery forming a solid triangular shape. Although the throne is lighter in appearance than Cimabue's Roman throne—and is, in fact, Gothic, with pointed arches—it, too, seems more firmly planted on the earth. Giotto's genius is also evident in his conception of the forms in three-dimensional space. They not only have height and width, as do those of Cimabue, but they also have depth and mass. This is particularly noticeable in the treatment of the angels. Their location in space is from front to rear rather than atop one another as in Cimabue's composition. The halos of the foreground angels obscure the faces of the background attendants, because they have mass and occupy space.

The Renaissance Begins, and So Does the Competition

With Cimabue and Giotto we witness strides toward an art that was very different from that of the Middle Ages. But artists, like all of us, must walk before they can run, and those very "strides" that express such a stylistic advance from the "cutout dolls" of the Ravenna mosaics and the "hinged marionettes" of the Romanesque era will look primitive in another half century. Because the art of Cimabue and Giotto contains vestiges of Gothicism, their style is often termed proto-Renaissance. But at the dawn of the fifteenth century in Florence, the Early Renaissance began—with a competition.

Imagine workshops and artists abuzz with news of one of the hottest projects in memory up for grabs. Think of one of the most prestigious architectural sites in Florence. Savor the possibility of being known as *the* artist who had cast, in gleaming bronze, the massive doors of the Baptistery of Florence. This landmark competition was held in 1401. There were countless entries, but only two panels have come down to us. The artists had been given a scene from the Old Testament to translate into bronze—the sacrifice of Isaac by his father, Abraham. There were specifications, naturally, but the most obvious is the **quatrefoil** format. Within this space, a certain cast of characters was mandated, including Abraham, Isaac, an angel, and two "extras" who appear to

have little or nothing to do with the scene. The event takes place out of doors, where God has commanded Abraham to take his only son and sacrifice him. When they arrive on the scene, Abraham, in loyalty to God, turns the blade to Isaac's throat. At this moment, God sends an angel to stop Abraham from completing the deed.

Filippo Brunelleschi and Lorenzo Ghiberti

The two extant panels were executed by Filippo Brunelleschi (c. 1377–1446) and Lorenzo Ghiberti (1378–1455). The obligatory characters, bushes, animals, and altar are present in both, but the placement of these elements, the artistic style, and the emotional energy within each work differ considerably. Brunelleschi's panel (Fig. 15-8) is divided into sections by strong vertical and horizontal elements, each section filled with objects and figures. In contrast to the rigidity of the format, a ferocious energy bordering on violence pervades the composition. Isaac's neck and body are distorted by his father's grasping fist, and Abraham himself lunges viciously toward his son's throat with a knife. With similar passion, an angel flies in from the left to grasp Abraham's arm. But this intense drama and seemingly boundless energy are weakened by the introduction of ancillary figures that are given more prominence than the scene requires. The donkey, for example, detracts from Isaac's plight by being placed broadside and practically dead center. Also, one is struck by the staccato movement throughout. Although this choppiness complements the anxiety in the work, it compromises the successful flow of space and tires the eye.

In Lorenzo Ghiberti's panel (Fig. 15-9), the space is divided along a diagonal rock formation that separates the main characters from the lesser ones. Space flows along this diagonal, exposing the figural group of Abraham and Isaac and embracing the shepherd boys and their donkey. The boys and donkey are appropriately subordinated to the main characters but not sidestepped stylistically. Abraham's lower body parallels the rock formation and then lunges expressively away from it in a dynamic counterthrust. Isaac, in turn, pulls firmly away from his father's forward motion. The forms move rhythmically together in a continuous flow of space. Although Ghiberti's emotion is not quite as intense as Brunelleschi's, and his portrayal of the sacrifice is not quite as graphic, the impact of Ghiberti's narrative is as strong.

It is interesting to note the inclusion of Classicizing elements in both panels. Brunelleschi, in one of his peasants, adapted the Classical sculpture of a boy removing a thorn from his foot, and Ghiberti rendered his Isaac in the manner of the fifth-century sculptor. Isaac's torso, in fact, may be the first nude in this style since Classical times.

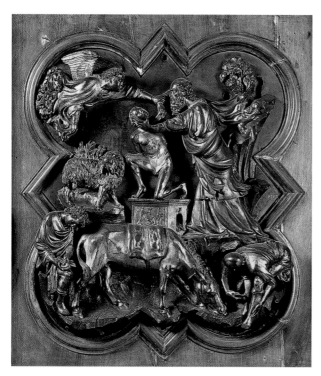

15-8 FILIPPO BRUNELLESCHI.
Sacrifice of Isaac (1401–1402).
Gilt bronze. 21″ × 17½″.
Museo Nazionale del Bargello, Florence. Copyright Edimedia/Corbis.

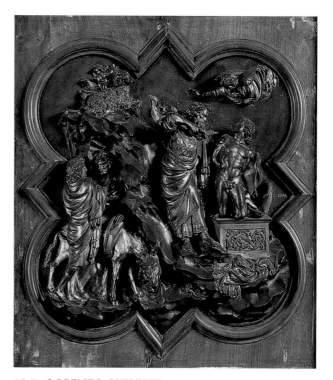

15-9 LORENZO GHIBERTI.
Sacrifice of Isaac (1401–1402).
Gilt bronze. 21″ × 17½″.
Museo Nazionale del Bargello, Florence. Copyright Edimedia/Corbis.

Oh, yes—Ghiberti won the competition and Brunelleschi went home with his chisel. The latter never devoted himself to sculpture again but went on to become the first great Renaissance architect. Ghiberti himself was not particularly modest about his triumph:

> To me was conceded the palm of victory by all the experts and by all . . . who had competed with me. To me the honor was conceded universally and with no exception. To all it seemed that I had at that time surpassed the others without exception, as was recognized by a great council and an investigation of learned men . . . highly skilled from the painters and sculptors of gold, silver, and marble.[4]

Donatello

If Brunelleschi and Ghiberti were among the last sculptors to harbor vestiges of the International style, Donatello (c. 1386–1466), the Florentine master, was surely among the first to create sculptures that combined Classicism with realism. In his *David* (Fig. 15-10), the first life-size nude statue since Classical times, Donatello struck a balance between the two styles by presenting a very real image of an Italian peasant boy in the guise of a Classical nude figure.

[4] E. G. Holt, ed., *Literary Sources of Art History* (Princeton, NJ: Princeton University Press, 1947), 87–88.

David, destined to be the second king of Israel, slew the Philistine giant Goliath with a stone and a sling. Even though Donatello was inspired by Classical statuary, notice that he did not choose a Greek youth in his prime as a prototype for his David. Instead, he chose a barely developed adolescent boy, his hair still unclipped and his arms flaccid for lack of manly musculature. After decapitating Goliath, whose head lies at David's feet, his sword rests at his side—almost too heavy for him to handle. Can such a youth have accomplished such a forbidding task? Herein lies the power of Donatello's statement. We are amazed, from the appearance of this young boy, that he could have done such a deed, much as David himself seems incredulous as he glances down toward his body. What David lacks in stature he has made up in intellect, faith, and courage. His fate was in his own hands—one of the ideals of the Renaissance man.

Masaccio

The Early Renaissance painters shared most of the stylistic concerns of the sculptors. However, included in their attempts at realism was the added difficulty of projecting a naturalistic sense of three-dimensional space on a two-dimensional surface. In addition to copying from nature and Classical models, these painters developed rules of perspec-

*The works made before [Masaccio's] day can be said to be painted,
while his are living, real, and natural.*

— Giorgio Vasari

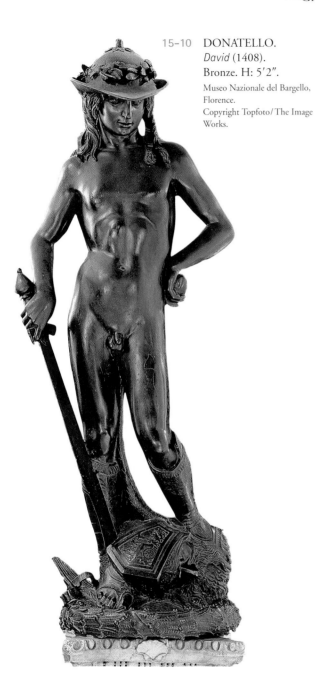

15-10 DONATELLO.
David (1408).
Bronze. H: 5′2″.
Museo Nazionale del Bargello,
Florence.
Copyright Topfoto/The Image
Works.

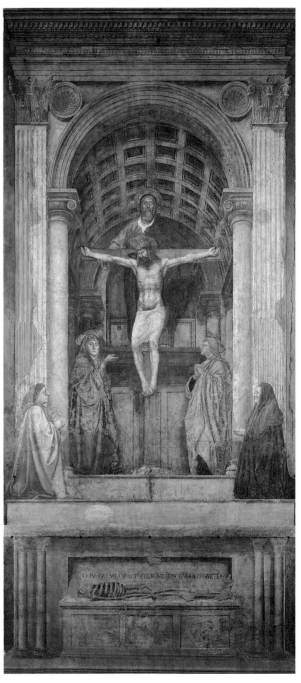

15-11 MASACCIO.
Holy Trinity, Santa Maria Novella, Florence (c. 1428).
Fresco. 21′ × 10′5″.
Erich Lessing/Art Resource, New York.

tive to depict images in the round on flat walls, panels, and
canvases. One of the pioneers in developing systematic laws
of one-point linear perspective was Brunelleschi, of Baptis-
tery doors near fame.

Masaccio's *Holy Trinity* (Fig. 15-11) uses these laws of
perspective. In this chapel fresco, Masaccio (1401–1428)

creates the illusion of an extension of the architectural space of the church by painting a barrel-vaulted "chapel" housing a variety of holy and common figures. God the Father supports the cross that bears his crucified son while the Virgin Mary and the apostle John attend. Outside the columns and pilasters of the realistic, Roman-inspired chapel kneel the donors, who are invited to observe the scene. Aside from the trompe l'oeil rendition of the architecture, the realism in the fresco is enhanced by the donors, who are given importance equal to that of the "principal" characters, similar to Campin's treatment of the donors in the *Merode Altarpiece* (Fig. 15-2). The architecture appears to extend our physical space, and the donors appear as extensions of ourselves.

Filippo Brunelleschi

The revival of Classicism was even more marked in the architecture of the Renaissance. Some 20 years after Brunelleschi's unsuccessful bid for the Baptistery doors project in Florence, he was commissioned to cover the crossing square of the cathedral of Florence with a dome. Interestingly, Ghiberti worked with him at the outset but soon

bowed out, and Brunelleschi was left to complete the work alone. It was quite an engineering feat, involving a double-shell dome constructed around 24 ribs (Fig. 15-12). Eight of these ribs rise upward to a crowning lantern on the exterior of the dome. You might wonder why Brunelleschi, whose architectural models were essentially Classical, would have constructed a somewhat pointed dome reminiscent of the Middle Ages. The fact is that the architect might have preferred a more rounded or hemispherical structure, but the engineering problem required an ogival, or pointed, section, which is inherently more stable. The dome was a compromise between a somewhat Classical style and traditional Gothic building principles.

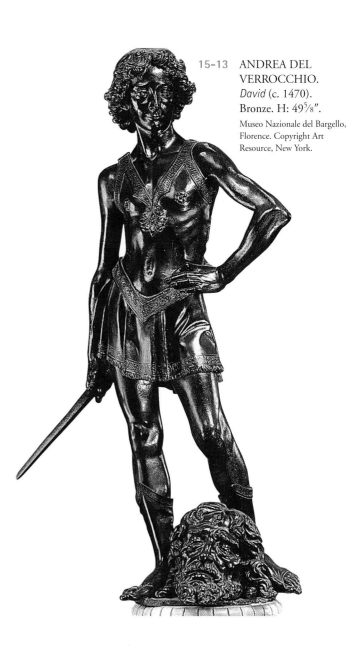

15-13 ANDREA DEL VERROCCHIO. *David* (c. 1470). Bronze. H: 49⅝".
Museo Nazionale del Bargello, Florence. Copyright Art Resource, New York.

15-12 FILIPPO BRUNELLESCHI. Construction of the cathedral dome, Florence (1420–1436).

Renaissance Art at Midcentury and Beyond

Andrea del Verrocchio

As we progress into the middle of the fifteenth century, the most important and innovative sculptor is Andrea del Verrocchio (1435–1488). An extremely versatile artist who was trained as a goldsmith, Verrocchio ran an active shop that attracted many young artists, including Leonardo da Vinci. We see in Verrocchio's bronze *David* (Fig. 15-13), commissioned by the Medici family, a strong contrast to Donatello's handling of the same subject. The Medici also owned the Donatello *David,* and Verrocchio probably wanted to outshine his predecessor. Although both artists chose to represent David as an adolescent, Verrocchio's hero appears somewhat older and exudes pride and self-confidence rather than a dreamy gaze of disbelief. Whereas Donatello reconciled realistic elements with an almost idealized, Classically inspired torso, Verrocchio's goal was supreme realism in minute details, including orientalizing motifs on the boy's doublet that would have made him look like a Middle Easterner. The sculptures differ considerably also in terms of technique. Donatello's *David* is essentially a closed-form sculpture with objects and limbs centered around an S-curve stance; Verrocchio's sculpture is more open, as is evidenced by the bared sword and elbow jutting away from the central core. Donatello's graceful pose has been replaced, in the Verrocchio, by a jaunty contrapposto that enhances David's image of self-confidence.

Piero della Francesca

The artists of the Renaissance, along with the philosophers and scientists, tended to share the sense of the universe as an orderly place that was governed by natural law and capable of being expressed in mathematical and geometric terms. Piero della Francesca (c. 1420–1492) was trained in mathematics and geometry and is credited with writing the first theoretical treatise on the construction of systematic perspective in art. Piero's art, like his scientific thought, was based on an intensely rational construction of forms and space.

His *Resurrection* fresco (Fig. 15-14) for the town hall of Borgo San Sepolcro reveals the artist's obsessions with order and geometry. Christ ascends vertical and triumphant, like a monumental column, above the "entablature" of his tomb, which serves visually as the pedestal of a statue. Christ and the other figures are constructed from the cones, cylinders, spheres, and rectangular solids that define the theoretical

15-14 PIERO DELLA FRANCESCA.
Resurrection (c. late 1450s).
Fresco. 7′5″ × 6′6½″.
Town Hall, Borgo San Sepolcro, Italy/
Scala/Art Resource, New York.

world of the artist. There is a tendency here toward the simplification of forms—not only of people, but also of natural features such as trees and hills. All the figures in the painting are contained within a triangle—what would become a major compositional device in Renaissance painting—with Christ at the apex. The sleeping figures and the marble sarcophagus provide a strong and stable base for the upper two-thirds of the composition. Regimented trees rise in procession behind Christ, as they never do when nature asserts its random jests; Piero's trees are swept back by the rigid cultivation of scientific perspective. They crown, as ordered, just above the crests of rounded hills. The artist of the Renaissance was not only in awe of nature but also commanded it fully.

Sandro Botticelli

During the latter years of the fifteenth century, we come upon an artistic personality whose style is somewhat in opposition to the prevailing trends. Since the time of Giotto, painters had relied on chiaroscuro, or the contrast of light and shade to create a sense of roundness and mass in their figures and objects, in an effort to render a realistic impression of three-dimensional forms in space. Sandro Botticelli (c. 1444–1510), however, constructed his compositions with line instead of tonal contrasts. His art relied primarily on drawing. Yet when it came to subject matter, his heart lay with his Renaissance peers, for, above all else, he loved to paint mythological themes. Along with other artists and men of letters, his mania for these subjects was fed and perhaps cultivated by the Medici prince Lorenzo the Magnificent, who surrounded himself with Neoplatonists, or those who followed the philosophy of Plato.

One of Botticelli's most famous paintings is *The Birth of Venus* (Fig. 15-15), or, as some art historians would have it, "Venus on the Half-Shell." The model for this Venus was Simonetta Vespucci, a cousin of Amerigo Vespucci, the navigator and explorer after whom America was named. The composition presents Venus, born of the foam of the sea, floating to the shores of her sacred island on a large scallop shell, aided in its drifting by the sweet breaths of entwined

15-15 SANDRO BOTTICELLI.
The Birth of Venus (c. 1486).
Tempera on canvas. 5'8⅞" × 9'1⅞".
Uffizi Gallery, Florence. Copyright Edimedia/Corbis.

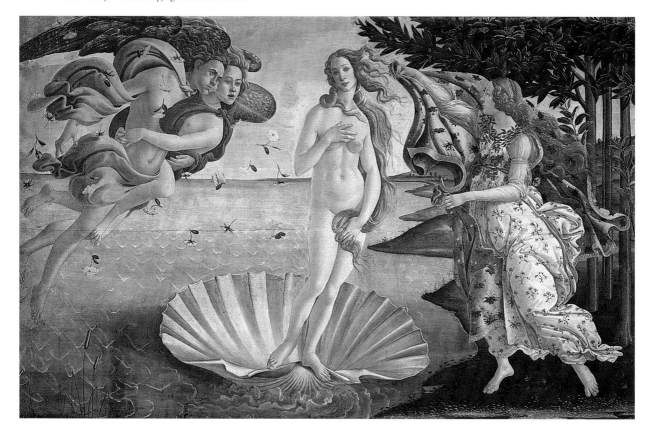

zephyrs. The nymph Pomona awaits her with an ornate mantle and is herself dressed in a billowing, flowered gown. Botticelli's interest in Classicism is evident also in his choice of models for the Venus. She is a direct adaptation of an antique sculpture of this goddess in the collection of the Medici family. Notice how the graceful movement in the composition is evoked through a combination of different lines. A firm horizon line and regimented verticals in the trees contrast with the subtle curves and vigorous arabesques that caress the mythological figures. The line moves from image to image and then doubles back to lead your eye once again. Shading is confined to areas within the harsh, linear, sculptural contours of the figures. Botticelli's genius lay in his ability to utilize the differing qualities of line to his advantage; with this formal element he created the most delicate of compositions.

Leon Battista Alberti

You could never accuse Leon Battista Alberti (1404–1472) of false modesty, or of any modesty at all. Like so many other artists of the Renaissance, including Ghiberti, Michelangelo, and Leonardo—and unlike the anonymous European artists of the Middle Ages—he sought fame with conscious conviction.

Some of the purest examples of Renaissance Classicism lie in the buildings Alberti designed. Alberti was among the first to study treatises written by Roman architects, the most famous of whom was Vitruvius, and he combined his Classical knowledge with innovative ideas in his grand opus, *Ten Books on Architecture.* One of his most visually satisfying buildings in the great Classical tradition is the Palazzo Rucellai (Fig. 15-16) in Florence. The building is divided by prominent horizontal string courses into three stories, crowned by a heavy cornice. Within each story are apertures enframed by pilasters of different orders. The first-floor pilasters are of the Tuscan order, which resembles the Doric order in its simplicity; the second story uses a composite capital of volutes and acanthus leaves, seen in the Ionic and Corinthian orders, respectively; and the top-floor pilasters are crowned by capitals of the Corinthian order. As in the Colosseum (see Fig. 13-22), this combination of orders gives an impression of increasing lightness as we rise from the lower to the upper stories. This effect is enhanced in Alberti's building by a variation in the masonry. Although the texture remains the same, the upper stories are faced with lighter-appearing smaller blocks in greater numbers. The palazzo's design, with its clear articulation of parts, overall balance of forms, and rhythmic placement of elements in horizontals across the facade, shows a clear understanding

15-16 LEON BATTISTA ALBERTI.
Palazzo Rucellai, Florence (1446–1451).
Copyright Canali Photobank, Milan.

of Classical design adapted successfully to the contemporary nobleman's needs.

The High Renaissance

Demanding patrons, the high cost of materials, and a lack of money have a way of fostering crabbiness among artists as well as butchers, bakers, and candlestick makers. It can be difficult to concentrate on our endeavors when others are mistreating us.

Sometime in 1542, Pope Julius II and Michelangelo Buonarroti were in conflict, with the artist bearing the brunt of the pontiff's behavior. As if backing out of his tomb commission and refusing to pay for materials were not enough, the pope laid the last straw by having Michelangelo thrown out of the Vatican on one occasion when the artist sought to redress his grievances. Was that any way to treat a genius?

I can make armored cars, safe and unassailable, which will enter the . . . ranks of the enemy

with their artillery, and there is no company of men at arms so great that they will not break it.

And behind these the infantry will be able to follow quite unharmed and without any

opposition. . . . If need shall arise, I can make cannon, mortars, and light ordnance,

of very beautiful and useful shapes, quite different from those in common use. . . .

Also I can execute sculpture in marble, bronze, and clay, and also painting, in which

my work will stand comparison with that of anyone else, who ever he may be.

—Leonardo da Vinci (from a letter of application for a job)

The artist thought not, as he complained in a letter to one of Julius's underlings:

> A man paints with his brains and not with his hands, and if he cannot have his brains clear he will come to grief. Therefore I shall be able to do nothing well until justice has been done me. . . . As soon as the Pope [carries] out his obligations towards me I (will) return, otherwise he need never expect to see me again.
>
> All the disagreements that arose between Pope Julius and myself were due to the jealousy of Bramante and of Raffaelo da Urbino; it was because of them that he did not proceed with the tomb, . . . and they brought this about in order that I might thereby be ruined. Yet Raffaello was quite right to be jealous of me, for all he knew of art he learned from me.[5]

Although this is only one side of the story, and Michelangelo might also have been somewhat jealous of Raffaelo (Raphael), this passage affords us a glimpse of the personality of an artist of the High Renaissance. He was independent yet indispensable—arrogant, aggressive, and competitive.

From the second half of the fifteenth century onward, a refinement of the stylistic principles and techniques associated with the Renaissance can be observed. Most of this significant, progressive work was being done in Florence, where the Medici family played an important role in supporting the arts. At the close of the decade, however, Rome was the place to be, as the popes began to assume the grand role of patron. The three artists who were in most demand—the great masters of the High Renaissance in Italy—were Leonardo da Vinci, a painter, scientist, inventor, and musician; Raphael, the Classical painter thought to have rivaled the works of the ancients; and Michelangelo, the painter, sculptor, architect, poet, and enfant terrible. Donato Bramante is deemed to have made the most sig-

nificant architectural contributions of this period. These are the stars of the Renaissance, the artistic descendants of the Giottos, Donatellos, and Albertis, who, because of their earlier place in the historical sequence of artistic development, are sometimes portrayed as but stepping-stones to the greatness of the sixteenth-century artists rather than as masters in their own right.

Leonardo da Vinci

If the Italians of the High Renaissance could have nominated a counterpart to the Classical Greek's "four-square man," it most assuredly would have been Leonardo da Vinci (1452–1519). His capabilities in engineering, the natural sciences, music, and the arts seemed unlimited, as he excelled in everything from solving drainage problems (a project he undertook in France just before his death), to designing prototypes for airplanes and submarines, to creating some of the most memorable Renaissance paintings.

The Last Supper (Figs. 15-17 and 15-18), a fresco painting executed for the dining hall of a Milan monastery, stands as one of Leonardo's greatest works. The condition of the work is poor, because of Leonardo's experimental fresco technique—although the steaming of pasta for centuries on the other side of the wall may also have played a role. Nonetheless, we can still observe the Renaissance ideals of Classicism, humanism, and technical perfection, now coming to full fruition. The composition is organized through the use of one-point linear perspective. Solid volumes are constructed from a masterful contrast of light and shadow. A hairline balance is struck between emotion and restraint.

The viewer is first attracted to the central triangular form of Jesus sitting among his apostles by orthogonals that converge at his head. His figure is silhouetted against a triple window that symbolizes the Holy Trinity and pierces the otherwise dark back wall. One's attention is held at this center point by the Christ-figure's isolation that results from the

[5] Robert Goldwater and Marco Treves, eds., *Artists on Art* (New York: Pantheon Books, 1972), 63.

15-17 LEONARDO DA VINCI.
The Last Supper (1495–1498).
Fresco (oil and tempera on plaster). 13′9″ × 29′10″.
Refectory, Santa Maria delle Grazie, Milan. Copyright Edimedia/Corbis.

leaning away of the apostles. Leonardo has chosen to depict the moment when Jesus says, "One of you will betray me." The apostles fall back reflexively at this accusation; they gesture expressively, deny personal responsibility, and ask, "Who can this be?" The guilty one, of course, is Judas, who is shown clutching a bag of silver pieces at Jesus' left, with his elbow on the table. The two groups of apostles, who sweep dramatically away from Jesus along a horizontal line, are subdivided into four smaller groups of three that tend to moderate the rush of the eye out from the center. The viewer's eye is wafted outward and then coaxed back inward through the "parenthetic" poses of the apostles at either end. Leonardo's use of strict rules of perspective and his graceful balance of motion and restraint underscore the artistic philosophy and style of the Renaissance.

Although Leonardo does not allow excessive emotion in his *Last Supper,* the reactions of the apostles seem genuinely human. There is probably no better example of humanism in sixteenth-century Renaissance art, however, than the subject of Virgin and Child. One of the most significant paintings to capture this spirit is the *Madonna of the Rocks*

15-18 LEONARDO DA VINCI.
The Last Supper (detail).
Refectory, Santa Maria delle Grazie, Milan/Scala/Art Resource, New York.

15-19 LEONARDO DA VINCI.
Madonna of the Rocks (c. 1483).
Oil on panel, transferred to canvas. 78½″ × 48″.
Louvre Museum, Paris. Copyright Edimedia/Corbis.

(Fig. 15-19) by Leonardo. Notice all that has changed in the representation of this figural group during the course of the preceding century. With Leonardo, Mary is no longer portrayed as the queen of heaven, enthroned and surrounded by angels in an ambiguous golden environment. Rather, she is shown as a mother in the midst of the world—in this case a grotto embellished with luscious vegetation and beautiful rock formations. She is human; she is "real." Compositionally, she forms the apex of a rather broad, stable triangle, extending her arms toward the infants Jesus and John the Baptist. Her right arm embraces John, but she is unable to reach the child Jesus because of the interfering hand of an angel

who sits near him. Mary's inability to complete her embrace may symbolize her ultimate inability to protect him from his fate. Yet the tender human aspect of the scene stands independent of its iconography.

Raphael Sanzio

A younger artist who assimilated the lessons offered by Leonardo, especially on the humanistic portrayal of the Madonna, was Raphael Sanzio (1483–1520). As a matter of fact, Michelangelo was not far off base in his accusation that Raphael copied from him, for the younger artist freely adopted whatever suited his purposes. Raphael truly shone in his ability to combine the techniques of other masters with an almost instinctive feel for Classical art. He rendered countless canvases depicting the Madonna and Child along the lines of Leonardo's *Madonna of the Rocks.* Raphael was also sought after as a muralist. Some of his most impressive Classical compositions, in fact, were executed for the papal apartments in the Vatican. The commission, of course, came from Pope Julius, and to add fuel to Michelangelo's fire, was executed at the same time Michelangelo was at work on the Sistine Chapel ceiling. For the Stanza della Segnatura, the room in which the highest papal tribunal was held, Raphael painted *The School of Athens* (Fig. 15-20), one of four frescoes designed within a semicircular frame. In what could be a textbook exercise of one-point linear perspective, Raphael crowded a veritable "who's who" of Classical Greece convening beneath a series of barrel-vaulted archways. The figures symbolize philosophy, one of the four subjects deemed most valuable for a pope's education. (The others were law, theology, and poetry.) The members of the gathering are divided into two camps representing opposing philosophies and are led, on the right, by Aristotle and on the left, by his mentor, Plato. Corresponding to these leaders are the Platonists, whose concerns are the more lofty realm of Ideas (notice Plato pointing upward), and the Aristotelians, who are more in touch with matters of the Earth, such as natural science. Some of the figures have been identified: Diogenes, the Cynic philosopher, sprawls out on the steps, and Herakleitos, a founder of Greek metaphysics, sits pensively just left of center. Of more interest is the fact that Raphael included a portrait of himself, staring out toward the viewer, in the far right foreground. He is shown in a group surrounding the geometrician Euclid. Raphael clearly saw himself as important enough to be commemorated in a Vatican mural as an ally of the Aristotelian camp.

As in *The Last Supper* by Leonardo, our attention is drawn to the two main figures by orthogonals leading directly to where they are silhouetted against the sky breaking

The School of Athens (1510–1511).
Fresco. 26′ × 18′.

Stanza della Segnatura, Vatican, Rome. Copyright Art Resource, New York.

through the archways. The diagonals that lead toward a single horizon point are balanced by strong horizontals and verticals in the architecture and figural groupings, lending a feeling of Classical stability and predictability. Stylistically, as well as iconographically, Raphael has managed to balance opposites in a perfectly graceful and logical composition.

Michelangelo Buonarroti

Of the three great Renaissance masters, Michelangelo (1475–1564) is probably most familiar to us. During the 1964 World's Fair in New York City, hundreds of thousands of culture seekers and religious pilgrims were trucked along a conveyor belt for a brief glimpse of his *Pietà* at the Vatican

Pavilion. Many of us have seen the film *The Agony and the Ecstasy,* in which Charlton Heston—who, by the way, bears a striking resemblance to the artist—lies flat on his back on a scaffold 70 feet off the ground painting a ceiling for the Pope. It took Charlton Heston under an hour and a half; Michelangelo, who was paid less, required four years. Such is the gulf between art and . . . art?

In any event, that famed ceiling is the vault of the chapel of Pope Sixtus IV, known as the Sistine Chapel. The decorative fresco cycle was commissioned by none other than Pope Julius II, but the iconographic scheme was Michelangelo's. The artist had agreed to the project in order to pacify the temperamental Julius in the hope that the pontiff would eventually allow him to complete work on his

mammoth tomb. For whatever reason, we are indeed fortunate to have this painted work from the sculptor's hand. After much anguish and early attempts to populate the vault with a variety of religious figures, Michelangelo settled on a division of the ceiling into geometrical "frames" (Figs. 15-21 and 15-22) housing biblical prophets, mythological soothsayers, and Old Testament scenes from Genesis to Noah's flood.

The most famous of these scenes is *The Creation of Adam* (Fig. 15-23). As Leonardo had done in *The Last Supper,* Michelangelo chose to communicate the event's most dramatic moment. Adam lies on the Earth, listless for lack of a soul, while God the Father rushes toward him amidst a host of angels, who enwrap him in a billowing cloak. The contrasting figures lean toward the left, separated by an illuminated diagonal that provides a backdrop for the Creation.

Amidst an atmosphere of sheer electricity, the hand of God reaches out to spark spiritual life into Adam—but does not touch him! In some of the most dramatic negative space in the history of art, Michelangelo has left it to the spectator to complete the act. In terms of style, Michelangelo integrated chiaroscuro with Botticelli's extensive use of line. His figures are harshly drawn and muscular with almost marble-like flesh. In translating his sculptural techniques to a two-dimensional surface, the artist has conceived his figures in

15-21 MICHELANGELO.
The Sistine Chapel in the Vatican, Rome (1508–1512).
5,800 sq. ft.
Vatican Museum, Rome. Copyright Canali Photobank, Milan. Nippon Television Network Corporation, Tokyo/Vatican Museum, Rome.

15-22 MICHELANGELO.
The ceiling of the Sistine Chapel in the Vatican, Rome (1508–1512).
5,800 sq. ft.
Vatican Museum, Rome. Copyright Canali Photobank, Milan. Nippon Television Network Corporation, Tokyo/Vatican Museum, Rome.

The Creation of Adam (1508–1512). Detail from the
ceiling of the Sistine Chapel in the Vatican, Rome.
Vatican Museum, Rome. Copyright Canali Photobank, Milan. Nippon
Television Network Corporation, Tokyo/Vatican Museum, Rome.

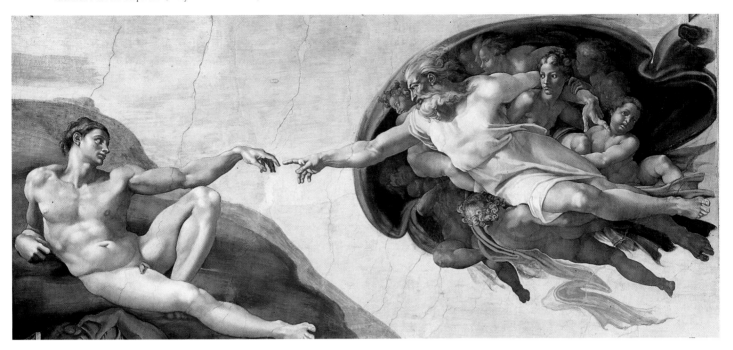

the round and has used the tightest, most expeditious line
and modeling possible to render them in paint.

It is clear that Michelangelo saw himself more as a
sculptor than as a painter. The "sculptural" drawing and
modeling in *The Creation of Adam* attest to this. When
Michelangelo painted the Sistine Chapel ceiling, he was all
of 33 years old, but he began his career some 20 years earlier
as an apprentice to the painter Domenico Ghirlandaio
(1449–1494). His reputation as a sculptor, however, was
established when, at the age of 27, he carved the 13½-foot-
high *David* (Fig. 15-26) from a single piece of almost un-
workable marble. Unlike the Davids of Donatello and
Verrocchio, Michelangelo's hero is not shown after conquer-
ing his foe. Rather, David is portrayed as a most beautiful
animal preparing to kill—not by savagery and brute force
but by intellect and skill. Upon close inspection, the tensed
muscles and the furrowed brow negate the first impression
that this is a figure at rest. David's sling is cast over his shoul-
der, and the stone is grasped in the right hand, the veins
prominent in anticipation of the fight. Michelangelo's *David*

is part of the Classical tradition of the "ideal youth" who has
just reached manhood and is capable of great physical and
intellectual feats. Like Donatello's *David,* Michelangelo's
sculpture is closed in form. All of the elements move tightly
around a central axis. Michelangelo has been said to have
sculpted by first conceptualizing the mass of the work and
then carefully extracting all of the marble that was not
part of the image. Indeed, in the *David,* it appears that he
worked from front to back instead of from all four sides of
the marble block, allowing the figure, as it were, to "step out
of" the stone. The identification of the figure with the mar-
ble block provides a dynamic tension in Michelangelo's
work, as the forms try at once to free themselves from and
succumb to the binding dimensions.

High and Late Renaissance in Venice

The artists who lived and worked in the city of Venice were
the first in Italy to perfect the medium of oil painting that
we witnessed with van Eyck in Flanders. Perhaps influenced

The "Davids" of Donatello, Verrocchio, Michelangelo, and Bernini

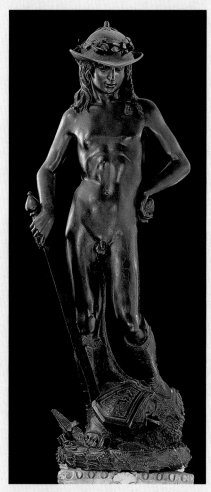

15-24 DONATELLO.
David (1408).
Bronze. H: 5′2″.
Museo Nazionale del Bargello, Florence/
Scala/Art Resource, New York.

Sometime soon after the year 1430, a bronze statue of David (Fig. 15-24) stood in the courtyard of the house of the Medici. The work was commissioned of Donatello by Cosimo de' Medici himself, the founding father of the Republic of Florence. It was the first freestanding, life-size nude since Classical antiquity, poised in the same contrapposto stance as the victorious athletes of Greece and Rome. But soft, and somehow oddly unheroic. And the incongruity of the heads: David's boyish, expressionless face, framed by soft tendrils of hair and shaded by a laurel-crowned peasant's hat; Goliath's tragic, contorted expression, made sharper by the pen-

tagonal helmet and coarse, disheveled beard. Innocence and evil. The weak triumphing over the strong. The city of Florence triumphing over the aggressive dukes of Milan? "David" as a civic-public monument.

In the year 1469, Ser Piero from the Tuscan town of Vinci moved to Florence to become a notary. He rented a house on the Piazza San Firenze, not far from the Palazzo Vecchio. His son, who was a mere 17 years old upon their arrival, began an apprenticeship in the Florentine studio of the well-known artist Andrea Verrocchio. At that time, Verrocchio was at work on a bronze sculpture of the young David (Fig. 15-25). Might the head of this fine piece be a portrait of the young Leonardo da Vinci?

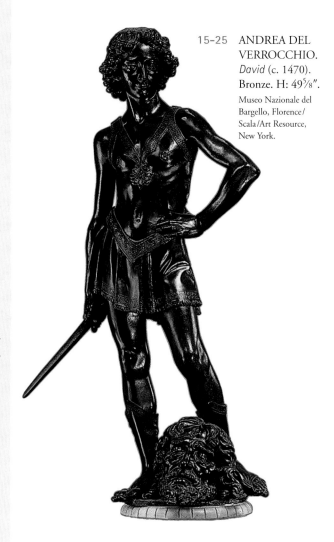

15-25 ANDREA DEL
VERROCCHIO.
David (c. 1470).
Bronze. H: 49⅝″.
Museo Nazionale del
Bargello, Florence/
Scala/Art Resource,
New York.

15-26 MICHELANGELO.
David (1501–1504).
Marble. H: 13½′.

Galleria dell'Accademia,
Florence/Scala/Art Resource,
New York.

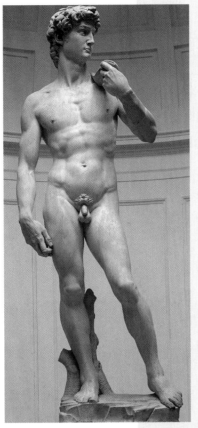

For many years a block of marble lay untouched, tossed aside as unusable, irretrievable evidence of a botched attempt to carve a human form. It was 18 feet high. A 26-year-old sculptor, riding high after the enormous success of his figure of the Virgin Mary holding the dead Christ, decided to ask for the piece. The wardens of the city in charge of such things let the artist have it. What did they have to lose? Getting anything out of it was better than nothing. So this young sculptor named Michelangelo measured and calculated. He made a wax model of David with a sling in his hand. And he worked on his David (Fig. 15-26) continuously for some three years until, a man named Vasari tells us, he brought it to perfect completion. Without letting anyone see it.

A century later, a 25-year-old sculptor stares into a mirror at his steeled jaw and determined brow. A contemporary source tells us that on this day, perhaps, the mirror is being held by Cardinal Maffeo Barberini while Bernini transfers what he sees in himself to the face of his David (Fig. 15-27). Gianlorenzo Bernini: sculptor and architect, painter, dramatist, composer. Bernini, who centuries later would be called the undisputed monarch of the Roman High Baroque, identifying with David, whose adversary is seen only by him.

The great transformation in style that occurred between the Early Renaissance and the Baroque can be followed in the evolution of David. Look at them: A boy of 12, perhaps, looking down incredulously at the physical self that felled an unconquerable enemy; a boy of 14 or 15, confident and reckless, with enough adrenaline pumping to take on an army; an adolescent on the brink of adulthood, captured at that moment when, the Greeks say, sound mind and sound body are one; and another full-grown youth at the threshold of his destiny as king. ■

15-27 GIANLORENZO BERNINI.
David (1623).
Marble. H: 6′7″.

Borghese Gallery, Rome/Scala/Art Resource, New York.

[Titian] made the promise of a figure appear in four brushstrokes. [Then] he used to turn his pictures to the wall and leave them there without looking at them, sometimes for several months. When he wanted to apply his brush again, he would examine them . . . to see if he could find any faults. . . . In this way, working on the figures and revising them, he brought them to the most perfect symmetry that the beauty of art and nature can reveal. [So] he gradually covered those essential forms with living flesh, bringing them . . . to a state in which they lacked only the breath of life.

—Palma il Giovane, contemporary of Titian

by the mosaics in St. Mark's Cathedral, perhaps intrigued by the dazzling colors of imports from Eastern countries into this maritime province, the Venetian artists sought the same clarity of hue and lushness of surface in their oil-on-canvas works. In the sixteenth century, Venice would come to figure as prominently in the arts as Florence had in the fifteenth.

Titian

Although he died in 1576, almost a quarter century before the birth of the Baroque era, the Venetian master Tiziano Vecellio (b. 1477)—called Titian—had more in common with the artists who would follow him than with his Renaissance contemporaries in Florence and Rome. Titian's pictorial method differed from those of Leonardo,

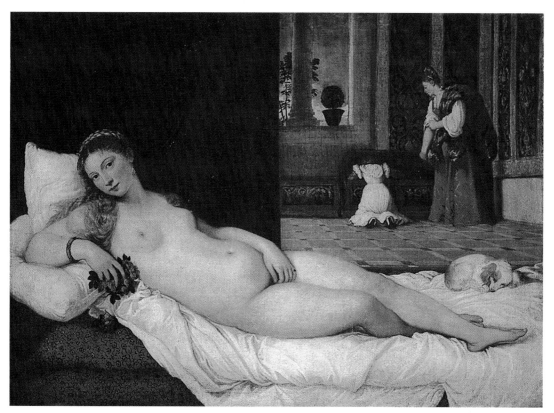

15-28 TITIAN.
Venus of Urbino (1538).
Oil on canvas. 47″ × 65″.
Uffizi Gallery, Florence/Scala/Art Resource, New York.

Raphael, and Michelangelo in that he was foremost a painter and colorist rather than a draftsman or sculptural artist. He constructed his compositions by means of colors and strokes of paint and layers of varnish rather than by line and chiaroscuro. A shift from painting on wood panels to painting on canvas occurred at this time, and with it a change from tempera to oil paint as the preferred medium. The versatility and lushness of oil painting served Titian well, with its vibrant, intense hues and its more subtle, semi-transparent glazes.

Titian's *Venus of Urbino* (Fig. 15-28) is one of the most beautiful examples of the glazing technique. The composition was painted for the duke of Urbino, from which its title derives. Titian adopted the figure of the reclining Venus from his teacher Giorgione, and it has served as a model for many compositions since that time. In the foreground, a nude **Venus pudica** rests on voluptuous pillows and sumptuous sheets spread over a red brocade couch. Her golden hair, complemented by the delicate flowers she grasps loosely in her right hand, falls gently over her shoulder. A partial drape hangs in the middle ground, providing a backdrop for her upper torso and revealing a view of her boudoir. The background of the composition includes two women looking into a trunk—presumably handmaidens—and a more distant view of a sunset through a columned veranda. Rich, soft tapestries contrast with the harsh Classicism of the stone columns and inlaid marble floor. Titian appears to have been interested in the interaction of colors and the contrast of textures. The creamy white sheet complements the radiant golden tones of the body of Venus, built up through countless applications of glazes over flesh-toned pigment. Her sumptuous roundness is created by extremely subtle gradations of tones in these glazes rather than the harshly sculptural chiaroscuro that Leonardo or Raphael might have used. The forms evolve from applications of color instead of line or shadow. Titian's virtuoso brushwork allows him to define different textures: the firm yet silken flesh, the delicate folds of drapery, the servant's heavy cloth dress, the dog's soft fur. The pictorial dominance of these colors and textures sets the work apart from so many examples of Florentine and Roman painting. It appeals primarily to the senses rather than to the intellect.

Titian's use of color as a compositional device is significant. We have already noted the drape, whose dark color forces our attention on the most important part of the composition—Venus's face and upper torso. It also blocks out the left background, encouraging viewers to narrow their focus on the vista in the right background. The forceful diagonal formed by the looming body of Venus is balanced by three elements opposite her: the little dog at her feet and the two handmaidens in the distance. They do not detract from her because they are engaged in activities that do not concern her or the spectator. The diagonal of her body is also balanced by an intersecting diagonal that can be visualized by integrating the red areas in the lower left and upper right corners. Titian thus subtly balances the composition in his placement of objects and color areas.

Tintoretto

Perhaps no other Venetian artist anticipated the Baroque style so strongly as Jacopo Robusti, called Tintoretto, or "little dyer," after the profession of his father. Supposedly a pupil of Titian, Tintoretto (1518–1594) emulated the master's love of color, although he combined it with a more linear approach to constructing forms. This interest in draftsmanship was culled from Michelangelo, but the younger artist's compositional devices went far beyond those of the Florentine and Venetian masters. His dynamic structure and passionate application of pigment provide a sweeping, almost frantic, energy within compositions of huge dimensions.

Tintoretto's painting technique was indeed unique. He arranged doll-like figures on small stages and hung his flying figures by wires in order to copy them in correct perspective on sheets of paper. He then used a grid to transcribe the figures onto much larger canvases.

Tintoretto primed the entire canvas with dark colors. Then he quickly painted in the lighter sections. Thus, many of his paintings appear very dark, except for bright patches of radiant light. The artist painted extremely quickly, using broad areas of loosely swathed paint. John Ruskin, a nineteenth-century art critic, is said to have suggested that Tintoretto painted with a broom.[6] Although this is unlikely, Tintoretto had certainly come a long way from the sculptural, at times marblelike, figures of the High Renaissance and the painstaking finish of Titian's glazed *Venus of Urbino*. This loose brushwork and dramatic white spotlighting on a dark ground anticipate the Baroque style.

[6] Frederick Hartt, *History of Italian Renaissance Art,* 2nd ed. (Englewood Cliffs, NJ: Prentice-Hall; New York: Harry N. Abrams, 1979), 615.

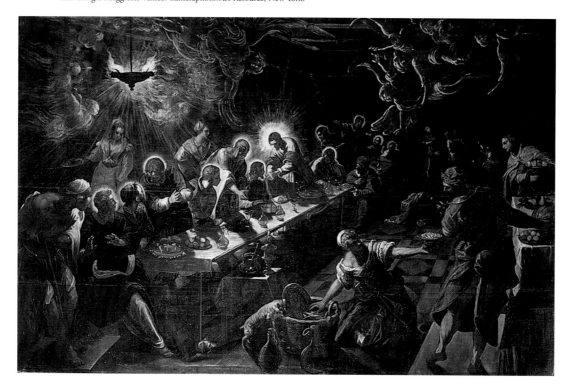

The Last Supper (Fig. 15-29) seals his relationship to the later period. A comparison of this composition with Leonardo's *The Last Supper* (Fig. 15-17) will illustrate the dramatic changes that had taken place in both art and the concept of art over almost a century. The interests in motion, space, and time; the dramatic use of light; and the theatrical presentation of subject matter are all present in Tintoretto's *The Last Supper.* We are first impressed by the movement. Everything and everyone are set into motion: people lean, rise up out of their seats, stretch, and walk. Angels fly and animals dig for food. The space, sliced by a sharp, rushing diagonal that goes from lower left toward upper right, seems barely able to contain all of this commotion; but this "cluttered" effect enhances the energy of the event. Leonardo's obsession with symmetry, along with his balance between emotion and restraint, yields a composition that appears static in comparison to the asymmetry and overpower-

ing emotion in Tintoretto's canvas. Leonardo's apostles seem posed for the occasion when contrasted with Tintoretto's spontaneously gesturing figures. A particular moment is captured. We feel that if we were to look away for a fraction of a second, the figures would have changed position by the time we looked back! The timelessness of Leonardo's figural poses has given way to a seemingly temporary placement of characters. The moment that Tintoretto has chosen to depict also differs from Leonardo's. The Renaissance master chose the point at which Jesus announced that one of his apostles would betray him. Tintoretto, on the other hand, chose the moment when Jesus shared bread, which symbolized his body as the wine stood for his blood. This moment is commemorated to this day during the celebration of Mass in the Roman Catholic faith. Leonardo chose a moment signifying death, Tintoretto a moment signifying life, depicted within an atmosphere that is teeming with life.

HIGH AND LATE RENAISSANCE OUTSIDE ITALY

El Greco

The Late Renaissance outside Italy brought us many different styles, and Spain is no exception. Spanish art polarized into two stylistic groups of religious painting: the mystical and the realistic. One painter was able to pull these opposing trends together in a unique pictorial method. El Greco (1541–1614), born Domeniko Theotokopoulos in Crete, integrated many styles in his work. As a young man he traveled to Italy, where he encountered the works of the Florentine and Roman masters, and he was for a time affiliated with Titian's workshop. The colors that El Greco incorporated in his paintings suggest a Venetian influence, and the distortion of his figures and use of an ambiguous space speak for his interest in Mannerism, which is discussed later.

These pictorial elements can clearly be seen in one of El Greco's most famous works, *The Burial of Count Orgaz* (Fig. 15-30). In this single work, El Greco combines mysticism and realism. The canvas is divided into two halves by a horizontal line of white-collared heads, separating "heaven" and "earth." The figures in the lower half of the composition are somewhat elongated, but well within the bounds of realism. The heavenly figures, by contrast, are extremely attenuated and seem to move under the influence of a sweeping, dynamic atmosphere. It has been suggested that the distorted figures in El Greco's paintings might have been the result of astigmatism in the artist's eyes, but there is no convincing proof of this. For example, at times El Greco's figures appear no more distorted than those of other Mannerists. Heaven and earth are disconnected psychologically but joined convincingly in terms of composition. At the center of the rigid, horizontal row of heads that separates the two worlds, a man's upward glance creates a path for the viewer into the upper realm. This compositional device is complemented by a sweeping drape that rises into the upper half of the canvas from above his head, continuing to lead the eye between the two groups of figures, left and right, up toward the image of the resurrected Christ. El Greco's color scheme also complements the worldly and celestial habitats. The colors used in the costumes of the earthly figures are realistic and vibrantly Venetian, but the colors of the upper half of the composition are of discordant hues, highlighting the otherworldly nature of the upper canvas. The emotion is high-pitched and exaggerated by the

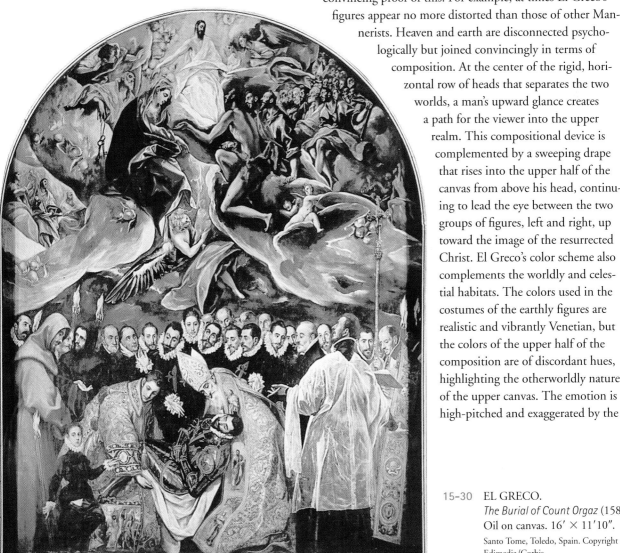

15-30 EL GRECO.
The Burial of Count Orgaz (1586).
Oil on canvas. 16′ × 11′10″.

15-31 PIETER BRUEGHEL THE ELDER.
The Peasant Wedding (1568).
Oil on wood. 45″ × 64½″.
Kunsthistorisches Museum, Vienna, Austria. Copyright Art Resource, New York.

tumultuous atmosphere. This emphasis on emotionalism links El Greco to the onset of the Baroque era. His work contains a dramatic, theatrical flair, one of the hallmarks of the seventeenth century.

Pieter Bruegel the Elder

During the second half of the sixteenth century in the Netherlands, changes in the subject matter of painting were taking place that would affect the themes of artists working in northern Europe during the Baroque period. Scenes of everyday life involving ordinary people were becoming more popular. One of the masters of this genre painting was Pieter Bruegel the Elder (c. 1520–1569), whose compositions focused on human beings in relation to nature and the life and times of plain Netherlandish folk. *The Peasant Wedding* (Fig. 15-31) is a good example of Bruegel's "slice-of-life" canvases. The painting transports us to a boisterous hall, where food and drink flow in abundance and music and merriment raise the rafters. The viewer's experience of this event relies on the degree to which the artist conveys the sense of noise, of laughter, of celebration. The circular rims of soup bowls are echoed in the spherical caps of the peasants and the mouths of the stacked, earthenware pitchers. In a sea of confusion, this simple repetitive element provides visual unity and guides the path of the eye. There is no hidden message here, no religious fervor, no battle between mythological giants. Human activities are presented as sincere and viable subject matter. There are few examples of such painting before this time, but genre painting will play

a principal role in the works of Netherlandish artists during the Baroque period.

MANNERISM

During the Renaissance, the rule of the day was to observe and emulate nature. Toward the end of the Renaissance and before the beginning of the seventeenth century, this rule was suspended for a while, during a period of art that historians have named Mannerism. Mannerist artists abandoned copying directly from nature and copied art instead. Works thus became "secondhand" views of nature. Line, volume, and color no longer duplicated what the eye saw but were derived instead from what other artists had already seen. Several characteristics separate **Mannerist art** from the art of the Renaissance and the Baroque periods: distortion and elongation of figures; flattened, almost two-dimensional space; lack of a defined focal point; and the use of discordant pastel hues.

Jacopo Pontormo

A representative of early Mannerism, Jacopo Pontormo (1494–1557) used most of its stylistic principles. In *Entombment* (Fig. 15-32), we witness a strong shift in direction from High Renaissance art, even though the painting was executed during Michelangelo's lifetime. The weighty sculptural figures of Michelangelo, Leonardo, and Raphael have given way to less substantial, almost weightless, forms that

balance on thin toes and ankles. The limbs are long and slender in proportion to the torsos, and the heads are dwarfed by billowing robes. There is a certain innocent beauty in the arched eyebrows of the haunted faces and in the nervous glances that dart this way and that past the boundaries of the canvas. The figures are pressed against the picture plane, moving within a very limited space. Their weight seems to be thrust outward toward the edges of the composition and away from the almost void center. The figures' robes are composed of odd hues, departing drastically in their soft pastel tones from the vibrant primary colors of the Renaissance masters. The weightlessness, distortion, and ambiguity of space create an almost otherworldly feeling in the composition, a world in which objects and people do not come under an earthly gravitational force. The artist accepts this "strangeness" and makes no apologies for it to the viewer. The ambiguities are taken in stride. For example, note that the character in a turban behind the head of the dead Jesus does not appear to have a body—there is really no room for it in the composition. And even though a squatting figure in the center foreground appears to be balancing Christ's torso on his shoulders after having taken him down from the cross a moment before, there is no cross in sight! Pontormo seems to have been most interested in elegantly rendering the high-pitched emotion of the scene. Iconographic details and logical figural stances are irrelevant.

The artists from the second half of the sixteenth century through the beginning of the seventeenth century all broke away from the Renaissance tradition in one way or another. Some were opposed to the stylistic characteristics of the Renaissance and turned them around in an original but ultimately uninfluential style called Mannerism. Others, such as Titian and Tintoretto, emphasized the painting *process,* constructing their compositions by means of stroke and color rather than line and shadow. Still others combined an implied movement and sense of time in their compositions, foreshadowing some of the concerns of the artist in the Baroque period. The High and Late Renaissance witnessed artists of intense originality who provide a fascinating transition between the grand Renaissance and the dynamic Baroque.

15-32 JACOPO PONTORMO.
Entombment (1525–1528).
Oil on panel. 10′3″ × 6′4″.
Capponi Chapel, Santa Felicità, Florence/
Scala/Art Resource, New York.

ART TOUR
Dallas/Fort Worth

One hundred years ago, Will Rogers said, "Fort Worth is where the West begins and Dallas is where the East peters out." His description remains on the money. While the city of Dallas conveys a certain formality and self-conscious sophistication, Fort Worth revels in its "Cowtown" image. Both cities can claim their skyscrapers, but the creation of an impressive Dallas-type skyline seems not to have been a temptation to the developers of Fort Worth. There things lie closer to the horizon, as shown in the downtown cobbled streets. It is as if the connection with the land wants to be emphasized, or will not be shaken. Dallas and Fort Worth, then, cannot be called twin cities. Yet they lie only 33 miles apart, and, along with their suburbs, they make up "the Metroplex."

If you are visiting Dallas or Fort Worth, chances are you drove in on one of the interstates or flew into Dallas/Fort Worth (DFW) International Airport, which sits halfway between the cities. Although the airport is one of the largest in the world and entertaining in and of itself, this is Texas and "big" is where you start.

Downtown Dallas is easy to navigate by subway or on foot, unless you're braving the heat of summer. Most museums and cultural sites can be found within reasonable proximity to one another. I say, get a big-brimmed hat and a bottle of water and "cowboy it up"! You can walk from one end of downtown to the other in an hour.

The Dallas Arts District is 60 acres of museums, a performing arts center, and outdoor sculptures. Its centerpiece is the Dallas Museum of Art—a space that stretches more than a quarter of a million square feet. The museum's vastness stretches not only over its site but also across continents and eras. It features works from the Americas, Africa, Asia, the Pacific, and Europe. You will find paintings by Frida Kahlo and Frederic Edwin Church, and more Mondrians than in any other museum in the country. The famous Wendy and Emery Reves collection is installed in a setting that recreates the owner–donors' home on the French Riviera. Among its stars are van Gogh, Monet, and Renoir.

Before you get too far, stroll in the Nasher Sculpture Garden (still have your hat on?) adjacent to the Dallas Art Museum. This 2.4-acre site was designed by Renzo Piano, architect of the famed Centre Pompidou in Paris (see your Paris Art Tour), and displays work by artists such as Alexander Calder, Willem de Kooning, Barbara Hepworth, Joan Miró, Richard Serra, and Auguste Rodin.

In the same neck of the woods, you'll find something very different—the Trammel Crow Museum. Once a private collection, it has grown into one of the largest collections of Asian art in the American Southwest. More than 300 objects and works of art from India, Japan, and China (including deities, shrines, scrolls, and vases) are amassed in a 12,000-square-foot space.

As you walk south toward the center of downtown Dallas—finally in dire need of a water break—you will happily come upon Fountain Palace. The fountain, one of Dallas's most popular sites, bears a famous signature; it was designed by I. M. Pei, who created the pyramidal entrance to the Louvre. More than a million gallons of water leap and dance in rhythm, while 172 bubbler fountains shoot water high into the air. Cool. Actually, very cool.

Elsewhere in Dallas you'll find quirky and not-so-quirky museums, collections, and sites, including the American Museum of Miniature Arts (fantastic dollhouses, tiny toy soldiers, itty-bitty trains and cars); the African American Museum of Art, History, and Culture (the only one in the Southwest and the largest in the nation); the Meadows Museum (nicknamed "The Prado on the Prairie" with one of the major collections of Spanish art outside Spain); the Women's Museum: An Institute for the Future (an exhibit that focuses on contributions of women throughout American history); and Pioneer Plaza (the setting for 70 six-foot tall, bronze longhorn steers being driven across a stream by a team of cowboys and probably the largest bronze monument in the world).

LOUIS I. KAHN, Kimbell Museum, Fort Worth.

Copyright 2005 Kimbell Art Museum, Fort Worth, TX.

Speaking of longhorns, it will be the Longhorn Trolley that will steer you (pun intended) toward any of the three main districts that make up the metropolitan area of Fort Worth—the Cultural District, downtown/Sundance Square, and the Fort Worth Stockyards National Historic District. Some of the country's best small museums are lined up like ducks in a row in Fort Worth's Cultural District—the Kimbell Art Museum, the Amon Carter Museum, and the Modern Art Museum.

The Kimbell has, in fact, been called "America's best small museum." The initial funding was provided in the will of the industrialist Kay Kimbell, who called for a "first-class" museum in his name. In the 30 years since it opened its doors, the museum has amassed a diverse collection of art from antiquity to the modern, from Asia to Mesoamerica to Africa. It is best known, however, for its stunning examples of European painting and sculpture from the Renaissance through the twentieth century. You will see works by Caravaggio, El Greco, Vigée-Lebrun, Delacroix, Monet, Renoir, Cézanne, Leger, Miró, and more—wrapped in the extraordinary architecture of Louis I. Kahn, one of the significant modern architects of the twentieth century.

The Amon Carter Museum opened in 1961 as a niche collection of Western art that belonged to the Fort Worth publisher and philanthropist Amon G. Carter. The original 400 paintings have grown to more than 300,000 works of art, and curators have cast a wide aesthetic net to include all styles of American paintings, drawings, prints, photographs, and sculptures. More recently, the Carter expanded (tripled!) its exhibition space to do what some museums cannot afford to do—bring their treasures out of storage and into public view.

The nearby Modern Art Museum of Fort Worth amplifies the city's modern and American collections with its mission of collecting and presenting post–World War II art. The roster of artists in its permanent collection reads like a who's who in European and American art at midcentury and beyond: Pablo Picasso and Hans Hofmann; Jackson Pollock

and Willem de Kooning; Agnes Martin and Dan Flavin; Andy Warhol and Jean-Michel Basquiat; Bill Viola and Tony Oursler; the list goes on and on—at least 2,800 objects in all. But the permanent collection represents only a part of what the museum has to offer. Its vast interior (150,000 square feet) also provides ample space for changing installations of contemporary work in all mediums.

The Fort Worth Stockyards and downtown Fort Worth offer two distinct clusters of tourist sites. As the name suggests, the Stockyards have a long and distinct history. If you are in the mood for a close-up, look at how "Cowtown" got its name—including Cattleman's Walk, the Fort Worth Livestock Exchange, and the Cowtown (rodeo) Coliseum—this is your destination. If, on the other hand, the symphony or ballet or opera is your game, blaze your trail to downtown/Sundance Square and visit the Bass Performance Hall. Nancy Lee and Perry R. Bass donated the land for this remarkable space, and it was built by private donations to the tune of $67.5 million. Cowtown architecture it is not. The structure is modeled after the great opera houses of old Europe, complete with an 80-foot-diameter dome and two 48-foot angels flanking a bank of tall, arched windows on the facade. In a bow to pride and tradition, this neo–Beaux Arts design is rendered in homegrown Texas limestone.

Dallas and Fort Worth offer a study in contrasts, but they also share common ground. Both cities, their traditions and their cultural aspirations, aim to preserve their unique identities and balance those identities with awareness of the world and their place in the world—and, of course, in Texas.

BASS PERFORMANCE HALL, FORT WORTH, SHOWING THE 48-FOOT ANGELS.

Hedrich-Blessing Ltd. Courtesy Bass Performance Hall, Fort Worth, TX.

 To continue your tour and learn more about Dallas/Fort Worth, go to our website.

THE AGE OF BAROQUE

Nature, and Nature's laws lay hid in night.
God said: "Let Newton be!" and all was Light!

—Alexander Pope

The Baroque period spans roughly the years from 1600 to 1750. Like the Renaissance, which preceded it, the Baroque period was an age of genius in many fields of endeavor. Sir Isaac Newton derived laws of motion and of gravity that have only recently been modified by the discoveries of Einstein. The achievements of Galileo and Kepler in astronomy brought the vast expanses of outer space into sharper focus. The Pilgrims also showed an interest in motion when, in 1620, they put to sea and landed in what is now Massachusetts. Our founders had a certain concern for space as well—they wanted as much as possible between themselves and their English oppressors.

The Baroque period in Europe included a number of post-Renaissance styles that do not have all that much in common. On the one hand, there was a continuation of the Classicism and naturalism of the Renaissance. On the other, a far more colorful, ornate, painterly, and dynamic style was born. If one name had to

be applied to describe these different directions, it is just as well that that name is **Baroque**—for the word is believed to derive from the Portuguese *barroco,* meaning "irregularly shaped pearl." The Baroque period was indeed irregular in its stylistic tendencies, and it also gave birth to some of the most treasured pearls of Western art.

Motion and *space* were major concerns of the Baroque artists, as they were of the scientists of the period. The concept of *time,* a dramatic use of *light,* and a passionate *theatricality* complete the list of the five most important characteristics of Baroque art, as we shall see throughout this chapter.

THE BAROQUE PERIOD IN ITALY

The Baroque era was born in Rome, some say in reaction to the spread of Protestantism resulting from the **Reformation.** Even though many areas of Europe were affected by the new post-Renaissance spirit (Map 16-1), it was more alive and well and influential in Italy than elsewhere—partly because of the strengthening of the papacy in religion, politics, and patronage of the arts. During the Renaissance, the principal patron of the arts was the infamous Pope Julius II. However, during the Baroque era, a series of powerful popes—Paul V, Urban VIII, Innocent X, and Alexander VII—assumed this role. The Baroque period has been called the Age of Expansion, following the Renaissance Age of Discovery, and this expansion is felt keenly in the arts.

16-1 Plan of St. Peter's Cathedral, Rome (1605–1613).

St. Peter's

The expansion and renovation of St. Peter's Cathedral in Rome (Fig. 16-1) is an excellent project with which to begin our discussion of the Baroque in Italy, for three reasons: The building expresses the ideals of the Renaissance, stands as a hallmark of the Baroque style, and brings together work by the finest artists of both periods—Michelangelo and Bernini.

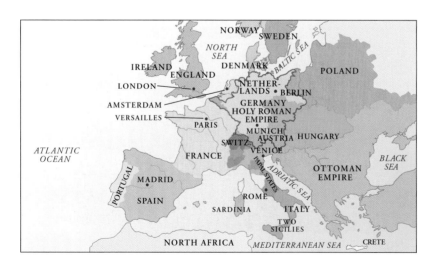

Map 16-1 Europe (mid-18th century).

The major change in the structure of St. Peter's was from the central Greek cross plans of Bramante and Michelangelo to a longitudinal Latin cross plan. Thus, three bays were added to the nave between the domed crossing and the facade. The architect Carlo Maderno was responsible for this task as well as the design for the new facade, but the job of completing the project fell into the hands of the most significant sculptor of the day, Gianlorenzo Bernini.

Gianlorenzo Bernini

Gianlorenzo Bernini (1598–1680) made an extensive contribution to St. Peter's as we see it today, both to the exterior and the interior. In his design for the **piazza** of St. Peter's, visible in the aerial view (Fig. 16-2), Bernini had con-

structed two expansive arcades extending from the facade of the church and culminating in semicircular "arms" enclosing an oval space. This space, the piazza, was divided into trapezoidal "pie sections," in the center of which rises an Egyptian obelisk. The Classical arcades, true in details to the arts that inspired them, stretch outward into the surrounding city, as if to welcome worshipers and cradle them in spiritual comfort. The curving arms, or arcades, are composed of two double rows of columns with a path between, ending in Classical pedimented "temple fronts." In the interior of the cathedral, beneath Michelangelo's great dome, Bernini designed a bronze canopy to cover the main altar. In the apse, Bernini combined architecture, sculpture, and stained glass in a brilliantly golden display for the Cathedra Petri,

16-2 GIANLORENZO BERNINI.
Piazza of St. Peter's (St. Peter's Square, Vatican State).
Copyright Art Resource, New York.

Art Meets History: The Funeral of a Pope

Karol Wojtyla died in his Vatican apartment on April 2, 2005. He was 84 years old and reigned over the Catholic Church as Pope John Paul II for 26 years—the second longest papacy in history. His death set into motion a series of rituals that had been fixed for centuries, from the destruction of his papal ring to the sequestering of the cardinals who would, in secrecy, elect his successor. The world bore witness to many if not most of these traditions as they unfolded before dignitaries, pilgrims, and the international media. And as an art appreciation and art history professor, I told all of my students, "Watch as much as you can." History was being made against the backdrop of the very art and architecture that they were studying—what *you* are studying in your Renaissance and Baroque chapters. For the most part, in our classes, we look at art outside its actual context, analyzing projected images that have the same dimensions regardless of the actual size of the actual art. We view photographs of works of architecture vast in scale with no sense whatsoever of what it might be like to *be* in those spaces. Regardless of one's religious beliefs, regardless of one's views on the teachings and actions of this particular pope, this meeting of history and art provided an opportunity to see—in context and on-site and in scale—some of the most spectacular treasures of Rome and the Vatican.

This brief portfolio of images was chosen to illustrate things that a student would not ordinarily see, even on a trip to Rome. We may study the design of Bernini's colonnades, extending from Maderno's facade and scooping around his elliptical piazza (Fig. 16-3). But how much better did we grasp Bernini's concept of the arms of the church extending to embrace its fold when we saw throngs of pilgrims cradled in that space as they paid final respects to their beloved pope? The elaborate frescoes of the Clementine Hall (Fig. 16-4) became for us more than disembodied slides. What's more, they are works rarely if ever seen by the public, for the hall—part of the Papal Palace near St. Peter's Basilica—is used only by the pope for formal ceremonies and private receptions . . . and for the private viewing of his body in death before it is moved to St. Peter's.

16-3 GIANLORENZO BERNINI.
Piazza of St. Peter's Cathedral, Rome
(1605–1613).
Bernini's piazza and colonnades of
St. Peter's with crowds assembling for
funeral Mass for Pope John Paul II,
April 8, 2005. Maderno's facade and
Michelangelo's dome can also be seen.
© Peter Turnley/Corbis.

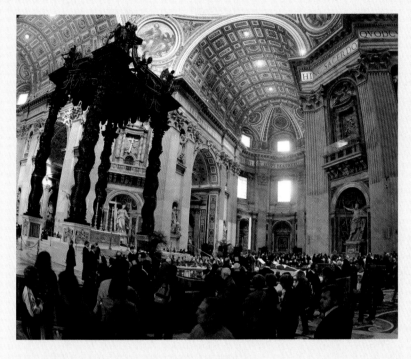

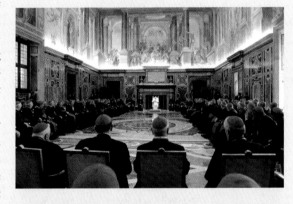

16-4 St. Peter's Basilica, Rome.
Pope John Paul II lying in state at the
foot of Bernini's bronze canopy (left)
in the transept of St. Peter's Basilica,
April 6, 2005. Bernini's *St. Longinus*
can be seen in niche at right.
Claudio Peri/EPA/Landov.

16-5 Clementine Hall, Papal Palace, Rome.
Pope Benedict XVI speaks during
an audience with the cardinals in the
Clementine Hall in the Vatican,
April 22, 2005.
Osseratore Romano/EPA/Landov.

And how to comprehend the vastness of the interior of St. Peter's Basil-
ica itself? As we viewed the tens upon tens of thousands of diminutive
mourners solemnly filing past the funeral bier at the foot of Bernini's colossal
bronze canopy; as we looked upward to Michelangelo's expansive, envelop-
ing dome and around the altar at the towering sculptures of saints standing
watch (Fig. 16-5); as we took in the sweep of the seemingly endless nave—
only then did we grasp the relationship between the magnitude of the event
and the monumentality of the setting.

And as the reign of John Paul II ended and the election of his successor
proceeded, the world's attention shifted to one of the Vatican's most beloved
landmarks—the Sistine Chapel (see Fig. 15-21). The vastness of St. Peter's
was supplanted by the intimacy of the Sistine. It was there that the College
of Cardinals spent hours in prayer and reflection as they elected the next
pope through a series of secret ballots. Isolated from the outside world and
surrounded by Michelangelo's scenes from the Bible and his terrifying Last
Judgment, it was within the walls of one of art history's most treasured
monuments that these men themselves judged who would be the next
among them to make history (Fig. 16-6). ■

16-6 Cardinal Joseph Ratzinger leading Mass in the transept
of St. Peter's Basilica.
Mass held April 18, 2005, before cardinals sequestered
themselves for their conclave. In the background is
Francesco Mochi's sculpture *Saint Veronica* (1629).
Photo by Pier Paolo Cito/Associated Press.

16-7 GIANLORENZO BERNINI.
The Ecstasy of St. Theresa (1645–1652).
Marble. Height of group: approx. 11′6″.
Cornaro Chapel, Santa Maria della Vittoria, Rome.
Copyright Canali Photobank, Milan.

ture: motion (in this case, implied), a different way of looking at space, and the introduction of the concept of time. The Davids by Donatello and Verrocchio were figures at rest after having slain their Goliaths. Michelangelo, by contrast, presented David before the encounter, with the tension and emotion evident in every vein and muscle, bound to the block of marble that had surrounded the figure. Bernini does not offer David before or after the fight, but instead *in the process* of the fight. He has introduced an element of time in his work. As in *The Last Supper* by Tintoretto (see Fig. 15-29), we sense that David would have used his weapon if we were to look away and then back. We, the viewers, are forced to complete the action that David has begun for us.

A new concept of space comes into play with David's positioning. The figure no longer remains still in a Classical contrapposto stance but rather extends *into* the surrounding space away from a vertical axis. This movement outward from a central core forces the viewer to take into account both solids and voids—that is, both the form and the spaces between and surrounding the forms—in order to appreciate the complete composition. We must move around the work in order to understand it fully, and as we move, the views of the work change radically.

We may compare the difference between Michelangelo's *David* and Bernini's *David* to the difference between Classical and Hellenistic Greek sculpture. The movement out of Classical art into Hellenistic art was marked by an extension of the figure into the surrounding space, a sense of implied movement, and a large degree of theatricality. The time-honored balance between emotion and restraint coveted by the Classical Greek artist as well as the Renaissance master had given way in the Hellenistic and Baroque periods to unleashed passion.

Uncontrollable passion and theatrical drama might best describe Bernini's *The Ecstasy of St. Theresa* (Fig. 16-7), a sculptural group executed for the chapel of the Cornaro family in the church of Santa Maria della Vittoria in Rome. The sculpture commemorates a mystical event involving St. Theresa, a Carmelite nun who believed that a pain in her

or Throne of St. Peter. Through his many other sculptural contributions to St. Peter's, commissioned by various popes, Bernini's reputation as a master is solidified.

Bernini's *David* (see Fig. 15-27) testifies to the artist's genius and illustrates the dazzling characteristics of Baroque sculpture. This David is remarkably different from those of Donatello, Verrocchio, and Michelangelo. Three of the five characteristics of Baroque art are present in Bernini's sculp-

It's pure mockery of realism. It's a lie. It's a stage setting. The same as . . . in films.
Put me a spotlight to the right and another on the left.

—Pablo Picasso, when asked whether Caravaggio was a realist

side was caused by an angel of God stabbing her repeatedly with a fire-tipped arrow. Her response combined pain and pleasure, as conveyed by the sculpture's submissive swoon and impassioned facial expression. Bernini summoned all of his sculptural powers to execute these figures and combined the arts of architecture, sculpture, and painting to achieve his desired theatrical effect. Notice the way in which Bernini described vastly different textures with his sculptural tools: the roughly textured clouds, the heavy folds of St. Theresa's woolen garment, the diaphanous "wet-look" drapery of the angel. "Divine" rays of glimmering bronze—illuminated by a hidden window—shower down on the figures, as if emanating from the painted ceiling of the chapel. Bernini enhanced this self-conscious theatrical effect by including marble sculptures in the likenesses of members of the Cornaro family in theater boxes to the left and right. They observe, gesture, and discuss the scene animatedly as would theatergoers. The fine line between the rational and the spiritual that so interested the Baroque artist was presented by Bernini in a tactile yet illusionary masterpiece of sculpture.

Caravaggio

This theatrical drama and passion had its counterpart in Baroque painting, as can be seen in the work of Michelangelo de Merisi, called Caravaggio (1573–1610). Unlike Bernini's somewhat idealized facial and figural types, the models for Caravaggio came directly from those around him. Whereas Bernini could move in the company of popes and princes, Caravaggio was more comfortable with the outcasts of society. In a way he was one of them, having a police record for violent assaults himself. Caravaggio chose lower-class models for his shocking painting *The Conversion of St. Paul* (Fig. 16-8). The artist marked the dramatic moment when Paul, persecuting Christians in the name of the Roman

16-8 CARAVAGGIO.
The Conversion of St. Paul (1600–1601).
Oil on canvas. 90″ × 69″.
Santa Maria del Popolo, Rome/Scala/Art Resource, New York.

Empire, was confronted with his actions and, in response, changed the course of his life. Thrown from his horse and blinded by a bright light, Paul professed to have heard a voice asking why he engaged in murderous persecution. The voice, that of Jesus according to Paul, directed him to proceed to Damascus, where he was cured of his blindness and began to preach the tenets of Christianity. Very much in the Baroque spirit, Caravaggio chose to focus on the exact moment when Paul was thrown from his horse. He lies flat on his back, eyelids shut, arms groping in the darkness of his blindness. Paul looks as if he might be trampled by his horse, except for the rugged yet calming hands of a man nearby. A piercing light flashes upon the scene, spotlighting certain parts and casting others into the night, resulting in an exaggerated chiaroscuro called tenebrism. **Tenebrism,** translated as "dark manner," is characterized by an often small and concentrated light source within the painting or what appears to be an external "spotlight" directed at specific points in the composition. The effect is harsh and theatrical, as if the events were playing out onstage and being lit from above. The lighting technique of tenebrism was used broadly by Italian Baroque painters but is seen throughout European painting at this time.

Artemisia Gentileschi

One of Caravaggio's foremost contemporaries was Artemisia Gentileschi (1593–c. 1652). Her father, the painter Orazio Gentileschi, who himself enjoyed much success in Rome, Genoa, and London, recognized and supported Artemisia's talents. Although one of her father's choices for her ended in

disaster—an apprenticeship with a man who ultimately raped her—Artemisia came to develop a personal, dramatic, and impassioned Baroque style. Her work bears similarities to that of Caravaggio, her own father, and others working in Italy at this moment, but it often stands apart in the emphatic rendering of its content or in its reconsideration and revision of subjects commonly represented by sixteenth- and seventeenth-century artists.

Consider, for example, the roughly contemporary paintings of *Judith and Holofernes* by Caravaggio (Fig. 16-9) and *Judith Decapitating Holofernes by* Gentileschi (Fig. 16-10). Both works reference a biblical story of the heroine Judith, who rescues her oppressed people by decapitating the tyrannical Assyrian general Holofernes. She steals into his tent under the cover of night and pretends to respond to his seductive overtures. When he is besotted, with her and with drink, she uses his own sword to cut off his head. Both paintings are prime examples of the Baroque style—vibrant palette, dramatic lighting, an impassioned subject heightened to excess by our coming face-to-terrified-face with a man at the precise moment of his bloody execution. But

16-9 CARAVAGGIO.
Judith and Holofernes (c. 1598).
Oil on canvas. Approx. 56¾″ × 76¾″.
Galleria Nazionale d'Arte Antica, Palazzo Barberini, Rome/Scala/Art Resource, New York.

16-10 ARTEMISIA GENTILESCHI.
Judith Decapitating Holofernes (c. 1620).
Oil on canvas. 72½″ × 55¾″.
Uffizi Gallery, Florence/Scala/Art Resource, New York.

16-11 BACICCIO.
Triumph of the Sacred Name of Jesus (1676–1679).
Ceiling fresco.
Il Gesu, Rome. Copyright Art Resource, New York.

consider the differences. How would you compare Gentileschi's image of Judith with Caravaggio's? Look at the delicacy of Judith's demeanor and the disgust in her facial expression. Now observe Gentileschi's Judith—determined, strong, physically and emotionally committed to the task. In Caravaggio's painting, Holofernes is caught unaware and falls victim in his compromised, drunken state. Gentileschi's tyrant snaps out of his wine-induced stupor and struggles for his life. He pushes and fights and is ultimately overpowered by a righteous woman. What, if any, gender differences can you interpret in these renderings?

Gentileschi's *Judith Decapitating Holofernes* is one of her most studied and violent paintings. She returned to the subject repeatedly in many different versions, leading some historians to suggest that her seeming obsession with the story signified her personal struggle in the wake of her rape and subsequent trial of her accuser, during which *she* was tortured in an attempt to verify the truth of her testimony. Do you think that this context is essential to understanding Gentileschi's work?

Baroque Ceiling Decoration

The Baroque interest in combining the arts of painting, sculpture, and architecture found its home in the naves and domes of churches and cathedrals, as artists used the three media to create an unsurpassed illusionistic effect. Unlike Renaissance ceiling painting, as exemplified by Michelangelo's decoration for the Sistine Chapel, the space was not divided into "frames" with individual scenes. Rather, the Baroque artist created the illusion of a ceiling vault open to the heavens with figures flying freely in and out of the church. Baciccio's *Triumph of the Sacred Name of Jesus*

(Fig. 16-11) is an energetic display of figures painted on plaster that spill out beyond the gilded frame of the ceiling's illusionistic opening. The trompe l'oeil effect is achieved by combining these painted figures with white stucco–modeled sculptures and a gilded stucco ceiling. Attention to detail is remarkable, from the blinding light of the heavens to the deep shadows that would be cast on the ceiling by the painted forms. Saints and angels fly upward toward the light while sinners are banished from the heavens to the floor of the church. Artists like Baciccio and their patrons spared no illusionistic device to create a total, mystical atmosphere.

Susannah and the Elders by Tintoretto and Gentileschi

Artemisia Gentileschi once said, in reaction to being cheated out of a potentially lucrative commission, "If I were a man, I can't imagine it would have turned out this way." How particularly apt a statement to keep in mind as we consider these works on the subject of Susannah and the Elders.

The story of Susannah can be found in the book of Daniel in the Old Testament, or Hebrew Bible. Susannah was the wife of Joachim, a wealthy Babylonian Jew whose home was frequently visited by judges and elders of the community. Susannah was as pious as she was enchantingly beautiful, and when she rejected the sexual advances of two such elders, they accused her of committing adultery in order to retaliate. Indeed, Susannah was put on trial for these fictitious accusa-

tions, was found guilty, and would have been stoned to death were it not for the appearance in the court of Daniel himself. God had answered Susannah's prayers and sent her a lawyer of sorts. Daniel cross-examined the elders individually, poking holes in their contrived testimony. The tables turned: Susannah was saved and the elders were put to death for bearing false witness.

With these details in mind, how would Tintoretto and Gentileschi tell this story pictorially? The choices they made are very different, and they are illuminating. Tintoretto's rendering of Susannah (Fig. 16-12) befits her status. Her beauty and sensuality are enhanced by a show of precious possessions—perfume bottles, jewels and pearls, silken cloth.

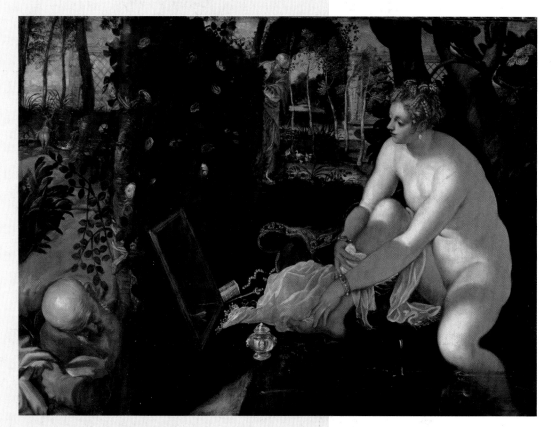

16-12 JACOPO TINTORETTO.
Susannah and the Elders (1555–1556).
Oil on canvas.
Kunsthistorisches Museum, Vienna, Austria/Erich Lessing/Art Resource, New York.

Bathing in the surrounds of a sumptuous, fertile garden, Susannah admires herself in a mirror propped up against a screen covered in vines and flowers. Our focus is entirely on her, as are the prying eyes of one of the elders whose bald head pokes around the screen in the lower left. Susannah, *pious?* Would we ever read that attribute in Tintoretto's image? Is Tintoretto suggesting that Susannah played some role in her seduction? Is he turning us, the spectators, into voyeurs such as those who menaced her?

Gentileschi's *Susannah and the Elders* (Fig. 16-13) tells the same story, but how? Tintoretto's deep, lush, garden setting, where Susannah lounges at her leisure, has been replaced by a compressed space in which she twists and turns her body to fend off the threatening, sleazy elders. There is nothing sensual about her contorted face and her nakedness against the harsh, cold stone. As one of the men gestures "Shhhhh! You better not say a word!" Susannah finds herself trapped in a claustrophobic space—between her seducers, the stone, and us. If our eyes focus on Susannah, they focus on her anguish.

Faced with a narrative to be rendered, artists always make choices. Ask yourselves: What are those choices? Why, in my opinion, did the artist make them? Aside from the story, or *text* of the work of art, is there some other message that the artist is trying to convey (that is, a *subtext*)? What do these choices say about the artist, or the patron, or the gender ideologies in place in the society that produced the work? ■

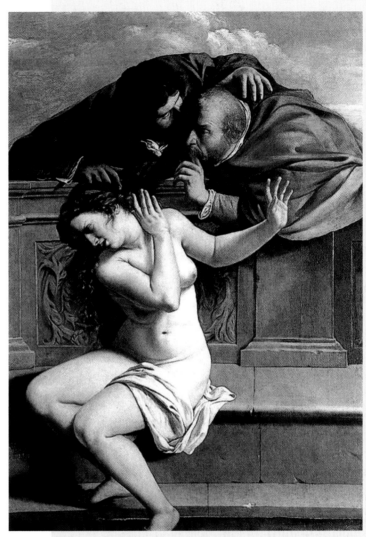

16-13 ARTEMISIA GENTILESCHI.
Susannah and the Elders (1610).
Oil on canvas. 66⅞″ × 46⅞″.
Private collection.

Francesco Borromini

Although it is hard to imagine an architect incorporating the Baroque elements of motion, space, and light in buildings, this was accomplished by the great seventeenth-century architect Francesco Borromini (1599–1667). His San Carlo alle Quattro Fontane (Fig. 16-14) shows that the change from Renaissance to Baroque architecture was one from the static to the organic. Borromini's facade undulates in implied movement complemented by the concave entablatures of the bell towers on the roof. Light plays across the plane of the facade, bouncing off the engaged columns while leaving the recessed areas in darkness. The stone seems to breathe

16-14 FRANCESCO BORROMINI.
San Carlo alle Quatro Fontane, Rome (1665–1667).
Copyright Canali Photobank, Milan.

because of the **plasticity** of the design and the innovative use of light and shadow. The interior is equally alive, consisting of a large oval space surrounded by rippling concave and convex walls. For the first time since we examined the Parthenon (see Fig. 13-9), we appreciate a building first as sculpture and only second as architecture.

THE BAROQUE PERIOD OUTSIDE ITALY

Baroque characteristics were found in the art of other areas of Europe also. Artists of Spain and Flanders adopted the Venetian love of color, and with their application of paint in loosely brushed swaths, they created an energetic motion in their compositions. Northern artists had always been interested in realism, and during the Baroque period they carried this emphasis to an extreme and used innovative pictorial methods to that end. Paintings of everyday life and activities became the favorite subjects of Dutch artists, who followed in Bruegel's footsteps and perfected the art of genre painting. The Baroque movement also extended into France and England, but there it often manifested itself in a strict adherence to Classicism. The irregularity of styles suggested by the term *baroque* is again apparent.

Spain

Spain was one of the wealthiest countries in Europe during the Baroque era—partly because of the influx of riches from the New World—and the Spanish court was lavish in its support of the arts. Painters and sculptors were imported from different parts of Europe for royal commissions, and native talent was cultivated and treasured.

Diego Velázquez

Diego Velázquez (1599–1660) was born in Spain and rose to the position of court painter and confidant of King Philip IV. Although Velázquez relied on Baroque techniques in his use of Venetian colors, highly contrasting lights and darks, and a deep, illusionistic space, he had contempt for the idealized images that accompanied these elements in the Italian art of the period. Like Caravaggio, Velázquez preferred to use common folk as models to assert a harsh realism in his canvases. Velázquez brought many a mythological subject down to earth by portraying ordinary facial types and naturalistic attitudes in his principal characters. Nor did he restrict this preference to paintings of the masses. Velázquez adopted the same genre format in works involving the royal family, such

Las Meninas, what a picture! What realism! There you have the true painter of reality.

—Pablo Picasso

as the famous *Las Meninas* (Fig. 16-15). The huge canvas is crowded with figures engaged in different tasks. *Las meninas,* "the maids of honor," are attending the little princess Margarita, who seems dressed for a portrait-painting session. She is being entertained by the favorite members of her entourage, including two dwarfs and an oversized dog. We suspect that they are keeping her company while the artist, Velázquez, paints before his oversized canvas.

Is Velázquez, in fact, supposed to be painting exactly what we see before us? Some have interpreted the work in this way. Others have noted that Velázquez would not be standing behind the princess and her attendants if he were painting them. Moreover, on the back wall of his studio, we see the mirror images of the king and queen standing next to one another with a red drape falling behind. Because we do not actually see them in the flesh, we may assume that they are standing in the viewer's position, before the canvas and the artist. Is the princess being given a few finishing touches before joining her parents in a family portrait? We cannot know for sure. The reality of the scene has been left a mystery by Velázquez, just as has the identity of the gentleman observing the scene from an open door in the rear of the room. It is interesting to note the prominence of the artist in this painting of royalty. It makes us aware of his importance to the court and to the king in particular. Recall the portrait of Raphael in *The School of Athens* (see Fig. 15-20). Raphael's persona is almost furtive by comparison.

Velázquez pursued realism in technique as well as in subject matter. Building upon the Venetian method of painting, Velázquez constructed his forms from a myriad of strokes that capture light exactly as it plays over a variety of surface textures. Upon close examination of his paintings (Fig. 16-16), we find small distinct

16-15 DIEGO VELÁZQUEZ.
Las Meninas (The Maids of Honor) (1656).
Oil on canvas. 10′5″ × 9′3¾″.
Prado Museum, Madrid. Copyright Edimedia/Corbis.

16-16 DIEGO VELÁZQUEZ.
Las Meninas (detail).
Museo del Prado, Madrid, Spain/
Scala/Art Resource, New York.

strokes that hover on the surface of the canvas, divorced from the very forms they are meant to describe. Yet from a few feet away, the myriad brushstrokes evoke an overall *impression* of silk or fur or flowers. Velázquez's method of dissolving forms into small, roughly textured brushstrokes that re-create the play of light over surfaces would be the foundation of a movement called **Impressionism** some two centuries later. In his pursuit of realism, Velázquez truly was an artist before his time.

Flanders

After the dust of Martin Luther's Reformation had settled, the region of Flanders was divided. The northern sections, now called the Dutch Republic (present-day Holland), accepted Protestantism, whereas the southern sections, still called Flanders (present-day Belgium), remained Catholic. This separation more or less dictated the subjects that artists rendered in their works. Dutch artists painted scenes of daily life, carrying forward the tradition of Bruegel, whereas Flemish artists continued painting the religious and mythological scenes already familiar to us from Italy and Spain.

Peter Paul Rubens

Even the great power and prestige held by Velázquez were exceeded by the Flemish artist Peter Paul Rubens (1577–1640). One of the most sought-after artists of his time, Rubens was an ambassador, diplomat, and court painter to dukes and kings. He ran a bustling workshop with numerous assistants to help him complete commissions. Rubens's style combined the sculptural qualities of Michelangelo's figures with the painterliness and coloration of the Venetians. He also emulated the dramatic chiaroscuro and theatrical presentation of subject matter we found in the Italian Baroque masters. Much as had Dürer, Rubens admired and adopted from his southern colleagues. Although Rubens painted portraits, religious subjects, and mythological themes, as well as scenes of adventure, his canvases were always imbued with the dynamic energy and unleashed passion we link to the Baroque era.

In *The Rape of the Daughters of Leucippus* (Fig. 16-17), Rubens recounted a tale from Greek mythology in which two mortal women were seized by the twin sons of Zeus, Castor and Pollux. The action in the composition is described by the intersection of strong diagonals and verticals that stabilize the otherwise unstable composition. Capitalizing on the Baroque "stop-action" technique, which depicts a single moment in an event, Rubens placed his struggling, massive forms within a diamond-shaped structure that rests in the foreground on a single point—the toes of a single man and woman. Visually, we grasp that all this energy cannot be supported on a single point, so we infer continuous movement. The action has been pushed up to the picture plane, where the viewer is confronted with the in-

16-17 PETER PAUL RUBENS.
The Rape of the Daughters of Leucippus (1617).
Oil on canvas. 7′3″ × 6′10″.
Alte Pinakothek, Munich. Copyright Bridgeman Art Library.

tense emotion and brute strength of the scene. Along with these Baroque devices, Rubens used color and texture much in the way the Venetians used it. The virile sun-tanned arms of the abductors contrast strongly with the delicately colored flesh of the women. The soft blond braids that flow outward under the influence of all of this commotion correspond to the soft, flowing manes of the overpowering horses.

Holland

The grandiose compositional schemes and themes of action executed by Rubens could not have been further removed from the concerns and sensibilities of most seventeenth-century Dutch artists. Whereas mysticism and religious naturalism flourished in Italy, Flanders, and Spain amidst the rejection of Protestantism and the invigorated revival of Catholicism, artists of the Low Countries turned to secular art, abiding by the Protestant mandate that humans not create "false idols." Not only did artists turn to scenes of everyday life but the collectors of art were themselves everyday folk. In the Dutch quest for the establishment of a middle class, aristocratic patronage was lost and artists were forced to "peddle" their wares in the free market. Landscapes, still lifes, and genre paintings were the favored canvases, and realism was the word of the day. Although the subject matter of Dutch artists differed radically from that of their colleagues elsewhere in Europe, the spirit of the Baroque, with many, if not most, of its artistic characteristics, was present in their work.

Rembrandt van Rijn

The golden-toned, subtly lit canvases of Rembrandt van Rijn (1606–1669) possess a certain degree of timelessness. Rembrandt concentrates on the personality of the sitter or the psychology of a particular situation rather than on surface characteristics. This introspection is evident in all of Rembrandt's works, whether religious or secular in subject, landscapes or portraits, drawings, paintings, or prints.

Rembrandt painted a great number of self-portraits that offer us an insight into his life and personality. In a self-portrait at the age of 46 (Fig. 16-18), Rembrandt paints an image of himself as a self-confident, well-respected, and sought-after artist who stares almost impatiently out toward the viewer. It is as if he had been caught in the midst of

working and has but a moment for us. It is a powerful image, with piercing eyes, thoughtful brow, and determined jaw that betray a productive man who is more than satisfied with his position in life. All of this may seem obvious, but notice how few clues he gives us to reach these conclusions about his personality. He stands in an undefined space with no props that reveal his identity. The figure itself is cast into darkness; we can hardly discern his torso and hands resting in the sash around his waist. The penetrating light in the canvas is reserved for just a portion of the artist's face. Rembrandt gives us a minute fragment with which he beckons us to complete the whole. It is at once a mysterious and revealing portrayal that relies on a mysterious and revealing light.

16-18 REMBRANDT VAN RIJN.
Self-Portrait (1652).
Oil on canvas. 45" × 32".
Kunsthistorisches Museum, Vienna. Copyright Art Resource, New York.

16-19 REMBRANDT VAN RIJN.
Syndics of the Drapers' Guild (1661–1662).
Oil on canvas. 72⅞″ × 107⅛″.
Rijksmuseum, Amsterdam. Copyright Rijksmuseum, Amsterdam.

Rembrandt also painted large group portraits. In his *Syndics of the Drapers' Guild* (Fig. 16-19), which you may recognize from the cover of Dutch Masters' cigar boxes, we, the viewers, become part of a scene involving Dutch businessmen. Bathed in the warm light of a fading sun that enters the room through a hidden window to the left, the men appear to be reacting to the entrance of another person. Some rise in acknowledgment. Others seem to smile. Still others gesture to a ledger as if to explain that they are gathering to "go over the books." Even though the group operates as a whole, the portraits are highly individualized and themselves complete. As in his self-portrait, Rembrandt concentrates his light on the heads of the sitters, from which we,

the viewers, gain insight into their personalities. The haziness that surrounds Rembrandt's figures is born from his brushstrokes and his use of light. Rembrandt's strokes are heavily loaded with pigment and applied in thick impasto. As we saw in the painterly technique of Velázquez, Rembrandt's images are more easily discerned from afar than from up close. As a matter of fact, Rembrandt is reputed to have warned viewers to keep their "nose" out of his painting because the smell of paint was bad for them. We can take this to mean that the technical devices Rembrandt used to create certain illusions of realism are all too evident from the perspective of a few inches. Above all, Rembrandt was capable of manipulating light. His is a light that alternately

I'd give the whole of Italian painting for Vermeer of Delft. There's a painter who simply said what he had to say without bothering about anything else. None of these mementos of antiquity for him.

—Pablo Picasso

constructs and destructs, that alternately bathes and hides from view. It is a light that can be focused as unpredictably, and that shifts as subtly, as the light we find in nature.

Although Rembrandt was sought after as an artist for a good many years and was granted many important commissions, he fell victim to the whims of the free market. The grand master of the Dutch Baroque died at the age of 63, out of fashion and penniless.

Jan Vermeer

If there is a single artist who typifies the Dutch interest in painting scenes of daily life, the commonplace narratives of middle-class men and women, it is Jan Vermeer (1632–1675). Although he did not paint many pictures and never strayed from his native Delft, his precisely sketched and pleasantly colored compositions made him well respected and influential in later centuries.

Young Woman with a Water Jug (Fig. 16-20) exemplifies Vermeer's subject matter and technique. In a tastefully underfurnished corner of a room in a typical middle-class household, a woman stands next to a rug-covered table, grasping a water jug with one hand and, with the other, opening a stained-glass window. A blue cloth has been thrown over a brass and leather chair, a curious metal box sits on the table, and a map adorns the wall. At once we are presented with opulence and simplicity. The elements in the composition are perfectly placed. One senses that their position could not be moved even a fraction of an inch without disturbing the composition. Pure colors and crisp lines grace the space in the painting rather than interrupt it. Every item in the painting is of a simple, almost timeless form and corresponds to the timeless serenity of the porcelain-like image of the woman. Her simple dress and starched collar and bonnet epitomize grace and serenity. We might not see this as a Baroque composition if it were not for three things: a single source of light bathing the elements in the composition, the genre subject, and a bit of mystery surrounding the moment

16-20 JAN VERMEER.
Young Woman with a Water Jug (c. 1665).
Oil on canvas. 18″ × 16″.
The Metropolitan Museum of Art, New York. Henry G. Marquand, 1889. Marquand Collection (89.15.21). Copyright 1993 The Metropolitan Museum of Art, New York.

captured by Vermeer. What is the woman doing? She has opened the window and taken a jug into her hand at the same time, but we will never know for what purpose. Some have said that she may intend to water flowers at a window box. Perhaps she was in the midst of doing something else and paused to investigate a noise in the street. Vermeer gives us a curious combination of the momentary and the eternal in this almost photographic glimpse of everyday Dutch life.

France

During the Baroque period, France, under the reign of the "sun king," Louis XIV, began to replace Rome as the center of the art world. The king preferred Classicism. Thus did the country, and painters, sculptors, and architects alike created works in this vein. Louis XIV guaranteed adherence to Classicism by forming academies of art that perpetuated this style. These academies were art schools of sorts, run by the state, whose faculties were populated by leading proponents of the Classical style.

When we examine European art during the Baroque period, we thus perceive a strong stylistic polarity. On the one hand, we have the exuberant painterliness and high drama of Rubens and Bernini, and on the other, a reserved Classicism that hearkens back to Raphael.

Nicolas Poussin

The principal exponent of the Classical style in French painting was Nicolas Poussin (1594–1665). Although he was born in France, Poussin spent much of his life in Rome, where he studied the works of the Italian masters, particularly Raphael and Titian. Although his *Rape of the Sabine Women* (Fig. 16-21) was painted four years before he was summoned back to France by the king, it illustrates the Baroque Classicism that Poussin would bring to his native

16-21 NICOLAS POUSSIN.
The Rape of the Sabine Women (c. 1636–1637).
Oil on canvas. $60\frac{7}{8}''\times82\frac{5}{8}''$.

The Metropolitan Museum of Art, New York. Harris Brisbane Dick Fund, 1946 (46.160). Copyright 1992 The Metropolitan Museum of Art, New York.

The subject or topic should be great, such as battles, heroic actions, and divine matters.

—Nicolas Poussin

country. The flashy dynamism of Bernini and Rubens gives way to a more static, almost staged motion in the work of Poussin. Harshly sculptural, Raphaelesque figures thrust in various directions, forming a complex series of intersecting diagonals and verticals. The initial impression is one of chaos, of unrestrained movement and human anguish. But as was the case with the Classical Greek sculptors and Italian Renaissance artists, emotion is always balanced carefully with restraint. For example, the pitiful scene of the old woman in the foreground, flanked by crying children, forms part of the base of a compositional triangle that stabilizes the work and counters excessive emotion. If one draws a vertical line from the top of her head upward to the top border of the canvas, one encounters the apex of this triangle, formed by the swords of two Roman abductors. The sides of the triangle, then, are formed by the diagonally thrusting torso of the muscular Roman in the right foreground, and the arms of the Sabine women on the left, reaching hopelessly into the sky. This compositional triangle, along with the Roman temple in the right background that prevents a radically receding space, are Renaissance techniques for structuring a balanced composition. Poussin used these, along with a stagelike, theatrical presentation of his subjects, to reconcile the divergent styles of the harsh Classical and the vibrant Baroque.

Polar opposites in style occur in other movements throughout the history of art. It will be important to re-member this aspect of the Baroque, because in later centuries we will encounter the polarity again, among artists who divide themselves into the camps Poussiniste and Rubeniste.

Versailles

The king's taste for the Classical extended to architecture, as seen in the Palace at Versailles (Fig. 16-22). Originally the site of the king's hunting lodge, the palace and surrounding area just outside Paris were converted by a host of artists, architects, and landscape designers into one of the grandest monuments to the French Baroque. In their tribute to Classicism, the architects Louis Le Vau (1612–1670) and Jules Hardouin-Mansart (1646–1708) divided the horizontal sweep of the facades into three stories. The structure was then divided vertically into three major sections, and these were in turn subdivided into three additional sections. The windows march along the facade in a rhythmic beat accompanied by rigid pilasters that are wedged between the strong horizontal bands that delineate the floors. A **balustrade** tops the palace, further emphasizing the horizontal sweep while restraining any upward movement suggested by the building's vertical members. The divisions into Classically balanced threes and the almost obsessive emphasis on the horizontal echo the buildings of Renaissance architects. The French had come a long way from the towering spires of their glorious Gothic cathedrals!

16-22 LOUIS LE VAU AND JULES HARDOUIN-MANSART.
Palace of Versailles, as seen from the garden (1669–1685).

THE ROCOCO

We have roughly dated the Baroque period from 1600 to 1750. However, art historians have recognized a more distinct style within the Baroque that began shortly after the dawn of the eighteenth century. This **Rococo** style strayed further from Classical principles than did the Baroque. It is more ornate and characterized by sweetness, gaiety, and light. The courtly pomp and reserved Classicism of Louis XIV were replaced with a more delicate and sprightly representation of the leisure activities of the upper class.

The early Rococo style appears as a refinement of the painterly Baroque in which Classical subjects are often rendered in wispy brushstrokes that rely heavily on the Venetian or Rubensian palette of luscious golds and reds. The later Rococo period, following midcentury, is more frivolous in its choice of subjects (that of love among the very rich), palette (that of the softest pastel hues), and brushwork (the most delicate and painterly strokes).

Jean-Honoré Fragonard

Jean-Honoré Fragonard (1732–1806) is one of the finest representatives of the Rococo style, and his painting *Happy Accidents of the Swing* (Fig. 16-23) is a prime example of the aims and accomplishments of the Rococo artist. In the midst of a lush green park, whose opulent foliage was no doubt inspired by the Baroque, we are offered a glimpse of the "love games" of the leisure class. A young, though not-so-innocent, maiden, with petticoats billowing beneath her sumptuous pink dress, is being swung by an unsuspecting bishop high over the head of her reclining gentleman friend, who seems delighted with the view. The subjects' diminutive forms and rosy cheeks make them doll-like, an image reinforced by the idyllic setting. This is eighteenth-century life at its best—pampered by subtle hues, embraced by lush textures, and bathed by the softest of lights. Unfortunately, this was all a mask for life at its worst. As the ruling class continued to ignore the needs of the common people, the latter were preparing to rebel.

Élisabeth Vigée-Lebrun

Whereas Rembrandt epitomizes the artists who achieve recognition after death, Élisabeth Vigée-Lebrun (1755–1842) was a complete success during her lifetime. The daughter of a portrait painter, she received instruction and encouragement from her father and his colleagues from an early age. As a youngster she also studied paintings in the Louvre and was particularly drawn to the works of Rubens. By the time she reached her early twenties, she commanded high prices for her portraits and was made an official portrait painter for Marie Antoinette, the Austrian wife of Louis XVI. Neither Marie Antoinette nor her husband survived the French Revolution, but Vigée-Lebrun's fame spread throughout Europe, and by the end of her career she had created some 800 paintings.

Marie Antoinette and Her Children (Fig. 16-24) was painted nearly a decade after Vigée-Lebrun had begun to paint the royal family. In this work she was commissioned to counter the antimonarchist sentiments spreading throughout the land by portraying the queen as, first and foremost, a loving mother. True, the queen is set within the imposing Salon de la Paix at Versailles, with the famous Hall of Mirrors to the left and the royal crown atop the cabinet on the right. True, the queen's enormous hat and voluminous skirts

16-23 JEAN-HONORÉ FRAGONARD.
Happy Accidents of the Swing (1767).
Oil on canvas. 31⅞″ × 25⅜″.

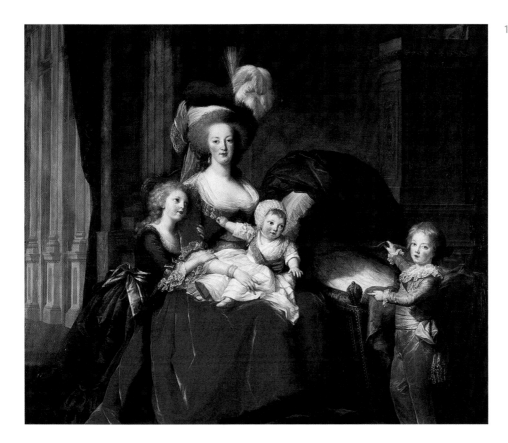

16-24 ÉLISABETH VIGÉE-LEBRUN.
Marie Antoinette and Her Children (1781).
Oil on canvas. 8'8" × 6'10".
Palace of Versailles, Versailles, France.
Copyright Art Resource, New York.

create a richness and monumentality to which the common person could not reasonably aspire. But the triangular composition and the child on the lap are reminiscent of Renaissance images of the Madonna and child (see Chapter 15), at once creating a sympathetic portrait of a mother and her children and, subliminally, asserting their divine right. Even amid the opulence at Versailles, Marie Antoinette displays her children as her real jewels. The young dauphin to the right, set apart as the future king, points to an empty cradle that might have originally contained the queen's fourth child, an infant who died two months before the painting was scheduled for exhibition.

The French populace, of course, was not persuaded by this portrait or by other public relations efforts to paint the royal family as accessible and sympathetic. The artist, in fact, did not exhibit her painting as scheduled for fear that the public might destroy it. Two years after the painting was completed, the convulsions of the French Revolution shook Europe and the world. The royal family was imprisoned and then executed. More than the royal family had passed into history, and more than democracy was about to be born.

Modern art was also to be ushered into this brave new world.

Chapters 12 through 16 have focused on art and the Western heritage. Yet "the West" comprises but a fraction of the world's population and a particular historical, cultural, and aesthetic approach to art. Art beyond the West is incredibly diverse. It is not united by a common history or by common ideas as to what art is, who will produce it, or what place art will occupy in people's lives. Even in the same general region, such as sub-Saharan Africa, there are diverse peoples and diverse approaches to art. The next chapter will bring us into contact with art that lies beyond the Western tradition, art that often requires a different critical vocabulary to be described, art that must be viewed in an altogether different context to be understood. For most Westerners, the art and culture of "the non-West" is "the other." In order to fully appreciate the meaning and function of art of cultures beyond the West, it is necessary, and immensely rewarding, to "think otherly"—to "reframe" your frame of reference to be something other than that which is familiar to you.

ART **TOUR**
London

BIG BEN.
Photo courtesy of
Lois Fichner-Rathus.
All rights reserved.

Europe's largest city cashes in big on tourism from the "colonies across the pond." There is a natural affinity between the United States and Britain for all sorts of reasons, ranging from a common language and common political causes to imports and exports such as Elvis and The Beatles. Even London's idiosyncratic phone booths have entered the popular culture with Austin Powers movies. Because of the ease of travel (it takes no longer to jet from New York to London than it does to fly from New York to Los Angeles) and the ease of communicating, London is a natural first-trip-abroad destination for students. It also serves as a logical jumping-off point for other cities worldwide, many of which can be reached by booking discounted student and youth fares with local London travel agents. The center of London is easily explored on foot, and almost all of the city is accessible by an inexpensive and highly efficient subway system.

A good place to start is at the symbolic heart of the city of London—St. Paul's Cathedral. The building as you see it today is the reincarnation—in Classical dress—of the original medieval church that was brought to ruin during the Great Fire of London in 1666. No stranger itself to destruction, the St. Paul's of today was literally kept standing by the "Watch," a team of volunteers who kept nightly vigil over the cathedral during the Blitz—the Nazi bombing raids on London in 1940 and 1941 that caused devastation all over the city. The cathedral is viewed as the masterpiece of the architect Sir Christopher Wren, who borrowed porticoes and pediments from Greek temple architecture and whose Classical vision dominates some of the more medieval aspects of the cathedral plan, such as the cross shape of the nave and transept. The most spectacular feature of St. Paul's is the dome, whose inner and outer shells rival one another for beauty. It is the second-largest dome in the world, after St. Peter's in Rome (designed by Michelangelo). It features an exterior, circular stone gallery, which offers the nonacrophobic a panoramic

SIGNATURE LONDON
TELEPHONE BOOTHS.
Photo courtesy of Lois Fichner-Rathus.
All rights reserved.

view of the city, and a pendant interior gallery—the so-called Whispering Gallery—from which you can hear whispers echoing from across the dome. St. Paul's is also a British monument that pays homage throughout to the United States for its unwavering devotion and support during World War II. The American visitor, while circling the apse, will come upon the American Memorial Chapel behind the high altar. St. Paul's has been the site of funerals (Sir Winston Churchill's) and weddings (Prince Charles and Lady Diana Spencer's) of the rich and famous and houses many memorials to popular heroes and historical figures from Lawrence of Arabia to Lord Nelson. Many more individuals who figure prominently in Britain's cultural history—from Darwin to Chaucer—can be found entombed or enshrined in Westminster Abbey. But keep walking . . .

From St. Paul's, you can luxuriate in a walk down to the Thames, that long and serpentine body of water on which you can take a circular cruise to view some of London's most famous (and infamous) sights: the Houses of Parliament (with the bell tower, Big Ben); the Tower Bridge; and Traitors' Gate, the creepy river entrance to the Tower of London, used for prisoners fresh from their trials in Westminster Hall. If you've chosen not to take this detour, continue across the new Millennium Bridge directly to the sensational Tate Modern, one of the world's premier collections of twentieth-century art, now housed in the vast, old Bankside Power Station. Upon entering the building, visitors proceed down a ramp into an enormous hall that contained turbines in former days and is now brought to life with large-scale works of art. From this level, escalators lead up to three large suites of

galleries arranged more or less chronologically to give some sense of a history of modern art. Interspersed among the many works by British artists in the museum are a large number of well-known international works, including Picasso's *Three Dancers* and Warhol's *Marilyn Diptych*. The Tate Modern also offers some of the best views of the city from across the river in its glass-enclosed top floors, one of which includes a restaurant.

Continuing west along the river, the visitor will reach the world's tallest observation wheel, the British Airways London Eye, constructed to celebrate the new millennium. On a clear day you can see forever (or maybe about 40 miles) from this overgrown Ferris wheel. As you can imagine, the lines are insufferably long, no matter the weather. Back across the river, a walk east and then north will bring you to the Covent Garden piazza and Central Market, where performers of all kinds command the square and where you can eat just about anything cheaply. From here, find your way to Leicester Square and the half-price ticket booth, which offers theater tickets for same-day performances in legendary theaters such as the Palladium. When in London, do as the Londoners do—at least one play per visit in one of the city's famous theaters is a must.

You can ask directions (in English!) to the queen's "in-town" residence, Buckingham Palace, and try to catch the well-known changing of the guard. During the height of the tourist season, this event takes place at 11:30 a.m. daily; the rest of the year it's every other day. Near the palace you can take a stroll through one of the most beautiful green spots in London, St. James Park. A route through the park will bring you eventually to Westminster Abbey, the site of the coronation chair and the final resting place for the kings and queens of England for centuries. In contrast to the Classical perfection and serenity of St. Paul's, Westminster Abbey is one of the most glorious examples of medieval architecture in London, if not in all of Europe. From its splendid west front towers and the massive flying buttresses to the vaulted ceiling of the Lady Chapel and the magnificent tiles of the octagonal Chapter House, the abbey does not disappoint the dense throngs who visit this "half national church–half national museum." Negotiating the many transepts and chapels will reveal some of the abbey's finest memorials to musicians, poets, and artists.

Even if your trip to London is brief and much of your "art tour" seems to be taking place outdoors, you will not want to miss the extraordinary British Museum. Wandering amidst the world's greatest collection of Mesopotamian, Egyptian, and Greek and Roman antiquities, even the most jaded or museum-fatigued among us will marvel at the Rosetta Stone—the slab we learned about in sixth grade,

WESTMINSTER ABBEY.

THE BRITISH MUSEUM.

which unlocked the mysterious code of Egyptian hieroglyphs—or the Parthenon (Fig. 13-10) marbles—removed from the temple by the British diplomat Lord Elgin between 1801 and 1804 and sold to the British nation in 1816. (In fact, Greece wants them back.) Admission to the British Museum and other wonderful art places, such as the National Gallery and National Portrait Gallery in Trafalgar Square, the Tate Modern, and the Tate Britain, is free!

 To continue your tour and learn more about London, go to our website.

ART BEYOND THE WEST

The map is open and connectable in all of its dimensions.

—Gilles Deleuze and Felix Guattari

"The world is shrinking." "The Global Village." "The Global Stage." "The Era of Globalization." As citizens of the world in the new millennium, we are connected to one another like never before. We travel to remote sites—across actual space (thanks to modern-day transportation) and cyberspace (thanks to the Internet). Money, goods, and services flow quickly from one part of the world to another. Information is more available to ordinary people as access to modes of international communication has become the rule for the many rather than the exception for the few. Although "globalization" is a term most often linked to the current state of global business and politics, the concept has expanded to include historical and cultural studies. While investment bankers, corporate businesses, and entrepreneurs have developed mutually beneficial relationships with countries around the globe, which have only recently begun to tap into their rich economic potential, new groups of individuals—such as research academicians (sociologists,anthropologists, historians, political scientists) have begun to investigate social, historical, cultural, and artistic phenomena of regions that are now within reach.

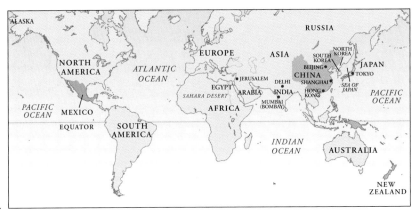

MAP 17-1 Art beyond the Western tradition.

As citizens of the world, we also share an extensive and varied heritage. Western culture and the Western tradition in art—that which solidified in ancient Greece and developed in Western Europe and later, the United States—may be more familiar to most of us than the art of other cultures and traditions that lie "beyond the West" (Map 17-1). But those traditions are rich and varied and represent other ways of seeing and knowing that enable us to expand our understanding of ourselves in relation to the world.

Ancient African sculpture and the masquerade, intricately carved catamarans of the Oceanic islanders, colossal stone heads from pre-Columbian Mexico, the South American metropolises, Native American cliff palaces—these are but a handful of examples of art that embody ways of life that have developed along their own courses. They often reflect societal organizations based on the village or the tribe that are rural and self-sufficient and continue from generation to generation with little change. The art of such societies serves to express the values and beliefs of a people and plays a pivotal role in the continuation of customs and traditions in societies dependent on oral rather than written history. Europeans who colonized these territories between the sixteenth and twentieth centuries did not think much of the fetishes, idols, and other curiosities upon which they gazed. Today this art is avidly collected throughout the world, including the Western world.

Islamic art or Chinese and Japanese art may be somewhat more familiar to the Western eye than the arts of Africa, Oceania, and Native America. As sacred spaces, the great mosques of the world of Islam, the cathedrals of Christian Europe, and synagogues around the world have some elements in common. Persian carpets are popular, and the Western eye need not be especially schooled to appreciate them. Some of the great works of the Indian subcontinent, such as the Taj Mahal, are also familiar, and the influence of China and Japan on Western art has been felt since the ex-

plorations and beginnings of trade, for many hundreds of years. The refined ceramics of the Chinese, for example, were known to European potters, and the perspective techniques and delicacy of Japanese drawings and paintings influenced many modern artists of the nineteenth century.

In this chapter we shall explore the world of art beyond the West. The breadth of the material precludes detailed discussion of the historical aspects of this work but need not preclude an appreciation for the widely diverse styles of these cultures and the significance of their art to their societies.

AFRICAN ART

African art is as varied as the cultures that have populated that continent. The earliest African art, like the earliest art of Europe and North America, consists of rock paintings and engravings that date to the Neolithic period. In tropical Africa—the central portion of the continent—the lost-wax technique was developed to cast small bronze sculptures as early as the ninth century.

The kingdom of Benin, which during the fourteenth through nineteenth centuries occupied what is now Nigeria, was rich in sculptures of many media, including iron, bronze, wood, ivory, and terra-cotta. Works such as the *Altar of the Hand* (Fig. 17-1) illustrate the skill with which the Benin manipulated bronze, as well as the importance of symbolism to their art. The many figures that are cast in relief around the circumference of this small work are meant to venerate the king and glorify his divine office. The king is the central figure in both the relief and in the freestanding figures on top of the altar. He holds the staffs of his office in his hands, and his head is larger than those of his attendants. This purposeful distortion signifies the head as the center of being and source of intelligence and power. The king's importance is further underscored by his placement within a triangular frame of sorts, his head at the apex. The entire

One of the first principles of art . . . is truth to material. . . . Wood has a stringy, fibrous consistency and [the African sculptor could carve it] into thin forms without breaking [it]. Much [African] carving . . . has pathos, a static patience and resignation to unknown mysterious powers; it is religious and, in movement, upward and vertical like the tree it was made from, but in its heavy bent legs is rooted in the earth.

—Henry Moore

altar is cast with symbolic forms or incised with decorative motifs, all arranged in a symmetrical pattern. The monumentality that this altar achieves in its mere 17 inches or so is remarkable and impressive.

This penchant for ornament can also be seen in more recent tribal art from Nigeria, such as that of the Yoruba. The carved wooden doors in Figure 17-2 depict scenes of

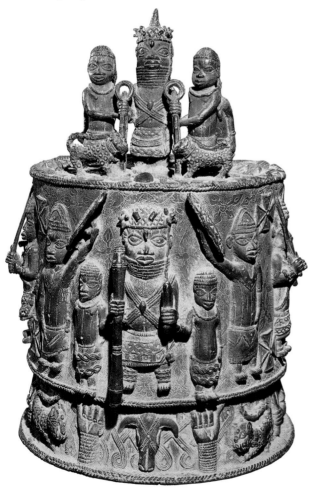

17-1 *Altar of the Hand,* Benin, Nigeria (17th–18th centuries?). Bronze. H: 17½".
British Museum, London. Heritage Image Partnership (HIP), heritage-images.com.

17-2 Door from Iderre, Nigeria (Yoruba, 1910–1914). Wood. H: 6'.
British Museum, London. Copyright Art Resource, New York.

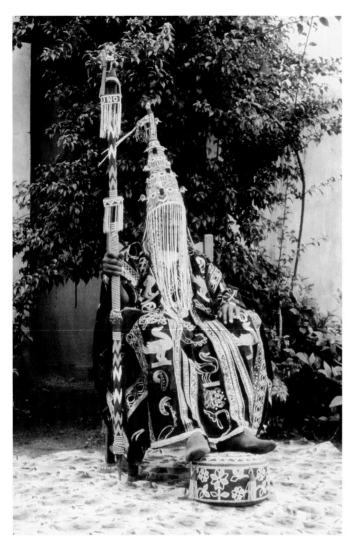

dent in headdresses similar to the crown that is worn by the royal Yoruba ruler in Figure 17-3 is created by a guild of artisans who pass their techniques down from generation to generation. In the ruler's costume, a veil composed of strands of beads covers the face, protecting onlookers from the power of the ruler's eyes. The height of the crown emphasizes the head as the center of power and often contains ritual medicines and potions to enhance that power.

Masks and headdresses are found in other regions of Africa as well, and their symbolism is as widely varied as their style. The simplest of these, such as the Etoumba mask (Fig. 17-6), have facial features resolved into abstract geometric shapes. They are also sometimes punched and slashed with markings intended to represent body scarification. More intricate pieces such as the *mboom* helmet mask from the Kuba people of Zaire (Fig. 17-4) might be embellished with brass, shells, beads, seeds, feathers, and furs. These contrasting textures, along with the protruding chin and prominent forehead, are symbols of royalty. The mask itself represents a primordial ancestor that oversees the passage of boys into adulthood.

17-3 The ruler of Orangun-Ila, Airowayoye I, with a beaded scepter, crown, veil, and footstool. Nigeria (Yoruba, 1977).
Copyright Jack Pemberton.

tribal life and ritual. The figures are angular and stylized; as in the *Altar of the Hand,* the king, who is seated on a throne, is shown larger than his attendants. The work reads rather like a comic strip, with parts of the narrative confined to small compartments. In most sections, a geometric-patterned background adds a rich, tapestry-like quality to the work. These doors continue artistic traditions established in much older works.

The Yoruba are famous for their mix of the old and the modern in fanciful objects crafted for ceremonial or ritualistic purposes. Masks and headdresses are used in performances called masquerades. They incorporate music, dance, and elaborate costuming in a combination of theater and ritual that often involves social criticism. The beadwork evi-

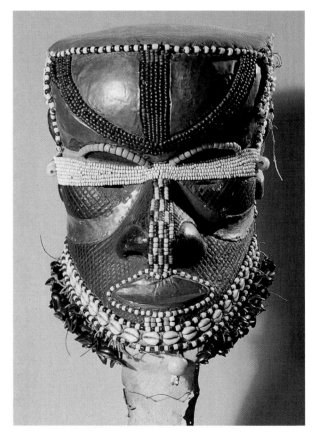

17-4 *Mboom* helmet mask, Zaire (Kuba, 19th–20th centuries). Wood, brass, cowrie shells, beads, seeds. H: 13″.
Royal Museum for Central Africa, Tervuren, Belgium.

Picasso's *Nude with Drapery* with an Etoumba Mask

In the early years of the twentieth century, painter Pablo Picasso saw two large exhibitions in Paris. One was of ancient sculpture from his native Spain, carved by the Iberians before their conquest by the Romans; the other was of the native art of African peoples. Both would have a lasting impression on his art.

Compare the facial features of Picasso's painting (Fig. 17-6) with those of an African mask like the ones he may have seen at the Musée de l'Homme in Paris (Fig. 17-5). What lines and shapes has Picasso adopted? What other conventions or stylizations of African art has he used? How has the painter captured the simplicity and strength of the traditional mask in his painting?

Picasso was enamored of the aesthetic of African art. But as he came to understand more fully the importance of the sa-

cred and mystical powers of that art to its society, he began to see his own art and perhaps art in general as "a form of magic designed to be a mediator between this strange, hostile world and us, a way of seizing the power by giving form to our terrors as well as our desires." ∎

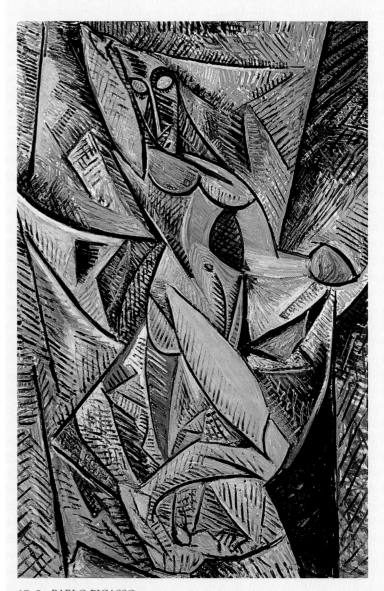

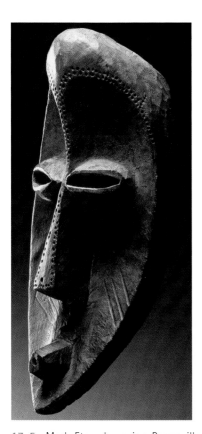

17-5 Mask, Etoumba region, Brazzaville, Zaire.
Wood. H: 13″.

Copyright abm archives Barbier-Müller, Geneva. Photograph by
Pierre-Alain Ferrazzini.

17-6 PABLO PICASSO.
Nude with Drapery (1907).
Oil on canvas.

The Hermitage, St. Petersburg. Copyright 2003 Estate of Pablo Picasso/
Artists Rights Society (ARS), New York.

17-7 Ancestral figure, Zaire (Kongo, 19th–20th centuries).
Wood and brass. H: 16″.
Royal Museum for Central Africa, Tervuren, Belgium.

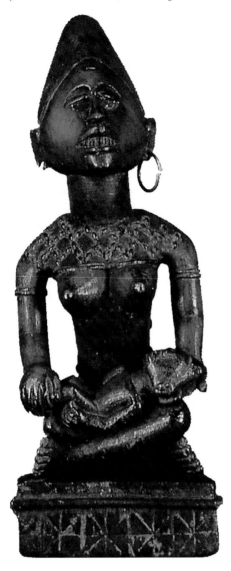

17-8 *Nkisi nkondi* (hunter figure), the Democratic Republic of
Congo (collected 1905).
Wood, metal, glass, and mixed media. H: 38″.
Copyright abm archives Barbier-Müller, Geneva. Photograph by Pierre-
Alain Ferrazzini.

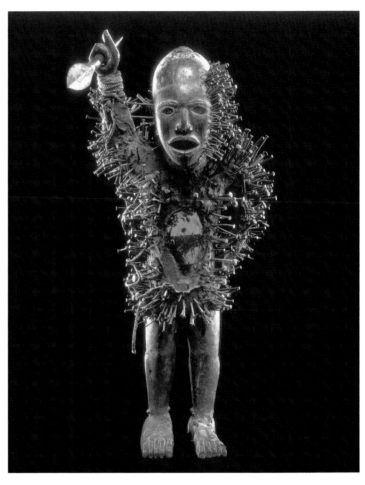

Other work from Zaire is more conventional in form. A so-called ancestral or power image from the Kongo peoples (Fig. 17-7) is a delicate wood carving of a mother and child, most likely intended as a repository of the soul of a deceased noblewoman (recall the Ka figures of Old Kingdom Egypt). The function of the sculpture was probably to receive prayers for the woman's continuing guardianship and care of the community, but other such figures served to channel ancestral powers from "medicines" placed within or on the sculptures to those in need—warriors in battle, farmers planting crops, or people trying to cure disease.

In many Western societies, Christians light votive candles to request favors from God, to seek the intervention of saints on their behalf, and to thank them for help. In a

number of African societies, priests have hammered nails into carved, wooden **fetish figures** (Fig. 17-8) to seek help from the gods, to ward off evil, to vanquish enemies, or solve problems in their villages. By driving nails into the figure, the villagers believe that wrongdoers will suffer pain. Once the social problem has been solved, the nails may be removed from the figure. Sometimes such fetish figures have human forms, but some are wild animals connected to ancestral spirits. In either case, these figures represent a vehicle for mediation between the living and the dead.

The seated primordial couple in Figure 17-9 are characteristic of another well-known style of African art—that of the Dogon people of Mali, in the western part of the continent. Although the Dogon artist often worked in a more nat-

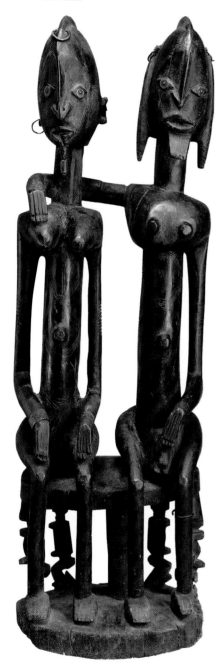

17-9 Ancestral couple, Mali (Dogon).
Wood. H: 28¾".

The Metropolitan Museum of Art, New York.
Gift of Lester Wunderman, 1977 (1977.394.15).
Copyright 1982 The Metropolitan Museum of Art,
New York.

uralistic style, here the artist has opted for a highly stylized, rigid, and elongated figure, incised with overall geometric patterns. This treatment removes the subjects from contemporary reality. The group represents the mythical ancestors of the human race, a kind of Adam and Eve of all of us.

Traders from North Africa brought Islam to Ghana in the eighth century CE, which, because of its wealth, became a vibrant center of Islamic culture. What emerged in terms of religious practice and art was a blend of both traditions. The plan of the Great Mosque at Djenne in Mali (Fig. 17-10), like that of all early mosques, is based on the model of Muhammad's home in Medina. It has a walled courtyard in front of a wall that faces Mecca. Unlike the stone mosques of the Middle East, however, the mosque at Djenne is built of sun-dried bricks and puddled clay. Wooden poles jutting through the clay serve as a kind of scaffold support for workers who replaster the structure yearly to prevent complete erosion of the clay. They also provide a form of exterior "ornamentation," an aspect of a highly decorative aesthetic Muslim art and architecture.

OCEANIC ART

The peoples and art of Oceania are also varied. They span millions of square miles of ocean, ranging from the continent of Australia and large islands of New Guinea and New Zealand to small islands such as the Gilberts, Tahiti, and

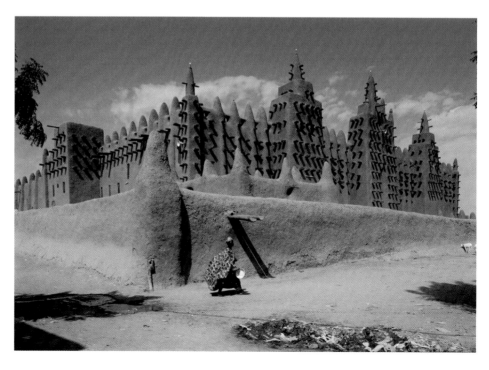

17-10 The Great Mosque, Djenne, Mali
(14th century CE).
Puddled clay, adobe brick,
and wooden poles.
Copyright Sandro Vannini/CORBIS.

Great stone figures on Easter Island
(Polynesian, 15th century CE).
H: approx. 30'.
Copyright George Holton/Photo Researchers,
Inc., New York.

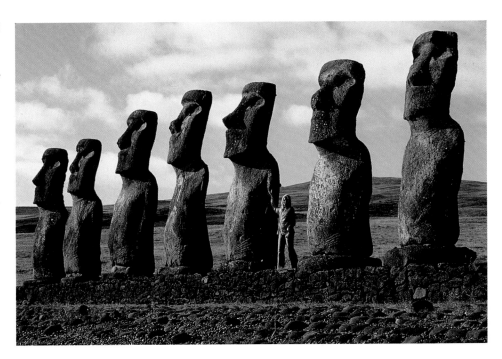

Easter Island. They are divided
into the cultures of Polynesia,
Melanesia, and Micronesia. We
shall discuss works from Polynesia
and Melanesia.

Polynesia

The Polynesian artists are known
for their figural sculptures, such as
the huge stone images of Easter
Island (Fig. 17-11). More than
600 of these heads and half-length
figures survive, some of them 60 feet tall. Polynesian art is
also known for its massiveness and compactness. Carved be-
tween the fifth and seventeenth centuries CE, their jutting,
monolithic forms have the abstracted quality of African
masks and ancestor figures. Figure after figure has the same
angular sweep of nose and chin, the severe pursed lips, and
the overbearing brow.

Archeologists have determined that these figures sym-
bolize the power that chieftains were thought to derive from

17-12 Canoe prow (Maori, pre-1935).
Wood. $70^7/8'' \times 29^1/2''$.
Musée d'Histoire Naturelle, Ethnographie et Prehistoire, Rouen, France.
Copyright RMN/Art Resource, New York.

the gods and to retain in death through their own deifi-
cation. Political power in Polynesia was believed to be a
reflection of spiritual power. The images of the gods were
thought to be combined with those of their descendants in
the carvings and other artworks like those on Easter Island.

The Polynesian Maori of New Zealand are known for
their wooden relief carvings. The plentiful nature of tough,
durable pinewood allowed them to sculpt works with the
curvilinear intricacy and vitality of the nearly six-foot-long
canoe prow shown in Figure 17-12. The figure at the front
of the prow is intended to have an earthy phallic thrust.

The winding snake pattern on the mythic figure and
scrollwork of the eighteenth-century canoe prow are like that
found on the Maori's tattooed bodies. Body painting and
tattooing are governed by tradition and are believed to link
the individual to the spirits of ancestors. Ancestor figures are
intended to appear menacing to outsiders, but they are per-
ceived as benevolent within the group. Other Maori carvings
are found on assembly houses, storehouses, and stockades.

Melanesia

Melanesian art is generally more colorful than that of Poly-
nesia. The cloth masks of New Britain are woven with a
certain flair, and the mixed-media ancestral poles of New
Guinea (Fig. 17-13) are painted in vivid hues. The intricate
poles are carved from single pieces of wood and adorned
with palm leaves and paint. Space flows around and through
the ancestral poles as it could not pass through the figures at
Easter Island. The expressionistically elongated and attenu-

[Mexican sculpture's] "stoniness," by which I mean its tremendous power without loss of sensitiveness, its astonishing variety and fertility of form-invention, and its approach to a full, three-dimensional concept of form, make it unsurpassed in my opinion by any other period of stone sculpture.

—Henry Moore

ated bodies again represent ancestors. The openwork banners are phallic symbols, intended to give courage to community men in ceremonies before combat with other tribes.

Practical, ceremonial, and decorative uses of art swept across the Pacific into the New World. Many historians and archeologists believe, in fact, that the Americas were first populated many thousands of years ago by migrations across the Pacific.

NATIVE ART OF THE AMERICAS

The art of the Americas was rich and varied before the arrival of European culture. We shall explore the native arts of North America and Peru.

Native Arts of Mexico

Some of the earliest, and certainly the most massive, art of the Americas was produced by the Olmecs in southern Mexico long before the Golden Age of Greece. In addition to huge heads such as that in Figure 17-14, the Olmecs produced small stone carvings, including reliefs.

More than a dozen great heads up to 12 feet in height have been found at Olmec ceremonial centers. The hard

17-13 Ancestor poles, New Guinea (Melanesian, Amsat tribe, 1960). Wood, paint, and fiber. Height of tallest pole: 17′11″.
The Metropolitan Museum of Art. The Michael C. Rockefeller Collection. Photograph copyright 1982 The Metropolitan Museum of Art, New York.

17-14 Colossal head, Villahermosa, Mexico (Olmec culture, c. 500 BCE–200 CE). Basalt. H: 8″.
Copyright Comstock.

17-15 Effigy vessel, girl on swing, from Remojadas region, Veracruz, Mexico (300–900 CE).
Ceramic: 9¼".

The Metropolitan Museum of Art, New York. The Michael C. Rockefeller Memorial Collection. Bequest of Nelson A. Rockefeller, 1979 (1979.206.574). Copyright 1991 The Metropolitan Museum of Art, New York.

basalt and jadeite from which they were carved had to be carted nearly 100 miles. The difficulty of working this material with primitive tools may to some degree account for the works' close adherence to the original monoliths. The heads share the same tight-fitting helmets, broad noses, full lips, and wide cheeks. Whether these colossal heads represent gods or earthly rulers is unknown, but there can be no doubting the power they project.

Henry Moore stated that Mexican sculpture is known for its massiveness. But contrast the Olmec heads with the sprightliness of the kinetic sculpture of the swinging girl (Fig. 17-15). This small piece is actually a whistle. The swinging girl was created many hundreds of years after the Olmec heads and was found in the same region of southern Mexico. We can find a continuity of tradition in the oversized head, but note the delicacy of the curved body. The entire length of the body is nothing but a spread-eagled, draped abstraction.

The Mayans, whose civilization reached its height in the Yucatán region of Mexico and the highlands of Guatemala from about 300 to 600 CE, built many huge limestone structures with **corbelled** vaults. Mayan temples were highly ornamented with figural relief carvings that represent rulers and gods and with commemorative and allegorical murals. The temple discovered at Bonampak in 1947 is decorated with murals of vivid hues such as that in Figure 17-16, in which prisoners are being presented for sacrifice.

The placement of the reasonably realistic figures along the receding steps symbolizes the social hierarchy. At the bottom are the common people. On the upper platform are noblemen and priests in richly embellished headdresses, as well as their personal attendants, and symbols of the heavens. The prisoners sit and kneel on various levels, visually without a home, whereas the Mayans are rigidly erect in their ascendance. There is no perspective; the figures on the upper registers are not smaller, even though they are farther away. The eye is drawn upward to the center of the composition by the pyramidal shape formed by the scattered prisoners. The figures face the center of the composition,

17-16 Mural from Mayan temple at Bonampak, Mexico (c. 6th century CE). Watercolor copy by Antonio Tejeda.
Copyright Peabody Museum, Harvard University.

17-17 Temple of Quetzalcóatl, Teotihuacán, Mexico
(300–700 CE).

Copyright Erich Lessing/Art Resource, New York.

17-18 Statue of Coatlicue (Aztec, Toltec culture, 15th century).
Stone. H: 99″.

National Museum of Anthropology, Mexico City.

providing symmetry, and the rhythm of the steps provides
unity. The subject of human sacrifice is repugnant to us, and
well it should be. The composition of the mural, however,
shows a classical refinement.

While the Mayans were reaching the height of their
power in lower Mexico, the population of the agricultural
civilization of Teotihuacán may have reached 100,000. The
temples of Teotihuacán, harmoniously grouped in the fertile
valley to the north of modern-day Mexico City, include the
massive 250-foot-high Pyramid of the Sun and the smaller
Temple of Quetzalcóatl (Fig. 17-17). The god Quetzalcóatl
was believed to be a feathered serpent. The high-relief head
of Quetzalcóatl projects repeatedly from the terraced sculp-
tural panels of the temple, alternating with the square-
brimmed geometric abstractions of Tlaloc, the rain god.
Bas-reliefs of abstracted serpent scales and feathers follow
sinuous paths on the panels in between.

The warlike Aztecs were a small group of poor nomads
until they established their capital, Tenochtitlán, in about
1325 CE on the site of modern Mexico City. Once estab-

lished in Tenochtitlán, the Aztecs made great advances in art
and architecture, as well as in mathematics and engineering.
But they also cruelly subjugated peoples from surrounding
tribes. Prisoners of war were used for human sacrifice in or-
der to compensate the sun god, who was believed to have
sacrificed himself in the creation of the human race. It is not
surprising that in the early part of the sixteenth century the
invading Spaniards found many neighbors of the Aztecs
more than eager to help them in their conquest of Mexico.
The Aztecs also helped seal their own fate by initially treat-
ing the Spaniards, who they believed were descended from
Quetzalcóatl, with great hospitality. The Spaniards, needless
to say, did not rush to disabuse their hosts of this notion and
were thus able to creep into the hearts of the Aztecs within
the Trojan Horse of mistaken identity.

Coatlicue was the Aztec goddess of earth and death.
In the compact, monumental stone effigy shown in Fig-
ure 17-18, Coatlicue takes the form of a composite beast
that never was. Her head consists of facing snakes. Her
hands are also snakes, her fingers fangs. Hands, hearts, and

Cambios: The Clash of Cultures and the Artistic Fallout

17-19 *Bargueño* (18th century).
Inlaid wood.
17¼″ × 28″ × 16¼″.
Collection of Michael Haskell,
Santa Barbara, CA.

17-20 MIGUEL CABRERA.
Castas (Depiction of Racial
Mixtures) (1763).
Oil on canvas. 52″ × 40½″.
Private collection.

In the year 1492, the king and queen of Spain funded Columbus's trip to the New World. The day after he left Spain's shores, Jews were expelled from the country by decree. Some 27 years later, the Spaniard Hernán Cortez sailed to Mexico and conquered the Aztec Empire. His campaign was brilliant; the empire fell to only 500 Spanish soldiers. The Aztec capital was vanquished in a bloody siege, and much of the Native Mexican population eventually succumbed to smallpox, a virus that the Spaniards introduced and to which the Native Mexicans had not developed immunity. The picture of Spain in the sixteenth century is one of sharp contrasts. It was a country in its "Golden Age," marked by feats of exploration and cultural masterworks, and at the same time, marked by prejudice, savage domination, and the infliction of pain.

The culture of Mexico survived, albeit in a transformed state. And the works of art that emerged during the Spanish Colonial period in Mexico, Central America, and South America bear evidence as well of artistic transformation. These works were the subject of a 1993 exhibition at the Santa Barbara Museum of Art in California—"Cambios: The Spirit of Transformation in Spanish Colonial Art." Cultural clash almost always leaves in its wake fascinating artistic imagery; perhaps in no other encounter of peoples has the interaction and reconciliation of disparate motifs been more well-defined than in the clash of the Spanish and Meso-American cultures.

The exhibition focused on how indigenous art forms, motifs, and techniques were integrated with European influences. In a review of the show in *Latin American Art,* Leslie Westbrook noted that the exhibit illustrated the great diversity of design influences as well as the willingness of artists to combine vocabularies from different cultures and contexts to create a "new world order" on the palette, so to speak.* Some examples of motifs include the Meso-American jaguar, flower-filled jars, leaf patterns, and elaborate borders (Fig. 17-19) reconciled with the lion image, a European formal symmetry, and of course, Christian subject matter. Of special interest is a newly attributed work by Miguel Cabrera entitled *Castas* (Depiction of Racial Mixtures) (Fig. 17-20). It represents the *mestizo*—the child born of the union of a European and a Native American. These children bear the physical characteristics of the two peoples and as such symbolize the "marriage" of two cultures.

The "Cambios" exhibition brought together remnants of a sometimes cruel history, where, as the reviewer remarked, one civilization superseded and dominated another. Yet nothing directly spoke of the cruel and devastating effects of Spanish domination. Instead, a freewheeling creativity—one of absorption, reconciliation, and ancestral legacy—dominated the show, a testimony to the resilience of the human spirit. ■

*Leslie A. Westbrook, "Cambios: The Spirit of Transformation in Spanish Colonial Art," *Latin American Art* 5, no. 1: 54–57.

skull compose her necklace. Coiled human figures hang from her midsection. Her gargantuan toes repeat the abstracted serpent fangs above. If one does not take into account the fearsome symbolic content of the statue, Coatlicue is a fascinating basalt assemblage of organic forms. But it is difficult to ignore the work's meanings.

Native Arts of Peru

The native arts of Peru include pyramid-shaped structures that form supports for temples, as in Mexico; stone carvings, mostly in the form of ornamental reliefs on ceremonial architecture; ceramic wares; and astounding feats of engineering.

The ceramic portrait jar shown in Figure 17-21 was created in about the fifth or sixth century CE by the Mochica culture along the Pacific coast of northern Peru. These realistic jars were modeled without benefit of a potter's wheel and probably accompanied the departed person into the grave. This particular jar is thought to be a portrait of a high-placed person, perhaps a warrior or a religious figure. It has a typical flat bottom and stirrup-shaped spout. Similar jars show their subjects grinning, sneering, or showing other expressions,

17-21 Ceramic portrait jar from Peru (Mochica culture, c. 500 CE).
Terra-cotta with paint.
Copyright Scala/Art Resource, New York.

17-22 Eskimo mask representing a moon goddess (before 1900).
Phoebe A. Hearst Museum of Anthropology.
The University of California at Berkeley.

which must have impressed the artist as characteristic of their dominant traits. Still other jars show entire human or animal figures, some of them caught in erotic poses.

The grand ruins of Machu Picchu, the fortress that straddled the Peruvian Andes, were noted in Chapter 10 (see Fig. 10-3). This structure, built by the Incas in about 1500 CE, shows an engineering genius that has been compared to the feats of the Romans. The tight fit of the dry masonry walls seems to reflect the tightness of the totalitarian fist with which the Incan nobility regulated the lives of their own masses and subjugated peoples from Ecuador and Chile. The conquering Spaniards were amazed by the great Incan "Royal Road of the Mountains." Thirty feet wide and walled for its entire 3,750 miles, it had no parallel in Europe.

Native Arts of the United States and Canada

Some native art objects in the United States and Canada date back nearly 12,000 years. As with African art, much of it is practical craft, much is ceremonial, and all is richly varied.

Eskimo, or Inuit, sculpture exhibits a simplicity of form and elegant refinement in both its realistic and abstract designs. It can also be highly imaginative, as in a mask representing a moon goddess (Fig. 17-22). Such masks, worn by

17-23 Kwakiutl headdress from Vancouver Island, British Columbia, Canada (c. 1895–1900). Wood and muslin. 52″ × 46″.
Courtesy of the National Museum of the American Indian, Smithsonian Institution, Washington, DC.

shamans in ritual ceremonies, were carved of ivory or wood and often had movable parts that added to the drama and realism of the object.

Prehistoric sites in what is now the United States also have yielded many interesting works. One of the larger ceremonial sculptures to survive is an earthwork called the Serpent Mound, a snakelike form of molded earth that meanders some 1,440 feet in the Ohio countryside. Pyramidal temple platforms reminiscent of those of Mexico and South America have also been unearthed, as has the magnificent Cliff Palace of Colorado's Mesa Verde National Park (see Fig. 10-1).

Among Native Americans, the Navajos of the Southwest are particularly noted for their fiber artistry and stylized sand paintings that portray the gods and mythic figures. Some of these works are believed to be empowered to heal. The "patient" sits in the center of the painting while a priest chants ritualistic prayers intended to speed well-being.

Peoples of the Northwest Coast have produced masks used by shamans in healing rituals, totem poles not unlike

17-24 *Custer's Last Stand* (Plains culture, late 19th century). Teepee lining. Painted muslin. 35″ × 85″.
National Museum of Natural History, Department of Anthropology, Smithsonian Institution, Washington, DC.

the ancestor poles of Oceania, bowls, clothing, and canoes and houses that are embellished with carving and painted ornamentation. The Chilkat robe discussed in Chapter 11 (see Fig. 11-17) was worn during ceremonies and consists of highly abstracted animal designs. The wood and muslin of a four-foot-high Kwakiutl headdress from British Columbia (Fig. 17-23) is vividly painted with abstracted human and animal forms. Like the Inuit moon goddess mask, it too has movable parts. When the string hanging from the inner mask is pulled, the two profiles to the sides are drawn together, forming another mask. The symbols represent the sun and other spirits. It is an extraordinary composition, balanced by the circular flow of fabric above the heads and by the bilateral symmetry in the placement of the shapes. As is often the case in ethnographic art, the embellishment of the work reflects traditional body decoration, such as painting, tattooing, or scarification.

The nomadic tribes of the Great Plains poured their artistic energies into embellishing portable items, such as garments and teepees. The muslin teepee lining of the Crow peoples of the Plains (Fig. 17-24) is a multihued and fairly realistic portrayal of nineteenth-century warfare with the U.S. cavalry. In this symbolic collection of events, Crow warriors advance rhythmically from the right. Many chieftains sport splendid feather headdresses. The cavalry is largely unhorsed and apparently unable to stop the implied momentum of the charge, which is very much like the sequence of frames in a motion picture.

Now that we have glanced at the native arts of Africa, Oceania, and the Americas, let us look once more across the Atlantic to the East. We will work our way across southern Europe and Asia so that we may sample the artistic contributions of the Islamic, Indian, Chinese, and Japanese cultures.

ISLAMIC ART

The era of Islam was founded in Arabia by Muhammad in 622 CE. Within a century, the Islamic—also known as Muslim—faith had been spread by conquering armies westward across North Africa to the Atlantic Ocean. It also spread to the east. So it is that many of the great monuments of Islamic art and architecture are found as far west as Spain and as far east as Agra in India. Muslims look upon the Old and New Testaments as well as the Koran as holy scriptures, and they number Abraham, Moses, and Jesus among their prophets.

The Great Mosque at Samarra, Iraq (Fig. 17-25), was constructed between 848 and 852 CE. Once the largest mosque in the world of Islam, it now lies in ruins. Its most striking feature is the spiral minaret, from which a crier known as a **muezzin** called followers to prayer at certain hours. Mosques avoid symbols, and early mosques in particular do not show ornamentation. Nor is there the clerical hierarchy in Islam that is found in many Christian religions. The leader of gatherings for worship, called the **imam,** stands on a pulpit in the mosque, near the wall that faces Mecca, the spiritual capital of Islam.

The mosque at Samarra was a simple building, 800 feet long and 520 feet wide, covered in part by a wooden roof, with a great open courtyard. The roof was supported by the **hypostyle** system of multiple rows of columns that could be expanded in any direction as the population of the

17-25 Great Mosque at Samarra, Iraq (Islamic, 848–852 CE).
Copyright Scala/Art Resource, New York.

17-26 Mihrab, Mosque at Isfahan, Iran (1617).
Copyright Art Resource, New York.

17-27 Taj Mahal, Agra, India (Islamic, 1630–1648).
Copyright Photo Researchers, Inc./Koch.

congregation grew. By bowing toward Mecca in the same yard, worshipers were granted equal psychological access to Allah, the Islamic name of God.

The interior of the mosque at Córdoba, Spain, which we used as an example of rhythm in Chapter 3 (see Fig. 3-28), shows the system of arches that spans the distances between columns in the hypostyle system. A system of vaults, supported by heavier piers, overspreads the arches. There is not the grand open space of the Western cathedral; rather, air and light flow through as in a forest of high-crowned, sturdy trees. The interiors of mosques traditionally have been decorated with finely detailed mosaics, as seen in a mosque in Isfahan, Iran (Figure 17-26). Our photograph is of the area of the **mihrab,** a niche in the mosque wall facing Mecca that provides a focus of worship.

The Taj Mahal at Agra (Fig. 17-27) is a mausoleum built by Shah Jahan in the seventeenth century in memory of his wife. In sharp contrast to the plainness of early Islamic architecture, tree-lined pools here reflect a study in refined elegance. The three-quarters sphere of the dome is a stunning feat of engineering. Open archways, with their ever-changing play of light and shade, slender minarets, and spires unify the composition and give the marble structure a look of weightlessness. Creamy marble seems to melt in the perfect order.

Islamic culture has also produced a wealth of fine craft objects. Persian rugs such as that shown in Figure 11-16, which was woven during the century in which the Taj Mahal was built, have set a high standard for the worldwide textile industry since the tenth century. Richly ornamented ceramics, enameled glass, highly embellished metalworks, and fine manuscript illumination also characterize the visual arts of the Muslim world.

INDIAN ART

Indian art, like that of the Americas, shows a history of thousands of years, and it too has been influenced by different cultures. Stone sculptures and **seals** that date to the second or third millennium BCE have been discovered. In low relief, the seals portray sensuous, rounded native animals and humanoid figures that presage the chief Hindu god, **Shiva.**

India once encompassed present-day Pakistan, Bangladesh, and the buffer states

between modern India and China. Many religious traditions have conflicted and sometimes peacefully coexisted in India, among them the Vedic religion, Hinduism, Buddhism, and Islam. Today Islam is the dominant religion of Pakistan, and Hinduism predominates in India. Indian art, like Islamic art, is found in many parts of Asia where Indian cultural influence once reigned, as in Indochina.

Buddhism flowered from earlier Indian traditions in the sixth century BCE, largely as a result of the example set by a prince named Siddhartha. In his later years Siddhartha renounced his birthright and earthly luxuries to become a **Buddha,** or enlightened being. Through meditation and self-denial, he is believed to have reached a comprehension of the universe that Buddhists call **nirvana.** After his death, Buddha's cremated remains were supposedly placed in **stupas** in eight different locations in India. These sites became places of worship and devotion for his followers. The Great Stupa at Sanchi (Fig. 17-28) was completed in the first century CE. The stupa is crowned by a large dome that symbolizes the sky. The dome is visually separated from the base of the structure by a stone railing or fence—known as the *vedika*—echoing the separation of the heavenly and earthly spheres. Pilgrims circumnavigate the mound in a clockwise direction, as if tracing the path of the sun across the sky.

The worshipers' relationship to the monument concentrates on the exterior rather than the interior as, for example, in the case of the Christian church.

The bracket figure (Fig. 17-29) on a gateway to the Great Stupa is a *yakshia*—pre-Buddhist goddess who was believed to embody the generative forces of nature. She appears to be nude, but a hemline reveals that she wears a diaphanous garment. Her ample breasts and sex organs symbolize the force of her productive powers. The voluptuousness of such figures stands in contrast to the often ascetic figures we find in Western religious art.

For many hundreds of years there were no images of the Buddha, but sculptures and other representations began to appear in the second century CE. Some sculpted Buddhas show a Western influence that can be traced to the conquest of northwestern India by Alexander the Great in 327 BCE. Others have a sensuous, rounded look that recalls the ancient seals and is decidedly Indian. The slender

17-29 *Yakshi* bracket figure from the east gate of the Great Stupa at Sanchi, India (Early Andhra period, 1st century BCE).
Stone. H: approx 60″.
Copyright Charles and Josette Lenars/CORBIS.

17-28 The Great Stupa, Sanchi, India (Shunga and Early Andhra periods, 3rd century BCE–early 1st century CE).
H: 65′.
Copyright Adam Woolfitt/CORBIS.

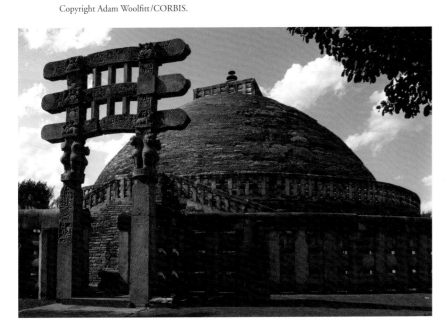

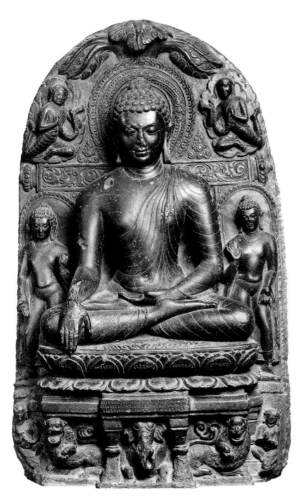

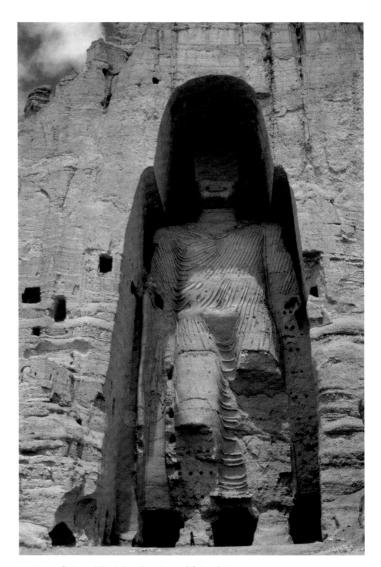

17-30 Buddha Calling on the Earth to Witness, India (Bengal
Pala period, 9th century CE).
Black chlorite. H: 99 cm.
Copyright The Cleveland Museum of Art. Dudley P. Allen Fund, 1935.

17-31 Colossal Buddha, Bamiyan, Afghanistan
(2nd–5th centuries CE). Destroyed in 2001.
Stone. H: 180'.
Copyright Charles and Josette Lenars/CORBIS.

chlorite Buddha (Fig. 17-30) shows delicate fingers and
gauzelike, revealing drapery. The face exhibits a pleasant cast
that is as inscrutable as the expression of La Gioconda in
Leonardo's *Mona Lisa* (see Fig. 1-1).

Let us briefly travel west of India to view the colossal
Buddha carved out of living rock at Bamiyan, Afghanistan
(Fig. 17-31). The statue portrays the eternal form of Buddha
in the belief that his earthly form was purely transient. The
concept of eternity is expressed in part through scale. This
Buddha, 180 feet tall, and its somewhat smaller companion,
120 feet tall, commanded the surrounding landscape and
was so well-known that tiny replicas were carved for visitors
as souvenirs that they carried back to their home countries.

Even though the photograph seems to suggest a rather
rough-hewn rendering of Buddha, it is quite possible that
it was gilded and had applications of plaster and pigment.
The Taliban destroyed these figures in 2001 despite pleas by
other nations to have them removed and preserved at their
own expense.

In the sixth and seventh centuries CE, Hinduism
rose to prominence in India, perhaps because it permitted
more paths for reaching nirvana, including the simple carry-
ing out of one's daily duties. Another reason for the popu-
larity of Hinduism may be its frank appreciation of eroti-
cism. Western religions impose a distinction between
the body or flesh, on the one hand, and the soul or mind,

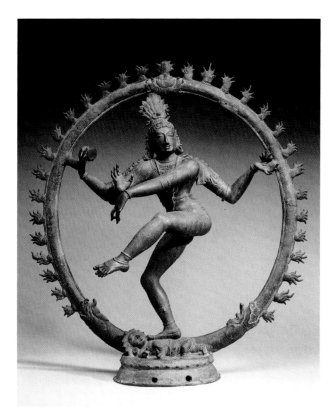

17-32 Nataraja: Shiva as King of Dance, South India
(Chola period, 11th century CE).
Bronze. H: 43⁷/₈″; W: 40″.

Copyright 2000 The Cleveland Museum of Art.
Purchase from the J. H. Wade Fund (1930.331).

17-33 Kandariya Mahadeva Temple, Khajuraho, India
(10th–11th centuries CE).

Copyright George Holton/Photo Researchers, Inc., New York.

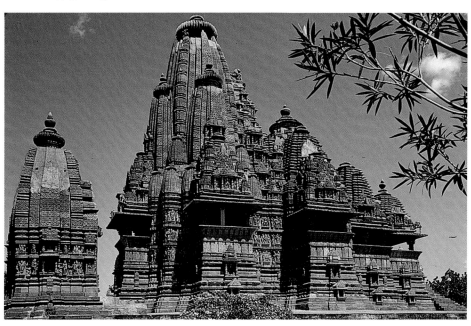

on the other. As a consequence, sex is often seen as being at odds with religious purity. Hinduism considers sexual expression to be one legitimate path to virtue. Explicit sexual acts in high reliefs adorn temple walls and amaze Western visitors.

There are many Hindu gods, including Shiva, the Lord of Lords and god of creation and destruction, which, in Hindu philosophy, are one. Figure 17-32 shows Shiva as Nataraja, the King of Dance. With one foot on the Demon of Ignorance, this eleventh-century bronze figure dances within a symbolically splendid fiery aura. The limbs are sensuous, even erotic. The small figure to the right side of his head is Ganga, the river goddess. This periodic dance destroys the universe, which is then reborn. So, in Hindu belief, is the human spirit reborn after death, its new form reflecting the sum of the virtues of its previous existences.

Hindu temples are considered to be the dwelling places of the gods, not houses of worship. The proportions of the famous Kandariya Mahadeva Temple at Khajuraho (Fig. 17-33) symbolize cosmic rhythms. The gradual unfolding of spaces within is highlighted by the sculptural procession of exterior forms. The organic, natural shapes of the multiple roofs are in most sections separated from the horizontal registers of the base by sweeping cornices. The main tower is an abstracted mountain peak, reached visually by ascending what appear to be architectural and natural hurdles. All this can be seen as representing human paths to oneness with the universe. The registers of the base are populated by high reliefs of gods, allegorical scenes, and idealized men and women in erotic positions.

Other Hindu temples are even more intricate. Vast pyramidal bases contain forests of towers and spires, corniced at the edges as they ascend from level to fanciful level. They are thick with low and high reliefs. In the Buddhist temples of Indochina, the giant face of Buddha looms from the walls of imposing towers and gazes in many directions. Indian art, including Indian painting—of which little, sad to say, survives—teaches us again how different the content of the visual arts can be. Still, techniques such as that of stone carving and bronze casting, as well as elements of composition, seem to possess a universal validity.

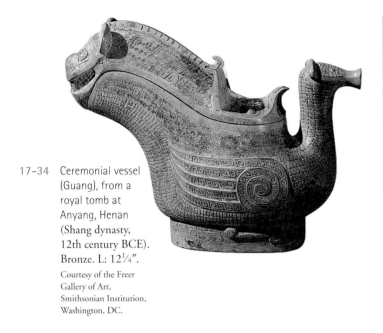

17-34 Ceremonial vessel (Guang), from a royal tomb at Anyang, Henan (Shang dynasty, 12th century BCE). Bronze. L: 12¼".

Courtesy of the Freer Gallery of Art, Smithsonian Institution, Washington, DC.

CHINESE ART

China houses more than a billion people in a country not quite as large as the United States. Nearly 4,000 years ago, inhabitants of China were producing primitive crafts. Beautiful bronze vessels embellished with stylized animal imagery were cast during the second millennium BCE, such as the one shown in Figure 17-34. During the feudal period of the Late Chou dynasty, which was contemporaneous with the Golden Age of Greece, royal metalworks were inlaid with gold, silver, and polished mirrors. Elegant carvings of fine jade were buried with their noble owners.

Confucianism ascended as the major Chinese way of life during the second century BCE. It is based on the moral principles of Confucius, which argue that social behavior must be derived from sympathy for one's fellows. Paintings and reliefs of this period show the **conceptual space** of Egyptian painting and create the illusion of depth by means of overlapping. Missionaries from India successfully introduced Buddhism to China during the second century CE, and many Chinese artists imitated Indian models for a few centuries afterward. But by the sixth century, Chinese art was again Chinese. Landscape paintings transported viewers to unfamiliar, magical realms. It was believed by many that artist and work of art were united by a great moving spirit. Centuries after the introduction of Buddhism, Confucianism again emerged. The present-day Peoples Republic of China is officially atheistic, but many Chinese still follow the precepts of Confucius.

Fan K'uan's *Travelers among Mountains and Streams* (Fig. 17-35) was painted on a silk scroll during the early

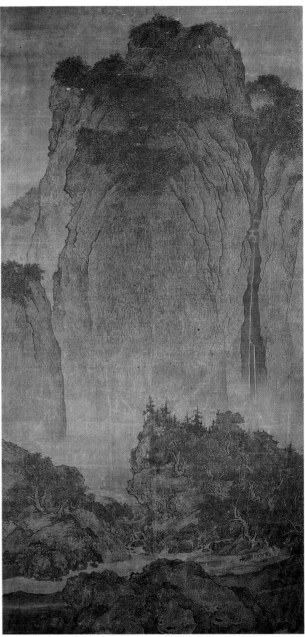

17-35 FAN K'UAN.
Travelers among Mountains and Streams (c. 1000 CE). Hanging scroll, ink and colors on silk. H: 81¾".
Collection of the National Palace Museum, Taiwan.

part of the eleventh century. Years of political turmoil had reinforced the artistic escape into imaginary landscapes. It is executed in the so-called Monumental style. Rocks in the foreground create a visual barrier that prevents the viewer from being drawn suddenly into the painting. Rounded forms rise in orderly, rhythmic fashion from foreground through background. Sharp brushstrokes clearly delineate conifers, deciduous trees, and small temples on the cliff in

A Chinese poem:

To what can our life on earth be likened?
To a flock of geese,
alighting on the snow.
Sometimes leaving a trace of their passage.

—Su Dongpo, 11th century CE

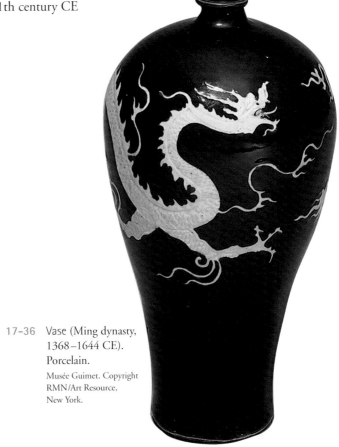

the middle ground. The waterfall down the high cliffs to the right is balanced by the cleft to the left. A high contrast in values picks out the waterfall from the cliffs. Distant mountains dwarf human figures. In contrast to the perspective typical of Western landscapes, there is no single vanishing point or set of vanishing points. The perspective shifts, offering the viewer a freer journey back across the many paths and bridges.

The blue and white porcelain vase from the Ming dynasty (Fig. 17-36) speaks eloquently of the refinement of Chinese ceramics. The crafting of vases such as these was a hereditary art, passed on from father to son over many generations. Labor was also frequently divided so that one craftsman made the vase and others glazed and decorated it. The vase in Figure 17-36 has a blue underglaze decoration—that is, a decoration molded or incised beneath rather than on top of the glaze. Transparent glazing increases the brilliance of the piece. In many instances the incising or molding was so subtle that it amounted to "secret" decoration.

Li K'an's fourteenth-century ink painting, *Bamboo* (Fig. 17-37), possesses an almost unbearable beauty. The entire composition consists of minor variations in line and tone. On one level it is a realistic representation of bamboo leaves, with texture gradient providing a powerful illusion of depth. On another level, it is a nonobjective symphony of

17-36 Vase (Ming dynasty, 1368–1644 CE). Porcelain.
Musée Guimet. Copyright RMN/Art Resource, New York.

17-37 LI K'AN.
Bamboo (1308 CE). Detail of 1st section.
Hand scroll. Ink on paper. 14¾″ × 93½″.
The Nelson-Atkins Museum of Art, Kansas City, MO. Purchase Nelson Trust.

calligraphic brushstrokes. The mass of white paper showing in the background is a symbolic statement of purity, not a realistic rendering of natural elements such as haze.

In much of Chinese art there is a non-Western type of reverence for nature in which people are seen as integral parts of the order of nature, neither its rulers nor its victims. In moments of enlightenment, we understand how we create and are of this order, very much in the way Li K'an must have felt that his spirit had both created and been derived from these leaves of bamboo and the natural order that they represent.

How can we hope to have spoken meaningfully about the depth and beauty of Chinese philosophies and Chinese arts in but a few sentences? Our words are mean strokes, indeed, but perhaps they point in the right direction.

JAPANESE ART

Japan is an island country off the eastern coast of Asia, holding more than 120 million people in an area not quite as large as California. The islands were originally formed from porous volcanic rock, and thus they are devoid of hard stone suitable for sculpture and building. Therefore, Japan's sculpture tradition has focused on clay modeling and bronze casting, and its structures have been built from wood.

The Japanese tradition, like the Western tradition, has various periods and styles. In Japanese art, as in Western art, we find a developing technology, the effect of native materials, indigenous and foreign influences, a mix of religious traditions, and disagreement as to what art is intended to portray. Despite its vast differences from Western art, Japanese art shows similar meanings and functions. Japanese artists also use the same elements of art, in their own fashion, to shape brilliant compositions.

Ceramic figures and vessels date to the fourth millennium BCE. Over the past 2,000 years, Japanese art has been intermittently influenced by the arts of nearby China and Korea. In the fifth and sixth centuries CE, the Japanese produced **haniwa,** hollow ceramic figures with tubular limbs modeled from slabs of clay. Haniwa were placed around burial plots, but their function is unknown.

By the beginning of the seventh century, Buddhism had been exported from China and established as the state religion in Japan. Many sculptors produced wooden and bronze effigies of the Buddha, and Buddhist temples reflected the Chinese style. Shinto, the native religion of Japan, teaches love of nature and the existence of many beneficent gods, who are never symbolized in art or any other visual form.

17-38 Kumano Mandala, Japan (Kamakura period, c. 1300 CE). Hanging scroll. Color on silk. 53¾″ × 24⅜″.
The Cleveland Museum of Art. John L. Severance Fund.

A Japanese poem:

Temple bells die out.
The fragrant blossoms remain.
A perfect evening!

—Matsuō Bash, 17th century CE

For nearly 2,000 years, wooden Shinto shrines, such as those shown in Figure 17-38, have been razed every 20 years and replaced by duplicates. The landscapes, portraits, and narrative scrolls produced by the Japanese during the Kamakura period, which spanned the late twelfth through the early fourteenth centuries CE, are highly original and Japanese in character. Some of them express the contemplative life of Buddhism, others express the active life of the warrior, and still others express the aesthetic life made possible by love of nature.

The Kumano Mandala (Fig. 17-38), a scroll executed at the beginning of the fourteenth century, represents three **Shinto** shrines. These are actually several miles apart in mountainous terrain, but the artist collapsed the space between them to permit the viewer an easier visual pilgrimage. The scroll pays homage to the unique Japanese landscape in its vivid color and rich detail. The several small figures of the seated Buddha portrayed within testify to the Japanese reconciliation of disparate spiritual influences. The repetition of forms within the shrines and the procession of the shrines themselves afford the composition a wonderful rhythm and unity. A **mandala** is a religious symbol of the design of the universe. It seems as though the universe of the shrines of the Kumano Mandala must carry on forever, as, indeed, it did in the minds of the Japanese.

Some periods of Japanese art have given rise to an extraordinary realism, as in the thirteenth-century wood sculpture of *The Sage Kuya Invoking the Amida Buddha* (Fig. 17-39). From the stance of the figure and the keen observation of every drapery fold, to the crystal used to create the illusion of actual eyes, this sculptor's effort to reproduce reality knew no bounds. The artist even went as far as to attempt to render speech: Six tiny images of Buddha come forth from the sage's mouth, representing the syllables of a prayer that repeats the name of Buddha. A remarkable balance between the earthly and the spiritual is achieved through the use of extreme realism to portray a subject that refers to religion.

17-39 *The Sage Kuya Invoking the Amida Buddha* (Kamakura period, 13th century CE).
Painted wood. H: approx. 46″.
Copyright Pacific Press, Tokyo.

Some three centuries later, Hasegawa Tohaku painted his masterful *Pine Wood* (Fig. 17-40) on a pair of screens. It is reminiscent of Li K'an's study of bamboo in that the plant life stands alone. No rocks or figures occupy the foreground. No mountains press the skies in the background. Like *Bamboo,* it is also monochromatic. The illusion of depth—and, indeed, the illusion of dreamy mists—is evoked by subtle gradations in tone and texture. Overlapping and relative size also play their roles in the provision of perspective. Without foreground and background, there is no point of reference from which we can infer the scale of the trees. Their monumentality is implied by the power of the artist's brushstrokes. The groupings of trees to the left have a soft sculptural quality and the overall form of delicate ceramic wares. The groupings of trees within each screen balance one another, and the overall composition is suggestive of the infinite directional strivings of nature to find form and express itself.

We noted that Picasso was strongly influenced by the art of Africa. Many Western artists of the nineteenth century were influenced by the art of the East, particularly prints from Japan, which were being imported to Paris and other

17-41 ANDO HIROSHIGE.
Rain Shower on Ohashi Bridge (1857).
Color woodblock on paper. 13⅞" × 9⅛".
The Cleveland Museum of Art. Gift of J. J. Wade.

Western cultural centers. The French Impressionist Edgar Degas, in fact, hung a print by Torii Kiyonaga in his bedroom. Modern artists were intrigued by the flatness of space, the decorative patterns, brilliant palette, and off-center compositions in Japanese woodcuts, such as Hiroshige's *Rain Shower on Ohashi Bridge* (Fig. 17-41). Vincent van Gogh, in fact, made an oil-on-canvas painting of this print, adding a decorative frame, complete with calligraphic patterns (Fig. 17-42). The ordinariness of Japanese subjects also struck a chord among the Modernists who were trying to escape the grip of mythological and historical painting.

The opening of trade between the Japan and the West in the mid-nineteenth century revealed new artistic worlds to the painters in Western Europe. Van Gogh wasn't the only artist of his time to copy or reinterpret the masterworks of Japanese painters, printmakers, and porcelain artists. Copying, as we have seen, has always been a way to

17-40 HASEGAWA TOHAKU.
Pine Wood (1539–1610 CE). Detail from a pair of sixfold screens. Ink on paper. H: 61".
Tokyo National Museum, Japan.

17-42 VINCENT VAN GOGH.
Bridge in the Rain, copy after Ando Hiroshige (1887).
Oil on canvas. 28¾″ × 18¼″.
Van Gogh Museum, Amsterdam. Copyright Corbis.

17-43 SYLVIA REINSTEIN.
Untitled.
Acrylic on paper with painted frame. 26″ × 20″.
Courtesy K. S. Art, New York.

come to understand—and to know deeply—the process and the product of art. But according to art critic Lyle Rexer, for some self-taught, "outsider" artists (see Chapter 1), it has also been a way to experience times and places that would otherwise remain unreachable. Although never intended to hang anywhere nor appear in any compendium of art history, Silvia Reinstein's untitled acrylic work on paper, embellished by a painted gold frame (Fig. 17-43), bears the same hallmark of inspiration by Japanese prints as the works of her "insider," Impressionist predecessors.

The ability to represent nature with exacting realism was a goal that united most Western artists through the ages. There were occasional deviations, as among the Christian artists of the Middle Ages, for whom representing the physicality of the figure was unimportant. Their choice was not based on an inability to mirror nature, but on the belief that the soul—and not the body—was a more relevant and intimate part of God's celestial plan. During the Renaissance, Western artists—including those who portrayed religious subjects—devised perspective to master the illusion of reality. As humanism took hold, the figure in sculpture and painting also appeared "more human."

Mimesis—imitation in representation—was never as much a goal for artists beyond the West, not because of lack of skill but because their artistic goals were not the same. Once art entered the modern era in the West, and artists had reached the height of their ability to represent nature with utmost accuracy, some, to be sure, continued in the realistic tradition, but others found it meaningless. After all, early enough in the nineteenth century, the camera would be able to do that for them. It was when art no longer needed to be consonant with realism that art beyond the West spoke most cogently to these artists. It was the exploration of art beyond the West that steered Western modernism on a different course.

MODERN ART

*Most painting in the European tradition was painting the mask. Modern art
rejected all that. Our subject matter was the person behind the mask.*

—Robert Motherwell

Historians of modern art have repeatedly posed the question, "When did modern art begin?" Some link the beginnings of modern painting to the French Revolution in 1789. Others have chosen 1863, the year of a landmark exhibition of "modern" painting in Paris.

Another issue of interest has been "Just what is modern about modern art?" The artists of the mid-fifteenth century looked upon their art as modern. They chose new subjects, materials, and techniques that signaled a radical change from a medieval past. Their development of one-point linear perspective altered the face of painting completely. From our perspective, modern art begins with the changes in the representation of space as introduced by artists of the late eighteenth century. Unlike the Renaissance masters, who sought to open up endless vistas within the canvas, the artists of the latter 1700s thrust all of the imagery toward the **picture plane.** The flatness or two-dimensionality of the canvas surface was asserted by the use of **planar recession** rather than **linear recession.** Not all artists of the eighteenth and nineteenth centuries abided by this novel treatment of space, but with this innovation the die was cast for the future of painting.

In short, what was *modern* about the modern art of the eighteenth century in France was its concept of space. In a very real sense, the history of modern art is the history of two differing perceptions and renderings of that space.

As we shall see in this chapter, the first period of modern art to use planar recession was *Neoclassicism.* We shall also examine its contemporaneous, though often contrary movement, *Romanticism.* We shall discuss the survival of Academic painting in the nineteenth century and address the use of art for political purposes. At mid-nineteenth century we shall witness the rise of a group of **bohemian** artists whose painting of optical impressions stood as the scandal of the age and the legacy to the future. Although we shall focus our attention on Paris and its surroundings—the center of the art world during these dynamic years—we shall glance at contemporaneous trends in Germany and in the United States.

The emphasis in this chapter will be on painting, the medium in which Modernism made its greatest strides.

NEOCLASSICISM

Modern art declared its opposition to the whimsy of the late Rococo style with **Neoclassical art.** The Neoclassical style is characterized by harsh sculptural lines, a subdued palette, and for the most part, planar instead of linear recession into space. The subject matter of Neoclassicism was inspired by

the French Revolution and designed to heighten moral standards. The new morality sought to replace the corruption and decadence of Louis XVI's France. The Roman Empire was often chosen as the model to emulate. For this reason, the artists of the Napoleonic era imitated the form and content of Classical works of art. This interest in antiquity was fueled by contemporaneous archeological finds at sites such as Pompeii as well as by numerous excavations in Greece.

Jacques-Louis David

The sterling proponent of the Neoclassical style and official painter of the French Revolution was Jacques-Louis David (1748–1825). David literally gave postrevolutionary France a new look. He designed everything from clothing to coiffures. David also set the course for modern art with a sudden and decisive break from the ornateness and frivolity of the Rococo.

In *The Oath of the Horatii* (Fig. 18-1), David portrayed a dramatic event from Roman history in order to heighten French patriotism and courage. Three brothers prepare to fight an enemy of Rome, swearing an oath to the empire on swords upheld by their father. To the right, their mother and other relatives collapse in despair. They weep for the men's safety but are also distraught because one of the enemy men is engaged to a sister of the Horatii. Family is pitted against family in a conflict that no one can win. Such a

18-1 JACQUES-LOUIS DAVID.
The Oath of the Horatii
(1784).
Oil on canvas. 14′ × 11′.
Louvre Museum, Paris/Scala/
Art Resources, New York.

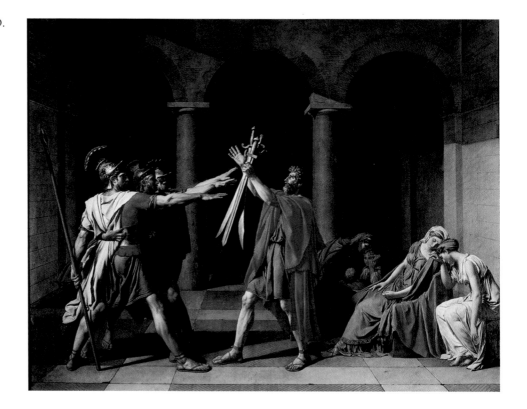

subject could descend into pathos, but David controlled any tendency toward sentimentality by reviving the Classical balance of emotion and restraint. The emotionality of the theme is countered by David's cool rendition of forms. The elements of the composition further work to harness emotionalism. Harsh sculptural lines define the figures and setting. The palette is reduced to muted blues and grays, with an occasional splash of deep red. Emotional response is barely evident in the idealized Classical faces of the figures.

A number of Classical devices in David's compositional format also function to balance emotion and restraint. The figural groups form a rough triangle. Their apex—the clasped swords of the Horatii—is the most important point of the composition. In the same way that Leonardo used three windows in his *Last Supper,* David silhouetted his dramatic moment against the central opening of three arches in the background. David further imitated Renaissance canvases by presenting cues for a linear perspective in the patterning of the floor. But unlike sixteenth-century artists, David led his orthogonals into a flattened space instead of a vanishing point on a horizon line. The closing off of this background space forces the viewer's eye to the front of the picture plane, where it encounters the action of the composition and the canvas surface itself. No longer does the artist desire to trick observers into believing they are looking through a window frame into the distance. Now the reality of the two-dimensionality of the canvas is asserted.

David was one of the leaders of the French Revolution, and his political life underwent curious turns. Although he painted *The Oath of the Horatii* for Louis XVI, he supported the faction that deposed him. Later he was to find himself painting a work commemorating the coronation of Napoleon. Having struggled against the French monarchy and then living to see it restored, David chose to spend his last years in exile in Brussels.

Angelica Kauffman

Angelica Kauffman (1741–1807) was another leading Neoclassical painter, an exact contemporary of David. Born in Switzerland and educated in the Neoclassical circles in Rome, Kauffman was responsible for the dissemination of the style in England. She is known for her portraiture, history painting, and narrative works such as *The Artist in the Character of Design Listening to the Inspiration of Poetry* (Fig. 18-2). In this allegorical work, Kauffman paints her

18-2 ANGELICA KAUFFMAN.
The Artist in the Character of Design Listening to the Inspiration of Poetry (1782).
Oil on canvas. D: 24″.
The Iveagh Bequest, Kenwood, London (English Heritage). Copyright Heritage Image Partnership (HIP), heritage-images.com.

The first virtue of a painting is to be a feast for the eyes.

—Eugène Delacroix

own features in the person of the muse of design, who is listening attentively with paper and pencil in hand to her companion muse of poetry. Poetry's idealized facial features, along with the severe architecture, classically rendered drapery, and rich palette place the work firmly in the Neoclassical style.

Jean-Auguste-Dominique Ingres

David abstracted space by using planar rather than linear recession. His most prodigious student, Jean-Auguste-Dominique Ingres (1780–1867), created sensuous, though pristinely Classical compositions in which line functions as an abstract element. Above all else, Ingres was a magnificent draftsman.

Ingres's work is a combination of harsh linearity and sculptural smoothness on the one hand, and delicacy and sensuality on the other. His *Grande Odalisque* (Fig. 18-4 in the nearby Compare and Contrast feature) portrays a Turkish harem mistress in the tradition of the great reclining Venuses of the Venetian Renaissance. Yet how different it is, for example, from Titian's *Venus of Urbino!* (See the Compare and Contrast feature later in the chapter.) The elongation of her spine, her attenuated limbs, and odd fullness of form recall the distortions and abstractions of Mannerist art. In the *Grande Odalisque,* Ingres also delights in the differing qualities of line. The articulation of heavy drapery contrasts markedly with the staccato treatment of the bed linens and the languid, sensual lines of the mistress's body. Like David's, Ingres's forms are smooth and sculptural, and his palette is muted. Ingres also flattens space in his composition by placing his imagery in the foreground, as in a relief.

Ingres's exotic nudes were a popular type of imagery in the late eighteenth century, but other artists often rendered such subjects quite differently. There was a popularity of style during this period that was similar to that existing during the Baroque era. On the one hand were artists such as David and Ingres, who represented the linear style. On the other hand were artists whose works were painterly. The foremost proponents of the painterly style were Géricault and Delacroix. The linear artists, called **Poussinistes,** followed in the footsteps of Classicism with their subdued palette and emphasis on draftsmanship and sculptural forms. The painterly artists, termed the **Rubenistes,**

adopted the vibrant palette and aggressive brushstroke of the Baroque artist. The two factions argued vehemently about the merits and the shortcomings of their respective styles. No artists were more deeply entrenched in this feud than the leaders of the camps, Ingres and Delacroix. Such was the state of art at the turn of the nineteenth century.

ROMANTICISM

Both Neoclassicism and **Romanticism** reflected the revolutionary spirit of the times. Neoclassicism emphasized restraint of emotion, purity of form, and subjects that inspired morality, whereas Romantic art sought extremes of emotion enhanced by virtuoso brushwork and a brilliant palette. As a movement, Romanticism is not as easily defined as Neoclassicism. Artists classified as Romantic differed in style. Some were mirror images of the Baroque, and others were more abstracted. Still others dedicated themselves wholeheartedly to representing the passion of the French Revolution.

Eugène Delacroix

The most famous Rubeniste—and Ingres's archrival—was Eugène Delacroix (1798–1863). Whereas Ingres believed that a painting was nothing without drawing, Delacroix advocated the spontaneity of painting directly on canvas without the tyranny of meticulous preparatory sketches. Ingres believed that color ought to be subordinated to line, but Delacroix maintained that compositions should be constructed of color. Their contrasting approaches to painting can be seen clearly in the *Odalisque* by each artist (Figs. 18-4 and 18-5 in the Compare and Contrast feature), fine examples of the difference between the Neoclassical and Romantic styles.

One of Delacroix's most dynamic statements of the Romantic style occurs in one of his many compositions devoted to the more exciting themes from literary history. *The Death of Sardanapalus* (Fig. 18-3), inspired by a tragedy by Byron, depicts the murder-suicide of an Assyrian king who, rather than surrender to his attackers, set fire to himself and his entourage. All of the monarch's earthly possessions, including concubines, servants, and Arabian stallions, are heaped upon his lavish gold and velvet bed, now turned

18-3 EUGÈNE DELACROIX.
The Death of Sardanapalus (1826).
Oil on canvas. 12′11½″ × 16′3″.
Louvre Museum, Paris. Copyright Edimedia/Corbis.

funeral pyre. The chaos and terror of the event are rendered by Delacroix with all the vigor and passion of a Baroque composition. The explicit contrast between the voluptuous women and the brute strength of the king's executioners brings to mind *The Rape of the Daughters of Leucippus* by Rubens (see Fig. 16-17). Arms reach helplessly in all directions, and backs arch in hopeless defiance or pitiful submission before the passive Sardanapalus. Delacroix's unleashed energy and assaulting palette were strongly criticized by contemporaries who felt that there was no excuse for such a blatant depiction of violence. But his use of bold colors and freely applied pigment, along with the observations on art and nature that he recorded in his journal, were an impor-

tant influence on the young artists of the nineteenth century who were destined to transform artistic tradition.

Francisco Goya

Ironically, the man considered the greatest painter of the Neoclassical and Romantic periods belonged to neither artistic group. He never visited France, the center of the art world at the time, and was virtually unknown to painters of the late eighteenth and early nineteenth centuries. Yet his paintings and prints foreshadowed the art of the nineteenth-century Impressionists.

Francisco Goya (1746–1828) was born in Spain and, except for an academic excursion to Rome, spent his entire

Ingres's *Grande Odalisque,* Delacroix's *Odalisque,* Cézanne's *A Modern Olympia,* and Sleigh's *Philip Golub Reclining*

Compare-and-contrast exercises are often used to stimulate a student's powers of visual recognition and discrimination, to test the student's ability to characterize and categorize, and to force the student to think critically about the content and context of the work. If put together just right, they ought also to act as a springboard for discussion of issues that push beyond the discipline of art. Tall order? You bet. But somehow these four meet the demands.

You can write paragraphs on the stylistic differences alone between the *Odalisque* by Ingres (Fig. 18-4) and by Delacroix (Fig. 18-5). They are arch examples of the contrast between a linear and painterly approach to the same subject; they offer clear evidence of the "battle" between the Poussinistes and the Rubenistes during the Romantic period (those whose draftsmanship was inspired by the Classical Baroque artist Nicholas Poussin versus those who "went to school" on the Flemish Baroque painter Peter Paul Rubens). On the other hand, they have one very important thing in common. Both bespeak an enormous fascination with the exotic, with the "Orient," with the *other;* a seemingly insatiable fascination not only with the trappings of an exotic *sens*uality—turbans, silken scarves, peacock feathers, opium pipes—but with what was perceived as an unrestrained and exotic *sex*uality. These two works are in abundant company in nineteenth-century France. Can you do a bit of leg work and find out what circumstances (historical, political, sociological, and so on) prevailed at this moment in time that might have led to a market for such paintings? Why did these very different artists find the same subject so captivating, so fashionable?

Nineteenth-century art historian and feminist scholar Linda Nochlin has suggested that such paintings speak volumes about contemporary ideology and gender discourse— "the ways in which representations of women in art are founded upon and serve to reproduce indisputably accepted assumptions held by society in general, artists in particular, and some artists more than others about men's power over, superiority to, difference from, and necessary control of

18-4 JEAN-AUGUSTE-DOMINIQUE INGRES.
Grande Odalisque (1814).
Oil on canvas. 35¼″ × 63¾″.
Louvre Museum, Paris. Copyright Art Resource, New York.

18-5 EUGÈNE DELACROIX.
Odalisque (1845–1850).
Oil on canvas. 14⅞″ × 18¼″.
Fitzwilliam Museum, Cambridge, England. Reproduction by permission of the Syndics of the Fitzwilliam Museum.

18-6 PAUL CÉZANNE.
A Modern Olympia (1873–1874).
Oil on canvas. 18¼″ × 21⅞″.
Musée D'Orsay, Paris. Copyright Erich Lessing/Art Resource, New York.

18-7 SYLVIA SLEIGH.
Philip Golub Reclining (1971).
Oil on canvas. 42″ × 60″.
Courtesy of the artist.

women, assumptions which are manifested in the visual structures as well as the thematic choices of the pictures in question." Among several that Nochlin lists are assumptions about women's weakness and passivity and sexual availability for men's needs.

The works in this feature speak to the tradition of the reclining nude in Western art. In another Compare and Contrast feature in this chapter, you can see some other examples of this tradition and are asked for whose "gaze" you think they were intended. In fact, the concept of the "male gaze" has been central to feminist theory for the past decade. In a landmark article written in 1973, the filmmaker Laura Mulvey explained the roles of the viewer and the viewed in art, literature, and film this way: Men are in the position of looking, and women are "passive, powerless objects of their controlling gaze."

Paul Cézanne's *A Modern Olympia* (Fig. 18-6) and Sylvia Sleigh's *Philip Golub Reclining* (Fig. 18-7) seem to address the issue of the "male gaze" straight on, but in ways that could not differ more from one another. Cézanne was surely commenting on Edouard Manet's *Olympia,* which was painted just 10 years before and had made quite a splash when exhibited. What are the similarities in content? What are the differences? Note, among other things, that Cézanne has placed himself in the picture—owning up, as it were, to the male gaze. Sleigh attacks the issue head on by reversing the "power relationship" in painting. The artist is seen in the background, in mirror reflection, painting the nude torso of Philip Golub from the rear. Does the work raise questions such as "Is this also what women really want to paint?" or "Is this what women want to gaze upon?" Or do you think the purpose of this painting is to call our attention to a tradition in the arts of perpetuating ideological gender attitudes? ∎

18-8 FRANCISCO GOYA.
The Third of May, 1808 (1814–1815).
Oil on canvas. 8′9″ × 13′4″.
Prado, Madrid. Copyright Edimedia/Corbis.

life there. He enjoyed a great reputation in his native country and was awarded many important commissions, including religious frescoes and portraits of Spanish royalty. But Goya is best known for his works with political overtones, ranging from social satire to savage condemnation of the disasters of war. One of his most famous depictions of war is *The Third of May, 1808* (Fig. 18-8). The painting commemorates the massacre of the peasant-citizens of Madrid after the city fell to the French. Reflecting the procedures of Velásquez and Rembrandt—two Baroque masters whom Goya acknowledged as influential in the development of his style—Goya focuses the viewer's attention on a single moment in the violent episode. A Spaniard thrusts his arms upward in surrender to the bayonets of the faceless enemy. The brusqueness of the application of pigment corresponds to the harshness of the subject. The dutiful and regimented procedure of the executioners, dressed in long coats, contrasts visually and psychologically with the expressions of

horror, fear, and helplessness on the faces of the ragtag peasants. The emotion is heightened by the use of acerbic tones and by a strong chiaroscuro that illuminates the pitiful victims while relegating all other details to darkness.

Goya devoted much of his life to the graphic representation of man's inhumanity to man. Toward the end of his life he was afflicted with deafness and plagued with bitterness and depression over the atrocities he had witnessed. These feelings were manifested in macabre paintings and lithographs, which presaged the style of the great painters of the nineteenth century.

The Academy

Ingres's paintings spoke of a calm, though exotic Classicism. Delacroix retrieved the dynamism of the Baroque. Goya swathed his canvases with the spirit of revolution. Ironically, the style of painting that had the least impact on the devel-

18-9 ADOLPHE WILLIAM BOUGUEREAU. *Nymphs and Satyr* (1873). Oil on canvas. $102\frac{3}{8}'' \times 70\frac{7}{8}''$. Sterling and Francine Clark Art Institute, Williamstown, MA.

opment of modern art was the most popular type of painting in its day. This was **Academic art,** so called because its style and subject matter were derived from conventions established by the Academie Royale de Peinture et de Sculpture in Paris.

Established in 1648, the Academy had maintained a firm grip on artistic production for more than two centuries. Many artists steeped in this tradition were followers rather than innovators, and the quality of their production left something to be desired. Some, however, like David and Ingres, worked within the confines of a style acceptable to the Academy but rose above the generally rampant mediocrity.

Adolphe William Bouguereau

One of the more popular and accomplished Academic painters was Adolphe William Bouguereau (1825–1905). Included among his oeuvre are religious and historical paintings in a grand Classical manner, although he is most famous for his meticulously painted nudes and mythological subjects. *Nymphs and Satyr* (Fig. 18-9) is nearly photographic in its refined technique and attention to detail. Four sprightly and sensuous wood nymphs corral a hesitant satyr and tug him into the water. Their innocent playfulness would have appealed to the Frenchman on the street, although the saccharine character of the subject matter and the extreme light-handedness with which the work was painted served only as a model against which the new wave of painters rebelled.

REALISM

The "modern" painters of the nineteenth century objected to Academic art on two levels: The subject matter did not represent life as it really was, and the manner in which the subjects were rendered did not reflect reality as it was observed by the naked eye.

The modern artists chose to depict subjects that were evident in everyday life. The way in which they rendered these subjects also differed from that of Academic painters. They attempted to render on canvas objects as they saw them—**optically**—rather than as they knew them to be—**conceptually.** In addition, they respected the reality of the medium they worked with. Instead of using pigment merely as a tool to provide an illusion of three-dimensional reality, they emphasized the two-dimensionality of the canvas and asserted the painting process itself. The physical properties of the pigments were highlighted. Artists who took these ideas to heart were known as the Realists. They include Honoré Daumier and two painters whose work stands on the threshold of the Impressionist movement: Gustave Courbet and Edouard Manet.

Honoré Daumier

Of all of the modern artists of the mid-nineteenth century, Honoré Daumier (1808–1879) was perhaps the most concerned with bringing to light the very real subject of the plight of the masses. Daumier worked as a caricaturist for Parisian journals, and he used his cartoons to convey his disgust with the monarchy and contemporary bourgeois society. His public ridicule of King Louis Philippe landed him in prison for six months.

Daumier is known primarily for his lithographs, which number some 4,000, although he was also an important painter. He brought to his works on canvas the technique and style of a caricaturist. Together, they make for a powerful rendition of his realistic subjects. One of Daumier's most famous compositions is *The Third-Class Carriage* (Fig. 18-10), an illustration of a crowded third-class compartment of a French train. His caricaturist style is evident in the flowing dark outlines and exaggerated features and gestures, but it also underscores the artist's concern for the working class by advertising their ill fortune. The peasants are crowded into the car, their clothing poor and rumpled, their faces wide and expressionless. They contrast markedly with bourgeois commuters, whose felt top hats tower above the kerchiefed heads. It is a candid-camera depiction of these people. Wrapped up in their own thoughts and disappointments, they live their quite ordinary lives from day to day, without significance and without notice.

Gustave Courbet

The term "realist," when it applies to art, is synonymous with Gustave Courbet (1819–1877). Considered to be the father of the Realist movement, Courbet used the term "realism" to describe his own work and even issued a manifesto

18-10 HONORÉ DAUMIER.
The Third-Class Carriage
(c. 1862).
Oil on canvas. 25¾″ × 35½″.
The Metropolitan Museum of Art, New York. Bequest of Mrs. H. O. Havemeyer, 1929. The H. O. Havemeyer Collection (29.100.129). Copyright 1985 The Metropolitan Museum of Art, New York.

> *To record the manners, ideas, and aspects of the age as I myself saw them—to be a man*
> *as well as a painter—in short to create a living art—that is my aim.*
>
> —Gustave Courbet

on the subject. As was the case with many artists who broke the mold of the Academic style, Courbet's painting was shunned and decried by contemporary critics. But Courbet proceeded undaunted. After his paintings were rejected by the jurors of the 1855 **Salon,** he set up his own pavilion and exhibited some 40 of his own paintings. Such antics, as well as his commitment to realistic subjects and vigorous application of pigment, served as a strong model for the younger painters at midcentury who were also to rebel against the established Academic tradition in art.

Paintings such as *The Stone-Breakers* (Fig. 18-11) were the objects of public derision. Courbet was moved to paint the work after seeing an old man and a young boy breaking stones on a roadside. So common a subject was naturally criticized by contemporary critics, who favored mythological or idealistic subjects. But Courbet, who was quoted as saying that he couldn't paint an angel because he had never seen one, continued in this vein despite the art world's rejection. It was not only the artist's subject matter, however, that the critics found offensive. They also spurned his painting technique. Although his choice of colors was fairly traditional—muted tones of brown and ocher—their quick application with a palette knife resulted in a coarsely textured surface that could not have been further removed from the glossy finish of an Academic painting. Curiously, although Courbet believed that this type of painting was more realistic than that of the

18-11 GUSTAVE COURBET.
The Stone-Breakers (1849).
Oil on canvas. 63″ × 102″.
Formerly Staatliche Kunstsammlungen, Dresden (destroyed in World War II). Copyright Bridgeman Art Library.

salons, in fact the reverse is closer to the truth. The Academic painter strove for what we would today consider to be an almost photographically exact representation of the figure, whereas Courbet attempted quickly to jot down his impressions of the scene in an often spontaneous flurry of strokes. (For this reason, Courbet can be said to have foreshadowed the Impressionist movement, which we discuss in the next section.) Despite Courbet's advocacy of hard-core realism, the observer of *The Stone-Breakers* is presented ultimately with the artist's subjective view of the world.

Edouard Manet

Courbet's painting may have laid the groundwork for Impressionism, but he himself was not to be a part of the new wave. His old age brought conservatism, and with it disap-

proval of the younger generation's painting techniques. One of the targets of Courbet's derision was Edouard Manet (1832–1883). According to some art historians, Manet is the artist most responsible for changing the course of the history of painting.

What was modern about Manet's painting was his technique. Instead of beginning with a dark underpainting and building up to bright highlights—a method used since the Renaissance—Manet began with a white surface and worked to build up dark tones. This approach lent a greater luminosity to the work, one that duplicated sunlight as closely as possible. Manet also did not model his figures with a traditional chiaroscuro. Instead, he applied his pigments flatly and broadly. With these techniques he attempted to capture an impression of a fleeting moment,

18-12 ÉDOUARD MANET.
Le Déjeuner sur L'Herbe (Luncheon on the Grass) (1863).
Oil on canvas. 7' × 8'1".
Musée d'Orsay, Galerie Nationale du Jeu de Paume, Paris. Copyright Edimedia/Corbis.

to duplicate on canvas what the eye would perceive within that collapsed time frame.

All too predictably, these innovations met with disapproval from critics and the public alike. Manet's subjects were found to be equally abrasive. One of his most shocking paintings, *Le Déjeuner sur l'Herbe* (Luncheon on the Grass) (Fig. 18-12), stands as a pivotal work in the rise of the Impressionist movement. Manet's luncheon takes place in a lush woodland setting. Its guests are ordinary members of the French middle class. It is culled from a tradition of Venetian Renaissance **pastoral** scenes common to the masters Giorgione and Titian. The composition is rather traditional. The figural group forms a stable pyramidal structure that is set firmly in the middle ground of the canvas. In fact, the group itself is derived from an engraving by Marcantonio Raimondi after a painting by Raphael called *The Judgment of Paris* (Fig. 18-13).

What was so alarming to the Parisian spectator, and remains so to this day, is that there is no explanation for the behavior of the picnickers. Why are the men clothed and the women undraped to varying degrees? Why are the men chatting between themselves, seemingly unaware of the women? The public was quite used to the painting of nudes, but they were not prepared to witness one of their fold—an ordinary citizen—displayed so shamefully on such a grand scale. The painting was further intolerable

because the seated woman meets the viewer's stare, as if the viewer had intruded on their gathering in a voyeuristic fashion.

Viewers expecting another pastoral scene replete with nymphs and satyrs got, instead, portraits of Manet's model (Victorine Meurend), his brother, and a sculptor friend. In lieu of a highly polished Academic painting, they found a broadly brushed application of flat, barely modeled hues that sat squarely on the canvas with no regard for illusionism. With this shocking subject and unconventional technique, Modernism was on its way.

Manet submitted the work to the 1863 Salon, and it was categorically rejected. He and other artists whose works were rejected that year rebelled so vehemently that Napoleon III allowed them to exhibit their work in what was known as the *Salon des Réfusés,* or Salon of the Rejected Painters. It was one of the most important gatherings of **avant-garde** painters in the century.

Although Manet was trying to deliver a message to the art world with his *Déjeuner,* it was not his wish to be ostracized. He was just as interested as the next painter in earning recognition and acceptance. Commissions went to artists whose style was sanctioned by the academics, and painting salon pictures was, after all, a livelihood. Fortunately, Manet had the private means by which he could continue painting in the manner he desired.

Manet was perhaps the most important influence on the French Impressionist painters, a group of artists that advocated the direct painting of optical impressions. *Déjeuner* began a decade of exploration of these new ideas that culminated in the first Impressionist exhibition of 1874. Although considered by his followers to be one of the Impressionists, Manet declined to exhibit with that avant-garde group. A quarter of a century later, only 17 years after his death, Manet's works were shown at the prestigious Louvre Museum.

Rosa Bonheur

Rosa Bonheur (1822–1899) was one of the most successful artists working in the second half of the nineteenth century. In terms of style, she is most closely related to Courbet and the other Realist painters, although for the most part she shunned human subjects in favor of animals—domesticated and wild. She was an artist who insisted on getting close to her subject; she reveled in working "in the trenches." Bonheur was seen in men's clothing and hip boots, plodding through the bloody floors of slaughterhouses in her struggle to understand the anatomy of her subjects.

18-13 MARCANTONIO RAIMONDI.
Engraving after Raphael's *The Judgment of Paris* (c. 1520). Detail.

Titian's *Venus of Urbino,* Manet's *Olympia,* Gauguin's *Te Arii Vahine,*
Valadon's *The Blue Room,* and Eidos Interactive's *Lara Croft*

"We never encounter the body unmediated by the meanings that cultures give to it." Right out of the starting gate, can you challenge yourself to support or contest this statement with reference to the five works in this exercise? The words are Gayle Rubin's, and they can be found in her essay "Thinking Sex: Notes for a Radical Theory of the Politics of Sexuality." Which of these works, in your view, are about "thinking sex"? Which address the "politics of sexuality"?

Titian's reclining nude (Fig. 18-14) was commissioned by the duke of Urbino for his private quarters. There was a considerable market for erotic paintings in the sixteenth century. Indeed, one point of view maintains that many of the "great nudes" of Western art were, in essence, created for the same purpose as the "pinup." Yet there is also no doubt that this particular reclining nude has had an undisputed place in the canon of "great art." And this much, at least, has been reaffirmed by the reinterpretations and revisions the work has inspired into contemporary times.

One of the first artists to use Titian's *Venus* as a point of departure for his own masterpiece was Edouard Manet. In his *Olympia* (Fig. 18-15), Manet intentionally mimicked the Renaissance composition as a way of challenging the notion that modern art lacked credibility when brought face-to-face with the "old masters." In effect, Manet seemed to be saying, "You want a Venus? I'll give you a Venus." And just where do you find a "Venus" in nineteenth-century Paris? In the bordellos of the Parisian demimonde. What do these paintings have in common? Where do they depart? What details does Titian use to create an air of innocence and vulnerability? What details does Manet use to do just the opposite?

Paul Gauguin, the nineteenth-century French painter who moved to Tahiti, was also inspired by the tradition of the Western reclining nude in the creation of *Te Arii Vahine* (The Noble Woman) (Fig. 18-16). The artist certainly knew Manet's revision of the work; in fact, he had a photograph of *Olympia* tacked on the wall of his hut. How does this Tahitian "Venus" fit into the mix? All three of these works have a sense of self-display. In which do the women solicit our gaze? refuse our gaze? How do the stylistic differences influence our interpretation of the women and our relationship to them? How is the flesh modeled in each work? What overall effects are provided by the different palettes? And the $64,000 ques-

18-14 TITIAN.
Venus of Urbino (1538).
Oil on canvas. 47″ × 65″.
Uffizi Gallery, Florence. Copyright Edimedia/Corbis.

18-15 ÉDOUARD MANET.
Olympia (1863–1865).
Oil on canvas. 51⅜″ × 74¾″.
Musée d'Orsay, Paris/Erich Lessing/Art Resource, New York.

18-16　PAUL GAUGUIN.
Te Arii Vahine (The Noble Woman) (1896).
Oil on canvas. 97 cm × 130 cm.

Pushkin Museum, Moscow. Copyright Erich Lessing/Art Resource, New York.

18-17　SUZANNE VALADON.
The Blue Room (1923).
Oil on canvas. 35½″ × 45⅝″.

Musée National d'Art Moderne, Centre Georges Pompidou/ Réunion des Musées Nationaux. Copyright CNAC/MNAM/RMN/ Art Resource, New York. Copyright 2003 Artists Rights Society (ARS), New York/ADAGP, Paris.

18-18　*Lara Croft.*
Computer-generated drawing.

Courtesy of Eidos Interactive.

tion: Are these paintings intended for the "male gaze," "the female gaze," or both?

Suzanne Valadon would probably say that such an image is *not* one that appeals equally to men and women. More to the point, Valadon would argue that the painting of such subjects is not at all of interest to women artists. Perhaps this belief was the incentive behind her own revision of the reclining nude: *The Blue Room* (Fig. 18-17). With this work she seems to be informing the world that when women relax, they really *don't* look like the "Venuses" of Titian, or Manet, or Gauguin. Instead, they get into their loose-fitting clothes, curl up with a good book, and sometimes treat themselves to a bit of tobacco.

The woman in *The Blue Room* may be real, but the cyberspace character in Figure 18-18 is the stuff of virtual reality. *Lara Croft* was created in the 1990s by Eidos Interactive as the player's alter ego in the Tomb Raider video games. If in his *Olympia* Manet was saying, "You want a Venus? I'll give you a Venus," Eidos Interactive seems to have been saying, "You want a Venus? We'll give you a millennium version— tall (5′9″), slim (110 lb), buffed up, with 'danger' for a middle name." The contemporary Olympia posed in this video game still serves as yet another revision of the enduring tradition of the reclining female figure—albeit one that seems to reverse power relationships. Unlike her art historical counterparts who recline before the male gaze, existing to substantiate "men's power over, superiority to, . . . and necessary control of women," Lara appears to be in control of her viewer—typically an adolescent male. But is she? When male players use Lara to vanquish their computer-generated enemies, do not her powers somehow meld with theirs? And does not the self-sufficient Lara present, on some level, something of the male desire for a superwoman? The vision of Lara Croft may be something quite new to the visual arts, but the issues (and eyebrows) she raises have any number of precedents. ▪

The Horse Fair (1853).
Oil on canvas. 8′¼″ × 16′7½″.
The Metropolitan Museum of Art, New York. Gift of Cornelius
Vanderbilt, 1887 (87.25). Copyright 1997 The Metropolitan Museum
of Art, New York.

The Horse Fair (Fig. 18-19) is a panoramic scene of extraordinary power, inspired by the Parthenon's horsemen frieze. The dimensions—more than twice as long as it is high—compel the viewer to perceive the work as just a small portion of a vast scene in which continuation of action beyond the left and right borders of the canvas is implied. The dramatic contrasts of light and dark underscore the struggle between man and beast, while the painterly brushwork heightens the emotional energy in the painting. *The Horse Fair* was an extremely popular work, which was bought widely in engraved reproductions, cementing Bonheur's fame and popularity.

IMPRESSIONISM

While Bonheur won quick acceptance by the Academy, a group of younger artists were banding together against the French art establishment. Suffering from lack of recognition and vicious criticism, many of them lived in abject poverty for lack of commissions. Yet they stand today as some of the most significant and certainly among the most popular artists in the history of art. They were called the *Impressionists*. The very name of their movement was coined by a hostile critic and intended to malign their work. The word *impressionism* suggests a lack of realism, and realistic representation was the standard of the day.

The Impressionist artists had common philosophies about painting, although their styles differed widely. They all reacted against the constraints of the Academic style and subject matter. They advocated painting out-of-doors and chose to render subjects found in nature. They studied the dramatic effects of atmosphere and light on people and objects and, through a varied palette, attempted to duplicate these effects on canvas.

Through intensive investigation, they arrived at awareness of certain visual phenomena. When bathed in sunlight, objects are optically reduced to facets of pure color. The actual color—or local color—of these objects is altered by different lighting effects. Solids tend to dissolve into color fields. Shadows are not black or gray but a combination of colors.

Technical discoveries accompanied these revelations. The Impressionists duplicated the glimmering effect of light bouncing off the surface of an object by applying their pigments in short, choppy strokes. They juxtaposed complementary colors such as red and green to reproduce the optical vibrations perceived when one is looking at an object in full sunlight. Toward this end they also juxtaposed primary

I have no other wish than a close fusion with nature, and I desire no other fate than to have worked and lived in harmony with her laws. Beside her grandeur, her power, and her immortality, the human creature seems but a miserable atom.

—Claude Monet

18-20 CLAUDE MONET.
Impression: Sunrise (1872).
Oil on canvas. 19½″ × 25½″.
Musée Marmottan, Paris. Copyright Scala/Art Resource, New York.

18-21 CLAUDE MONET.
Rouen Cathedral (1894).
Oil on canvas. 39¼″ × 25⅞″.
The Metropolitan Museum of Art, New York. Theodore M. Davis Collection, 1915 (30.95.250). Copyright 1996 The Metropolitan Museum of Art, New York.

colors such as red and yellow to produce, in the eye of the spectator, the secondary color orange. We shall discuss the work of the Impressionists Claude Monet, Pierre-Auguste Renoir, Berthe Morisot, and Edgar Degas.

Claude Monet

The most fervent follower of Impressionist techniques was the painter Claude Monet (1840–1926). His canvas *Impression: Sunrise* (Fig. 18-20) inspired the epithet "impressionist" when it was exhibited at the first Impressionist exhibition in 1874. Fishing vessels sail from the port of Le Havre toward the morning sun, which rises in a foggy sky to cast its copper beams on the choppy, pale blue water. The warm blanket of the atmosphere envelops the figures, their significance having paled in the wake of nature's beauty.

The dissolution of surfaces and the separation of light into its spectral components remain central to Monet's art. They are dramatically evident in a series of canvases depicting *Rouen Cathedral* (Fig. 18-21) from a variety of angles,

One morning, one of us, lacking black, used blue: Impressionism was born.

—Pierre-Auguste Renoir

18-22 PIERRE-AUGUSTE RENOIR.
Le Moulin de la Galette (1876).
Oil on canvas 51½" × 69".
Musée d'Orsay, Paris/Erich Lessing/Art Resource, New York.

during different seasons and times of day. The harsh stone facade of the cathedral dissolves in a bath of sunlight, its finer details obscured by the bevy of brushstrokes crowding the surface. Dark shadows have been transformed into patches of bright blue and splashes of yellow and red. With these delicate touches, Monet has recorded for us the feeling of a single moment in time. He offers us his impressions as eyewitness to a set of circumstances that will never be duplicated.

Pierre-Auguste Renoir

Most Impressionists counted among their subject matter landscape scenes or members of the middle class enjoying leisure-time activities. Of all the Impressionists, however,

Pierre-Auguste Renoir (1841–1919) was perhaps the most significant figure painter. Like his peers, Renoir was interested primarily in the effect of light as it played across the surface of objects. He illustrated his preoccupation in one of the most wonderful paintings of the Impressionist period, *Le Moulin de la Galette* (Fig. 18-22). With characteristic feathery strokes, Renoir communicated all of the charm and gaiety of an afternoon dance. Men and women caress and converse in frocks that are dappled with sunlight filtering through the trees. All of the spirit of the event is as fresh as if it were yesterday. From the billowing skirts and ruffled dresses to the rakish derbies, top hats, and skimmers, Renoir painted all the details that imprint such a scene on the mind forever.

It is very good to copy what one sees; it is much better to draw what you can't see anymore but is in your memory. It is a transformation in which imagination and memory work together. You only reproduce what struck you; that is to say, the necessary.

—Edgar Degas

Berthe Morisot

Like a number of other Impressionists, Berthe Morisot (1841–1895) exhibited at the Salon early in her career, but she surrendered the safe path as an expression of her allegiance to the new. Morisot was a granddaughter of the eighteenth-century painter Jean-Honoré Fragonard (see Chapter 16) and the sister-in-law of Edouard Manet. Manet painted

18-23 BERTHE MORISOT.
Young Girl by the Window (1878).
Oil on canvas. 29¹⁵⁄₁₆″ × 24″.
Musée Fabre, Montpellier, France. Marie de Montpellier. Copyright Art Resource, New York.

her quite often. In fact, Morisot is the seated figure in his painting *The Balcony.*

In Morisot's *Young Girl by the Window* (Fig. 18-23), surfaces dissolve into an array of loose brushstrokes, applied, it would seem, at a frantic pace. The vigor of these strokes contrasts markedly with the tranquility of the woman's face. The head is strongly modeled, and a number of structural lines, such as the back of the chair, the contour of her right arm, the blue parasol astride her lap, and the vertical edge of drapery to the right, anchor the figure in space. Yet in this, as in most of Morisot's works, we are most impressed by her ingenious ability to suggest complete forms through a few well-placed strokes of pigment.

Edgar Degas

We can see the vastness of the aegis of Impressionism when we look at the work of Edgar Degas (1834–1917), whose approach to painting differed considerably from that of his peers. Degas, like Morisot, had exhibited at the Salon for many years before joining the movement. He was a superb draftsman who studied under Ingres. While in Italy, he copied the Renaissance masters. He was also intrigued by Japanese prints and the new art of photography.

The Impressionists, beginning with Manet, were strongly influenced by Japanese woodcuts, which were becoming readily available in Europe, and oriental motifs appeared widely in their canvases. They also adopted certain techniques of spatial organization found in Japanese prints, including the use of line to direct the viewer's eye to different sections of the work and to divide areas of the essentially flattened space (see Chapter 17). They found that the patterning and flat forms of oriental woodcuts complemented similar concerns in their own painting. Throughout the Impressionist period and even more so in the Post-impressionist period, the influence of Japanese artists remained strong.

Degas was also strongly influenced by the developing art of photography, and the camera's exclusive visual field served as a model for the way in which he framed his own

18-24 EDGAR DEGAS.
The Rehearsal (Adagio) (1877).
Oil on canvas. 26" × 39⅜".
The Burrell Collection, Glasgow Art Gallery and Museum, Glasgow.

paintings. *Ballet Rehearsal (Adagio)* (Fig. 18-24) contains elements both of photographs and of Japanese prints. Degas draws us into the composition with an unusual and vast off-center space that curves around from the viewer's space to the background of the canvas. The diagonals of the floorboards carry our eyes briskly from outside the canvas to the points at which the groups of dancers congregate. The imagery is placed at eye level so that we feel we are part of the scene. This feeling is enhanced by the fact that our "seats" at the rehearsal are less than adequate; a spiral staircase to the left blocks our view of the ballerinas. In characteristic camera fashion, the borders of the canvas slice off the forms and figures in a seemingly arbitrary manner.

Although it appears as if Degas has failed to frame his subject correctly or has accidentally cut off the more important parts of the scene, he carefully planned the placement of his imagery. These techniques are what render his asymmetrical compositions so dynamic and, in the spirit of Impressionism, so immediate.

POSTIMPRESSIONISM

The Impressionists were united in their rejection of many of the styles and subjects of the art that preceded them. These included Academic painting, the emotionalism of Romanticism, and even the depressing subject matter of some of the Realist artists. During the latter years of the nineteenth century, a group of artists that came to be called Postimpressionists were also united in their rebellion against that which came before them—in this case, Impressionism. The Postimpressionists were drawn together by their rebellion against what they considered an excessive concern for fleeting impressions and a disregard for traditional compositional elements.

Although they were united in their rejection of Impressionism, their individual styles differed considerably. Postimpressionists fell into two groups that in some ways parallel the stylistic polarities of the Baroque period as well as the Neoclassical-Romantic period. On the one hand, the work

of Georges Seurat and Paul Cézanne had at its core a more systematic approach to compositional structure, brushwork, and color. On the other hand, the lavishly brushed canvases of Vincent van Gogh and Paul Gauguin coordinated line and color with symbolism and emotion.

Georges Seurat

At first glance, the paintings by Georges Seurat (1859–1891), such as *A Sunday Afternoon on the Island of La Grande Jatte* (Fig. 18-25), have the feeling of Impressionism "tidied up." The small brushstrokes are there, as are the juxtapositions of complementary colors. The subject matter is entirely acceptable within the framework of Impressionism. However, the spontaneity of direct painting found in Impressionism is relinquished in favor of a more tightly controlled, "scientific" approach to painting.

Seurat's technique has also been called **pointillism,** after his application of pigment in small dabs, or points, of pure color. Upon close inspection, the painting appears to be a collection of dots of vibrant hues—complementary colors abutting one another, primary colors placed side by side. These hues intensify or blend to form yet another color in the eye of the viewer who beholds the canvas from a distance.

Seurat's meticulous color application was derived from the color theories and studies of color contrasts by the scientists Hermann von Helmholtz and Michel-Eugène Chevreul. He used these theories to restore a more intellectual approach to painting that countered nearly two decades of works that focused wholly on optical effects.

18-25 GEORGES SEURAT.
A Sunday Afternoon on the Island of La Grande Jatte (1884–1886).
Oil on canvas. 81″ × 120⅜″.
The Art Institute of Chicago. Helen Birch Bartlett Memorial Collection/
Topfoto/The Image Works.

The same subject seen from a different angle gives a subject for study of the highest interest and so varied that I think I could be occupied for months without changing my place, simply bending a little more to the right or left.

—Paul Cézanne

18-26 PAUL CÉZANNE.
Still Life with Basket of Apples (c. 1895).
Oil on canvas. 65 cm × 80 cm.
The Art Institute of Chicago. Helen Birch Bartlett Memorial Collection. Photo courtesy of the Art Institute of Chicago.

Paul Cézanne

From the time of Manet, there was a movement away from a realistic representation of subjects toward one that was abstracted. Early methods of abstraction assumed different forms. Manet used a flatly painted form, Monet a disintegrating light, and Seurat a tightly painted and highly patterned composition. Paul Cézanne (1839–1906), a Postimpressionist who shared with Seurat an intellectual approach to painting, is credited with having led the revolution of abstraction in modern art from those first steps.

Cézanne's method for accomplishing this radical departure from tradition did not disregard the old masters. Although he allied himself originally with the Impressionists and accepted their palette and subject matter, he drew from old masters in the Louvre and desired somehow to reconcile their lessons with the thrust of Modernism, saying, "I want

to make of Impressionism something solid and lasting like the art in the museums." Cézanne's innovations include a structural use of color and brushwork that appeals to the intellect, and a solidity of composition enhanced by a fluid application of pigment that delights the senses.

Cézanne's most significant stride toward Modernism, however, was a drastic collapsing of space, seen in works such as *Still Life with Basket of Apples* (Fig. 18-26). All of the imagery is forced to the picture plane. The tabletop is tilted toward us, and we simultaneously view the basket, plate, and wine bottle from front and top angles. Cézanne did not paint the still-life arrangement from one vantage point either. He moved around his subject, painting not only the objects but the relationship among them. He focused on solids as well as on the void spaces between two objects. If you run your finger along the tabletop in the background of the painting, you will see that it is not possible to trace a continuous line. This discontinuity follows from Cézanne's movement around his subject. In spite of this spatial inconsistency, the overall feeling of the composition is one of completeness.

Cézanne's painting technique is also innovative. The sensuously rumpled fabric and lusciously round fruits are constructed of small patches of pigment crowded within dark outlines. The apples look as if they would roll off the table were it not for the supportive facets of the tablecloth.

Cézanne can be seen as advancing the flatness of planar recession begun by David more than a century earlier. Cézanne asserted the flatness of the two-dimensional canvas by eliminating the distinction between foreground and background, and at times merging the two. This was perhaps his most significant contribution to future modern movements.

Vincent van Gogh

One of the most tragic and best-known figures in the history of art is the Dutch Postimpressionist Vincent van Gogh (1853–1890). We associate him with bizarre and painful acts, such as the mutilation of his ear and his suicide. With these events, as well as his tortured, eccentric painting, he typifies the impression of the mad, artistic talent. Van Gogh also epitomizes the cliché of the artist who achieves recognition only after death: just one of his paintings was sold during his lifetime.

"Vincent," as he signed his paintings, decided to become an artist only 10 years before his death. His most beloved canvases were created during his last 29 months. He began his career painting in the dark manner of the Dutch Baroque, only to adopt the Impressionist palette and brushstroke after he settled in Paris with his brother, Theo. Feeling that he was a constant burden on his brother, he left Paris for Arles, where he began to paint his most significant Postimpressionist works. Both his life and his compositions from this period were tortured, as Vincent suffered from what may have been bouts of epilepsy and mental illness. He was eventually hospitalized in an asylum at Saint-Rémy, where he painted the famous *Starry Night* (Fig. 18-27).

18-27 VINCENT VAN GOGH.
Starry Night (1889).
Oil on canvas. 29″ × 36¼″.
The Museum of Modern Art, New York.
Acquired through the Lillie P. Bliss Bequest.
Copyright The Museum of Modern Art,
New York/Art Resource, New York.

Why Did van Gogh Cut Off His Ear?

Two days before Christmas in the year 1888, the 35-year-old Vincent van Gogh cut off the lower half of his left ear (Fig. 18-28). He took the ear to a brothel, asked for a prostitute by the name of Rachel, and handed it to her. "Keep this object carefully," he said.

How do we account for this extraordinary event? Over the years, many explanations have been advanced. Many of them are psychoanalytic in nature.* That is, they argue that van Gogh fell prey to unconscious primitive impulses.

As you consider the following suggestions, keep in mind that van Gogh's bizarre act occurred many years ago and that we have no way today to determine which, if any, of them is accurate. Perhaps one of them cuts to the core of van Gogh's urgent needs; perhaps several of them contain a kernel of truth. But it could also be that all of them fly far from the mark. In any event, here are a number of explanations suggested in the *Journal of Personality and Social Psychology:*[†]

18-28 VINCENT VAN GOGH.
Self-Portrait with Bandaged Ear
(1889–1890).
Oil on canvas. 23⅝″ × 19¼″.
Courtauld Institute Galleries, London/
Edimedia/Corbis.

1. Van Gogh was frustrated by his brother's engagement and his failure to establish a close relationship with Gauguin. The aggressive impulses stemming from the frustrations were turned inward and expressed in self-mutilation.

2. Van Gogh was punishing himself for experiencing homosexual impulses toward Gauguin.

3. Van Gogh identified with his father, toward whom he felt resentment and hatred, and the cutting off of his own ear was a symbolic punishment of his father.

4. Van Gogh was influenced by the practice of awarding the bull's ear to the matador after a bullfight. In effect, he was presenting such an "award" to the lady of his choice.

5. Van Gogh was influenced by newspaper accounts of Jack the Ripper, who mutilated prostitutes. Van Gogh was imitating the "ripper," but his self-hatred led him to mutilate himself rather than others.

6. Van Gogh was seeking his brother's attention.

7. Van Gogh was seeking to earn the sympathy of substitute parents. (The mother figure would have been a model he had recently painted rocking a cradle.)

8. Van Gogh was expressing his sympathy for prostitutes, with whom he identified as social outcasts.

9. Van Gogh was symbolically emasculating himself so that his mother would not perceive him as an unlikable "rough" boy. (Unconsciously, the prostitute was a substitute for his mother.)

10. Van Gogh was troubled by auditory hallucinations (hearing things that were not there) as a result of his mental state. He cut off his ear to put an end to disturbing sounds.

11. In his troubled mental state, Van Gogh may have been acting out a biblical scene he had been trying to paint. According to the New Testament, Simon Peter cut off the ear of the servant Malchus to protect Christ.

12. Van Gogh was acting out the Crucifixion of Jesus, with himself as victim. ∎

*William McKinley Runyan, *Journal of Personality and Social Psychology* (June 1981).
[†] Ibid.

Art is either plagiarism or revolution.

—Paul Gauguin

In *Starry Night* an ordinary painted record of a sleepy valley town is transformed into a cosmic display of swirling fireballs that assault the blackened sky and command the hills and cypresses to undulate to their sweeping rhythms. Vincent's palette is laden with vibrant yellows, blues, and greens. His brushstroke is at once restrained and dynamic. His characteristic long, thin strokes define the forms but also create the emotionalism in the work. He presents his subject not as we see it but as he would like us to experience it. His is a feverish application of paint, an ecstatic kind of drawing, reflecting at the same time his joys, hopes, anxieties, and despair. Vincent wrote in a letter to his brother Theo, "I paint as a means to make life bearable. . . . Really we can speak only through our paintings."

Paul Gauguin

Paul Gauguin (1848–1903) shared with van Gogh the desire to express his emotions on canvas. But whereas the Dutchman's brushstroke was the primary means to that end, Gauguin relied on broad areas of intense color to transpose his innermost feelings to canvas.

Gauguin, a stockbroker by profession, began his artistic career as a weekend painter. It was not until the age of 35 that he devoted himself full-time to his art, leaving his wife and five children to do so. Gauguin identified early with the Impressionists, adopting their techniques and participating in their exhibitions. But Gauguin was a restless soul. Soon he decided to leave France for Panama and Martinique,

primitive places where he hoped to purge the civilization from his art and life. The years until his death were spent between France and the South Seas, where he finally died of syphilis five years after a failed attempt to take his own life.

Gauguin developed a theory of art called **Synthetism,** in which he advocated the use of broad areas of unnaturalistic color and primitive or symbolic subject matter. His *Vision after the Sermon (Jacob Wrestling with the Angel)* (Fig. 18-29), one of the first canvases to illustrate his theory, combines reality with symbolism. After hearing a sermon on the subject, a group of Breton women believed they had a vision of Jacob, ancestor of the Hebrews, wrestling with an angel. In a daring composition that cancels pictorial depth by thrusting all elements to the front of the canvas, Gauguin presented all details of the event, actual and symbolic. An animal in the upper left portion of the canvas walks near a tree that interrupts a bright vermilion field with a slashing diagonal. The Bible tells us that it was on the banks of the Jabbok River in Jordan that Jacob had wrestled with an angel. Caught, then, in a moment of religious fervor, the Breton women may have imagined the animal's four legs to have been those of the wrestling couple, and the tree trunk might have been visually analogous to the river.

Gauguin's contribution to the development of modern art lay largely in his use of color. Writing on the subject, he said, "How does that tree look to you? Green? All right, then use green, the greenest on your palette. And that shadow, a little bluish? Don't be afraid. Paint it as blue as you can." He intensified the colors he observed in nature to the point where they became unnatural. He exaggerated his lines and patterns until they became abstract. These were the lessons he learned from the primitive surroundings of which he was so fond. They were his legacy to art.

Henri de Toulouse-Lautrec

Henri de Toulouse-Lautrec (1864–1901), along with van Gogh, is one of the best-known nineteenth-century European artists—both for his art and for the troubled aspects of his personal life. Born into a noble French family, Toulouse-Lautrec broke his legs during adolescence and

18-29 PAUL GAUGUIN.
Vision after the Sermon (Jacob Wrestling with the Angel) (1888).
Oil on canvas. 28¾" × 36½".
National Galleries of Scotland, Edinburgh / Edimedia / Corbis.

they failed to develop correctly. This deformity resulted in alienation from his family. He turned to painting and took refuge in the demimonde of Paris, at one point taking up residence in a brothel. In this world of social outcasts, Toulouse-Lautrec, the dwarflike scion of a noble family, apparently felt at home.

He used his talents to portray life as it was in this cavalcade of cabarets, theaters, cafes, and bordellos—sort of seamy, but also vibrant and entertaining, and populated by "real" people. He made numerous posters to advertise cabaret acts (see Fig. 11-30) and numerous paintings of his world of night and artificial light. In *At the Moulin Rouge* (Fig. 18-30), we find something of the Japanese-inspired oblique perspective we found earlier in his poster work. The extension of the picture to include the balustrade on the bottom and the heavily powdered entertainer on the right is reminiscent of those "poorly cropped snapshots" of Degas, who had influenced Toulouse-Lautrec. The fabric of the entertainer's dress is constructed of fluid Impressionistic brushstrokes, as are the contents of the bottles, the lamps in the background, and the amorphous overall backdrop—lost suddenly in the unlit recesses of the Moulin Rouge. But the strong outlining, as in the entertainer's face, marks the work of a Postimpressionist. The artist's palette is limited and muted, except for a few accents, as found in the hair of the woman in the center of the composition and the bright mouth of the entertainer. The entertainer's face is harshly sculpted by artificial light from beneath, rendering the shadows a grotesque but not ugly green. The green and red mouth clash, of course, as green and red are complementary colors, giving further intensity to the entertainer's masklike visage. But despite her powdered harshness, the entertainer remains human—certainly as human as her audience. Toulouse-Lautrec was accepting of all his creatures, just as he hoped that they would be accepting of him. The artist is portrayed within this work as well, his bearded profile facing left, toward the upper part of the composition, just left of center—a part of things, but not at the heart of things, certainly out of the glare of the spotlight. There, so to speak, the artist remained for many of his brief 37 years.

18-30 HENRI DE TOULOUSE-LAUTREC. *At the Moulin Rouge* (1892). Oil on canvas. 123 cm × 141 cm. The Art Institute of Chicago. Helen Birch Bartlett Memorial Collection. Photo courtesy of the Art Institute of Chicago/Edimedia/Corbis.

EXPRESSIONISM

A polarity existed in Postimpressionism that was like the polarity of the Neoclassical-Romantic period. On the one hand were artists who sought a more scientific or intellectual approach to painting. On the other were artists whose works were more emotional, expressive, and laden with symbolism. The latter trend was exemplified by van Gogh and particularly Gauguin. These artists used color and line to express inner feelings. In their vibrant palettes and bravura brushwork, van Gogh and Gauguin foreshadowed Expressionism.

Edvard Munch

The expressionistic painting of Gauguin was adopted by the Norwegian Edvard Munch (1863–1944), who studied the Frenchman's works in Paris. Munch's early work was Impressionistic, but during the 1890s he abandoned a light palette and lively subject matter in favor of a more somber style that reflected an anguished preoccupation with fear and death.

The Scream (Fig. 18-31) is one of Munch's best-known works. It portrays the pain and isolation that became his central themes. A skeletal figure walks across a bridge toward the viewer, cupping his ears and screaming. Two figures in the background walk in the opposite direction, unaware of or uninterested in the sounds of desperation piercing the atmosphere. Munch transformed the placid landscape into one that echoes in waves the high-pitched tones that

The sky was suddenly blood-red—I stopped and leaned against the fence, dead tired. I saw the flaming clouds like blood and a sword—the bluish-black fjord and town—my friends walked on—I stood there, trembling with anxiety—and I felt as though Nature were convulsed by a great unending scream.

—Edvard Munch

Where do all the women who have watched so carefully over the lives of their beloved ones get the heroism to send them to face the cannon?

—Käthe Kollwitz

emanate from the sunken head. We are reminded of the swirling forms of van Gogh's *Starry Night,* but the intensity and horror pervading Munch's composition speak of his view of humanity as being consumed by an increasingly dehumanized society.

Käthe Kollwitz

It is not often in the history of art that we find two artists whose backgrounds are so similar that we can control for just about every variable except for personality when com-

paring their work. But such is the case with Edvard Munch and Käthe Kollwitz (1867–1945). They were born and died within a few years of each other. They both lived through two world wars; Kollwitz lost a son in World War I and a grandson in World War II. Both are Expressionist artists. Yet their choice of subjects speaks of their idiosyncratic concerns. Whereas Munch looked for symbols of isolation that would underscore his own sense of loneliness, or themes of violence and perverse sexuality that reflected his own psychological problems, Kollwitz sought universal symbols for inhumanity, injustice, and humankind's destruction of itself.

The Outbreak (Fig. 18-32) is one of a series of seven prints by Kollwitz representing the sixteenth-century Peasants' War. In this print, Black Anna, a woman who led the

18-31 EDVARD MUNCH.
The Scream (1893).
Casein on paper. $35\frac{1}{2}'' \times 28\frac{2}{3}''$.
National Gallery, Oslo, Norway/Erich Lessing/Art Resource, New York.

18-32 KÄTHE KOLLWITZ.
The Outbreak (1903). Plate no. 5 from *The Peasants' War.*
Library of Congress, Washington, DC. Collection of Ellen and Max Friedman. Copyright 2003 Artists Rights Society (ARS), New York/ VG Bild-Kunst, Bonn.

laborers in their struggle against their oppressors, incites an angry throng of peasants to action. Her back is toward us, her head down, as she raises her gnarled hands in inspiration. The peasants rush forward in a torrent, bodies and weapons lunging at Anna's command. Although the work records a specific historical incident, it stands as an inspiration to all those who strive for freedom against the odds. There are few more forceful images in the history of art.

The styles of these early Expressionists would be adopted in the twentieth century by younger German artists who shared their view of the world. Many revived the woodcut medium to complement their expressive subjects. This younger generation of artists worked in various styles, but collectively were known as the Expressionists. We shall examine their work in Chapter 19.

AMERICAN EXPATRIATES

Until the twentieth century, art in the United States remained fairly provincial. Striving artists of the eighteenth and nineteenth centuries would go abroad for extended pilgrimages to study the old masters and mingle with the avant-garde. In some cases, they immigrated to Europe permanently. These artists, among them Mary Cassatt and James Abbott McNeill Whistler, are called the American Expatriates.

Mary Cassatt

Mary Cassatt (1844–1926) was born in Pittsburgh but spent most of her life in France, where she was part of the inner circle of Impressionists. The artists Manet and Degas, photog-

raphy, and Japanese prints influenced Cassatt's early career. She was a figure painter whose subjects centered on women and children.

A painting such as *The Boating Party* (Fig. 18-33), with its flat planes, broad areas of color, and bold lines and shapes, illustrates Cassatt's interest and skill in merging French Impressionism with elements of Japanese art. Like many of her contemporaries in Paris, she became aware of Japanese prints and art objects after trade was established between Japan and Europe in the mid-nineteenth century. In their solidly constructed compositions and collapsed space, Cassatt's lithographs, in particular, stand out from the more ethereal images of other Impressionists.

James Abbott McNeill Whistler

In the same year that Monet painted his *Impression: Sunrise* and launched the movement of Impressionism, the American artist James Abbott McNeill Whistler (1834–1903) painted one of the best-known compositions in the history of art. Who among us has not seen "Whistler's Mother," whether on posters, billboards, or television commercials?

18-33 MARY CASSATT.
The Boating Party (1893–1894).
Oil on canvas. 35½″ × 46⅛″.
National Gallery of Art, Washington, DC. Chester Dale Collection. Copyright 2003 Board of Trustees, National Gallery of Art, Washington, DC.

JAMES ABBOTT MCNEILL
WHISTLER.
*Arrangement in Black and Gray:
The Artist's Mother* (1871).
Oil on canvas. 57" × 64½".
Louvre Museum, Paris / Edimedia / Corbis.

Arrangement in Black and Gray: The Artist's Mother (Fig. 18-34) exhibits a combination of candid realism and abstraction that indicates two strong influences on Whistler's art: Courbet and Japanese prints. Whistler's mother is silhouetted against a quiet backdrop in the right portion of the composition. The strong contours of her black dress are balanced by an oriental drape and simple rectangular picture on the left. The subject is rendered in a harsh realism reminiscent of northern Renaissance portrait painting. However, the composition is seen first as a logical and pleasing arrangement of shapes in tones of black, gray, and white that work together in pure harmony.

AMERICANS IN AMERICA

While Whistler and Cassatt were working in Europe, several American artists of note remained at home working in the Realist tradition. This realism can be detected in figure painting and landscape painting, both of which were tinted with Romanticism.

Thomas Eakins

The most important American portrait painter of the nineteenth century was Thomas Eakins (1844–1916). Although his early artistic training took place in the United States, his study in Paris with painters who depicted historical events provided the major influence on his work. The penetrating realism of a work such as *The Gross Clinic* (Fig. 18-35) stems from Eakins's endeavors to become fully acquainted with human anatomy by working from live models and dissecting corpses. Eakins's dedication to these practices met with disapproval from his colleagues and ultimately forced his resignation from a teaching post at the Pennsylvania Academy of Art.

The Gross Clinic—no pun intended—depicts the surgeon Dr. Samuel Gross operating on a young boy at the Jefferson Medical College in Philadelphia. Eakins thrusts the

18-35 THOMAS EAKINS.
The Gross Clinic (1875).
Oil on canvas. 96" × 78".
Jefferson Medical College of Thomas Jefferson University, Philadelphia.

brutal imagery to the foreground of the painting, spotlighting the surgical procedure and Dr. Gross's bloody scalpel while casting the observing medical students in the background into darkness. The painting was deemed so shockingly realistic that it was rejected by the jury for an exhibition. Part of the impact of the work lies in the contrast between the matter-of-fact discourse of the surgeon and the torment of the boy's mother. She sits in the lower left corner of the painting, shielding her eyes with whitened knuckles. In brush technique Eakins is close to the fluidity of Courbet, although his compositional arrangement and dramatic lighting are surely indebted to Rembrandt.

Eakins devoted his career to increasingly realistic portraits. Their haunting veracity often disappointed sitters who would have preferred more flattering renditions. The artist's passion for realism led him to use photography extensively as a point of departure for his paintings as well as an art form in itself. Eakins's style and ideas influenced American artists of the early twentieth century who also worked in a Realist vein.

Thomas Cole

During the nineteenth century, American artists turned, for the first time, from the tradition of portraiture to landscape painting. Inspired by French landscape painting of the Baroque period, these artists fused this style with a pride in the beauty of their native United States and a Romantic vision that was embodied in the writings of James Fenimore Cooper.

One such artist was Thomas Cole (1801–1848). Cole was born in England and immigrated to the United States at the age of 17. Cole was always fond of landscape painting and settled in New York, where there was a ready audience for this genre. Cole became the leader of the **Hudson River School**—a group of artists whose favorite subjects included the scenery of the Hudson River Valley and the Catskill Mountains in New York State.

The Oxbow (Fig. 18-36) is typical of such paintings. It records a natural oxbow formation in the Connecticut River Valley. Cole combines a vast, sun-drenched space with meticulously detailed foliage and farmland. There is

18-36 THOMAS COLE.
The Oxbow (*Connecticut River near Northampton*) (1836).
Oil on canvas. 51½″ × 76″.
The Metropolitan Museum of Art, New York. Gift of Mrs. Russell Sage, 1908 (08.228). Copyright 1995 The Metropolitan Museum of Art, New York.

Weaving Together Biblical and Personal Stories

In 1859, Harriet Beecher Stowe, renowned author of *Uncle Tom's Cabin,* described the quilting bee:

> *The day was spent in friendly gossip as they rolled and talked and laughed. . . . One might have learned in that instructive assembly how best to keep moths out of blankets; how to make fritters of Indian corn undistinguishable from oysters; how to bring up babies by hand; how to mend a cracked teapot; how to take grease from a brocade; how to reconcile absolute decrees with free will; how to make five yards of cloth answer the purpose of six; and how to put down the Democratic party.*[*]

Many years later, an author on quiltmaking quoted her great-grandmother: "My whole life is in that quilt. It scares me sometimes when I look at it. All my joys and all my sorrows are stitched into those little pieces."[†]

The art of quiltmaking was clearly not only an acceptable vehicle for women's artistic expression but also an arena for consciousness raising on the practical and political problems of the day. Beyond this, the object recorded family history, kept memory alive, and ensured the survival of the matriarch/quilter through that historical record.

Toward the end of the nineteenth century, African American quilter Harriet Powers created her *Bible Quilt.* Its 15 squares of cotton appliqué weave together stories from the Bible with significant events from the family and community of the artist (Fig. 18-37). For example, reading left to right, the fourth square is a symbolic depiction of Adam and Eve in the Garden of Eden. A serpent tempts Eve beneath God's all-seeing eye and benevolent hand. In the sixth square, Jonah is swallowed by a whale. The last square is a stylized depiction of the Crucifixion.

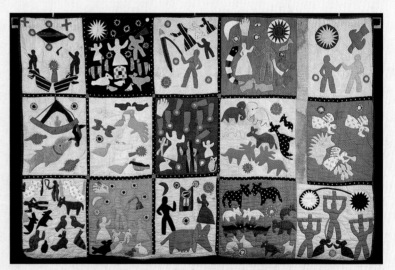

18-37 HARRIET POWERS.
Bible Quilt: The Creation of the Animals (1895–1898).
Pieced, appliquéd, and printed cotton embroidered with cotton and metallic yarn.
69″ × 105″.
Bequest of Maxim Karolik. Courtesy Museum of Fine Arts, Boston, MA.

Amidst the religious subjects are records of meaningful days. For example, the eleventh square was described by Powers as "Cold Thursday," February 10, 1895. A woman is shown frozen at a gateway while at prayer. Icicles form from the breath of a mule. All bluebirds are killed. The thirteenth square includes an "independent" hog that was said to have run 500 miles from Georgia to Virginia, and the fourteenth square depicts the creation of animals in pairs.

Unity in the quilt is created by a subtle palette of complementary hues and by simple, cutout shapes that define celestial orbs, biblical and familial characters, and biblical and local animals. The quilt has an arresting combination of widely known themes and private events known to the artist and her family. The juxtaposition establishes an equivalence between biblical and personal stories. The work personalizes the religious events and imbues the personal and provincial events with universal meaning.

Because of the hardness of the times, the artist sold the quilt for five dollars.[‡] ■

[*] Harriet Beecher Stowe, *The Minister's Wooing* (New York: Derby and Jackson, 1859).
[†] Marguerite Ickis, *The Standard Book of Quiltmaking and Collecting* (New York: Dover, 1960).
[‡] In Mirra Bank, *Anonymous Was a Woman* (New York: St. Martin's Press, 1979), 118.

a contrast in moods between the lazy movement of the river, which meanders diagonally into the distance, and the more vigorous diagonal of the gnarled tree trunk in the left foreground. Half of the canvas space is devoted to the sky, whose storm clouds roll back to reveal rays of intense light. These atmospheric effects, coupled with our "crow's-nest" vantage point, magnify the awesome grandeur of nature and force us to contemplate the relative insignificance of humans.

ART NOUVEAU

In looking at examples of French, Norwegian, and American art of the nineteenth century, we witnessed a collection of disparate styles that reflected the artists' unique situations or personalities. Given the broad range of circumstances that give rise to a work of art, it would seem unlikely that a cross-cultural style could ever evolve. However, as the nineteenth century turned to the twentieth, there arose a style called

Art Nouveau whose influence extended from Europe to the United States. Its idiosyncratic characteristics could be found in painting and sculpture as well as architecture, furniture, jewelry, fashion, and glassware.

Art Nouveau is marked by a lyrical linearity, the use of symbolism, and rich ornamentation. There is an overriding sense of the organic in all of the arts of this style, with many of the forms, such as those in Victor Horta's (1861–1947) staircase (Fig. 18-38), reminiscent of exotic plant life. Antonio Gaudi's (1852–1926) apartment house in Barcelona, Spain (Fig. 18-39), shows an obsessive avoidance of straight lines and flat surfaces. The material looks as if it had grown in place or hardened in malleable wood forms, as would cement; in actuality, it is cut stone. The rhythmic roof is wave-like, and the chimneys seem dispensed like shaving cream or soft ice cream. Nor are any two rooms on a floor alike. This multistory organic hive is clearly the antithesis of the steel-cage construction that was coming into its own at the same time.

Art Nouveau originated in England. It was part of an arts and crafts movement that arose in rebellion against the pretentiousness of nineteenth-century art. Although it continued into the early years of the twentieth century, the style

18-38　VICTOR HORTA.
Staircase in the Hotel van Eetvelde, Brussels (1895).
Brussels, Belgium. Copyright Foto Marburg/Art Resource, New York.

18-39　ANTONIO GAUDI.
Casa Mila Apartment House, Barcelona (1905–1907).
Copyright Art Resource, New York.

The only thing is to see.

—Auguste Rodin

disappeared with the onset of World War I. At that time art began to reflect the needs and fears of humanity faced with self-destruction.

THE BIRTH OF MODERN SCULPTURE

Some of the most notable characteristics of modern painting include a newfound realism of subject and technique; a more fluid, or impressionistic handling of the medium; and a new treatment of space. Nineteenth-century sculpture, for the most part, continued stylistic traditions that artists saw as complementing the inherent permanence of the medium with which they worked. It would seem that working on a large scale with materials such as marble or bronze was not well suited to the spontaneous technique that captured fleeting impressions.

One nineteenth-century artist, however, changed the course of the history of sculpture by applying to his work the very principles on which modern painting was based, including Realism, Symbolism, and Impressionism—Auguste Rodin.

Auguste Rodin

Auguste Rodin (1840–1917) devoted his life almost solely to the representation of the human figure. His figures were imbued with a realism so startlingly intense that he was accused of casting the sculptures from live models. (It is interesting to note that casting of live models is used today without criticism.)

Rodin's *The Burghers of Calais* (Fig. 18-40) represents all of the innovations of Modernism thrust into three dimensions. The work commemorates a historical event in which six prominent citizens of Calais offered their lives to the conquering English so that their fellow townspeople might be spared. They present themselves in coarse robes with nooses around their necks. Their psychological states range from quiet defiance to frantic desperation. The reality of the scene is achieved in part by the odd placement of the figures. They are not a symmetrical or cohesive group. Rather, they are a scattered collection of individuals, who were meant to be seen at street level. Captured as they are, at a particular moment in time, Rodin ensured that spectators would partake of the tragic emotion of the scene for centuries to come.

Rodin preferred modeling soft materials to carving because they enabled him to achieve highly textured surfaces that captured the play of light, much as in an Impressionist painting. As his career progressed, Rodin's sculptures took on an abstract quality. Distinct features were abandoned in favor of solids and voids that, together with light, constructed the image of a human being. Such works were outrageous in their own day—audacious and quite new. Their abstracted features set the stage for yet newer and more audacious art forms that would rise with the dawn of the twentieth century.

18-40 AUGUSTE RODIN.
The Burghers of Calais (1884–1895).
Bronze. $79\frac{3}{8}'' \times 80\frac{7}{8}'' \times 77\frac{1}{8}''$.

Copyright Hirshhorn Museum and Sculpture Garden.
Gift of Joseph Hirshhorn, 1966.

ART **TOUR**

Paris

You could devote your entire life to the pursuit and still not see all the visual delights of Paris. The city itself is one of the most beautiful in the world—a work of art in itself. Its origins, however, are far more humble. When the Romans conquered Paris in 55 BCE, it was a small fishing village on the north ("right") bank of the Seine River. Paris today has spread across the river to the Left Bank, and that tiny fishing village has expanded to hold more than 2 million people. It occupies the center of what is known as the Île-de-France, now home to one-fifth of France's 50 million people. The Île-de-France includes Versailles to the west (site of the glorious palace of King Louis XIV), Chartres with its famed Gothic cathedral (Fig. 14-23) to the southwest, and numerous chateaus, such as Fontainebleau and—my favorite—Chantilly. Twenty miles and a short train or auto ride to the east is Disneyland Paris, and a ride northwest will get you to Giverny and Monet's famous gardens, where the famed Impressionist painted water lilies, a Japanese footbridge, and many other outdoor delights. When in doubt, use the train. The Paris subway, called the Metro, is one of the best in the world, and the high-velocity trains out of town will move you around rapidly.

Take the Metro to the Trocadéro stop to visit the Eiffel Tower. Be captivated by the vista as you walk downhill between the museums on Chaillot Hill (Picasso might never have painted *Les Demoiselles d'Avignon* if he hadn't seen the African masks at the Musée de l'Homme) and across the Seine to the tower, which was built in 1889 for an industrial exhibition. At the time, the architect Gustave Eiffel was castigated by critics for building an open structure that lacked the standard masonry facade. The pieces of the 984-foot-tall tower were prefabricated, and the tower was assembled at the site in 17 months by only 150 workers. Napoleon's tomb and the Rodin Museum are a relatively short walk from the Tower.

Much of Paris is centered around the Place de la Concorde, from which one can look in any direction and find major monuments. This hub features a 3,200-year-old Egyptian obelisk that occupies the exact spot where, in the wake of the French Revolution (the Place de la Concorde was once the Place de la Revolution), a guillotine stood and the heads of more than 1,000 people rolled. To the west of the Concorde, along the Champs-Élysées—a wide boulevard where you can shop till you drop—is the Place de l'Étoile. The centerpiece of this star-shaped intersection is the Arc de Triomphe, built by Napoleon to celebrate his victorious military campaigns. It is one of the world's craziest rotaries; motorists enter it without looking anywhere but straight ahead. It is incumbent on the drivers already in the mess to do the watching out.

Just to the east of the Place de la Concorde—heading away from the Arc de Triomphe—is the Jardin (garden) des Tuileries, with lovely paths for strolling, donkey rides, a carousel, and even a Ferris wheel. Along the north side of the Tuileries, you will find the Rue de Rivoli and some of the most expensive shopping in Paris.

Just past the Jardin des Tuileries is the Louvre Museum, which many art historians consider to have the foremost collection of the art in the world. Here you will find Leonardo's *Mona Lisa* (Fig. 1-1), David's *The Oath of the Horatii* (Fig. 4-12), Géricault's *The Raft of the "Medusa," Aphrodite of Melos* (*Venus de Milo,* Fig. 13-16), Delacroix's *The Death of Sardanapalus* (Fig. 18-3), Manet's *Olympia* (Fig. 18-15), Whistler's *Arrangement in Black and Gray: The Artist's Mother* ("Whistler's Mother," Fig. 18-34), and many more famed works from around the world. But the museum itself has become a more noted work of art with I. M. Pei's controversial addition (the traditional first wing of the Palais du Louvre was built by François I in 1527).

The south side of the Jardin des Tuileries runs along the Seine and is connected to the Left Bank by many bridges. Across from the Jardin you will find the Musée d'Orsay. Before its opening in 1986, the building had been the old Gare d'Orsay, the grandest railway station in the city. In its new incarnation, the familiar floriated clock still tells time. Manets,

EIFFEL TOWER.

I. M. PEI, Pyramid at the Louvre.

MUSÉE D'ORSAY.
Copyright Stefano Bianchetti/Corbis.

NOTRE-DAME.
Copyright Yann Arthus-Bertrand/Corbis.

Monets, Renoirs, Courbets, Rodins, and other beloved works from the second half of the nineteenth century and the first decade of the twentieth populate byways where passengers once rushed. From its roof you can view the church of Sacré Coeur to the north, the Jardin des Tuileries just across the river, and the Louvre just to the right of the Jardin.

On the Right Bank in central Paris you will find a very different museum, one of contemporary art: the Georges Pompidou National Center of Art and Culture, designed by Richard Rogers and Renzo Piano. It could not be more different from the Greek-inspired Classicism of the Louvre, given its trussed steel-cage structure, service ducts, huge escalator, and stacks that remind one of an ocean liner. While in the vicinity of the Pompidou Center, take in some of the street life in the large square in front of the building or relax by the Stravinsky Fountain with its huge red lips and other sculptures, thanks to the contemporary artistry of Niki de Saint Phalle. You will find numerous cafés around the fountain and the square. This is a great place to take a rest.

To the east of the Musée d'Orsay and the Louvre, the majestic cathedral of Notre-Dame rises on an island in the Seine—the Île de la Cité. With the stories of the hunchback of Notre-Dame, and with its perch on the banks of the river, the cathedral is one of the most famous buildings in the history of architecture. Notre-Dame is a curious mixture of old and new elements, begun in 1163 and not completed until almost a century later. While on the Île de la Cité, do not miss seeing Saint-Chapelle, which has been hailed as ethereal, magical, and one of the architectural wonders of the Western world. Multicolored light floods the upper chapel through 15 stained-glass windows.

Behind Notre-Dame—past the flying buttresses, a little park, and across a street usually populated by parked tourist buses—you'll find another park and then a surprising Deportation Memorial (*Mémorial des Martyrs et de la Déporta-*

tion), which is below ground level and against the river. You descend a narrow stairway onto a platform with bars that prevent you from reaching the water. No way out. A room off the platform names the Nazi death camps to which Jews and others were deported.

If you head south from the Île de la Cité along Boulevard St. Michel, you'll find outdoor cafés, including the Deux Magots, where Ernest Hemingway and F. Scott Fitzgerald drank and dined. Cross Boulevard Saint-Germain and you're in University of Paris territory. Within a few blocks on the left you'll see the Pantheon, which houses an interesting crypt where Madame Curie, among others, is interred. On the right side you will come to the Luxembourg Gardens, with its hedged trees, palace, and sailboat pond.

Don't pass up Père Lachaise, which is the major cemetery in Paris. You will find graves and fascinating mausoleums for the Romantic painters Eugène Delacroix and Théodore Géricault, the Polish composer Frédéric Chopin, the British writer Oscar Wilde, the French actress Sarah Bernhardt, the French playwright Molière, the American Jim Morrison (lead singer of the Doors), and dozens of others whom you are likely to recognize.

No visit to Paris is complete without a trip to Versailles (Fig. 16-22). This complex began as a hunting lodge and was rebuilt in 1668 by the Sun King (Louis XIV) into the grandest palace in Europe. The palace is well known for its magnificent Hall of Mirrors and its art collection, but you'll also want to spend time strolling in the gardens. When at Versailles, be sure to visit the Grand Trianon, one of the "outbuildings" of the complex, for its colonnade and sweeping vistas of hedged trees and human-made lakes. Take a boat ride or just wander among the greenery, as did Queen Marie Antoinette in her peasant-girl attire. Sometimes we all need to escape.

 To continue your tour and learn more about Paris, go to our website.

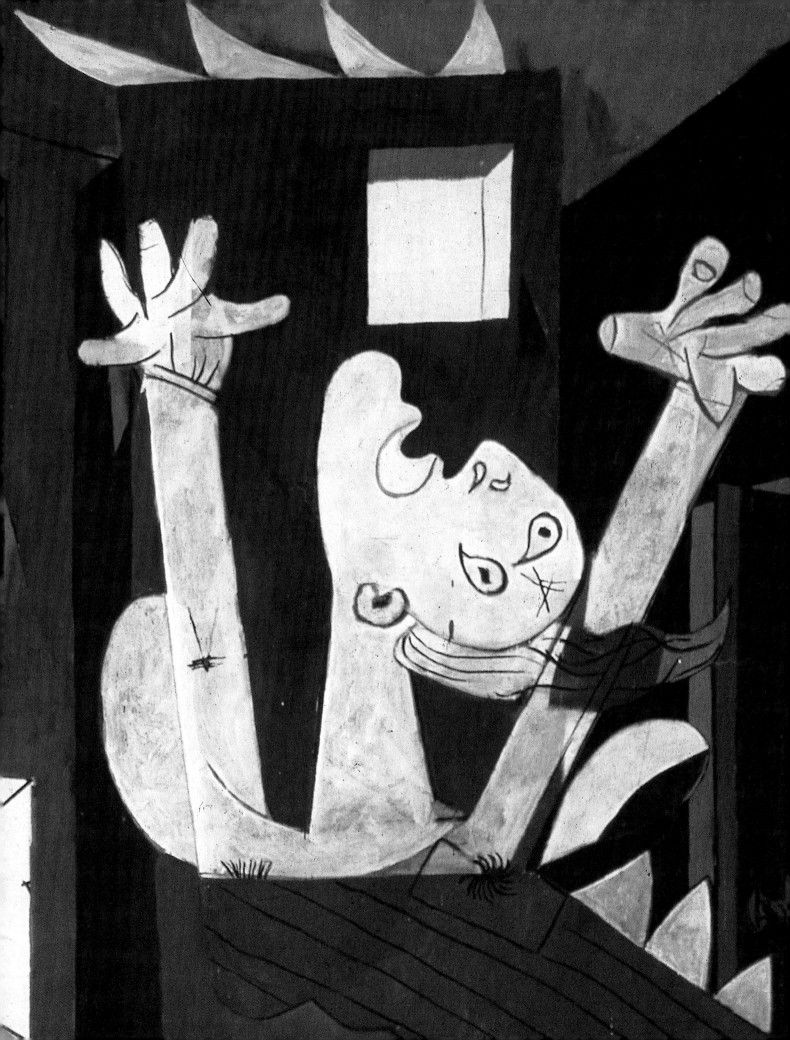

THE TWENTIETH CENTURY: THE EARLY YEARS

When people ask me to compare the 20th century to older civilizations,
I always say the same thing: "The situation is normal."

—Will Durant

It could be said that the art world has been in a state of perpetual turmoil for the last hundred years. All the important movements that were born during the late nineteenth and early twentieth centuries met with the hostile, antiseptic gloves of critical disdain. When Courbet's paintings were rejected by the 1855 Salon, he set up his own Pavilion of Realism and pushed the Realist movement on its way. Just eight years later, rejection by the Salon jury prompted the origin of the Salon des Réfusés, an exhibition of works including those of Manet. These ornery French artists went on to found the influential Impressionist movement. Their very name—*Impressionism*—was coined by a hostile critic who degraded their work as mere "impressions," sort of quick and easy sketches of the painter's view of the world. Impressionism ran counter to the preferred illusionistic realism of Academic painting.

The opening years of the twentieth century saw no letup to these scandalous entrees into the world of modern art. In 1905 the **Salon d'Automne**—an independent exhibition so named to distinguish it from the Academic Salons that were traditionally held in the spring—brought together the works of an exuberant group of French avant-garde artists who assaulted the public with a bold palette and distorted forms. One art critic who peeked in on the show saw a Renaissance-type sculpture surrounded by these blasphemous forms. He was sufficiently unnerved by the juxtaposition to exclaim, "Donatello au milieu des fauves!" (that is, "Donatello among the wild beasts!"). With what pleasure, then, the artists adopted as their epithet: "The Fauves." After all, it was a symbol of recognition.

THE FAUVES

In some respects, **Fauvism** was a logical successor to the painting of van Gogh and Gauguin. Like these Postimpressionists, the Fauvists also rejected the subdued palette and delicate brushwork of Impressionism. They chose their color and brushwork on the basis of their emotive qualities. Despite the aggressiveness of their method, however, their subject matter centered on traditional nudes, still lifes, and landscapes.

What set the Fauves apart from their nineteenth-century predecessors was their use of harsh, nondescriptive color; bold linear patterning; and a distorted form of perspective. They saw color as autonomous, a subject in and of itself, not merely an adjunct to nature. Their vigorous brushwork and emphatic line grew out of their desire for a direct form of expression, unencumbered by theory. Their skewed perspective and distorted forms were also inspired by the discovery of ethnographic works of art from Africa, Polynesia, and other ancient cultures.

André Derain

One of the founders of the Fauvist movement was André Derain (1880–1954). In his *London Bridge* (Fig. 19-1) we find the convergence of elements of nineteenth-century styles and the new vision of Fauvism. The outdoor subject matter is reminiscent of Impressionism (Monet, in fact, painted many renditions of Waterloo Bridge in London), and the distinct zones of unnaturalistic color relate the work to Gauguin. But the forceful contrasts of

primary colors and the delineation of forms by blocks of thickly applied pigment speak of something new.

Nineteenth-century artists emphasized natural light and created their shadows from color components. Derain and the Fauvists evoked light in their canvases solely with color contrasts. Fauvists tended to negate shadow altogether. Whereas Gauguin used color areas primarily to express emotion, the Fauvist artists used color to construct forms and space. Although Derain used his bold palette and harsh line to render his emotional response to the scene, his bright blocks of pigment also function as building facades. Derain's oblong patches of color define both stone and water. His thickly laden brushstroke constructs the contour of a boat and the silhouette of a fisherman.

Henri Matisse

Along with Derain, Henri Matisse (1869–1954) brought Fauvism to the forefront of critical recognition. Yet Matisse was one of the few major Fauvist artists whose reputation exceeded that of the movement. Matisse started law school at the age of 21, but when an illness interrupted his studies, he began to paint. Soon thereafter he decided to devote himself totally to art. Matisse's early paintings revealed a strong and traditional compositional structure, which he gleaned from his first mentor, Adolphe William Bouguereau

19-1 ANDRÉ DERAIN.
London Bridge (1906).
Oil on canvas. 26″ × 39″.

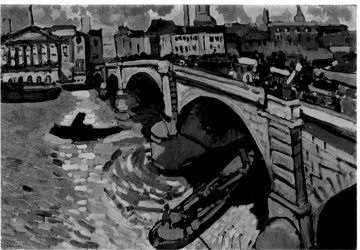

My choice of colors does not rest on any scientific theory; it is based on observation, on feeling, on the very nature of each experience.

—Henri Matisse

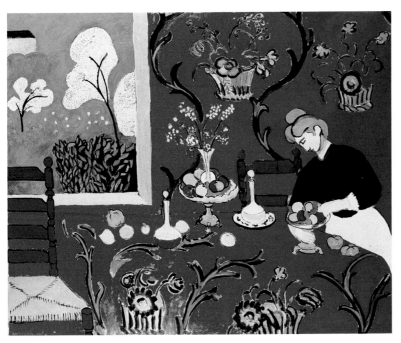

19-2 HENRI MATISSE.
Red Room (Harmony in Red) (1908–1909).
Oil on canvas. 69¾″ × 85⅞″.

The Hermitage, St. Petersburg, Russia. Copyright 2003 Succession H. Matisse, Paris/Artists Rights Society (ARS), New York/Scala/Art Resource, New York.

A curious contest between flatness and three dimensions in *Red Room* characterizes much of Matisse's work. He crowds the table and wall with the same patterns. They seem to run together without distinction. This jumbling of patterns propels the background to the picture plane, asserting the flatness of the canvas. The two-dimensionality of the canvas is further underscored by the window in the upper left, which is rendered so flatly that it suggests a painting of a garden scene instead of an actual view of a distant landscape. Yet for all of these attempts to collapse space, Matisse counteracts the effect with a variety of perspective cues: the seat of the ladder-back chair recedes into space, as does the table; and the dishes are somewhat foreshortened, combining frontal and bird's-eye views.

Matisse used line expressively, moving it rhythmically across the canvas to complement the pulsing color. Although the structure of *Red Room* remains assertive, Matisse's foremost concern was to create a pleasing pattern. Matisse insisted that painting ought to be joyous. His choice of palette, his lyrical use of line, and his brightly painted shapes are all means toward that end. He even said of his work that it ought to be devoid of depressing subject matter, that his art ought to be "a mental soother, something like a good armchair in which to rest."[1]

Although the colors and forms of Fauvism burst explosively on the modern art scene, the movement did not last very long. For one thing, the styles of the Fauvist artists were very different from one another, so the members never formed a cohesive group. After about five years, the "Fauvist qualities" began to disappear from their works as they pursued other styles. Their disappearance was, in part, prompted by a retrospective exhibition of Cézanne's painting held in 1907, which revitalized an interest in this nineteenth-century artist's work. His principles of composition and constructive brush technique were at odds with the Fauvist manifesto.

(see Fig. 18-9), and from copying old masters in the Louvre. His loose brushwork was reminiscent of Impressionism, and his palette was inspired by the color theories of the Postimpressionists. In 1905 he consolidated these influences and painted a number of Fauvist canvases in which, like Derain, he used primary color as a structural element. These canvases were exhibited with those of other Fauvists at the Salon d'Automne of that year.

In his post-Fauvist works, Matisse used color in a variety of other ways—structurally, decoratively, sensually, and expressively. In his *Red Room (Harmony in Red)* (Fig. 19-2), all of these qualities of color are present. A vibrant palette and curvilinear shapes create the gay mood of the canvas. The lush red of the wallpaper and tablecloth absorb the viewer in their brilliance. The arabesques of the vines create an enticing surface pattern.

[1] Robert Goldwater and Marco Treves, eds., *Artists on Art* (New York: Pantheon Books, 1972), 413.

While Fauvism was descending from its brief colorful flourish in France, related art movements, termed **expressionistic,** were ascending in Germany.

EXPRESSIONISM

Expressionism is the distortion of nature—as opposed to the imitation of nature—in order to achieve a desired emotional effect or representation of inner feelings. According to this definition, we have already seen many examples of this type of painting. The work of van Gogh and Gauguin would be clearly expressionistic, as would the paintings of the Fauves. Even Matisse's *Red Room* distorts nature or reality in favor of a more intimate portrayal of the artist's subject, colored, as it were, by his emotions. Edvard Munch and Käthe Kollwitz were expressionistic artists who used paintings and prints as vehicles to express anxieties, obsessions, and outrage.

Three other movements of the early twentieth century have been termed expressionistic: Die Brücke, Der Blaue Reiter, and The New Objectivity, or Neue Sachlichkeit. Although very different from one another in the forms they took, these movements were reactions against Impressionism and Realism. They also sought to communicate the inner feelings of the artist.

Die Brücke (The Bridge)

Die Brücke (The Bridge) was founded in Dresden, Germany, at the same time that Fauvism was afoot in France. The artists who began the movement chose the name *Die Brücke* because, in theory, they saw their movement as bridging a number of disparate styles. Die Brücke, like Fauvism, was short-lived because of the lack of cohesion among its proponents. Still, Die Brücke artists showed some common interests in techniques and subject matter that ranged from boldly colored landscapes and cityscapes to horrific and violent portraits. Their emotional upheaval may, in part, have reflected the mayhem of World War I.

Emil Nolde

The supreme colorist of the Expressionist movement was Emil Nolde (1867–1956), who joined Die Brücke a year after it was founded. Canvases of his, such as *Dance around the Golden Calf* (Fig. 19-3), are marked by a frenzied brush technique in which clashing colors are applied in lush strokes. The technique complements the nature of the subject—a biblical theme recounting the worshiping of an idol by the Israelites even as their liberator, Moses, was receiving the Ten Commandments on Mount Sinai. In Nolde's characteristic fashion, both ecstasy and anguish are brought to the same uncontrolled, high pitch.

19-3 EMIL NOLDE.
Dance around the Golden Calf (1910).
Oil on canvas. 34⅜″ × 41″.
Staatsgalerie Moderner Kunstmuseum, Munich.
Copyright Bridgeman Art Gallery.

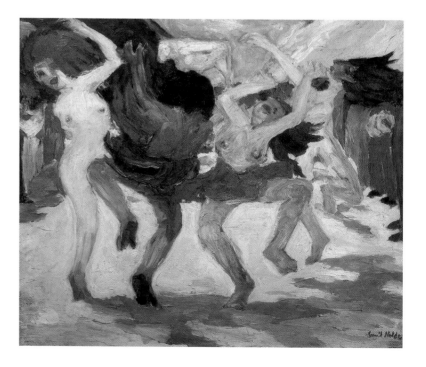

Nolde was also well known for his graphics. He used the idiosyncratic, splintered characteristics of the woodcut—a medium that had not been in vogue for centuries—to create ravaged, masklike portraits of pain and suffering.

Der Blaue Reiter (The Blue Rider)

Emotionally charged subject matter, often radically distorted, was the essence of Die Brücke art. **Der Blaue Reiter (The Blue Rider)** artists—who took their group name from a painting of that title by Wassily Kandinsky, a major proponent—depended less heavily on content to communicate feelings and evoke an emotional response from the viewer. Their work focused more on the contrasts and combinations of abstract forms and pure colors. In fact, the work of Der Blaue Reiter artists, at times, is completely without subject and can be described as nonobjective, or abstract. Whereas Die Brücke artists always used nature as a point of departure, Der Blaue Reiter art sought to free itself from the shackles of observable reality.

Wassily Kandinsky

One of the founders of Der Blaue Reiter was Wassily Kandinsky (1866–1944), a Russian artist who left a career in law to become an influential abstract painter and art theorist. During numerous visits to Paris early in his career, Kandinsky was immersed in the works of Gauguin and the Fauves and was himself inspired to adopt the Fauvist idiom. The French experience opened his eyes to color's powerful capacity to communicate the artist's inmost psychological and spiritual concerns. In his seminal essay "Concerning the Spiritual in Art," he examined this capability and discussed the psychological effects of color on the viewer. Kandinsky further analyzed the relationship between art and music in this study.

Early experiments with these theories can be seen in works such as *Sketch I for Composition VII* (Fig. 19-4), in which bold colors, lines, and shapes tear dramatically across the canvas in no preconceived fashion. The pictorial elements flow freely and independently throughout the painting, reflecting, Kandinsky believed, the free flow of unconscious thought. *Sketch I for Composition VII* and other works of this series underscore the importance of Kandinsky's early Fauvist contacts in their vibrant palette, broad brushstrokes, and dynamic movement, and they also stand as harbingers of a new art unencumbered by referential subject matter.

For Kandinsky, color, line, and shape were subjects in themselves. They were often rendered with a spontaneity born of the psychological process of free association. At this time free association was also being explored by the founder of psychoanalysis, Sigmund Freud, as a method of mapping the geography of the unconscious mind.

19-4 WASSILY KANDINSKY.
Sketch I for Composition VII (1913).
Oil on canvas. 30¾" × 39⅜".
Photo copyright Sotheby's Picture Library. Copyright 2003 Artists Rights Society (ARS)/ADAGP, Paris.

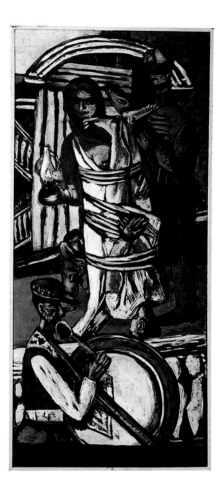

19-5 MAX BECKMANN.
Departure (1932–1933).
Oil on canvas. Triptych, center panel 7′3¾″ × 3′3⅜″; side panels each 7′3¾″ × 3′1¼″.
The Museum of Modern Art, New York. Given anonymously. Copyright Art Resource, New York.
Copyright 2003 Artists Rights Society (ARS), New York/VG, Bild-Kunst, Bonn.

The New Objectivity (Neue Sachlichkeit)

As World War I drew to a close and World War II loomed on the horizon, different factions of German Expressionism could be observed. Some artists, such as Max Beckmann (1884–1950), calling themselves **The New Objectivity (Neue Sachlichkeit)**, reacted to the horrors and senselessness of wartime suffering with an art that commented bitterly on the bureaucracy and military with ghastly visions of human torture. In *Departure* (Fig. 19-5), a painting whose subject is exile, two panels depicting such torture flank a central canvas in which a king looks back longingly on his homeland. He stands as a universal symbol for all of those who were forced to flee their native lands with Adolf Hitler's rise to power.

CUBISM

The history of art is colored by the tensions of stylistic polarities within given eras, particularly the polarity of an intellectual versus an emotional approach to painting. Fauvism and German Expressionism found their roots in Romanticism and the emotional expressionistic work of Gauguin and van Gogh. The second major art movement of the twentieth century, Cubism, can trace its heritage to Neoclassicism and the analytical and intellectual work of Cézanne.

Cubism is like standing at a certain point on a mountain and looking around. If you go higher, things will look different; if you go lower, again they will look different. It is a point of view.

—Jacques Lipchitz

I paint objects as I think them, not as I see them.

—Pablo Picasso

Cubism is an offspring of Cézanne's geometrization of nature and his abandonment of scientific perspective, his rendering of multiple views, and his emphasis on the two-dimensional canvas surface. Picasso, the driving force behind the birth of Cubism, and perhaps the most significant artist of the twentieth century, combined the pictorial methods of Cézanne with formal elements from native African, Oceanic, and Iberian sculpture.

Pablo Picasso

Pablo Ruiz y Picasso (1881–1973) was born in Spain, the son of an art teacher. As an adolescent, he enrolled in the Barcelona Academy of Art, where he quickly mastered the illusionistic techniques of the realistic Academic style. By the age of 19, Picasso was off to Paris, where he remained for more than 40 years—introducing, influencing, or reflecting the many styles of modern French art.

Picasso's first major artistic phase has been called his Blue Period. Spanning the years 1901 to 1904, this work is characterized by an overall blue tonality, a distortion of the human body through elongation reminiscent of El Greco and Toulouse-Lautrec, and melancholy subjects consisting of poor and downtrodden individuals engaged in menial tasks or isolated in their loneliness. *The Old Guitarist* (Fig. 19-6) is but one of these haunting images. A contorted, white-haired man sits hunched over a guitar, consumed by the tones that emanate from what appears to be his only possession. The eyes are sunken in the skeletal head, and the bones and tendons of his hungry frame protrude. We are struck by the ordinariness of poverty, from the unfurnished room and barren window view (or is he on the curb outside?) to the uneventfulness of his activity and the insignificance of his plight. The monochromatic blue palette creates an unrelenting somber mood. Tones of blue eerily echo the ghostlike features of the guitarist.

Picasso's Blue Period was followed by works that were lighter both in palette and in spirit. Subjects from this so-called Rose Period were drawn primarily from circus life and

19-6 PABLO PICASSO.
The Old Guitarist (1903).
Oil on canvas. $47\frac{3}{4}$″ × $32\frac{1}{2}$″.
The Art Institute of Chicago. Copyright 2003 Estate of Pablo Picasso/Artists Rights Society (ARS), New York.

rendered in tones of pink. During this second period, which dates from 1905 to 1908, Picasso was inspired by two very different art styles. He, like many artists, viewed and was strongly influenced by the Cézanne retrospective exhibition held at the Salon d'Automne in 1907. At about that time,

19-7 PABLO PICASSO.
Les Demoiselles d'Avignon (1907).
Oil on canvas. 8' × 7'8".

The Museum of Modern Art, New York.
Acquired through the Lillie P. Bliss Bequest.
Copyright Edimedia. Copyright 2003 Estate
of Pablo Picasso/Artists Rights Society (ARS),
New York.

Picasso also became aware of the formal properties of ethnographic art from Africa, Oceania, and Iberia, which he viewed at the Musée de l'Homme. These two art forms, which at first glance might appear dissimilar, had in common a fragmentation, distortion, and abstraction of form that were adopted by Picasso in works such as *Les Demoiselles d'Avignon* (Fig. 19-7).

This startling, innovative work, still primarily pink in tone, depicts five women from Barcelona's red-light district. They line up for selection by a possible suitor who stands, as it were, in the position of the spectator. The faces of three of the women are primitive masks. The facial features of the other two have been radically simplified by combining frontal and profile views. The thick-lidded eyes stare stage front, calling to mind some of the Mesopotamian votive sculptures we saw in Chapter 12.

The bodies of the women are fractured into geometric forms and set before a background of similarly splintered drapery. In treating the background and the foreground imagery in the same manner, Picasso collapses the space between the planes and asserts the two-dimensionality of the canvas surface in the manner of Cézanne. In some radical passages, such as the right leg of the leftmost figure, the limb takes on the qualities of drapery, masking the distinction between figure and ground. The extreme faceting of form, the use of multiple views, and the collapsing of space in *Les Demoiselles* together provided the springboard for **Analytic Cubism,** cofounded with the French painter Georges Braque in about 1910.

Analytic Cubism

The term "Cubism," like so many others, was coined by a hostile critic. In this case the critic was responding to the predominance of geometrical forms in the works of Picasso and Braque. Cubism is a limited term in that it does not ad-

Art is meant to disturb.

—Georges Braque

equately describe the appearance of Cubist paintings, and it minimizes the intensity with which Cubist artists analyzed their subject matter. It ignores their most significant contribution—a new treatment of pictorial space that hinged upon the rendering of objects from multiple and radically different views.

The Cubist treatment of space differed significantly from that in use since the Renaissance. Instead of presenting an object from a single view, assumed to have been the complete view, the Cubists, like Cézanne, realized that our visual comprehension of objects consists of many views that we perceive almost at once. They tried to render this visual "information gathering" in their compositions. In their dissection and reconstruction of imagery, they reassessed the notion that painting should reproduce the appearance of reality. Now the very reality of appearances was being questioned. To Cubists, the most basic reality involved consolidating optical vignettes instead of reproducing fixed images with photographic accuracy.

Georges Braque

During the analytic phase of Cubism, which spanned the years from 1909 to 1912, the works of Picasso and Braque were very similar. The early work of Georges Braque (1882–1963) graduated from Impressionism to Fauvism to more structural compositions based on Cézanne. He met Picasso in 1907, and from then until about 1914 the artists worked together toward the same artistic goals.

The theory of Analytic Cubism reached the peak of its expression in 1911 in works such as Braque's *The Portuguese* (Fig. 19-8). Numerous planes intersect and congregate at the center of the canvas to form a barely perceptible triangular human figure, which is alternately constructed from and dissolved into the background. There are only a few concrete signs of its substance: dropped eyelids, a mustache, the circular opening of a stringed instrument. The multifaceted, abstracted form appears to shift position before our eyes, simulating the time lapse that would occur in the visual assimilation of multiple views. The structural lines—sometimes called the *Cubist grid*—that define and fragment the figure are thick and dark. They contrast with the delicately modeled short, choppy brushstrokes of the remainder of the

composition. The monochromatic palette, chosen so as not to interfere with the exploration of form, consists of browns, tans, and ochers.

Although the paintings of Picasso and Braque were almost identical at this time, Braque first began to insert words and numbers and to use trompe l'oeil effects in portions of his Analytic Cubist compositions. These realistic elements contrasted sharply with the abstraction of the major figures and reintroduced the nagging question, "What is reality and what is illusion in painting?"

19-8 GEORGES BRAQUE.
The Portuguese (1911).
Oil on canvas. 45½″ × 31½″.

Oeffentliche Kunstsammlung, Kunstmuseum, Basel. Copyright 2003 Artists Rights Society (ARS), New York/ADAGP, Paris.

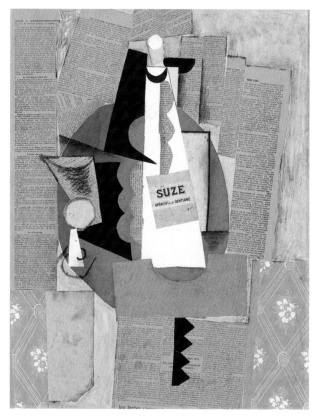

19-9 PABLO PICASSO.
The Bottle of Suze (1912–1913).
Pasted paper with charcoal. 25¾″ × 19¾″.
Washington University Gallery of Art, St. Louis. University Purchase,
Kende Sale Fund, 1946. Copyright 2003 Estate of Pablo Picasso/
Artists Rights Society (ARS), New York.

Synthetic Cubism

Picasso and Braque did not stop with the inclusion of precisely printed words and numbers in their works. They began to add characters cut from newspapers and magazines, other pieces of paper, and found objects such as labels from wine bottles, calling cards, theater tickets—even swatches of wallpaper and bits of rope. These items were pasted directly onto the canvas in a technique Picasso and Braque called *papier collé*—what we know as **collage.** The use of collage marked the beginning of the synthetic phase of Cubism.

Some Synthetic Cubist compositions, such as Picasso's *The Bottle of Suze* (Fig. 19-9), are constructed entirely of found elements. In this work, newspaper clippings and

opaque pieces of paper function as the shifting planes that hover around the aperitif label and define the bottle and glass. These planes are held together by a sparse linear structure much in the manner of Analytic Cubist works. In contrast to Analytic Cubism, however, the emphasis is on the form of the object and on constructing instead of disintegrating that form. Color reentered the compositions, and much emphasis was placed on texture, design, and movement.

After World War I, Picasso and Braque no longer worked together, and their styles, although often reflective of the Cubist experience they shared, came to differ markedly. Braque, who was severely wounded during the war, went on to create more delicate and lyrical still-life compositions, abandoning the austerity of the early phase of Cubism. Although many of Picasso's later works carried forward the Synthetic Cubist idiom, his artistic genius and versatility became evident after 1920 when he began to move in radically different directions. These new works were rendered in Classical, Expressionist, and Surrealist styles.

When civil war gripped Spain, Picasso protested its brutality and inhumanity through highly emotional works such as *Guernica* (Fig. 19-10). This mammoth mural, painted for the Spanish Pavilion of the Paris International Exposition of 1937, broadcast to the world the carnage of the German bombing of civilians in the Basque town of Guernica. The painting captures the event in gruesome details such as the frenzied cry of one woman trapped in rubble and fire and the pale fright of another woman who tries in vain to flee the conflagration. A terrorized horse rears over a dismembered body while an anguished mother embraces her dead child and wails futilely. Innocent lives are shattered into Cubist planes that rush and intersect at myriad angles, distorting and fracturing the imagery. Confining himself to a palette of harsh blacks, grays, and whites, Picasso expressed, in his words, the "brutality and darkness" of the age.

Cubist Sculpture

Cubism was born as a two-dimensional art form. Cubist artists attempted to render on canvas the manifold aspects of their subjects as if they were walking around three-dimensional forms and recording every angle. The attempt was successful, in part, because they recorded these views with intersecting planes that allowed viewers to perceive the many sides of the figure.

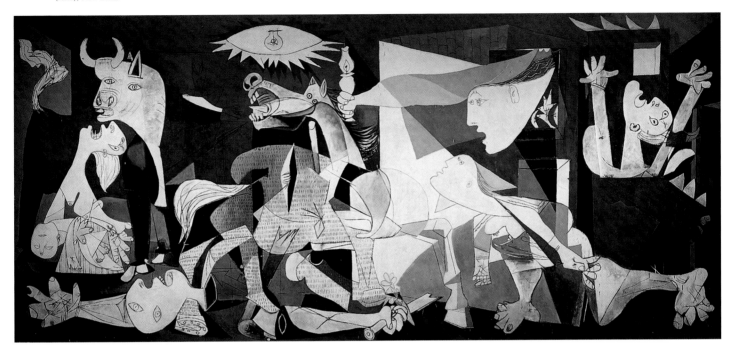

Because Cubist artists were trying to communicate all
the visual information available about a particular form, they
were handicapped, so to speak, by the two-dimensional sur-
face. In some ways the medium of sculpture was more natu-
ral to Cubism, because a viewer could actually walk around
a figure to assimilate its many facets. The "transparent"
planes that provided a sense of intrigue in Analytical Cubist
paintings were often translated as flat solids, as in Jacques
Lipchitz's (1891–1964) *Still Life with Musical Instruments*
(Fig. 19-11).

Alexander Archipenko

One of the innovations in Cubist sculpture was the three-
dimensional interpenetration of Cubist planes, as implied
in Lipchitz's relief. Another was the use of void space as solid

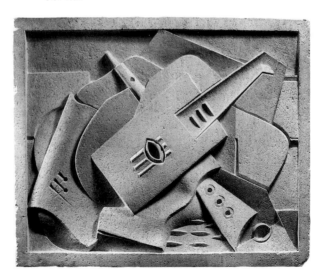

Walking Woman (1912).
Bronze. H: 26½".

Copyright 2003 Estate of Alexander Archipenko/Artists Rights Society (ARS), New York. Courtesy Rachel Adler Gallery, New York.

form, as seen in *Walking Woman* (Fig. 19-12) by Alexander Archipenko (1887–1964). True to Cubist principles, the figure is fragmented; the contours are broken and dislocated. But what is new here are the open spaces of the torso and head, now as much a part of the whole as the solid forms of the composition. Although there is a good degree of abstract simplification in the figure, the overall impression of the forms prompts recognition of the humanity of the subject.

FUTURISM

Several years after the advent of Cubism, a new movement sprang up in Italy under the leadership of poet Filippo Marinetti (1876–1944). **Futurism** was introduced angrily by Marinetti in a 1909 manifesto that called for an art of "violence, energy, and boldness" free from the "tyranny of . . . harmony and good taste."[2] In theory, Futurist painting and sculpture were to glorify the life of today, "unceasingly and violently transformed by victorious science." In practice, many of the works owed much to Cubism.

Umberto Boccioni

An oft-repeated word in Futurist credo is **dynamism,** defined as the theory that force or energy is the basic principle of all phenomena. The principle of dynamism is illustrated in Umberto Boccioni's (1882–1916) *Dynamism of a Soccer Player* (see Fig. 2-73). Irregular, agitated lines communicate the energy of movement. The Futurist obsession with illustrating images in perpetual motion also found a perfect outlet in sculpture. In works such as *Unique Forms of Continuity in Space* (Fig. 19-13), Boccioni, whose forte was sculpture, sought to convey the elusive surging energy that blurs an image in motion, leaving but an echo of its passage. Although it retains an overall figural silhouette, the sculpture is devoid of any representational details. The flamelike curving surfaces of the striding figure do not exist to define movement; instead, they are a consequence of it.

Giacomo Balla

The Futurists also suggested that their subjects were less important than the portrayal of the "dynamic sensation" of the subjects. This declaration manifests itself fully in Giacomo Balla's (1871–1958) pure Futurist painting, *Street Light*

[2]F. T. Marinetti, "The Foundation and Manifesto of Futurism," in *Theories of Modern Art,* ed. Herschel B. Chipp, 284–88 (Berkeley: University of California Press, 1968).

Everything moves, everything runs, everything turns swiftly. The figure in front of us never is still, but ceaselessly appears and disappears. Owing to the persistence of images on the retina, objects in motion are multiplied, distorted, following one another like waves through space. Thus a galloping horse has not four legs; it has twenty.

—Umberto Boccioni

(Fig. 19-14). The light of the lamp pierces the darkness in reverberating circles; V-shaped brushstrokes simultaneously fan outward from the source and point toward it, creating a sense of constant movement. The palette consists of complementary colors that forbid the eye to rest. All is movement; all is sensation.

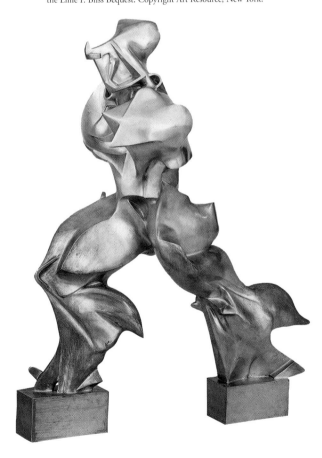

19-13 UMBERTO BOCCIONI.
Unique Forms of Continuity in Space (1913).
Bronze (cast 1931). $43\frac{7}{8}'' \times 34\frac{7}{8}'' \times 15\frac{3}{4}''$.

The Museum of Modern Art, New York. Acquired through the Lillie P. Bliss Bequest. Copyright Art Resource, New York.

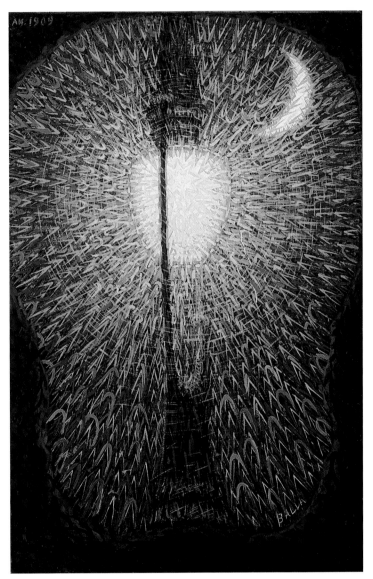

19-14 GIACOMO BALLA.
Street Light (1909).
Oil on canvas. $68\frac{3}{4}'' \times 45\frac{1}{4}''$.

The Museum of Modern Art, New York. Hillman Periodicals Fund. Copyright The Museum of Modern Art, New York / Licensed by Scala / Art Resource, New York. Copyright Artists Rights Society (ARS), New York / SIAE, Rome.

I said to myself—I'll paint what I see—what the flower is to me but I'll paint it big and they will be surprised into taking the time to look at it—I will make even busy New Yorkers take time to see what I see of flowers.

—Georgia O'Keeffe

Cubist and Futurist works of art, regardless of how abstract they might appear, always contain vestiges of representation, whether they be unobtrusive details like an eyelid or mustache, or an object's recognizable contours. Yet with Cubism, the seeds of abstraction were planted. It was just a matter of time until they would find fruition in artists who, like Kandinsky, would seek pure form unencumbered by referential subject matter.

American artists who were influenced by the Parisian avant-garde—Picasso, Matisse, and others—in his 291 gallery (at 291 Fifth Avenue in New York). Georgia O'Keeffe was among the artists supported by Stieglitz.

Throughout her long career, Georgia O'Keeffe (1887–1986) painted many subjects, from flowers to city buildings to the skulls of animals baked white by the sun of the desert Southwest. In each case she captured the essence of her sub-

EARLY TWENTIETH-CENTURY ABSTRACTION IN THE UNITED STATES

The Fauvists and German Expressionists had an impact on art in the United States as well as Europe. Although the years before the First World War in America were marked by an adherence to Realism and subjects from everyday rural and urban life, a strong interest in European Modernism was brewing.

291 Gallery

It was the American photographer Alfred Stieglitz who propounded and supported the development of abstract art in the United States by exhibiting modern European works along with those of

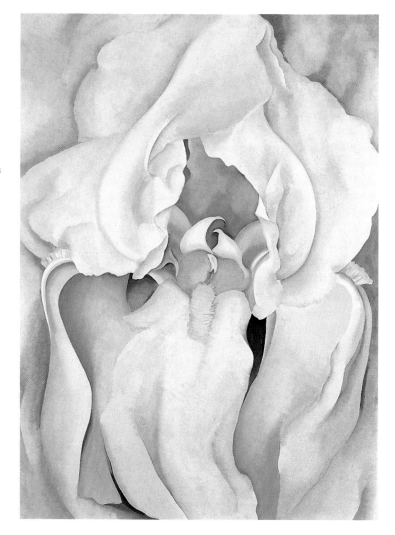

19-15 GEORGIA O'KEEFFE.
White Iris (1930).
Oil on canvas. 40″ × 30″.
Virginia Museum of Fine Arts. Gift of
Mr. And Mrs. Bruce Gottwald. Copyright
Virginia Museum of Fine Arts. Photo by Ron Jennings.
Copyright 2003 The Georgia O'Keeffe Foundation/
Artists Rights Society (ARS), New York.

jects by simplifying their forms. In 1924, the year O'Keeffe married Stieglitz, she began to paint enlarged flower pictures such as *White Iris* (Fig. 19-15). In these paintings, she magnified and abstracted the details of her botanical subjects, so that often a large canvas was filled with but a fragment of the intersection of petals. These flowers have a yearning, reaching, organic quality, and her botany seems to function as a metaphor for zoology. That is, her plants are animistic; they seem to grow because of will, not merely because of the blind interactions of the unfolding of the genetic code with water, sun, and minerals. And although O'Keeffe denied any attempt to portray sexual imagery in these flowers (those who saw it, she said, were speaking about themselves and not her), the edges of the petals, in their folds and convolutions, are frequently reminiscent of parts of the female body. The sense of will and reaching renders these petals active rather than passive in their implied sexuality, so they seem symbolically to express a feminist polemic. This characteristic might be one of the reasons that O'Keeffe was "invited" to Judy Chicago's Dinner Party.

The Armory Show

Between 1908 and 1917, Stieglitz brought to 291—and thus to New York City—European Modernists, the likes of Toulouse-Lautrec, Cézanne, Matisse, Braque, and Brancusi. In 1913 the sensational Armory Show—the International Exhibition of Modern Art held at the 69th Regiment Armory in New York City—assembled works by leading American artists and an impressive array of Europeans ranging from Goya and Delacroix to Manet and the Impressionists; from Van Gogh and Gauguin to Picasso and Kandinsky. There were many more American than European works exhibited, but the latter dominated the show—raising the artistic consciousness of the Americans while, at the same time, raising some eyebrows. The most scandalous of the Parisian works, Marcel Duchamp's *Nude Descending a Staircase #2* (see Fig. 2-72), was dismissed as a "pile of kindling wood." But the message to American artists was clear: Europe was the center of the art world. For now.

In the years following the Armory Show, American artists explored abstraction to new heights, finding ways to maintain a solid sense of subject matter in combination with geometric fragmentation and simplification. Charles Demuth (1883–1935) was one of a group of artists called "Cubo-Realists" or "Precisionists" who overlaid stylistic elements from Cubism and Futurism on authentic American imagery. *My Egypt* (Fig. 19-16) is a precise rendition of a grain elevator in Demuth's hometown of Lancaster, Pennsyl-

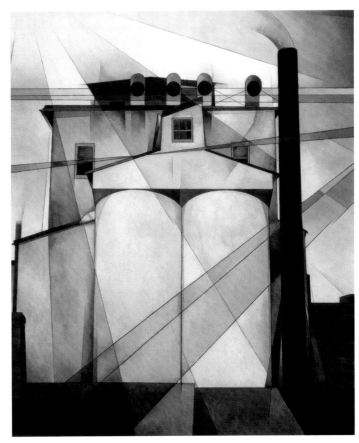

19-16 CHARLES DEMUTH.
My Egypt (1927).
Oil on composition board. 35¾″ × 30″
(90.8 cm × 76.2 cm).
Whitney Museum of American Art, New York.

vania. Diagonal lines—contradictory rays of light and shadow—sweep across the solid surfaces and lessen the intensity of the stonelike appearance of the masses. The shapes in *My Egypt* are reminiscent of limestone monoliths that form the gateways to ancient temple complexes such as that at Karnak in Egypt. The viewer cannot help being drawn to Demuth's title, which acknowledges the association of the architectural forms and, at the same time, asserts a sense of American pride and history in the possessive adjective, "My." It seems to reflect the desire on the part of the American artist to be conversant and current with European style while maintaining a bit of chauvinism about subjects that have meaning to their own time and place.

EARLY TWENTIETH-CENTURY ABSTRACTION IN EUROPE

The second decade of the twentieth century witnessed the rise of many dynamic schools of art in Europe. Two of these —**Constructivism** and **De Stijl**—were dedicated to pure abstraction, or nonobjective art. Nonobjective art differs from the abstraction of Cubism or Futurism in its total lack of representational elements. It does not use nature or visual reality as a point of departure; it has no subject other than that of the forms, colors, and lines that compose it. In nonobjective art, the earlier experiments in abstracting images by Cézanne and then by the Cubists reached their logical conclusion. Kandinsky is recognized as the first painter of pure abstraction, although several artists were creating nonobjective works at about the same time.

Constructivism

Whereas nonobjective painting was the logical outgrowth of Analytic Cubism, Cubist collage gave rise to Constructivist sculpture. Born in Russia, Constructivism challenged the traditional sculptural techniques of carving and casting that emphasized mass rather than space.

Naum Gabo

Naum Gabo (1890–1977), a Constructivist sculptor, challenged the ascendance of mass over space by creating works in which intersecting planes of metal, glass, plastic, or wood defined space. The nonobjective *Column* (Fig. 19-17) exudes a high-tech feeling. It is somewhat reminiscent of magnetic fields, of things plugged in, or even of the skyscrapers that are being imagined as this page is being written—a theme that would be revisited by the **Deconstructivist architects** at the end of the twentieth century and the early years of the third millennium. But the subject of the work consists in the constructed forms themselves. The column itself is suggested by intersecting planes that interact with the surrounding space; it does not envelop space, and—true to the Constructivist aesthetic—it denies mass and weight. The beauty of *Column* is found in the purity of its elements and in the contrasts between horizontal and vertical elements and translucent and opaque elements.

Piet Mondrian

Influenced by Vincent van Gogh, fellow Dutch painter Piet Mondrian (1872–1944) began his career as a painter of Impressionistic landscapes. In 1910 he went to Paris and was immediately drawn to the geometricism of Cubism. During

19-17 NAUM GABO.
Column (c. 1923).
Perspex, wood, metal, glass. 41½″ × 29″ × 29″.
Copyright Solomon R. Guggenheim Museum, New York.

the war years, when he was back in Holland, his studies of Cubist theory led him to reduce his forms to lines and planes and his palette to the primary colors and black and white. These limitations, Mondrian believed, permitted a more universally comprehensible art.

Mondrian developed his own theories of painting that are readily apparent in works such as *Composition with Red, Blue, and Yellow* (Fig. 19-18):

> Painting occupies a plane surface. The plane surface is integral with the physical and psychological being of the painting. Hence the plane surface must be respected, must be allowed to declare itself, must not be falsified by imitations of volume. Painting must be as flat as the surface it is painted on.[3]

[3] Robert Goldwater and Marco Treves, eds., *Artists on Art* (New York: Pantheon Books, 1972), 426.

All painting is composed of line and color. Line and color are the essence of painting. Hence they must be freed from their bondage to the imitation of nature and allowed to exist for themselves.

—Piet Mondrian

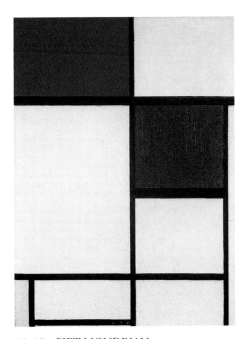

19-18 PIET MONDRIAN.
Composition with Red, Blue, and Yellow (1930).
Oil on canvas. 28½″ × 21¼″.

19-19 GERRIT RIETVELD.
Schroeder House, Utrecht (1924).

If Mondrian's views had been a theory of architecture, perhaps they would have found expression in works such as Gerrit Rietveld's *Schroeder House* (Fig. 19-19), which was built early in the twentieth century but continues to inspire architects today. Here there is an almost literal translation of geometry and color to architecture. Broad expanses of white concrete intersect to define the strictly rectilinear dwelling, or appear to float in superimposed planes. As in a Mondrian painting, these planes are accented by black verticals and horizontals in supporting posts or window mullions. The surfaces are unadorned, like the color fields of a Mondrian.

Mondrian's obsessive respect for the two-dimensionality of the canvas surface is the culmination of the integration of figure and ground begun with the planar recession of Jacques-Louis David (see Fig. 18-1). No longer was it necessary to tilt tabletops or render figure and ground with the same brushstrokes and palette to accomplish this task. Canvas and painting, figure and ground were one.

Constantin Brancusi

The universality sought by Mondrian through extreme simplification can also be seen in the sculpture of Constantin Brancusi (1876–1957). Yet unlike Mondrian's, Brancusi's works, however abstract they appear, are rooted in the figure.

Brancusi was born in Romania 13 years after the Salon des Réfusés. After an apprenticeship as a cabinetmaker and studies at the Bucharest Academy of Fine Arts, he traveled to Paris to enroll in the famous École des Beaux-Arts. In 1907 Brancusi exhibited at the Salon d'Automne, leaving favorable impressions of his work.

Brancusi's work, heavily indebted to Rodin at this point, did indeed grow in a radically different direction. As early as 1909 he reduced the human head—a favorite theme he would draw upon for years—to an egg-shaped form with sparse indications of facial features. In this, and

in other abstractions such as *Bird in Space* (Fig. 19-20), he reached for the essence of the subject by offering the simplest contour that, along with a descriptive title, would fire recognition in the spectator. *Bird in Space* evolved from more representational versions into a refined symbol of the cleanness and solitude of flight.

19-20 CONSTANTIN BRANCUSI.
Bird in Space (c. 1928).
Bronze (unique cast). H: 54″.

FANTASY AND DADA

Throughout the history of art, most critics and patrons have seen the accurate representation of visual reality as a noble goal. Those artists who have departed from this goal, who have chosen to depict their personal worlds of dreams or supernatural fantasies, have not had it easy. Before the twentieth century, only isolated examples of what we call **Fantastic art** could be found. The early 1900s, however, saw many artists exploring fanciful imagery and working in styles as varied as their imaginations.

How do we describe Fantastic art? The word *fantastic* derives from the Greek *phantastikos,* meaning "the ability to represent something to the mind" or "to create a mental image." *Fantasy* is further defined as "unreal, odd, seemingly impossible, and strange in appearance." Fantastic art, then, is the representation of incredible images from the artist's mind. At times the images are joyful reminiscences; at times, horrific nightmares. They may be capricious or grotesque.

Paul Klee

One of the most whimsical yet subtly sardonic of the Fantastic artists is Paul Klee (1879–1940). Although influenced early in his career by nineteenth-century artists such as Goya, who touched upon fantasy, Klee received much of his stylistic inspiration from Cézanne. In 1911 he joined Der Blaue Reiter, where his theories about intuitive approaches to painting, growing abstraction, and love of color were well received.

A certain innocence pervades Klee's idiosyncratic style. After abandoning representational elements in his art, Klee turned to ethnographic and children's art, seeking a universality of expression in their extreme simplicity. Many of his works combine a charming naïveté with wry commentary. *Twittering Machine* (Fig. 19-21), for example, offers a humorous contraption composed of four fantastic birds balanced precariously on a wire attached to a crank. The viewer who is motivated to piece together the possible function of this apparatus might assume that turning the crank would result in the twittering suggested by the title.

In this seemingly innocuous painting, Klee perhaps satirizes contemporary technology, in which machines may sometimes seem to do little more than express the whims and ego of the inventor. But why a machine that twitters? Some have suggested a darker interpretation in which the mechanical birds are traps to lure real birds to a makeshift coffin beneath. Such gruesome doings might in turn symbolize the entrapment of humans by their own existence. In

19-21 PAUL KLEE.
Twittering Machine (1922).
Watercolor, pen and ink. 25¼″ × 19″.

The Museum of Modern Art, New York. Copyright The Museum of Modern Art. Licensed by Scala/Art Resource, New York. Copyright 2003 Artists Rights Society (ARS), New York/VG Bild-Kunst, Bonn.

any event, it is evident that Klee's simple, cartoonlike subjects may carry a mysterious and rich iconography.

Giorgio de Chirico

Equally mysterious are the odd juxtapositions of familiar objects found in the works of Giorgio de Chirico (1888–1978). Unlike Klee's figures, Chirico's are rendered in a realistic manner. Chirico attempted to make the irrational believable. His subjects are often derived from dreams, in which ordinary objects are found in extraordinary situations. The realistic technique tends to heighten the believability of these events and imparts a certain eeriness characteristic of dreams or nightmares. Part of the intrigue of Chirico's subjects lies in their ambiguity and in the uncertainty of the outcome. Often we do not know why we dream what we dream. We do not know how the strange juxtapositions

occur nor how the story will evolve. We may now and then "save" ourselves from danger by awakening.

The intrigues of the dream world are captured by Chirico in works such as *The Mystery and Melancholy of the Street* (Fig. 19-22). Some of his favorite images—the icy arcade, the deserted piazza, the empty boxcar—provide the backdrop for an encounter between two figures at opposite ends of a diagonal strip of sunlight. A young girl, seemingly unaware of the tall dark shadow beyond her, skips at play with stick and hoop. What is she doing there? Why is she alone? Who is the source of the shadow? Is it male or female? What is the spearlike form by the figure? We quickly perceive doom. We wonder what will happen to the girl and

19-22 GIORGIO DE CHIRICO.
The Mystery and Melancholy of the Street (1914).
Oil on canvas. 34¼″ × 28⅛″.

Private collection, U.S.A. Copyright Foundation Giorgio de Chirico/ Copyright 2003 Artists Rights Society (ARS), New York/SIAE, Rome.

Leonardo's *Mona Lisa,* Duchamp's *Mona Lisa (L.H.O.O.Q.),* Odutokun's *Dialogue with Mona Lisa,* and Lee's *Bona Lisa*

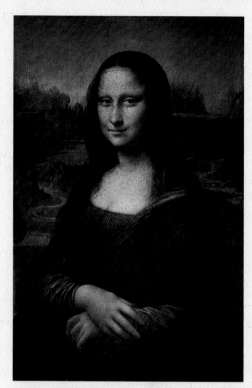

19-23　LEONARDO DA VINCI.
Mona Lisa (c. 1503).
Oil on panel. 30¼″ × 21″.
Louvre Museum, Paris/Edimedia/Corbis.

If you were asked to close your eyes and think of the most famous work of art in all of history, what would you say? Odds are that the first piece to come up on your memory screen would be none other than the leadoff work in this exercise. Her portrait has captivated poets and lyricists, museumgoers and, yes, artists, for centuries. Simply put, her face has been everywhere. Why and how did she attain this icon status? The *Mona Lisa* (Fig. 19-23) is a portrait of a banker's wife, worked on by Leonardo for four years and, as was much of his work, left unfinished.

In its own day, though, it was quite an innovative composition. Among other things, Leonardo rejected the traditional profile portrait bust in favor of a three-quarter-turned, half-length figure. The inclusion of the hands in a natural position, for the most part uncharacteristic of earlier portraiture, was essential for Leonardo as a method of exploring and re-

vealing the personality of the sitter: "A good painter has two chief objects to paint, man and the intention of his soul; the former is easy, the latter hard, because he has to represent it by the attitudes and movements of the limbs." A new look at portrait painting, to be sure. But there is still the matter of that enigmatic smile. And those eyes, which many have vouched, follow the viewer's movements across a room. The *Mona Lisa* is a beautiful painting, but does that account for why a visitor in search of the masterpiece in Paris's Louvre Museum need only look for the one painting that cannot be viewed because of the crowd surrounding it?

The selection of images in this exercise represents but a sampling of work that attempts to come to terms with "Mona Lisa: The Icon." One of the earlier revisions of Leonardo's

19-24　MARCEL DUCHAMP.
Mona Lisa (L.H.O.O.Q.) (1919).
Rectified readymade; pencil on a reproduction.
7¾″ × 4⅞″.
Philadelphia Museum of Art. Private collection. Copyright 2003 Artists Rights Society (ARS), New York/ADAGP, Paris/Succession Marcel Duchamp.

19-25　G. ODUTOKUN.
Dialogue with Mona Lisa (1991).
Gouache on paper. 30″ × 22″.
Private collection. Photo: Visual Arts Library, London.
Copyright Art Resource, New York.

painting was assembled by the Dada artist, Marcel Duchamp (Fig. 19-24). Using a reproduction of the original work, Duchamp modified the image—graffiti style—by penciling in a mustache and goatee. Beneath the image of the banker's wife is Duchamp's irreverent explanation of that enigmatic smile: If you read the letters aloud with their French pronunciation, using a slurred, legato style, the sound your ears will hear is "elle a chaud au cul." (Rough PG-13-rated translation: "She is hot in the pants.") Part of the underlying philosophy of the Dada movement was the notion that the museums of the world are filled with "dead art" that should be "destroyed." Why do you imagine Duchamp would have used the image of the *Mona Lisa* to convey something of this philosophy? Duchamp was certainly a capable enough draftsman to have rendered his own copy of the *Mona Lisa*. Do you think he used a reproduction simply to expedite completion of the work?

The gouache composition by G. Odutokun (Fig. 19-25) is another clear illustration of the icon status of the *Mona Lisa*. In this work, cultural exchanges are explored through the interaction between images symbolic of Western and non-Western traditions. What do you think the artist aims to suggest through the title of the work? Look closely at the content of the piece. Who is painting whom; who is sculpting whom? Even though the artist seems to be portraying a cross-cultural encounter, would this work be as relevant to a contemporary European viewer as a contemporary African viewer? What does this composition say about standards of beauty that are culturally defined?

And is the standard of beauty that the *Mona Lisa* has represented for generations one that is gender biased as well as culturally biased? This question is posed in Sadie Lee's revision entitled *Bona Lisa* (Fig. 19-26). At first glance, the portrait seems to be a male version of Leonardo's female sitter. In reality, Lee has represented the banker's wife as a lesbian with close-cropped hair and masculine attire. Edward Lucie-Smith has interpreted this work as an "ironic comment on the popular image of a 'butch' lesbian."

From politics and protest to the protest of political correctness, each of the artists we have here observed has understood the significance of attaching his or her message to Leonardo's masterwork. What are your impressions?　■

19-26　SADIE LEE.
Bona Lisa (1992).
Oil on board. 23″ × 19″.
Copyright Visual Arts Library, London/Art Resource, New York.

The most important thing about Dada, it seems to me, is that Dadaists despised what is commonly regarded as art, but put the whole universe on the lofty throne of art.

—Jean Arp

imagine the worst. For example, we are not likely to assume that the girl is rushing to her father standing by a flagpole. Viewers must stew in their active imaginations, pondering the simple clues to a mystery that Chirico will not unlock.

Dada

In 1916, during World War I, an international movement arose that declared itself against art. Responding to the absurdity of war and the insanity of a world that gave rise to it, the Dadaists declared that art—a reflection of this sorry state of affairs—was stupid and must be destroyed. Yet in order to communicate their outrage, the Dadaists created works of art! This inherent contradiction spelled the eventual demise of their movement. Despite centers in Paris, Berlin, Cologne, Zurich, and New York City, Dada ended with a whimper in 1922.

The name **Dada** was supposedly chosen at random from a dictionary. It is an apt epithet. The nonsense term describes nonsense art—art that is meaningless, absurd, unpredictable. Although it is questionable whether this catchy label was in truth derived at random, the element of chance was indeed important to the Dada art form. Dada poetry, for example, consisted of nonsense verses of random word combinations. Some works of art, such as the Dada collages, were constructed of materials found by chance and mounted randomly. Yet however meaningless or unpredictable the poets and artists intended their products to be, in reality they were not. In an era dominated by the doctrine of psychoanalysis, the choice of even nonsensical words spoke something at least of the poet. Works of art supposedly constructed in random fashion also frequently betrayed the mark of some design.

Marcel Duchamp

In an effort to advertise their nihilistic views, the Dadaists assaulted the public with irreverence. Not only did they attempt to negate art but they also advocated antisocial and amoral behavior. Marcel Duchamp offered for exhibition a urinal, turned on its back and entitled *Fountain* (see Fig. 1-32). Later he summed up the Dada sensibility in works such as *Mona Lisa (L.H.O.O.Q.)* (see Fig. 19-24 in

19-27 MAX ERNST.
Two Children Are Threatened by a Nightingale (1924).
Oil on wood with wood construction.
27½″ × 22½″ × 4½″.

The Museum of Modern Art, New York. Purchase. Copyright Art Resource, New York. Copyright 2003 Artists Rights Society (ARS), New York/ADAGP, Paris.

nearby Compare and Contrast feature), in which he impudently defiled a color print of Leonardo da Vinci's masterpiece with a mustache and goatee. In *Nude Descending a Staircase #2* (see Fig. 2-72), Duchamp's simulation of the fourth dimension of time through a series of overlapping images added a new element to the experiments of Cubism.

Fortified by growing interest in psychoanalysis, Dada, with some modification, would provide the basis for a movement called Surrealism that began in the early 1920s. Like Max Ernst's Dada composition, *Two Children Are Threat-*

ened by a Nightingale (Fig. 19-27), some Surrealist works offer irrational subjects and the chance juxtaposition of everyday objects. These often menacing paintings also incorporate the Realistic technique and the suggestion of dream imagery found in Fantastic art.

SURREALISM

Surrealism began as a literary movement after World War I. Its adherents based their writings on the nonrational, and thus they were naturally drawn to the Dadaists. Both literary groups engaged in **automatic writing,** in which the mind was to be purged of purposeful thought and a series of free associations were then to be expressed with the pen. Words were not meant to denote their literal meanings but to symbolize the often seething contents of the unconscious mind. Eventually the Surrealist writers broke from the Dadaists, believing that the earlier movement was becoming too academic. Under the leadership of the poet Andre Breton, they defined their movement as follows in a 1924 manifesto:

> *Surrealism,* noun, masc., pure psychic automatism by which it is intended to express either verbally or in writing, the true function of thought. Thought dictated in the absence of all control exerted by reason, and outside all aesthetic or moral preoccupations.

> *Encycl. Philos.* Surrealism is based on the belief in the superior reality of certain forms of association heretofore neglected, in the omnipotence of the dream, and in the disinterested play of thought. It leads to the permanent destruction of all other psychic mechanisms and to its substitution for them in the solution of the principal problems of life.

From the beginning, Surrealism expounded two very different methods of working. **Illusionistic Surrealism,** exemplified by artists such as Salvador Dalí and Yves Tanguy, rendered the irrational content, absurd juxtapositions, and metamorphoses of the dream state in a highly illusionistic manner. The other, called **Automatist Surrealism,** was a direct outgrowth of automatic writing and was used to divulge mysteries of the unconscious through abstraction. The Automatist phase is typified by Joan Miró and Andre Masson.

Salvador Dalí

Modesty was not his strong suit. One of the few "household names" in the history of art belongs to a leading Surrealist figure, the Spaniard Salvador Dalí (1904–1986). His reputation for leading an unusual—one could say surrealistic—life would seem to precede his art, for many not familiar with his canvases had seen Dalí's outrageous mustache and knew of his shenanigans. Once as a guest on the Ed Sullivan television show, he threw open cans of paint at a huge canvas.

Dalí began his painting career, however, in a somewhat more conservative manner, adopting, in turn, Impressionist, Pointillist, and Futurist styles. Following these forays into contemporary styles, he sought academic training at the Academy of Fine Arts in Madrid. This experience steeped him in a tradition of illusionistic realism that he never abandoned.

In what may be Dalí's most famous canvas, *The Persistence of Memory* (Fig. 19-28), the drama of the oneiric imagery is enhanced by his trompe l'oeil technique. Here, in a barren landscape of incongruous forms, time, as all else, has expired. A watch is left crawling with insects like scavengers

19-28 SALVADOR DALÍ.
The Persistence of Memory (1931).
The Museum of Modern Art, New York. Given anonymously. Digital image © The Museum of Modern Art / Licensed by Scala / Art Resource, New York.

*My way is to seize an image that moment it has formed in my mind, to trap it as a bird
and to pin it at once to canvas. Afterward I start to tame it, to master it.
I bring it under control and I develop it.*

—Joan Miró

over carrion; three other watches hang limp and useless over a rectangular block, a dead tree, and a lifeless, amorphous creature that bears a curious resemblance to Dalí. The artist conveys the world of the dream, juxtaposing unrelated objects in an extraordinary situation. But a haunting sense of reality threatens the line between perception and imagination. Dalí's is, in the true definition of the term, a surreality — or reality above and beyond reality.

Joan Miró

Not all of the Surrealists were interested in rendering their enigmatic personal dreams. Some found this highly introspective subject matter meaningless to the observer and sought a more universal form of expression. The Automatist Surrealists believed that the unconscious held such universal imagery, and through spontaneous, or automatic, drawing, they attempted to reach it. Artists of this group, such as Joan Miró (1893–1983), sought to eliminate all thought from

their minds and then trace their brushes across the surface of the canvas. The organic shapes derived from intersecting skeins of line were believed to be unadulterated by conscious thought and thus drawn from the unconscious. Once the basic designs had been outlined, a conscious period of work could follow in which the artist intentionally applied his or her craft to render them in their final form. But because no conscious control was to be exerted to determine the early course of the designs, the Automatist method was seen as spontaneous, as employing chance and accident. Needless to say, the works are abstract, although some shapes are amoebic.

Miró was born near Barcelona and spent his early years in local schools of art learning how to paint like the French Modernists. He practiced a number of styles ranging from Romanticism to Realism to Impressionism, but Cézanne and van Gogh seem to have influenced him most. In 1919 Miró moved to Paris, where he was receptive to a number of

19-29 JOAN MIRÓ.
Painting (1933).
Oil on canvas. 68½″ × 77¼″.
The Museum of Modern Art, New York.
Loula D. Lasker Bequest (by exchange).
Copyright Art Resource, New York. Copyright
Succession Miró. Copyright Artists Rights Society
(ARS), New York/ADAGP, Paris.

art styles. The work of Matisse and Picasso along with the primitive innocence of Rousseau found their way into his canvases. Coupled with a rich native iconography and an inclination toward fantasy, these different elements would shape Miró's unique style.

Miró's need for spontaneity in communicating his subjects was compatible with Automatist Surrealism, although the whimsical nature of most of his subjects often appears at odds with that of other members of the movement. In *Painting* (Fig. 19-29), meandering lines join or intersect to form the contours of clusters of organic figures. Some of these shapes are left void to display a nondescript background of subtly colored squares. Others are filled in with sharply contrasting black, white, and bright red pigment.

In this work, Miró applied Breton's principles of psychic automatism in an aesthetically pleasing, decorative manner.

By 1930 Surrealism had developed into an international movement, despite the divorce of many of the first members from the group. New adherents exhibiting radically different styles kept the movement alive. As the decade of the 1930s evolved, however, Adolf Hitler rose to power and war once again threatened Europe. Hitler's ascent drove refugee artists of the highest reputation to the shores of the United States. Among them were the leading figures of Abstraction and Surrealism, two divergent styles that would join to form the basis of an avant-garde American painting. The center of the art world had moved to New York.

CONTEMPORARY ART

Being an artist now means to question the nature of art.

—Joseph Kosuth

There is a saying, once thought to be a Chinese curse, that reads, "May you live in interesting times." Whatever the origin, it captures the value of stimulation and novelty, even at the expense, perhaps, of tranquility. When it comes to contemporary art, we live in nothing if not interesting times. Louise Bourgeois, who was born in 1911 and continues to work avidly in her nineties, noted that "there are no settled ways"; there is "no fixed approach." Never before in history have artists experimented so freely with so many media, such different styles, such a wealth of content. Never before in history have works of art been so accessible to so many people. Go to "Google Images," and the world of art and artists is a mouse-click away.

CONTEMPORARY ART

In this chapter we discuss painting, sculpture, architecture, and other works that have appeared since the end of World War II—the art of recent times and of today. After the war, the center of the art world shifted to New York following its long tenure in Paris. There were a number of reasons. The wave of immigrant artists who escaped the Nazis had settled largely in New York. Among them were Marcel Duchamp, Fernand Léger, Josef Albers, Hans Hofmann, and others. The Federal Art Project of the WPA (Works Progress Administration) had also nourished the New York artist community during the Great Depression. This group included Arshile Gorky, Willem de Kooning, Jack Tworkov, James Brooks, Philip Guston, and Stuart Davis, among many others. Together these were known as the first-generation New York School. Even the Mexican muralists Diego Rivera and José Clemente Orozco sojourned and taught in the city.

Just before the Great Depression began, Orozco had already argued that the artists of the New World should no longer look to Europe for their inspiration and their models. In January 1929 he wrote: "If new races have appeared upon the lands of the New World, such races have the unavoidable duty to produce a New Art in a new spiritual and physical medium. Any other road is plain cowardice." Despite his devotion to the arts and culture of the Mexican Native Americans, Orozco added: "Already the architecture of Manhattan is a new value, something that has nothing to do with Egyptian pyramids, with the Paris Opera, with the Geralda of Seville, or with Saint Sofia, any more than it has to do with the Maya palaces of Chichen-Itzá or with the pueblos of Arizona."[1]

There is no question that the postwar generation produced an art never before seen on the face of the planet. It is a lively art that stirs both adoration and controversy. It is also a fertile art, giving birth to exploration down many branching avenues.

PAINTING

Many vital movements have given shape to contemporary painting. We will begin with painters of the first-generation New York School and their powerful new movement of **Abstract Expressionism.** Then we will consider the work of a younger, second generation of New York School painters, including color-field and hard-edge painters. Finally, we will discuss a number of the other movements in painting that have defined the postwar years, including figurative painting, Pop Art, Photorealism, and Op Art.

THE NEW YORK SCHOOL: THE FIRST GENERATION

At mid-twentieth century the influences of earlier nonobjective painting, the colorful distortions of Expressionism, Cubist design, the supposedly automatist processes of Surrealism, and a host of other factors—even an interest in Zen Buddhism—converged in New York City. From this artistic melting pot, Abstract Expressionism flowered. At first, like other innovative movements in art, it was not universally welcomed by critics. Writing in *The New Yorker* in 1945, Robert M. Coates commented:

> [A] new school of painting is developing in this country. It is small as yet, no bigger than a baby's fist, but it is noticeable if you get around to the galleries much. It partakes a little of Surrealism and still more of Expressionism, and although its main current is still muddy and its direction obscure, one can make out bits of Hans Arp and Joan Miró floating in it, together with large chunks of Picasso and occasional fragments of [African American] sculptors. It is more emotional than logical in expression, and you may not like it (I don't either, entirely), but it can't escape attention.[2]

Abstract Expressionism is characterized by spontaneous execution, large gestural brushstrokes, abstract imagery, and fields of intense color. Many canvases are quite large, lending monumentality to the imagery. The abstract shapes frequently have a calligraphic quality found in the painting of the Far East (see Chapter 17). However, the scope of the brushstrokes of the New York group was vast and muscular compared with the gentle, circumscribed brushstrokes of Chinese and Japanese artists.

Turning the Corner toward an Abstract Expressionism

Before we discuss the work of the major Abstract Expressionists, let us explore the vibrant canvases of two artists whose work, near mid-twentieth century, showed the

[1] Robert Goldwater and Marco Treves, eds., *Artists on Art* (New York: Pantheon Books, 1972), 479.

[2] Robert M. Coates, "The Art Galleries," *The New Yorker,* May 26, 1945, 68.

The vital task was a wedding of abstraction and surrealism. Out of these opposites something
new could emerge, and Gorky's work is part of the evidence that this is true.

—Adolph Gottlieb

influence of earlier trends and, in turn, presaged Abstract Expressionism: Arshile Gorky and Hans Hofmann.

Arshile Gorky

Born in Armenia, Arshile Gorky (1905–1948) immigrated to the United States in 1920 and became part of a circle that included Willem de Kooning and Stuart Davis. Some of Gorky's early still lifes show the influence of the nineteenth-century painter Paul Cézanne. Later abstract works resolve the shapes of the objects of still lifes into sharp-edged planes that recall the works—and the fascination with native forms—of Pablo Picasso and Georges Braque. Abstractions of the late 1940s show the influence of Expressionists such as Wassily Kandinsky and Surrealists such as Joan Miró.

Gorky's *The Liver Is the Cock's Comb* (Fig. 20-1) is six feet high and more than eight feet long. Free, spontaneous lines pick out unstable, organic shapes from a lush molten background of predominantly warm colors: analogous reds, oranges, and yellows.

Many of Gorky's paintings, like those of the Surrealists, are like erotic panoramas. Here and there we can pick out abstracted forms that seem to hark back to dreams of childhood or to the ancestral figures of primitive artists. Transitional works such as this form a logical bridge between early twentieth-century abstraction, Automatist Surrealism, and the gestural painting of Jackson Pollock and Willem de Kooning.

Hans Hofmann

Born in Bavaria, Hans Hofmann (1880–1966) studied in Paris early in the twentieth century. He witnessed at close hand the Fauvists' use of high-keyed colors and the Cubists' resolution of shapes into abstract planes. He immigrated to the United States from Germany in 1932 and established schools of fine art in New York City and in Provincetown, Massachusetts.

Hofmann's early works were figural and expressionistic, showing the influence of Henri Matisse. From the war years

20-1 ARSHILE GORKY.
The Liver Is the Cock's Comb
(1944).
Oil on canvas. 72″ × 98″.
Albright-Knox Art Gallery, Buffalo, New York. Gift of Seymour H. Knox, 1956. Copyright 2003 Artists Rights Society (ARS), New York.

on, however, his paintings showed a variety of abstract approaches, from lyrically free, curving lines to the depiction of geometrical masses. Hofmann is considered a transitional figure between the Cubists and the Abstract Expressionists. In his abstract paintings, he shows some allegiance to Fauvist coloring and Cubist design, but Hofmann also used color architecturally to define structure.

In *The Golden Wall* (Fig. 20-2), intense fields of complementary and primary colors are pitted against one another in Fauvist fashion, but they compose abstract rectangular forms. The gestural brushstrokes in the color fields of paintings such as these would soon spread through the art world. Hofmann, the analyst and instructor of painting, knew very well that the cool blues and greens in *The Golden Wall* would normally recede and the warm reds and oranges would emerge; but sharp edges and interposition press the blue and green areas forward, creating tension between planes and flattening the canvas. Hofmann saw this tension as symbolic of the push and pull of nature; but the "tension" is purely technical, for the mood of *The Golden Wall,* as of most of his other works, is joyous and elevating.

Later Hofmann would claim that paintings such as these were derived from nature, even though no representational imagery can be found. In their expressionistic use of color and their abstract subject matter, Hofmann's

20-3 Jackson Pollock at work in his Long Island studio (1950).
Copyright Hans Namuth, Ltd.

paintings form a clear base for the flowering of Abstract Expressionism.

Focus on Gesture

For some Abstract Expressionists, such as Jackson Pollock and Willem de Kooning, the gestural application of paint seems to be the most important aspect of their work. For others, the structure of the color field seems to predominate.

Jackson Pollock

> Pollock's talent is volcanic. It has fire. It is unpredictable. It is undisciplined. It spills itself out in a mineral prodigality not yet crystallized. It is lavish, explosive, untidy. . . . What we need is more young men who paint from inner compulsion without an ear to what the critic or spectator may feel— painters who will risk spoiling a canvas to say something in their own way. Pollock is one.[3]

Jackson Pollock (1912–1956) is probably the best known of the Abstract Expressionists. Photographs or motion pictures of the artist energetically dripping and splashing paint across his huge canvases (Fig. 20-3) are familiar to many Americans. Pollock would walk across the surface of the canvas as if controlled by primitive impulses and unconscious ideas.

20-2 HANS HOFMANN.
The Golden Wall (1961).
Oil on canvas. 60″ × 72½″.
Photograph courtesy of The Art Institute of Chicago. Mr. and Mrs. Logan G. Prize Fund. Copyright 2003 Artists Rights Society (ARS), New York.

[3] Clement Greenberg, quoted in Introduction to catalog of an exhibition, "Jackson Pollock," Art of This Century Gallery, New York, November 9–27, 1943.

20-4 JACKSON POLLOCK.
One (Number 31, 1950) (1950).
Oil and enamel paint on canvas. $8'10'' \times 17'5\frac{5}{8}''$.

Accident became a prime compositional element in his painting. Art critic Harold Rosenberg coined the term **action painting** in 1951 to describe the outcome of such a process—a painting whose surface implied a strong sense of activity, as created by the signs of brushing, dripping, or splattering of paint.

Born in Cody, Wyoming, Pollock came to New York to study with Thomas Hart Benton at the Art Students League. The 1943 quote from Clement Greenberg shows the impact that Pollock made at an early exhibition of his work. His paintings of this era (see Fig. 4-7) frequently depicted actual or implied figures that were reminiscent of the abstractions of Picasso and, at times, of Expressionists and Surrealists.

Aside from their own value as works of art, Pollock's drip paintings of the late 1940s and early 1950s made a number of innovations that would be mirrored and developed in the work of other Abstract Expressionists. Foremost among these was the use of an overall gestural pattern barely contained by the limits of the canvas. In *One* (Fig. 20-4), the surface is an unsectioned, unified field. Overlapping skeins of paint create dynamic webs that project from the picture plane, creating an illusion of infinite depth. In Pollock's best work, these webs seem to be composed of energy that pushes and pulls the monumental tracery of the surface like the architectural shapes of a Hofmann painting.

Pollock was in psychoanalysis at the time he executed his great drip paintings. He believed strongly in the role of the unconscious mind, of accident and spontaneity, in the creation of art. He was influenced not only by the intellectual impact of the Automatist Surrealists but also by what must have been his impression of walking hand in hand with his own unconscious forces through the realms of artistic expression. Before his untimely death in 1956, Pollock had returned to figural paintings that were heavy in impasto and predominantly black. One wonders what might have emerged if the artist had lived a fuller span of years.

I merge what I call the organic with what I call abstract.

—Lee Krasner

Lee Krasner

Lee Krasner (1908–1984) was one of only a few women in the mainstream of Abstract Expressionism. Yet, in spite of her originality and strength as a painter, her work, until fairly recently, had taken a critical "back seat" to that of her famous husband—Jackson Pollock. She once noted,

> I was not the average woman married to the average painter. I was married to Jackson Pollock. The context is bigger and even if I was not personally dominated by Pollock, the whole art world was.[4]

Krasner had a burning desire to be a painter from the time she was a teenager and received academic training at some of the best art schools in the country. She was influenced by artists of diverse styles, including Hoffman (under whom she studied), Picasso, Mondrian, and the Surrealists. Most important, like Pollock and the other members of the Abstract Expressionist school, she was exposed to the work of a number of European émigrés who came to New York in the 1930s and 1940s.

Both Pollock and Krasner experimented with allover compositions around 1945, but the latter's work was smaller in scale and exhibited much more control. Even after 1950, when Krasner's work became much freer and larger, the accidental nature of Pollock's style never took hold of her own. Rather, Krasner's compositions might be termed a synthesis of choice and chance.

Easter Lilies (Fig. 20-5) was painted in 1956, the year of Pollock's fatal accident. The jagged shapes and bold black lines against the muddied greens and ochers render the composition dysphoric; yet in the midst of all that is harsh are the recognizable contours of lilies, whose bright whites offer a kind of hope in a sea of anxiety. Krasner once remarked of her work, "My painting is so autobiographical, if anyone can take the trouble to read it."[5]

20-5 LEE KRASNER.
Easter Lilies (1956).
Oil on cotton duck. 48¼″ × 60⅛″.
Private collection. Courtesy of the Robert Miller Gallery, New York. Copyright 2003 The Pollock-Krasner Foundation/Artists Rights Society (ARS), New York.

Willem de Kooning

Born in Rotterdam, Holland, Willem de Kooning (1904–1997) immigrated to the United States in 1926, where he joined the circle of Gorky and other forerunners of Abstract Expressionism. Until 1940 de Kooning painted figures and portraits. His first abstractions of the 1940s, like Gorky's, remind one of Picasso's paintings. As the 1940s progressed, de Kooning's compositions began to combine biomorphic, organic shapes with harsh, jagged lines. By mid-twentieth century, his art had developed into a force in Abstract Expressionism.

De Kooning is best known for his series of paintings of women that began in 1950. In contrast to the appealing figurative works of an earlier day, many of his abstracted women are frankly overpowering and repellent. Faces are frequently resolved into skull-like native masks reminiscent of ancient fertility figures; they assault the viewer from a loosely brushed backdrop of tumultuous color. Perhaps they portray what was a major psychoanalytic dilemma during the 1950s—how women could be at once seductive, alluring, and castrating. In our own liberated times, this notion

[4] Lee Krasner, in Roberta Brandes Gratz, "Daily Close-Up—After Pollock," *New York Post,* December 6, 1973.
[5] Lee Krasner, in Cindy Nemser, "A Conversation with Lee Krasner," *Arts Magazine* 47 (April 1973): 48.

[A critic] thought that American painting couldn't be abstract—it wasn't American.

—Willem de Kooning

20-6 WILLEM DE KOONING.
Two Women (1953).
Pastel drawing. 18⅞″ × 24″.

Photograph courtesy of The Art Institute of Chicago. Joseph H. Wrenn
Memorial Collection. Copyright 2003 The Willem de Kooning
Foundation/Artists Rights Society (ARS), New York.

of woman or of eroticism as frightening seems sexist or out of joint. In any event, in some of his other paintings, abstracted women communicate an impression of being unnerved, even vulnerable.

The subjects of *Two Women* (Fig. 20-6) are among the more erotic of the series. Richly curved pastel breasts swell from a sea of spontaneous brushstrokes that here and there violently obscure the imagery. The result is a free-floating eroticism. A primal urge has been cast loose in space, pushing and pulling against the picture plane. But de Kooning is one of the few Abstract Expressionists who never completely surrendered figurative painting.

De Kooning's work frequently seems obsessed with the violence and agitation of the "age of anxiety." The abstract backgrounds seem to mirror the rootlessness many of us experience as modern modes of travel and business call us to foreign towns and cities.

Focus on the Color Field

For a number of Abstract Expressionists, the creation of pulsating fields of color was more important than the gestural quality of the brushstroke. These canvases are so large that they seem to envelop the viewer with color, the subtle mod-

ulations of which create a vibrating or resonating effect. Artists who subscribed to this manner of painting, such as Mark Rothko and Barnett Newman, had in common the reworking of a theme in an extended series of paintings. Even though the imagery often remains constant, each canvas has a remarkably different effect due to often radical palette adjustments.

Mark Rothko

Mark Rothko (1903–1970) painted lone figures in urban settings in the 1930s and biomorphic surrealistic canvases through the early 1940s. Later in that decade he began to paint the large floating, hazy-edged color fields for which he is renowned. During the 1950s, the color fields consistently assumed the form of rectangles floating above one another in an atmosphere defined by subtle variations in tone and gesture. They alternately loom in front of and recede from the picture plane, as in *Blue, Orange, Red* (Fig. 20-7). The large scale of these canvases absorbs the viewer in color.

20-7 MARK ROTHKO.
Blue, Orange, Red (1961).
Oil on canvas. 90¾″ × 81″.

Hirshhorn Museum and Sculpture Garden, Smithsonian Institution,
Washington, DC. Gift of the Hirshhorn Foundation, 1966.
Copyright 2003 Artists Rights Society (ARS), New York.

Early in his career, Rothko had favored a palette of pale hues. During the 1960s, however, his works grew somber. Reds that earlier had been intense, warm, and sensuous were now awash in deep blacks and browns and took on the appearance of worn cloth. Oranges and yellows were replaced by grays and black. Light that earlier had been reflected was now trapped in his canvases. Despite public acclaim, Rothko suffered from depression during his last years. In 1968 he was diagnosed as having heart disease, and one year later his second marriage was in ruins. He committed suicide the following winter. His paintings of the later years may be an expression of the turmoil and the fading spark within.

Combined Gesture and Color-Field Painting

For some artists of the Abstract Expressionist era, the most original work lay in the bridging of gesture and color field. Artists such as Adolph Gottlieb, Robert Motherwell, and Clifford Still enlarged simple forms and made them the predominant themes of their compositions. Often these forms were set in large expanses of washed color, their contours eroded by the resonating hues.

Adolph Gottlieb

Adolph Gottlieb (1903–1974) is preeminent among those artists who chose to combine the two styles of Abstract Expressionism. He was born in New York and studied under American Realist painter John Sloan at New York City's Art Students League. During the 1940s and early 1950s, he painted a series of "pictographs" in which the canvases were sectioned into rectangular compartments filled with schematized or abstract forms such as ancestral images, sinuous shapes of reptiles and birds, pure geometric forms, anatomic parts, and complex shapes suggestive of cosmic symbols or microscopic life-forms. He denied that the pictographs had any meaning beyond their interesting shapes, but much of the enjoyment in viewing them stems from trying to decipher the content.

Some of Gottlieb's most successful paintings belong to the *Bursts* series that began in 1957. In the Bursts, there is an implied horizontal division of the canvas. An orb of color pulsates in the upper part of the canvas while broad, gestural strokes burst beneath it against a washed field of color. Visually, the Bursts are studies in contrast between pure closed forms and amorphous open forms. On a symbolic level, they seem to reflect the opposites in human nature.

Green Turbulence (Fig. 20-8), painted in 1968, is a variation on the Bursts theme. Below an implied horizon line, a simple black pictograph floats against a field of green while three pristine orbs hover above. Smaller and less perfectly formed spheres seem to break out of the chaotic, "earthly" zone and await their voyage to the celestial realm. The pictograph is strongly calligraphic, as if the baser history of our species is being broadly recorded in swaths of paint. By comparison, the orbs seem immaculate in conception. These

20-8 ADOLPH GOTTLIEB.
Green Turbulence (1968).
Oil on canvas.
94″ × 157″.

Photograph courtesy of Adolph and Esther Gottlieb Foundation, Inc., New York. Copyright Adolph and Esther Gottlieb Foundation/Licensed by VAGA, New York.

20-9 ROMARE BEARDEN. *Prevalence of Ritual: Mysteries* (1964). Collage. $11\frac{1}{4}'' \times 14\frac{1}{4}''$.

Museum of Fine Arts, Boston. Ellen Kelleran Gardner Fund, 1971. Copyright Romare Bearden Foundation/Licensed by VAGA, New York.

pulsating shapes imply a pure but obscure symbol that is close at hand yet unreachable.

Abstract Expressionism may be the major movement in painting of the postwar era, but contemporary painting has been a rich and varied undertaking, with tentative strokes and brilliant bursts of fulfillment in many directions.

Romare Bearden

Abstract Expressionism has been viewed by some critics as an exclusive "club" of white male artists. Indeed, the main figures associated with the movement do not count among them women and artists of color. Yet these artists did experiment with the style of Abstract Expressionism, developing their own artistic voices.

African American artist Romare Bearden (1914–1988) experimented with the Abstract Expressionist style in the 1950s and a decade later enhanced his artistic vocabulary with collage techniques that would become characteristic of his mature style. Although his compositions have a familiar allover design that reflects his interest in Abstract Expressionism, one of the ways in which he departed from their style is his emphasis on imagery that reflected his experiences and memories of life in North Carolina, his birthplace, and in Harlem, where he carried out most of his work.

The son of middle-class parents, Bearden attended the Art Students League and New York University in the 1940s. He believed that African Americans should create their own art form, just as they had developed musical styles such as jazz and the blues. In the 1960s he arrived at his signature style, which combined painting and collage. *Prevalence of Ritual: Mysteries* (Fig. 20-9) is constructed of pasted papers that read as flashes of memory. Objects, faces, photos of houses, and swatches of newsprint appear something like a scrapbook of consciousness and experience. The rituals Bearden observed in his early life all seem to blend together—planting, sowing, picking cotton, family meals, river baptisms, "down-home" jazz, or blues. Ralph Ellison wrote of Bearden's art:

> Bearden's meaning is identical with his method. His combination of technique is in itself eloquent of the sharp breaks, leaps in consciousness, distortions, paradoxes, reversals, telescoping of time and surreal blending of styles, values, hopes and dreams which characterize much of [African] American history.[6]

[6] Ralph Ellison, introduction to *Romare Bearden: Paintings and Projections* (Albany, NY, 1968).

THE NEW YORK SCHOOL: THE SECOND GENERATION

Abstract Expressionism was a painterly movement. Contours and colors were loosely defined, edges were frequently blurred, and long brushstrokes trailed off into ripples, streaks, and specks of paint. During the mid-1950s, a number of younger abstract artists, referred to as the "second-generation" New York School, began to either build upon or deemphasize this painterly approach; some furthered the staining technique that Pollock used in his last years, whereas others focused increasingly on clarity of line and clearness of edges. Beyond a few common features, their styles were quite different, and they modified and extended in a number of ways the forces that had led to Abstract Expressionism. Some of these artists, such as Morris Louis, Helen Frankenthaler, and Kenneth Noland, became known as **color-field painters.** Others, such as Ellsworth Kelly, whose work focused on clear geometric shapes with firm contours that separated them from their fields, were known as **hard-edge painters.** Many of this new crop of abstract painters, Noland and Kelly among them, also pioneered the **shaped canvas,** which challenges the traditional orientation of a painting and often extends the work into three-dimensional space. Some artists in the 1980s would use the shaped canvas exclusively in their works.

Color-Field Painting

Helen Frankenthaler

Kenneth Noland once said of Helen Frankenthaler (b. 1928), "She was a bridge between Pollock and what was possible." He claimed that it was Frankenthaler who showed him and Morris Louis a way to push beyond Pollock, showed them "a way to think about and use, color."[7] In fact, it is works like *Lorelei* (Fig. 20-10) that best describe the manner in which Frankenthaler

built on Pollock's legacy. The canvas is awash in color. Broad expanses of thinned pigment are allowed to seep into the fibers of the canvas, thus softening the edges of the varied shapes. The shapes themselves are interspersed with flowing lines and paint spatters that make reference to Pollock's techniques. The roles of accident and spontaneity are not diminished. *Lorelei* is in many ways a reconciliation between gesture and color-field Abstract Expressionism; yet its uniqueness lies in its combination of a vibrant palette, staining technique, and above all, strong abstract image in a structurally sound composition. Frankenthaler is capable of suggesting space through subtle color modulations. By pouring fields of thinned vibrant color onto unprimed canvas, the resulting central image is open, billowing, and abstract, free of gestural brushing.

Minimal Art

Paintings involving the shaped canvas, color field, and images derived from mathematical systems, gave rise to an art form known as **Minimal art,** or simply **Minimalism.** Many

20-10 HELEN FRANKENTHALER.
Lorelei (1957).
Oil on canvas. 70¾″ × 87″.
The Brooklyn Museum. Gift of Alan D. Emil.

[7] Kenneth Noland, in James McC. Truitt, "Art-Arid D.C. Harbors Touted 'New' Painters," *Washington Post,* December 21, 1961, A20.

My pictures have neither subject nor space nor lines nor anything else—no forms.
They are light, and are about fusion and formlessness, about dissolving form.

—Agnes Martin

20-11 AGNES MARTIN.
Untitled (1989).
Acrylic and graphite on canvas. 12″ × 12″.
Courtesy of PaceWildenstein Gallery, New York.

artists in the 1960s purified their images and painting processes to reflect their commitment to intellectual theory and mathematics as bases for their compositions. Common to all is the sense of the contradictory: an extraordinary lightness and transience that belies the solidity and permanence of their shapes.

Agnes Martin

Untitled (Fig. 20-11) by Agnes Martin (b. 1912) is a quintessential example of the Minimalist style. A tiny 12″ × 12″ canvas provides a luminous backdrop for finely wrought bands of shimmering graphite. The absolute square of the canvas is softened by the delicacy of technique.

Martin said of her paintings, "When I cover the square with rectangles, it lightens the weight of the square, destroys its power."[8]

FIGURATIVE PAINTING

Although abstraction has been a driving force in American painting since the years just prior to World War II, a number of figurative painters have remained strong in their commitment to nature, or reality, as a point of departure for their work. De Kooning's *Women* series remains figurative, although he was an active participant in the Abstract Expressionist movement. Other artists have portrayed human and animal figures in any number of styles—realistic, expressionistic, even abstracted. In the thick of Abstract Expressionism, and in the decade following, when artists sought to create new forms of expression within its canon, painters such as Alice Neel and Francis Bacon used the figure, respectively, in compositions of extreme verity and surrealist juxtaposition.

Alice Neel

One of the most dramatic figurative painters of the era was a portrait painter named Alice Neel (1900–1984). The designation "portraitist," however, in no way prepares the viewer for the radical nature of Neel's work. She took no commissions but rather handpicked her sitters from all strata of society and often painted them in the nude, or seminude. The drama, curiously, lies in the very *un*dramatic character of her work—stark, unflinching realism. Neel's sitters were wildly diverse (from painter Andy Warhol to her housekeeper, Carmen), but her harsh style remained constant, as did her belief that she could convey something of a person's inner self through a meticulous rendering of its physical embodiment.

[8] H. H. Arnason, *History of Modern Art,* 3rd ed. (Englewood Cliffs, NJ: Prentice-Hall/Abrams, 1986), 520.

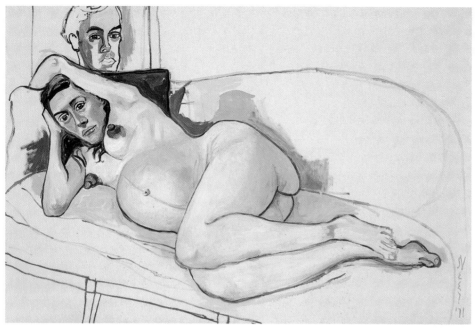

Pregnant Woman (Fig. 20-12) is one in a series of canvases devoted to the nude pregnant woman. Although her subject reclines in a pose traditionally reserved for the Renaissance goddess, her facial features prevent us from reading the work as either stereotypical or archetypal. They are specific; they belong to this woman and no one else. Maria does not symbolize maternity or childbirth for all women. This experience is hers alone.

20-12 ALICE NEEL.
Pregnant Woman (1971).
Oil on canvas. 40″ × 60″.
Courtesy of the Robert Miller Gallery, New York.
Copyright The Estate of Alice Neel.

Francis Bacon

Many of the figurative canvases of Francis Bacon (1909–1992) rework themes by masters such as Giotto, Rembrandt, and van Gogh. But Bacon's personalized interpretation of history is expressionistically distorted by what must be a very raw response to the quality of contemporary life.

Head Surrounded by Sides of Beef (Fig. 20-13) is one of a series of paintings from the 1950s in which Bacon reconstructed Velázquez's portrait of Pope Innocent X. The tormented, open-mouthed figure is partially obscured, as if seen through a curtain or veil. The brilliantly composed slabs of beef, which stand like totems richly threaded with silver and gold, replace ornamental metalwork posts that rise from the back corners of the papal throne in the Velázquez portrait. Profiles can be seen in the sides of beef, and a goblet of noble proportions is constructed from the negative space between them. The bloody whisperings shared by the profiles are anybody's guess. Whereas the background of Velázquez's subject was a textured space of indefinite

20-13 FRANCIS BACON.
Head Surrounded by Sides of Beef (1954).
Oil on canvas. 50⅞″ × 48″.
The Art Institute of Chicago. Harriott A. Fox Fund. Copyright The Art Institute of Chicago. Copyright 2003 The Estate of Francis Bacon/Artists Rights Society (ARS), New York/DACS, London.

depth, Bacon's seated figure and the sides of beef are set by single-point perspective within an abstract black box.

POP ART

If one were asked to choose the contemporary art movement that was most enticing, surprising, controversial, and also exasperating, one might select Pop Art. The term "Pop" was coined by English critic Lawrence Alloway in 1954 to refer to the universal images of "popular culture," such as movie posters, billboards, magazine and newspaper photographs, and advertisements. Pop Art, by its selection of common-place and familiar subjects—subjects that are already too much with us—also challenges commonplace conceptions about the meaning of art.

Whereas many artists have strived to portray the beautiful, Pop Art intentionally depicts the mundane. Whereas many artists represent the noble, stirring, or monstrous, Pop Art renders the commonplace, the boring. Whereas other forms of art often elevate their subjects, Pop Art is often matter-of-fact. In fact, one tenet of Pop Art is that the work should be so objective that it does not show the "personal signature" of the artist. This maxim contrasts starkly, for example, with the highly personalized gestural brushstroke found in Abstract Expressionism.

Richard Hamilton

Despite the widespread view that Pop Art is a purely American development, it originated during the 1950s in England. British artist Richard Hamilton (b. 1922), one of its creators, had been influenced by Marcel Duchamp's idea that the mission of art should be to destroy the normal meanings and functions of art.

Hamilton's tiny collage *Just What Is It That Makes Today's Homes So Different, So Appealing?* (see Fig. 1-26) is one of the earliest and most revealing Pop Art works. It is a collection of objects and emblems that form our environment. It is easy to read satire and irony into Hamilton's work, but his placement of these objects within the parameters of "art" encourages us to truly *see* them instead of just coexisting with them. The artist's selection or portrayal of these images imbues them with a larger meaning. It is up to us to divine what we will.

Robert Rauschenberg

American Pop artist Robert Rauschenberg (b. 1925) studied in Paris and then with Josef Albers and others at the famous Black Mountain College in North Carolina. Before developing his own Pop Art style, Rauschenberg experimented with

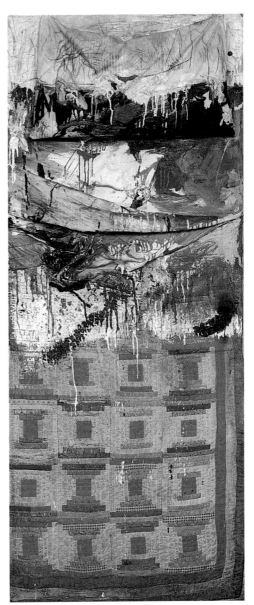

20-14 ROBERT RAUSCHENBERG.
The Bed (1955).
Combine painting: Oil and pencil on pillow, quilt, and sheet on wood supports. 75¼″ × 31½″ × 6½″.
The Museum of Modern Art, New York. Gift of Leo Castelli in honor of Alfred H. Barr Jr. Copyright The Museum of Modern Art / Licensed by Scala / Art Resource, New York. Copyright Robert Rauschenberg. Licensed by VAGA, New York.

loosely and broadly brushed Abstract Expressionist canvases. He is best known, however, for introducing a construction referred to as the **combine painting,** in which stuffed animals, bottles, articles of clothing and furniture, and scraps of photographs are attached to the canvas.

Rauschenberg's *The Bed* (Fig. 20-14) is a paint-splashed quilt and pillow, mounted upright on a wall as any painting

might be. Here the artist toys with the traditional relationships between materials, forms, and content. The content of the work is actually its support; rather than a canvas on a stretcher, the quilt and pillow are the materials on which the painter drips and splashes his pigments. Perhaps even more outrageous is Rauschenberg's famous 1959 work *Monogram,* in which a stuffed ram—an automobile tire wrapped around its middle—is mounted on a horizontal base that consists of scraps of photos and prints and loose, gestural painting.

Jasper Johns

Jasper Johns (b. 1930) was Rauschenberg's classmate at Black Mountain College, and their appearance on the New York art scene was simultaneous. His early work also integrated the overall gestural brushwork of the Abstract Expressionists with the use of found objects, but unlike Rauschenberg, Johns soon made the object central to his compositions. His works frequently portray familiar objects such as numbers, maps, color charts, targets, and flags integrated into a unified field by thick gestural brushwork.

One "tenet" of Pop Art is that imagery is to be presented objectively, that the personal signature of the artist is to be eliminated. That principle must be modified if we are to include as Pop the works of Rauschenberg, Johns, and others, for many of them immediately betray their devotion to expressionistic brushwork.

A work by Johns that adheres more to Pop Art dogma is his *Painted Bronze (Ale Cans)* (Fig. 20-15). In the tradition of Duchamp's readymades, Johns has bronzed two Ballantine beer cans and painted facsimile labels thereon. As with works such as the Dadaist's *Fountain* (see Fig. 1-32) or *Mona Lisa (L.H.O.O.Q.)* (see Fig. 19-24), questions concerning the definition of art are raised: Is it art because the artist chooses the object? because he or she manipulates it? or because the artist says it is art? One difference separates the Dada and Pop aesthetics, however: Whereas Duchamp believed that art should be destroyed, Johns firmly believes in the creative process of art. Whereas it was left

20-15 JASPER JOHNS.
Painted Bronze (Ale Cans) (1960).
Painted bronze. 5½″ × 8″ × 4¾″.
Kunstmuseum (Ludwig Collection), Basel.
Copyright Rheinisches Bildarchiv. Copyright
Jasper Johns/Licensed by VAGA, NY.

20-16 ANDY WARHOL.
Green Coca-Cola Bottles (1962).
Oil on canvas. 82¼″ × 57″.

Collection of Whitney Museum of American Art, New York. Purchase with funds from the Friends of the Whitney Museum of American Art. Copyright 2003 Andy Warhol Foundation for the Visual Arts/Artists Rights Society (ARS), New York. Jasper Johns/Licensed by VAGA, New York.

for Duchamp to stop making art (he devoted his life to the game of chess), Johns remains first and foremost an artist.

Andy Warhol

Andy Warhol (1930–1987) once earned a living designing packages and Christmas cards. Today he epitomizes the Pop artist in the public mind. Just as Campbell's soups represent bland, boring nourishment, Andy Warhol's appropriation of hackneyed portraits of celebrities (see Fig. 1-9),

his Brillo boxes (see Fig. 11-29), and his Coca-Cola bottles (Fig. 20-16) elicit comments that contemporary art has become bland and boring and that there is nothing much to be said about it. Warhol also evoked contempt here and there for his underground movies, which have portrayed sleep and explicit eroticism (*Blue Movie*) with equal disinterest. Even his shooting (from which he recovered) by a disenchanted actress seemed to evoke yawns and a "What-can-you-expect?" reaction from the public.

Warhol painted and printed much more than industrial products. During the 1960s he reproduced multiple photographs of disasters from newspapers. He executed a series of portraits of public figures such as Marilyn Monroe (see Fig. 1-9) and Jackie Kennedy in the 1960s, and he turned to portraits of political leaders such as Mao Ze-dong in the 1970s. Although his silkscreens have at least in their technique met the Pop Art objective of obscuring the personal signature of the artist, his compositions and his expressionistic brushing of areas of his paintings achieved an individual stamp.

It could be argued that other Pop artists owe some of their popularity to the inventiveness of Andy Warhol. Without Warhol, Pop Art might have remained a quiet movement, one that might have escaped the notice of the art historians of the new millennium.

What, then, do we make of Pop Art? Is it a cynical gesture to place expensive but meaningless objects in a gullible marketplace? Is it the sincere expression of deeply felt experience? Is it, perhaps, the only contemporary art movement that is a reflection of its times? Is it an attempt to countermand the unreachable and esoteric in the art of the 1940s and 1950s and provide the public with an art to which it can relate on some level?

PHOTOREALISM

Photorealism, or the rendering of subjects with sharp, photographic precision, is firmly rooted in the long, realistic tradition in the arts. But as a movement that first gained major recognition during the early 1970s, it also owes some of its impetus to the Pop artist's objective portrayal of familiar images. Photorealism is also in part a reaction to the expressionistic and abstract movements of the twentieth century. That is, Photorealism permits artists to do something very new to the eye even while they are doing something very old.

20-17 AUDREY FLACK.
World War II (Vanitas)
(1976–1977).
Oil over acrylic on canvas.
96″ × 96″.

Photograph courtesy of the
Louis K. Meisel Gallery, New York.
Incorporating a portion of Margaret
Bourke White's photograph
"Buchenwald, 1945."
Copyright Time, Inc.

Audrey Flack

Audrey Flack (b. 1931) was born in New York and studied at the High School of Music and Art, at Cooper Union, and at Yale University's Graduate School. During the 1950s she showed figure paintings that were largely ignored, in part because of the popularity of Abstract Expressionism, in part because women artists, in general, had not been privy to the critical attention that their male colleagues had received. Yet throughout these years she persisted in a sharply realistic, or trompe l'oeil style. Her illusionistically real canvases often result from a technique involving the projection of color slides onto her canvases, which she then sketches and paints in detail. Since the 1970s, Flack's focus has largely shifted away from the human figure to richly complex still-life arrangements.

One of Flack's best-known works from the 1970s is *World War II (Vanitas)* (Fig. 20-17), a painting that combines Margaret Bourke-White's haunting photo *The Living Dead of Buchenwald* (see Fig. 8-12) with ordinary objects that teem with life—pastries, fruit, a teacup, candle, a string of pearls. The subtitle of the work, *Vanitas,* refers to a type of still life frequently found in the sixteenth and seventeenth centuries. The content was selected specifically to encourage the viewer to meditate on death as the inescapable end to human life. Flack's items are all the more poignant in their juxtaposition because they suggest lives cut short—abruptly and drastically—by Hitler's Holocaust. The painting further functions as a memorial to those who perished at the hands of the Nazis and as a tribute to survivors. Flack is fascinated by the ways in which objects reflect light, and in this

painting and others she uses an airbrush to create a surface that imitates the textures of these objects. She layers primary colors in transparent glazes to produce the desired hues without obvious brushstrokes. The resulting palette is harsh and highly saturated, and the sense of realism stunning.

OP ART (OPTICAL PAINTING)

In Op Art, also called optical painting, the artist manipulates light or color fields, or repeats patterns of line, in order to produce visual illusions. The effects can sometimes

20-18 RICHARD ANUSZKIEWICZ.
Entrance to Green (1970).
Acrylic on canvas. 9′ × 6′.
Private collection. Copyright Richard Anuszkiewicz / Licensed by VAGA, New York.

be disorienting. Hungarian-born Victor Vasarely (1908–1997) may be the best-known Op artist. In many paintings of recent decades, Vasarely has experimented with the illusion of three dimensions in two-dimensional space through the use of linear perspective and atmospheric effects (see Fig. 2-44).

Richard Anuszkiewicz

Entrance to Green (Fig. 20-18), a composition by Richard Anuszkiewicz (b. 1930), is a fine example of the sense of movement that can be achieved in Op Art. Finely drawn rectangles that decrease in size as we move from the outer edges of the canvas to its center create the optical illusion of openings that recede into space. This recession, however, is balanced by the use of warm and cool colors that typically have their own tendency to advance or recede. Thus, the warm yellow and orange of the center rectangles push forward, while the greens and blues fade into the background. The resultant tension creates a vibrating effect. We read foreground as background, and vice versa.

NEW IMAGE PAINTING

The decade of the 1970s witnessed a strong presence of realism in the visual arts that was, in part, a virulent reaction against the introspective and subjective abstract tendencies that had gripped American painting since World War II.

Toward the end of that decade—in 1978—New York's Whitney Museum of American Art mounted a controversial, though significant exhibition called "New Image Painting." The participants, including Jennifer Bartlett (b. 1941), Susan Rothenberg (b. 1945), and eight other artists, were doing something very different. They were, in their own way, reconciling the disparate styles of abstraction and representation. The image was central to their compositions, much in the tradition of Realist artists. The images were often so simplified, however, that they conveyed the grandeur of abstract shapes. These images never dominated other aesthetic components of the work, such as color, texture, or even composition. Rather, they cohabited the work in elegant balance.

20-19 JENNIFER BARTLETT.
Spiral: An Ordinary Evening in New Haven (1989).
Painting: oil on canvas, 108″ × 192″; tables: painted
wood, 30½″ × 32″ × 35″; painted wood with steel base,
39½″ × 41″ × 35″; cones: welded steel,
20″ × 30¼″ × 21″.
Courtesy of the artist.

20-20 SUSAN ROTHENBERG.
Diagonal (1975).
Acrylic and tempera on canvas.
40″ × 60″.
Private collection. Courtesy Sperone Westwater,
New York. Copyright Susan Rothenberg/Artists
Rights Society (ARS), New York.

Jennifer Bartlett

Jennifer Bartlett's *Spiral: An Ordinary Evening in New Haven* (Fig. 20-19) combines a painted canvas and several sculptural objects in a virtual maelstrom of imagery that is alternately engulfed by flames and apparently spewed out by the turbulent blaze. In this work, Bartlett includes figurative imagery and explores the use of line and color. The title and the work itself invite the viewer's speculation as to exactly what has happened to cause the conflagration and how it can possibly represent an "ordinary evening" anywhere. This sort of interplay between the verbal and the visual is another hallmark of **New Image painting.** Bartlett combines narrative, conceptual art, representation, and some abstract process painting of the sort we find in Abstract Expressionism.

Susan Rothenberg

Susan Rothenberg's *Diagonal* (Fig. 20-20) also stands as an example of New Image painting in bringing together representational and abstract art. The highly simplified and sketchy contours of a horse in full gallop barely separate the animal from the lushly painted field. Although the subject is strong and inescapable, its reality is diminished by the unified palette, the bisecting diagonal line, and the structured composition with its repetitive triangles. Rothenberg favored the horse as image in the 1970s, although in the 1980s she turned to the human form. The artist has said of her earlier compositions, "The horse was a way of not doing people, yet it was a symbol of people, a self-portrait, really."[9]

PATTERN PAINTING

Though painted at the same time, it would seem that no two works could be more drastically at odds with one another than Rothenberg's epitome of the "new image" aesthetic and Kim MacConnel's (b. 1946) riotous **pattern painting.** The stylistic and pictorial heritages of these artists are completely different. Whereas Rothenberg's originality lies in her ability to work within and expand the possibilities of representational and abstract constructs, MacConnel allowed his early experiments with rigid geometric forms to be subsumed by a vast and more lively array of evocative signs,

20-21 KIM MACCONNEL.
Le Tour (1979).
Acrylic silkscreen on fabric. 86½″ × 87½″.
Collection of Anita Grossman. Courtesy of the Artist and Holly Solomon Gallery.

symbols, and patterns. What had heretofore been a term of degradation in the arts—"decorative"—became the cornerstone of his compositions. *Le Tour* (Fig. 20-21) is composed of patterned strips that are silkscreened onto fabric and stitched together. A remarkable balance and contradictory reserve are achieved through the juxtaposition of simple and complex patterns and the almost architectural placement of the vertical panels. MacConnel's art form attacks all conventions, from the banality of decoration to the materials and methods associated with women's artistic endeavors.

THE SHAPED CANVAS

The art of the 1980s was nothing if not pluralistic. Painters of extraordinary talent and innovation affirmed their love of the medium and put an end to the speculation of the late 1960s and 1970s that "painting was dead." Many artists, including Frank Stella, Judy Pfaff, and Elizabeth Murray, have obscured the lines between painting, sculpture, and installations by radically changing the shapes of their canvases.

[9] Susan Rothenberg, in Grace Glueck, "Susan Rothenberg: New Outlook for a Visionary Artist," *The New York Times Magazine,* July 22, 1984, 20.

20-22 ELIZABETH MURRAY.
Sail Baby (1983).
Oil on canvas. 126″ × 135″.
Collection of the Walker Art Center, Minneapolis.
Walker Special Purchase Fund, 1984.

Elizabeth Murray

In Elizabeth Murray (b. 1940) we find a painter who has affirmed a belief in abstraction as a viable style, in the midst of trends that find it sterile and unreachable. Coupling clear-cut, abstract shapes that nonetheless are suggestive of organic forms, or taking specific objects—such as a teacup or a table—and treating them as isolated abstract shapes, Murray has created an art form that is personal and reachable in spite of its emphasis on formal concerns. *Sail Baby* (Fig. 20-22) is a huge work composed of three shaped canvases. Although the somewhat repetitive shapes have strong, separate identities because of their prominent contours, the entire work is unified by the painting of a teacup that traverses all three supports. Beyond the common imagery, Murray has explained that the painting functions as a narrative: "[It is] about my family. It's about myself and my brother and my sister, and I think, it is also about my own three children, even though Daisy (her youngest daughter) wasn't born yet."[10] The individual identities of the separate shapes

[10]*Elizabeth Murray: Paintings and Drawings,* exhibition catalogue organized by Sue Graze and Kathy Halbreich, essay by Roberta Smith (New York: Abrams, in association with the Dallas Museum of Art and the MIT Committee on the Visual Arts, 1987), 64.

may, in this context, represent the individuality of the siblings, whereas their interconnectedness is established by the image that overrides them as well as the snakelike green line (an umbilical cord?) that flows from the smallest shape and wends around to the right, behind the largest. Though essentially an abstract work, its references to human experience cannot be ignored or minimized. They are essential to our comprehension of the piece.

NEO-EXPRESSIONISM

The center of the art world moved to New York in the 1940s for historical as well as artistic reasons. The first-generation Abstract Expressionists developed a style that was viewed worldwide as highly original and influential. They laid claim to the tenet that the *process* of painting was a viable alternative to subject matter. In the early 1980s, a group of artists who were born during the Abstract Expressionist era—though on other shores—wholeheartedly revived the gestural manner and experimentation with materials that the Americans had devised four decades earlier, but with an added dimension. These young German and Italian artists, who came to be called **Neo-Expressionists,** detested painting "about nothing." Born as they were during the darkest years of postwar Europe, when Germany and Italy stood utterly defeated, these artists would mature to portray the bitter ironies and angst of their generation in emotionally fraught images that are rooted in history, literature, and expressionistic art.

Anselm Kiefer

Perhaps the most remarkable of these Neo-Expressionists is Anselm Kiefer (b. 1945). Kiefer has been able to synthesize an expressionistic painterly style with strong abstract elements in a narrative form of painting that makes multivalent references to German history and culture. The casual observer cannot hope to decipher Kiefer's paintings; they are highly intellectual, obscure, and idiosyncratic. But at the same time, they are overpowering in their scale, their larger-than-life subjects, and their textural, encrusted surfaces.

Kiefer's *Dein Goldenes Haar, Margarethe* (Fig. 20-23) serves as an excellent example of the artist's formal and literary concerns. The title of the work, and others of this series, refers to a poem by Paul Celan entitled "Your Golden Hair, Margarethe," which describes the destruction of European Jewry through the images of a golden-haired German woman named Margarethe and a dark-haired Jewish woman, Shulamith. Against a pale gray blue background,

20-23 ANSELM KIEFER.
Dein Goldenes Haar, Margarethe (1981).
Mixed media on paper. 14″ × 18¾″.
Courtesy of the Marian Goodman Gallery, New York.

Kiefer uses actual straw to suggest the hair of the
German woman, contrasting it with thick black
paint that lies charred on the upper canvas, to sym-
bolize the hair of her unfortunate counterpart. Be-
tween them a German tank presides over this hu-
man destruction, isolated against a wasteland of its
own creation. Kiefer here, as often, scrawls his titles
or other words across the canvas surface, sometimes
veiling them with his textured materials. The mate-
rials function as content; they become symbols
to which we must emotionally and intellectually
respond.

Eric Fischl

A number of American painters responded to European Neo-
Expressionism with narrative works that have American refer-
ences. For example, New York painter Eric Fischl (b. 1948)
focused on middle-class life in the suburbs, including Levit-
town, Long Island. Fischl's *A Visit To / A Visit From / The Is-
land* (Fig. 20-24) shifts the locale from big-city suburbs to an

20-24 ERIC FISCHL.
A Visit To / A Visit From / The Island (1983).
Oil on canvas. Two panels; each panel: 84″ × 84″.
Collection of the Whitney Museum of American Art, New York.
Purchase, with funds from the Louis and Bessie Adler Foundation, Inc.,
Seymour M. Klein, President.

20-25 JEAN-MICHEL BASQUIAT.
Melting Point of Ice (1984).
Acrylic, oil paintstick, and silkscreen on canvas. 86″ × 68″.
The Broad Art Foundation, Santa Monica, CA. Photo: Douglas Parker Studio. Estate of Jean-Michel Basquiat. Copyright 2005 Artists Rights Society (ARS), New York/ADAGP, Paris.

island vacation setting. While his transported suburbanites blithely bob along in the turquoise waters of the Caribbean, oblivious to anything other than pleasure seeking, their counterparts—native islanders—are drowning in the surf. Fischl is underscoring the bipolar social structure we find in these vacation "paradises"—the affluent tourists versus the poverty-stricken workers. Although Fischl's style can be characterized as a lush realism, in some ways very different from that of the Europeans, he too embraces a narrative format.

Jean-Michel Basquiat

Jean-Michel Basquiat (1960–1988) was a Haitian-Hispanic artist who dropped out of school at 17, rose quickly to fame and fortune in his early twenties, and died at 27 of a drug overdose. He is now considered to have been one of the most talented artists of his generation as well as a symbolic casualty of the cycle of work, success, and burnout that characterized the 1980s in the United States.

Basquiat's origins as an artist were not propitious. The themes, symbols, and strokes for which he is known first appeared on downtown New York City walls as graffiti. With Andy Warhol as a mentor, he brought his own complex form of collage to canvas, combining photocopies, drawing, and painting in intricate and overworked layers. In virtually all of Basquiat's art there is a complex iconography at work. References to the black experience—from slavery and discrimination (Fig. 20-25) to hard-won successes of African Americans like jazz musician Charlie Parker or athlete Jesse Owens—pour across the canvases in images, symbols, and strands of text. As Fischl and other artists of his generation looked back to the Expressionism of Jackson Pollock, Basquiat sought to emphasize the process of painting while never losing focus of the essential role of narrative.

SCULPTURE

True experimentation in the medium of sculpture came with the advent of the twentieth century, and contemporary sculptors owe much to the trail-blazing predecessors who embraced unorthodox materials, techniques, and influences. Style, content, composition, materials, and from midcentury onward, *scale,* were completely up for grabs.

Sculpture at Mid-Twentieth Century

In the middle of the twentieth century, there were two major directions in sculpture: figurative and abstract. Sometimes they are divergent paths. Yet they seamlessly converge with the British artist Henry Moore, whose work encompasses both the figurative and the abstract and who, more than any other individual, epitomizes sculpture in the twentieth century.

Henry Moore

Henry Moore (1898–1986) had a long and prolific career that spanned the seven decades since the 1920s, but we introduce him at this point because, despite his productivity, his influence was not generally felt until after World War II.

In the late 1920s, Moore was intrigued by the massiveness of stone. In an early effort to be true to his material, he executed blocky reclining figures reminiscent of the Native American art of Mexico. In the 1930s, Moore turned to bronze and wood and was also influenced by Picasso. His figures became abstracted and more fluid. Voids opened up, and air and space began to flow through his works.

At mid-twentieth century, Moore's works received the attention they deserve. He continued to produce figurative works, but he also executed a series of abstract bronzes in the tradition of his early reclining figures, such as the one at Lincoln Center for the Performing Arts in New York City (Fig. 20-26). No longer as concerned about limiting the

The sensitive observer of sculpture must . . . learn to feel shape simply as shape, not as description or reminiscence. He must, for example, perceive an egg as a simple single solid shape, quite apart from its significance as food, or from the literary idea that it will become a bird.

—Henry Moore

20-26 HENRY MOORE.
Reclining Figure,
Lincoln Center (1963–1965).
Bronze. H: 16′; W: 30′.

scope of his expression because of material, he could now let his bronzes assume the massiveness of his earlier stone-work. However, his continued exploration of abstract bio-morphic shapes and his separation and opening of forms created a lyricism that was lacking in his earlier sculptures.

Contemporary Figurative Sculpture

Figurative art continues to intrigue sculptors as well as painters. Some figurative works are utterly realistic. Others are highly abstract, such as the reclining figures of Henry Moore.

George Segal

George Segal (1926–2000) was a student of Hans Hof-mann and painted until 1958. During the 1960s he achieved renown as a Pop Art sculptor. As in *Three Figures and Four Benches* (see Fig. 9-6), he cast his figures in plaster from live models and then typically surrounded them with familiar objects—Coke machines, Formica and chrome tables, porcelain sinks and copper pipes, mirrors, neon signs, telephone booths, television sets, park benches. His figures evoke a mood of isolation and detachment, surrounded as they are by ordinary symbols of their day and age.

Segal also made sensuous reliefs of women and still lifes, as in *Cézanne Still Life #5* (Fig. 20-27). The plaster

20-27 GEORGE SEGAL.
Cézanne Still Life #5 (1982).
Painted plaster, wood, and metal. 37″ × 36″ × 29″.

20-28 MARISOL.
Women and Dog (1964).
Fur, leather, plaster, synthetic polymer, and wood.
72" × 82" × 16".
Collection of the Whitney Museum of American Art, New York.
Copyright Marisol Escobar/Licensed by VAGA, New York.
Purchase, with funds from the Friends of the Whitney
Museum of American Art.

20-29 DUANE HANSON.
Tourists (1970).
Polyester resin/fiberglass. Life-size.
Courtesy of Mrs. Duane Hanson. Copyright Estate of Duane Hanson.
Licensed by VAGA, New York.

of the drapery is modeled extensively by the sculptor's fingers in these reliefs, giving large areas an almost gestural quality. In many of his later works, Segal used primary colors, eliminating the ghostlike quality of his earlier works.

Marisol

Venezuelan artist Marisol Escobar (b. 1930), known to the world as Marisol, creates figurative assemblages from plaster, wood, fabric, paint, found objects, photographs, and other sources. As in *Women and Dog* (Fig. 20-28), Marisol frequently repeats images of her own face and body in her work. She has also used these techniques to render satirical portraits of world leaders.

Duane Hanson

Duane Hanson (1925–1996) was reared on a dairy farm in Minnesota. His *Tourists* (Fig. 20-29) is characteristic of the work of a number of contemporary sculptors in that it uses synthetic substances such as liquid polyester resin to closely approximate the visual and tactile qualities of flesh. Such literal surfaces allow the artist no expression of personal signature. In the presence of a Hanson figure, or a John De Andrea nude, viewers watch for the rising and falling of the

chest. They do not wish to stare too hard or to say something careless on the off chance that the sculpture is real. There is an electricity in gallery storerooms where these sculptures coexist in waiting. One tries to decipher which ones will get up and walk away.

Duane Hanson's liberal use of off-the-rack apparel and objects such as "stylish" sunglasses, photographic paraphernalia, and shopping bags gave these figures a caustic, satirical edge. But not all of Hanson's sculptures are lighthearted. Like Warhol, Hanson also portrayed disasters, such as death scenes from the conflict in Vietnam. In his later work, the artist focused more on the psychological content of his figures, as expressed by tense postures and grimaces.

Deborah Butterfield

Montana sculptor Deborah Butterfield (b. 1949) has been interested in horses since her childhood in California. Horses, of course, are powerful creatures, and there is a history of

20-30 DEBORAH BUTTERFIELD.
Horse #6-82 (1982).
Steel, sheet aluminum, wire, and tar. 76″ × 108″ × 41″.
Dallas Museum of Art Foundation for the Arts Collection,
Edward S. Marcus Fund.

equestrian sculptures that commemorate soldiers. Such
horses are usually stallions that are vehicles of war, but Butter-
field turns to mares. In this way, like Susan Rothenberg, she
uses horses to create something of a symbolic self-portrait:

> I first used horse images as a metaphorical substitute for
> myself—it was a way of doing a self-portrait one step
> removed from the specificity of Deborah Butterfield. . . .
> The only horse sculpture I'd ever seen was very masculine. . . .
> No knight or soldier would ever be caught riding a mare
> into battle, it was just not done. . . . [What] I wanted to do
> [was] to make this small reference to the [Vietnam] war [with
> a] big sculpture that was very powerful and strong, and yet,
> very feminine and capable of procreation rather than just
> destruction.[11]

Horse #6-82 (Fig. 20-30) is constructed from
scrap metal derived from a crushed aluminum
trailer. Ribbons of shiny metal wrap surfaces splat-
tered with tar, giving form to the animal. Although
her horses are figural, Butterfield notes that their
meaning "isn't about horses at all."[12]

[11] Excerpts from Deborah Butterfield in *Deborah Butterfield*
(Winston-Salem, NC: Southeastern Center for Contemporary
Art, 1983; and Providence: Rhode Island School of Design
Museum of Art, 1981).
[12] Deborah Butterfield, in Graham W. J. Beal, "Eight
Horsepower," in *Viewpoints: Deborah Butterfield: Sculpture*
(Minneapolis: Walker Art Center, 1982).

Contemporary Abstract Sculpture

Abstract sculpture remains vital, ever varied in form and
substance. Contemporary abstract sculptures range from the
site-specific works of Smithson (see Fig. 9-19) and Christo
(see Fig. 9-23) to the mobiles of Alexander Calder (see
Fig. 2-67), the mysterious wooden walls of Louise Nevelson
(see Fig. 9-13), the machined surfaces of David Smith's
cubes (see Figs. 2-20 and 20-31), and the anti-art machines
of Jean Tinguely (Fig. 20-35).

David Smith

American artist David Smith (1906–1965) moved away
from figurative sculpture in the 1940s. His works of the
1950s were compositions of linear steel that crossed back
and forth as they swept through space.

Many sculptors of massive works create the designs but
then farm out their execution to assistants or to foundries.
Smith, however, took pride in constructing his own metal
sculptures. Even though Smith's shapes are geometrically
pure (Fig. 20-31), his loving burnishing of their highly
reflective surfaces grants them the overall gestural quality
found in Abstract Expressionist paintings.

20-31 DAVID SMITH.
Cubi Series.
Stainless steel. (Left) *Cubi XVIII* (1964), H: 9′8″,
Museum of Fine Arts, Boston. (Center) *Cubi XVII*
(1963), H: 9′, Dallas Museum of Fine Arts. (Right)
Cubi XIX (1964), H: 9′5″, Tate Gallery, London.
Copyright Estate of David Smith / Licensed by VAGA, New York.

Jackie Ferrara

Jackie Ferrara's (b. 1929) works during the 1960s employed fetishistic materials such as feathers, fur, and rope, which were often suspended from the ceiling. In the 1970s she began to deal with gravity from the other end, so to speak, and created a number of pyramidal forms set firmly on the floor. *A207 Recall* (Fig. 20-32) has something of the appearance of a Postmodern chimney and is constructed from pieces of pine that are glued together. Her concern with the interior as well as the exterior of the work is suggested by the series of patterned glimpses within that alternately complement the shape of the exterior and set it further awry. Although the wooden surface renders her work warm and the partial

revelations make it mysterious, the sculpture was created with attention to precise mathematical relationships.

Judy Pfaff

Another contemporary sculpture form is the **installation,** in which materials from planks of wood to pieces of string and metal are assembled to fit within specific room-sized exhibition spaces. Installations are not necessarily intended to be permanent. In *Dragon* (Fig. 20-33), by Judy Pfaff (b. 1946), the viewer roams around within the elements of the piece, an experience that can be pleasurable and overwhelming among the vibrant colors and assorted textures. Many of the elements of Pfaff's installations hang down around the viewer, creating an atmosphere reminiscent of foliage, sometimes of an underwater landscape.

20-32 JACKIE FERRARA.
A207 Recall (1980).
Pine. 76½″ × 37½″ × 37½″.
Courtesy of the artist.

20-33 JUDY PFAFF.
Dragon (January–April 1981).
Installation view, Whitney Biennial, The Whitney Museum of American Art, New York.
Courtesy of the Holly Solomon Gallery.

The only stable thing is movement.

—Jean Tinguely

20-34 NANCY GRAVES.
Tarot (1984).
Bronze with polychrome patina and enamel.
88″ × 49″ × 20″.

Private collection. Courtesy of M. Knoedler and Company, Inc., New York.
Copyright Nancy Graves Foundation / Licensed by VAGA, New York.

Nancy Graves

Nancy Graves (b. 1940) has worked both in figural and abstract styles and is comfortable with ignoring the traditional boundary between them. In addition to sculpture, she has also created drawings, prints, paintings, and films. When she was only 29 years old, the Whitney Museum exhibited her life-size, naturalistic camels.

Tarot (Fig. 20-34) is made of traditional bronze but is directly cast such that the original object is destroyed as it is reborn into the metal. In a sense, Graves redoes nature. Much of the innovation of the piece is derived from the jux-

tapositions and coloration. Graves has focused much of her attention on the development of polychrome (multicolored) patinas with poured acrylic and baked enamel. *Tarot* (the word refers to a set of allegorical cards used in fortune-telling) is an assemblage of sundry human-made and natural elements—strange flowers, lacy plants, noodles, dried fish, lampshades, tools and machinery, even packing materials. With this concoction—or perhaps this history—humankind is cast an eccentric fortune indeed.

Jean Tinguely

Swiss-born kinetic sculptor Jean Tinguely (1925–1991) was an able satirist of the machine age who shares the Dadaist view of art as anti-art. He is best known for his *Homage to New York* (Fig. 20-35), a motorized, mixed-media construction that self-destructed (intentionally) in the garden of the Museum of Modern Art. But an unexpected fire within the machine necessitated the intervention of the New York Fire Department, which provided a spontaneous touch without charge. Tinguely's machines, more than those on

20-35 JEAN TINGUELY.
Fragment from *Homage to New York* (1960).
Painted metal. 6′8¼″ × 29⅝″ × 7′3⅞″.

The Museum of Modern Art, New York. Gift of the artist. Digital image © The Museum of Modern Art, New York / Licensed by Scala / Art Resource, New York. Copyright 2005 Artists Rights Society (ARS), New York / ADAGP, Paris.

Delacroix's *Liberty Leading the People,* Kollwitz's *Outbreak,* Catlett's *Harriet,* and Goya's *And They Are Like Wild Beasts*

The evolution of feminist art finds its parallel in the evolution of feminist art history. The dust jacket of a text entitled *Women, Art, and Power and Other Essays* by the nineteenth-century-art scholar Linda Nochlin, bears a detail of Eugene Delacroix's *Liberty Leading the People* (Fig. 20-36). At its center is the allegory of Liberty—a fast-striding woman bearing the tricolor in one hand and a bayonet in the other—looking, for all the world, like an Amazon of ancient Greece. An archetypal figure set within an archetypal setting of an archetypal revolution. So, where's the rub?

Nochlin, who also explored the uncharted territory of feminist issues in art history and criticism, notes in her text: "Delacroix's powerful figure of Liberty is, like almost all feminine embodiments of human virtue—Justice, Truth, Temperance, Victory—an allegory rather than a concrete historical woman, an example of what Simone de Beauvoir (French existential philosopher and author of *The Second Sex*) has called Woman-as-Other." By contrast, the forceful figure who inspires courage and motivates action in Kollwitz's *The Outbreak* (Fig. 20-37) is a historically documented leader of the sixteenth-century German Peasants' War. She was known as Black Anna. Delacroix's Liberty does not portray the role of women in the French Revolution but rather embodies the intangible spirit that fueled the burning desire for freedom. Kollwitz's Anna is at the front. It is through her example—her indomitable spirit at the cost of her own life—that we experience, firsthand, the quest for justice.

A striking visual parallel can be seen in Elizabeth Catlett's *Harriet* (Fig. 20-38), a linoleum block print that records the actions of Harriet Tubman, one of the "conductors" of the Underground Railroad, who led more than 300 slaves to

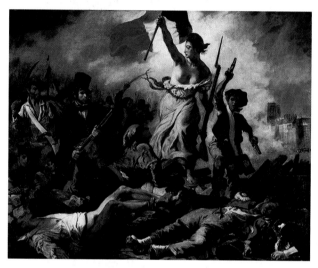

20-36　EUGÈNE DELACROIX.
Liberty Leading the People (1830).
Oil on canvas. 8'6" × 10'10".
Louvre Museum, Paris / Erich Lessing / Art Resource, New York.

20-37　KÄTHE KOLLWITZ.
The Outbreak (1903).
Plate #5 from *The Peasants' War.* Etching and aquatint.
Library of Congress, Washington, DC. Courtesy of The Library of Congress, Washington, DC. Copyright 2003 Artists Rights Society (ARS), New York / VG Bild-Kunst, Bonn.

20-38 ELIZABETH CATLETT.
Harriet (1975).
Linoleum block print. 12½″ × 10⅛″.

freedom. Like Kollwitz's Anna, Harriet is a historic figure who loomed larger than life and is so depicted through her relative size.

The Spanish artist Francisco Goya also turned his attention to the subject of women and aggression (Fig. 20-39) in one of a suite of prints entitled *Disasters of War*. At first glance we observe a group of women, one with an infant astride her hip, defending themselves with rocks and sticks against the swords and guns of male soldiers. Theirs is a valiant effort, inspired by raw courage and maternal instinct. And yet, if we make note of the title of the work, we come to understand that Goya equates this desperate attempt to protect themselves and their children with the animal instincts of "wild beasts."

In all four works, we witness the images of women astride or in the midst of chaos and destruction. How does each artist use vantage point in the composition (frontal, profile, rear) to involve the observer in the action of the scene? What is our relationship to the female figures, and indeed to the action as a whole, in each of these works? Are we observers? participants? Stylistically, how does each artist use the medium to enhance the subject of the work? How do the use of perspective and compositional arrangement intensify the narrative? Can you speculate as to the gender ideologies reflected in or reaffirmed by the artists of each of these compositions? ■

20-39 FRANCISCO GOYA Y LUCIENTES.
And They Are Like Wild Beasts (Y son Fieras).
From *Disasters of War* (1808–1820).
Etching and aquatint. 15.5 cm × 20.1 cm.

20-40 JACKIE WINSOR.
Exploded Piece (before and after) (1980–1982).
Wood, reinforced concrete, plaster, gold leaf, and explosive residue. 34½″ × 34½″ × 34½″.
Private collection. Photos courtesy of Paula Cooper Gallery, New York.

which his work comments, frequently fail to perform precisely as intended.

As a further reflection of his philosophy of art, in the 1950s Tinguely introduced kinetic sculptures that served as "painting machines." One of them produced thousands of "Abstract Expressionist" paintings—on whose quality, perhaps, we need not comment.

Jackie Winsor

Canadian-born Jackie Winsor (b. 1941), like many of her contemporaries, is taken with the primal aesthetics of simple geometric forms. Yet unlike the machined smoothness employed by David Smith, her works are more likely to have a weathered organic, handmade look. Winsor's works are a while in the making, and though she has the resources to have others construct them from her design, hers is an art of the hand as well as of the heart and the mind.

Exploded Piece (Fig. 20-40) is one of the sculptures that Winsor also sees as a performance piece. Winsor is not destructive in the mold of Tinguely. (In fact, the culmination of the "performance" was her reconstruction of the exploded parts into a perfect whole.) Rather, she seems preoccupied with the nature and the potentials of her materials. Another

work, *Burnt Piece,* seemed to pose and answer the question, "What will happen to a half-concrete, half-wood cube when it is set afire?" *Exploded Piece,* similarly, explores the results of detonating an explosive charge within a cube made of wood, reinforced concrete, and other materials.

It seems appropriate to leave the section on abstract sculpture with a bang.

FEMINIST ART

If it were customary to send little girls to school and to teach them the same subjects as are taught to boys, they would learn just as fully and would understand the subtleties of all arts and sciences.

—Christine de Pisan, *Cité des Dames,* 1405

While on the East Coast Pop Art was on the wane and Photorealism on the rise, happenings on the West Coast were about to change the course of women's art, history, and criticism forever. In 1970, a midwestern artist named Judy Gerowitz (b. 1939)—who would soon call herself Judy Chicago—initiated a feminist studio art course at Fresno State

College in northern California. One year later, she collaborated with artist Miriam Schapiro (b. 1923) on a feminist art program at the California Institute of Arts in Valencia. Their interests and efforts culminated in another California project—a communal installation in Hollywood called *Womanhouse*.

What was *Womanhouse*? Beyond being a milestone in the history of women's art, it was a fantastic undertaking, a daring project. Teaming up with students from the University of California, Chicago and Schapiro took over a dilapidated mansion and refurbished each room in a theme built around women's experiences: The "Kitchen," by Robin Weltsch, was covered from walls to ceiling with breast-shaped eggs; a "Menstruation Bathroom," by Chicago, included the waste products of female menstruation cycles in a sterile white environment.

Miriam Schapiro and Sherry Brody

Another room in *Womanhouse* housed a child-sized dollhouse, in which Schapiro and Sherry Brody juxtaposed mundane and frightening objects to effect a kind of black humor (Fig. 20-41). The now-famous installation became a much-needed hub for area women's groups and was itself the impetus for the founding a year later of the Los Angeles Women's Building, still active today.

Why was *Womanhouse* important? The reasons are as varied as they are numerous. At the very least, it called attention to women artists, their wants, their needs. It some ways it was an expression of anger toward injustice of art-world politics that many women artists experienced—lack of attention by critics, curators, and historians; pressure to work in canonical styles. It announced to the world, through shock and exaggeration, that men's subjects are not necessarily of interest to women; that women's experiences, although not heroic, are significant. And perhaps of most importance, particularly in light of the subsequent careers of its participants, the exhibition exalted women's ways of working.

We have already seen a number of works by women that might be considered feminist (see Jenny Holzer's *Untitled* from *Inflammatory Essays*, Fig. 1-16; Laurie Simmons's *Red Library #2*, Fig. 1-20; Suzanne Lacy and Leslie

20-41 MIRIAM SCHAPIRO, in collaboration with SHERRY BRODY.
The Doll House (1972).
Mixed media. 84" × 40" × 41".
Collection of the artist. The Smithsonian Institution, Washington, DC / Art Resource / New York.

Labowitz's *In Mourning and in Rage*, Fig. 1-29; Barbara Kruger's *Untitled (We Don't Need Another Hero)*, Fig. 4-15); that highlight women's accomplishments (Judy Chicago's *The Dinner Party*, Fig. 1-10); or that assimilate traditional women's craft (Miriam Schapiro's *Wonderland*, Fig. 1-31; Faith Ringgold's *Tar Beach*, Fig. 1-24). In this section we shall examine a number of other works by women artists.

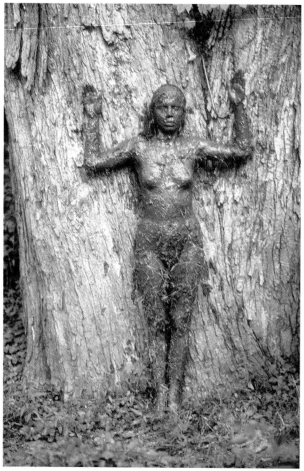

20-42 ANA MENDIETA.
Arbol de la Vida, no. 294, from the *Arbol de la Vida /
Silueta* (Tree of Life / Silhouette) series (1977).
Color photograph. 20″ × 13¼″.
Documentation of earth–body sculpture with artist, tree
trunk, and mud, at Old Man's Creek, Iowa City, IA.

20-43 BARBARA KRUGER
We Won't Play Nature to Your Culture (1983).

They, too, have been chosen because they make sharp femi-
nist statements, speak directly to women's experiences, or
raise to the level of fine art materials and methods that have
been employed by women for centuries.

Ana Mendieta

Much of the impact of *Arbol de la Vida* (Tree of Life), no.
294 (Fig. 20-42), is related to the shock value of its extraor-
dinary contrasts of texture. In this performance piece, femi-
nist artist Ana Mendieta (1948–1985) presented her own
body, draped in mud (an "earth–body sculpture"), against
the craggy bark of a tree. Like some women artists, she

shunned painting, especially abstract painting, as historically
inundated with male values. Mendieta tied her flesh and
blood, instead, across time and cultures, to the ancient
myths of the earth mother goddesses.

Barbara Kruger

Many women artists have tried to call attention to stereo-
types that influence the way women are perceived. Laurie
Simmons's "Stepford Wife" in her *Red Library* shows a
woman locked into the compulsive care of her home, to the
exclusion of more worthwhile and rewarding activity. Bar-
bara Kruger (b. 1945), in *Untitled (We Don't Need Another*

Hero), confronts her male and female viewers with stereo-typical epithets for the "dominant sex," seeming to criticize females for feeding male expectations as much as males for having them.

Kruger's juxtaposition of images and text, tabloid-like in their visual attraction, cause the viewer to reconsider the ideological hold that words and pictures and familiar phrases have on us. *We Won't Play Nature to Your Culture* (Fig. 20-43) forces us to define those words and to come to terms with the way that women have been relegated to "na-ture" (motherhood, domesticity, the literal or figurative sequestering in the home) while men have had the privilege of participating in "culture" (the world of ideas, of thinking, talking, sharing, and acting). As in many of Kruger's works, her medium is the message—a call to action.

Joan Snyder

The work of women artists can be fiercely angry, as is Jenny Holzer's *Inflammatory Essays.* It can also be uplifting and celebratory, as is Schapiro's *Wonderland,* a work of so-called femmage, which interweaves memorabilia specific to women's experiences with stitching and quilting techniques that are a part of women's collective traditions. It can also draw attention to women's accomplishments, as in Chicago's *The Dinner Party* or Joan Snyder's *Small Symphony for Women #1* (Fig. 20-44). From the early 1970s onward, Sny-der focused on women's issues in her work, unifying her nar-rative content with lush brushwork and an often dramatic palette. *Small Symphony* is broken into three sections, or

variations on a theme. The first square presents, according to Snyder, "political ideas, dreams, colors, materials, angers, rage" that are written, scratched out, or emphatically boxed. The center square offers a kind of directory of Snyder's sig-nature images, words and brushstrokes; the third is a resolu-tion or consolidation of the other two sections. The paint-ing, three times as long as it is high, reads from left to right like a codified narrative. It is at once unique and universal, telling something of woman's plight as well as Snyder's pri-vate view of the world

DECONSTRUCTIVIST ARCHITECTURE

What we have known as modern architecture is no longer "modern," at least not in the sense of relating to the *present.* It's not even Postmodern, if we want to pigeonhole style. As we move forward in the third millennium, the world of ar-chitecture seems completely enmeshed in a movement called *Deconstructivism.*

The Deconstructivist movement originated in the 1960s with the ideas of the French philosopher Jacques Derrida. He argued, in part, that literary texts can be read in different ways and that it is absurd to believe that there can be only one proper interpretation. Similarly, in Deconstruc-tivist architectural design, the whole is less important than the parts. In fact, buildings are meant to be seen in bits and

20-44 JOAN SNYDER.
Small Symphony for Women #1 (1974).
Oil and acrylic on canvas. Three parts: each 24″ × 24″; 24″ × 72″ overall.
Collection Suellen Snyder. Courtesy of the artist.

Guerrilla Girl Warfare

THE ADVANTAGES OF BEING A WOMAN ARTIST:

Working without the pressure of success.
Not having to be in shows with men.
Having an escape from the art world in your 4 free-lance jobs.
Knowing your career might pick up after you're eighty.
Being reassured that whatever kind of art you make it will be labeled feminine.
Not being stuck in a tenured teaching position.
Seeing your ideas live on in the work of others.
Having the opportunity to choose between career and motherhood.
Not having to choke on those big cigars or paint in Italian suits.
Having more time to work after your mate dumps you for someone younger.
Being included in revised versions of art history.
Not having to undergo the embarrassment of being called a genius.
Getting your picture in the art magazines wearing a gorilla suit.

Please send $ and comments to:
Box 1056 Cooper Sta. NY, NY 10276 **GUERRILLA GIRLS** CONSCIENCE OF THE ART WORLD

WHEN RACISM & SEXISM ARE NO LONGER FASHIONABLE, WHAT WILL YOUR ART COLLECTION BE WORTH?

The art market won't bestow mega-buck prices on the work of a few white males forever. For the 17.7 million you just spent on a single Jasper Johns painting, you could have bought at least one work by all of these women and artists of color:

Bernice Abbott	Elaine de Kooning	Dorothea Lange	Sarah Peale
Anni Albers	Lavinia Fontana	Marie Laurencin	Ljubova Popova
Sofonisba Anguisolla	Meta Warwick Fuller	Edmonia Lewis	Olga Rosanova
Diane Arbus	Artemisia Gentileschi	Judith Leyster	Nellie Mae Rowe
Vanessa Bell	Marguérite Gérard	Barbara Longhi	Rachel Ruysch
Isabel Bishop	Natalia Goncharova	Dora Maar	Kay Sage
Rosa Bonheur	Kate Greenaway	Lee Miller	Augusta Savage
Elizabeth Bougereau	Barbara Hepworth	Lisette Model	Vavara Stepanova
Margaret Bourke-White	Eva Hesse	Paula Modersohn-Becker	Florine Stettheimer
Romaine Brooks	Hannah Hoch	Tina Modotti	Sophie Taeuber-Arp
Julia Margaret Cameron	Anna Huntingdon	Berthe Morisot	Alma Thomas
Emily Carr	May Howard Jackson	Grandma Moses	Marietta Robusti Tintoretto
Rosalba Carriera	Frida Kahlo	Gabriele Münter	Suzanne Valadon
Mary Cassatt	Angelica Kauffmann	Alice Neel	Remedios Varo
Constance Marie Charpentier	Hilma af Klimt	Louise Nevelson	Elizabeth Vigée Le Brun
Imogen Cunningham	Kathe Kollwitz	Georgia O'Keeffe	Laura Wheeling Waring
Sonia Delaunay	Lee Krasner	Meret Oppenheim	

Information courtesy of Christie's, Sotheby's, Mayer's International Auction Records and Leonard's Annual Price Index of Auctions

Please send $ and comments to:
Box 1056 Cooper Sta. NY, NY 10276 **GUERRILLA GIRLS** CONSCIENCE OF THE ART WORLD

20-45 Guerrilla Girls (c. 1987).
Poster.
Guerrilla Girls, 13-40-88-438.

During the 1980s something of a backlash against inclusion of women and ethnic minorities in the arts could be observed.* For example, a 1981 London exhibition, *The New Spirit in Painting,* included no women artists. A 1982 Berlin exhibition, *Zeitgeist,* represented 40 artists, but only 1 was a woman. The 1984 inaugural exhibition of the Museum of Modern Art's remodeled galleries, *An International Survey of Recent Painting and Sculpture,* showed the works of 165 artists, only 14 of whom were women. The New York exhibition *The Expressionist Image: American Art from Pollock to Now* included the works of 24 artists, only 2 of whom were women. And so it goes.

To combat this disturbing trend, an anonymous group of women artists banded together as the Guerrilla Girls. The group appeared in public with gorilla masks and proclaimed themselves to be the "conscience of the art world." They mounted posters on buildings in Manhattan's SoHo district, one of the most active centers in the art world today. They took out ads of protest.

Figure 20-45 shows one of the Guerrilla Girls' posters. This particular poster sardonically notes the "advantages" of being a woman artist in an art world that, despite the "liberating" trends of the postfeminist era, continues to be dominated by men. It also calls attention to the blatant injustice of the relative price tags on works by women and men. Note that at this writing, the inequity persists. A 1993 cover story for the *New York Times Magazine* pictures the "art world all-stars" of dealer Arnold Glimcher (Fig. 20-46). Women artists and artists of color are conspicuous by their absence. ■

*Whitney Chadwick, *Women, Art, and Society* (London and New York: Thames and Hudson, 1990).

20-46 Arnold Glimcher and His Art World All-Stars.
Used on the cover of *New York Times Magazine* (October 3, 1993).
© NYTPictures

pieces. The familiar elements of traditional architecture are taken apart, discarded, or disguised so that what remains seems randomly assembled.

Deconstructivist architects deny the modern maxim that form should follow function. Instead, they tend to reduce their structures to purer geometric forms made possible by contemporary materials, and they make liberal use of color to express emotion. An early (1988) exhibition of Deconstructivist works at the Museum of Modern Art connected Deconstructivist architecture with Cubism and with the Constructivist Russian painting and sculpture of the 1920s (see Naum Gabo's *Column,* Fig. 19-17). American architect Philip Johnson contributed to that exhibition at the age of 82, and he was the only architect of note to have been a driving force in the Modern, Postmodern, and Deconstructivist movements.

We have already viewed one Deconstructivist work: Frank Gehry's Guggenheim Museum in Bilbao, Spain (see Fig. 2-21). Walls go off in their own directions; forms collide in an irregular manner. The overall composition might have been shaped differently, as it was in developmental drawings and models, but when all was said and done, Gehry brought it together as it exists today. There are no pediments or architraves in this museum, no steel cages, no industrial anonymity, no Chippendale motifs. And there is no overriding sense of a whole. Shapes, textures, and colors seem to exist purely for their own sake, the uniqueness of their "personalities" to be savored by the viewer.

You will find that most architecture going up around you is *not* Deconstructivist. Most new office buildings are variations on Modern and Postmodern themes. Most residential and civic architecture in the United States is traditional. Architectural clients typically want familiar-looking buildings, and most architects are in business to supply them. It is the exception to the rule that surprises and titillates.

Frank Gehry

The Guggenheim Museums have always been on the cutting edge of design, beginning with Frank Lloyd Wright's unique spiral-shaped monument on New York City's Fifth Avenue across from Central Park (see ArtTour™ New York in Chapter 9). Frank Gehry designed the no-less-remarkable Guggenheim Museum Bilbao, which brings many thousands of tourists to that industrial Spanish city each year. Gehry is now poised to launch designs for an ambitious project in Brooklyn, New York—one that will not only bring a major sports stadium to the city borough but also transform its skyline along with the quality of neighborhood life. Gehry's preliminary designs are a hodgepodge of shapes and surfaces and sizes (Fig. 20-47) leading, in his mind, to the sense that

20-47 FRANK GEHRY. Brooklyn Arena Plan (2005).

Gehry Partners LLP.

The void is one of the organizing features of the building. . . . It is the cut through German history, Jewish history. It is the extermination of Jews and the deportation of Jews not only from this city but from Germany and from Europe.

—Daniel Libeskind

the completed whole will seem more like an "organic city, and less like a single-vision project." He further asserted this Deconstructivist aesthetic in saying, "By breaking it down and making it look like a city it has a sense of belonging and a sense of choice. You're not saying everybody's got to live in the same thing."

The Brooklyn plan will be home to a new arena for the New York Nets basketball team, the center point around which everything pivots, everything congregates. Seventeen buildings in all, some topping out at 50 or 60 stories, the megalopolis will include skyscrapers and towers, commercial and residential spaces, gardens, walkways, and a reflecting pool–turned–skating rink in winter. The project is estimated at $3.5 billion and has been dubbed the largest construction undertaking outside Manhattan in decades.

20-48 DANIEL LIBESKIND.
Extension of the Berlin Museum (1989–1996).
Copyright Studio Daniel Libeskind.

Daniel Libeskind

Although Daniel Libeskind (who, as we saw in Chapter 10, obtained the commission to rebuild the World Trade Center site only to see his vision fall before the special interests of committees) seems to have taken Deconstructivism as a point of departure in his design for the Jewish Museum Department of the Berlin Museum (Fig. 20-48), he invested its parts with profound symbolism. The addition is intended to

> communicate the vastness and also the legacy of things that are not completely visible. Contrary to public opinion the flesh of architecture is not cladding, insulation and structure, but the substance of the individual in society and history; a figuration of the inorganic, the body and the soul.

The zigzag, or lightning-bolt shape of the building, resembles a broken Star of David. It was derived mathematically by plotting the Berlin addresses of Jewish writers, artists, and composers who were killed during the Holocaust. The overall design is punctuated by voids that symbolize the absence of Jewish people and culture in Berlin.

The zinc exterior of the museum is slashed by a linear pattern of windows that was determined by connecting the addresses of German and Jewish Berliners on a map of the museum's neighborhood. The visitor cannot help being struck by the overwhelming sense that every structural, design, and symbolic element—each of which attracts and holds interest—has been informed by the historic circumstances that gave rise to the building.

Rem Koolhaas

Herbert Muschamp, the architectural critic for the *New York Times* said in his article on the Central Library (Fig. 20-49) in Seattle, Washington, that "there's never been a great building without a strong client in the history of the world, and Ms. [Deborah L.] Jacobs [Seattle's city librarian] is now up there with popes and princes as an instigator of fabulous cities." The accolades for the design of this extraordinary building go to Dutch architect Rem Koolhaas, but the laurels for making it happen go to Ms. Jacobs.

Koolhaas's name has become synonymous with Deconstructivist architecture. The library's exterior is faceted into folded planes of glass and steel supported by a diagonal grid of light blue metal. True to this aesthetic, the angles and shapes seem almost arbitrary, and the essential structure of the building is hard to decipher from the outside looking in. But within the building, Koolhaas's love of distinct parts and his tendency to subvert their traditional placement can be seen everywhere—from the bright red grand staircase and spiral ramp of book stacks to the "Mixing Chamber" at the heart of the building where librarians greet and help readers. Muschamp sees the Central Library as "a series of episodes in urban space." He also sees it as "where architecture is going."

20-49 REM KOOLHAAS.
Central Library, Seattle (2004).
© Lara Swimmer/ESTO.

Santiago Calatrava

In the meantime, Spaniard Santiago Calatrava's architecture seems to be going up everywhere: a symphony center in Atlanta; a total of 30 bridges including 3 that will span the Trinity River in Dallas; a $2 billion transportation hub for Ground Zero (the World Trade Center site); and a residential tower composed of 12 cubes cantilevered from a concrete core overlooking the East River in New York City (Fig. 20-50). *Time* magazine named him one of the 100 most influential people of 2005, and the American Institute of Architects awarded him their coveted gold medal in the same year.

The inspiration for the tower came from a series of cubed sculptures made by Calatrava decades ago. He has said that he considers architecture "the greatest of all arts" because it embraces all of the others, including music, painting, and sculpture. Calatrava believes that he "couldn't be an architect without doing those things." Indeed, his cross-disciplinary focus has yielded designs that seem sculptural, even painterly at times. His client for the transportation station called him "the da Vinci of our time . . . [an artist who] combined light and air and structural elegance with strength."

20-50 SANTIAGO CALATRAVA.
Residential Tower on South Street, New York.
Santiago Calatrava, S.A./© David Sundberg/ESTO.

A PORTFOLIO OF ART IN THE NEW MILLENNIUM

We have traveled thousands of years together, observing the ebb and flow of style in architecture and art. Where are we going? What is new? Can we label the trends?

We can make some generalizations, but the specifics are countless. The inclination to question the nature of art—mentioned at the outset of the chapter—remains central. You will have no trouble recognizing much of the art on the following pages as *art,* but the performances of Vanessa Beecroft and William Pope.L may leave you puzzled. The integration of audio and visual mediums—film and electronic—is firmly in place, as you will see in the works of Matthew Barney, Shirin Neshat, and Lorna Simpson. Software and microchips are a new set of artist tools, as we see in Ken Feingold's talking heads. Installations maintain their popularity and, in fact, enhance the opportunities for interactivity between the work and the spectator. Although new media appear to be taking center stage, painting seems to be reasserting itself with the help of influential collectors.

As your experience with art continues and grows, you will encounter artists who use pastels and paint, marble and bronze alongside those using video and film, their own bodies and those of others. You will see things that today you cannot even imagine.

Here, then, is a portfolio of art as we enter the new millennium. It represents the tip of the iceberg when it comes to the things that are happening in the art world today.

Matthew Barney

Stephen Holden, the *New York Times* film critic, considers Matthew Barney (b. 1967) to be "the most important American artist of his generation." Contemporary artists continue to challenge the use of traditional media, and Barney is no exception, having sculpted dumbbells of tapioca pudding and an exercise bench of petroleum jelly. But Barney is best known for his *Cremaster* series of five films. The characters in the films include androgynous nymphs, satyrs, and other legendary figures who are, or are not, what they seem to be. The narratives, enhanced with eclectic sound tracks, circle around various ritual masculine athletic challenges and a good deal of symbolic pagan pageantry. Much of *Cremaster 2* takes place in the wide-open spaces of the "Wild West," accompanied by folk songs, the Mormon Tabernacle Choir, and other music. One scene transports the viewer to the 1893 Columbia International Exhibition in which the novelist Norman Mailer imperson-

ates the escape artist Harry Houdini (Fig. 20-51), standing next to the artist in the guise of a bizarrely attired Gary Gilmore. Mailer's book *The Executioner's Song* was about convicted murderer Gary Gilmore, who was executed by a firing squad in 1977. Gilmore, unlike Houdini, did not escape.

Vanessa Beecroft

Performance is alive and well in the new millennium, taking on any number of shapes and forms. Italian-born Vanessa Beecroft (b. 1969), who lives and works in the United

20-51 MATTHEW BARNEY.
Cremaster 2 (1999), from the *Cremaster* film series (1994–2002).
Silkscreened digital videodisc, tooled saddle leather, sterling silver, beeswax, polycarbonate honeycomb, acrylic, and nylon vitrine, with 35 mm print; digital video transferred to film with audio, 1:19:00, vitrine: 38⅜″ × 40″ × 46⅝″. Edition 8/10.
Copyright 1999 Matthew Barney. Courtesy of the Gagosian Gallery, New York. Photo by Michael James O'Brien. Courtesy, Barbara Gladstone.

States, has staged numerous performances of nearly nude women in museums and galleries the world over. The women have included models, actresses, and individuals encountered by the artist in chance meetings. The women have been variously clad—string bikinis, strappy high-heel shoes and khaki uniform caps, cowboy hats and pantyhose. In one piece, completely nude women whose heads were covered with smooth, oval, flesh-covered masks, pranced around a gallery installation amidst ordinary spectators. They sat, stood motionless, and every so often moved ever so slightly, oddly reminiscent of the poseable wooden models used in drawing studios. Figure 20-52 is a close-up photograph of one of the women in *VB43* (signifying Vanessa Beecroft's forty-third performance), held at London's Gagosian Gallery for one evening on May 9, 2000. Critics noted that although the art world is quite familiar with the subject of the female nude, the presentation of multiple nudes doing nothing more than simultaneously occupying space in a gallery is an experience that compels viewers to reconsider the mutual roles of nude subject and clothed spectator. The viewers are forced into the position of voyeur, never fully comfortable, and like the performers, never fully sure of what they should be doing or how they should be reacting. The women do not talk. They do not

20-53 KEN FEINGOLD.
If / Then (2001).
Silicone, pigment, fiberglass, steel, and electronics.
24″ × 28″ × 24″.
Courtesy of the artist. Courtesy, Postmasters Gallery, New York.

interact with gallerygoers. They exist in space as "living sculptures," or, as some have described them, "portraits in three dimensions."

Ken Feingold

Multimedia works employing computerized systems have become familiar artistic fare in the new millennium. Ken Feingold's (b. 1952) *If / Then* (Fig. 20-53), exhibited in the Whitney Biennial 2002, is composed of what have become the artist's signature puppets, robots, and talking heads. Two disembodied, mannequin-like heads constructed of silicone, fiberglass, and steel are nestled in a Styrofoam-filled carton in such a position as to facilitate dialogue between the two. And converse they do—to the tune of some 50,000 "thought units" available to them through their custom software. The title of the piece, *If / Then,* reflects the basis of deductive logic, in which a conclusion is derived from a premise. Yet the logic of the thought units occurs in a human vacuum. The heads seem to be unaware of their humble origins and unaware of their complete ensnarement.

20-52 VANESSA BEECROFT.
VB43 (2000).
Digital c-print. 75″ × 52″.
Courtesy of the Gagosian Gallery, New York.

Jacques-Louis David on a Brooklyn Tennis Court

Jacques Louis David's *Intervention of the Sabine Women* (Fig. 20-54), in all of its Classical idealization, patriotism, and heroism, hangs among other prized examples of Neoclassicism in a quiet, stately gallery in the Louvre Museum in Paris. But on a raw, wintery day in 2005, the myth that gave birth to one of David's most symbolic works was revisited—reenacted—on a tennis court in Brooklyn, New York. Video artist Eve Sussman was once again exploring the "pictorial evolution of a masterpiece." In Sussman's version, the men wore suits (in David's painting, they are in their birthday suits). The women were not in chic retro Roman attire; they wore vintage 1960s couture.

We have already studied Nicolas Poussin's *The Rape of the Sabine Women* (see Fig. 16-21), which recounts the subject of the Romans' abduction of their neighbors' (the Sabines) women for the dubious purpose of growing their city's population. David's painting is, in effect, a follow-up to the story. Three years after the attack by Romulus (Rome's founder) and his men, the Sabine men organized a counterattack to reclaim their women. When they arrive, the Sabine-turned-Roman women intervene! For the first time in David's career as a history painter, he placed a woman at the center of the action. She is Hersilia, daughter of the Sabine Tatius and wife of Romulus himself. And she's not going back. Hersilia and other now-Roman women stand between the warriors and their children and, through their gestures, appeal for a peaceful solution to the crisis. As in most examples of the Neoclassical style, there is balance between action and restraint. The flailing arms and emotional expressions of the women contrast with the firmly planted stances of the fighting men. The movement seems controlled, even frozen, in spite of the overall sense of violence and chaos.

Enter Eve Sussman. Lights . . . camera . . . smoke machine. "Just walk around," her choreographer told the actors. "O.K., now find somebody in the group and lock eyes with them, like they are a magnet pulling you together. Now lean your body against theirs." From these first, tentative movements, a full-scale battle scene ensued (Fig. 20-55). Clothes were ripped off, people bumped, grinded, and fell over one another. The women screamed, cried, and desperately

20-54 JACQUES-LOUIS DAVID. *The Intervention of the Sabine Women* (1799). Oil on canvas. 385 cm × 522 cm. Louvre Museum, Paris / RMN / Art Resource, New York.

held children up in the air. Figures moved through the mist stepping over the carnage, surveying the destruction. Cut.

The scene thus shot may or may not be used in Sussman's video–opera project, *Raptus,* a piece in progress that is based on the myth of the Sabine women (*raptus,* in ancient Rome, meant "carrying off by force" and was a crime of property theft). It follows a similar successful work based on Diego Velázquez's *Las Meninas* (see Fig. 16-15) called *89 Seconds at Alcazar* (Fig. 20-56). The video and film stills visualize imagined moments before and after the scene that Velázquez chose to represent. Sussman said of her thought process in generating the idea for *89 Seconds at Alcazar,* "[The painting] has the feeling of a snapshot . . . as if the Enfanta could walk out and come back again. And you think, if this is a film still, then there is a still that came before, and one that came after."

Unlike *89 Seconds at Alcazar,* which involved sets and elaborate costumes replicating the interior backdrop of Velázquez's famous portrait, *Raptus* is far more loosely based on the David prototype. The artist admits to making it up as she and the actors go along. Working with a loose outline rather than a complete script, the collaborators are coming up with their own version of the myth, based on interpretation, interaction, and reaction. "We know we want a fight involving the Sabine women, and other than that we don't have a clue." ∎

20-55 EVE SUSSMAN.
Footage for *Raptus* (2005).
Performance video.
Michael Nagle / The New York Times.

20-56 EVE SUSSMAN.
Screen grab from *89 Seconds at Alcázar.*
© 2004 by the artist / Whitney Museum of American Art, New York.

> *You have to think twice about everything I say, no matter whether I mean it seriously or jokingly. That is provocative.*
>
> —Sarah Lucas

20-57 SARAH LUCAS.
The Fag Show (2000).
Installation view, Sadie Coles HQ, London.
Copyright Sarah Lucas. Courtesy Sadie Coles HQ, London.

They go on and on as if the platitudes they utter had some actual meaning. Their identical features give the lie to their sense of individuality. One cannot escape the feeling that our own use of logic is ultimately meaningless in the broad scheme of things and that our senses of individuality and freedom may be no more than illusions.

Sarah Lucas

Much of British-born Sarah Lucas's (b. 1962) work comments on male–female relationships in life and in art. She has been profoundly interested in the political issues surrounding the "male gaze" and the woman as the stereotypical object of desire. One of her best-known works, *Au Naturel,* features an old mattress with a cucumber, pieces of fruit, and a bucket as stand-ins for male and female body parts. *The Fag Show* (Fig. 20-57) was inspired by Lucas's conquest of her addiction to tobacco. (*Fag* is the slang word in Britain for cigarette.) The outer skins of the objects in the installation, including vacuum cleaners and Disneyesque dwarves, consist of swirling linear patterns of cigarettes.

Much of Lucas's work focuses on blatant sexual imagery and the stuff of self-destruction and death.

Shirin Neshat

We met Iranian-born Shirin Neshat (b. 1957) in Chapter 8, in which we saw her photograph *Untitled (Woman of Allah)* (see Fig. 8-22). Neshat's films, like her photographs, are obsessed with gender roles in Islamic society. Although men in Iran can reveal their individual faces to the world, women share a collective cultural identity that seems to be defined by the chador, the required head-to-toe covering, that serves both as a symbol of repression and of female identity. Her film *Passage* (Fig. 20-58), commissioned by the composer Philip Glass, follows the ritual of passage from this world to the next as men carry a shrouded body, women prepare a grave with their bare hands, and a little girl sets a fire that comes to circumscribe the scene. During one of the film's most abstract and intensely visual passages, Glass's pulsating score juxtaposed with a close-up of the women's thrumming chadors creates a sense of oil bubbling from the desert

20-58 SHIRIN NESHAT.
Still from Passage (2001).
Color video installation with sound, 00:11:40, dimensions vary with installation. Edition 5/6.
Solomon R. Guggenheim Museum, New York. Purchased with funds contributed by the International Director's Council and Executive Committee Members. 2001.70. Copyright The Solomon R. Guggenheim Museum, New York. Photograph courtesy of the artist.

ground. The ingredients are natural and elemental—sticks, stones, fire, smoke, sand, and dust—and the repetitive movements, chanting, and music form a circle of life, death, and perhaps, rebirth.

William Pope.L

William Pope.L's (b. 1956) business card proclaims himself "The friendliest Black artist in America"—a descriptor that also serves as the title of an MIT Press book on the artist. William Pope.L, a professor at Bates College in Maine, paints, sculpts, and produces some of the most intriguing and witty performance art in the United States. Pope.L's reputation soared when the chairman of the National Endowment for the Arts overturned the recommendation of his advisory panel and denied support for Pope.L's retrospective exhibition, *eRacism.* Given this notoriety, Pope.L became a cause célèbre and was featured in newspapers across the nation. Many of Pope.L's performances take place on "the street." He has publicly eaten (and thrown up) copies of *The Wall Street Journal,* handed out (rather than solicited) cash from a bank door, and walked Harlem's 125th Street sporting a 12-foot cardboard phallus. *Training Crawl, Lewiston, ME* (Fig. 20-59) is one of his many signature "crawls" in which he usually appears in a city, unannounced, dressed in athletic wear or a business suit, and inches along public streets until he is exhausted. Figure 20-59 shows Pope.L training for a 22-mile crawl up Broadway, which he expects will take five years to complete—despite the Superman costume.

20-59 WILLIAM POPE.L.
Training Crawl, Lewiston, ME (Fall 2001).
William Pope.L trains for *The Great White Way,* his marathon five-year crawl up Broadway in Manhattan.
Photograph courtesy of the artist.

20-60 DAVID SALLE.
Angel (2000).
Oil and acrylic on canvas and linen (two panels).
72″ × 96″.
"Pastoral," Jan. 20–Mar. 3, 2001, Gagosian Gallery, 555 West 24th Street, New York. Courtesy Gagosian Gallery, New York. Copyright David Salle. Licensed by VAGA, New York.

David Salle

Oklahoma-born David Salle (b. 1952) is best known for his use of *pastiche*—that is, the appropriation of images from other sources. His thought-provoking compositions juxtapose images culled from his own photographs, art historical icons (e.g., Velázquez, Bernini, Cézanne, Giacometti, Magritte, Jasper Johns), print ads, "how-to-draw" manuals, even pornographic magazines. Salle is one of the most successful proponents of Neo-Expressionism, and his work has inspired a revival of large-scale, figurative painting. *Angel* (Fig. 20-60) is one of Salle's "pastoral" paintings, which art critic David Kuspit characterizes as highly learned, even scholarly. Here we find a portrait of the artist and his muse in baroque costume. Their relationship is intriguing—sophisticated, formal, yet exhibiting an underlying sexual tension. Questions arise as to the artist's creativity, originality, potency. In any case, Salle is not afraid to reconfirm the appeal of solid figurative painting.

Damien Hirst

A perceived resurgence in the interest in painting can perhaps be symbolized by Damien Hirst's (b. 1965) own foray into the medium after a long association with anything but. Hirst established his reputation as one of the YBAs (young British artists) making conceptual art that seemed to challenge ethics, morality, and plain good taste. He is perhaps

20-61 DAMIEN HIRST.
Mortuary (2003–2004).
Photograph courtesy of the Gagosian Gallery, New York.

best known for his infamous installation of a dismembered shark suspended in formaldehyde (*The Physical Impossibility of Death in the Mind of Someone Living,* 1991), but Hirst's latest paintings consist of often no less difficult imagery rendered, however, in a Photorealist style (Fig. 20-61).

Hirst's patron and promoter, the influential British collector Charles Saatchi, sold the so-called pickled shark for a reputed $13 million. Saatchi seems to have found a new passion for contemporary painting, focusing his efforts (and his financial support) on a series of exhibitions featuring 56 artists working exclusively in the medium. Saatchi has labeled it "The Triumph of Painting."

Lorna Simpson

Lorna Simpson (b. 1960) often combines black-and-white photography and text to address racial issues in her work, but for the most part indirectly. She has been particularly concerned with the place of African American women in the United States, portraying them variously as victims, protagonists, and survivors. The use of fragmentation as a device for communicating the line between the individuality and anonymity of her subjects has also been a persistent visual construct and is evident here in the film *Easy to Remember* (Fig. 20-62). A grid of 15 mouths—15 African American jazz singers—hum along to the Rodgers and Hart song *Easy to Remember,* rendered as a lilting ballad by the saxophonist John Coltrane. Although the singing is mostly in unison, slight variations are evident in individual rendition. The title of the work and the song resonate with meaning for the

artist, recalling memories from her childhood. The work was selected for the Whitney Biennial 2002.

Kara Walker

As an African American woman, Kara Walker (b. 1969) has experienced much of her life in terms of black and white and now, like Lorna Simpson, produces much of her art in this dichotomous palette. She has worked in many media, but her life-size paper cutouts, which are used to silhouette her comments on the often brutal history of race relations in the United States, have captured the attention of the art world. Her figures are two-dimensional—often black figures pasted onto white gallery walls—and their flatness seems to echo the stereotyping that prevents people of one background from seeing people of other backgrounds in their full vitality and individualism.

Insurrection! (Our Tools Were Rudimentary, Yet We Pressed On) (Fig. 20-63) recounts some grisly events taken from the history of slavery in the United States. A nude slave is propositioned by a plantation owner. A woman with a baby barely escapes being lynched. Elsewhere a group tortures a victim. The piece fills the walls of a large room where additional shapes are projected onto the walls, and visitors find their own shadows projected among them. Viewers are thus integrated into the haunting works, as if they share in culpability or victimhood. Walker's installations are haunting in their disconnect between the lyrical shadow-puppet display and the dark content of the narrative.

20-62 LORNA SIMPSON.
Still from *Easy to Remember* (2001).
16 mm film transferred to DVD, sound; 2½ minutes.
Courtesy of the Sean Kelly Gallery, New York.

We are all working so hard to change people's attitudes about race, but it's like handling a wet eel.

—Kara Walker

20-63 KARA WALKER.
Insurrection! (Our Tools Were Rudimentary,
Yet We Pressed On) (2000). Installation view.
Cut paper silhouettes and light projections, site-specific
dimensions.

Sam Taylor-Wood

Edward Steichen wrote, "Every other artist begins [with] a blank canvas, a piece of paper . . . the photographer begins with the finished product." Implicit in Steichen's statement is the reality of the planning and selection that permits the instantaneous creation of an image to be a "finished product." The contemporary images of Sam Taylor-Wood (b. 1967), who lives and works in England, are created with extensive forethought and with knowledge of, and reverence for, the history of art.

Taylor-Wood has become known for her room-encompassing video installations and 360-degree photographic panoramas, accompanied by sound tracks, that depict people in the midst of personal dramas and fantasies. Although the actors in her dramas may be visually attractive, something about them is awkward and vulnerable, out of place. Even though some are involved in sexual activity, they appear to be emotionally isolated. Taylor-Wood's photo-

graphs are often structured like multipaneled Renaissance altarpieces, replete with art-historical references. In her *Soliloquy III,* for example, a reclining nude mimics the pose of Velázquez's *Rokeby Venus* (1650). Her grand-scale *Self-Pietà* (Fig. 20-64) mimics Michelangelo's *Pietà,* in which the Virgin Mary holds her dead son in her lap. In Taylor-Wood's photo, the artist herself holds a motionless male, an icon, as it were, that threatens to slip from her hands. Although there is a sense of contemporary alienation in Taylor-Wood's work, it is rooted in the art-historical past. Although the art of today is exploding in many directions, it explodes not in a vacuum but from a past with identifiable traditions.

Where the explosions will take us, we cannot say. But just as scientists study the origins of the universe in the stars of their own sphere of study, so the art historians and critics of the future will see the origins of the works before them in the art of our past and today.

20-64 SAM TAYLOR-WOOD.
Self-Pietà (2001).
C-print. 53″ square.
Courtesy Jay Jopling/White Cube, London.

GLOSSARY

Abstract art A form of art characterized by simplified (abstracted) or distorted rendering of an object that has the essential form or nature of that object; a form of *nonobjective art* in which the forms make no reference to visible reality.

Abstract Expressionism A style of painting and sculpture of the 1950s and 1960s in which artists expressionistically distorted abstract images with loose, gestural brushwork. Also see *expressionistic*.

Academic art A neoclassical, nonexperimental style promoted by the Royal French Academy during the eighteenth and nineteenth centuries.

Achromatic Without color.

Acquisition Purchase (of a work of art) for a museum or a formal collection.

Acropolis The fortified upper part of a Greek city; literally, "city on a hill."

Acrylic paint A paint in which pigments are combined with a synthetic plastic medium that is durable, water soluble, and quick drying.

Action painting A contemporary method of painting characterized by *implied motion* in the brushstroke and splattered and dripped paint on the canvas.

Actual balance Equal distribution of weight. Contrast with *pictorial balance*.

Actual line The path made by a moving point; a connected and continuous series of points. Contrast with *implied line*.

Actual mass The physical mass of an object as determined by its weight. Contrast with *implied mass*.

Actual motion The passage of a body or an object from one place to another. Contrast with *implied motion*.

Actual texture The texture of an object or picture, as determined by the sense of touch. Contrast with *visual texture*.

Additive process In sculpture, adding or assembling materials, as in modeling and constructing. Contrast with *subtractive process*.

Adobe Brick that has been dried in the sun rather than fired in a kiln.

Afterimage The lingering impression from a stimulus that has been removed. The afterimage of a color is its complement. Also see *complementary color*.

Allegory A narrative in which people and events have been given consistent symbolic meanings; extended metaphor.

Altar A raised platform or stand used for sacred ceremonial or ritual purposes.

Alternate a-b-a-b support system An architectural support system in which every other nave wall support sends up a supporting rib that crosses the vault as a transverse arch.

Alternate support system An architectural support system in which alternating structural elements bear the weight of the walls and the load of the ceiling.

Ambulatory In a church, a continuation of the side aisles of a *Latin cross plan* into a passageway that extends behind the choir and apse and allows traffic to flow to the chapels, which are often placed in this area (from *ambulare*, Latin for "to walk").

Amorphous Without clear shape or form.

Amphitheater A round or oval open-air theater with an arena surrounded by rising tiers of seats.

Analogous colors Colors that lie next to one another on the color wheel and share qualities of hue as a result of the mixture of adjacent hues; harmonious hues.

Analytic Cubism The early phase of Cubism (1909–1912) during which objects were dissected or analyzed in a visual information-gathering process and then reconstructed on the canvas.

Animation Creation of an animated cartoon; the photographing of a series of drawings, each of which shows a stage of movement that differs slightly from the previous one, so that figures appear to move when projected in rapid succession.

Annunciation The angel Gabriel's announcement to Mary that she would give birth to Jesus.

Aperture Opening.

Apocalypse The ultimate triumph of good over evil foretold in Judeo-Christian writings.

Apse A semicircular or polygonal projection of a building with a semicircular dome, especially on the east end of a church.

Aquarelle A watercolor technique in which a transparent film of paint is applied to a white, absorbent surface.

Aquatint An etching technique in which a metal plate is colored with acid-resistant resin and heated, causing the resin to melt. Before printing, areas of the plate are exposed by a needle, and the plate receives an acid bath. Aquatinting can be manipulated to resemble washes.

Aqueduct A bridgelike structure that carries a canal or pipe of water across a river or valley (from Latin roots meaning "to carry water").

Arch A curved or pointed structure consisting of wedge-shaped blocks that span an open space and support the weight of material above by transferring the load outward and downward over two vertical supports, or piers.

Archaic period A period of Greek art dating roughly 660–480 BCE. The term *archaic* means "old" and refers to the art created before the Classical period.

Architectural style A style of Roman painting in which walls were given the illusion of opening onto a scene.

Architecture The art and science of designing aesthetic buildings, bridges, and other structures to help people meet their personal and communal needs.

Architrave In architecture, the lower part of an *entablature*, which may consist of one or more horizontal bands.

Archivolts In architecture, concentric moldings that repeat the shape of an arch.

Armature In sculpture, a framework for supporting plastic material.

Art Nouveau A highly ornamental style of the 1890s characterized by floral patterns, rich colors, whiplash curves, and vertical attenuation (French for "new art").

Assemblage A work of art that consists of three-dimensional objects assembled to create an image. Artists often manipulate preexisting objects in various ways and incorporate them with other media, such as painting or printmaking.

Asymmetrical balance Balance in which the right and left sides of a composition contain different shapes, colors, textures, or other elements and yet are arranged or "weighted" so that the overall impression is one of balance. Contrast with *symmetrical balance*.

Athena The Greek goddess of wisdom, skills, and war.

Atmospheric perspective An illusion of depth created through grades of texture and brightness, color saturation, and warm and

cool colors. An indistinct or hazy effect produced by distance and the illusion of distance in visual art (the term derives from recognition that the atmosphere between the viewer and the distant objects would cause the effect).

Atrium A hall or entrance court.

Automatic writing Writing based on free association, practiced by Dadaists and Surrealists.

Automatist surrealism An outgrowth of automatic writing in which the artist attempts to derive the outlines of images from the unconscious through free association.

Avant-garde The leaders in new, unconventional movements; the vanguard (from French, "advance guard").

Balance The distribution of the weight, mass, or other elements of a work of art so as to achieve harmony.

Balloon framing In architecture, a wooden skeleton of a building constructed from prefabricated studs and nails.

Balustrade A railing held up by small posts, or balusters, as on a staircase.

Baroque A seventeenth-century European style characterized by ornamentation, curved lines, irregularity of form, dramatic lighting and color, and exaggerated gestures.

Barrel vault A roofed-over space or tunnel constructed as an elongated arch.

Basalt A dark, tough volcanic rock.

Basketry The craft of making baskets.

Bas-relief Sculpture that projects only slightly from its background (from *bas,* French for "low"). Contrast with *high relief.*

Batik The process of making designs in cloth by waxing fabric to prevent dye from coloring certain areas; a cloth or design made in this way.

Bay In architecture, the area or space spanned by a single unit of vaulting that may be marked off by piers or columns.

Bevel To cut at an angle.

Bilateral symmetry Mirror-type similarity between the sides of a composition. Also termed "pure" or "formal" symmetry.

Binder A material that binds substances together.

Biomorphic Having the form of a living organism.

Bisque firing In ceramics, a preliminary firing that hardens the body of a ware.

Bitumen Asphalt.

Black-figure painting A three-stage firing process that gives vases black figures on a reddish ground. In the first, oxidizing phase of firing, oxygen in the kiln turns the vase and slip red. In the second, reducing phase, oxygen is eliminated from the kiln and the vase and slip turn black. In the third, reoxidizing phase, oxygen is reintroduced into the kiln, turning the vase red once more.

Bohemian Literally, of Bohemia, a section of the Czech Republic. Because Gypsies, or

Roma, in transit to Western Europe passed through Bohemia, the term has come to signify a nonconformist, unconventional style of life.

Brass A yellowish alloy of copper and zinc.

Brick A hard substance made from clay, fired in a kiln or baked in the sun, and used in construction.

Brightness gradient The relative degree of intensity in the rendering of nearby and distant objects, used to create an illusion of depth in a two-dimensional work.

Buddha An enlightened man.

Buon fresco True fresco, executed on damp lime plaster. Contrast with *fresco secco.*

Burin A pointed cutting tool used by engravers.

Burnish To make shiny by rubbing or polishing.

Buttress To support or prop up construction with a projecting structure, usually built of brick or stone; a massive masonry structure on the exterior wall of a building that presses inward and upward to hold the stone blocks of arches in place. Also see *flying buttress.*

Byzantine A style associated with Eastern Europe that arose after 300 CE, the year that Emperor Constantine moved the capital of his empire from Rome to Byzantium and renamed the city Constantinople (present-day Istanbul). The style was concurrent with the Early Christian style in Western Europe.

Calligraphy Beautiful handwriting; penmanship; ornamental writing with a pen or brush.

Camera obscura An early camera consisting of a large dark chamber with a lens opening through which an image is projected onto the opposite surface in its natural colors.

Candid In photography, unposed, informal.

Canon of proportions A set of rules governing the proportions of the human body as they are to be rendered by artists.

Capital In architecture, the area at the top of the shaft of a column that provides a solid base for the horizontal elements above. Capitals provide decorative transitions between the cylinder of the column and the rectilinear *architrave* above.

Caricature The gross exaggeration or distortion of natural features for the purpose of benign or malevolent satire.

Carolingian Referring to Charlemagne or his period. Charlemagne was emperor of the Holy Roman Empire from 800 to 814 CE.

Cartoon Originally, a preparatory drawing made for a fresco, usually on paper and drawn to scale; a drawing that caricatures or satirizes an event or person of topical interest. Also see *animation.*

Carving In sculpture, the process of cutting away material, such as wood.

Cast iron A hard alloy of iron containing silicon and carbon that is made by casting.

Casting The process of creating a form by pour-

ing a liquid material into a mold, allowing it to harden, and then removing the mold.

Catacomb A vault or gallery in an underground burial place.

Cella The small inner room of a Greek temple, used to house the statue of the god or goddess to whom the temple is dedicated. Located behind solid masonry walls, the cella was accessible only to the temple priests.

Centering In architecture, a wooden scaffold used in the construction of an arch.

Central plan A design for a church or a chapel with a primary central space surrounded by symmetrical areas around each side. Contrast with *longitudinal plan.*

Ceramics The art of creating baked clay objects, such as pottery and earthenware.

Chalk A form of soft limestone that is easily pulverized and can be used as a drawing implement.

Charcoal A form of carbon produced by partially burning wood or other organic matter; it can be used as a drawing implement.

Chiaroscuro An artistic technique in which subtle gradations of value create the illusion of rounded three-dimensional forms in space; also termed *modeling* (from Italian for "light-dark").

China Whitish or grayish porcelain that rings when struck.

Cinematography The photographic art of creating motion pictures.

Cinerary urn A vessel used for keeping the ashes of the cremated dead.

Clapboard In architecture, siding composed of thin, narrow boards placed in horizontal, overlapping layers.

Classical Art Art of the Greek Classical period, spanning roughly 480–400 BCE; also known as Hellenic Art (from "Hellas," the Greek name for Greece).

Clerestory In a *Latin cross plan,* the area above the *triforium* in the elevation of the nave, which contains windows to provide direct lighting for the nave.

Close-up In cinematography or video, a "shot" made from very close range, providing intimate detail.

Coffer A decorative sunken panel.

Coiling A pottery technique in which lengths of clay are wound in a spiral fashion.

Collage An assemblage of two-dimensional objects to create an image; works of art in which materials such as paper, cloth, and wood are pasted to a two-dimensional surface, such as a wooden panel or canvas (from *coller,* French for "to paste").

Colonnade A series of columns placed side by side to support a roof or a series of arches.

Color negative film Film from which color negatives are made.

Color reversal film Film from which color prints ("positives") are made directly, without the intervening step of creating negatives.

Color-field painting Painting that uses visual

elements and principles of design to suggest that areas of color stretch beyond the canvas to infinity; figure and ground are given equal emphasis.

Combine painting A contemporary style of painting that attaches other media, such as found objects, to the canvas.

Complementary color One of a specific pair of colors (e.g., red and green) that most enhance, or exaggerate, one another by virtue of their simultaneous contrast. Each pair of complementary colors contains one primary color plus the secondary color made by mixing the other two primaries. Because the complements do not share characteristics of hue and are as unlike as possible, the eye readily tells them apart. When complementary colors are placed next to one another, the effects are often jarring.

Composition The organization of the visual elements in a work of art.

Compound pier In Gothic style, a complexly shaped vertical support to which a number of colonnettes (thin half columns) are often attached.

Compressive strength The degree to which a material can withstand the pressure of being squeezed.

Computer art The production of images with the assistance of the computer. Artists can use the computer to create art for its own sake or as a design tool, as in architecture and graphic design.

Computer-assisted design (CAD) The use of the computer to assist artists and designers working in other media, such as architecture. CAD permits interior designers and architects to view their designs from various vantage points and to see how the modification of one element affects the entire design.

Conceptual Portrayed as a person or object is known or thought (conceptualized) to be; not copied from nature at any given moment. Conceptual figures tend to be stylized rather than realistic.

Conceptual art An anticommercial movement begun in the 1960s in which works of art are conceived and executed in the mind of the artist. The commercial or communal aspect of the "work" is often a set of instructions for what exists in the artist's mind.

Conceptual space Space that is depicted as conceptualized by the artist rather than in realistic perspective.

Conceptual unity Unity in a work that is achieved through the relationship between the meaning and function of the images.

Constructed sculpture Sculpture in which forms are built up from such materials as wood, paper, string, sheet metal, and wire.

Constructivism A sculptural outgrowth of Cubist collage in which artists attempt to use a minimum of mass to create volumes in space.

Contact print A photographic print that is made by placing a negative in contact with

a sheet of photosensitive paper and exposing both to light so that the second sheet of paper acquires the image.

Conté crayon A wax crayon with a hard texture.

Content All that is contained in a work of art: the visual elements, subject matter, and underlying meaning or themes.

Contour line A perceived line that marks the edge of a figure as it curves back into space.

Contrapposto A position in which a figure is obliquely balanced around a central vertical axis. Also see *weight-shift principle.*

Cool color A color such as a blue, green, or violet that appears to be cool in temperature and tends to recede spatially behind warm colors.

Corbel A supportive, bracket-shaped piece of metal, stone, or wood.

Corinthian order The most ornate of the Greek architectural styles, characterized by slender, fluted columns and capitals with an acanthus leaf design.

Cornice In architecture, a horizontal molding that projects along the top of a wall or a building; the uppermost part of an *entablature.*

Cosmetic palette A palette for mixing cosmetics, such as eye makeup, with water.

Crayon A small stick of colored wax, chalk, or charcoal.

Cross-hatching Intersecting sets of parallel lines used to shade a drawing.

Crossing square In architecture, the area that defines the right-angle intersection of the vaults of the nave and the transept of a church.

Cubism A twentieth-century style developed by Picasso and Braque that emphasizes the two-dimensionality of the canvas, characterized by multiple views of an object and the reduction of form to cubelike essentials.

Cuneiform Wedge-shaped; descriptive of the characters used in ancient Akkadian, Assyrian, Babylonian, and Persian alphabets.

Curvilinear Consisting of a curved line or lines.

Dada A post–World War I movement that sought to use art to destroy art, thereby underscoring the paradoxes and absurdities of modern life.

Daguerreotype A photograph made from a silver-coated copper plate; named after Louis Daguerre, the innovator of the method.

Deconstructivist architecture A Postmodern approach to the design of buildings that disassembles and reassembles the basic elements of architecture. The focus is on the creation of forms that may appear abstract, disharmonious, and disconnected from the functions of the building. Deconstructivism challenges the view that there is one correct way to approach architecture.

Der Blaue Reiter (The Blue Rider) A twentieth-century German Expressionist movement that focused on the contrasts between,

and combinations of, abstract form and pure color.

Design The combination of the visual elements of art according to such principles as balance and unity.

De Stijl An early twentieth-century movement that emphasized the use of basic forms, particularly cubes, horizontals, and verticals.

Diagonal rib In architecture, a *rib* that connects the opposite corners of a groin vault.

Die Brücke (The Bridge) A short-lived German Expressionist movement characterized by boldly colored landscapes and cityscapes and by violent portraits.

Digital art Art that makes use of—or is developed with the assistance of—electronic instruments, such as computers, that store and manipulate information through the use of series of zeros and ones (digits); including but not limited to web design, *graphic design,* and *digital photography.*

Digital photography Photography that stores visual information electronically rather than on film.

Direct-metal sculpture Metal sculpture that is assembled by such techniques as welding and riveting rather than *casting.*

Dissolve In cinematography and video, a fading technique in which the current scene grows dimmer as the subsequent scene grows brighter.

Dome In architecture, a hemispherical structure that is round when viewed from beneath.

Doric order The earliest and simplest of the Greek architectural styles, consisting of relatively short, squat columns, sometimes unfluted, and a simple, square-shaped capital. The Doric *frieze* is usually divided into *triglyphs* and *metopes.*

Drawing The art of running an implement that leaves a mark over a surface; a work of art created in this manner.

Dry masonry Brick or stone construction without use of mortar.

Dry media Drawing materials that do not involve the application of water or other liquids. Contrast with *fluid media.*

Drypoint A variation of engraving in which the surface of the matrix is cut with a needle to make rough edges. In printmaking, rough edges make soft rather than crisp lines.

Dynamism The Futurist view that force or energy is the basic principle that underlies all events, including everything we see. Objects are depicted as if in constant motion, appearing and disappearing before our eyes.

Earthenware Reddish tan, porous pottery fired at a relatively low temperature (below 2,000°F).

Earthwork A work of art in which large amounts of earth or land are shaped into a sculpture.

Eastern Orthodox A form of Christianity dominant in Eastern Europe, western Asia, and North Africa.

Editing In cinematography and video, rearranging a film or video record to provide a more coherent or interesting narrative or presentation of the images.

Egg tempera A painting medium in which ground pigments are bound with egg yolk.

Emboss To decorate with designs that are raised above a surface.

Embroidery The art of ornamenting fabric with needlework.

Emphasis A design principle that focuses the viewer's attention on one or more parts of a composition by accentuating certain shapes, intensifying value or color, featuring directional lines, or strategically placing the objects and images.

Empire period The Roman period from about 27 BCE to 395 CE, when the empire was divided.

Emulsion A suspension of a salt of silver in gelatin or collodion used to coat film and photographic plates.

Enamel To apply a hard, glossy coating to a surface; a coating of this type.

Encaustic A method of painting in which the colors in a wax medium are burned into a surface with hot irons.

Engraving Cutting; in printmaking, an *intaglio* process in which plates of copper, zinc, or steel are cut with a burin and the ink image is pressed onto paper.

Entablature In architecture, a horizontal structure supported by columns, which, in turn, supports any other element, such as a pediment, that is placed above; from top to bottom, the entablature consists of a *cornice,* a *frieze,* and an *architrave.*

Entasis In architecture, a slight convex curvature of a column used to provide the illusion of continuity of thickness as the column rises.

Equestrian portrait A depiction of a figure on horseback.

Etching In printmaking, an *intaglio* process in which the matrix is first covered with an acid-resistant ground. The ground is removed from certain areas with a needle, and the matrix is dipped in acid, which eats away at the areas exposed by the needle. These areas become grooves that are inked and printed.

Etruscan From ancient Etruria, located along the northwestern shores of present-day Italy.

Existentialism A literary and philosophical movement of the early twentieth century characterized by the belief that human beings are free and responsible for their behavior and actions. This freedom, according to proponents Søren Kierkegaard, Jean-Paul Sartre, and Margin Heidegger, leads to humanity's pain and anguish.

Expressionism A modern school of art in which an emotional impact is achieved through agitated brushwork, intense coloration, and violent, hallucinatory imagery.

Expressionistic Emphasizing the distortion of color and form to achieve an emotional impact.

Extreme unity Unification of all elements in a composition.

Extrude To force metal through a die or small holes to give it shape.

Facade A French term for the face or front of a building.

Fading In cinematography and video, the gradual dimming or brightening of a scene, used as a transition between scenes.

Fantastic art The representation of fanciful images, sometimes joyful and whimsical, sometimes horrific and grotesque.

Fauvism An early twentieth-century style of art characterized by the juxtaposition of areas of bright colors that are often unrelated to the objects they represent, and by distorted linear perspective (from French for "wild beast").

Fenestration The arrangement of windows and doors in a structure, often used to create balance and rhythm as well as light, air, and access.

Ferroconcrete Same as *reinforced concrete.*

Fertile Crescent The arable land lying between the Tigris and Euphrates rivers in ancient Mesopotamia.

Fertile Ribbon The arable land lying along the Nile River in Egypt.

Fetish figure An object believed to have magical powers.

Fiber A slender, threadlike structure or material that can be woven.

Fiberglass Fine spun-glass filaments that can be woven into textiles.

Figurative art Art that represents the likeness of human and other figures.

Figure–ground relationship The relationship between the primary subject (figure) and other parts of the composition (ground or background).

Figure–ground reversal A shift in a viewer's perception of a composition in which what at one moment appears to be the figure becomes the ground (or background), and vice versa.

Film A thin sheet of cellulose material coated with a photosensitive substance.

Flashback In cinematography and video, an interruption of the story line with the portrayal of an earlier event.

Flash-forward In cinematography and video, an interruption of the story line with the portrayal of a future event.

Flint glass A hard, bright glass containing lead oxide.

Fluid media Liquid-based drawing materials. Contrast with *dry media.*

Flying buttress A buttress that is exterior to a building but connected in a location that permits the buttress to support an interior vault.

Focal point A specific part of a work of art that seizes and holds the viewer's interest.

Foreshortening Diminishing the size of the parts of an object that are represented as farthest from the viewer. Specifically, rendering parts of an object as receding from the viewer at angles oblique to the picture plane so that they appear proportionately shorter than parts of the object that are parallel to the picture plane.

Forge To form or shape metal (usually heated) with blows from a hammer, press, or other implement or machine.

Form The totality of what the viewer sees in a work of art; a product of the composition of visual elements.

Formalist criticism An approach to art criticism that concentrates on the elements and design of works of art rather than on historical factors or the biography of the artist.

Forum An open public space, particularly in ancient Rome, used as a market and a gathering place.

Freestanding sculpture Sculpture that is carved or cast in the round, unconnected to a wall, and thereby capable of being viewed in its entirety by walking around it. Freestanding sculpture can also be designed for a niche, which limits the visible portion of the sculpture.

Fresco A type of painting in which pigments are applied to a fresh, wet plaster surface or wall and thereby become part of the surface or wall (from Italian for "fresh").

Fresco secco Dry fresco; painting executed on dry plaster. Contrast with *buon fresco.*

Frieze In architecture, a horizontal band between the *architrave* and the *cornice* that is often decorated with sculpture.

Futurism An early twentieth-century style that portrayed modern machines and the dynamic character of modern life and science.

Gate In the lost-wax technique of casting, one of a number of wax rods connected to the mold; as molten bronze flows into the mold, gates allow air to escape.

Gauffrage An inkless *intaglio* process.

Genre painting Simple human representations; realistic figure painting that focuses on themes taken from everyday life.

Geometric period A period of Greek art from about 900 to 700 BCE during which works of art emphasized geometric patterns.

Geometric shape A shape that is regular, easy to measure, and easy to describe, as distinguished from *organic* or *biomorphic shape,* which is irregular, difficult to measure, and difficult to describe.

Gesso Plaster of Paris that is applied to a wooden or canvas support and used as a surface for painting or as the material for sculpture (from Italian for "gypsum").

Gild To apply thin sheets of gold leaf or gold-like substance to a surface.

Glassblowing The art of shaping molten glass

into glass objects by blowing air through a tube.

Glaze In painting, a semitransparent coating on a painted surface that provides a glassy or glossy finish. In ceramics, a hard, glossy coating formed by applying a liquid suspension of powdered material to the surface of a ware, which is then dried and fired at a temperature that causes the ingredients to melt together.

Golden mean The principle that a small part of a work should relate to a larger part of the work in proportion to the manner in which the larger part relates to the whole.

Golden rectangle A rectangle based on the *golden mean* and constructed so that its width is 1.618 times its height.

Golden section Developed in ancient Greece, a mathematical formula for determining the proportional relationship of the parts of a work to the whole.

Gothic A Western European style developed between the twelfth and sixteenth centuries CE, characterized in architecture by ribbed vaults, pointed arches, flying buttresses, and steep roofs.

Gouache Watercolor paint that is made opaque by mixing pigments with a particular gum binder.

Graphic design Design for advertising and industry that includes design elements such as typography and images for communication purposes.

Graphite A soft black form of carbon used as a drawing implement (from *graphein,* Greek for "to write").

Graver A cutting tool used by engravers and sculptors.

Greek cross plan A cross-shaped design, particularly of a church, in which the arms (nave and transept) are equal in length.

Griffin A mythical creature with the body and back legs of a lion, and the head, talons, and wings of an eagle.

Groin vault In architecture, a vault that is constructed by placing *barrel vaults* at right angles so that a square is covered.

Ground The surface on which a two-dimensional work of art is created; a coat of liquid material applied to a surface that serves as a base for drawing or painting. Also, the background in a composition. Also see *figure–ground relationship.*

Gum A sticky substance found in many plants, used to bind pigments as found, for example, in silverpoint, chalk, and pastel drawings.

Gum arabic A gum obtained from the African acacia plant.

Haniwa A hollow ceramic figure placed at ancient Japanese burial plots.

Hard-edge painting A contemporary style in which geometric forms are rendered with precision but with no distinction between foreground and background.

Hatcher An engraving instrument that produces thousands of tiny pits that will hold ink.

Hatching Fine parallel lines drawn or engraved to represent shading.

Heliography A photographic process in which bitumen is placed on a pewter plate to create a photosensitive surface that is exposed to the sun (from *helios,* Greek for "sun").

Hellenism The culture, thought, and ethical system of ancient Greece.

Herringbone perspective A portrayal of space in which *orthogonals* vanish to a specific point along a vertical line that divides a canvas.

Hierarchical scaling The use of relative size to indicate the comparative importance of the depicted objects or people.

High relief Sculpture that projects from its background by at least half its natural depth. Contrast with *bas relief.*

Horizon In linear perspective, the imaginary line (frequently, where the earth seems to meet the sky) along which converging lines meet. Also see *vanishing point.*

Horizontal balance Balance in which the elements on the left and right sides of the composition seem to be about equal in number or visual emphasis.

Horus The ancient Egyptian sun god.

Hudson River School A group of nineteenth-century American artists whose favorite subjects included the scenery of the Hudson River Valley and the Catskill Mountains of New York State.

Hue Color; the distinctive characteristics of a color that enable us to label it (as blue or green, for example) and to assign it a place in the visible spectrum.

Humanism A system of belief in which humankind is viewed as the standard by which all things are measured.

Hypostyle In architecture, a structure with a roof supported by rows of piers or columns.

Ibex A wild goat.

Iconography A set of conventional meanings attached to images; as an artistic approach, representation or illustration that uses the visual conventions and symbols of a culture.

Iconology The study of visual symbols, which frequently have literary or religious origins.

Idealism The representation of forms according to a concept of perfection.

Illumination Illustration and decoration of a manuscript with pictures or designs.

Illusionistic surrealism A form of *surrealism* that renders the irrational content, absurd juxtapositions, and changing forms of dreams in a highly illusionistic manner that blurs the distinctions between the real and the imaginary.

Imam A prayer leader in a mosque; a religious and temporal ruler of a Muslim community or state.

Imbalance A characteristic of works of art in which the areas of the composition are unequal in *actual weight* or *pictorial weight.*

Impasto Application of a medium such as oil or acrylic paint so that an actual texture is built up on a surface.

Implied line A line that is completed by the viewer; a discontinuous line that the viewer perceives as being continuous; a line suggested by series of points or dots or by the nearby end-points of series of lines; or a line evoked by the movements and glances of the figures in a composition. Contrast with *actual line.*

Implied mass The apparent mass of a depicted object as determined, for example, by the use of forms or fields of color. Contrast with *actual mass.*

Implied motion An impression of movement created by the use of visual elements, composition, or content. Contrast with *actual motion.*

Implied time An impression of time's passage through the depiction of events that occur over a period of time.

Impressionism A late nineteenth-century style characterized by the attempt to capture the fleeting effects of light by painting in short strokes of pure color.

Incise To cut into with a sharp tool.

Industrial design The planning and artistic enhancement of industrial products.

Installation A work of art created for a specific gallery space or outdoor site.

Intaglio A printing process in which metal plates are incised, covered with ink, wiped, and pressed against paper. The print receives the image of the areas that are below the surface of the matrix.

Intarsia A style of decorative mosaic inlay.

International Gothic style A refined style of painting in late fourteenth-century and early fifteenth-century Europe characterized by splendid processions and courtly scenes, ornate embellishment, and attention to detail.

International style A post–World War I school of art and architecture that used modern materials and methods and expressed the view that form must follow function.

Investiture The fire-resistant mold used in metal casting.

Ionic order A moderately ornate Greek architectural style introduced from Asia Minor and characterized by spiral scrolls (*volutes*) on capitals and a continuous *frieze.*

Jamb In architecture, the side post of a doorway, window frame, fireplace, etc.

Jasper A kind of porcelain (also called jasperware) developed by Josiah Wedgwood that is characterized by a dull green or blue surface and raised white designs.

Ka figure According to ancient Egyptian belief, an image of a body in which the soul would dwell after death.

Keystone In architecture, the wedge-shaped stone placed in the top center of an arch to prevent the arch from falling inward.

Kiln An oven used for drying and firing ceramics.

Kinetic art Art that moves, such as the mobile.

Kinetic sculpture Sculpture that actually moves (as opposed to providing the illusion of movement).

Kiva A circular, subterranean structure built by Native Americans of the Southwest for community and ceremonial functions.

Kore figure A clothed female figure of the Greek Archaic style, often adorned with intricate carved detail. A counterpart to the male kouros figure.

Kouros figure The male figure as represented in the sculpture of the geometric and Archaic styles (from Greek for "boy").

Labyrinth Maze.

Lamination The process of building up by layers.

Lapis lazuli An opaque blue, semiprecious stone.

Latin cross plan A cross-shaped church design in which the nave is longer than the transept.

Lavender oil An aromatic oil derived from plants of the mint family.

Lens A transparent substance with at least one curved surface that causes the convergence or divergence of light rays passing through it. In the eye and the camera, lenses are used to focus images onto photosensitive surfaces.

Lift-ground etching A technique in which a sugar solution is brushed onto a resin-coated plate, creating the illusion of a brush-and-ink drawing.

Light The segment of the spectrum of electromagnetic energy that stimulates the eyes and produces visual sensations.

Linear Determined or characterized by the use of line.

Linear perspective A system of organizing space in two-dimensional media in which lines that are in reality parallel and horizontal are represented as converging diagonals. The method is based on foreshortening, in which the space between the lines grows smaller until it disappears, just as objects appear to grow smaller as they become more distant.

Linear recession Depth as perceived through the convergence of lines at specific points in the composition, such as the horizon line.

Lintel In architecture, a horizontal member supported by posts.

Lithography A surface printing process in which an image is drawn onto a matrix with a greasy wax crayon. When dampened, the waxed areas repel water while the material of the matrix absorbs it. An oily ink is then applied, which adheres only to the waxed areas. When the matrix is pressed against

paper, the paper receives the image of the crayon.

Living rock Natural rock formations, as on a mountainside.

Local color The hue of an object created by the colors its surface reflects under normal lighting conditions (contrast with *optical color*). Color that is natural rather than symbolic for the depicted objects.

Logo A distinctive company trademark or signature (short for "logogram" or "logotype").

Longitudinal plan A church design in which the nave is longer than the transept and in which parts are symmetrical against an axis. Contrast with *central plan.*

Longshot In cinematography and video, an image or sequence made from a great distance, providing an overview of a scene.

Loom A machine that weaves thread into yarn or cloth.

Lost-wax technique A bronze-casting process in which an initial mold is made from a model (usually clay) and filled with molten wax. A second, fire-resistant mold is made from the wax, and molten bronze is cast in it.

Lunette A crescent-shaped space or opening (French for "little moon").

Magazine In architecture, a large supply chamber.

Mandala In Hindu and Buddhist traditions, a circular design symbolizing wholeness or unity.

Mannerist art A sixteenth-century, post-Renaissance style characterized by artificial poses and gestures, vivid—sometimes harsh—color, and distorted, elongated figures.

Manuscript illumination Illustration or decoration of books and letters with pictures or designs.

Mass In painting, a large area of one form or color; in three-dimensional art, the bulk of an object. Also see *implied mass* and *actual mass.*

Matrix In printmaking, the working surface of the block, slab, or screen. In sculpture, a mold or hollow shape used to give form to a material that is inserted in a plastic or molten state.

Measure Extent, dimensions, or capacity as determined by a standard.

Medium The materials and methods used to create an image or object in drawing, painting, sculpture, and other arts (from Latin for "means").

Megalith A huge stone, especially as used in prehistoric construction.

Megaron A rectangular room with a two-columned porch.

Mesolithic Of the Middle Stone Age.

Metope In architecture, the panels containing *relief sculpture* that appear between the *triglyphs* of the *Doric frieze.*

Mezzotint A nonlinear engraving process in which the *matrix* is pitted with a *hatcher.*

Middle Ages The thousand-year span (400–1400 CE) from the end of Roman Classical Art to the rebirth of Classical traditions in the Renaissance. Although this period is sometimes referred to as the Dark Ages, it was actually a time of important contributions to economics, science, and the arts.

Mihrab A niche in the wall of a mosque that faces Mecca and thus provides a focus of worship.

Mimesis The practice of exact imitation in artistic representation.

Minaret A tall, slender tower of a mosque from which Muslims are called to prayer.

Minimal art Contemporary art that adheres to the Minimalist philosophy.

Minimalism A twentieth-century style of *non-objective art* in which a minimal number of visual elements are arranged in a simple fashion.

Mixed media The use of two or more media to create a single image.

Mobile A type of *kinetic* sculpture that moves in response to air currents.

Modeling In two-dimensional works of art, the creation of the illusion of depth through the use of light and shade (*chiaroscuro*). In sculpture, the process of shaping a pliable material, such as clay or wax, into a three-dimensional form.

Modernism A contemporary style of architecture that deemphasizes ornamentation and uses recently developed materials of high strength.

Mold A pattern or matrix for giving form to molten or plastic material; a frame on which something is modeled.

Monochromatic Literally, "one-colored"; descriptive of images that are executed in a single color or with so little color contrast as to appear uniform in hue.

Monolith A single, large block of stone; in sculpture, monolithic refers to a work that retains much of the shape of the original block of stone.

Monotype In printmaking, a technique in which paint is brushed onto a matrix that is pressed against a sheet of paper, yielding a single print.

Montage In cinematography or video, the use of flashing, whirling, or abruptly alternating images to convey connected ideas, suggest the passage of time, or provide an emotional effect.

Mortuary temple An Egyptian temple of the New Kingdom in which the pharaoh worshiped and was worshiped after death.

Mosaic A medium in which the ground is wet plaster on an architectural element, such as a wall, into which small pieces (tesserae) of colored tile, stone, or glass are assembled to create an image.

Muezzin Crier who calls Muslims to prayer five times a day from a *minaret.*

Mummification A process by which a body is preserved, often by removing all moisture.

Mural Image(s) painted directly on a wall or intended to cover a wall completely (from *muralis,* Latin for "of a wall").

Mural quality A surface suitable for mural painting.

Narrative editing In cinematography or video, selecting from multiple images of the same subject to advance a story.

Narthex A church vestibule that leads to the nave, constructed for use by the catechumens (individuals preparing to be baptized).

Naturalism Representation that strives to imitate nature rather than to express intellectual theory.

Naturalistic style A style prevalent in Europe during the second half of the nineteenth century that depicted the details of ordinary life.

Nave The central aisle of a church, constructed for use by the congregation at large.

Negative In photography, an exposed and developed film or plate on which values—that is, light and dark—are the reverse of what they are in the actual scene and in the print, or *positive.*

Negative shape Space that is empty or filled with imagery that is secondary to the main objects or figures depicted in the composition. Contrast with *positive shape.*

Neoclassical style An eighteenth-century revival of Classical Greek and Roman art, characterized by simplicity and straight lines.

Neo-Expressionism A violent, figurative style of the second half of the twentieth century that largely revived the German Expressionism of the early twentieth century.

Neolithic Of the New Stone Age.

Neutrals "Colors" (black, white, and gray) that do not contribute to the hue of other colors with which they are mixed.

New image painting An art style of the second half of the twentieth century that sought to reconcile abstraction and representation through the use of simplified images to convey the grandeur of abstract shapes without dominating visual elements such as color and texture.

New Objectivity (Neue Sachlichkeit) A post–World War I German art movement that rebelled against German Expressionism and focused on the detailed representation of objects and figures.

Nib The point of a pen; the split and sharpened end of a quill pen.

Nirvana In Buddhist belief, a state of perfect blessedness in which the individual soul is absorbed into the supreme spirit.

Nonobjective art Art that does not portray figures or objects; art without real models or subject matter.

Nonporous Not containing pores and thus not permitting the passage of fluids.

Nonrepresentational art Art that does not represent figures or objects.

Ocher A dark yellow color derived from an earthy clay.

Oculus In architecture, a round window, particularly one placed at the apex of a dome (from Latin for "eye").

Offset lithography A variation of *lithography* in which the image is hand drawn by the artist on Mylar.

Oil paint Paint in which pigments are combined with an oil medium.

One-point perspective Linear perspective in which a single vanishing point is placed on the horizon.

Op Art A style of art dating from the 1960s that creates the illusion of vibrations through afterimages, disorienting perspective, and the juxtaposition of contrasting colors. Also called "optical art" or "optical painting."

Optical Portrayal of objects as they are seen at the moment, especially depicting the play of light on surfaces. The painting of optical impressions is a hallmark of *Impressionism.*

Optical art See *Op Art.*

Optical color The perception of the color of an object, which may vary markedly according to atmospheric conditions. Contrast with *local color.*

Oran A praying figure.

Organic shape A shape characteristic of living things and thus appearing soft, curvilinear, and irregular. Contrast with *geometric shape.*

Orthogonal Composed of right angles.

Ottonian Of the period characterized by the consecutive reigns of German kings named Otto, beginning in 936 CE.

Oxidizing phase See *black-figure painting.*

Paint A mixture of a pigment with a vehicle or medium.

Painting The application of a pigment to a surface; a work of art created in this manner.

Palatine chapel A chapel that is part of a palace.

Palette A surface on which pigments are placed and prepared and from which the artist works; the artist's choice of colors as seen in a work of art.

Pan To move a motion picture or video camera from side to aide to capture a comprehensive or continuous view of a subject.

Panel painting A painting, usually in tempera but sometimes in oil, whose ground is a wooden panel.

Panorama An unlimited view in all directions.

Papyrus A writing surface made from the papyrus plant.

Parallel editing In cinematography or video, shifting back and forth from one event or story line to another.

Pastel A drawing implement made by grinding coloring matter, mixing it with gum, and forming it into a crayon.

Pastoral Relating to idyllic rural life, especially of shepherds and dairymaids.

Patina A fine crust or film that forms on bronze or copper because of oxidation. It usually provides a desirable greenish or greenish blue tint to the metal.

Patrician A member of the noble class in ancient Rome.

Pattern painting A decorative contemporary style that uses evocative signs, symbols, and patterns.

Pediment In architecture, any triangular shape surrounded by *cornices,* especially one that surmounts the *entablature* of the *portico facade* of Greek temple. The Romans frequently placed pediments without support over windows and doorways.

Pencil A rod-shaped drawing instrument with an inner shaft that is usually made of *graphite.*

Pendentive In architecture, a spherical triangle that fills the wall space between the four arches of a *groin vault* in order to provide a circular base on which a dome may rest.

Peplos In Greek Classical Art, a heavy woolen wrap.

Photography The creation of images by exposure of a photosensitive surface to light.

Photorealism A movement dating from the 1960s in which subjects are rendered with hard, photographic precision.

Photosensitive Descriptive of a surface that is sensitive to light and therefore capable of recording images.

Photo silkscreen A variation of *serigraphy,* or *silkscreen printing,* that allows the artist to create photographic images on a screen covered with a light-sensitive gel.

Piazza An open public square or plaza.

Pictograph A simplified symbol of an object or action; for example, a schematized or abstract form of an ancestral image, animal, geometric form, anatomic part, or shape suggestive of a cosmic symbol or microscopic life.

Pictorial balance The distribution of the apparent or *visual weight* of elements in two-dimensional works of art. Contrast with *actual balance.*

Picture plane The flat, two-dimensional surface on which a picture is created. In much Western art, the picture plane is viewed as a window opening onto deep space.

Pier In architecture, a columnlike support with a rectilinear rather than cylindrical profile. Piers generally support arches.

Pigment Coloring matter that is usually mixed with water, oil, or other substances to make paint.

Pilaster In architecture, a decorative element that recalls the shape of a structural *pier.* Pilasters are attached to the wall plane and project very little. They may have all the visual elements of piers, including base, shaft, *capital,* and *entablature* above.

Pile weave A weave in which knots are tied, then cut, forming an even surface.

Plain weave A weave in which the woof thread passes above one warp fiber and below the next.

Planar recession Perspective in which the illusion of depth is created through parallel planes that appear to recede from the picture plane.

Planographic printing Any method of printing from a flat surface, such as *lithography.*

Plastic elements Those elements of a work of art, such as line, shape, color, and texture, that artists manipulate to achieve desired effects.

Plasticity Capacity of a material to be molded or shaped.

Plebeian class In ancient Rome, the common people.

Plywood Sheets of wood that resist warping because they are constructed of layers glued together with the grain oriented in different directions.

Pointed arch An arch that comes to a point rather than curves at the top.

Pointillism A systematic method of applying minute dots of unmixed pigment to the canvas; the dots are intended to be "mixed" by the eye when viewed. Also called "divisionism."

Pop Art An art style originating in the 1960s that uses commercial and popular images and themes as its subject matter.

Porcelain A hard, white, translucent, nonporous clay body. The *bisque* is fired at a relatively low temperature and the *glaze* at a high temperature.

Portico The entrance facade of a Greek temple, adapted for use with other buildings and consisting of a *colonnade, entablature,* and *pediment* (from Greek for "porch").

Positive shape The spatial form defined by the objects or figures represented in works of art. Contrast with *negative shape.*

Post-and-beam construction Construction in which vertical elements (posts) and horizontal timbers (beams) are pieced together with wooden pegs.

Post-and-lintel construction Construction in which vertical elements (posts) are used to support horizontal crosspieces (lintels). Also termed "trabeated structure."

Postimpressionism A late nineteenth-century style that relies on the gains made by Impressionists in terms of the use of color and spontaneous brushwork but that employs these elements as expressive devices. The Postimpressionists, however, rejected the essentially decorative aspects of Impressionist subject matter.

Postmodernism A contemporary style that arose as a reaction to Modernism and that returns to ornamentation drawn from Classical and historical sources.

Pottery Pots, bowls, dishes, and similar wares made of clay and hardened by heat; a shop at which such objects are made.

Poussiniste Those Neoclassical artists who took Nicolas Poussin as their model. Contrast with *Rubeniste.*

Prefabricate In architecture, to build before-

hand at a factory rather than at the building site.

Pre-Hellenic Of ancient Greece before the eighth century BCE.

Primary color A hue—red, blue, or yellow—that is not obtained by mixing other hues; all other colors are derived from primary colors.

Print In printmaking, a picture or design made by pressing or hitting a surface with a plate or block; in photography, a photograph, especially one made from a negative.

Prism A transparent, polygonal body that breaks down white light into the colors of the visible spectrum.

Proportion The relationship of the size of the parts to the whole.

Propylaeum In architecture, a gateway building leading to an open court in front of a Greek or Roman temple; specifically, such a building on the Acropolis.

Psychic automatism A process of generating imagery through ideas received from the unconscious mind and expressed in an unrestrained manner.

Quarry tile Reddish brown tile, similar to terracotta.

Quatrefoil In architecture, a design made up of four converging arcs that are similar in appearance to a flower with four petals.

Quill A pen made from a large, stiff feather.

Radial balance Balance in which the design elements radiate from a center point.

Radiating chapel An apse-shaped chapel, several of which generally radiate from the *ambulatory* in a *Latin cross plan.*

Rasp A rough file that has raised points instead of ridges.

Rationalism The belief that ethical conduct is determined by reason; in philosophy, the theory that knowledge is derived from the intellect, without the aid of the senses.

Readymade Found objects that are exhibited as works of art, frequently after being placed in a new context with a new title.

Realism A style characterized by accurate and truthful portrayal of subject matter; a nineteenth-century style that portrayed subject matter in this manner.

Rectangular bay system A church plan in which rectangular *bays* serve as the basis for the overall design. Contrast with *square schematism.*

Rectilinear Characterized by straight lines.

Reducing phase See *black-figure painting.*

Reformation A social and religious movement of sixteenth-century Europe in which various groups attempted to reform the Roman Catholic Church by establishing rival religions (Protestant sects).

Register A horizontal segment of a structure or work of art.

Regular repetition The systematic repetition

of the visual elements in a work to create *rhythm.*

Reinforced concrete Concrete that is strengthened by steel rods or mesh. Same as *ferroconcrete.*

Relative size The size of an object or figure in relation to other objects or figures or the setting. See *scale.*

Relief printing Any printmaking technique in which the matrix is carved with knives so that the areas not meant to be printed (that is, not meant to leave an image) are below the surface of the matrix.

Relief sculpture Sculpture that is carved to ornament architecture or furniture, as opposed to *freestanding sculpture.* Also see *bas-relief* and *high relief.*

Renaissance A period spanning the fourteenth and fifteenth centuries CE in Europe. The Renaissance (French for "rebirth") rejected medieval art and philosophy; it first turned to Classical antiquity for inspiration and then developed patterns of art and philosophy that paved the way toward the modern world.

Reoxidizing phase See *black-figure painting.*

Representational art Art that presents natural objects in recognizable form.

Republican period The Roman period lasting from the victories over the Etruscans to the death of Julius Caesar (527–509 BCE).

Resolution In video and digital photography, the sharpness of a picture as determined by the number of lines or pixels composing the picture.

Rhythm The orderly repetition or progression of the visual elements in a work of art.

Rib In Gothic architecture, a structural member that reinforces the stress points of *groin vaults.*

Rococo An eighteenth-century style during the Baroque era that is characterized by lighter colors, greater wit, playfulness, occasional eroticism, and yet more ornate decoration.

Romanesque style A style of European architecture of the eleventh and twelfth centuries that is characterized by thick, massive walls, the *Latin cross plan,* the use of a *barrel vault* in the *nave,* round arches, and a twin-towered facade.

Romanticism A nineteenth-century movement that rebelled against academic Neoclassicism by seeking extremes of emotion as enhanced by virtuoso brushwork and a brilliant palette.

Root five rectangle A rectangle whose length is 2.236 (the square root of 5) times its width that can be constructed by rotating the diagonal of a half square left and right.

Rosette A painted or sculpted circular ornament with petals and leaves radiating from the center.

Rose window A large circular window in a Gothic church, assembled in segments that resemble the petals of a flower, usually

adorned with stained glass and plantlike ornamental work.

Rubeniste Those Romantic artists who took Peter Paul Rubens as their model. Contrast with *Poussiniste.*

Salon An annual exhibition of the French Academy held in the spring during the eighteenth and nineteenth centuries.

Salon d'Automne An independent exhibition of experimental art held in the autumn of 1905; named the "Salon of Autumn" to distinguish it from the Academic salons that were usually held in the spring.

Sanguine Blood colored, ruddy; cheerful and confident (from Latin for "blood").

Sarcophagus A coffin or tomb, especially one made of limestone.

Satin weave A weave in which the woof passes above and below several warp threads at a time.

Saturation The degree of purity of hue measured by its intensity or brightness.

Scale The relative size of an object compared to other objects, the setting, or people.

Sculpture The art of carving, casting, modeling, or assembling materials into three-dimensional figures or forms; a work of art made in such a manner.

S curve Developed in the Classical style as a means of balancing the human form, consisting of the distribution of tensions so that tension and repose are passed back and forth from one side of the figure to the other, resulting in an S shape; *contrapposto.*

Seal A design or stamp placed on a document as a sign of authenticity.

Secondary color A color that is derived from mixing pigments of primary colors in equal amounts. The secondary colors are orange (obtained by mixing red and yellow), violet (red and blue), and green (blue and yellow).

Serigraphy A printmaking process in which stencils are applied to a screen of silk or similar material stretched on a frame. Paint or ink is forced through the open areas of the stencil onto paper beneath. Also termed *silkscreen printing.*

Service systems In architecture, mechanical systems that provide structures with transportation, heat, electricity, waste removal, and other services.

Shade The degree of darkness of a color determined by the extent of its mixture with black.

Shaft grave A vertical hole in the ground in which one or more bodies are buried.

Shape An area within a composition that has boundaries that separate it from its surroundings.

Shaped canvas A canvas that departs from the traditional rectangle and often extends the work into three-dimensional space, thus challenging the traditional orientation of a painting.

Shinto A major religion of Japan that emphasizes nature and ancestor worship.

Shiva The Hindu god of destruction and regeneration.

Shrine A repository for sacred relics and art objects intended to arouse feelings of religious devotion. A small structure or area intended for private religious devotion; a site or structure used in religious devotion.

Shutter In photography, a device for opening and closing the aperture of a lens so that the film is exposed to light.

Siding In architecture, a covering for an exterior wall.

Silica A hard, glossy mineral compound of silicon and oxygen.

Silkscreen printing A printmaking process in which stencils are applied to a screen of silk or similar material stretched on a frame. Paint or ink is forced through the open areas of the stencil onto paper beneath. Also termed *serigraphy.*

Silverpoint A drawing medium in which a silver-tipped instrument inscribes lines on a surface that has been coated with a *ground* or pigment.

Slip In ceramics, clay that is thinned to the consistency of cream for use in casting, decorating, or cementing.

Slow motion A cinematographic process in which action is made to appear fluid but slower than actual motion by shooting a greater than usual number of frames per second and then projecting the film at the usual number of frames per second.

Soft-ground etching An etching technique in which a ground of softened wax yields effects similar to those of pencil or crayon drawings.

Sound track An area on the side of a strip of motion picture film that carries a record of the sound accompanying the visual information.

Square schematism A church plan in which the crossing square serves as the basis for determining the overall dimensions of the building. Contrast with *rectangular bay system.*

Squeegee A T-shaped tool with a rubber blade used to remove liquid from a surface.

Stainless steel Steel that has been alloyed with chromium or other metals to make it virtually immune to corrosion.

Stamp To impress or imprint with a mark or design.

Steel A hard, tough metal composed of iron, carbon, and other metals, such as nickel or chromium.

Steel cable A strong cable composed of multiple intertwined steel wires.

Steel-cage construction A method of building that capitalizes on the strength of steel by piecing together slender steel beams to form the skeleton of a structure.

Stele (or **stela**) An engraved stone slab or pillar that serves as a grave marker.

Stereoscopy An illusion of three-dimensionality created by simultaneously viewing two photographs of a scene taken from slightly different angles (as the scene would be seen by a pair of eyes).

Stippling Drawing or painting small dots or dabs to create shading or a dappled effect.

Stoicism The philosophy that the universe is governed by natural laws and that people should follow virtue, as determined by reason, and remain indifferent to passion or emotion.

Stoneware A ceramic that is fired at 2,300°F–2,700°F. The resulting object is usually gray but can be tan or reddish. Stoneware is nonporous or slightly porous and is used in dinnerware and ceramic sculpture.

Stop In photography, the aperture of a lens, which is typically adjustable; the "f-number."

Stopped time In photography, an image that captures action in midmovement by exposing the film very briefly.

Stroboscopic motion The creation of the illusion of movement by the presentation of a rapid progression of stationary images, such as the frames of a motion picture.

Stupa A dome-shaped Buddhist shrine.

Style A characteristic manner or mode of artistic expression or design.

Stylobate A continuous base or platform that supports a row of columns.

Stylus A pointed, needlelike tool used in drawing, printmaking, making impressions on electronic media, and so on.

Subtractive process In sculpture, the removal of material, as in carving. Contrast with *additive process.*

Subversive texture Texture that is chosen or created by artists to foil or undermine our ideas about the objects that they depict.

Support A surface on which a two-dimensional work of art is made.

Surrealism A twentieth-century art style whose imagery is believed to stem from unconscious, irrational sources and that therefore takes on *fantastic* forms. Although the imagery is fantastic, it is often rendered with extraordinary realism.

Symmetrical balance Balance in which imagery on one side of a composition is mirrored on the other side. Symmetrical balance can be pure, or it can be *approximate,* in which case the whole of the work has a symmetrical feeling but with slight variations that provide more visual interest than would a mirror image. Contrast with *asymmetrical balance.*

Symmetry Similarity of form or arrangement on both sides of a dividing line.

Synthetic Cubism The second phase of Cubism, which emphasized the form of the object and constructing rather than disintegrating that form.

Synthetism Gauguin's theory of art, which advocated the use of broad areas of unnatural color and primitive or symbolic subject matter.

Telephoto lens A lens that is shaped and distanced from the photosensitive surface so that it produces large images of distant objects.

Tempera A kind of painting in which pigments are mixed with casein, size, or egg—particularly egg yolk—to create a dull finish.

Tenebrism A style of painting in which the artist goes rapidly from highlighting to deep shadow, using very little modeling.

Tensile strength The degree to which a material can withstand being stretched.

Terra-cotta A hard, reddish brown earthenware used in sculpture and pottery; usually left unglazed.

Tertiary colors Colors derived from mixing pigments or primary colors and the secondary colors that adjoin them on the color wheel.

Texture The surface character of materials as experienced by the sense of touch.

Texture gradient The relative roughness of nearby and distant objects in two-dimensional media; nearby objects are usually rendered with more detailed and rougher surfaces than distant objects.

Tholos In architecture, a beehive-shaped tomb.

Throwing (a pot) In ceramics, the process of shaping that takes place on the potter's wheel.

Tie-dyeing Making designs by sewing or tying folds in cloth to prevent a dye from reaching certain areas.

Tier A row or rank.

Tint The lightness of a color as determined by the extent of its mixture with white.

Transept The "arms" of a *Latin cross plan,* used by pilgrims and other visitors for access to the area behind the crossing square.

Transverse rib In architecture, a rib that connects the midpoints of a *groin vault.*

Tribune gallery In architecture, the space between the *nave* arcade and the *clerestory* that is used for traffic above the side aisles on the second stage of the elevation.

Triforium In a church, a gallery or arcade in the wall above the arches of the *nave, transept,* or *choir.*

Triglyph In architecture, a panel incised with vertical grooves (usually three; hence, *triglyph*) that serve to divide the scenes in a *Doric frieze.*

Trompe l'oeil A painting or other art form that creates such a realistic image that the viewer may wonder whether it is real or an illusion (from French for "fool the eye").

Truss A rigid, triangular frame used for supporting structures such as roofs and bridges.

Twill weave A weave with broken diagonal patterns.

Two-point perspective Linear perspective in which two vanishing points are placed on the horizon line.

Tympanum Semicircular space above the doors of a cathedral.

Typography The art of designing, arranging, and setting type for printing.

Umber A kind of earth that has a yellowish or reddish brown color.

Unity The oneness or wholeness of a work of art.

Upper Paleolithic The later years of the Old Stone (Paleolithic) Age.

Value The lightness or darkness of a color.

Value contrast The degrees of difference between shades of gray.

Vanishing point In linear perspective, a point on the horizon where parallel lines appear to converge.

Vantage point The actual or apparent spot from which a viewer observes an object or picture.

Vault In architecture, any series of arches other than an *arcade* used to create space. See *barrel vault* and *groin vault.*

Vehicle A liquid such as water or oil with which pigments are mixed for painting.

Veneer In architecture, a thin layer of high-quality material used to enhance the appearance of the facade of a structure.

Venus The Roman goddess of beauty; a prehistoric fertility figure, such as the Venus of Willendorf.

Venus pudica A Venus with her hand held over her genitals for modesty.

Vertical balance Balance in which the elements in the top and bottom of the composition are in balance.

Video A catch-all term for several arts that use a video screen or monitor, including, but not limited to, commercial and public television, *video art,* and *computer graphics.*

Video art Works that use a video screen or an assemblage of screens or monitors; images shown on video monitors.

Visible light That segment of the spectrum of electromagnetic energy that excites the eyes and produces visual sensations.

Visitation In Roman Catholicism, the visit of the Virgin Mary to Elizabeth; a church feast commemorating the visit.

Visual elements Elements, such as line, shape, color, and texture, that are used by artists to create imagery. Also termed *plastic elements.*

Visual texture Simulated texture in a work of art; the use of line, color, and other visual elements to create the illusion of various textures in flat drawings and paintings. Contrast with *abstract texture.*

Visual unity The unity in a work of art as created by use of visual elements. Contrast with *conceptual unity.*

Vitrify To become hard, glassy, and nonporous.

Volume The mass or bulk of a three-dimensional work; the amount of space such a work contains.

Volute In architecture, a spiral scroll ornamenting an Ionic or Corinthian capital.

Volute krater A wide-mouthed vessel (krater) with scroll-shaped handles.

Voussoir A wedge-shaped stone block used in the construction of an arch.

Ware Pottery or porcelain; a good to be sold by a merchant.

Warm color Colors—reds, oranges, and yellows—that appear to be warm and to advance toward the viewer. Contrast with *cool colors.*

Warp In weaving, the threads that run lengthwise in a loom and are crossed by the weft or woof.

Wash A thin, watery film of paint, especially watercolor, applied with even, sweeping movements of the brush.

Watercolor A paint with a water medium. Watercolors are usually made by mixing pigments with a gum binder and thinning the mixture with water.

Weaving The making of fabrics by the interlacing of threads or fibers, as on a loom.

Webbing In architecture, a netlike structure that composes that part of a ribbed vault that lies between the ribs.

Weft In weaving, the yarns that are carried back and forth across the warp. Also called *woof.*

Weight-shift principle The situating of the human figure so that the legs and hips are turned in one direction and the chest and arms in another. This shifting of weight results in a diagonal balancing of tension and relaxation. See *contrapposto.*

Wide-angle lens A lens that covers a wider angle of view than an ordinary lens.

Woodcut Relief printing in which the grain of a wooden matrix is carved with a knife.

Wood engraving A type of relief printing in which a hard, laminated, nondirectional wood surface is used as the matrix.

Woof See *weft.*

Wordwork A contemporary work of art whose imagery consists of words.

Zen a Buddhist sect that seeks inner harmony through introspection and meditation.

Ziggurat A temple tower in the form or a terraced pyramid, built by ancient Assyrians and Babylonians.

Zoogyroscope An early motion-picture projector.

Zoom To use a zoom lens, which can be adjusted to provide long shots or close-ups while keeping the image in focus.

INDEX